FRENCH PAINTING
FROM THE PUSHKIN MUSEUM

17th to 20th CENTURY

Irina Kuznetsova

*Director, Department of Western European
and American Art*

Evgenia Georgievskaya

Chief Curator

HARRY N. ABRAMS, INC., PUBLISHERS, NEW YORK

AURORA ART PUBLISHERS, LENINGRAD

Layout and design by I. Zhikharev

Translated by V. Friedman and Yu. Pamfilov

Library of Congress Catalogue Card Number: 78-8817
International Standard Book Number: 0-8109-0909-X

Created by Aurora Art Publishers, Leningrad,
for joint publication of Aurora and Harry N. Abrams,
Incorporated, New York

Printed and bound in the USSR

CONTENTS

THE PUSHKIN MUSEUM OF FINE ARTS IN MOSCOW

The idea of a Moscow museum of fine arts was conceived in the eighteenth century. One of its advocates at the time was the first rector of the Moscow University, Alexei Argamakov. Later, in 1831, *The Telescope* magazine published a program for "an aesthetical museum." In 1857, when a chair of art history was begun at the Moscow University, its first professor, Karl Herz, again spoke about the necessity to open an art museum. But it was not until the early twentieth century that this idea began to be put into practice. The heart and soul of this project was Herz's successor, Professor Ivan Tsvetayev (1847—1913), who had made its realization his life work.

From the late eighteenth century the Moscow University had owned a collection of coins and medals known as the "Münzkabinett." At the end of the nineteenth century it acquired a collection of plaster casts taken from antique sculptures. These two collections were to become the cornerstones of the future museum. Tsvetayev, who managed to enlist broad public support of the project, took active steps to ensure the growth of these collections and to begin the construction of a special museum building that was to house an exposition of casts representing masterpieces of European sculpture from antiquity to the Renaissance. From the very start the founders of the museum intended to enlarge its collections by introducing original works of art. In 1909, when the museum building was still under construction,[1] the museum received its first donation (from the diplomat Mikhail Shchokin) — eight paintings of the Italian school. In 1911 it received the famous collection of Egyptian antiquities which had formerly belonged to Vladimir Golenishchev. In 1912, after the building had been completed, the museum was formally inaugurated as the Emperor Alexander III Museum of Fine Arts affiliated to the Moscow University.[2]

The October Revolution ushered in a new stage in the life of the Museum. Among the first decrees of the Soviet State signed by Lenin in 1918 there was a decree on nationalization of the biggest private art collections. Subsequently they were handed over to state museums. A special decision taken in November, 1923, transformed the Museum of Fine Arts from a branch of the Moscow University into a self-governing institution. Its collections were to be enlarged by original works of art, especially by paintings.

Now the main concern of the Museum was organization of the picture gallery. Very soon, in January 1924, it received more than 300 canvases by Old Masters which had formerly belonged to the Rumiantsev Museum.[3] They were followed by paintings and sculptures from the famous collection of Dmitry Shchukin which after the nationalization of 1918 had formed a museum of old Western European painting. Before the end of 1924 the Museum also received 180 pictures from the Moscow collection of G. Brocard, 174 canvases from the Hermitage, and a number of excellent works from Yusupov's and Shuvalov's collections, the Tretyakov Gallery and the State Museum Reserve. On November 10, 1924, the Museum opened the first two rooms of its new picture gallery which were devoted to Netherlandish, Dutch and Old German art and also included an exposition of French paintings transferred from Leningrad collections.

In 1925 the Museum continued its collecting activities on an even larger scale. The further transfers from the Hermitage, the Tretyakov Gallery and various Moscow collections were accompanied by new important additions from the Yusupov and Shuvalov collections which had

contained many outstanding masterpieces. To mark the anniversary of the October Revolution, the Museum opened the rooms of Italian, Flemish and French painting, thus bringing to an end the first stage in organizing its picture gallery.

During this crucial period in the life of the Museum, its first director, Professor Nikolai Romanov (1867—1948), was directly responsible for the reorganization and development work. His closest assistants were Abram Efros (1888—1954), Curator of the picture gallery from 1928, and Professor Victor Lazarev (1897—1976) who in 1929 succeeded Efros as Curator of the picture gallery.

At the head of a group of young specialists who came to the Museum when its picture gallery was being organized, Romanov carried out tremendous work, exploring the state museum reserves, selecting pictures from a host of different collections, classifying them and undertaking their scientific investigation. It was a laborious task to unite in a harmonious whole the material of so many different collections. In some sections the gallery tended to become overburdened with works that did not differ considerably from one another, while in others there remained lacunas. Superfluous material was handed over to other museums, and at the same time no effort was spared in obtaining such works as were needed to make the exposition representative of all the links in the development of European art.

At the end of the first four years the character of the gallery was more or less defined. The sections of the Dutch and French schools, which included many first-rate works, were its best and most representative expositions. But even here there were some gaps that prevented a full historical survey of the artistic process. What the gallery was lacking were large, fundamental works. Such canvases could be obtained only from the Hermitage. The problem was studied by a special commission of experts which elaborated a plan for redistributing some of the museum treasures. It enabled the Hermitage to get some pictures from the Moscow Museum of Modern Western Art for its exposition of modern French painting. In turn, some of its Old Masters were to be handed over to the Museum of Fine Arts. As the result of this transfer, which took place in 1930, the Museum became the owner of seventy-three canvases which included masterpieces by Poussin, Rembrandt, Rubens, and Murillo. It considerably increased the importance of the gallery, making it one of the best European art depositories.

The first period in the formation of the gallery came to an end. In subsequent years the main source of its enlargement were purchases. They were made according to the decisions of the Museum Board of Experts, this work being directed by Professor Boris Vipper (1888—1967) who was then in charge of all the research activities in the Museum.

A very important addition was made to the gallery in 1948, when it received more than 200 pictures from the Museum of Modern Western Art. Most of the canvases transferred from this excellent collection were works by French painters—Manet, Monet, Pissarro, Renoir, Degas, Cézanne, Gauguin, Matisse. There were also some paintings by Van Gogh, Van Dongen, Miro and Picasso—the artists whose life and œuvre were inseparable from French culture. This last transfer greatly enriched the French exposition and, in particular, extended its chronology: now it included many works of the twentieth century. With the new masterpieces the artistic importance of the whole gallery increased considerably. Now its general character, correlation of different national schools and historical periods took a definite shape. The time of radical changes apparently was over. Nevertheless, the gallery continued to grow.

Apart from regular acquisitions, the collection increased in size and value as a result of bequests and donations which came from the artists themselves (Léger, Guttuso, Manzù, Kent, and others) and from collectors in the Soviet Union and other countries.

The Museum organizes many temporary and loan exhibitions. Very often they are devoted to French art, as the Museum collection can provide any amount of material. Many French

paintings of the seventeenth to twentieth centuries were displayed in Moscow (1955) and Leningrad (1956). Large one-man exhibitions devoted to the art of Cézanne and Marquet were held in Moscow and Leningrad (1956, 1958 and 1959). French works of the 1850s to the 1890s were sent by different Soviet art museums to the Moscow exhibition of 1960. The centenary of Matisse was marked in 1969 by a large show of his work organized jointly with the Hermitage. The French school was widely represented in the display of new acquisitions mounted by the Museum in 1969, at the exhibition of Western European portraiture from the fifteenth to the early twentieth century (1972) and the exhibition of Impressionist painting in 1974.

French paintings from the Museum collection often appear in exhibition halls of Brussels, Montreal, London, Paris, Bordeaux, Prague, Tokyo, Vienna, Rotterdam, New York and many other cities of the world.

Several times during the year one can see new colors flying on flagstaffs in front of the Pushkin Museum. These are the national flags of the countries that have sent in their expositions or individual masterpieces of art.

The magnificent collection of the Moscow Museum makes an important contribution to the cultural exchanges between the Soviet Union and other countries of the world.

I. KUZNETSOVA
E. GEORGIEVSKAYA

FRENCH PAINTING OF THE SEVENTEENTH,
EIGHTEENTH AND THE FIRST HALF OF THE NINETEENTH CENTURY

The Pushkin Museum of Fine Arts can justly pride itself on its collection of old French painting. This part of the Museum has some 500 canvases representing all the main genres and schools of that period. Excellent canvases illustrate the art of the seventeenth-century Classicism, Rococo and Empire styles. Many important and typical paintings represent the work of Poussin, Claude Lorrain, Boucher, Joseph Vernet, Fragonard, Greuze, Corot and the magnificent Barbizon School. The pictures by Watteau, Chardin, Delacroix and Ingres are not so numerous, but are also important and characteristic. The development of French landscape painting is traced from Poussin throughout all this period. Excellent canvases by Largillière, Nattier, Vanloo, Duplessis, David and his pupils give an idea of every stage in portrait painting from Louis XIV to the early nineteenth century.

The French collection was formed for the great part in the 1920s. But long before that many of its best pictures were known to the Russian public and influenced its aesthetic tastes: they began to appear in the Hermitage and in galleries of Russian noblemen 150 years before the establishment of this Museum.

The Hermitage art collection was started in 1763, when Empress Catherine II bought from J. E. Gotzkowski, a Prussian merchant, a collection of paintings that he had intended to sell to Frederick II, King of Prussia, but was unsuccessful as the royal treasury was in a deplorable state after the Seven Years' War. Though the bulk of that collection consisted of Dutch and Flemish works, it is thanks to it that the Museum owes its monumental canvas *The Death of Virginia* which was formerly attributed to Simon Vouet.

An important acquisition was the famous Brühl Collection which was purchased for the Hermitage in 1769. Count Heinrich von Brühl (1700—1768), Prime Minister of Saxony under Augustus III, had patronized the Dresden Gallery which during his term of office received its most important works. In his Dresden palace Brühl also had a large picture gallery where, among numerous Dutch and Flemish masters, were some notable French artists. [4] From their works the Museum acquired *Satire on Physicians* by Watteau and *The Denial of St Peter* by Valentin.

The famous Crozat Collection was acquired for the Hermitage in 1772. Its purchase was negotiated in Paris by Diderot. Louis Antoine Crozat, Baron de Thiers (1700—1770), belonged to one of the richest families of France, which produced several generations of art enthusiasts and collectors. The Baron's uncle, Pierre Crozat, a banker who had been appointed royal treasurer, had gathered in his Paris mansion vast collections of drawings, paintings, stone carvings and sculptures. [5] His excellent collection of painting, more than 400 canvases, was bequeathed to his elder nephew Louis François Crozat, Marquis de Châtel. Later its two parts were inherited by his brothers, but finally the famous collection was united again in the hands of the younger brother, Baron de Thiers. The new owner continued to enlarge it, and in his lifetime it won European renown. [6] The acquisition of this collection was probably the most important in the history of the Hermitage.

The French works from this collection, which were subsequently transferred to the Pushkin Museum, include *Satyr and Nymph* by Nicolas Poussin, *Landscape with a Hermit* by François Boucher, two pictures from Raoux's *The Five Senses* series—*The Allegory of Smell* and *The Allegory of Taste, Resting in the Wood* by Francisque Millet, *Singing Lesson* by Santerre, etc.

A number of very good Rubenses, Van Dycks, Rembrandts, and Murillos, seventy-odd works of the Italian school, almost as many German pictures, and twenty-two canvases by French masters of the seventeenth century came to the Hermitage in 1779 from the collection of Sir Robert Walpole (1676—1745), Prime Minister in the reign of George I and George II. Among the French paintings the most important were Poussins. One of them — *The Magnanimity of Scipio* — was transferred to the Museum in 1927. Earlier the Museum received another picture from the same collection — *A Little Town in Latium* by Gaspard Dughet. Until 1862 it had been in the Hermitage and after that in the Rumiantsev Museum.

The pictures from the collections of Brühl, Crozat and Walpole once formed the basis of the Hermitage gallery. Now many of them have been transferred to Moscow.

Very many French paintings of the seventeenth and eighteenth centuries came to the Museum from old Russian collections nationalized after the October Revolution. The most important of them were the collections of the Yusupovs and the Shuvalovs.

Prince Nikolai Yusupov (1751—1831) was the most prominent Russian collector and patron of arts in the late eighteenth and early nineteenth centuries.[7] He spent many years abroad. After his arrival in Paris in 1772 he began to buy works of art, sometimes dealing directly with the artists. At that time he focused his attention on fashionable works by contemporary French masters — Boucher, Vanloo, Vernet, Lancret, and Lemoine. In 1778 his collection, not yet extensive, was seen and appreciated by Bernulis, a well-known scientist and traveler.[8]

During his diplomatic service as ambassador in Turin, Yusupov continued to buy paintings and statues both for his own collection and for the Hermitage. Later, in Paris, he gave a number of commissions to Greuze and bought pictures by Fragonard, Vigée-Lebrun, Hubert Robert and other contemporary masters. Changes in artistic tastes, to which he was always responsive, made him pay attention to works of the Neoclassic movement. Soon he was giving commissions to David and artists of his school — Guérin, François Gérard and Gros. He also took an interest in the extremely popular genre painters — Boilly, Marguerite Gérard, De Marne and others.

After forty years of continuous collecting, during which he met many artists and art connoisseurs and could always afford any purchase, Yusupov succeeded in forming an excellent gallery of Western European painting. A catalogue published in 1839, after the owner's death, listed more than 500 items, including canvases by Rembrandt, Van Dyck, Tiepolo, Murillo, Correggio and other illustrious masters of the sixteenth, seventeenth and eighteenth centuries.

The French section in Yusupov's gallery consisted of 130 paintings. More than any other section, it reflected the owner's personal taste. It had certain lacunas: the art of Poussin or such eighteenth-century masters as Watteau and Chardin was not represented at all. At the same time it included all the main exponents of the Rococo style: Lancret, Natoire, Lemoine, Boucher and others. The principal stages in the development of French landscape painting were illustrated by excellent compositions by Claude Lorrain, Joseph Vernet, Le Prince and Hubert Robert. There were numerous pictures of the late eighteenth and early nineteenth centuries representing different genres, schools and individual artists. Yusupov's heirs made several insignificant additions to the gallery, but basically its character remained unchanged.

After the nationalization of 1918 the Yusupovs' palace in Petrograd was turned into a museum. In 1920, the museum published a new catalogue of the gallery. Four years later the museum in the palace was closed and a greater part of its collection went to the Hermitage and the newly established picture gallery of the Moscow Museum. For the Museum it was a very important acquisition. Among the pictures from Yusupov's gallery, received between 1924 and 1930, there were about forty French works from the seventeenth and eighteenth centuries. They included Largillière's *Portrait of a Lady*, Lancret's *Company at the Edge of a*

Wood, Lemoine's *The Rape of Europa, Hercules and Omphale* by Boucher and two of Claude Lorrain's best works — the famous companion pieces *The Rape of Europa* and *The Battle on the Bridge*. These canvases featured as important links in this section and greatly enriched the gallery as a whole.

The French section also received a number of pictures from the nationalized collections of the Shuvalovs and the Bariatinskys. For several generations members of the Shuvalov family had bought works of art. In Count Shuvalov's St Petersburg palace these works were not arranged in any definite system, their function was purely decorative.

This collection was started in the second half of the eighteenth century. It could not boast great masterpieces, but had interesting canvases, mostly productions of the Italian, Spanish, French and Dutch schools. The Museum received seventy paintings from Shuvalov's St Petersburg palace on the Fontanka. Among the twenty pictures that entered the French exposition the most important were *Christ in the House of Martha and Mary* — a work by Lafosse that had once belonged to Crozat, *Chevalier de Malte* by Tournières, several excellent compositions by Hubert Robert, *Portrait of Count Andrei Shuvalov* by Greuze as well as a large genre scene by the same author — *The Fisrt Furrow*. All these works were important in that they either introduced new names or made the already existing displays more representative.

The pictures that came from the Bariatinsky Collection[9] included Vouet's monumental work, *The Annunciation*. The beautiful, highly artistic portrait of Countess Darya Saltykova, signed by Drouais the Younger, formerly was in the collection of Prince Golitsyn.[10]

The Leuchtenberg Gallery[11] was another important source from which the Museum received many French paintings of the Empire period. That gallery originated in the first half of the nineteenth century.

The large collections of the eighteenth- and early nineteenth-century painting, which contributed so greatly to the Museum's French section, were gathered exclusively by rich noblemen. They marked the early period of art collecting in Russia. Besides them there were other sources — numerous private collections of more recent times — which played an important role in the making of the gallery. These collections were the product of a different epoch which was characterized by other aesthetic ideals and a new approach to artistic heritage.

From the mid-nineteenth century the main figures in art collecting were not aristocrats but progressive intellectuals and men from the middle class who looked upon it as an important public cause. Their interest was focused primarily on works of the Russian school of painting, which in those years was successfully developing. Among the collectors active at that period were Fiodor Prianishnikov, Kozma Soldatenkov, Vasily Kokorev and Pavel Tretyakov. All these men set themselves the task of promoting national culture through propaganda of national art.

The interest in Western European artists, which had weakened temporarily, rose again in the late 1870s. Now, however, the collectors concentrated on contemporary realistic art, which had much in common with the Russian school, rather than on the Old Masters. Characteristic in this respect was the activity of Sergei Tretyakov (1834—1892) who had begun, like his brother Pavel Tretyakov, by collecting Russian paintings, but from the 1870s increasingly turned to works of the Western European schools. His collection was very popular both with professional artists and art lovers.

Sergei Tretyakov bought his pictures from Moscow antiquaries (Corot's *Diana Bathing*, for instance, was bought from the art dealers Boussod and Valadon) and in Paris, at art auctions or directly from the artists. In Paris he often consulted A. Bogoliubov, the author of well-known seascapes and the founder of the Radishchev Art Museum in Saratov. Bogoliubov lived for a long time in Paris and was well acquainted with French artists of the period, espe-

cially with the landscape painters of the Barbizon School. Following his recommendations Tretyakov bought for his collection a considerable number of paintings, among them *The Sea* by Courbet, Fromentin's *Waiting for the Ferryboat across the Nile*, and several works by Troyon and Daubigny.

A good and exacting judge of art, Tretyakov selected his pictures with purpose and system, not allowing himself to buy irrelevant or mediocre works just for the sake of increasing their number. As a result he created a collection of very high artistic quality. Covering the development of French painting from the 1830s until the 1870s, it gave an idea of the most progressive artistic trends of that period. The leading masters of the time, from Géricault and Delacroix to Courbet, Millet and the Barbizon group, were represented by notable works. "Pavel Mikhailovich's brother," wrote Alexei Bakhrushin, a man of theater and literature, "collects paintings by contemporary foreign masters; he does not have very many of them, but all are first-rate."[12] All those who were fortunate to see Tretyakov's collection noted its unique character.

In 1892, on the death of Sergei Tretyakov, all his collections, including eighty-four paintings by Western European masters, were bequeathed to the Moscow Municipal Gallery of Pavel and Sergei Tretyakov. In the Gallery the foreign paintings were displayed in special rooms. In 1925 they were transferred to the Museum and occupied a prominent place in the French exposition, forming a kind of link between the sections of old and new art.

Excellent works by Corot and Barbizon painters came to the Museum from the collection of P. and V. Kharitonenko (from 1920 it had belonged to the Rumiantsev Museum).

Among the Russian collectors of Western painting active at the turn of the century Dmitry Shchukin (1855—1932)[13] was a prominent figure. His first acquisitions, made in the 1880s, marked the beginning of a career that was to last for over thirty years. Shchukin bought most of his pictures in Germany. There he could seek counsel from such authorities on art as Bode, Tschudi and Friedlaender and was able to find some works of remarkable quality. After many years of unceasing activity Shchukin created what could be properly termed a museum. In 1914 he made a will in which he bequeathed his collection to the Rumiantsev Museum. When the collection was nationalized after the October Revolution and formed the basis of the Museum of Old Western Painting, its former owner was appointed special curator. In June 1922, the collection was transferred to the Rumiantsev Museum and later came to the Museum of Fine Arts. On the day when the Museum opened its picture gallery, the People's Commissariat for Education appointed Shchukin a member of the Museum Board and curator of the Italian section. Besides paintings, Shchukin's collection gave the Museum a great number of drawings, sculptures and works of applied art. The collection of painting consisted of 125 works of which 20 belonged to the brush of French masters. The most notable of these were Chardin's grisaille *Autumn*, reproducing a bas-relief by Bouchardon, Boucher's pastel *A Woman's Head*, Lancret's exquisitely colored picture *Portrait of a Lady in the Garden*, a large full-dress portrait of Adelaide of Savoy by François de Troy, several decorative canvases by Hubert Robert, and excellent works by La Joue, Le Prince, Taraval and other eighteenth-century painters.

Much poorer was the collection of G. Brocard which was acquired by the Museum in the first year of its existence. Though numerically it was one of the biggest acquisitions, only a few of the pictures were good enough to be included in the exposition. The illustrious authorship of the paintings given in the catalogue was in many cases unconfirmed. The owner himself "took liberties" with the pictures, having them cut to a desired size or adding details at his will. Subsequently the Museum had to dispose of such works.

The large collections mentioned above supplied the bulk of the material for the French section which covered the period from the seventeenth to the mid-nineteenth century.

Besides these additions a number of interesting works were received from different organizations, archives and local museums. Two characteristic examples are the composition *The Battle of Poltava* by Nattier, a gift of the Sychovka town museum, and *Portrait of Prosper Crébillon* by Joseph Aved, a contribution of the Tiutchev Memorial Museum in Muranovo.

Another important source of enlarging the French collection was the policy of purchases that has been pursued by the Museum since the late 1940s. The acquisitions from recent years included several excellent landscapes by Gaspard Dughet, Joseph Vernet and Hubert Robert, portraits by Voille and Mlle Rivière, Van der Meulen's composition *The Entrance of Louis XIV into Vincennes*, works by Charles Jacques, Eugène Isabey and *The Maypole Celebration* by Jean-Baptiste Pater — a charming canvas that several times during the eighteenth century had been bought for the best Paris collections, but after an auction of 1805 had disappeared.

The best works from the French display of paintings of seventeenth to mid-nineteenth century are reproduced in the book. Below we intend to characterize this collection as a whole. Special emphasis will be laid on its masterpieces, the genres that are represented with greater fullness, and the work of the most important artists.

Different from the paintings of the French Renaissance, rather limited in scope and haphazard, the collection of seventeenth century painting is remarkable for its diversity and high quality of works.

Very notable is the part devoted to Nicolas Poussin in which the art of the great French master is illustrated by pictures of different periods and genres. The earliest of the pictures is *The Victory of Joshua over the Amorites*. Together with another biblical composition, *The Victory of Joshua over the Amalekites*, it was purchased for the Hermitage in the eighteenth century. According to Bellori and Félibien, the artist's first biographers, they could have been painted soon after his arrival in Rome in 1624. The importance of these works is enhanced by the fact that this period in the artist's career still presents many problems to the scholars. It is significant that *The Victory of Joshua over the Amorites* was chosen for Poussin's memorial exhibition in Paris (1960).

The next stage in the painter's work is represented by *Satyr and Nymph*, a picture from the Crozat Collection, and *Rinaldo and Armida* with a subject taken from Torquato Tasso's *Jerusalem Delivered*. With its companion piece, *Tancred and Erminia*, it was bought for the Hermitage in 1766. The vitality of style, the beauty of the faces and figures, and the vigorous coloring executed with powerful strokes of red, blue and yellow united by the general golden tone all reveal the influence of Titian, which is evident in many of Poussin's works of the late 1620s and early 1630s.

The Magnanimity of Scipio, a canvas from the Walpole Collection, is believed to have been painted between 1643 and 1645, after the artist's visit to Paris made by order of Cardinal Richelieu in the early 1640s. This is already the creation of a mature master, and here the Classicist principles of Poussin are set forth with almost mathematical precision. The episode chosen by the painter has a definite ethical message: the triumph of honor and duty over blind passion. The two-dimensional design resembles antique bas-relief compositions. The subject is rendered with utmost clarity, the pose and gestures of each personage indicating the role he plays in the developing drama. The sensuous effects of the "Titian cycle" give way to local harshness of color and sharp, vigorous drawing. The figures are nothing but embodiments of definite human qualities.

The monumental work, *Landscape with Hercules and Cacus*, is characteristic of the artist's late period. Together with another Poussin picture, *Landscape with Polyphemus*, it was acquired in 1772 for the Hermitage. The pictures were bought from Marquis de Conflan in Paris for 3,000 livres. *Landscape with Polyphemus* was dated 1649, and it was believed that

14

Landscape with Hercules and Cacus as its companion piece was painted about 1650. A stylistic analysis made by A. Blunt, one of the leading authorities on Poussin, showed, however, that the picture must have been produced at least five years later. In recent publications it is dated even as late as 1659—60. *Landscape with Hercules and Cacus* is undoubtedly one of the artist's greatest achievements. The scene includes a motif from Virgil's *Aeneid*, but actually it is devoid of narrative or allegorical element. What we see is a broad and majestic portrayal of nature in all its primeval power and beauty.

Good examples of seventeenth-century Classicist landscape painting are *Landscape with a Flock of Sheep* by Francisque Millet, which came to the Museum from Sergei Obraztsov's collection in 1960, and Gaspard Dughet's *A Little Town in Latium*. The latter picture belonged to the Walpole Collection and in 1778 was reproduced in an engraving by J. Mason—a sure proof of its popularity at the time.

The most remarkable among the Museum's Lorrains are *The Rape of Europa* and *The Battle on the Bridge*, both coming from the Yusupov Collection. These are companion pictures signed and dated 1655. Commissioned by Cardinal Chigi (later Pope Alexaner VII), they belonged to his heirs until 1798, when they were bought by Yusupov. Another variant of *The Rape*, dated 1667, is in the Royal Collection in Buckingham Palace (London).

A work of high artistic merit is *Landscape with Apollo and Marsyas*. The picture was once in the Crozat Collection and came to the Museum from the Hermitage. Showing a woodland scenery, it strikes more intimate and lyrical notes than the previous two pictures with their broad and shining expanses of the sea.

A good example of the democratic trend in the art of the 1600s—1650s is Valentin de Boulogne's large canvas *The Denial of St Peter*, representing the evangelic legend in a period setting. A group of soldiers who are playing dice in a dimly-lit room, dramatic contrasts of light and shade — all this calls to mind the favorite motifs and effects of Caravaggism. The Museum does not own any original productions of Louis Lenain, but it has several works of his school. The author of *The Fight* could be Mathieu Lenain or some master of a later period — the problem still awaits its researcher. The motif as well as some details of this interesting picture are evocative of Claude Gillot's *Scène avec deux porteurs de chaise*. A fine specimen of Vouet's decorative style is *The Annunciation*. Its outward effects and dispassionate mastery are presages of academic art. Much more dynamic and vigorous is *The Death of Virginia*. The picture was one of the first acquisitions of the Hermitage. At present its traditional attribution is disputed: some of the authors ascribe it to Jacques de Lestin.

The academic art of the late seventeenth century is represented in several large monumental canvases, mostly with biblical subjects. The most notable are *Noah's Sacrifice* by Sébastien Bourdon, *The Presentation in the Temple* by Laurent de la Hyre, *The Judgment of Solomon* by Louis Boullogne. These as well as some other works show the influence of Poussin's Classicism and the Baroque tendencies derived from Vouet.

The works of Charles Le Brun in the Museum collection show the art of the founder of the Royal Academy from a rather unusual angle. These are *The Crucifixion*, an early canvas dated 1637, and the dynamic profile portrait of Molière.

A noteworthy part of the collection is the gallery of seventeenth- and eighteenth-century portraits. A contrast to the formal portraits by Largillière and François de Troy, with their rich finery skillfully conveyed through the texture of the paint, is the austere monastic image of the moralist writer Jeanne Marie Bouvier by Elisabeth Chéron. A foil to *Duchess de La Vallière Represented as Flora* is Tournières's *Chevalier de Malte*. The first portrait, deliberately artificial and decorative, preludes mythological disguises in portraits of the eighteenth century, the second is obviously related to the realistic tradition of Dutch art.

The conventional approach, characteristic of the time, is combined with subtle psychology in the formal portrait of a man in a red gown by an anonymous painter. The same penetrating insight into the character of the sitter is revealed by Rigaud in his likeness of Fontenelle. Whatever doubts may arise as to its traditional attribution, it must be admitted that it is a good and vivid portrayal. The small piece, *Portrait of a Horseman in Blue*, cannot compare with the aforesaid works in power of characterization. But when you look at this figure, playful and elegant, reminiscent at once of a court rout and a masquerade, you see a whole epoch come to life before your eyes.

Van der Meulen, painter of battle scenes and Court Painter to Louis XIV, is represented by several characteristic works. Beside his effective canvases we see Nattier's *The Battle of Poltava* — the only known battlepiece of this famous portraitist. The picture was commissioned by Peter the Great, who sat for his portrait in Nattier's studio in The Hague. In Russia it soon disappeared, and its whereabouts was not known until after the October Revolution, when it was discovered at the museum of Sychovka, a town in the Smolensk region.[14] In 1926, it was handed over to the Museum. The "Rubensite" Charles de Lafosse is one of the historical painters of Louis XIV's time. The Museum owns several excellent canvases ascribed to this master of coloring, five of them are authenticated. They show the painter's art in evolution, from the early works executed in the traditional style of academism to *Susannah and the Elders*, obviously inspired by Rembrandt, using his glowing tones and vibrating light but handled by Lafosse in his own distinctive manner.

The section of eighteenth-century French art is remarkable for its size and diversity. Canvases illustrating all the artistic genres and trends of the time give a vivid and comprehensive picture of the French school at this stage of its development.

There are two early works by Antoine Watteau—*Satire on Physicians* and *The Bivouac*. Popular characters and scenes from Italian and French comedies were the subjects in many of the master's pictures. *Satire on Physicians* is probably nothing else but a scene from Molière's *Le Malade imaginaire* or *Monsieur de Pourceaugnac*, which were popular in Watteau's time. This farcical scene shows the characteristic features of the artist's early work: elongated figures, a somewhat constrained composition, prevalence of subdued dark tones. It probably belongs to the period of Watteau's apprenticeship in the Paris workshop of Gillot. *The Bivouac* was painted in 1710 as a recollection of a trip to his native Valenciennes which shortly before that had been a war arena. Portraying a group of soldiers during a halt, it has none of the effects peculiar to battle paintings of that period. At the same time it is rich in narrative details, unprettified and keenly observed. Here Watteau already displays his remarkable gift of a draughtsman. Expressive representation of poses and gestures is combined with exquisite hues of the color scheme to lend the picture a highly poetic quality.

Unfortunately, the Museum cannot boast of any *fêtes galantes* to which Watteau owed much of his popularity. On the other hand, this genre is generously illustrated by the works of his followers such as Pater, Quillard and Lancret.

Pater's *Maypole Celebration*, which was acquired by the Museum in 1966, is undoubtedly one of his best works. Here, as in all his work, Pater does not display a gift for portraiture, but the rare beauty of colors testifies to his being a worthy pupil of Watteau. In the mid-eighteenth century the picture was in the Paris collection of Duc de Choiseul which was sold at auction in 1772. After 1805 the painting was lost. An engraving, which for 150 years was the only remembrance of Pater's picture, helped to identify it when the canvas was again offered for sale. After its purchase it was found out that for some time it had belonged to A. Likhachov, an archaeologist and art collector who lived in Kazan and died in 1894. He must have bought it during one of his visits to France in the 1860s or 1870s.

The Museum's four Lancrets are works of very high artistic quality, in no way inferior to the best specimens of the master's art displayed in the Hermitage, the Louvre or the Sans Souci Palace in Potsdam. The attraction of Quillard's *Pastoral Scene* is the poetic landscape with a fine lacework of silver and bluish tones.

In the display of decorative Rococo painting we find the works of Raoux, Taraval, Vanloo, Natoire, Lemoine and other masters. Its most important exhibits, however, are eight canvases by François Boucher, representing practically every facet of his art. The earliest of them is *Hercules and Omphale*. In this youthful work there is already something that characterizes Boucher as a pupil of Lemoine and also an admirer of Rubens: a bold, vigorous stroke, saturated colors, a daring, energetic execution. Next comes *Jupiter and Callisto* (1744), a composition in predominantly light colors, somewhat motley and harsh. It is an example of the artist's later period, when his types were becoming increasingly conventional and the pictorial surface acquired enamellike smoothness. The pastel portrait, *A Woman's Head*, combines the features of the female type common to many of Boucher's works with an attempt at individualization. There are two landscapes in the collection, both remarkable for elegance and masterly composition. *Landscape with a Hermit*, with the subject taken from La Fontaine, is known to have been displayed in the Salon of 1742.

The art of Chardin, unfortunately, is not represented by any of his genre scenes. The Museum possesses only two still lifes, both of high artistic merit. *Still Life with the Attributes of the Arts* comes from the Petersburg collection of Princess Paley. The artist's works on the same subject, but differing in size and composition, are kept in the Hermitage, the Louvre and the Musée Jacquemart-André. A delicate, airy handling and fine harmonies of values make the Pushkin Museum picture one of the master's most successful works.

As a recorder of the life of *tiers état* Chardin influenced the art of Subleyras and Lépicié. Dumont's *Savoyarde* is another example of this realistic democratic trend. The picture was shown by the artist in the Salon of 1748.

The work of Greuze was tremendously popular with the contemporary public, largely due to dreamy-eyed, semidraped figures of young girls of mawkish sentimentality. Greuze, who had a gift for making his subjects at once moralizing and entertaining, was particularly valued by patrons of art. Thus, the gallery of Nikita Demidov, the grandson and heir of the founder of metallurgical works in the Urals, possessed twenty-five canvases by Greuze. Almost as many were included in the collections of Yusupov and Shuvalov. The half-length portrait of Andrei Shuvalov, which was acquired by the Museum from the Shuvalov family collection, testifies to Greuze's outstanding mastery as a portrait painter. *The First Furrow*, showing the marked influence of Rousseau's philosophy, is one of the most significant works in the artist's late years. The picture appeared in the Salon of 1801. The contrast between these two pictures and the canvases on gallant subjects, in the lighthearted and sometimes frankly erotic vein, received from the Yusupov Collection, is an indication of the dual character of this master's art.

The vivacity and temperament of Fragonard's art are vividly illustrated in the three small-scale pieces included in the exposition. Two of them—*A Poor Family* and *A Little Organ-grinder*—come from the Yusupov Collection, which contained four Fragonards (the other two were transferred to the Hermitage). The third work—a small study entitled *At the Fireside*—was discovered in post-revolutionary times by the Mozhaisk District Board of Education. The picture is not signed, but the authorship of Fragonard can hardly be disputed. Everything in this small masterpiece is pervaded by a real sense of life: the dynamic diagonal composition and the bright flashes of color against the dimly-lit brownish background.

A similar motif of a fireplace and stooping female figures can be found in some drawings made by Fragonard during his first Italian trip. *A Poor Family* and *A Little Organ-grinder*,

17

showing a certain influence of Sentimentalism, are marked by freedom and freshness of handling, lyrical feeling combined with sly humor. This raises them above excessive sentimentality which was so common in works of contemporary painters.

Landscape and portraiture are the most fully represented genres in the section containing French eighteenth-century painting.

The magnificent canvases by Drouais the Younger, Vanloo, Aved, Nattier and Tocqué carry on the tradition of formal portrait painting ascending to Rigaud and Largillière. Examples of a newer tendency are the works by Subleyras, Greuze, Labille-Guiard, Vigée-Lebrun and Voille. These artists prefer to place the models in their ordinary setting. The gallery of portraits is completed by the portrait of Louis XVI belonging to the brush of Duplessis—a work remarkable for its fearlessness and force of psychological interpretation.

The gallery of landscapists is dominated by two names: Joseph Vernet and Hubert Robert. The reason why these generally recognized masters are represented by numerous works both at the Hermitage and the Pushkin Museum was their great popularity in Russia. The Museum owns thirteen Vernets illustrating all the stages in the artist's career. The three best works, dated 1746, come from a series of eight pictures that was commissioned by Marquis de Villette. Two of them — *Sunrise* and *Sunset* — still show an attachment to the Classical tradition of Claude Lorrain, combining it, however, with a more accurate and direct representation of the actual scenery. *Landscape in the Style of Salvatore Rosa*, an indication of the impact which the Italian master had on eighteenth-century painting, is a romantic composition with rocks, a cataract and armored warriors. A contrast to it is *View in the Park of Villa Pamphili* — a scene in a corner of contemporary Rome, faithfully rendered and animated by the tiny figures of people who fill the paths and avenues of the park. In the "shipwrecks" of the master's later period the devices and composition become somewhat trite. There was a time when the demand for these theatrically romantic scenes was so great that Vernet was not able to meet all the commissions.

In the time following that of Vernet a notable figure in French landscape painting was Hubert Robert. The Museum owns a considerable number of his works, not all of equally high artistic merit. The best of them are marked, however, by genuine poetical feeling and artistry. A painter as prolific as Vernet, Robert had an extraordinary imagination and ingenuity in composition. He never repeated himself; the works collected in the Museum are another proof of this. The highly decorative style of his work made him a popular painter of murals. His success in Russia was probably even greater than that of Vernet. In St Petersburg he executed panels for the interiors of Shuvalov's palace. His work in Yusupov's country residence Arkhangelskoye is the only surviving example of this kind in the master's legacy.

The works of David, completing the exposition of eighteenth-century French painting, illustrate the two main lines of his art—historical and portrait painting. *Andromache Mourning over Hector* is a smaller version of the picture that David presented in 1783 to the Academy upon application for membership. This work already has all the distinctive features of Neoclassicism which was to reform French art on the eve of the 1789 revolution.

The portrait of a young man, which at different times belonged to large Paris collections and was previously in the gallery of Sergei Tretyakov, was catalogued as *Portrait of Ingres as a Young Man*. At present the identity of the sitter is disputed by many French authors. But, whoever his model was, the great artist has created an image of remarkable spiritual power, which embodies in itself the features of the new romantic generation whose heroes live in the novels of Stendhal, Balzac and Musset.

The Museum exposition gives a very good idea of the art of Neoclassicism. It includes works of all notable artists of the time, with the exception of mature David. We can see here

pictures of different trends and genres, from full-length formal portraits and mythological compositions by Gros, Guérin, Regnault and Wicar to landscapes and genre scenes by minor artists such as Granet, De Marne, Swebach, Drölling and Marguerite Gérard.

The huge equestrian portrait of young Prince Boris Yusupov, the work of Antoine Gros, was commissioned by the model's father, Prince Nikolai Yusupov, during his last sojourn in Paris. When visiting the Salon of 1808, the old prince was captivated by a portrait of Jérôme Bonaparte, King of Westphalia, galloping on a mettled steed. He asked the painter to copy the horse exactly in the portrait of his son. The young prince is dressed in an exotic "Tartar" costume—a reminder of the fact that the family was of Tartar extraction. Though not the artist's best achievement, the picture is interesting as an early manifestation of Romanticism in the field of portraiture.

Next to the works of renowned portraitists (*Portrait of Princess Maria Kochubei* by François Gérard, etc.) we see likenesses painted by less-known artists: Laurent Mosnier and Mlle Rivière.

Mosnier, who emigrated from France during the French revolution of 1789, came to St Petersburg in 1802 and soon became a professor of the Academy. His portrait of Ekaterina Muravyova and her son is imbued with the warmth of genuine feeling.

Mlle Rivière's *Portrait of a Lady with a Lyre* is different from the previous work in that it represents a typified image reflecting the prevailing tastes of the epoch, its aesthetic ideal. Our knowledge of the artist's life is very scarce: we know neither her first name nor the dates of her birth and death. But it is known that she took part in several Salons where invariably she was a success. Anyway, her *Lady with a Lyre* with its precise drawing and pondered composition is an indication of a good classical schooling which characterized the works of even the less talented followers of David.

Pierre Narcisse Guérin, one of the pillars of the Neoclassical style, is represented by two works. *Aurora and Cephalus* differs only slightly from the Louvre picture of the same name. It has a tinge of romantic mysteriousness, but on the whole accords with the rules of orthodox Classicism. The execution of the other work, *Aeneas and Dido*, is marked by greater freedom and artistry. It is a small but beautiful study for *Aeneas and Dido* which is in the Louvre.

A great contrast to these compositions in the grand manner is the work of numerous historical and genre painters who did not win academic laurels but were a success with the public. The Museum owns a large canvas by Granet, the author of *The Inner View of a Gallery in a Capuchin Monastery* which in its time enraptured the Russian artist Alexei Venetsianov. His work belonging to the Museum—*The Painter Jacques Stella in Prison*—was exhibited in the Salon of 1810 and was bought then by Empress Josephine; later it was housed in the Leuchtenberg Gallery.

The leaders of French Romanticism, Géricault and Delacroix, or their famous opponent Ingres, are represented, unfortunately, by very few works. This serious gap is explained by the fact that in the period between the 1820s and 1850s the collecting activity of aristocrats was on the wane, while the new interest in art connected with the ideas of enlightenment, which were disseminated by democratic elements in the Russian public, did not reach its peak until the 1860s and 1870s. For this reason only comparatively few works of the Romantic school found their way into Russian collections. At that time its leading masters, such as Géricault and Delacroix, were still practically unknown in Russia, and romantic painting was mostly illustrated through the works of less important, though fashionable, painters, such as Couture, Paul Delaroche, Horace Vernet and others.

Géricault's *Study of a Male Model* and Delacroix's *After a Shipwreck* are the only examples of their art in the Museum. Like *Portrait of Ingres as a Young Man*(?) by David,

these two pictures came from the collection of Sergei Tretyakov who, as we know, acquired representative works of all notable French painters of the period.

Study of a Male Model, an excellent piece with plastic modeled forms and dramatic highlights, evidently belongs to the time of Géricault's apprenticeship in the workshop of Guérin. The small canvas by Delacroix presents a rather interesting approach to the theme with which the artist concerned himself over many years, from *Dante's Barque* to *The Boat of Don Juan* and numerous versions of *Storm on the Gennesaret Lake*. The work was displayed in the Salon of 1847.

The Museum collection of Corots is large and representative. Originally it included seven highly successful works among which were two masterpieces: *A Gust of Wind* and *Château de Pierrefonds*. Subsequently it grew as a result of purchases and transfers from the State Museum Reserve, and now consists of fourteen pictures ranging from early works of the first Italian period to pictures of the 1870s, one of which is *Diana Bathing*. All these provide a very convincing illustration of the importance of Corot as one of the greatest French landscape painters of the nineteenth century. The Museum also houses very good and characteristic works by Théodore Rousseau, Díaz de la Peña, Dupré, Daubigny and Troyon.

Ingres's *Virgin Adoring the Eucharist* (1841) was commissioned by the successor to the Russian throne, the future Tsar Alexander II. Evidently at the court it was found too "catholic" and very soon was sent to the Academy of Arts. Ingres's angry note referring to the reception given to his picture and to the way it was displayed at the Academy is cited by Lapauze.[15] The picture came to the Museum from the Hermitage. Thirteen years after the execution of this first variant the artist painted a new version in which he substituted images of angels for the figures of Russian saints. This later work is now in the Louvre.

The last link in the display of old French painting belongs to the leaders of the realistic trend — Courbet and Millet. Most of their works in the collection are landscapes representing a new stage in the evolution of the genre which was illustrated in the gallery by so many good examples from the seventeenth century on. Millet's *Brushwood Gleaners* (*Charcoal Burners*) is a very characteristic work, remarkable for brilliance of painterly technique. The Museum's four Courbets include a youthful and little known but very interesting canvas, *In a Hammock*. The best in the collection are *The Sea*,[16] which A. Bogoliubov bought in Paris for Tretyakov's collection, and *A Hut in the Mountains*, a production of Courbet's last years spent in Switzerland. A broad handling of form allied to an expressive elaboration of detail give this small and modest piece a sense of monumentality which makes it comparable with the large seascape. The intensity of color, the richly treated paint surface and delicate effects of lighting — the distinguishing marks of *A Hut in the Mountains* — gave Yakov Tugendhold, an eminent Russian art historian, good reasons to describe it as "one of the starting-points of all contemporary French painting."[17]

Thus we come to the end of our review of French painting from Poussin to Courbet, which was based on the material of the Museum collection. The following pages deal with the second part of the exposition — works by the leading masters of the modern times.

I. KUZNETSOVA

FRENCH PAINTING OF THE SECOND HALF OF THE NINETEENTH AND OF THE TWENTIETH CENTURY

The gallery of modern French painting in the Pushkin Museum has earned a high reputation. Only the largest museums in the world—the Louvre and the Musée National d'Art Moderne (Paris), the Tate Gallery (London), the Metropolitan Museum of Art (New York) and the Art Institute of Chicago—can vie with the Moscow Museum in quality, diversity and scope of their French collections.

The exposition illustrates all the artistic schools and trends developing in French painting during this period: from Impressionism and Post-Impressionism to Symbolism, Fauvism, Cubism and, lastly, Neo-Realism which originated after the Second World War.

The gallery owes its present scope to several generations of collectors, art scholars, museum experts and artists. At the turn of the century art collectors played the main role. After the October Revolution, which attached national importance to museum work, among the gallery's most active builders were many intellectuals: museum experts, art historians and artists.

No one writing about the history of the collection fails to note the extraordinary importance of its founders—Sergei Shchukin and Ivan Morozov. Much has been written about their activities, but there are still important documents in state and museum archives as well as reminiscences and opinions of contemporaries that are known only to few people. Some of them will be mentioned in the present edition and this, we hope, will help to elucidate some facts and even refute certain erroneous views that are current now.[18]

Originally the Museum exposition of modern French painting was based on two famous private collections which in the early 1900s were built up by Moscow art connoisseurs Sergei Shchukin and Ivan Morozov. It also included pictures from the well-known collections of Mikhail Morozov (Ivan Morozov's elder brother) and Ilya Ostroukhov. Like the Tretyakov brothers, these four enthusiasts represented a new type of art collector that took shape in the Moscow artistic milieu during the last decades of the nineteenth century.

In the early 1860s Pavel Tretyakov put forward the idea of establishing a Moscow gallery of Russian and Western European painters.[19] He himself concentrated on a collection of Russian masters, except for a few occasional foreign purchases in the first years. However, his example could not but influence the younger generation of Moscow collectors who were greatly impressed by the success of his gallery and by its bequeathal to the city of Moscow in 1892. His activities were an inspiration to his brother Sergei Tretyakov, a collector of Western European paintings. The catalogue of the Municipal Gallery of Pavel and Sergei Tretyakov, drawn up in 1894 under the heading *Foreign Paintings and Drawings Collected by S. M. Tretyakov*, listed eighty-four items. Among them were canvases by Dagnan-Bouveret, Bonnat, Vollon, Bastien-Lepage, Breton, Cabanel—works which are now in the possession of the Museum.

From the mid-nineteenth century Moscow came to the fore as a center of art collecting in Russia. It was here that the first serious attempts were made to start systematic purchases of contemporary foreign paintings. In 1920, comparing the activities of St Petersburg and Moscow collectors, A. Sidorov, an art historian and himself a collector of drawings, wrote that in St Petersburg "good things were collected, but only those which were generally accepted." On the other hand, "Moscow from the very start concerned itself with the young revolutionary art, which was not yet understood or appreciated."[20]

21

The Morozov brothers, Shchukin and Ostroukhov followed in the footsteps of the Tretyakovs. They all had wide connections in the artistic circles of Russia and Western Europe, particularly France. Some of them were also active as painters, either professional (Ostroukhov) or amateur (the Morozov brothers).

Buying productions of the Impressionists, Van Gogh, Cézanne, Gauguin, Picasso and Matisse long before they began to gain recognition either in Russia or France, the Morozov brothers and Shchukin displayed good judgment and foresight.

The first Russian collector of French Impressionist and Post-Impressionist paintings was Mikhail Morozov (1870—1903).[21] In the early 1890s, though a very young man, he was already a well-known art connoisseur.

Starting from 1891, almost every year Morozov visited Paris.[22] His first trips to France resulted in buying Manet's *The Bar* and Van Gogh's *Seascape at Saintes-Maries*. These were the cornerstones in his collection of late nineteenth-century French painting which was to become very popular with the Russian public.

Morozov must have had an exceptional artistic flair and courage to buy a sketchy work of Manet, when in the artist's own country bitter disputes had hardly died down over the acceptance of his famous *Olympia* by the Louvre (1890). Until now *The Bar* remains the great master's best work in the museums of the Soviet Union. It gives a good idea of Manet's chief merit — his amazing ability to convey the immediacy of the first optical impression. In the mid-1890s, Mikhail Morozov witnessed another dispute going on in Paris: whether the Musée de Luxembourg should accept a collection of Impressionist paintings which in 1894 was bequeathed to it by Gustave Caillebotte.

Morozov's career was cut short by his early death.[23] In 1910, his widow (evidently in pursuance of his will) donated a considerable part of his collection to the Tretyakov Gallery. Besides Russian paintings, the Gallery received works by Manet, Van Gogh and Toulouse-Lautrec. In 1925, they were transferred to the Pushkin Museum.

Many French paintings (for the most part works of Impressionists and Post-Impressionists) came to the Museum from the collection of Ivan Morozov (1871—1921).[24] His first considerable acquisitions of French paintings were made in 1902—3 (prior to that he had concentrated on works of the Russian school). Like his brother, Ivan Morozov was a man of considerable culture. One of his tutors in landscape painting was the artist Konstantin Korovin.[25] In 1900, Ivan Morozov left Tver and settled in Moscow, where he soon made friends with painters and actors whom he met in the house of his brother. From that time on Morozov was in contact with many Russian artists and was known in the artistic circles of France.

Morozov had a predilection for Impressionist and Post-Impressionist painting. One of the first pictures that attracted his attention was Sisley's landscape *Frosty Morning in Louveciennes*. He bought it from Durand-Ruel in 1903. His favorite artists were Monet, Pissarro, Renoir, Sisley. Somewhat later he became attracted to the works of Van Gogh, Cézanne, Signac, Valtat, Bonnard. The year 1907 was the beginning of the most active period in his career as an art collector. In that year Durand-Ruel sold him Monet's *Boulevard des Capucines*, and at Vollard's he bought a number of pictures including two Cézannes — *Peaches and Pears* and *Field by Mount Sainte-Victoire*, Derain's *Drying Sails (Sail Boats)*, Vlaminck's *Boats on the Seine*, six canvases by Valtat, etc. In 1908, his purchases at Vollard's included Renoir's *Baignade dans la Seine*. Bonnard's *Mirror in the Dressing-room* was bought from Bernheim Jeune. Finally, the year 1908 brought Morozov his first Picasso — *The Strolling Gymnasts*, which was also acquired at Vollard's. It may be noted that three years later Morozov wrote to Vollard, asking about the artist's first name. "The answer to your question about Picasso's first name has only been received today: it is Pablo..."[26] answered Vollard to Morozov on June 1911.

Among the acquisitions of 1909 were three canvases by Van Gogh which were bought at the Paris gallery of Druet. Two of them—*The Red Vineyard* and *The Prison Courtyard*—belong to the master's best works. According to Boris Ternovetz, when selecting these pictures in Paris Morozov sought advice from the artist Valentin Serov.[27] Besides Serov, he often consulted Konstantin Korovin, Sergei Vinogradov, Fiodor Botkin, Matisse. Thus, in one of his letters Matisse called his attention to a large canvas by Gauguin which he had seen at an art dealer's in Faubourg-Saint-Honoré.[28]

The final decision, however, was always made by Morozov himself. He would choose his pictures unhurriedly, with deliberation. Sergei Makovsky, the author of the first publication devoted to Morozov's collection (1912), thus described his visits to the gallery: "I remember, on one of my first visits, being surprised to notice a void on the wall which was hung with works by Cézanne. Answering my question, Morozov explained: 'The place is reserved for *a blue Cézanne* (i. e., for a landscape of the artist's late period). I have been considering a purchase for a long time, but cannot make my choice.' For over a year the place remained vacant, and only recently a new magnificent *Blue Landscape*, chosen from dozens of others, has been enthroned next to the other select creations."[29]

In Paris Morozov had an agent whom he occasionally entrusted with purchases and the dispatch of the acquired objects of art to Russia. Morozov kept up correspondence with collectors and art dealers—Durand-Ruel, Bernheim Jeune, Vollard, Druet.[30] He also corresponded with many French artists, including Matisse. When staying in Paris he visited the Salon d'Automne, the Salon des Indépendants, private galleries and studios.[31]

In 1920, Félix Fénéon, a French art critic and author, described Morozov's method of choosing pictures in the following lines: "No sooner had he got off the train than he found himself in an art shop, seated in one of those deep and low armchairs in which a customer would sit, having no wish to rise, looking at the parade of pictures which followed one another in succession, like stills in a film. In the evening Mr Morozov, a spectator capable of great concentration, was too tired even to think of going to the theater. After a few days spent in this way he would leave for Moscow, without having seen anything but pictures and carrying with him several canvases selected during that time."[32]

As a collector known in the French artistic circles Morozov often received invitations from art dealers and painters to visit their galleries or studios.[33] Some of them came from Matisse. "Can I hope," he wrote in 1913, "that during your next visit to Paris you will come to see me? I have two Moroccan pictures that could be of interest to you, but I prefer not to send you their photographs."[34]

Morozov was also in correspondence with Vuillard, Bonnard, Denis, and sometimes commissioned works from them, as well as from Maillol.[35] During a comparatively short period (1903—13) Morozov was able to build up an excellent collection of French art consisting of more than 140 paintings and a considerable number of drawings and sculptures. His last important acquisitions were made in 1913.

Among the pictures that subsequently came to the Museum from Morozov's collection are such excellent works as *Boulevard des Capucines* by Monet, *Baignade dans la Seine* by Renoir, *The Garden of Hoschedé* by Sisley, *Peaches and Pears, Field by Mount Sainte-Victoire, The Banks of the Marne* by Cézanne, *Bathers* — a highly expressive little study by the same master.

Thanks to Ivan Morozov, the Museum owns a very good selection of Van Goghs. The master's three pictures — *The Prison Courtyard, The Red Vineyard* and *Landscape with Carriage and Train* — vividly characterize his art in general and show different stages of its development.

For his collection Morozov acquired Gauguin's still life *Parrots*, remarkable for exquisite color harmonies. He also bought a charming little study by Signac — *Spring in Provence*. His

gallery included characteristic works by Marquet, Derain, Vlaminck. The monumental genre was represented by Bonnard's large decorative panels, *Early Spring in the Country* and *Autumn (Fruit Picking)*.

Along with other pictures by Matisse, Ivan Morozov acquired a youthful work of 1896 — the still life *The Bottle of Schiedam*. It is an indication of his desire to show the master's art in its evolution (the same principle was adopted in selecting canvases by Cézanne). All the works of Matisse that were acquired for his collection were of very high artistic quality. The most notable among them were the still life *Fruit and Bronzes* and the *Moroccan Triptych*.

Morozov bought only three of Picasso's early works: *The Strolling Gymnasts, Young Girl on a Ball* and *Portrait of Ambroise Vollard* (all are now in the Museum collection). In our days the importance of these pictures in Picasso's early period is quite obvious.

Very many paintings came to this section of the Museum from the collection of Sergei Shchukin (1854—1936). As a collector of French painting Shchukin followed the example of Ivan Morozov. Among his first acquisitions, which were made in the late 1890s, there were canvases by Cottet and Simon. In 1897, Fiodor Botkin, who had lived in Paris for many years, called his attention to works by Monet which were displayed in the gallery of Durand-Ruel. At that time Shchukin bought *Lilac in the Sun*. This early piece was followed by many canvases of the artist's mature period. Some of these excellent pictures are now in the Museum: *Luncheon on the Grass*, *The Rocks at Etretat* and *The Rocks at Belle-Ile* — two of Monet's most successful seascapes, two views of the Rouen Cathedral (*Rouen Cathedral at Noon* and *Rouen Cathedral in the Evening*), *Water Lilies*, *Vétheuil* and *Sea Gulls. The Thames in London. The Houses of Parliament*.

Shchukin's collection illustrated every stage in Monet's artistic evolution. Likewise, characteristic works represented the art of other Impressionists and their followers. Suffice it to mention Pissarro's *Avenue de l'Opéra*, Renoir's *Nude*, or Degas's *Dancers in Blue*.

The gallery contained several pictures by Cézanne, the most notable being *Landscape at Aix (Mount Sainte-Victoire)* — one of the artist's late achievements, and the genre composition *Mardi Gras (Pierrot and Harlequin)* — a very rare and valuable example of this kind of painting in his work. At the early stages of his career Shchukin built up a large collection of Gauguins, its gems being *Her Name Is Vaïraumati* and *Are You Jealous?*

Shchukin's gallery had a high reputation in the artistic circles and was known to the Moscow public. Its first systematic description was published in 1908 by P. Muratov. In a letter to his friend Alexander Turygin (1911) Mikhail Nesterov wrote that Sergei Shchukin was buying "French decadents — Puvis, Monet, Manet, Degas, Marquet, Denis, Cézanne, Matisse, Sisley and Pissarro," and further on, "Shchukin also has the best Gauguins, which are worth several hundred thousand francs (the last picture was bought for 100,000 francs)."[36] Shchukin showed a particularly fervent interest in Matisse and Picasso. Their numerous and excellent works formed the bulk of his collection. Matisse was represented by thirty-seven canvases, Picasso by more than fifty, all of the highest quality. Tugendhold wrote: "I have seen many of his (Matisse's — E. G.) exhibitions in Paris and have been to his own studio, but it is only after my visit to Shchukin's house that I can say that I really know Matisse."[37] The fairness of this appraisement was vividly confirmed in 1969 by an exhibition of the artist's works which was held in Moscow and Leningrad to mark the centenary of his birth.

At the time when Matisse had not yet painted his panels for the Barnes Foundation at Merion (USA), Shchukin's gallery was the only place where one could see the best specimens of the artist's monumental and decorative work.[38] It also contained such masterpieces as *Bois de Boulogne*, the still life *Statuette and Vase on an Oriental Carpet*, *Still Life with Goldfish*, *Spanish Woman with a Tambourine* and *The Large Studio*. Matisse maintained friendly rela-

tions with Shchukin and Morozov. In 1911, on Shchukin's invitation, Matisse visited Moscow and St Petersburg.[39]

Shchukin's vast collection of Picassos consisted mainly of Cubist paintings, but there were also some very good early works. At present a greater part of this collection belongs to the Hermitage, Leningrad. Among the paintings that came to the Pushkin Museum are *Spanish Woman from Mallorca, Portrait of the Poet Sabartés, The Rendezvous, Old Beggar and a Boy,* as well as the Cubist works, *A Hut in the Garden* and *Queen Isabeau.* Most of the Picassos acquired by Shchukin were important and characteristic paintings.

Besides the works of Matisse and Picasso, French painting from 1900 to 1914 was represented in Shchukin's gallery by numerous pictures of other contemporary masters. Thus it included seven canvases by Henri Rousseau, nine works of Marquet, sixteen pictures by Derain, paintings by Rouault, Denis and Signac.

In Sergei Shchukin's family all six brothers were engaged in collecting objects of art. Judging from his correspondence with his brother Piotr (1853—1912), the latter owned a considerable collection of French Impressionists.[40] Piotr Shchukin intended to sell a part of his collection and asked Sergei to negotiate the sale with Paris art dealers. In a letter of May 6/19, 1912, Sergei wrote to him from Italy: "I shall be in Paris in the early days of July and shall speak to Durand-Ruel, the Bernsteins (evidently the Bernheims — E. G.), Druet and others about your pictures. On the other hand, it will be regrettable if such good works are sold out of Russia. I, for my part, will be glad to buy some 8 or 10 of your pictures." And further: "I shall give you a good price and am prepared to take your Degas, Renoir, two Monets, Sisley, Pissarro, M. Denis, Cottet, Forain and Raffaëlli."[41]

The discovery of these documents in the archives added to our knowledge of Piotr Shchukin's role as a contributor to the Museum's French collection. Prior to that the history of its formation was associated mostly with the name of Sergei Shchukin. It is to Piotr Shchukin that the Museum owes its best Renoir — *Nude.* The purchase of this canvas, at Piotr's request, was negotiated by his brother Ivan Shchukin with Durand-Ruel in October 1898.[42] In the early 1910s Piotr Shchukin sold his collection, and its best Impressionist paintings entered the gallery of Sergei Shchukin. In those years Sergei Shchukin's gallery was known to many people abroad. Art connoisseurs, artists, museum experts, art historians came to Moscow from different countries in order to see that extraordinary collection.[43]

P. Muratov, the author of the first publication devoted to Sergei Shchukin's gallery, wrote: "According to the expressed will of its collector and owner, Sergei Shchukin, it will be donated to the Municipal Tretyakov Gallery, where it will add to and extend Sergei Tretyakov's collection of European painting."[44] Three years later, in 1911, it was confirmed by Mikhail Nesterov: "Both collections of the Shchukin brothers are intended as a gift to the city of Moscow!"[45] Their intention to offer the collections as a gift to Moscow was evidently inspired by the example of the Tretyakov brothers. Sergei Shchukin's letter to his brother Piotr, sent on May 6/19, 1912, from Italy, also indicates that they had such plans: "You know that I have left my collections to the city."[46]

The author of the book *Mercantile Moscow,* P. Buryshkin, who in the 1920s met Sergei Shchukin in emigration, cites Shchukin's words concerning the fate of his collection: "I did not collect so much for my personal benefit as for the benefit of my country and its people; whatever happens in our land, my collections should remain there."[47] Alexander Benois wrote about him: "His activities as an art collector were not a whim but an exploit..."[48]

One of the collectors of French paintings of the 1850s to 1890s was Ilya Ostroukhov (1858—1929). A landscape painter, the author of the popular picture *Siverko (The North Wind),* he participated in the work of the Society for Circulating Art Exhibitions and was closely con-

nected with the Tretyakov Gallery, where he served on the Board of Trustees. Like the Tretyakov brothers, he was an enthusiastic collector of art and began buying paintings in the 1880s.

The pride of his collection were old Russian icons. There were also about forty foreign paintings — a comparatively modest part, but also characterized by high quality of works. To Ostroukhov the Museum owes the privilege of having in its exposition Manet's *Portrait of Antonin Proust*.

The five leading Moscow collectors of modern French painting — Sergei Tretyakov, Mikhail and Ivan Morozov, Sergei Shchukin and Ilya Ostroukhov — were in contact with one another, exchanging pictures and taking interest in each other's collections. Thus, after the death of Mikhail Morozov, Ostroukhov, as some documents in his archives indicate, made an inventory and evaluation of his collection.[49] Sergei Shchukin is known to have maintained friendly relations with Mikhail Morozov's family.[50] In the early 1900s interest in art collecting brought together Sergei Shchukin and Ivan Morozov.[51]

By 1914, the Moscow collections of the Morozov brothers, Sergei Shchukin and Ilya Ostroukhov became the main depositories of modern French painting in Russia. Their importance will be understood better if we take into consideration some general factors which in those years characterized the artistic life of France and Russia.

By the early twentieth century only some of the Impressionists had been partially recognized in their own country and were represented at the Musée de Luxembourg and the private collections of J. de Camondo, J.-B. Faure, Paul Durand-Ruel, Georges Petit, etc. It was only in 1900 that Ambroise Vollard, following the advice of Degas and Pissarro, began to buy pictures by Cézanne and Renoir.[52]

The favorites of the official art critics were Carolus-Duran, Bonnat, Blanche. Their canvases were given the pride of place at exhibitions. The Salon d'Automne, which was established in 1903, admitted works by Van Gogh, Toulouse-Lautrec, Seurat, Gauguin, Cézanne. In 1901—7 it mounted several retrospective exhibitions of these masters. However, its first shows passed almost unnoticed either in public or official criticism.

Works by Matisse and Picasso appeared at official exhibitions, but they were hardly noticed in the flow of ordinary artistic production. At that time they were collected by very few people: Marcel Sembat bought pictures by Matisse; the Steins in the United States, works by Picasso. The only event that attracted attention of the public and critics was a scandal caused in the artistic circles by a group of Fauvists who appeared in the Salon d'Automne of 1905. The first serious article about Matisse was published by Apollinaire in 1907.[53] The next year the artist himself expounded his views in the article *An Artist's Notes* (*Notes d'un peintre*).[54]

Those collectors abroad who bought examples of the new, unrecognized art usually focused their interest on a certain tendency, or on one or two masters. None of them acquired these works so boldly or on such a scale as did Sergei Shchukin and Ivan Morozov.

The views and tastes of Shchukin and Morozov were strongly influenced by the Russian artistic milieu in which they moved in the 1890s and 1900s. That period was marked by a general democratization of culture, by the rise of new artistic tendencies and, as a result of this, the organization of numerous exhibitions. The new artistic group, The World of Art, held its first exhibition in 1898—99. Exhibitions of Russian and Western European, mostly French, art were regularly shown in Moscow and St Petersburg.[55] French art was a constant subject of discussion among critics and artists. Their attitudes towards the same facts and masters often changed considerably from year to year.[56] The role of the leading collectors and their galleries in the current artistic life was very active. Besides foreign art, they took an interest in contemporary Russian painting. Thus, Ivan Morozov owned many canvases by Mikhail Vrubel, Konstantin Korovin, Piotr Konchalovsky, Ilya Mashkov, Marc Chagall, Mikhail Larionov.

Pictures from the Tretyakov, Morozov and Shchukin galleries appeared at different exhibitions in Moscow and St Petersburg. French paintings from the collection of Sergei Tretyakov, for example, were shown at the French industrial fair held in Moscow, May 1891, and at the display of pictures from Moscow private collections, mounted in 1892.

In 1899, canvases from Sergei Shchukin's collection were shown at the Petersburg international exhibition of painting which was sponsored by *The World of Art* journal. Pictures from Moscow private collections were on display in 1908, at an exposition mounted in the Salon of the *Zolotoye Runo* (*The Golden Fleece*) magazine.

After the October Revolution national artistic heritage became the property of the people. In Soviet legislation there is a special law providing for preservation of cultural monuments. Under the new Constitution of the Soviet Union, the protection of artistic wealth is a duty of every citizen. A scientific approach to revealing, conserving and distributing artistic works ensured an effective and uniform handling of the former private collections, which were nationalized soon after the establishment of the Soviet State.

Sergei Shchukin's gallery was nationalized by a Decree of the Council of People's Commissars of October 29, 1918. This document, signed by Lenin, described the gallery as "a remarkable collection of European, predominantly French, masters of the late nineteenth and early twentieth centuries."[57] The galleries of Morozov and Ostroukhov were proclaimed national property by a Decree of December 19, 1918. Soon after the nationalization Shchukin's gallery, now called the First Museum of Modern Western Painting, was opened in the house that had formerly belonged to Shchukin (8, Znamensky Lane).

The Second Museum of Modern Western Painting, based on Ivan Morozov's collection, was opened on May 1, 1919. The museum was housed in Morozov's mansion (21, Prechistenka Street). The two museums were complementary in that they both represented the French School and even the same masters. The character of the collections dictated the necessity of their amalgamation. In 1923, their administration was united and they formed a single Museum of Modern Western Art. The collections, however, remained in their old buildings and were called respectively the First and the Second Sections of the Museum. Now the museum was more strictly specialized as a collection of Western European art of the nineteenth and twentieth centuries. In 1928, all its exhibits were gathered in one building — the mansion of Ivan Morozov.[58]

Romain Rolland, who visited the museum on June 29, 1935, left the following note in the visitors' book: "Walking round this remarkable museum, I was amazed and deeply moved to see once again some of the excellent canvases which had captivated me in my younger days: Renoir, Claude Monet, and Cézanne, then a budding painter whom Vollard had jealously hidden in his shops. I was fortunate to live in the period which proved to be so fruitful for French art and so significant in the history of painting. I am happy to see this profusion of French paintings thriving under the friendly sky of the USSR."[59]

The collections of the museum grew continuously from the time of its establishment. The first additions were made in the 1920s. Many excellent works by Western European artists came in 1925 from the Tretyakov Gallery. Among them were paintings by Manet, Renoir, Denis, Van Gogh, Gauguin, Toulouse-Lautrec. Before the Revolution most of them had belonged to Mikhail Morozov. During his visit to an exhibition of decorative art (Paris, 1925), the director of the museum, Boris Ternovetz (1884—1941), acquired two paintings, Vlaminck's *Landscape at Auvers* and Ozenfant's still life. He also received a gift for the Museum — several drawings by French artists. It was the beginning of the excellent collection of French drawings of the late nineteenth and twentieth century now belonging to the Pushkin Museum.

From the first years of its existence the Museum's collections were continually added to as a result of donations made by Soviet and foreign artists and private collectors. Later this

practice turned into a worthy tradition. In 1927, the Museum received a gift from Mr Pierre —
Miro's *Composition*. In the same year Jean Lurçat presented two of his works, one of them
Oriental Landscape. Among other donations of that year were André Lhote's *Landscape with
Houses* and Léger's three drawings and the painting *Composition*. Another important source
of enlarging the collection were purchases of pictures displayed at various exhibitions.

In 1928, the Museum of Modern Western Art and the Academy of Arts sponsored an exhi-
bition of modern French art. Among the paintings acquired for the Museum was *La Rue du
Mont-Cenis* by Utrillo. For a long time this picture remained the only painting of the master
in the Soviet Union. Manet's *Portrait of Antonin Proust* was received from the collection of
Ostroukhov. Until 1929 this collection had belonged to the Museum of Icons and Paintings; after
the death of the collector some of his pictures were distributed among other museums.

In the 1920s and 1930s, on the basis of the Museum's French collection, the staff of the
Museum organized numerous exhibitions, both monographic and thematic: an exposition of
works by Cézanne and Van Gogh (1926), a display of French landscape painting of the nine-
teenth and twentieth centuries (1939), an exhibition of Renoir (1941), etc.

A brief catalogue of the Museum's paintings and sculptures was published in 1928. In the
early 1940, Ternovetz and other Museum workers prepared for publication a *catalogue raisonné*,
but their work was interrupted by the war. Later the study of the collection was resumed,
though on a different basis. In 1948, French paintings of the nineteenth and twentieth centuries
from the Museum of Modern Western Art were transferred partly to the Pushkin Museum and
partly to the Hermitage in Leningrad.[60] The reorganization was needed for a more complete
and historically consistent representation of Western European painting in these two museums
of world art, the largest in the Soviet Union.

The post-war years were marked by increasingly active museum work in the country.
During this period the Pushkin Museum received numerous gifts from its friends in the Soviet
Union and abroad. This ensured a steady growth of its French exposition, the collection of
nineteenth- and twentieth-century painting in particular. In 1958, Lydia Délectorskaya pre-
sented an excellent work by Matisse, *Still Life with a Seashell* (1940). In the Museum it is the
only product of the artist's late period. A very good Van Dongen, *Spanish Woman*, was donat-
ed in 1966 by G. Kostaki. Two paintings, by Utrillo and by Dufy, both of very high artistic
merit, are a gift of the Paris art dealer M. Kaganovitch (1969). One of the most generous
donors[61] is Nadia Léger. In 1969 she gave to the Museum two remarkable works of Fernand
Léger: *Reading* (*Portrait of Nadia Léger*) (1949) and *Builders* (1951). Another gift of Délec-
torskaya — Matisse's *Corsican Landscape with Olives* — was received in 1970. An exposition
of French Neo-Realism, and post-war French painting in general, was started by the acquisition
of three canvases by Fougeron. They were bought in 1968, during an exhibition of the mas-
ter's work in the Museum.

The jubilee of the picture gallery in 1974 was marked by the opening of a new exposition
which included French paintings of the 1850s to the 1950s. It was favorably received both by
specialists and the general public. The importance of the inimitable ensemble of masterpieces
in the French exposition of the nineteenth and twentieth centuries stands out with particular
clearness when we compare the Moscow gallery with any of the numerous foreign collections.

To our brief description of the history of the collection and its general character we want
to add a few observations on some of its individual parts.

The two paintings by Edouard Manet can serve as a key to understanding the new tend-
encies that appeared in French painting in the latter half of the nineteenth century. *The Bar*
testifies to the growing interest in depicting ordinary scenes of town life, while the portrait of
the artist's friend Antonin Proust indicates that the traditional formal portraits were giving

way to psychological, realistic portraiture. The novel approach entails new methods of execution: the master's manner is bold and sketchy, the colors are pure and without intermediate tones.

The revolutionary principles of Manet's art were sustained and developed in the works of the Impressionists. The Museum collection of Impressionist painting is remarkable both for its size and representative character.

The achievements of Impressionism in its most important genre — landscape — are shown in numerous and diverse examples. Practically all exponents of this movement — the landscape painters (Monet, Pissarro, Sisley) and the painters of portraits and genre scenes (Renoir, Degas) — contributed to landscape painting.

Eleven magnificent canvases represent the art of Claude Monet, the leader of Impressionism and its most consistent champion. *Luncheon on the Grass* (1866) is unique in that it is a replica of a large canvas of which only two fragments have survived (one belongs to the Louvre, the other is the property of a Paris collector). It was produced a few years before the first public appearance of the Impressionists and concentrated in itself the main postulates of their program: to employ the new methods of painting *en plein air* in order to reveal the beauty, multiformity and mutability of nature, to depict ordinary scenes of contemporary rural and town life. One of Monet's most successful Impressionist works, the townscape *Boulevard des Capucines*, was displayed at the First Impressionist Exhibition.

The master's first work brought to Russia, *Lilac in the Sun*, is believed to have been painted in Argenteuil. The two marine paintings of the mid-1880s, which were done by Monet in Belle-Ile and Etretat, testify to his gift as a painter of seascapes. Some of the other works — two views of the Rouen Cathedral, *Water Lilies* and the view of the Thames in London — give an idea of the principles of late Impressionism.

The exposition includes several landscapes by Camille Pissarro and Sisley. Pissarro's early work *Ploughland* reminds us of his interest in recording rural life, while his *Avenue de l'Opéra* characterizes him as an outstanding master of Impressionist townscape. The small work by Sisley, *Frosty Morning in Louveciennes* (1873), only presages the birth of Impressionist painting *en plein air*. On the other hand, his landscapes *The Garden of Hoschedé* and *The Edge of the Forest at Fontainebleau* are mature creations of Impressionist art.

In the excellent collection of Renoirs two canvases deserve special mention: a study for the portrait of the actress Jeanne Samary and *Nude*. These pictures of the late 1870s, the artist's most productive period, can be ranked with his greatest works.

Three of the Museum's four Degas are devoted to the artist's favorite subject — ballet. The best of them are *Dancers at the Rehearsal* and *Dancers in Blue*.

In spite of some gaps (the exposition does not represent the art of Bazille, Caillebotte and Berthe Morisot), the importance of the collection of the Impressionists, which shows the movement in evolution and the individuality of its leading exponents, can hardly be overestimated.

The exposition of Post-Impressionist painters — Cézanne, Gauguin, Van Gogh — is remarkable for its size and diversity.

The Museum collection of Cézannes, consisting of fourteen paintings, is reputed to be one of the best in the world. It traces the artist's evolution from the early works of the 1860s (*Interior with Two Women and a Child*) to the masterpieces of his last years (*Landscape at Aix*, c. 1905). The collection includes a number of pictures which have won fame: *Mardi Gras* (*Pierrot and Harlequin*), *Peaches and Pears*, *The Banks of the Marne*, *Self-Portrait* and the small study *Bathers*.

Most of the Museum's fourteen Gauguins belong to the Tahiti and Dominique periods. Only one of these pictures, *Café at Arles*, was painted in France. Several works — *Self-Portrait*, *Are You Jealous?*, *The King's Wife*, *The Great Buddha* — were important landmarks in

Gauguin's art. The still life *Parrots* is one of the few examples of the master's work in this genre. In the large canvas *Gathering Fruit* the subject reminds us of the picture *Preparations for a Feast* belonging to the Tate Gallery. The collection of Gauguin's paintings in the Soviet Union has won international reputation. As was noted by Th. Rousseau, an American art historian, France and Denmark own many of the artist's early works, while the masterpieces of the Tahiti period are mainly in the possession of the United States and Russia.[62]

The art of Van Gogh is represented by five canvases, all painted after 1886 in France, and showing well-defined characteristics of his mature style. The most noteworthy in the lot are *The Red Vineyard* and *Landscape with Carriage and Train*. Here is the history of some of these paintings: *The Prison Courtyard* and *Landscape with Carriage and Train* once belonged to Jo Van Gogh-Bönger, the artist's sister-in-law. *Portrait of Dr Rey* (1889, Arles) was the artist's gift to Dr Rey. In 1900, Rey sold it to the Paris art dealer Ambroise Vollard; Sergei Shchukin bought it from the latter and took it to Russia.

The Museum owns two pictures by Toulouse-Lautrec. One of them, the portrait of the singer Yvette Guilbert, carries the author's inscription indicating that he presented it to Arsène Alexandre, critic and editor of *Le Rire*. The excellent canvases by Signac are typical of the artist's style and at the same time characteristic of the principles of Neo-Impressionism of which he was the leader and theorist.

With the exception of Seurat, the gallery comprises all the major French painters of the late nineteenth century. Now, when more than one hundred years have passed since the birth of Impressionism, and the art of Cézanne, Gauguin, Van Gogh and Toulouse-Lautrec has also become history, their contribution to French and world painting can be appraised comprehensively and objectively. Their revolutionary art, which until 1879 was contemporary with the work of Daumier, is now recognized as the most important turning point in French painting at the end of the century.

The importance of the Museum's French collection is also based on the fact that it gives a balanced picture, representing the new art side by side with the work of other schools and trends. It includes paintings by Bastien-Lepage, Dagnan-Bouveret, Lhermitte and Cottet which indicate that the traditions of Courbet and Millet were kept up until the end of the century. The canvases by Cabanel, Gérôme, Bonnat and some other painters are characteristic examples of the art that predominated at the official salons from the 1870s to the 1890s. The symbolist current in French painting is illustrated by the works of Puvis de Chavannes and Odilon Redon. Puvis de Chavannes, a painter of a vivid decorative style, deserves special notice. In *A Poor Fisherman* (1879, a sketch for the Louvre picture), the theme of poverty and misery foreshadows the early works of Picasso. French painting of the 1890s is shown in all its numerous, and often conflicting, manifestations and trends. Among the exhibits representing French art of that period are canvases by Denis, Bonnard and Vuillard which together give a very good idea of the principles of the Nabis. No other museum in the world can boast such magnificent works of Bonnard as the monumental panels *Spring* and *Autumn*.

The collection contains many typical works by the originators and followers of Fauvism: Matisse, Marquet, Manguin, Derain, Vlaminck, Friesz, Dufy. Derain's *Saturday* is an important work ranking with the master's best achievements. Eight landscapes by Marquet, dating from the late 1900s, vividly characterize this outstanding landscape painter of the twentieth century. The art of Henri Rousseau is illustrated by several pictures, including *The Poet and His Muse*. The model for the picture and its subsequent owner was Guillaume Apollinaire.

The large and varied collections of the leading Western European masters of the twentieth century, Picasso and Matisse, complete an exceptionally comprehensive collection of French painting of the late nineteenth and early twentieth centuries.

The collection of Picassos includes paintings from 1900 to 1912. Each of the three stages distinguished in the master's work at that period—Blue, Pink and Cubist—is illustrated by excellent examples. The earliest in the collection, *The Rendezvous*, dates from 1900, the time of the artist's first stay in Paris. The tenor of the work is clearly determined by the young painter's humanistic program. *The Strolling Gymnasts* (Paris, 1901) gives a good idea of the type of painting prevailing in Picasso's early output, when he took his subjects from the life of itinerant actors, clowns and gymnasts. *Young Girl on a Ball*, which is undoubtedly his best early work on this theme, was formerly in the collections of Gertrude Stein and Henri Kahnweiler and was later acquired by Ivan Morozov.

One of the most important canvases of the Blue period—*Old Beggar and a Boy*—was painted in 1903, in Barcelona, to which Picasso returned several times from Paris. The features of tragic desperation, the dramatic expressiveness clearly reveal the influence of his Spanish compatriots, El Greco and Morales. The fact that Picasso was an outstanding twentieth-century portraitist is vividly illustrated by two works in the collection: *Portrait of the Poet Sabartés* (a Spanish poet who was a friend of the artist's) and *Portrait of Ambroise Vollard*. A comprehensive idea of the artist's Cubist production is given by *A Hut in the Garden, Still Life with a Violin, Queen Isabeau* and *Lady with a Fan*.

The Museum collection of Matisses contains examples of his early works, such as *The Bottle of Schiedam, Corsican Landscape with Olives, Bois de Boulogne*, as well as paintings of the mature period (*A Statuette and Vase on an Oriental Carpet, Fruit and Bronzes*). [63]

In 1911—12, working at Issy-les-Moulineaux near Paris, the artist painted *Still Life with Goldfish, The Large Studio, Studio with "La Danse", Corner of the Studio*. The motif of goldfish in an aquarium is known to have been varied more than ten times, but the version belonging to the Moscow Museum excels all the rest in the beauty of color and artistry of composition. Exquisite color harmonies of *The Large Studio* make it one of the artist's best works in the genre of interior composition, which was his speciality. Superb artistry marks his *Moroccan Triptych* (*View from the Window. Tangier, Zorah on the Terrace, Entrance to the Casbah*) as well as the still life *Irises, Arums and Mimosas*. These are works of the Moroccan period, which was very fruitful for Matisse.

Owing to a generous gift of the artist's lifelong friend and secretary, Lydia Délectorskaya, the Museum was able to enlarge its collection by two works produced by Matisse in his later years: *Seated Nude*, a charming little study dating from the 1930s, and *Still Life with a Seashell* (1940), one of the pictures the artist himself was very fond of.

The Museum's ensemble of modern French painting is indeed remarkable for the number and quality of works. Together with the canvases by Léger, Jean Lurçat, Ozenfant, Rouault, Van Dongen, Dufy and pictures by Fougeron, which are more recent acquisitions, the French collection of the late nineteenth and twentieth century now counts more than 240 paintings. The best of them are reproduced in this book.

E. GEORGIEVSKAYA

1 It was designed and built by architect Roman Klein (1858—1924). His other important works in Moscow include the Middle Shopping Center (1902), now called the Central Department Stores, the cinema-theater *Colosseum*, the Borodino Bridge (1912), etc.

2 After the October Revolution it was called the Museum of Fine Arts. Its present name, the Pushkin Museum of Fine Arts, was given it in 1937 in commemoration of the centenary of Pushkin's death.

3 The Rumiantsev Museum (full name — the Moscow Public and Rumiantsev Museum) occupied the mansion which now is known as the old building of the All-Union Lenin Library. It was established in 1862 to include the art collections and the library of Count N. Rumiantsev and some other collections, among them over two hundred paintings from the Hermitage. When in 1924 the Museum was closed, its picture gallery and other collections were distributed among several museums, while the library formed the basis of the Lenin Library which was opened in 1925.

4 The pictures from Count Brühl's gallery were published as a collection of engravings under the title: *Recueil d'estampes gravées d'après les Tableaux de la Galerie et du Cabinet de S. E. Mr le Comte de Brühl*, etc., Dresde, MDCCLIV. (Only the first volume appeared; the second was not published because of the owner's death.)

5 A part of this collection was published by Pierre Crozat in two volumes of engravings under the title: *Recueil d'estampes d'après les plus beaux tableaux et les plus beaux dessins qui sont en France dans le cabinet du Roy, dans celui du Duc d'Orléans et dans d'autres Cabinets*. A Paris, Imprimerie Royale, MDCCXXIX; second ed.: A Paris, chez Bazan, MDCCLXIII.

6 A catalogue of the Crozat Gallery was published under the title: *Catalogue des Tableaux du Cabinet de M. Crozat, baron de Thiers...* A Paris, chez De Bure l'Aîné, MDCCLV.

7 In Yusupov's lifetime his art collections were in Arkhangelskoye, his country residence near Moscow. There they were seen by Pushkin who dedicated to their owner his well-known poem *To a Nobleman*. In Arkhangelskoye these "idols and pictures" were shown to numerous visitors and soon became one of Moscow's cultural attractions. After Yusupov's death the majority of his artistic treasures were taken to the family's St Petersburg residence, where they were practically inaccessible to the public.

8 Johann Bernulis, *Reisen durch Brandenbourg, Pommern, Preussen, Curland, Russland und Pohlen in den Jahren 1777 und 1778*, Leipzig, 1780.

9 Prince Bariatinsky's collection was partly housed in the family's St Petersburg mansion, partly in the country estate Ivanovskoye, in Kursk Province.

10 One part of Prince Golitsyn's collection was in Moscow, the other part — in Bolshie Viazemy, the family estate near Moscow.

11 The excellent collection of the Dukes of Leuchtenberg was brought to Russia from Munich in 1852. At one time it belonged to Eugène Beauharnais, the son of Empress Josephine, who considerably enlarged the vast collections inherited from his mother. For the most part he bought paintings by the Old Masters, but at the same time acquired some works by artists popular at the period. His son, Maximilian of Leuchtenberg, married to the daughter of Tsar Nicholas I, brought the whole collection to St Petersburg. From 1884 the paintings were displayed in the halls of the St Petersburg Academy of Arts.

12 А. П. Бахрушин, *Кто что собирает?*, Moscow, 1916, p. 22.

13 Six Shchukin brothers, the sons of a Moscow merchant, all were devoted collectors of art. Dmitry Shchukin's gallery was displayed in his Moscow house, in Staro-Koniushenny Lane.

14 It was found in Meshchersky's estate Dugino.

15 H. Lapauze, *Ingres*, Paris, 1911, p. 352.

16 In the Tretyakov Gallery Catalogue it was listed as *The Sea at the Shores of Brittany*.

17 Я. Тугендхольд, "Французское собрание С. И. Щукина", *Аполлон*, St Petersburg, 1914, 1—2, p. 8.

18 It particularly concerns the history of S. Shchukin's collection.

19 А. Боткина, *Павел Михайлович Третьяков в жизни и в искусстве*, Moscow, 1951, p. 52.

20 *Творчество*, Moscow, 1920, 7—10, p. 33.

21 M. Morozov was always in touch with the Russian painters V. Serov, K. Korovin, M. Vrubel, A. Vasnetsov, I. Ostroukhov, V. Surikov, V. Perepliotchikov. He often bought their pictures. Among the actors, musicians and singers who visited his house were F. Shaliapin and M. Sadovsky. A frequent guest there was I. Morozov whose views on art collecting were shaped under the influence of his brother.

22 *Воспоминания М. К. Морозовой (урожденной Мамонтовой)*, part 2: 1891—1903, ЦГАЛИ, ф. 1956, оп. 2, ед. хр. 7, л. 96, 101, 102, 108, 111, 125, 142, 156, 162, 163.

23 In an obituary published by the newspaper *Moskovskiye Novosti* (1903, No 281) were the following lines: "We should also pay tribute to the work done by the late M. Morozov on the Committee for the construction of the Emperor Alexander III Museum of Fine Arts attached to the Moscow University."

24 His collection was housed in his Moscow mansion (21, Prechistenka St.).

25 Б. Терновец, "Собиратели и антиквары", *Среди коллекционеров*, 1921, 10.

26 "Je reçois aujourd'hui seulement le renseignement que vous m'avez demandé pour le prénom de Picasso lequel est Pablo..." (Архив ГМИИ, оп. Н/II, л. 18).

27 Б. Терновец, *Каталог собрания И. А. Морозова*, Архив ГМИИ. According to his widow, N. Yavorskaya, B. Ternovetz learned about this directly from I. Morozov.

28 Архив ГМИИ, ф. 13, д. 40.

29 С. Маковский, "Французские художники в собрании И. А. Морозова", *Аполлон*, St Petersburg, 1912, 2, p. 5.

[30] Durand-Ruel's letter to Morozov of October 24, 1907 can give some idea of what were the duties of Morozov's agent in Paris, M. Tarchevsky, and also of his estimation of the pictures he dealt with: "Pursuant to the instructions in your letter, today I have sent Monet's picture, *View of London*, to your representative M. Tarchevsky, 46, Rue de la Petite Ecurie. To my regret, I couldn't deliver simultaneously the other work of this master, *Le Boulevard des Capucines*, as it has not yet arrived. You know that it was sent to the Mannheim exhibition which will last until the 20th. I hope we shall receive it without delay. Then we shall send it directly to your representative. P.S. Your representative did not wish to take upon himself the picture we have sent him, saying that, being unable to dispatch both pictures at once, he would not like to keep a picture of such value." (Архив ГМИИ, H/5, л. 28.)

[31] I. Morozov was an honorary member of the Salon d'Automne Society, on a par with such prominent figures of French culture as Anatole France, Claude Debussy and the well-known Paris collectors Cheramy and J. de Camondo.
The library of the Pushkin Museum houses catalogues from the Salons d'Automne and the Salons des Indépendants of 1903—13 with notes made by I. Morozov. From short pencil notes in the Salons d'Automne catalogues of 1909—10 we can learn what artists interested him at the time. These were Ch. Guérin, Lacoste, Valtat, Bonnard, Van Dongen, Le Fauconnier, Metzinger.

[32] "...Et à peine hors du train, il s'installait dans les fauteuils des boutiques d'art, lesquels sont bas et profonds afin que l'amateur renonce à se relever cependant que passent devant lui des toiles dont la succession s'enchaîne comme les épisodes d'un film. Le soir, M. Morosoff, regardeur singulièrement attentif, était trop fatigué pour aller même au théâtre. Après des jours de ce régime, il repartait pour Moscou n'ayant vu que des tableaux; il en emportait quelques-uns, pièces de choix." (*Bulletin de la vie artistique*, May 15, 1920.) Cited after the book: F. Fénéon, *Au-delà de l'Impressionnisme* (présentation par Françoise Cachin), Paris, 1966, p. 152.

[33] Examples of these are a letter from Druet (Архив ГМИИ, H/II, л. 4, letter of April 4, 1910) and a letter from J. Manouri, the owner of a private gallery in Paris (Архив ГМИИ, H/II, л. 14, letter of 1911).

[34] "Puis-je espérer, à votre prochain voyage à Paris, avoir votre visite; deux importants tableaux du Maroc que j'ai chez moi pourraient vous intéresser; je préfère ne pas vous en envoyer la photographie." (Архив ГМИИ, ф. 13, д. 40.)

[35] In 1908—9, upon Morozov's order, Denis painted eleven panels, *The Story of Psyche*. They were intended for the concert hall in Morozov's mansion. Now these works belong to the Leningrad Hermitage.
In 1910—12, Maillol produced four bronze figures for the grand hall of the same mansion: *Pomona* (1910), *Flora* (1911), *Female Figure* (1912) and *Woman with Flowers* (1912). All are now at the Pushkin Museum.
In 1911, Bonnard painted a triptych, *The Mediterranean*, which had been commissioned by Morozov for the main staircase of his mansion. Now the work is at the Leningrad Hermitage. Large decorative panels, *Early Spring in the Country* and *Autumn (Fruit Picking)* (*Spring* and *Autumn*, 1912), also executed by Bonnard on Morozov's commission, are now at the Museum.

[36] М. Нестеров, *Из писем*, Leningrad, 1968, p. 197.

[37] Я. Тугендхольд, "Французское собрание С. И. Щукина", *Аполлон*, 1914, 1—2, с. 23.

[38] The works referred to are the panels *The Dance* and *Music* painted by Matisse in 1910. They were intended by Shchukin for his house. Now both are at the Leningrad Hermitage.

[39] Documents confirming Matisse's visit to St Petersburg were published by Yu. Rusakov (Ю. А. Русаков, *Матисс в России осенью 1911 года*, in: *Труды Государственного Эрмитажа*, vol. 14, Leningrad, 1973, pp. 167—184).

[40] Piotr Shchukin also kept his collection in Moscow.

[41] ГИМ ОПИ, ф. 265, ед. хр. 213, л. 62, 63.

[42] Here is what Ivan Shchukin wrote to his brother Piotr from Paris on October 3, 1898: "In accordance with your desire, I called on Durand-Ruel to ask about the price of Renoir's *Nude* (at the exhibition the picture was hanging close to the entrance, on the left side). At first Durand-Ruel declared that this work—one of Renoir's best, and this is quite true — was part of his private collection in the Rue de Rome. But since he had named the price, he agreed to sell it. The price is 15,000 francs. He wouldn't accept less than that." (ГИМ ОПИ, ф. 265, ед. хр. 208, л. 37 и об.)

[43] Here are some lines from S. Shchukin's letter to Matisse of October 10, 1913: "It is two weeks since my return to Moscow and during that time I've had the pleasure of a visit from Mr. Osthaus, founder of the museum of Hagen, and again the visit of many museum directors (Dr. Peter Tessen of Berlin, Dr. H. von Trenkmold of Frankfort, Dr. Hampe of Nuremberg, Dr. Polaczek of Strassburg, Dr. Sauerman of Flensburg, Dr. Stettiner of Hamburg, Dr. Back of Darmstadt, Max Sauerlandt of Halle, and Jens Thiis of Christiania). All these gentlemen looked at your pictures with the greatest attention and everybody called you a great master ('ein grosser Meister'). Mr. Osthaus has come here twice (once for luncheon, once for dinner). I observed that your pictures made a deep impression on him... Jens Thiis, director of the museum of fine arts in Christiania (in Norway), spent two days in my house studying principally your pictures (the second day he stayed from ten o'clock in the morning until six in the evening)...
"Mr. Morosov is ravished by your Moroccan pictures. I've seen them and I understand his admiration. All three are magnificent. Now he is thinking of ordering from you three big panels for one of his living rooms. He is returning to Paris the 20th of October and will speak to you about it." (A. Barr, *Matisse. His Art and His Public*, New York, 1951, p. 147.)

[44] П. Муратов, *Щукинская галерея*, Moscow, 1908, p. 117.

[45] М. Нестеров, *op. cit.*, p. 197.

[46] ГИМ ОПИ, ф. 265, ед. хр. 213, л. 62—63.

[47] Cited after the book: *Валентин Серов в воспоминаниях, дневниках и переписке современников*, vol. 1, Leningrad, 1971, p. 377.

[48] *Ibid.*

[49] И. С. Остроухов, ЦГАЛИ, ф. 622, оп. 1, ед. хр. 45, л. 132. Unfortunately, his manuscript was not dated. It is likely that the work was done at the time when M. Morozov's widow decided to donate the collection to the Tretyakov Gallery. An indication of this can be found in a letter of February 28, 1910, which was sent by Valentin Serov, a friend of Morozov's, to Ilya Ostroukhov: "Four or five days ago Margarita Kirillovna (Mrs Morozov) invited me to call on her and formally declared that she was giving the collection of Mikhail Abramovich (Morozov) to the Gallery, except for a few pieces which she wanted to keep for the time being; she asked me to call a meeting of the Board at her house, at an earliest possible date, about 4 p.m." (В. А. Серов, *Переписка*, Leningrad — Moscow, 1937,

p. 251). Thus the collection of M. Morozov was added in 1910 to the Tretyakov Gallery.

50 S. Shchukin and his wife are known to have visited Morozov's family in Switzerland, in 1904, a year after his death (*Воспоминания М. К. Морозовой*, part 3, ЦГАЛИ, ф. 1956, оп. 2, ед. хр. 46, л. 2).

51 Б. Терновец, "Собиратели и антиквары", *Среди коллекционеров*, 1921, 10 p. 41.

52 F. Fels, *L'Art vivant. De 1900 à nos jours*, Geneva, 1950, p. 94.

53 *Guillaume Apollinaire. Chroniques d'Art (1902—1918)*. Textes réunis, avec préface et notes, par L.-C. Breunig, Paris, 1960, pp. 40—41.

54 *An Artist's Notes* were published in the journal *Grande Revue* of December 25, 1908. The Russian translation appeared in the journal *Zolotoye Runo* (*The Golden Fleece*), 1909, 6.

55 Г. Ю. Стернин, *Художественная жизнь России на рубеже XIX—XX веков*, Moscow, 1970, pp. 98—99.

56 Thus, Igor Grabar admitted that in 1890 he had not yet heard about Impressionism, while in the mid-1890s Russian critics discussed the role of Monet and Sisley in the development of European painting (Г. Ю. Стернин, *op. cit.*, pp. 92, 95). Sternin also points out that the attitude to the art of Puvis de Chavannes underwent an interesting evolution: it was unfavorably looked upon by V. Stasov and I. Repin, but M. Nesterov and V. Borisov-Musatov were fascinated by it, and A. Lunacharsky appreciated it very highly (*ibid.*, pp. 100—101).

57 *Известия*, 1918, No 242.

58 Moscow, 21, Kropotkinskaya St. At present the building houses the USSR Academy of Arts.

59 The English version of Romain Rolland's words follows a Russian translation of the original text, unfortunately lost.

60 In 1948, the Museum of Modern Western Art ceased to exist.

61 The names mentioned above include only donors of French paintings.

62 *Gauguin. Paintings. Drawings. Prints. Sculpture. The Art Institute of Chicago. The Mertopolitan Museum of Art*, Chicago, 1959, p. 25.

63 The well-known Russian painter V. Serov used Matisse's still life *Fruit and Bronzes* as the background for his portrait of I. Morozov. The portrait, painted in 1910, belongs to the Tretyakov Gallery.

PLATES

For fuller data on exhibitions and publications cited
in the notes in abbreviated form, see pp. 412 and 418.

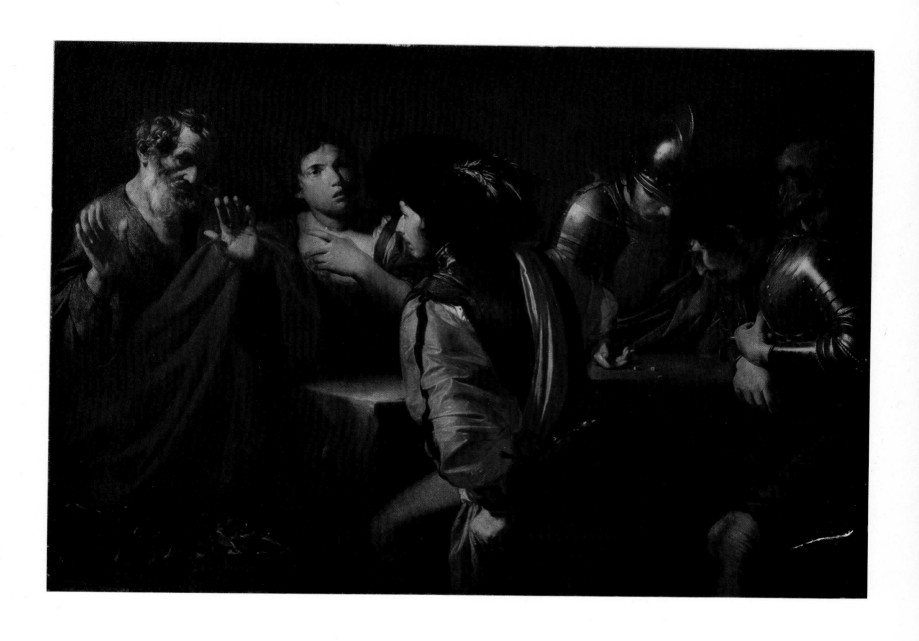

1 THE DENIAL OF ST PETER
Oil on canvas. 119 × 172 cm. Inv. No 1489
Other versions of the composition are in the Herzog Anton Ulrich Museum, Braunschweig, in the Palazzo Barberini, Rome, in the Frascione Collection, France, and in the Certosa di S. Margarita, Naples. The picture was engraved with a burin by F. Basan, etched in black by J. Walker, with a needle by J. Sanders.

Provenance: until 1769 The H. Brühl Collection, Dresden; 1769—1930 The Hermitage, St Petersburg — Leningrad; since 1930 The Pushkin Museum of Fine Arts, Moscow

Exhibitions: 1922—25 Petrograd; 1955 Moscow, Cat., p. 24; 1956 Leningrad, Cat., p. 11; 1965 Bordeaux, Cat. 13; 1965—66 Paris, Cat. 12; 1973 Leningrad, Cat. 10

Bibliography: Кат. ГМИИ 1948, p. 15; Кат. ГМИИ 1957, p. 22; Кат. ГМИИ 1961, p. 30; Labensky 1805, vol. 2, pp. 17—19, ill.; C. Landon, *Choix de tableaux et statues des plus célèbres musées*, vol. 3, Paris, 1819, No 33; Notice sur l'Ermitage 1828, pp. 66, 142; Dussieux 1856, p. 442; Cat. Ermitage 1863, No 1489; Waagen 1864, p. 303; Сомов 1900, No 1489; Бенуа 1912, p. 141; Ernst 1928, p. 164; Réau 1929, No 357; Sterling 1957, p. 16, ill. 4; R. Longhi, "A propos de Valentin", *La Revue des Arts*, 1958, 2, p. 61; B. Nicolson, "Some Northern Caravaggesques in Russia", *The Burlington Magazine*, 1965, August, p. 426, ill.; ГМИИ 1966, No 52

**2 THE VICTORY OF JOSHUA
OVER THE AMORITES**

Oil on canvas. 96 × 130 cm. Inv. No 1046

This picture is a pendant to *The Victory of Joshua over the Amalekites* (The Hermitage, Inv. No 1395). The subject is taken from the Bible (*Joshua*, 10). This is one of Poussin's earliest known canvases. According to G. Bellori and A. Félibien, it was painted in 1625 or 1626, i.e. after the artist's arrival in Rome. The composition shows the influence of the School of Fontainebleau as well as of antique bas-reliefs and certain works of Giulio Romano, which Poussin could have seen in Italy. A preliminary drawing for the picture is in the Fitzwilliam Museum, Cambridge; another drawing is in the Albertina, Vienna.

Provenance: 1770s—1927 The Hermitage, St Petersburg — Leningrad; since 1927 The Pushkin Museum of Fine Arts, Moscow

Exhibitions: 1955 Moscow, Cat., p. 57; 1956 Leningrad, Cat., p. 48; 1960 Paris, Cat. 3; 1978 Düsseldorf, Cat. O

Bibliography: Кат. ГМИИ 1948, p. 63; Кат. ГМИИ 1957, p. 113; Кат. ГМИИ 1961, p. 151; G. Bellori, *Le Vite dei pittori, scultori ed architetti moderni*, Rome, 1672, p. 411; Florent Le Comte, *Cabinet des singularités d'architecture, peinture et sculpture*, 2nd ed., vol. 3, Paris, 1702, p. 24; F. Baldinucci, *Delle Notizie dei professori del disegno*, vol. 16, Florence, 1767—74, p. 99; Cat. Ermitage 1774, No 908; Notice sur l'Ermitage 1828, p. 70; Smith 1837, No 36; Cat. Ermitage 1863, No 1396; Waagen 1864, p. 282; Сомов 1900, No 1396; Friedlaender 1914, pp. 23, 112; Grautoff 1914, vol. I, p. 65; *ibid.*, vol. II, No 5; Magne 1914, p. 205, No 139; Кат. Эрмитажа 1916, No 1396; Ernst 1928, p. 164; Réau 1929, No 277; L. Hourticq, *La jeunesse de Poussin*, Paris, 1937, p. 153; S.-Ch. Emmerling, *Antikenanwendung und Antikenstudium bei Nicolas Poussin*, Würzburg, 1939, pp. 27, 76, ill.; F. Licht, *Die Entwicklung der Landschaft in den Werken von Nicolas Poussin*, Basle — Stuttgart, 1954; Sterling 1957, p. 29; A. Blunt, *La Première période romaine de Poussin*, in: *Actes du Colloque Poussin*, vol. 1, Paris, 1960, pp. 166, 168, 169, 171, 174; A. Blunt, Ch. Sterling, *Exposition Nicolas Poussin*, Paris, 1960, p. 42, No 3; F. Parisot, *Les Natures mortes chez Poussin*, in: *Actes du Colloque Poussin*, vol. 1, Paris, 1960, p. 217; J. Thuillier, *Premiers compagnons français de Poussin à Rome*, in: *Actes du Colloque Poussin*, vol. 2, Paris, 1960, p. 75; Прокофьев 1962, ill. 16; Musée de Moscou 1963, p. 134, ill.; Blunt 1967, p. 65, ill. 4; Thuillier 1974, No 12, ill.

3 RINALDO AND ARMIDA

Oil on canvas. 95 × 133 cm. Inv. No 2762

The subject is taken from Torquato Tasso's *Jerusalem Delivered* (XIV). O. Grautoff and A. Blunt date the picture to 1630—35, J. Thuillier to 1625—26, taking it to be one of Poussin's first works on a secular subject. A picture on a similar subject is known to have been executed by Poussin for his friend, the painter Jacques Stella. The Moscow painting is probably its replica. A later copy was in the Kaiser-Friedrich-Museum in Berlin until 1914. Among the numerous variants on this theme the one now in the Dulwich College Gallery (England) is best-known. The picture was etched with a needle by J. Sanders (1809) and by A. Reveil (1829).

Provenance: 1766—1930 The Hermitage, St Petersburg — Leningrad (acquired together with Poussin's *Tancred and Erminia*); since 1930 The Pushkin Museum of Fine Arts, Moscow

Exhibitions: 1955 Moscow, Cat., p. 51; 1956 Leningrad, Cat., p. 49

Bibliography: Кат. ГМИИ 1948, p. 63; Кат. ГМИИ 1957, p. 113, ill.; Кат. ГМИИ 1961, p. 152, ill.; G. Bellori, *Le Vite dei pittori, scultori ed architetti moderni*, 2nd ed., Rome, 1728, p. 191; Cat. Ermitage 1774, No 15; Labensky 1805, vol. 1, p. 27, ill.; C. Landon, *Poussin*, in: *Vie et œuvres des peintres les plus célèbres. Ecole française*, Paris, 1809, ill. 103; Notice sur l'Ermitage 1828, pp. 67, 143; Smith 1837, No 287; Dussieux 1856, p. 441; Cat. Ermitage 1863, No 1407; Waagen 1864, p. 284; Сомов 1900, No 1407; Бенуа 1912, p. 170; Friedlaender 1914, pp. 51, 115; Grautoff 1914, vol. I, p. 109; *ibid.*, vol. II, No 40; Magne 1914, p. 218, No 330; Кат. Эрмитажа 1916, No 1407; Réau 1929, No 291; L. Hourticq, *La Jeunesse de Poussin*, Paris, 1937, pp. 92—95, 174, 175; R. Lee, "Ut Pictures Poesis. The Humanist Theory of Painting", *The Art Bulletin*, 22, 1940, ill.; Вольская 1946, pp. 45—47, 155—156, ill.; P. Jamot, *Connaissance de Poussin*, Paris, 1948, pp. 38, 72; Sterling 1957, ill. 16, p. 31; D. Mahon, *Poussin au carrefour des années trente*, in: *Actes du Colloque Poussin*, vol. 1, Paris, 1960, p. 262; F. Parisot, *Les Natures mortes chez Poussin*, in: *Actes du Colloque Poussin*, vol. 1, Paris, 1960, p. 219; Прокофьев 1962, ill. 18; ГМИИ 1966, No 53; Blunt 1967, p. 148, ill. 85; Charmet 1970, pp. 18, 19, ill.; Thuillier 1974, No 10, ill.; Antonova 1977, No 59

4 THE MAGNANIMITY OF SCIPIO

Oil on canvas. 114.5 × 163.5 cm. Inv. No 1048

The subject is taken from Livy's work *Ab urbe condita* (XXVI : 50). The picture was painted in the 1640s after Poussin's return to Rome. A copy by J. Smibert, executed in the early 1720s, is in the Bowdoin College Museum in Brunswick (USA). A preliminary drawing for the picture is in the Musée Condé at Chantilly (No 185 bis).

Provenance: in the early 18th century The Collection of J.-B. de Morville, France; 1722—45 The R. Walpole Collection, Houghton Hall, England; 1779—1927 The Hermitage, St Petersburg — Leningrad (purchased from the heirs of R. Walpole); since 1927 The Pushkin Museum of Fine Arts, Moscow

Exhibitions: 1955 Moscow, Cat., p. 52; 1956 Leningrad, Cat., p. 48

Bibliography: Кат. ГМИИ 1957, p. 113; Кат. ГМИИ 1961, p. 152; H. Walpole, *Aedes Walpolianae or a Description of the Collection of Pictures at Houghton Hall in Norfolk*, 3rd ed., London, 1767, p. 89; Labensky 1805, vol. 1, p. 115, ill.; C. Landon, *Poussin*, in: *Vie et œuvres des peintres les plus célèbres. Ecole française*, Paris, 1809, ill. 143; Notice sur l'Ermitage 1828, pp. 68, 143; Smith 1837, No 171; A. Andresen, *Nicolas Poussin. Verzeichnis der nach seinen Gemälden gefertigten Kupferstiche...*, Leipzig, 1863, No 320; Cat. Ermitage 1863, No 1406; Waagen 1864, p. 285; Сомов 1900, No 1406; Friedlaender 1914, pp. 80, 117; Grautoff 1914, vol. I, pp. 222—223, No 107; Magne 1914, p. 199, No 43; Кат. Эрмитажа 1916, No 1406; Réau 1929, No 617; Вольская 1946, pp. 115, 117, 156, ill.; Прокофьев 1962, ill. 22; Thuillier 1974, No 135, ill.; Antonova 1977, No 60

5 LANDSCAPE WITH HERCULES AND CACUS
Oil on canvas. 156 × 202 cm. Inv. No 2763
The subject is taken from Virgil's *Aeneid* (VIII). The picture was considered to be a pendant to *Landscape with Polyphemus* (The Hermitage, Inv. No 1186), but judging by the manner of its execution, it belongs to a later period. A. Blunt and D. Mahon date it to 1659—61.

Provenance: until 1772 The Collection of L. de Brienne, Marquis de Conflan, Paris; 1772—1930 The Hermitage, St Petersburg — Leningrad (acquired together with Poussin's *Landscape with Polyphemus*); since 1930 The Pushkin Museum of Fine Arts, Moscow

Exhibitions: 1955 Moscow, Cat., p. 52; 1956 Leningrad, Cat., p. 49; 1960 Paris, Cat. 108

Bibliography: Кат. ГМИИ 1948, p. 63, ill.; Кат. ГМИИ 1957, p. 113; Кат. ГМИИ 1961, p. 152, ill.; Smith 1837, No 307; Dussieux 1856, p. 440; Cat. Ermitage 1863, No 1413; Waagen 1864, p. 288; M. Tourneux, *Diderot et Catherine II*, Paris, 1890, pp. 58, 428; Сомов 1900, No 1413; Бенуа 1912, p. 172; Friedlaender 1914, p. 252; Grautoff 1914, vol. I, p. 257; *ibid.*, vol. II, No 136; Magne 1914, p. 217, No 306, ill.; Кат. Эрмитажа 1916, No 1413; Dimier 1926—27, vol. 1, p. 52, ill.; Réau 1929, No 283; M. Alpatov, "Poussin's Problem", *The Art Bulletin*, 17, 1935, p. 22; A. Blunt, "The Heroic and the Ideal Landscape in the Work of Nicolas Poussin", *Journal of the Warburg and Courtauld Institute*, 1944, p. 157, 167; Вольская 1946, p. 131, ill.; B. Dorival, "Expression littéraire et expression picturale du sentiment de la nature au XVIIe siècle français", *La Revue des Arts*, 1953, 3, p. 51; F. Licht, *Die Entwicklung der Landschaft in den Werken von Nicolas Poussin*, Basle — Stuttgart, 1954, p. 153; Sterling 1957, ill. 20, p. 32; H. Bardon, *Poussin et la littérature latine*, in: *Actes du Colloque Poussin*, vol. 1, Paris, 1960, p. 130; A. Blunt, Ch. Sterling, *Exposition Nicolas Poussin*, Paris, 1960, p. 215, No. 108; D. Mahon, *Réflexion sur les paysages de Poussin*, in: *Art de France*, 1961, pp. 126, 127; Прокофьев 1962, ill. 26; D. Mahon, "Poussiniana", *Gazette des Beaux-Arts*, 60, 1962, pp. 2, 116, 121; M. Alpatov, *Poussins Landschaft mit Herkules und Cacus in Moskau*, in: *Walter Friedlaender zum 90. Geburtstag*, Berlin, 1965, p. 9, ill.; D. Mahon, *Plea for Poussin as a Painter*, in: *Walter Friedlaender zum 90. Geburtstag*, Berlin, 1965, p. 141; ГМИИ 1966, No 55; Blunt 1967, pp. 320—321, ill. 241; Thuillier 1974, No 215, ill.; Antonova 1977, No 58

6 THE DEATH OF VIRGINIA
Oil on canvas. 192 × 157 cm. Inv. No 2766
The subject is taken from Livy's work *Ab urbe condita* (III : 47 ff.). In the Hermitage catalogues the picture was listed as *The Death of Lucretia*. At present the traditional attribution of the picture to Vouet is considered doubtful. According to Ch. Sterling's presumption it belongs to an artist of the J. Blanchard circle. J. P. Saint-Marie ascribes it to Jacques de Lestin.

Provenance: until 1764 The J. E. Gotzkowski Collection, Berlin; 1764—1930 The Hermitage, St Petersburg — Leningrad; since 1930 The Pushkin Museum of Fine Arts, Moscow

Bibliography: Кат. ГМИИ 1948, p. 21; Кат. ГМИИ 1961, p. 45; Cat. Ermitage 1774, No 237; Cat. Ermitage 1863, No 1443; Waagen 1864, p. 296; Сомов 1900, No 1443; Бенуа 1912, p. 206; Кат. Эрмитажа 1916, No 1443; Dussieux 1856, pp. 83, 443; Réau 1929, No 409 (entitled *The Death of Lucretia*); W. R. Crelly, *The Painting of Simon Vouet*, New Haven — London, 1962, p. 179, No 69

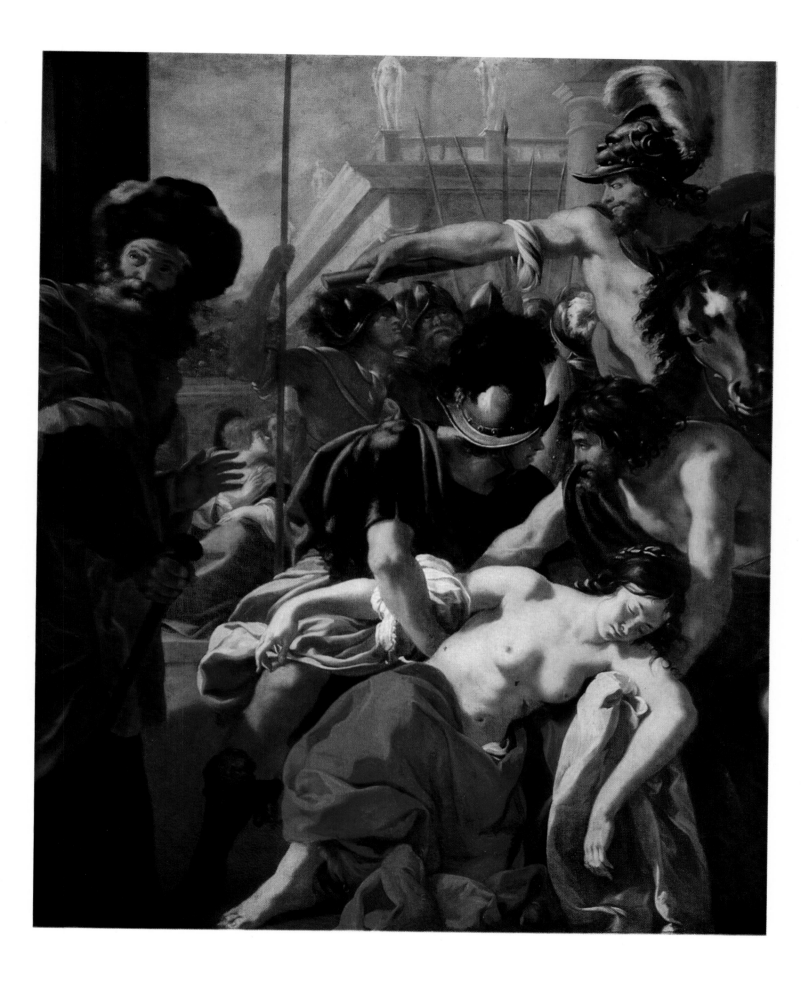

CLAUDE LORRAIN (CLAUDE GELLÉE). 1600—1682

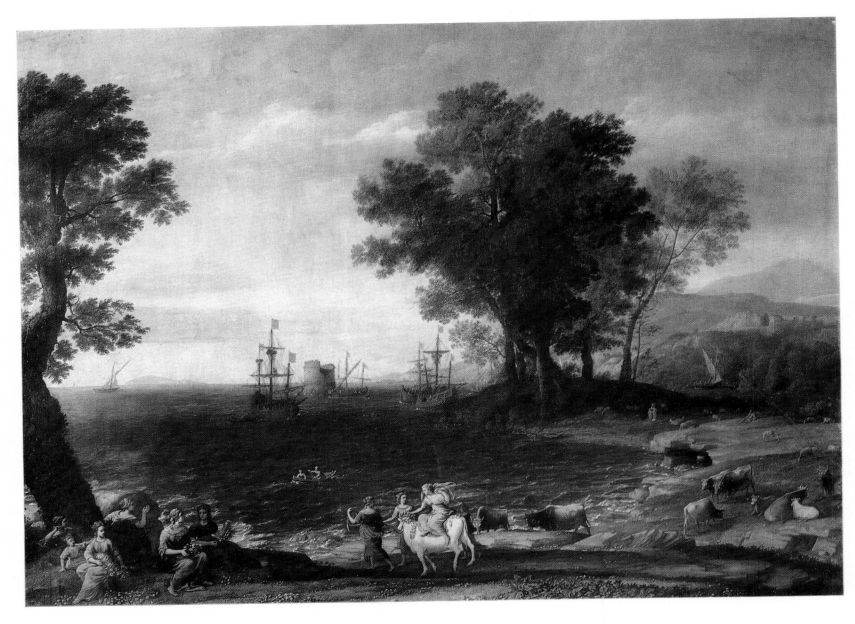

7 THE RAPE OF EUROPA. 1655
Oil on canvas. 100 × 137 cm. Inv. No 916
Signed and dated lower right: *Claude G. Romae 1655*
The subject is taken from Ovid's *Metamorphoses* (2: 835—877). Together with its pendant, *The Battle on the Bridge*, the picture was painted in 1655 on the order of Cardinal Fabio Chigi (1599—1667), who had become Pope Alexander VII by the time of its completion. It remained the property of the Pope's descendants until 1798. Reproduced by the author in his series of drawings known as *Liber Veritatis* under No 136. A preliminary drawing for the picture was in the Print Room of the Kaiser-Friedrich-Museum in Berlin until 1941. There are three main variants of the picture, the best known of which is now in Buckingham Palace in London. This variant, dated 1667, is very close to the one owned by the Pushkin Museum.
Provenance: 1798—1924 The Yusupovs Collection, Arkhangelskoye (near Moscow) and St. Petersburg — Petrograd; 1924—27 The Hermitage, Leningrad; since 1927 The Pushkin Museum of Fine Arts, Moscow

Exhibitions: 1908 St Petersburg; 1955 Moscow, Cat., p. 42; 1956 Leningrad, Cat., p. 36

Bibliography: Кат. ГМИИ 1948, p. 47; Кат. ГМИИ 1957, p. 82, ill.; Кат. ГМИИ 1961, p. 112, ill.; Musée Youssoupoff 1839, No 26; Waagen 1864, p. 417; Pattison 1884, pp. 71, 94, 190, 191, 216, 227, 276, 306; А. Прахов 1901, p. 69, ill. 58; А. Прахов 1907, pp. 133, 134, ill. 74; Бенуа 1908, p. 722; Anciennes écoles de peinture 1910, pp. 108—109; Бенуа 1912, p. 196; Кат. Юсуповской галереи 1920, No 86; W. Friedlaender, *Claude Lorrain*, Berlin, 1921, pp. 8, 241; Эрнст 1924, pp. 2—3, ill.; Dimier 1926—27, vol. 1, p. 78, ill.; S. Ernst, "Les Tableaux de Claude Lorrain dans les collections Youssoupoff et Stroganoff", *Gazette des Beaux-Arts*, 2, 1929, pp. 246, 249, ill.; Réau 1929, No 587; P. Courthion, *Claude Gellée dit Le Lorrain*, Paris, 1932, p. 77, ill.; M. Röthlisberger, "Les Pendants dans l'œuvre de Claude Lorrain", *Gazette des Beaux-Arts*, 51, 1958, p. 221; Röthlisberger 1961, pp. 24, 25, 276, 325—328; Прокофьев 1962, ill. 29; Musée de Moscou 1963, p. 136, ill.; ГМИИ 1966, No 56; Antonova 1977, No 57

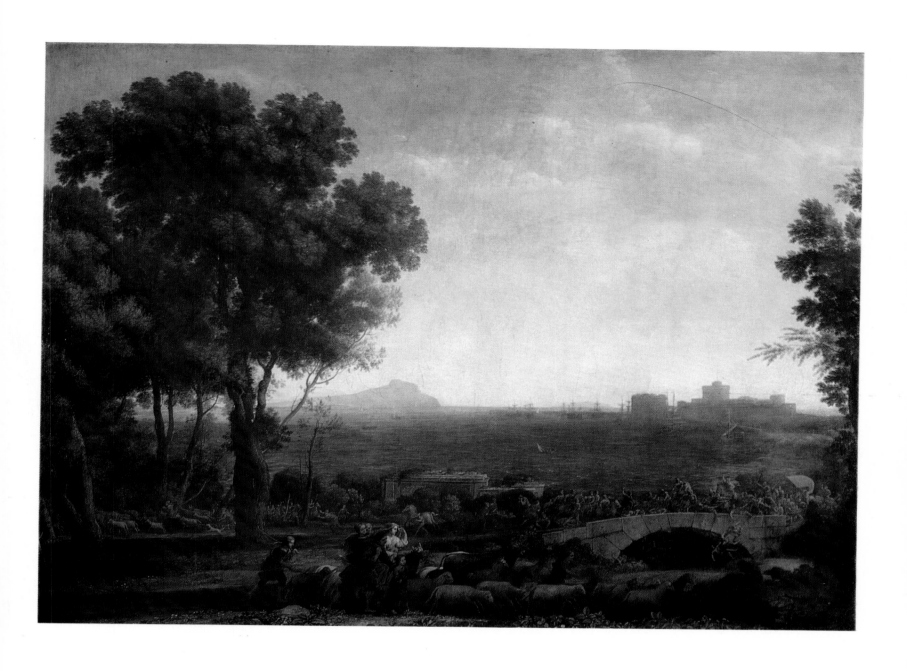

8 THE BATTLE ON THE BRIDGE. 1655
Oil on canvas. 100 × 137 cm. Inv. No 1283
Signed and dated lower right: *Claudio G V Romae 1655*

Together with *The Rape of Europa* this picture was commissioned by Cardinal Chigi. Some scholars interpreted the subject as *The Battle between Maxentius and Constantine*. Reproduced in the *Liber Veritatis* under No 137. A preliminary drawing was in the Print Room of the Kaiser-Friedrich-Museum in Berlin until 1941. There is an earlier variant of the picture in the *Liber Veritatis* (No 26), and an exact replica made by the author (the Virginia Museum, Richmond, USA).

Provenance: 1798—1924 The Yusupovs Collection, Arkhangelskoye (near Moscow) and St Petersburg — Petrograd; 1924—27 The Hermitage, Leningrad; since 1927 The Pushkin Museum of Fine Arts, Moscow

Exhibitions: 1908 St Petersburg, Cat. 279; 1955 Moscow, Cat., p. 42; 1956 Leningrad, Cat., p. 35
Bibliography: Кат. ГМИИ 1948, p. 47; Кат. ГМИИ 1957, p. 82; Кат. ГМИИ 1961, p. 112; Smith 1837, No 137; Musée Youssoupoff 1839, No 8; Waagen 1864, p. 47; Pattison 1884, pp. 71, 72, 190, 218, 227; А. Прахов 1901, p. 57, ill. 46; А. Прахов 1907, pp. 134, 135, ill. 75; Бенуа 1908, p. 722; Anciennes écoles de peinture 1910, pp. 108—109; Бенуа 1912, p. 196, ill.; Кат. Юсуповской галереи 1920, No 79; W. Friedlaender, *Claude Lorrain*, Berlin, 1921, p. 241; Эрнст 1924, p. 4, ill.; S. Ernst, "Les Tableaux de Claude Lorrain dans les collections Youssoupoff et Stroganoff", *Gazette des Beaux-Arts*, 2, 1929, p. 247, ill.; Réau 1929, No 588; M. Röthlisberger, "Les Pendants dans l'œuvre de Claude Lorrain", *Gazette des Beaux-Arts*, 51, 1958, p. 221; Röthlisberger 1961, pp. 146, 326, 329—330

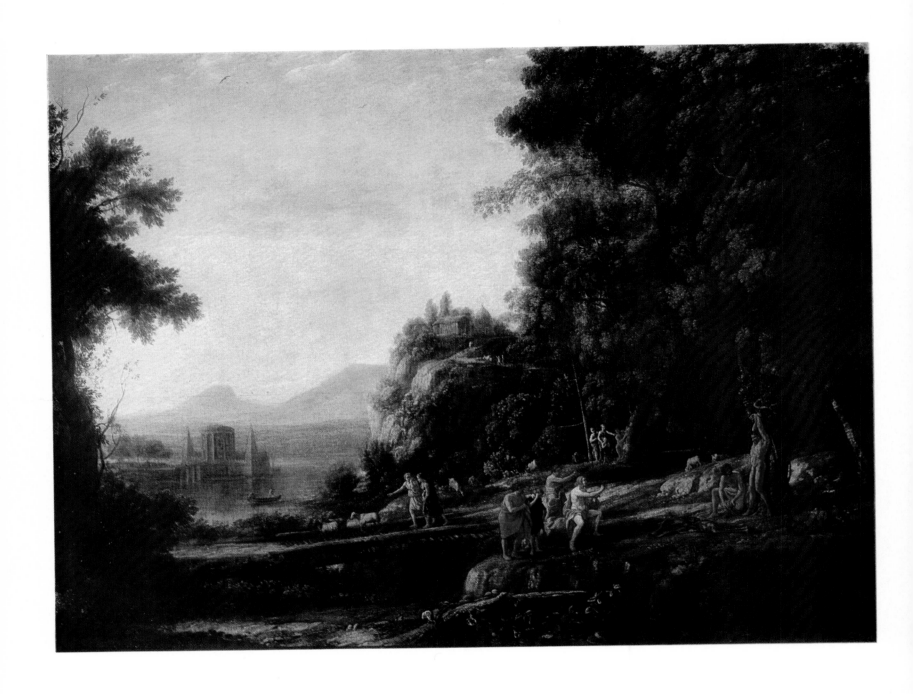

9　LANDSCAPE WITH APOLLO AND MARSYAS
Oil on canvas. 101 × 133 cm. Inv. No 915
The subject is taken from Ovid's *Metamorphoses* (6: 382—400). The picture was painted for Dr Perroche around 1639—40. Reproduced in the *Liber Veritatis*. A similar composition is in a private collection in England.

Provenance: until 1772 The Collection of L. A. Crozat, Baron de Thiers, Paris; 1772—1924 The Hermitage, St Petersburg — Petrograd; since 1924 The Pushkin Museum of Fine Arts, Moscow

Exhibition: 1972 Dresden, Cat. 24

Bibliography: Кат. ГМИИ 1948, p. 46; Кат. ГМИИ 1957, p. 82; Кат. ГМИИ 1961, p. 113; Cat. Crozat 1755, p. 9; D'Argenville, *Voyage pittoresque de Paris*, Paris, 1757, p. 120; Cat. Ermitage 1774, No 1133; Smith 1837, No 45; Cat. Ermitage 1863, No 1438; Waagen 1864, p. 291; Pattison 1884, pp. 211, 215, 246; Dimier 1926—27, vol. 1, p. 76, ill.; Réau 1929, No 589; P. Courthion, *Claude Gellée dit Le Lorrain*, Paris, 1932, ill.; Röthlisberger 1961, pp. 178, 255, 256; Stuffmann 1968, p. 131, No 150

10 A LITTLE TOWN IN LATIUM
Oil on panel. 34 × 41 cm. Inv. No 506
Signed lower left: *Gasp D*
Engraved by J. Mason in 1778.

Provenance: until 1779 The R. Walpole Collection,
Houghton Hall, England; 1779—1862 The Hermitage, St
Petersburg (purchased from the heirs of R. Walpole);
1862—1924 The Rumiantsev Museum, Moscow; since
1924 The Pushkin Museum of Fine Arts, Moscow

Bibliography: Кат. ГМИИ 1948, p. 30; Кат. ГМИИ
1957, p. 55; Кат. ГМИИ 1961, p. 79; H. Walpole,
*Aedes Walpolianae or a Description of the Collection
of Pictures at Houghton Hall in Norfolk*, 3rd ed.,
London, 1767, p. 70; Прокофьев 1962, ill. 28

LOUIS BOULLOGNE THE YOUNGER. 1654—1733

11 THE JUDGEMENT OF SOLOMON. 1710
Oil on canvas. 133 × 166 cm. Inv. No 1221
Signed and dated lower left: *Boulogne fit 1710*
The subject is taken from the Bible (*I Kings* 3:16—28). A picture, similar in drawing and composition, is in the Museum of Troyes (Cat. 1911, No 43, 46 × 57 cm; signed left, undated). It is probably the same picture that was exhibited in the Salon of 1699, together with *The Judgement of Solomon*.

Provenance: since 1927 The Pushkin Museum of Fine Arts, Moscow (received from the State Museum Reserve)

Bibliography: Кат. ГМИИ 1948, p. 13; Кат. ГМИИ 1957, p. 20; Кат. ГМИИ 1961, p. 28

12 NOAH'S SACRIFICE
Oil on canvas. 77 × 102 cm. Inv. No 724
The subject is taken from the Bible (*Gen.* 8:20—21).
The present work is a smaller replica of the picture
belonging to the Arras Museum (formerly in The Lou-
vre). Another variant on the same theme is in the Mu-
sée Fabre at Montpellier.

Provenance: 1867—1924 The Yusupovs Collection,
Arkhangelskoye (near Moscow) and St Petersburg—
Petrograd; since 1924 The Pushkin Museum of Fine
Arts, Moscow

Exhibition: 1972 Prague, Cat. 4

Bibliography: Кат. ГМИИ 1948, p. 47; Кат. ГМИИ
1957, p. 20; Кат. ГМИИ 1961, p. 28; Musée Youssou-
poff 1839, No 185; Dussieux 1856, p. 444; Ch. Pon-
sonailhe, *Sébastien Bourdon, sa vie et son œuvre*,
Paris, 1883, p. 286, 299; А. Прахов 1907, ill. 81;
Бенуа 1912, p. 224; Кат. Юсуповской галереи 1920,
No 76; Эрнст 1924, p. 16, ill.; Réau 1929, No 447;
Sterling 1957, p. 26

13 THE FIGHT

Oil on canvas. 57 × 68 cm. Inv. No 2974

The picture was attributed to Mathieu Lenain by P. Weiner, an opinion shared by S. Ernst and V. Lazarev. Ch. Sterling believed it to be the work of an unknown painter, the author of *The Procession with a Ram*. This attribution was confirmed by J. Thuillier in the catalogue of the exhibition "Les frères Le Nain", 1978, Paris. Another variant of the picture (72 × 92 cm) was in 1938 in the Weissmann Collection, Paris.

Provenance: until 1918 The Sheremetevs Collection, Ostankino (near Moscow); 1918—37 The Ostankino Estate Museum; since 1937 The Pushkin Museum of Fine Arts, Moscow

Exhibition: 1978 Paris, Cat. 80

Bibliography: Кат. ГМИИ 1948, p. 43; Кат. ГМИИ 1957, p. 80; Кат. ГМИИ 1961, p. 10; П. Вейнер, "Жизнь и искусство в Останкине", *Старые годы*, 1910, May — June, p. 59, ill.; S. Ernst, "Les Œuvres des frères Le Nain en Russie", *Gazette des Beaux-Arts*, 13, 1926, pp. 310, 311, ill.; В. Лазарев, *Братья Ленен*, Moscow — Leningrad, 1936, p. 59; G. Isarlo, "Les Trois Le Nain et leur suite", *La Renaissance*, 1938, March, p. 22, ill.; ГМИИ 1966, No 51; Antonova 1977, No 55

14 PEASANTS BY THE WELL
Oil on canvas. 94 × 119 cm. Inv. No 1239
A picture of the same name, similar in composition to the work reproduced here, is now in the Art Institute of Chicago; in all probability this is the work of the master tentatively called by J. Thuillier "Le Maître aux beguins" in the catalogue of the 1978 exhibition.

Provenance: since 1927 The Pushkin Museum of Fine Arts, Moscow (received from the State Museum Reserve)

Exhibition: 1978 Paris, Cat. 75

Bibliography: V. Lazareff, "An Unknown Picture by Michelin", *Art in America*, 1933, December, p. 32, ill.; В. Лазарев, *Братья Ленен*, Moscow — Leningrad, 1936, pp. 71, 72, 84; G. Isarlo, "Les Trois Le Nain et leur suite", *La Renaissance*, 1938, March, p. 1; М. Каган, *Братья Антуан, Луи и Матье Ле Нен*, Moscow, 1972, pp. 20, 21, ill.

15 THE CRUCIFIXION. 1637

Oil on panel. 52 × 41 cm. Inv. No 2770

Signed and dated right: *C le Brun 1637*

One of the artist's earliest pictures, it was probably painted when he worked under S. Vouet at Fontainebleau. The picture was engraved in 1641 (in reverse) by J. Rousselet with a dedication to Chancellor Séguier, patron of the young Le Brun. It was also engraved by E. Skotnikov, Elisabeth Boucher (copy after Rousselet) and by an anonymous master (copy after Boucher, with altered details in the background). Other pictures on the same subject, representing variants very similar to the Pushkin Museum composition, are known from engravings by F. de Noilly Duflos and Boulanger.

Provenance: until 1930 The Hermitage, St Petersburg—Leningrad (acquired during the reign of Catherine II); since 1930 The Pushkin Museum of Fine Arts, Moscow

Exhibition: 1963 Versailles, Cat. 1

Bibliography: Кат. ГМИИ 1948, p. 45; Кат. ГМИИ 1957, p. 173; Кат. ГМИИ 1961, p. 109; Cat. Ermitage 1774, No 20; Cat. Ermitage 1863, No 1454; H. Jouin, *Charles Le Brun et les arts sous Louis XIV*, Paris, s.a. [1889], p. 477; Сомов 1900, No 1454; P. Marcel, *Charles Le Brun*, Paris, s.a. [1909], p. 168; A. Blunt, "The Early Work of Charles Le Brun", *The Burlington Magazine*, 1944, July—August, p. 166; D. Wildenstein, "Les Œuvres de Ch. Le Brun d'après les gravures de son temps", *Gazette des Beaux-Arts*, 66, 1965, p. 13, No 70

16 PORTRAIT OF MOLIÈRE
Oil on canvas. 67 × 57 cm. Inv. No 3105
The portrait may be dated to the 1660s.

Provenance: 1915 The K. Klachkova Collection, Moscow; since 1938 The Pushkin Museum of Fine Arts, Moscow (purchased from Grachova)

Exhibitions: 1915 Moscow, Cat. 79; 1955 Moscow, Cat., p. 41; 1973 Paris, Cat. 250

Bibliography: Кат. ГМИИ 1948, p. 45; Кат. ГМИИ 1957, p. 79; Кат. ГМИИ 1961, p. 108; Прокофьев 1962, ill. 34

17 CHEVALIER DE MALTE
Oil on canvas. 68 × 50 cm. Inv. No 1121
The portrait may be dated to the 1700s.

Provenance: until 1924 The Shuvalovs Collection, St
Petersburg — Petrograd; since 1924 The Pushkin Museum of Fine Arts, Moscow

Exhibition: 1972 Moscow, Cat., p. 99

Bibliography: Кат. ГМИИ 1957, p. 136; Кат. ГМИИ 1961, p. 183; Золотов 1968, p. 21, ill.

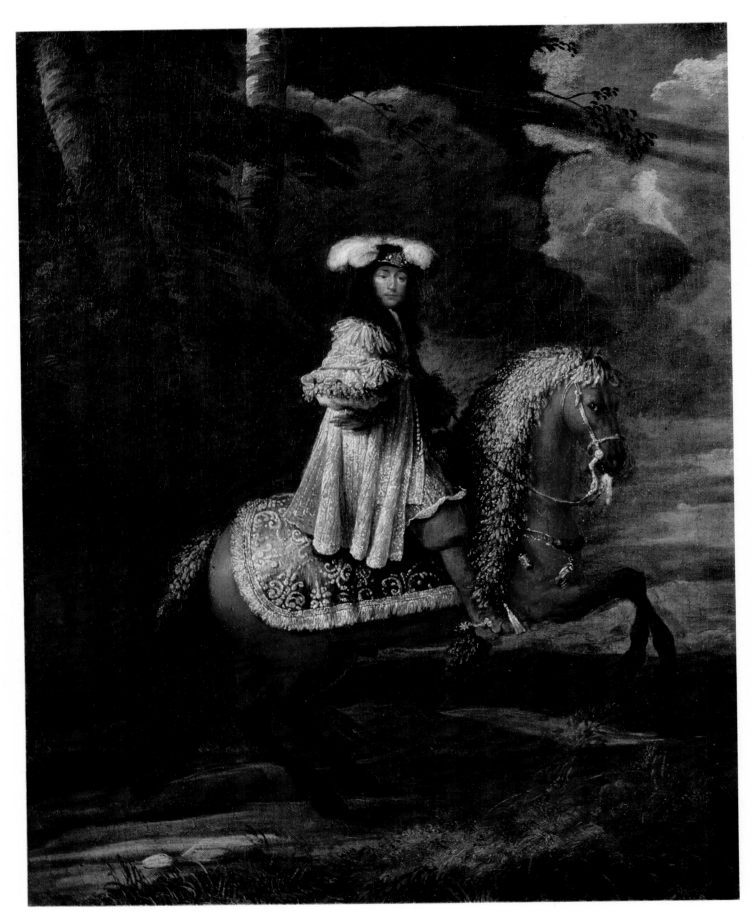

18　PORTRAIT OF A HORSEMAN IN BLUE
Oil on canvas. 46 × 35 cm. Inv. No 1163

Provenance: until 1924 The Rumiantsev Museum, Moscow (gift of A. Bakhrushina in the early 1900s); since 1924 The Pushkin Museum of Fine Arts, Moscow

Exhibition: 1972 Moscow, Cat., p. 73

Bibliography: Кат. ГМИИ 1961, p. 189; Золотов 1968, p. 14, ill.; Antonova 1977, ill. 56

19　A CAVALRY ENCOUNTER
Oil on canvas. 58 × 83 cm. Inv. No 2916
Signed lower center: *A F V Meulen Fecit*
This picture, painted still entirely in the spirit of
the Flemish tradition, belongs to the artist's early
period, i.e. before his work for Louis XIV. It may
be dated to the early 1660s.

Provenance: 1915 The Z. Yevreinova Collection, Petro-
grad; since 1936 The Pushkin Museum of Fine Arts,
Moscow (purchased from Bavstrup)

Exhibition: 1914 Petrograd, Cat. 107a

Bibliography: Кат. ГМИИ 1948, p. 51; Кат. ГМИИ
1957, p. 90; Кат. ГМИИ 1961, p. 123

20 LANDSCAPE WITH A FLOCK
OF SHEEP ON THE ROAD
Oil on canvas. 77 × 100 cm. Inv. No 3794
A similar composition, though of smaller dimensions
(53.5 × 65 cm), is in the Kunsthalle, Hamburg (No 104).
There is another variant of the picture (54 × 66 cm)
in the Musée du Petit-Palais in Paris (No Dut. 950).

Provenance: until 1960 The S. Obraztsov Collection,
Moscow; since 1960 The Pushkin Museum of Fine
Arts, Moscow

Exhibition: 1970 Moscow, Cat. 27 (listed as G. Du-
ghet's work)

21 SUSANNAH AND THE ELDERS. 1715
Oil on canvas. 74 × 91 cm. Inv. 1715
Signed and dated left: *De Troy fils 1715*
The subject is taken from the Bible (*Dan.* 13:19—23). Other pictures by De Troy on the same theme are in The Hermitage (Inv. No 1240, formerly Inv. No 1498; 235 × 178 cm; signed and dated 1721; a pendant to *Lot and His Daughters*, also in The Hermitage, formerly attributed to François De Troy); in the Musée des Beaux-Arts in Rouen (80 × 65 cm; dated 1727; a pendant to *Bathsheba* in the Musée des Beaux-Arts at Angers); in the Farr Collection in Philadelphia (94 × 135 cm; dated 1748), and in the V. Mamurovsky Collection in Moscow (variant of the Pushkin Museum picture).

Provenance: until 1930 The Hermitage, St Petersburg—Leningrad (acquired during the reign of Catherine II); since 1930 The Pushkin Museum of Fine Arts, Moscow

Bibliography: Кат. ГМИИ 1957, p. 50; Кат. ГМИИ 1961, p. 72; Cat. Ermitage 1863, No 1499; Waagen 1864, No 304; L. Clément de Ris, "Musée Impérial de l'Ermitage", *Gazette des Beaux-Arts*, 21, 1880, p. 268; Сомов 1900, No 1499; Dimier 1928—30, vol. 2, p. 34, No 6; Réau 1929, No 358

22 PORTRAIT OF ADELAÏDE OF SAVOY. 1697
Oil on canvas. 98 × 79 cm. Inv. No 1118
Signed and dated lower left: *Marie Adelaïde de Savoye Nee Le 5-me Dec-re. 1685. Peint A Paris Par François de Troy En Mars 1697*
Marie-Adelaïde (1685—1712), daughter of Victor-Amédée II, Duke of Savoy, in 1697 married Louis, Dauphin of France, Duke of Burgundy and grandson of Louis XIV. It was to mark this occasion that De Troy painted this portrait.
Provenance: 1894—1924 The D. Shchukin Collection, Moscow; since 1924 The Pushkin Museum of Fine Arts, Moscow
Exhibition: 1972 Moscow, Cat., p. 62

Bibliography: Кат. ГМИИ 1948, p. 27, ill.; Кат. ГМИИ 1957, p. 50; Кат. ГМИИ 1961, p. 73; S. Scheikevitch, "Correspondance de Russie", *Gazette des Beaux-Arts*, 1894, August, pp. 170—172, ill.; Н. Прахов 1905, p. 119, ill. 61; Бенуа 1912, p. 248; Réau 1929, No 658; Золотов 1968, p. 21; Antonova 1977, No 61

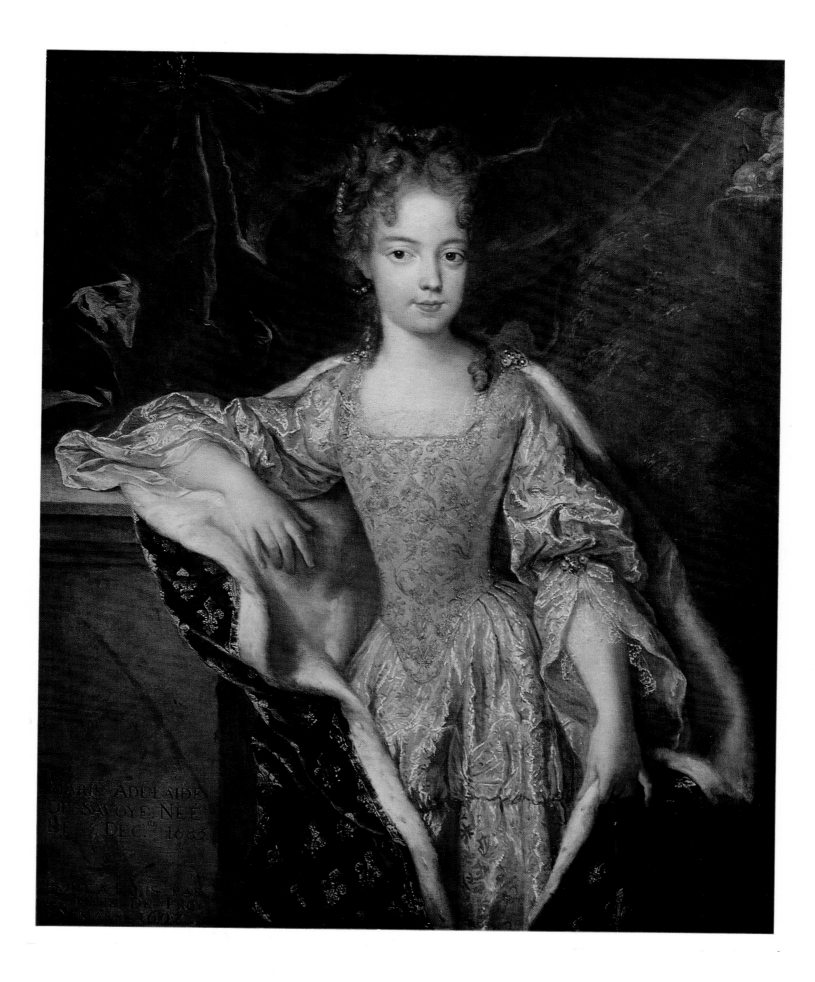

23 PORTRAIT OF A LADY
Oil on canvas. 80 × 64 cm (oval). Inv. No 986
The portrait may be dated to the late 1680s or early 1690s.

Provenance: until 1924 The Yusupovs Collection, Arkhangelskoye (near Moscow) and St Petersburg—Petrograd; 1924—27 The Hermitage, Leningrad; since 1927 The Pushkin Museum of Fine Arts, Moscow

Exhibitions: 1955 Moscow, Cat., p. 41; 1956 Leningrad, Cat., p. 32; 1972 Moscow, Cat., p. 64

Bibliography: Кат. ГМИИ 1948, p. 44; Кат. ГМИИ 1957, p. 78; Кат. ГМИИ 1961, p. 107, ill.; Эрнст 1924, p. 20, ill.; Réau 1929, No 570; Прокофьев 1962, ill. 39; ГМИИ 1966, No 57; Золотов 1968, p. 24, ill.

24 PORTRAIT OF DUCHESS
DE LA VALLIERE AS FLORA

Oil on panel. 47 × 36 cm (oval). Inv. No 1021

Louise Françoise de La Baume Le Blanc, Duchess de La Vallière (1644—1710), was a favorite of Louis XIV. Finished her days in a Carmelite convent.

The iconography of the portrait has long been contested. Disagreeing with the traditional title, G. F. Waagen believed it to be a portrait of Mignard's daughter Catherine de Fouquières whom the sitter greatly resembles. It seems more probable, however, that the subject should be sought among the ladies of the Court, since there is another portrait by Mignard, kept at Versailles, almost identical in composition and representing another favorite of the King, Mme de Montespan. The Pushkin Museum portrait could be a replica of a larger one, conceived as a companion piece to the portrait of Mme de Montespan, and may be dated to the 1660s.

Provenance: 1770s — 1924 The Hermitage, St Petersburg — Petrograd; since 1924 The Pushkin Museum of Fine Arts, Moscow

Bibliography: Кат. ГМИИ 1948, p. 52; Кат. ГМИИ 1957, p. 93; Кат. ГМИИ 1961, p. 127; Cat. Ermitage 1774, No 1173; Dussieux 1856, p. 440; Cat. Ermitage 1863, No 1458; Waagen 1864, pp. 298—299; Сомов 1900, No 1458; Кат. Эрмитажа 1916, No 1458; Réau 1929, No 597

25 ROMULUS AND REMUS. 1715
Oil on canvas. 45 × 55 cm. Inv. No 1135
The subject is taken from Plutarch's *Lives* (*Theseus and Romulus*). M. Stuffmann holds that the picture was painted in the artist's later period, i. e. after 1700.
Provenance: until 1925 The Armory of the Moscow Kremlin; since 1925 The Pushkin Museum of Fine Arts, Moscow
Exhibition: 1955 Moscow, Cat., p. 41
Bibliography: Кат. ГМИИ 1948, p. 26; Кат. ГМИИ 1957, p. 79; Кат. ГМИИ 1961, p. 108; Réau 1929, No 564; M. Stuffmann, "Charles de La Fosse", *Gazette des Beaux-Arts*, 64, 1964, p. 110, No 63, ill.

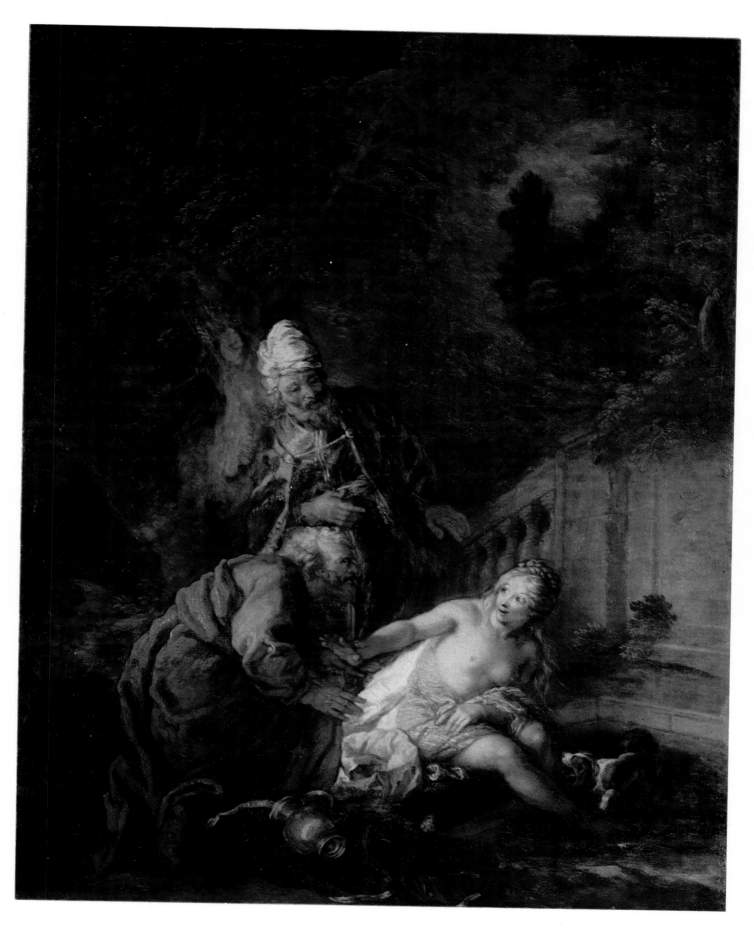

26 SUSANNAH AND THE ELDERS

Oil on canvas. 64 × 51 cm. Inv. No 1138

The subject is taken from the Bible (*Dan.* 13:19—23).
The picture was evidently painted in Lafosse's last
years when, living at Crozat's and studying his art
collection, he began to imitate the style of Rembrandt.

Provenance: until 1769 The H. Brühl Collection, Dres-
den; 1769—1925 The Hermitage, St Petersburg—Petro-
grad; since 1925 The Pushkin Museum of Fine Arts,
Moscow

Exhibitions: 1920 Petrograd; 1922—25 Petrograd

Bibliography: Кат. ГМИИ 1948, p. 26; Кат. ГМИИ
1961, p. 108; Cat. Ermitage 1774, No 2028; Ernst
1928, p. 169; Réau 1929, No 561; M. Stuffmann,
"Charles de La Fosse", *Gazette des Beaux-Arts*, 64
1964, p. 112, No 69, ill.

27 SATIRE ON PHYSICIANS
Oil on panel. 26 × 37 cm. Inv. No 763
The picture was painted after Watteau's arrival in
Paris, during his training under Gillot, a painter of
theatrical scenes, between 1703 and 1708. The subject
of the canvas is taken from Molière's comedies *Le
Malade imaginaire* and *Monsieur de Pourceaugnac*.
There are a great number of replicas, variants and
copies of the picture. In the late 1850s one such va-
riant was in the collection of Eugène Delacroix.

Provenance: until 1769 The H. Brühl Collection, Dres-
den; since 1769 The Hermitage, St Petersburg; from
the mid-19th century to 1923 The Ekaterininsky Pal-
ace, Tsarskoye Selo (at present the town of Push-
kin); 1923—28 The Hermitage, Leningrad; since 1928
The Pushkin Museum of Fine Arts, Moscow

Exhibitions: 1922—25 Petrograd; 1955 Moscow, Cat.,
p. 25; 1956 Leningrad, Cat., p. 12

Bibliography: Кат. ГМИИ 1948, p. 15; Кат. ГМИИ
1957, p. 23; Кат. ГМИИ 1961, p. 33; *Mercure de
France*, 1727, November, p. 2491; Cat. Ermitage 1774,
No 40; *Abecedario de P. J. Mariette et autres notes
inédites de cet amateur sur les arts et les artistes*,
in: *Archives de l'Art Français*, vol. 6, Paris, 1859—
60, p. 110; E. de Goncourt, *Catalogue raisonné de
l'œuvre peint, dessiné et gravé d'Antoine Watteau*,
Paris, 1875, p. 34, No 25; L. de Fourcaud, "Antoine

Watteau. Scènes et figures théâtrales", *Revue de
l'Art Ancien et Moderne*, 16, 1904, pp. 203—204, ill.;
V. Josz, *Antoine Watteau*, Paris, s.a. [1904], p. 222;
E. Pilon, *Watteau et son école*, Brussels, 1912, p. 26;
Г. Лукомский, *Краткий каталог Музея Екатери-
нинского дворца*, Petrograd, 1918, pp. 29, 47 (entitled
Scene from 'Le Malade imaginaire'); E. Dacier,
A. Vuaflart, *Jean de Julienne et les graveurs de Wat-
teau au XVIIIe siècle*, Paris, 1922, p. 74, No 150;
E. Hildebrandt, *Antoine Watteau*, vol. 1, Berlin, 1922,
p. 171, ill. (reproduced after Caylus's engraving);
Ernst 1928, p. 173, ill.; Dimier 1928—30, vol. 1,
p. 48, No 181; Réau 1929, No 694; H. Adhémar,
Watteau, Paris, 1950, pp. 10, 72, 146, 155, 156, 190,
202, 253, No 9, ill. 5 (erroneously referred to as a pic-
ture from the Hermitage); Ю. Золотов, *Современные
сюжеты в творчестве Антуана Ватто. Материалы
по теории и истории искусства*, МГУ им. Ломоно-
сова, Moscow, 1956, p. 100, ill.; K. T. Parker, F. Ma-
they, *Antoine Watteau. Catalogue complet de son
œuvre dessiné*, vol. I, Paris, 1957, pp. 5, 8, 9; Ster-
ling 1957, ill. 23, p. 37; Прокофьев 1962, ill. 42; A. Че-
годаев, *Антуан Ватто*, Moscow, 1963, ill.; *Musée
de Moscou 1963*, p. 138, ill.; И. Немилова, *Ватто и
его произведения в Эрмитаже*, Leningrad, 1964,
pp. 75. 77, 172, ill.; E. Comesasca, P. Rosenberg, *Tout
l'œuvre peint de Watteau*, Paris, 1970, No 13; Anto-
nova 1977, No 63

Oil on canvas. 32 × 45 cm. Inv. No 1226

According to P. J. Mariette, the picture was painted by Watteau at the request of his friend P. Sirois, an antiquary and artist, from whom it passed into the collection of the dealer E. F. Gersaint, also a friend of Watteau. It belongs to the *Délassements de la Guerre* series painted from sketches made by the artist during his trip to Valenciennes in 1709—10. The picture was engraved with a burin by Ch. Cochin.

Provenance: from the late 19th century until 1928 The Hermitage, St Petersburg — Leningrad; since 1928 The Pushkin Museum of Fine Arts, Moscow

Exhibitions: 1937 Paris, Cat. 227; 1955 Moscow, Cat. 24; 1956 Leningrad, Cat., p. 12; 1965 Bordeaux, Cat. 42; 1965—66 Paris, Cat. No 40

Bibliography: Кат. ГМИИ 1948, p. 16, ill.; Кат. ГМИИ 1957, p. 23, ill.; Кат. ГМИИ 1961, p. 33, ill.; *Mercure de France,* 1727, December, p. 2677; *L'Œuvre d'Antoine Watteau, Peintre du Roy... gravé d'après ses tableaux et dessins originaux... par les soins de M. de Julienne,* vol. 2, Paris, s.a. [1730—40], p. 58, ill. (after the engraving by Cochin); *Abecedario de P. J. Mariette et autres notes inédites de cet amateur sur les arts et les artistes,* in: *Archives de l'Art Français,* vol.

6, Paris, 1859—60, p. 109; E. de Goncourt, *Catalogue raisonné de l'œuvre peint, dessiné et gravé d'Antoine Watteau,* Paris, 1875, p. 55, No 52; Сомов 1900, No 1874; V. Josz, *Antoine Watteau,* Paris, s.a. [1904], pp. 56, 222, ill. (entitled *Délassements de la Guerre*); X. Zimmermann, *Watteau* (Klassiker der Kunst), Stuttgart, 1912, No 4, ill.; Кат. Эрмитажа 1916, No 1874; E. Dacier, A. Vuaflart, *Jean de Julienne et les graveurs de Watteau au XVIIIᵉ siècle,* Paris, 1922, p. 73, No 148; E. Hildebrandt, *Antoine Watteau,* vol. 1, Berlin, 1922, p. 92; Dimier 1928—30, vol. 1, p. 32, No 40; Réau 1929, N° 693; В. Вольская, *Ватто,* Moscow, 1933, pp. 32, 34, 35, ill.; H. Adhémar, *Watteau,* Paris, 1950, pp. 35, 99, 179, 250, No 37, ill. 18; P. Francastel, *Histoire de la peinture française,* vol. I, Paris, 1955, ill.; Ю. Золотов, *Современные сюжеты в творчестве Антуана Ватто. Материалы по теории и истории искусства,* МГУ им. Ломоносова, Moscow, 1956, p. 85, ill.; K. T. Parker, F. Mathey, *Antoine Watteau. Catalogue complet de son œuvre dessiné,* vol. I, Paris, 1957, pp. 35, 37; Sterling 1957, ill. 28, p. 37; Прокофьев 1962, ill. 45; А. Чегодаев, *Антуан Ватто,* Moscow, 1963, p. 15, ill.; И. Немилова, *Ватто и его произведения в Эрмитаже,* Leningrad, 1964, pp. 44, 170, ill.; ГМИИ 1966, No 58; E. Comesasca, P. Rosenberg, *Tout l'œuvre peint de Watteau,* Paris, 1970, No 44

ÉLISABETH SOPHIE CHÉRON. 1648—1711

29 PORTRAIT OF JEANNE-MARIE BOUVIER
DE LA MOTTE GUYON
Oil on canvas. 61 × 51 cm. Inv. No 1144
Mme Bouvier de La Motte Guyon (1648—1717), preacher and visionary, was a representative of a religious-mystical trend which became known as quietism. She set forth her views in a number of publications that were censured by the Catholic Church. From 1695 to 1702 she was imprisoned in the Bastille. Her last years were spent at Blois. A collection of her works published during 1713—22 in Amsterdam was reprinted in Paris in forty volumes (1790). In the portrait the model looks about fifty years old. This, together with the style of her dress, permits the portrait to be dated to the early 1700s.

Provenance: 1909—24 The Rumiantsev Museum, Moscow (gift of M. Volkova); since 1924 The Pushkin Museum of Fine Arts, Moscow

Bibliography: Кат. ГМИИ 1957, p. 148; Кат. ГМИИ 1961, p. 195; Кат. Румянцевского музея 1912, No 13; Кат. Румянцевского музея 1915, No 198

30 PORTRAIT OF FONTENELLE (?)

Oil on canvas. 54 × 44 cm. Inv. No 1056

Bernard le Bouvier, sieur de Fontenelle (1657—1757), was a writer, member of the French Academy and secretary of the Academy of Sciences.

The portrait of Fontenelle, painted by Rigaud in 1702, was engraved by Dossier for the writer's complete works published in 1709. The whereabouts of the portrait is unknown, but there are a number of old copies the best of which belongs to the Musée Fabre at Montpellier. Some French art historians considered the Pushkin Museum portrait to be one of these copies, although it is absolutely different from the portrait in the Musée Fabre. As there is no evidence to suggest that Rigaud painted two portraits of Fonte-

nelle, the traditional attribution of the portrait appears to be doubtful.

Provenance: 1811—1925 The Hermitage, St Petersburg—Petrograd; since 1925 The Pushkin Museum of Fine Arts, Moscow

Exhibitions: 1955 Moscow, Cat., p. 54; 1956 Leningrad, Cat., p. 52; 1972 Moscow, Cat., p. 92

Bibliography: Кат. ГМИИ 1948, p. 66; Кат. ГМИИ 1957, p. 119, ill.; Кат. ГМИИ 1961, p. 159, ill.; Notice sur l'Ermitage 1828, p. 74; Dussieux 1856, p. 441; Cat. Ermitage 1863, No 1538; Waagen 1864, p. 309; Сомов 1900, No 1538; Бенуа 1912, p. 262; Кат. Эрмитажа 1916, No 1538; Réau 1929, No 624; Прокофьев 1962, ill. 40; Золотов 1968, p. 14, ill.

31 PORTRAIT OF A MAN IN A RED GOWN
Oil on canvas. 89 × 72 cm. Inv. No 1172

Provenance: until 1924 The Yusupovs Collection, Arkhangelskoye (near Moscow) and St Petersburg—Petrograd; since 1924 The Pushkin Museum of Fine Arts, Moscow

Exhibition: 1972 Moscow, Cat., p. 73

Bibliography: Кат. ГМИИ 1948, p. 82; Кат. ГМИИ 1957, p. 144; Кат. ГМИИ 1961, p. 162; А. Прахов 1907, p. 162, ill. 91; Кат. Юсуповской галереи 1920, No 158; Эрнст 1924, p. 22, ill.

ANTOINE QUILLARD. 1704—1733

32 PASTORAL SCENE
Oil on canvas. 72 × 91.5 cm. Inv. No 766
The picture was identified as Quillard's work by
V. Miller in 1930. It may be dated to the early 1730s.

Provenance: until 1918 The O. and L. Zubalovs Col-
lection, Moscow (listed as a work of an unknown
master of the Watteau circle); 1918—22 The State
Museum Reserve; 1922—24 The Rumiantsev Museum,
Moscow; since 1924 The Pushkin Museum of Fine
Arts, Moscow

Exhibitions: 1955 Moscow, Cat., p. 37; 1956 Lenin-
grad, Cat., p. 28

Bibliography: Кат. ГМИИ 1948, p. 37, ill.; Кат. ГМИИ
1957, p. 69; Кат. ГМИИ 1961, p. 96, ill.; V. Miller,
"Un Maître inconnu: P. A. Quillard", *Revue de l'Art
Ancien et Moderne*, 57, 1930, p. 133; Прокофьев
1962, ill. 57; ГМИИ 1966, No 62

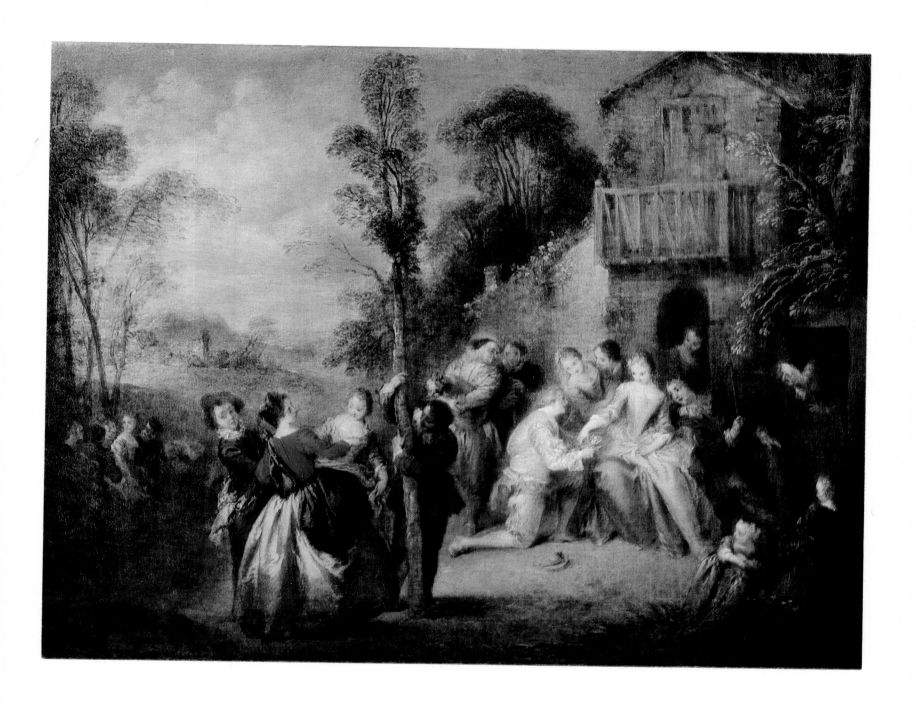

33 THE MAYPOLE CELEBRATION

Oil on canvas. 34 × 44 cm. Inv. No 3994
This picture is a companion painting to *Fortune-teller* (*La Diseuse de bonne aventure*) whose whereabouts is unknown. Before it entered The Pushkin Museum, *The Maypole Celebration* was also believed to have been lost after the auction of 1805 and was known only from the engraving by J.-B. Patas. It is a mature Pater, which may be dated to the early 1730s. A variant was in the M. de Rothschild Collection in Paris.

Provenance: 1772 Auction of the E. F. de Choiseul Collection, Paris; 1774 Auction of the Du Barry Collection, Paris; 1805 Auction of the De Saint-Ives Collection, Paris; The A. Likhachov Collection, Kazan; 1948—66 The E. Rode Collection, Moscow; since 1966 The Pushkin Museum of Fine Arts, Moscow

Exhibition: 1970 Moscow, Cat. 58

Bibliography: *Recueil d'estampes d'après les tableaux du cabinet de Monseigneur le duc de Choiseul par les soins du S. Basan*, Paris, 1771, p. 11 (reproduced after Patas's engraving); F. Ingersoll-Smouse, *Pater*, Paris, 1928, p. 79, No 526, ill. 151 (reproduced after Patas's engraving); И. Кузнецова, "Новая картина Музея", *Художник*, 1969, 7, p. 57

NICOLAS LANCRET. 1690—1743

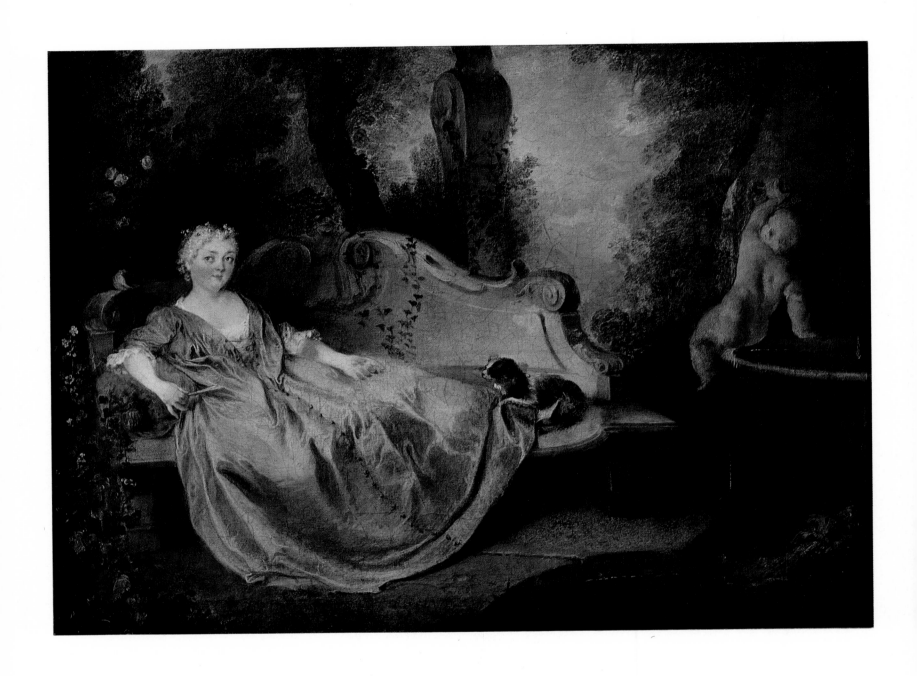

34 PORTRAIT OF A LADY IN THE GARDEN
Oil on canvas. 37 × 47 cm. Inv. No 981
The picture can undoubtedly be regarded as a por-
trait, like other works by Lancret of the same type,
among them *Portrait of the Saint-Martin Family*
from the G. Wildenstein Collection, which was put
up on sale at Sotheby's (London), or *Portrait of a
Lady with Her Children* from the David Weill Col-
lection in Paris, in which the figures are depicted
against the background of a park landscape. The pres-
ent work may be dated to the 1730s.

Provenance: until 1924 The D. Shchukin Collection,
Moscow; since 1924 The Pushkin Museum of Fine
Arts, Moscow

Exhibitions: 1955 Moscow, Cat., p. 40; 1972 Moscow,
Cat., p. 87

Bibliography: Кат. ГМИИ 1948, p. 44; Кат. ГМИИ
1957, p. 77; Кат. ГМИИ 1961, p. 106; Н. Прахов 1905, ill.

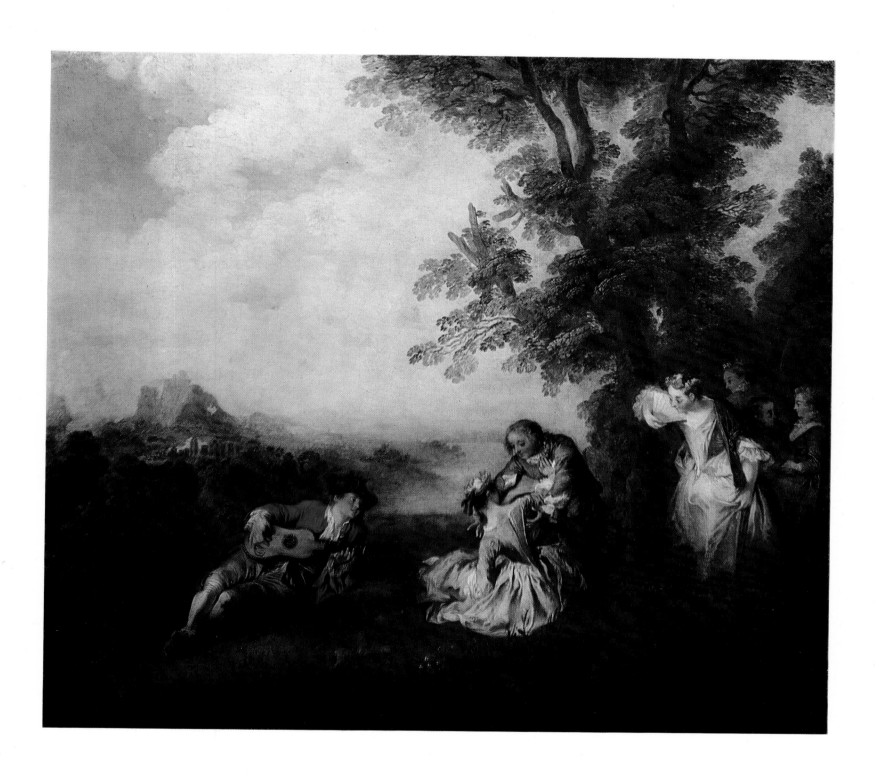

35 A COMPANY AT THE EDGE OF A WOOD
Oil on canvas. 64 × 79 cm. Inv. No 983
This picture, painted under the direct influence of
Watteau's later manner, may be dated to the early
1720s.

Provenance: 1827—1924 The Yusupovs Collection, Ar-
khangelskoye (near Moscow) and St Petersburg—Petro-
grad; since 1924 The Pushkin Museum of Fine Arts,
Moscow

Exhibition: 1908 St Petersburg, Cat. 288 (listed as
a work by Pater)

Bibliography: Кат. ГМИИ 1948, p. 44; Кат. ГМИИ
1957, p. 78; Кат. ГМИИ 1961, p. 106; Musée Youssou-
poff 1839, No 37; Anciennes écoles de peinture 1910,
p. 114, ill.; Кат. Юсуповской галереи 1920, No 64;
Эрнст 1924, p. 30, ill.; G. Wildenstein, *Lancret*, Par-
is, 1927, No 395, ill.

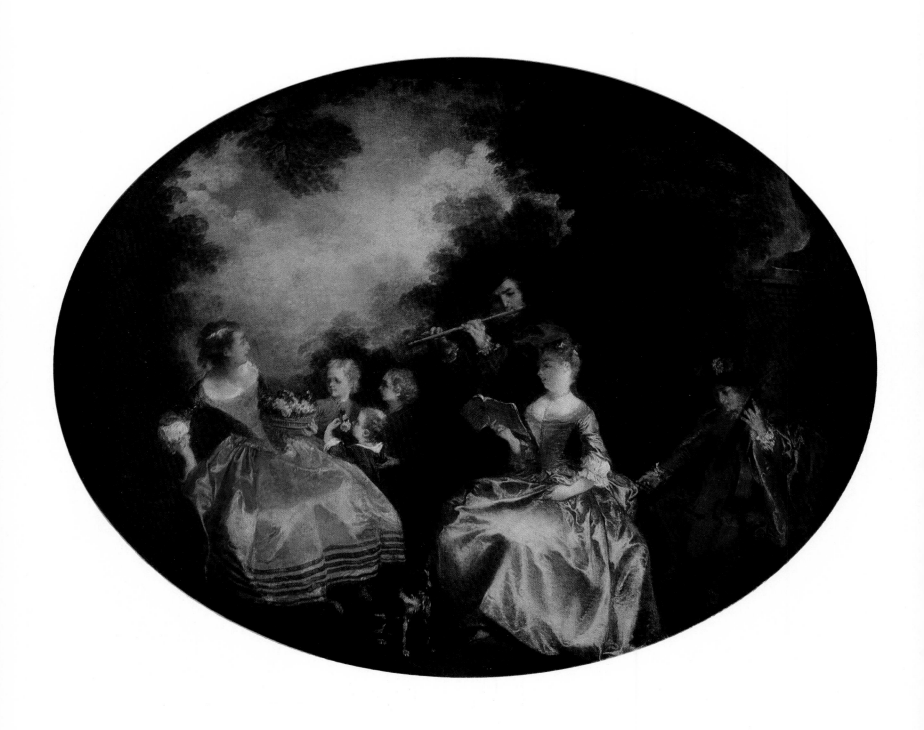

36 CONCERT IN THE PARK

Oil on canvas. 83 × 104 cm (oval). Inv. No 960
This picture is a companion piece to *Shepherd and
Shepherdess with a Cage*, with which it was in the
Berenghen Collection sale on June 2, 1770 (lot 32).
The picture may be dated to the 1730s.

Provenance: until 1918 The Vorontsov-Dashkovs Col-
lection, St Petersburg — Petrograd; 1918—25 The
Hermitage, Leningrad; since 1925 The Pushkin Mu-
seum of Fine Arts, Moscow

Exhibitions: 1922—25 Petrograd; 1955 Moscow, Cat.,
p. 40

Bibliography: Кат. ГМИИ 1948, p. 44; Кат. ГМИИ
1957, p. 77; Кат. ГМИИ 1961, p. 106; G. Wildenstein,
Lancret, Paris, 1927, No 298; Ernst 1928, p. 173

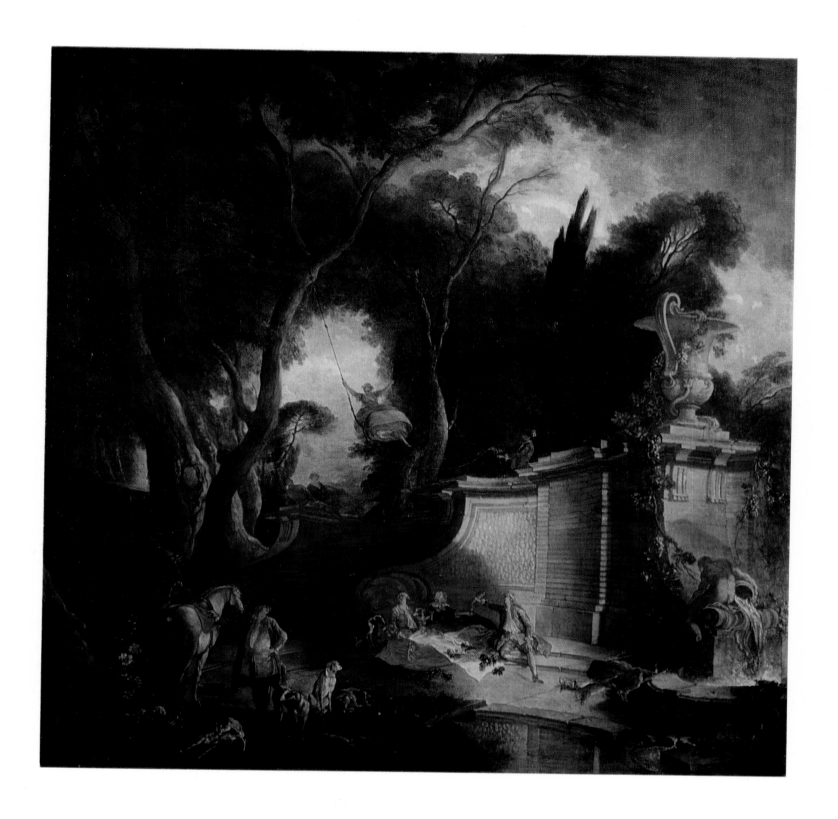

37 REST AFTER THE HUNT
Oil on canvas. 129.5 × 129.5 cm. Inv. No 979
Signed lower right: *Lajoue*
The picture may be dated to the 1730s.

Provenance: until 1924 The D. Shchukin Collection,
Moscow; since 1924 The Pushkin Museum of Fine Arts,
Moscow

Bibliography: Кат. ГМИИ 1948, p. 43; V. Mamourovsky,
"*Le Repos après la chasse* par Lajoue", *Gazette des
Beaux-Arts*, 11, 1934, 2, p. 67, ill.

38 THE ALLEGORY OF SMELL
Oil on canvas. 58 × 72 cm. Inv. No 2794
Signed lower left: *J*
The picture is a companion piece to *The Allegory of Taste* (The Pushkin Museum of Fine Arts, Inv. No 2176). Engraved by J. Moyreau. May be dated to the late 1720s.

Provenance: until 1772 The Collection of L. A. Crozat, Baron de Thiers, Paris; 1772—1928 The Hermitage, St Petersburg — Leningrad; since 1928 The Pushkin Museum of Fine Arts, Moscow

Bibliography: Кат. ГМИИ 1948, p. 63; Кат. ГМИИ 1957, p. 114; Кат. ГМИИ 1961, p. 153; Cat. Crozat 1755, p. 57; Cat. Ermitage 1774, No 765; Dussieux 1856, p. 441; Dimier 1928—30, vol. 2, pp. 271, 281, No 10; Stuffmann 1968, p. 133, No 167

39 THE ALLEGORY OF TASTE
Oil on canvas. 56 × 72 cm. Inv. No 2176
The picture is a companion piece to *The Allegory of Smell* (The Pushkin Museum of Fine Arts, Inv. No 2794). In the catalogue of Raoux's works compiled by J. Bataille it was listed as non-extant, under the heading: *Pictures Known Only by Their Engravings*. The picture was engraved by J. Moyreau. May be dated to the late 1720s.

Provenance: until 1772 The Collection of L. A. Crozat, Baron de Thiers, Paris; 1772—1928 The Hermitage, St Petersburg — Leningrad; since 1928 The Pushkin Museum of Fine Arts, Moscow

Bibliography: Кат. ГМИИ 1948, p. 63; Кат. ГМИИ 1957, p. 114; Кат. ГМИИ 1961, p. 153; Cat. Crozat 1755, p. 57; Cat. Ermitage 1774, No 764; Dussieux 1856, p. 441; Dimier 1928—30, vol. 2, pp. 271, 278, 281 (in the Catalogue the picture is listed twice: under No 18 as *A Company in the Park*, with reference to Réau; under No 11 as *The Allegory of Taste*, the lost original known through an engraving by J. Moyreau); Réau 1929, No 620; Stuffmann 1968, p. 133, No 168

40 DOGS AND DEAD GAME
Oil on canvas. 72 × 93 cm. Inv. No 869

Provenance: until 1915 the D. Shchukin Collection, Moscow; 1915—24 The Rumiantsev Museum, Moscow (gift of D. Shchukin); since 1924 The Pushkin Museum of Fine Arts, Moscow

Bibliography: Кат. ГМИИ 1961, p. 71; Réau 1929, No 504; W. Mamourovsky, "Les Chiens dans les tableaux de Desportes et d'Oudry au Musée des Beaux-Arts à Moscou", Revue de l'Art Ancien et Moderne, 67, 1935, p. 135, ill.

41 STILL LIFE WITH FRUIT. 1721
Oil on canvas. 74 × 52 cm. Inv. No 2768
Signed and dated lower left: *J. B. Oudry 1721*
It is a pendant to the picture *Vase and Fruit* (The
Hermitage, Inv. No 1121).

Provenance: 1763/74—1930 The Hermitage, St Peters-
burg — Leningrad; since 1930 The Pushkin Museum
of Fine Arts, Moscow

Exhibition: 1955 Moscow, Cat., p. 59

Bibliography: Кат. ГМИИ 1948, p. 79; Кат. ГМИИ
1957, p. 139; Кат. ГМИИ 1961, p. 184; Сомов 1900,
No 1816; Бенуа 1912, p. 310; J. Locquin, *Catalogue
raisonné de l'œuvre de J.-B. Oudry*, Paris, 1912,
No 41; Кат. Эрмитажа 1916, No 1816; Dimier 1928—
30, vol. 2, p. 170, No 270; Réau 1929, No 260; Е. Нот-
гафт, "Жан-Батист Удри и его произведения", *ТГЭ*,
vol. 2, 1941, p. 172, ill.

42 PORTRAIT OF A LADY. 1757
Oil on canvas. 54 × 45 cm. Inv. No 1034
Signed and dated right: *Nattier px. 1757*
It is a replica of the picture that had belonged to
M. A. Vasilchikov, was taken abroad and sold in the
early twentieth century by the art dealer Heinemann
as a portrait of Princess Holstein-Boeck.

Provenance: until 1918 The Gudovich Collection,
Vvedenskoye Estate, Moscow province; until 1924 The
Rumiantsev Museum, Moscow; since 1924 The Pushkin
Museum of Fine Arts, Moscow

Exhibitions: 1918 Moscow, Cat. 71; 1955 Moscow, Cat.,
p. 49; 1956 Leningrad, Cat., p. 43; 1972 Moscow, Cat.,
p. 90

Bibliography: Кат. ГМИИ 1948, pp. 55—56; Кат.
ГМИИ 1957, p. 101; Кат. ГМИИ 1961, p. 136; Dimier
1928—30, vol. 2, p. 128, No 132; Réau 1929, No 608;
Sterling 1957, ill. 33, p. 49; Золотов 1968, p. 41, ill.

43 THE BATTLE OF POLTAVA. 1717
Oil on canvas. 90 × 112 cm. Inv. No 1035
Signed and dated lower center:
Nattier jn-r p. 1717
The picture was commissioned by Peter the Great,
whose portrait Nattier painted in Amsterdam in 1717.
Shortly after that it passed out of public sight and
was believed to be lost. It was discovered in the
museum of Sychovka, a town in the Smolensk Region,
in 1926. A copy is in the Ostankino Estate Museum
near Moscow.

Provenance: until 1919 The Meshcherskys Collection,
Sychovka district, Smolensk province; 1919—26 The
Sychovka Museum, Smolensk Region; since 1926 The
Pushkin Museum of Fine Arts, Moscow

Exhibitions: 1955 Moscow, Cat. 49 (entitled *The Battle
near Lesnaya*); 1956 Leningrad, Cat. 43 (entitled *The
Battle near Lesnaya*); 1965 Bordeaux, Cat. 27; 1965—
66 Paris, Cat. 26; 1974—75 Paris (Grand Palais), Cat.
506; 1975 Moscow

Bibliography: Кат. ГМИИ 1948, p. 55; Кат. ГМИИ
1957, p. 101; Кат. ГМИИ 1961, p. 136; Е. Гаршин,
"Ж. М. Наттье в его отношениях к России", *Вест-
ник изящных искусств*, 1888, 6, p. 435; P. de Nol-
hac, *Nattier, peintre de la cour de Louis XV*, Paris,
1910, p. 24; Réau 1924, p. 73; Réau 1929, No 607;
В. Мамуровский, "*Полтавский бой* Ж. М. Наттье",
Жизнь музея. Бюллетень ГМИИ, 1930, p. 25; L. Réau,
Le Rayonnement de Paris au XVIIIᵉ siècle, Paris,
1946, p. 138

44 VENUS AND VULCAN
Oil on canvas. 64 × 53 cm. Inv. 1036
Signed lower left: *C. Natoire f.*
The subject of the picture is taken from Virgil's *Aeneid* (8:370—385). The present work is either an original sketch or a smaller replica of a picture on the same subject, which was painted by Natoire in 1734 and for which he received the title of Academician. This picture is now in the Musée Fabre at Montpellier (192 × 138 cm, No 420), where it was transferred from The Louvre in 1803. Another picture on the same subject, included into the *Four Elements* series as an Allegory of Fire (110 × 150 cm), is now in the Museum of Fontainebleau, where it also came from The Louvre. There is yet another variant in the Musée des Beaux-Arts in Bordeaux (though the attribution is doubtful). The Detroit Institute of Arts (USA) has a replica of the Moscow picture (63 × 51 cm), but its poor draughtsmanship does not warrant its attribution as a Natoire work.
In 1732, two years before Natoire, François Boucher painted a picture on the same subject (The Louvre, 252 × 175 cm, No 2709) which is compositionally very similar to the Pushkin Museum canvas.

Provenance: 1779 Sale of the Abbé Gevigney Collection; 1827—1924 The Yusupovs Collection, Arkhangelskoye (near Moscow) and St Petersburg — Petrograd; since 1924 The Pushkin Museum of Fine Arts, Moscow

Exhibition: 1972 Prague, Cat. 27

Bibliography: Кат. ГМИИ 1948, p. 56; Кат. ГМИИ 1957, p. 102; Кат. ГМИИ 1961, p. 136; Mantz 1880, p. 38; А. Прахов 1907, pp. 169, 170, ill. 102; Кат. Юсуповской галереи 1920, No 108; Эрнст 1924, p. 48, ill.; Réau 1929, No 605; F. Boyer, *Catalogue raisonné de l'œuvre de Charles Natoire*, in: *Archives de l'Art Français*, vol. 21, Paris, 1949, p. 353, No 45

45 HERCULES AND OMPHALE

Oil on canvas. 90 × 74 cm. Inv. No 2764

The subject, taken from Greek mythology, was a favorite one with artists of the Rococo period. The well-known picture of the same title by F. Lemoine was painted in 1724 and is now in The Louvre. The present canvas belongs to the early period of Boucher's career (early 1730s), when his palette and artistic manner were still very close to those of Lemoine. A copy of Boucher's work made by Fragonard was put up at an auction of the Sireuil Collection in 1781.

Provenance: 1777 Sale of the Collection of Randon de Boisset, Paris; 1787 Sale of the Collection of Count de Vaudreuil, Paris; 1820 The M. Golitsyn Collection, Moscow; from the mid-1820s to 1924 The Yusupovs Collection, Arkhangelskoye (near Moscow) and St Petersburg — Petrograd; 1924—30 The Hermitage, Leningrad; since 1930 The Pushkin Museum of Fine Arts, Moscow

Exhibitions: 1908 St Petersburg, Cat. 285; 1955 Moscow, Cat., p. 23; 1956 Leningrad, Cat., p. 10

Bibliography: Кат. ГМИИ 1948, p. 14; Кат. ГМИИ 1957, p. 21; Кат. ГМИИ 1961, p. 30, ill.; P. Remy, *Catalogue des tableaux du cabinet de feu M. Randon de Boisset*, Paris, 1777, No 192; Musée Youssoupoff 1839, No 86; Michel 1886, p. 10; L. Souillié, Ch. Masson, *Catalogue raisonné de l'œuvre peint et dessiné de François Boucher*, in: A. Michel, *François Boucher*, Paris, 1889, No 167; A. Прахов 1906, pp. 208—209, ill. 96; Nolhac 1907, p. 115; Бенуа 1908, p. 731, ill.; H. MacFall, *Boucher*, London, 1908, p. 146; H. Roujon, *François Boucher*, Paris, s.a. [1900], p. 21; Anciennes écoles de peinture 1910, p. 116, ill.; Бенуа 1912, p. 334, ill.; Кат. Юсуповской галереи 1920, No 40; Эрнст 1924, p. 56, ill.; L. Réau, *Histoire de la peinture française au XVIII siècle*, vol. I, Paris — Brussels, 1925, p. 41; Réau 1929, No 13; Sterling 1957, ill. 38, pp. 44—45; Прокофьев 1962, ill. 59; Musée de Moscou 1963, p. 142, ill.; Charmet 1970, pp. 19—20, ill.; Antonova 1977, No 66; Кузнецова 1978, ill. 1—3

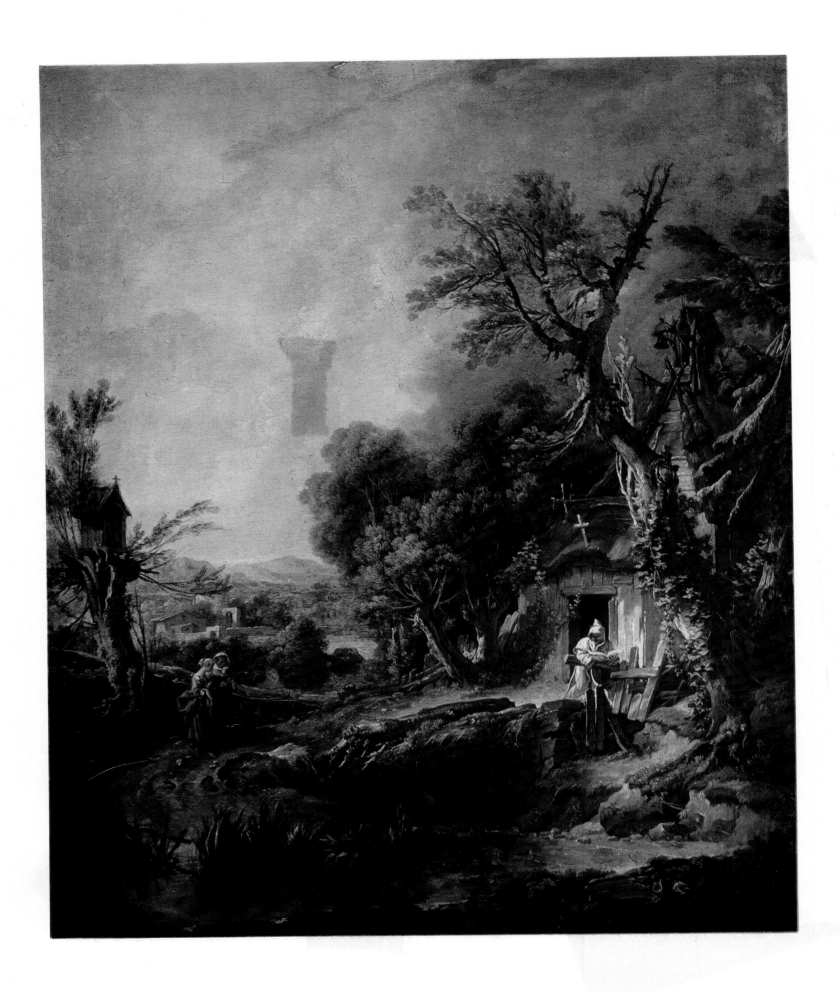

47 THE MILL (THE FARM). 1752
Oil on canvas. 49 × 59 cm. Inv. No 734
Signed and dated lower, center: *Boucher, 1752*

Provenance: until 1925 The Pokrovskoye-Streshnevo
Estate Museum (near Moscow); since 1925 The Pushkin
Museum of Fine Arts, Moscow

Exhibitions: 1955 Moscow, Cat., p. 24; 1956 Lenin-
grad, Cat., p. 10; 1972 Dresden, Cat. 7

Bibliography: Кат. ГМИИ 1948, p. 14; Кат. ГМИИ
1957, p. 21; Кат. ГМИИ 1961, p. 30; Прокофьев 1962,
ill. 61; ГМИИ 1966, No 60; Antonova 1977, ill. 67;
Кузнецова 1978, ill. 12, 13

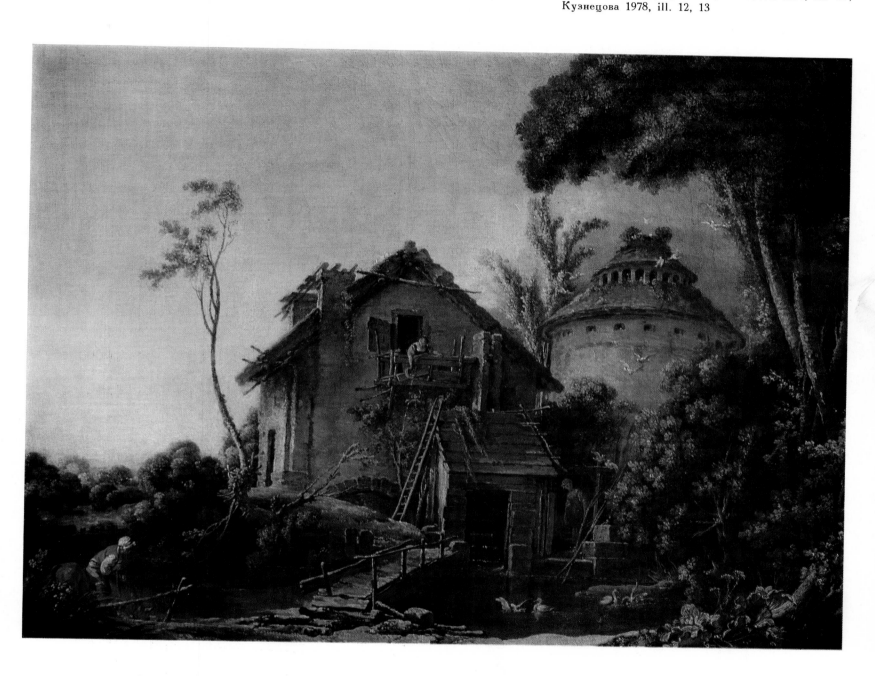

46 LANDSCAPE WITH A HERMIT. 1742
Oil on copper-plate. 66.5 × 55.5 cm. Inv. No 2765
Signed and dated lower right: *F. Boucher 1742*
The subject is taken from La Fontaine's fable *The
Hermit*. The picture was engraved by P. C. Chedel.

Provenance: until 1772 The Collection of L. A. Crozat,
Baron de Thiers, Paris; 1772—1882 The Gatchina Pal-
ace (near St Petersburg); 1882—1930 The Hermitage,
St Petersburg — Leningrad; since 1930 The Pushkin
Museum of Fine Arts, Moscow

Exhibitions: 1742 Paris (Salon), Cat. 21 bis; 1955
Moscow, Cat., p. 24; 1956 Leningrad, Cat., p. 10;
1965 Bordeaux, Cat. 15; 1965—66 Paris, Cat. 13

Bibliography: Кат. ГМИИ 1948, p. 14; Кат. ГМИИ
1957, p. 21; Кат. ГМИИ 1961, p. 30; Cat. Crozat 1755,
p. 59; Cat. Ermitage 1774, No 775; E. et J. de Gon-
court, *L'Art du XVIII^e siècle*, Paris, 1880, p. 182;
Mantz 1880, p. 92; Michel 1886, p. 54; L. Souillié, Ch.
Masson, *Catalogue raisonné de l'œuvre peint et des-
siné de François Boucher*, in: A. Michel, *François
Boucher*, Paris, 1889, No 1739; Сомов 1900, No 1798,
ill.; Nolhac 1907, p. 41, ill.; Кат. Эрмитажа 1916,
No 1798; M. Fenaille, *F. Boucher*, Paris, 1925, p. 59;
Réau 1929, No 12; Sterling 1957, ill. 39, p. 45; Stuff-
mann 1968, p. 126, No 108; Antonova 1977, No 64;
Кузнецова 1978, ill. 10, 11

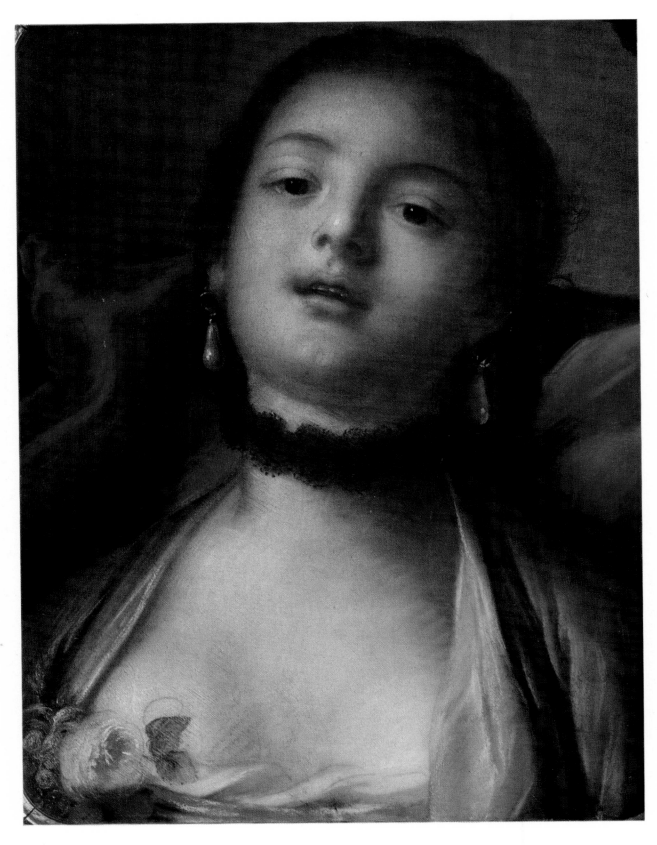

48 A WOMAN'S HEAD

Pastel on parchment. 39 × 31 cm. Inv. No 729

In all probability, this pastel and its pendant depicting a sleeping girl were put up as lot 41 at the sale of the J. O. Bergeret Collection in Paris in 1785. The pastels were entitled *The Awakening* and *The Dream*. A number of repetitions or copies appeared at various sales, for example those of the Craemer Collection, Paris (1913, lot 11), and of the R. Lepke Collection, Berlin (1928, lot 359). In the Arkhangelskoye Estate Museum near Moscow there is a copy of the Pushkin Museum picture, identified as a work by Rotari; another copy is now in the Kuskovo Estate Museum, also near Moscow. The pastel may be dated to the 1740s. It was engraved in the eighteenth century by I. F. Poletnik and J.-B. Michel under the title of *La Voluptueuse*, and its pendant as *La Dormeuse*.

Provenance: 1785 Sale of the J. O. Bergeret Collection, Paris; until 1924 The D. Shchukin Collection, Moscow; since 1924 The Pushkin Museum of Fine Arts, Moscow

Bibliography: Кат. ГМИИ 1948, p. 15; Кат. ГМИИ 1957, p. 22; Кат. ГМИИ 1961, p. 30; Н. Прахов 1905, p. 119, ill. 64; Nolhac 1907, p. 139; G. Wildenstein, "Un Amateur de Boucher et de Fragonard, J. O. Bergeret. 1715—1789", *Gazette des Beaux-Arts*, 58, 1961, p. 67; Кузнецова 1978, ill. 14

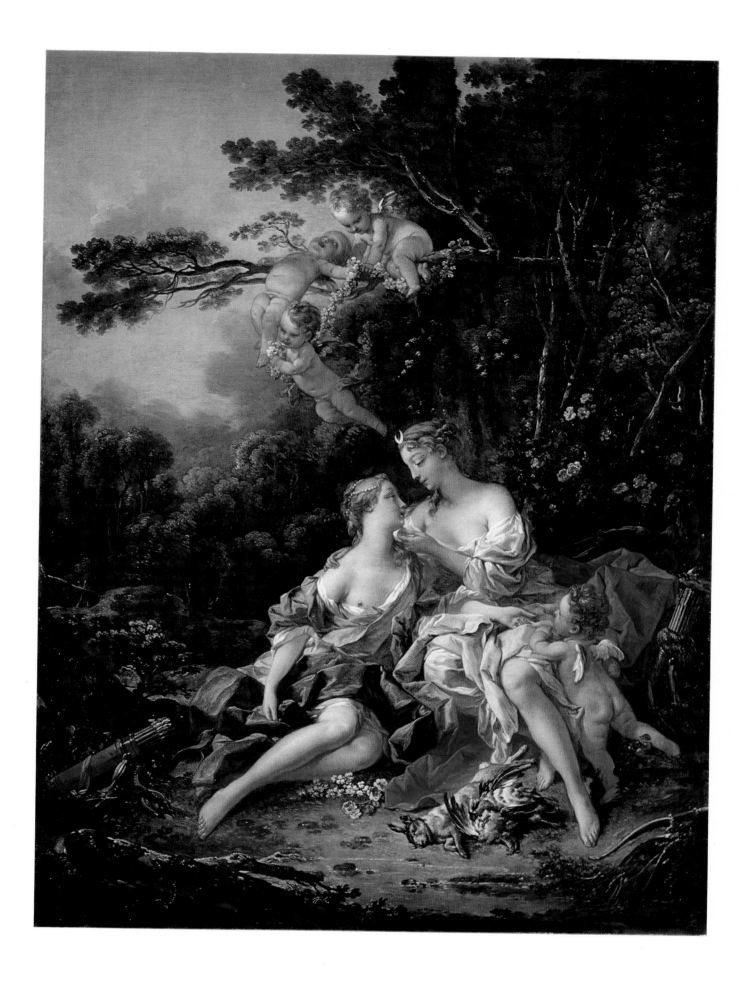

49 JUPITER AND CALLISTO. 1744
←
Oil on canvas. 98 × 72 cm. Inv. No 733
Signed and dated lower left: *F. Boucher 1744*
The subject is taken from Ovid's *Metamorphoses* (2: 409 ff.). There are numerous variants of the picture, all bearing the same title.

Provenance: 1773 Sale of the Collection of P. de Vigny, Paris; 1777 Sale of the Collection of Prince L. F. De Conti, Paris; 1779 Sale of the Abbé Gevigney Collection, Paris; 1827—1924 The Yusupovs Collection, Arkhangelskoye (near Moscow) and St Petersburg — Petrograd; 1924—25 The Hermitage, Leningrad; since 1925 The Pushkin Museum of Fine Arts, Moscow

Exhibitions: 1955 Moscow, Cat., p. 23; 1956 Leningrad, Cat., p. 9; 1972 Dresden, Cat. 6

Bibliography: Кат. ГМИИ 1948, p. 15; Кат. ГМИИ 1957, p. 21; Кат. ГМИИ 1961, p. 30; Musée Youssoupoff 1839, No 39; E. et J. de Goncourt, *L'Art du XVIII^e siècle*, Paris, 1880, pp. 189—190; Michel 1886, p. 106; L. Souillié, Ch. Masson, *Catalogue raisonné de l'œuvre peint et dessiné de François Boucher*, in: A. Michel, *François Boucher*, Paris, 1889, p. 122; А. Прахов 1906, pp. 209—210, ill. 95; Бенуа 1912, p. 332, ill.; Кат. Юсуповской галереи 1920, No 39; Эрнст 1824, p. 52, ill.; Д. Дидро, *Собрание сочинений*, vol. 6, Moscow, 1935, pp. 110—111, ill.; Sterling 1957, p. 45; Прокофьев 1962, ill. 58; Antonova 1977, No 65; Кузнецова 1978, ill. 4—7

50 THE RAPE OF EUROPA. 1725
Oil on canvas. 72 × 60 cm. Inv. No 992
Signed and dated lower left: *Lemoyne 1725*
The subject is taken from Ovid's *Metamorphoses* (2: 835—877). According to A. C. Caylus, the picture was painted for the Duke Louis de Mortemart. The composition betrays the influence of the Veronese murals in the Doges' Palace in Venice, which Lemoine could have studied during his stay in Italy. The picture was engraved by Cars in 1753.

Provenance: The Collection of Duke de Chevreuse, Paris; 1809 Sale of the Langlier and Paillet collections, Paris; 1827—1924 The Yusupovs Collection, Arkhangelskoye (near Moscow) and St Petersburg — Petrograd; 1924—25 The Hermitage, Leningrad; since 1925 The Pushkin Museum of Fine Arts, Moscow

Exhibitions: 1725 Paris (Salon); 1955 Moscow, Cat., p. 41; 1956 Leningrad, Cat., p. 33

Bibliography: Кат. ГМИИ 1948, p. 45; Кат. ГМИИ 1957, p. 80; Кат. ГМИИ 1961, p. 109; D'Argenville, *Abrégé de la vie des plus fameux peintres*, Paris, 1762, p. 428; A. C. Caylus, *Vies des premiers peintres du roi depuis M. Lebrun jusqu'à présent*, vol. 2, Paris, 1772, p. 65; Musée Youssoupoff 1839, No 372; Mantz 1880, pp. 21, 22; А. Прахов 1907, p. 62, ill. 41; Бенуа 1912, p. 324, ill.; Кат. Юсуповской галереи 1920, No 176; Эрнст 1924, p. 26, ill.; Dimier 1928—30, vol. 1, p. 91, No 8; Réau 1929, No 582; Прокофьев 1962, ill. 48; Musée de Moscou 1963, p. 141, ill.; ГМИИ 1966, No 59

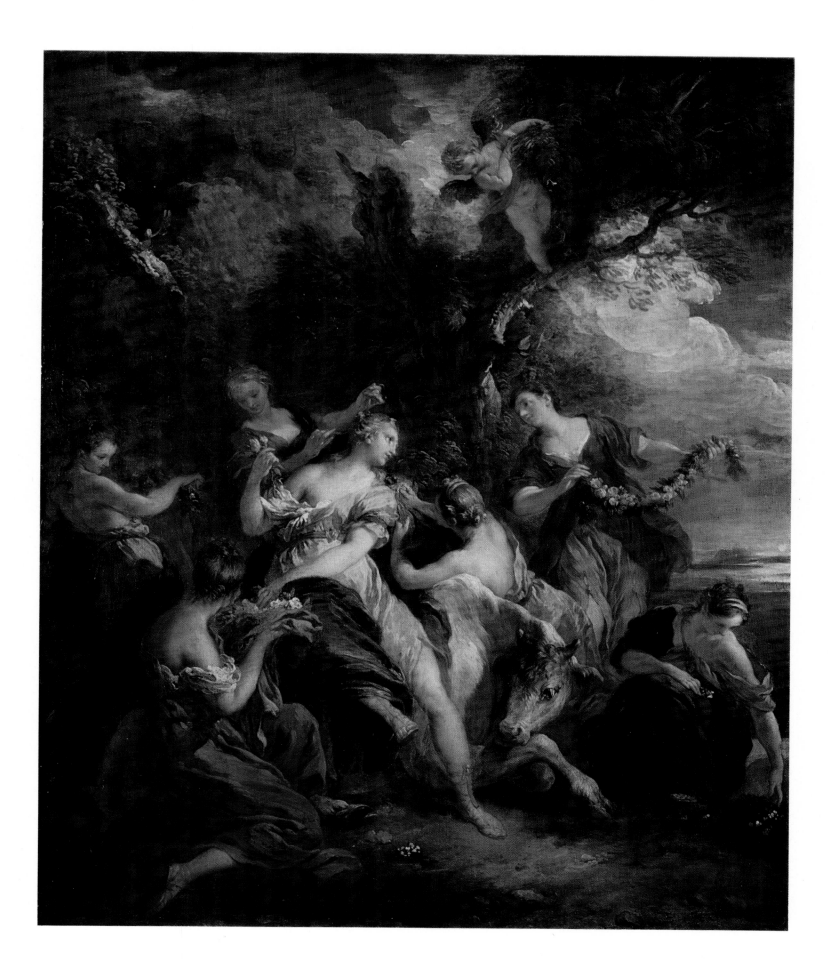

51 STILL LIFE WITH THE ATTRIBUTES
OF THE ARTS
Oil on canvas. 53 × 110 cm. Inv. No 1140
Signed lower right: *Chardin*
This still life may be dated to the 1750s. Chardin
executed a large number of similar compositions sym-
bolizing music, painting, etc., of which Wildenstein's
Catalogue lists 21. In its subject matter the Pushkin
Museum picture is close to *Still Life with the Attri-
butes of the Arts* in The Hermitage (1766, Inv. No 5627),
its variant (1769?) in the Minneapolis Museum of Arts
(USA), and *Still Life with the Attributes of the Arts*
in The Louvre. The latter was exhibited in the Salon
of 1765.

Provenance: until 1918 The O. Paley Collection, Tsar-
skoye Selo (near St Petersburg); 1918—24 The Palace
Museum (formerly the Paley Palace), Detskoye Selo

(near Petrograd); 1924—27 The Hermitage, Leningrad;
since 1927 The Pushkin Museum of Fine Arts, Moscow

Exhibitions: 1937 Paris, Cat. 142; 1955 Moscow, Cat.,
p. 61; 1956 Leningrad, Cat., p. 61

Bibliography: Кат. ГМИИ 1948, p. 86, ill.; Кат.
ГМИИ 1957, p. 148, ill.; Кат. ГМИИ 1961, p. 195,
ill.; D. Diderot, *Œuvres complètes*, vols. 1—12, Paris,
1875—77, vol. 10, p. 301; *ibid.*, vol. 11, p. 409; Э. Гол-
лербах, *Собрание Палей в Детском Селе*, Petrograd,
1923, pp. 12—13; Réau 1929, No 451; G. Wildenstein,
Chardin, Paris, 1933, No 1140, ill.; G. Wildenstein,
Chardin, Paris, 1968, No 237, ill.; Е. Нотгафт, "Ат-
рибуты искусства и проблемы аллегорического на-
тюрморта у Шардена", *Ежегодник Гос. Эрмитажа*,
vol. I, 1, 1937, p. 6, ill.; Прокофьев 1962, ill. 55;
Musée de Moscou 1963, p. 145, ill.; ГМИИ 1966, No 64;
Charmet 1970, p. 20, ill.; Antonova 1977, No 69

52 AUTUMN. After Bouchardon's bas-relief. 1770
Oil on canvas. 51 × 82.5 cm. Inv. No 1139
Signed and dated lower right: *Chardin 1770*
The picture is the imitation of Bouchardon's bas-relief *Autumn* which constitutes part of his sculptural group *Seasons of the Year* installed in the Rue de Grenelle fountain in Paris. Among Chardin's works there are at least twenty compositions imitating bas-reliefs and dating from different years of his artistic career.

Provenance: until 1924 The D. Shchukin Collection, Moscow; since 1924 The Pushkin Museum of Fine Arts, Moscow

Exhibitions: 1771 Paris (Salon), Cat. 38; 1955 Moscow, Cat., p. 61

Bibliography: Кат. ГМИИ 1948, p. 86; Кат. ГМИИ 1957, p. 148; Кат. ГМИИ 1961, p. 195; D. Diderot, *Œuvres complètes*, vols. 1—12, Paris, 1875—77, vol. 11, p. 48; Réau 1929, No 452; G. Wildenstein, *Chardin*, Paris, 1933, No 1203, ill.; G. Wildenstein, *Chardin*, Paris, 1968, No 362, ill.

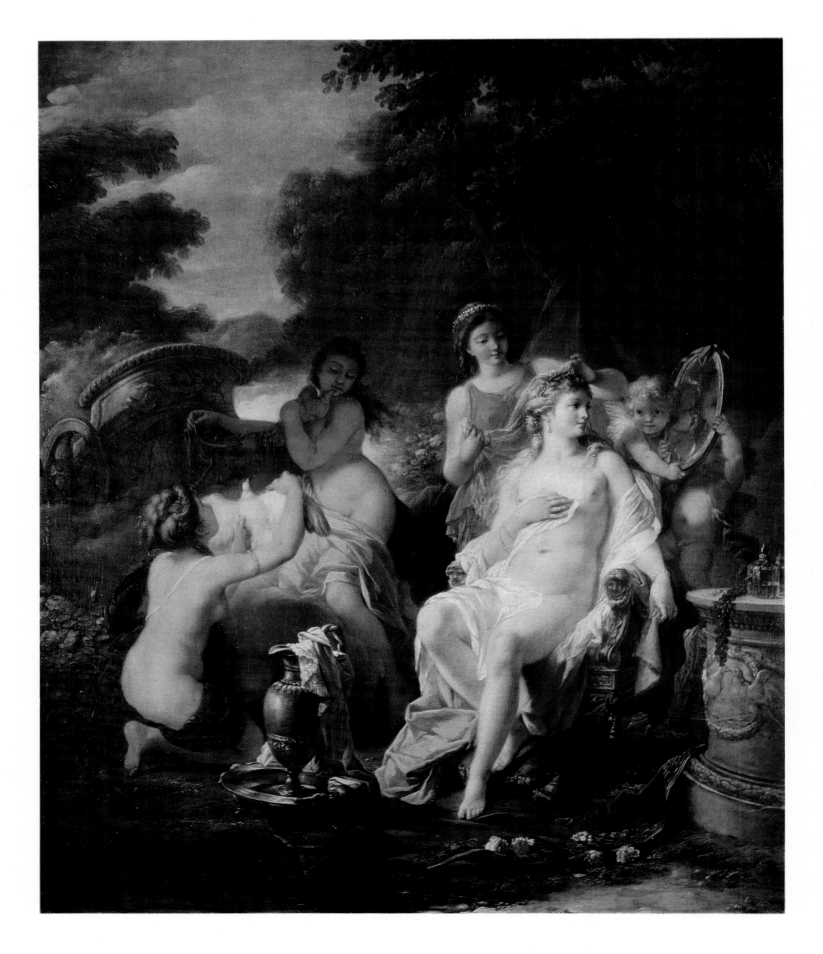

53 THE TOILET OF VENUS
Oil on canvas. 100 × 82 cm. Inv. No 737
In the early 1890s the picture was identified by
S. Scheikevich as Boucher's work and as such entered
The Pushkin Museum of Fine Arts. The authorship of
Taraval was suggested by A. Chegodayev on stylistic
evidence.

Provenance: until 1894 The A. Golitsyn Collection, Mos-
cow; 1894—1924 The D. Shchukin Collection, Moscow;
since 1924 The Pushkin Museum of Fine Arts, Moscow
Bibliography: Кат. ГМИИ 1948, p. 76; Кат. ГМИИ
1957, p. 174; Кат. ГМИИ 1961, p. 177; S. Scheike-
vitch, "Correspondance de Russie", *Gazette des Beaux-
Arts*, 1894, August, p. 172

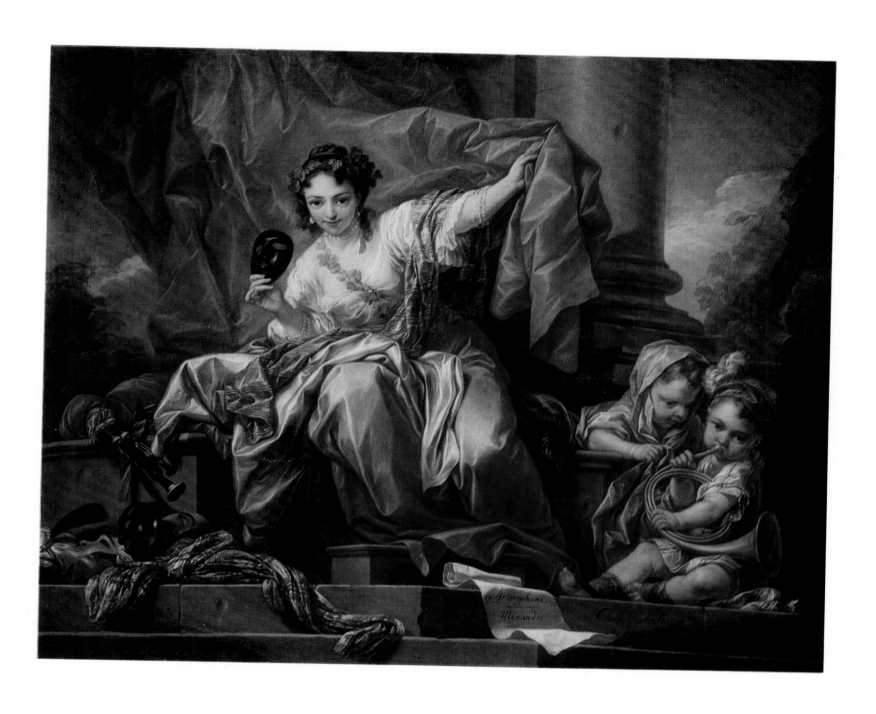

54 THE ALLEGORY OF COMEDY. 1753
Oil on canvas. 122 × 151 cm. Inv. No 742
Signed lower right: *Carle Vanloo*
It is a companion picture to *The Allegory of Trag-edy* (The Pushkin Museum of Fine Arts, Inv. No 741) and was painted in 1753 on the commission of Jeanne Antoinette Poisson, Marquise de Pompadour, for her Château de Bellevue. After her death both canvases went to her brother Abel Poisson, Marquis de Marigny.

Provenance: until 1918 The Vorontsov-Dashkovs Col-lection, St Petersburg — Petrograd; 1918—27 The Her-mitage, Leningrad; since 1927 The Pushkin Museum of Fine Arts, Moscow

Exhibitions: 1861 St Petersburg; 1922—25 Petrograd

Bibliography: Кат. ГМИИ 1961, p. 32; Ernst 1928, p. 180, ill.; Réau 1929, No 672; L. Réau, *Carle Vanloo,* in: *Archives de l'Art Français,* vol. 19, Paris, 1938, No 72

55 PORTRAIT OF NIKITA DEMIDOV
Oil on canvas. 138 × 111 cm. Inv. No 1105
N. Demidov (1724—1789) was grandson of Nikita Demi-
dov, the famous owner of the Urals foundries and
mines in the times of Peter the Great. Patron of
sciences and the arts, he was in correspondence with
Voltaire.
The portrait was probably painted by Tocqué during
his stay in St Petersburg in 1756—58.

Provenance: from the late 1750s The N. Demidov Col-
lection, St Petersburg; Moscow Archives of the Min-
istry of Foreign Affairs (gift of its director, K. Obo-
lensky); until 1924 The State Archives, Moscow; since
1924 The Pushkin Museum of Fine Arts, Moscow

Exhibitions: 1905 St Petersburg, Cat. 311; 1912 St
Petersburg, Cat. 125

Bibliography: Кат. ГМИИ 1961, p. 180; Н. Врангель,
"Иностранцы в России", Старые годы, 1911, July —
September, p. 5, ill.; А. Бенуа, "Выставка, посвя-
щенная времени императрицы Елизаветы Петровны",
Старые годы, 1912, May, p. 21; Réau 1924, p. 107;
A. Doria, Louis Tocqué, Paris, 1929, pp. 20, 36,
No 104, ill.; Réau 1929, No 656; Золотов 1968, p. 48, ill.

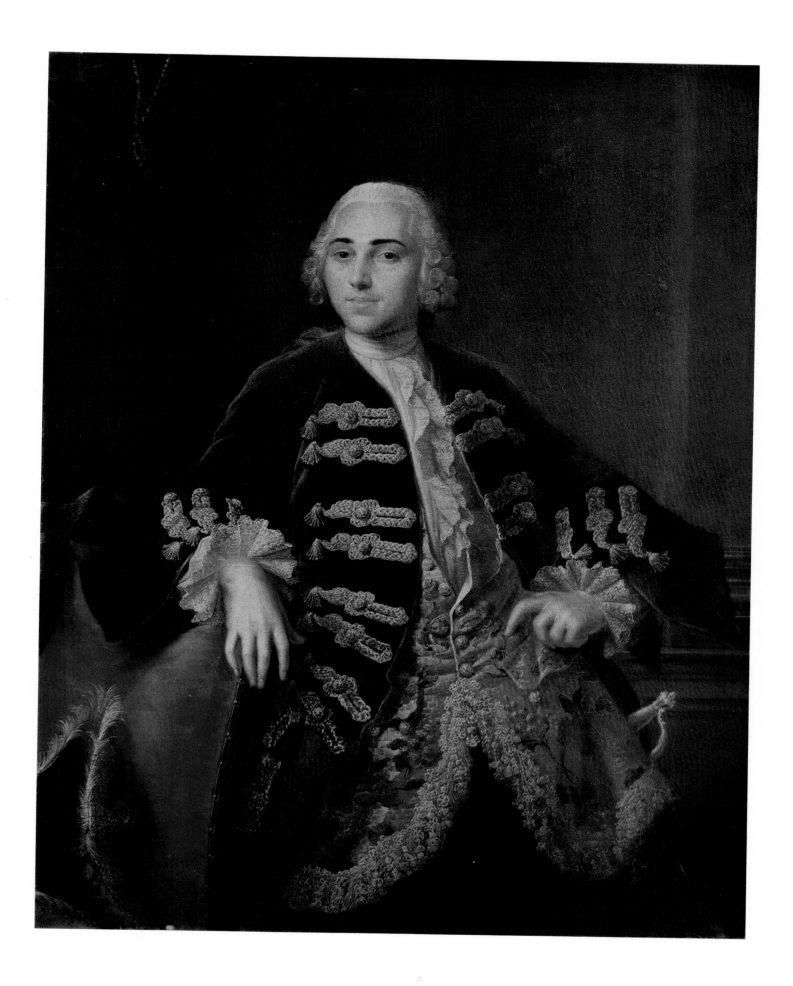

56 HEAD OF A BOY
Oil on canvas. 36 × 27.5 (oval). Inv. No 1101
This picture is a companion piece to *Head of a Girl*
(The Hermitage, Inv. No 4674).

Provenance: until 1823 The A. Golovkin Collection,
Moscow; *c.* 1827—1924 The Yusupovs Collection, Ar-
khangelskoye (near Moscow) and St Petersburg —

Petrograd; 1924—27 The Hermitage, Leningrad; since
1927 The Pushkin Museum of Fine Arts, Moscow

Exhibition: 1955 Moscow, Cat., p. 57

Bibliography: Кат. ГМИИ 1948, p. 76; Кат. ГМИИ
1957, p. 135, ill.; Кат. ГМИИ 1961, p. 177, ill.; Кат.
Юсуповской галереи 1920, No 126; Эрнст 1924, p. 40,
ill.; Réau 1929, No 642; ГМИИ 1966, No 61

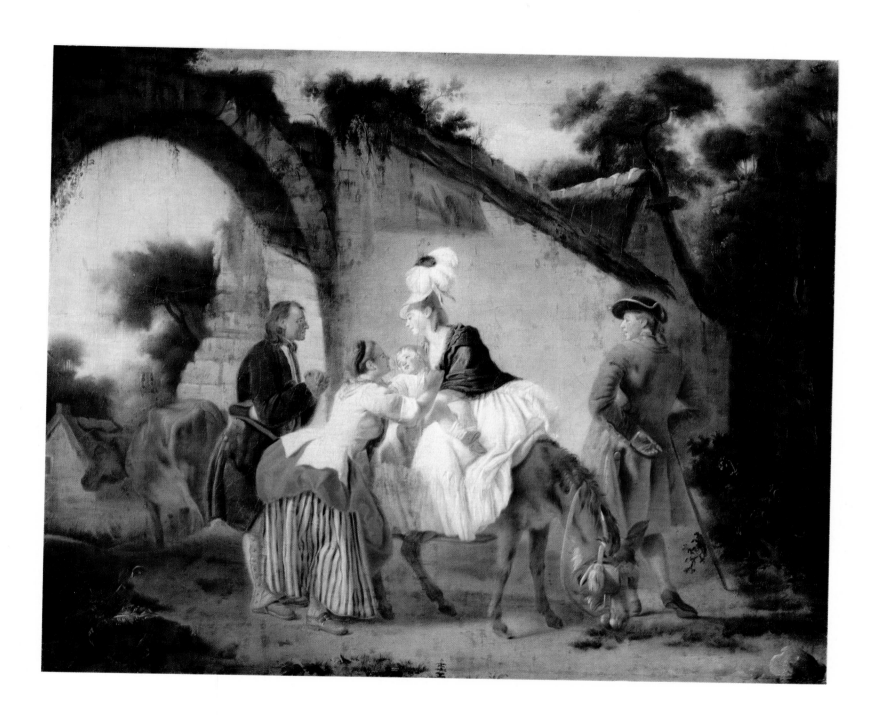

57 PARTING WITH THE
 FOSTER MOTHER. 1767
Oil on canvas. 52 × 63 cm. Inv. No 3153
The picture was exhibited in the Salon of 1777. It is
a companion piece to another picture by Aubry, *Visit-
ing the Foster Mother*, or *A Lesson in Brotherly
Friendship* (in 1925 the latter was in the G. Wilden-
stein Collection, Paris). Engraved by Robert de Lau-
ney in 1779.

Provenance: 1785 Sale of the Collection of Marquis
de Veri, Paris; since 1938 The Pushkin Museum of

Fine Arts, Moscow (received from the State Anti-
quarian Reserve in Moscow)

Exhibition: 1777 Paris (Salon), Cat. 126

Bibliography: Кат. ГМИИ 1957, p. 174; Кат. ГМИИ
1961, p. 141; *Catalogue raisonné d'objets d'art du
cabinet de feu M. de Silvestre*, Paris, 1810, No 2;
E. de Goncourt, *La Maison d'un artiste*, vol. I, Paris,
1881, pp. 40—41; F. Ingersoll-Smouse, "Quelques tab-
leaux de genre inédits par Etienne Aubry (1745—
1781)", *Gazette des Beaux-Arts*, 11, 1925, pp. 82—83;
Ernst 1928, pp. 206—207

58 PORTRAIT OF PROSPER CRÉBILLON
Oil on canvas. 140 × 109 cm. Inv. No 3779
Prosper Jolyot Crébillon (1674—1762) was a well-known French playwright, author of the tragedies *Idoménée* (1705), *Atrée et Thyeste* (1707), *Rhadamiste et Zénobie* (1711), *Pyrrhus* (1726), etc.
The portrait was painted in 1746, as witnessed by the inscription on the engraving of J. Baléchou. In the same year, the portrait was exhibited in the Salon. In 1905 it was identified by S. Diaghilev as a portrait of Count Heinrich Johann Ostermann by an unknown master. The present correct attribution was made by N. Vaudeau in 1953, on the basis of Baléchou's burin engraving. There are numerous engravings of the portrait made by other artists.

Provenance: until 1905 The Kurakins Collection, Nadezhdino Estate, Saratov province; 1905—21 The N. Tiutchev Collection, Moscow (purchased from F. Kurakin); 1921—56 The Tiutchev Estate Museum, Muranovo; since 1956 The Pushkin Museum of Fine Arts, Moscow

Exhibitions: 1746 Paris (Salon), Cat. 79; 1905 St Petersburg, Cat. 329; 1955 Moscow, Cat., p. 21; 1956 Leningrad, Cat., p. 7

Bibliography: Кат. ГМИИ 1957, p. 7; Кат. ГМИИ 1961, p. 7; *Catalogue raisonné de la collection de feu M. Aved*, appendix 3, Paris, 1766, p. 225, No 128; G. Wildenstein, *Le Peintre J. A. J. Aved. Sa vie et son œuvre*, 2 vols., Paris, 1922, vol. 1, p. 70, vol. 2, No 27; Н. Водо, "Неопубликованный портрет драматурга Кребийона работы Аведа", *Труды ГМИИ*, 1960, p. 247; Золотов 1968, p. 76, ill.

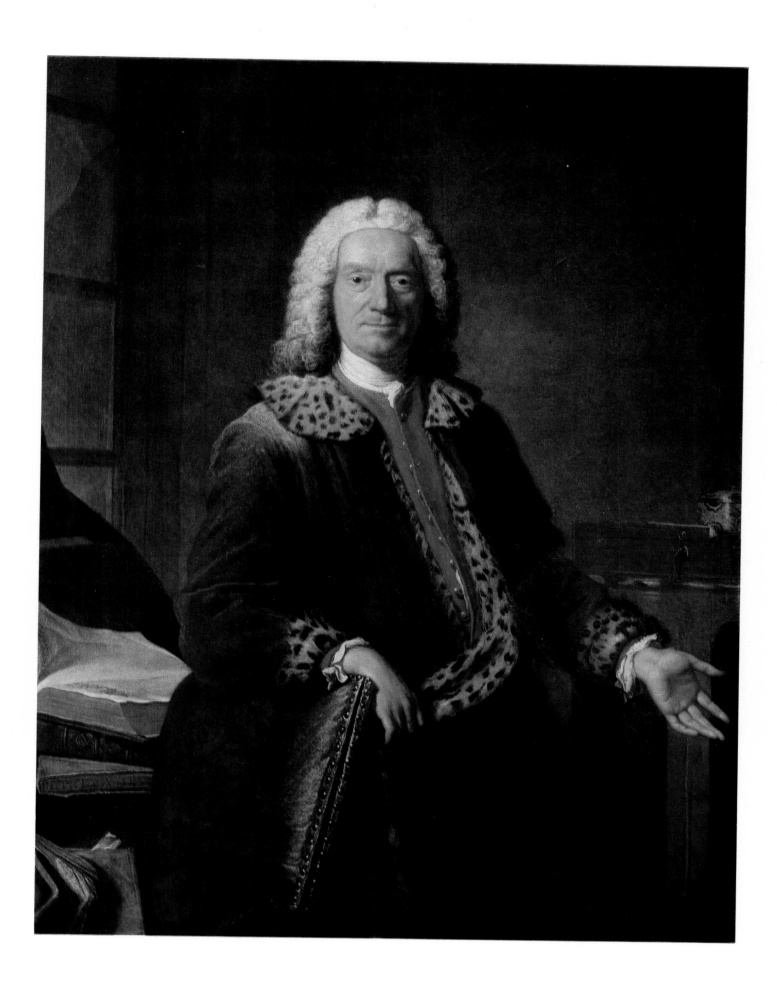

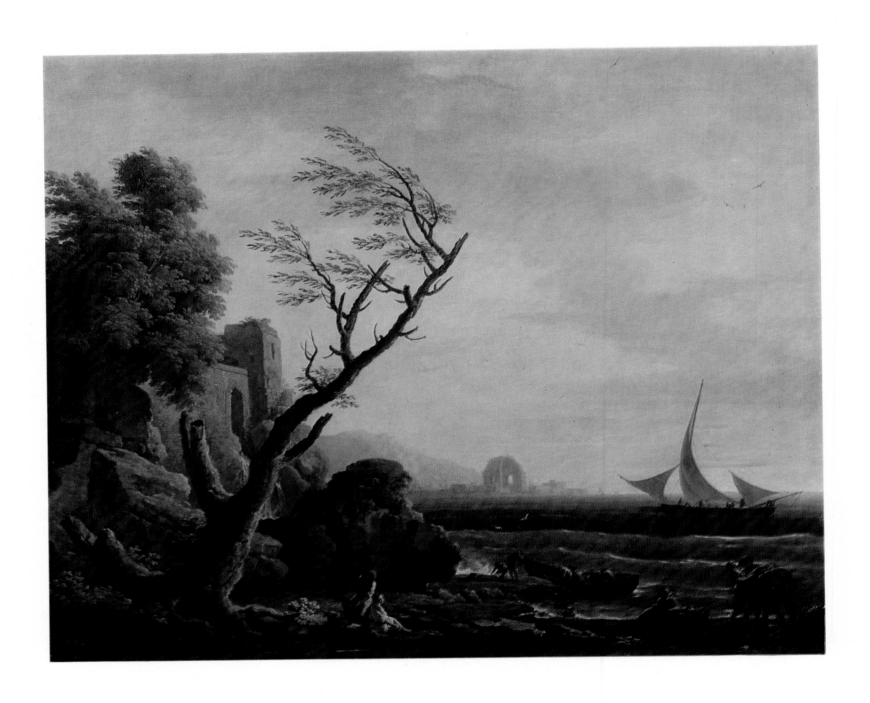

59 SUNRISE. 1746

Oil on canvas. 68 × 84 cm. Inv. No 768

Signed and dated lower left: *J. Vernet, f. Romae 1746*

A companion picture to *Sunset* (The Pushkin Museum of Fine Arts, Inv. No 769), this was commissioned by Marquis de Villette in 1745. Engraved by P. J. Duret in reverse under the title *Fishermen Returning from the Sea*, with a dedication to Marquis de Villette.

Provenance: 1765 Sale of the Collection of Marquis de Villette, Paris; until 1924 The Rumiantsev Museum, Moscow (received from the F. Sokovnin Collection);

since 1924 The Pushkin Museum of Fine Arts, Moscow (entered as *Seaside View*)

Exhibition: 1753 Paris (Salon), Cat. 132

Bibliography: Кат. ГМИИ 1948, p. 18; Кат. ГМИИ 1957, p. 26; Кат. ГМИИ 1961, p. 36; Lagrange 1864, pp. 185, 325—327; *Каталог Румянцевского музея,* Moscow, 1865, No 196; А. Новицкий, *Художественная галерея Московского Публичного и Румянцевского музеев,* Moscow, 1889, No 223; Кат. Румянцевского музея 1915, No 520; Ingersoll-Smouse 1926, vol. 1, No 136; Réau 1929, No 680 (entitled *Une marine avec des ruines sur le rivage*)

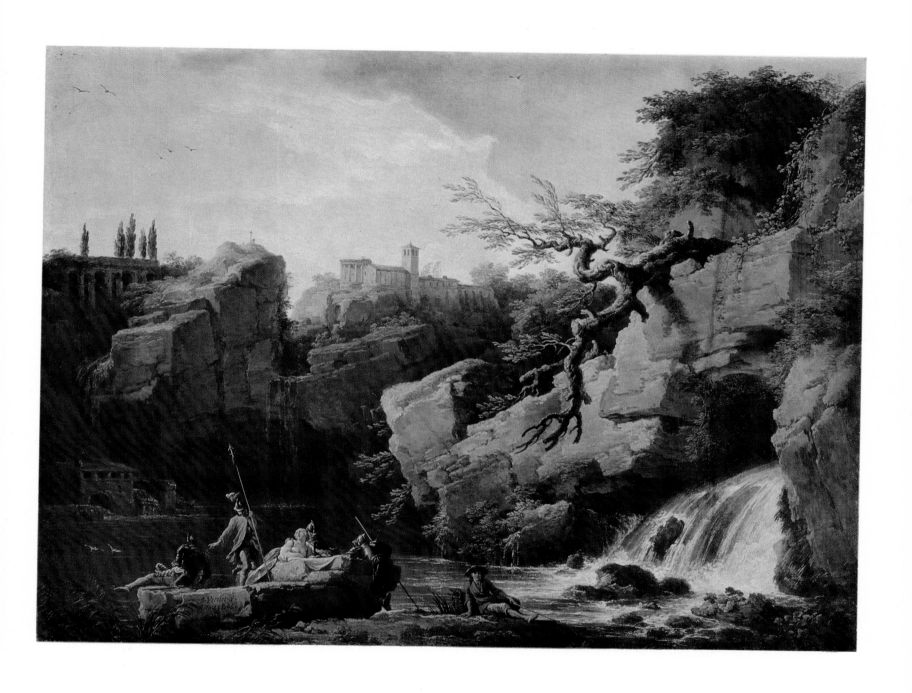

60 ROMANTIC LANDSCAPE
(LANDSCAPE IN THE STYLE
OF SALVATORE ROSA). 1746
Oil on canvas. 74 × 97 cm. Inv. No 770
Signed and dated lower left: *J. Vernet Romae 1746*

It is one of the eight pictures commissioned by Marquis de Villette in 1746. Engraved by L. J. Cathelin.

Provenance: 1765 Sale of the Collection of Marquis de Villette, Paris; from the late 18th century until 1924 The Yusupovs Collection, Arkhangelskoye (near Moscow) and St Petersburg — Petrograd; since 1924 The Pushkin Museum of Fine Arts, Moscow

Bibliography: Кат. ГМИИ 1948, p. 18; Кат. ГМИИ 1957, p. 26; Кат. ГМИИ 1961, p. 36; Musée Youssoupoff 1839, No 207; Lagrange 1864, pp. 185, 327, 360, 463; Waagen 1864, p. 417; Эрнст 1924, p. 68, ill.; Ingersoll-Smouse 1926, vol. 1, No 168, ill. XVI (entitled *A View in the Environs of Tivoli*); Réau 1929, No 681; W. Constable, "Carlo Bonavia", *The Art Quarterly*, Spring 1959, p. 40, ill.

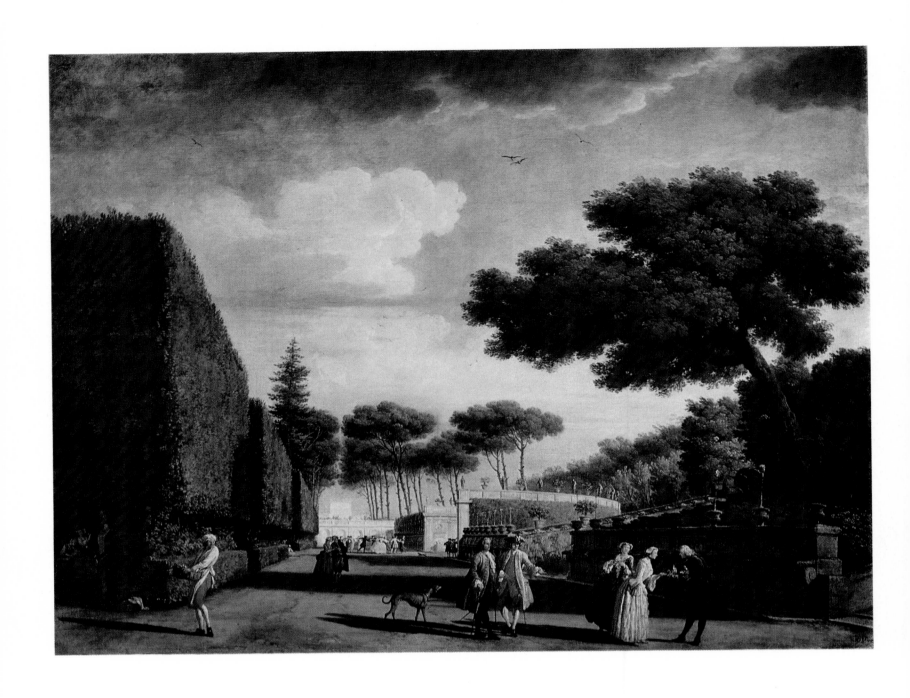

61 VIEW IN THE PARK OF VILLA PAMPHILI. 1749
Oil on canvas. 76 × 101 cm. Inv. No 2769
Signed and dated lower right: *Joseph Vernet, F. Roma 1749*
A companion picture to *View in the Park of Villa Ludovisi* (The Hermitage, Inv. No 3684), it was commissioned by Marquis de Villette in 1746.

Provenance: 1765 Sale of the Villette Collection, Paris; 1768—1922 The Academy of Arts, St Petersburg — Petrograd; 1922—30 The Hermitage, Leningrad; since 1930 The Pushkin Museum of Fine Arts, Moscow

Exhibitions: 1955 Moscow, Cat., p. 25; 1956 Leningrad, Cat., p. 13; 1965 Bordeaux, Cat. 37; 1965—66 Paris, Cat. 26; 1976—77 Paris, Cat. 21

Bibliography: Кат. ГМИИ 1948, p. 18; Кат. ГМИИ 1957, p. 26; Кат. ГМИИ 1961, p. 36; Lagrange 1864, p. 327; А. Сомов, *Картинная галерея Императорской Академии художеств*, part 2: *Каталог произведений иностранной живописи*, St Petersburg, 1874, No 586 (entitled *View in the Park*); Ingersoll-Smouse 1926, vol. 1, No 212, ill. XXIV; Réau 1929, No 393; Sterling 1957, p. 58; Antonova 1977, No 71

62 BEGGAR WOMAN WITH CHILDREN
(SAVOYARDE). 1737
Oil on canvas. 66 × 52 cm. Inv. No 3018
Signed and dated: *du Mont 1737*
This is a companion picture to *Strolling Musician
(Savoyard)* (The Hermitage, Inv. No 3546). The pic-
ture was etched by Dumont himself; J. Daullé com-
pleted the engraving with a burin.

Provenance: until 1790 The Collection of Marquis de
Livois, Paris; 1920 Private collection, Petrograd;
since 1937 The Pushkin Museum of Fine Arts, Moscow

Exhibitions: 1748 Paris (Salon); 1922—25 Petrograd
Bibliography: Кат. ГМИИ 1957, p. 56; Кат. ГМИИ
1961, pp. 79—80; А. Бенуа, "Картина Ж. Дюмона
Ромэна в Эрмитаже", *Сборник Эрмитажа*, 1923, 2,
p. 103, ill.; Ernst 1928, p. 247; Réau 1929, p. 27;
R. Planchenault, "La Collection du marquis de Li-
vois", *Gazette des Beaux-Arts*, 10, 1933, pp. 22, 23,
226; B. Lossky, "Œuvres anciennement connues ou
nouvellement retrouvées de Jacques Dumont le Ro-
main aux musées de Tours", *Gazette des Beaux-Arts*,
64, 1964, p. 230

63 PORTRAIT OF PRINCESS EKATERINA
(SMARAGDA) GOLITSYNA. 1759
Oil on canvas. 97 × 83 cm. Inv. No 747
Signed and dated center left: *Van Loo 1759*

Ekaterina Golitsyna (1720—1761), sister of the Rus-
sian Classicist writer Antioch Kantemir, was lady-in-
waiting to Empress Elizaveta Petrovna and wife of
Prince Dmitry Golitsyn, Russian ambassador to Vien-
na and the founder of the Golitsyn Hospital in Moscow.
The portrait of Princess Golitsyna is a companion
piece to the portrait of her husband, Prince Dmitry
Golitsyn, executed by Drouais the Younger (The Push-
kin Museum of Fine Arts, Inv. No 894). The picture
was painted during Golitsyna's sojourn in Paris be-
tween 1757 and 1761. Engraved by P. Gaillard.

Provenance: until 1918 The Golitsyn Hospital, Moscow;
1919—25 The Tretyakov Gallery, Moscow; since 1925
The Pushkin Museum of Fine Arts, Moscow

Exhibitions: 1905 St Petersburg, Cat. 347; 1918 Mos-
cow, Cat. 72; 1965 Bordeaux, Cat. 26; 1965—66 Paris,
Cat. 25; 1972 Moscow, Cat., p. 98; 1974—75 Paris
(Grand Palais), Cat. 478; 1975 Moscow

Bibliography: Кат. ГМИИ 1948, p. 15; Кат. ГМИИ
1957, p. 23; Кат. ГМИИ 1961, p. 32; Dussieux 1856,
p. 408; Н. Голицын, *Род князей Голицыных*, St Pe-
tersburg, 1898, pp. 133, 138, 139; Русские портреты
1905—9, vol. II, No 27, ill.; Н. Врангель, "Импера-
трица Елизавета в искусстве ее времени", *Аполлон*,
1912, 7, p. 6, ill.; Réau 1924, p. 208, ill.; Золотов
1968, p. 132, ill.

FRANÇOIS-HUBERT DROUAIS,
called DROUAIS THE YOUNGER. 1727—1775

64 PORTRAIT OF PRINCE
 DMITRY GOLITSYN. 1762
 Oil on canvas. 97 × 78 cm. Inv. No 894
 Signed and dated: *Peint par Drouais le fils en 1762*
 Dmitry Golitsyn (1721—1793), son of Field-Marshal
 General M. Golitsyn, was a famous Russian diplomat.
 From 1757 he lived in Paris, in 1760 was the Russian
 ambassador there. From 1761 to 1791 he was the Russian
 ambassador to Vienna. A connoisseur of art, he as-
 sembled a large collection of paintings. He founded
 the Golitsyn Hospital in Moscow.
 The picture is a pendant to the portrait of Princess
 E. Golitsyna by L. M. Vanloo (The Pushkin Museum
 of Fine Arts, Inv. No 747). Engraved with a burin
 by J. Tardieu.
 Provenance: until 1918 The Golitsyn Hospital, Moscow;
 1919—24 The Rumiantsev Museum, Moscow; since 1924
 The Pushkin Museum of Fine Arts, Moscow

 Exhibitions: 1763 Paris (Salon), Cat. 155; 1905 St Pe-
 tersburg, Cat. 355; 1918 Moscow, Cat. 86

 Bibliography: Кат. ГМИИ 1948, p. 30; Кат. ГМИИ
 1957, p. 55; Кат. ГМИИ 1961, p. 78; Н. Голицын,
 Род князей Голицыных, St Petersburg, 1898, p. 138;
 Русские портреты 1905—9, vol. II, No 26, ill.; Réau
 1924, p. 258, ill.; Réau 1929, No 513, ill.; Золотов
 1968, p. 134, ill.

65 AT THE FIRESIDE
Oil on canvas. 25 × 35 cm. Inv. No 2744

Provenance: since 1934 The Pushkin Museum of Fine Arts, Moscow (received from the Mozhaisk Board of Public Education)

Exhibitions: 1955 Moscow, Cat., p. 60; 1956 Leningrad, Cat., p. 60

Bibliography: Кат. ГМИИ 1948, p. 81; Кат. ГМИИ 1957, p. 143; Кат. ГМИИ 1961, p. 188; Sterling 1957, ill. 44, p. 50; Прокофьев 1962, ill. 73; ГМИИ 1966, No 63

66 A POOR FAMILY

Oil on canvas. 47 × 61 cm. Inv. No 1129

The picture may be dated the early 1760s. It is a companion piece to *The Snatched Kiss* (The Hermitage, Inv. No 5646). Engraved by J. Huc.

Provenance: 1764 Sale of the Le Clerc Collection, Paris; from the late 18th century to 1924 The Yusupovs Collection, Arkhangelskoye (near Moscow) and St Petersburg — Petrograd; 1924—25 The Hermitage, Leningrad; since 1925 The Pushkin Museum of Fine Arts, Moscow

Exhibitions: 1955 Moscow, Cat., p. 60; 1956 Leningrad, Cat., p. 60; 1965 Bordeaux, Cat., p. 20; 1965—66 Paris, Cat., p. 18

Bibliography: Кат. ГМИИ 1948, p. 86; ill.; Кат. ГМИИ 1957, p. 142; Кат. ГМИИ 1961, p. 188; Musée Youssoupoff 1839, No 365; R. Portalis, *Fragonard, sa vie, son œuvre*, Paris, 1889, No 103; A. Прахов 1906, p. 201, ill. 126; Кат. Юсуповской галереи 1920, No 68; Эрнст 1924, p. 214, ill.; Réau 1929, No 525; L. Réau, *Fragonard, sa vie, son œuvre*, Paris, 1956, p. 168; G. Wildenstein, *The Paintings of Fragonard*, London, 1960, No 120, ill.

67 THE FIRST FURROW
Oil on canvas. 118 × 148 cm. Inv. No 818
The picture was painted in 1801. A drawing in In-
dia ink, representing the first sketch for this canvas,
is in the possession of the Museum of Tournus. An-
other drawing is in the Cailleux Collection in Paris.
Provenance: 1801—1924 The Shuvalovs Collection,
St Petersburg — Petrograd (acquired by P. Shuva-
lov); since 1924 The Pushkin Museum of Fine Arts,
Moscow

Exhibitions: 1801 Paris (Salon), Cat. 159; 1861 St Pe-
tersburg, Cat. 135; 1897 St Petersburg, Cat. 24; 1908

St Petersburg, Cat. 97; 1914 Petrograd, Cat. 219; 1965
Bordeaux, Cat. 22; 1965—66 Paris, Cat. 20

Bibliography: Кат. ГМИИ 1948, p. 24, ill.; Кат. ГМИИ
1957, p. 43; Кат. ГМИИ 1961, p. 61; Бенуа 1908,
pp. 732—733, ill. (entitled *The First Ploughing*); An-
ciennes écoles de peinture 1910, p. 118, ill.; C. Mau-
clair, *J.-B. Greuze*, p. 15, Nos 126, 193; Бенуа 1912,
p. 377, ill.; L. Hautecœur, *Greuze*, Paris, 1913, p. 143;
Réau 1924, p. 199; Réau 1929, No 540; A. Brookner,
"Jean-Baptiste Greuze", *The Burlington Magazine*,
1956, June, pp. 196, 199; A. Brookner, *Greuze*, Lon-
don, 1972, pp. 80, 87, 133, ill.

68 FEMALE HEAD IN A MOBCAP
Oil on canvas. 40 × 31 cm. Inv. No 821
The picture may be dated to the early 1760s.

Provenance: from the late 18th century to 1924 The
Yusupovs Collection, Arkhangelskoye (near Moscow)
and St Petersburg — Petrograd; since 1924 The Push-
kin Museum of Fine Arts, Moscow

Exhibition: 1897 St Petersburg, Cat. 117

Bibliography: Кат. ГМИИ 1948, p. 24; Кат. ГМИИ
1957, p. 43; Кат. ГМИИ 1961, p. 61; Musée Youssou-
poff 1839, No 47; А. Прахов 1906, p. 196, ill. 118;
Кат. Юсуповской галереи 1920, No 154; Эрнст 1924,
p. 100, ill.; Réau 1929, No 539

69 PORTRAIT OF COUNT ANDREI SHUVALOV

Oil on canvas. 60 × 50.5 cm (oval). Inv. No 1228

Andrei Shuvalov (1744—1789) was a poet and an Honorary Member of the Academy of Arts in St Petersburg. Met Voltaire, carried on a correspondence with him and other figures of the French Enlightenment. The picture is a companion piece to the portrait of Countess E. Shuvalova (The Hermitage, Inv. No. 5726). It was painted in Paris between 1776 and 1781.

Provenance: until 1924 The Shuvalovs Collection, St Petersburg — Petrograd; 1924—28 The Hermitage, Leningrad; since 1928 The Pushkin Museum of Fine Arts, Moscow

Exhibitions: 1870 St Petersburg, Cat. 477; 1897 St Petersburg, Cat. 25; 1905 St Petersburg, Cat. 547; 1914 Petrograd, Cat. 220; 1955 Moscow, Cat., p. 28; 1956 Leningrad, Cat., p. 18

Bibliography: Кат. ГМИИ 1948, p. 24; Кат. ГМИИ 1957, p. 43; Кат. ГМИИ 1961, p. 61; Русские портреты 1905—9, vol. II, No 31, ill.; Réau 1924, p. 199; Réau 1929, No 541; A. Brookner, *Greuze*, London, 1972, p. 80

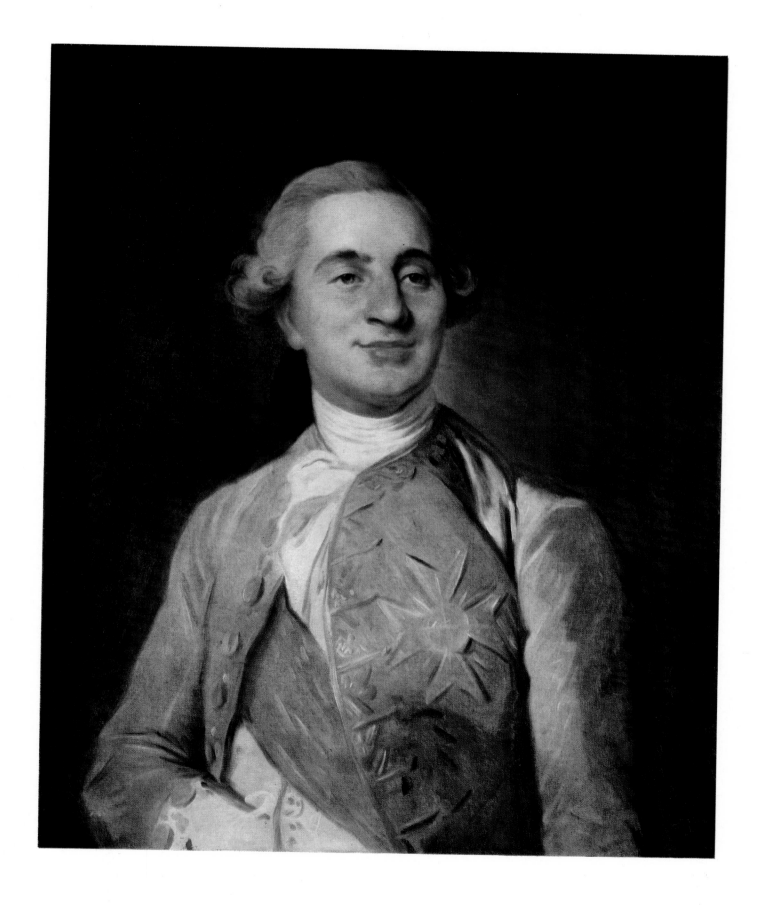

70 PORTRAIT OF LOUIS XVI
Oil on canvas. 70 × 57 cm. Inv. No 2170
Louis XVI (1754—1793) was King of France from 1775.
His reign was marked by the French Revolution; he
was guillotined. This is evidently a sketch for the
large coronation portrait of Louis XVI which was ex-
hibited in the Salon of 1777 and is now at Versailles.
Provenance: until 1927 The Hermitage, Leningrad;

since 1927 The Pushkin Museum of Fine Arts, Moscow
Exhibitions: 1955 Moscow, Cat., p. 34; 1956 Lenin-
grad, Cat., p. 25; 1972 Moscow, Cat., p. 86
Bibliography: Кат. ГМИИ 1948, p. 31; Кат. ГМИИ
1957, p. 56; Кат. ГМИИ 1961, p. 80; J. Belleudy,
J. S. Duplessis, peintre du Roi, Chartres, 1913, pp.
53—79, 326—327; Réau 1929, No 518; Прокофьев 1962,
ill. 76; Золотов 1968, p. 152, ill.

LOUIS GABRIEL MOREAU THE ELDER. 1739—1805

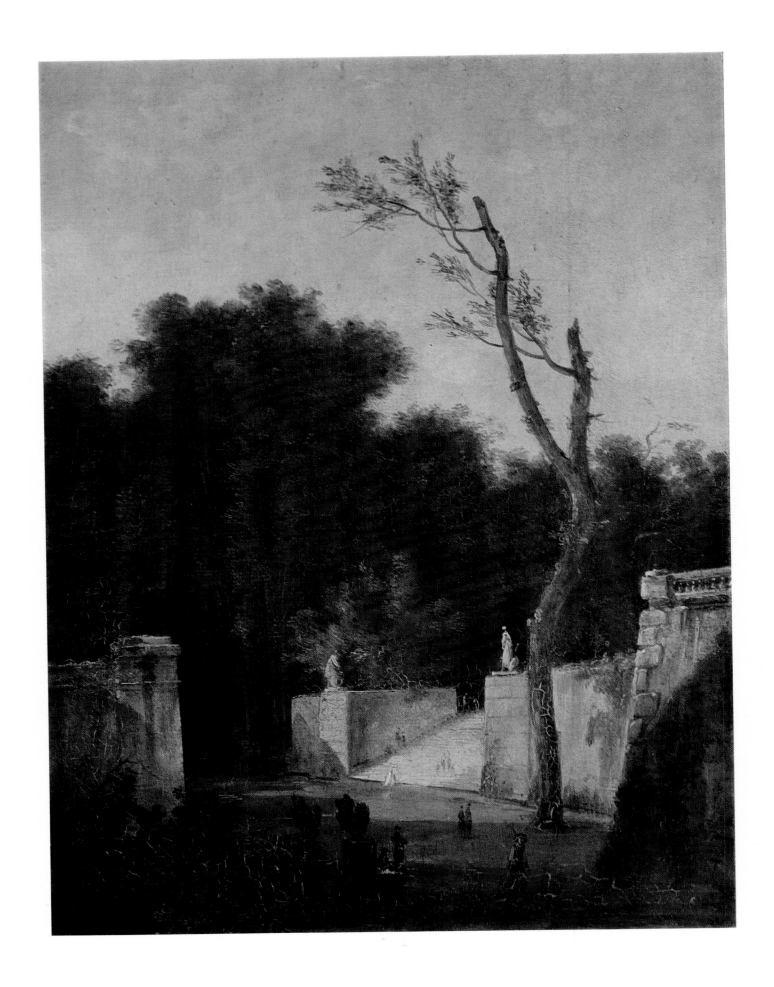

71 STAIRWAY IN THE PARK
Oil on paper. 32 × 24 cm. Inv. No 3010
Signed by two initials: *L. M.*
The motif of a large stairway in the park occurs in
many paintings and etchings of Moreau.

Provenance: since 1937 The Pushkin Museum of Fine
Arts, Moscow
Exhibition: 1955 Moscow, Cat., p. 48
Bibliography: Кат. ГМИИ 1948, p. 54; Кат. ГМИИ
1957, p. 98; Кат. ГМИИ 1961, p. 133

←

Oil on panel. 35 × 30 cm. Inv. No 846

Debucourt's work of the same title, also painted on panel, was put up in an auction on November 20, 1780, in Paris. In the Salon of 1783, the artist exhibited another variant of the picture, smaller in size (15 × 15 cm). A drawing of the same title was displayed in the Salon of 1814. The Pushkin Museum piece may be dated to the early 1780s.

Provenance: until 1924 The Yusupovs Collection, Arkhangelskoye (near Moscow) and St Petersburg — Petrograd; 1924—27 The Hermitage, Leningrad; since 1927 The Pushkin Museum of Fine Arts, Moscow

Exhibitions: 1912 St Petersburg, Cat. 180; 1955 Moscow, Cat., p. 30; 1956 Leningrad, Cat., p. 20

Bibliography: Кат. ГМИИ 1948, p. 25; Кат. ГМИИ 1957, p. 46; Кат. ГМИИ 1961, p. 66; Musée Youssoupoff 1839, No 7; Кат. Юсуповской галереи 1920, No 54; Эрнст 1924, p. 168, ill.; Reau 1929, No 488

73 A CLASSICAL BASILICA. 1768

Oil on canvas. 183 × 129 cm. Inv. No 868

Signed and dated lower right: *Demachy 1768*

Provenance: 1768—1862 The Hermitage, St Petersburg (acquired in France for Catherine II by D. Golitsyn); 1862—1924 The Rumiantsev Museum, Moscow; since 1924 The Pushkin Museum of Fine Arts, Moscow

Bibliography: Кат. ГМИИ 1961, p. 70; Cat. Ermitage 1774, No 359; Dussieux 1856, p. 440; *Каталог Румянцевского музея*, Moscow, 1865, No 194; А. Новицкий, *Художественная галерея Московского Публичного и Румянцевского музеев*, Moscow, 1889, No 227; Бенуа 1912, p. 393, ill.; Кат. Румянцевского музея 1912, No 1; Кат. Румянцевского музея 1915, No 9; Réau 1929, No 497

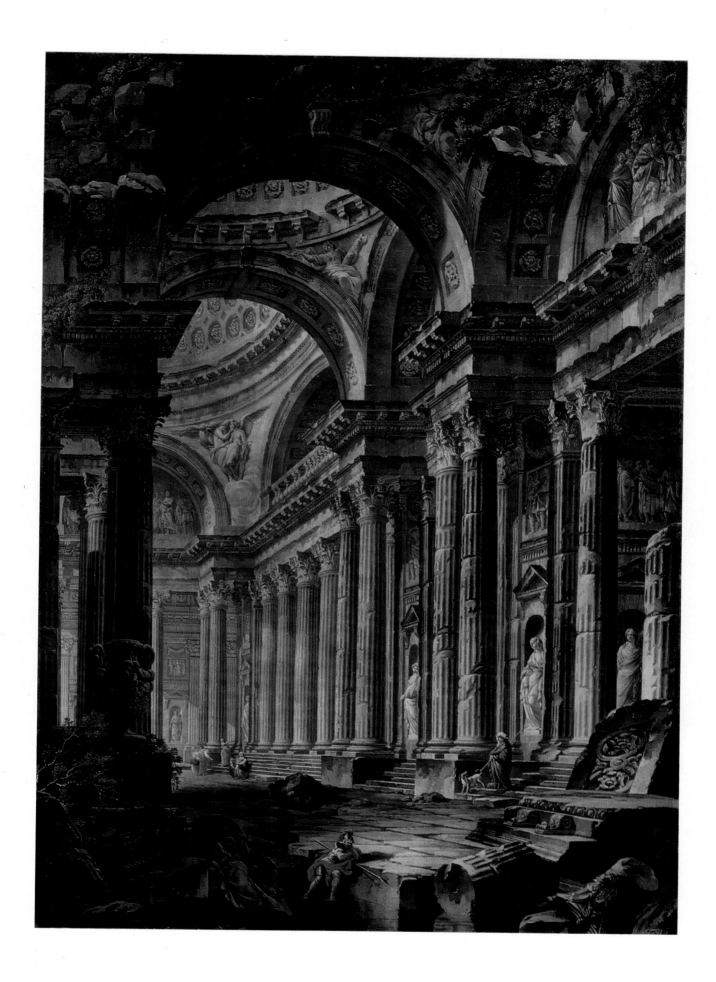

74 THERMAE. 1778
Oil on canvas. 108 × 149 cm. Inv. No 1063
Signed and dated lower right: *1778, Robert*
A picture with a similar subject, entitled *An Ancient Building in Use as a Public Bathhouse* (The Hermitage, Inv. No 1262), was exhibited in the Salon of 1798.

Provenance: until 1924 The D. Shchukin Collection, Moscow; since 1924 The Pushkin Museum of Fine Arts, Moscow

Exhibition: 1972 Prague, Cat. 32

Bibliography: C. Gabillot, *Hubert Robert et son temps*, Paris, 1895, pp. 104, 106, 272, 280; P. de Nolhac, *Hubert Robert*, Paris, 1910, pp. 144, 159; T. Каменская, *Гюбер Робер*, Leningrad, 1939, p. 48

75 THE DESTRUCTION OF A TEMPLE

Oil on canvas. 87 × 69 cm. Inv. No 1076

The picture may be dated to the early 1790s.

Provenance: 1876—1924 The Rumiantsev Museum, Moscow (gift of N. and V. Mukhanovs); since 1924 The Pushkin Museum of Fine Arts, Moscow

Bibliography: Кат. ГМИИ 1948, p. 68; Кат. ГМИИ 1957, p. 121; Кат. ГМИИ 1961, p. 161; А. Новицкий, *Художественная галерея Московского Публичного и Румянцевского музеев*, Moscow, 1889, No 232 (entitled *Ruins*); Кат. Румянцевского музея 1912, No 37; Кат. Румянцевского музея 1915, No 529; Réau 1929, No 629

76 PYRAMIDS AND TEMPLE
Oil on canvas. 100 × 136 cm. Inv. No 1069
Signed lower left in imitation Greek letters:
РОВЕРТ ТО ЕΔОVΑΔ ΔΙΛΛΟΝ

Edouard Dillon (1750—1839), a French aristocrat, took
part in the Revolutionary War (1775—83) and in
1789 emigrated from France.

Provenance: until 1924 The Hermitage, Petrograd;
since 1924 The Pushkin Museum of Fine Arts, Moscow
Exhibition: 1976 Rome, Dijon, Cat. 183
Bibliography: Кат. ГМИИ 1948, p. 69

77 FESTIVAL OF SPRING
Oil on canvas. 61 × 50 cm. Inv. No 1067
Signed lower right: *H. Robert G. L.*
The subject is symbolic in meaning, and can be
traced to the artist's release from confinement in 1794.
A preparatory drawing for the picture, as well as
a pendant to this drawing, on the theme *Birds Being
Imprisoned in a Cage*, were in the Count Vallombrosa
Collection. Another drawing with a slightly different
composition is in the Musée Atger at Montpellier.

Provenance: until 1924 The Shuvalovs Collection, St
Petersburg — Petrograd; since 1924 The Pushkin Mu-
seum of Fine Arts, Moscow

Exhibition: 1914 Petrograd, Cat. 240

Bibliography: Кат. ГМИИ 1948, p. 68; Кат. ГМИИ
1957, p. 121; Кат. ГМИИ 1961, p. 160; P. de Nolhac,
Hubert Robert, Paris, 1910, pp. 80, 82; Ch. Saunier,
"Le Musée Xavier Atger à Montpellier", *Gazette des
Beaux-Arts*, 5, 1922, p. 160; Réau 1929, No 643; T. Ка-
менская, *Гюбер Робер*, Leningrad, 1939, p. 46, ill.

LOUIS LÉOPOLD BOILLY. 1761—1845

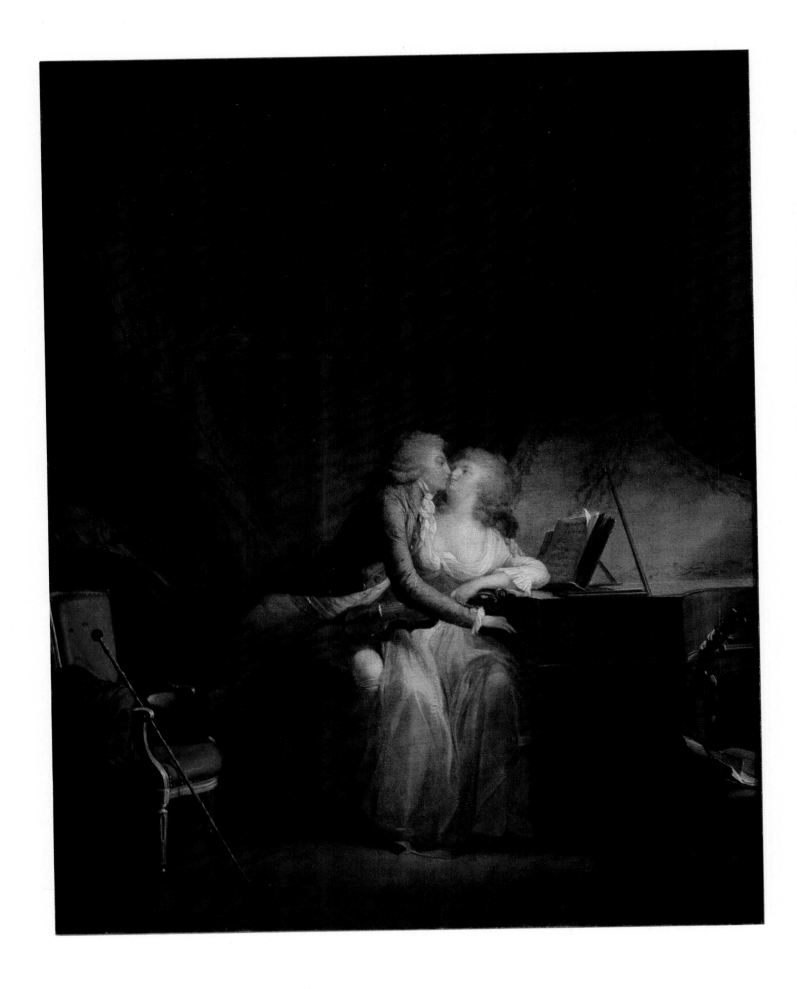

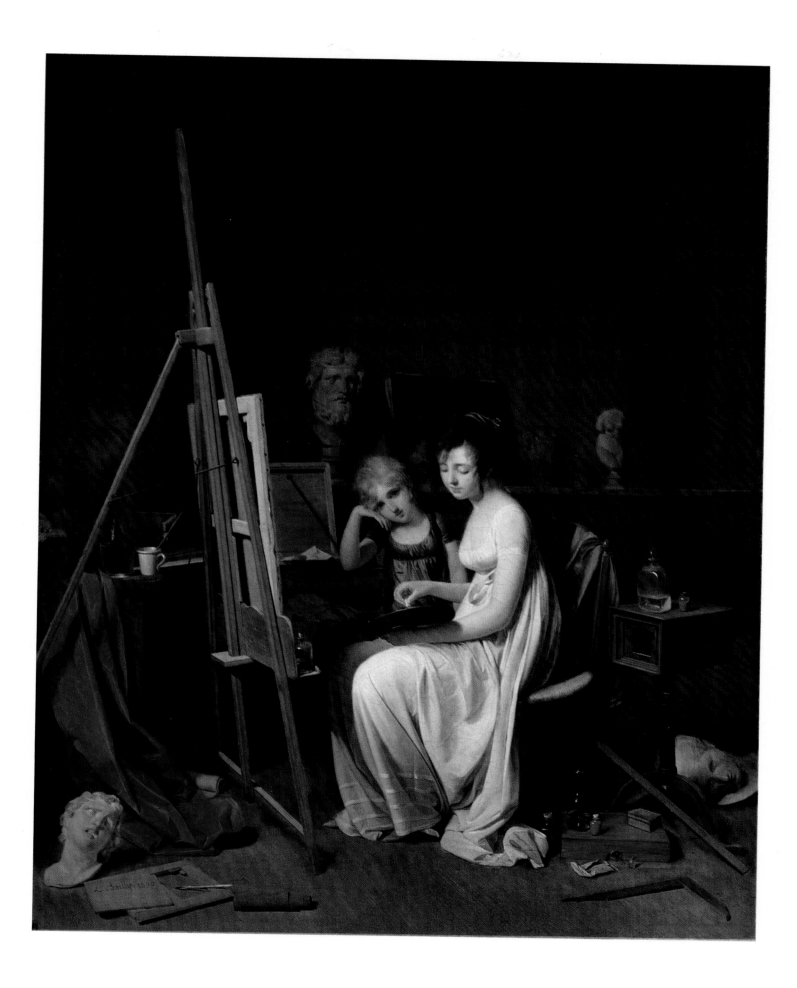

78 PRELUDE
←
Oil on canvas. 40 × 33 cm. Inv. No 722
Signed lower right: *L. Boilly pinx.*
The French title of the picture, *Prélude de Nina*,
refers to N. Dalayrac's opera, *Nina ou la Folle par
amour*, which in 1786 was staged in Paris with great
success. This circumstance permits the picture to be
dated 1786. It was reproduced in dotted print by
A. Chapponier.

Provenance: until 1918 The Collection of Grand Duke
Vladimir Alexandrovich, St Petersburg — Petrograd;
1918—24 The Hermitage, Petrograd; since 1924 The
Pushkin Museum of Fine Arts, Moscow

Exhibitions: 1922—25 Petrograd; 1955 Moscow, Cat.,
p. 22

Bibliography: Кат. ГМИИ 1948, p. 13; Кат. ГМИИ
1957, p. 19; Кат. ГМИИ 1961, p. 27; H. Harrisse,
L. L. Boilly, Paris, 1898, No 451; Ernst 1928, p. 250;
Réau 1929, No 426

79 YOUNG WOMAN PAINTER. 1800
←
Oil on canvas. 63 × 57 cm. Inv. No 1260
Signed and dated lower left: *L. Boilly 1800*
There exist numerous variants made by the artist,
one of which was exhibited in the Salon of 1800.

Provenance: until 1924 The Yusupovs Collection, Ar-
khangelskoye (near Moscow) and St Petersburg —
Petrograd; 1924—27 The Hermitage, Leningrad; since
1927 The Pushkin Museum of Fine Arts, Moscow

Exhibition: 1974—75 Paris, Cat. 7

Bibliography: Кат. ГМИИ 1948, p. 13; Кат. ГМИИ
1957, p. 19; Кат. ГМИИ 1961, p. 27; Musée Youssou-
poff 1839, No 229; А. Прахов 1901, p. 60, ill. 48;
А. Прахов 1906, p. 213, ill. 134; Кат. Юсуповской
галереи 1920, No 74; Эрнст 1924, p. 200, ill.; Réau
1929, No 431

80 PORTRAIT OF EKATERINA NARYSHKINA.
1787
Oil on canvas. 64.5 × 54 cm. Inv. No 803
Signed and dated lower right: *Voille 1787*
Ekaterina Naryshkina (1769—1844), née Stroganova,
was the wife of Ivan Naryshkin, High Chamberlain
and Grand Master of Ceremonies to the Royal Court.
The portrait was executed in the year of their mar-
riage.

Provenance: since 1787 The I. Naryshkin Collection,
St Petersburg; since 1905 The N. Sollogub Collection,
Moscow; since 1924 The Pushkin Museum of Fine Arts,
Moscow (received from the State Museum Reserve)

Exhibitions: 1905 St Petersburg, Cat. 467; 1955 Mos-
cow, Cat., p. 26

Bibliography: Кат. ГМИИ 1948, p. 21; Кат. ГМИИ
1957, p. 31; Кат. ГМИИ 1961, p. 44; Русские пор-
треты 1905—9, vol. I, No 166, ill.; Д. Рош, "Несколько
замечаний о Вуале и Виоллие", *Старые годы*, 1909,
October, p. 575; Réau 1929, No 690; Золотов 1968,
p. 221, ill.

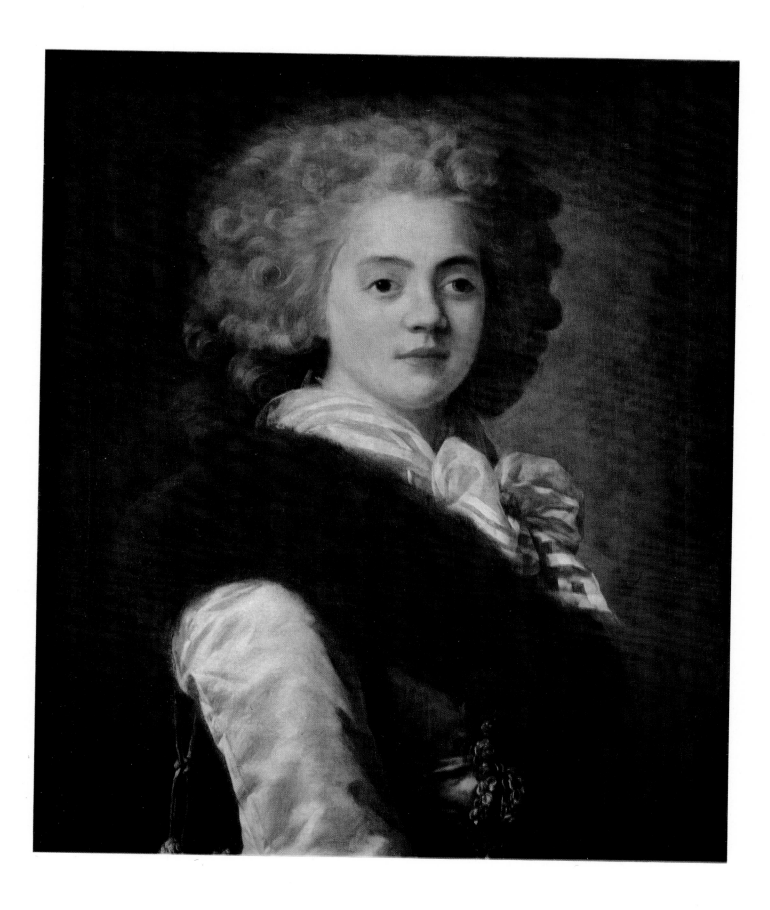

81 ANDROMACHE MOURNING
 OVER HECTOR. 1783
 Oil on canvas. 58 × 43 cm. Inv. No 843
 Signed and dated lower left: *L. David 1783*
 The picture is a finished sketch for the painting of
 the same name, which was presented to the jury of
 the Royal Academy on August 22, 1783, and won
 David the title of Academician (it is now in The
 Louvre). A preliminary drawing for this picture in
 black chalk and wash (29 × 24.6 cm; Inv. No 180) is
 in the Musée du Petit-Palais in Paris. Signed and
 dated 1782, it differs in some details from the Push-
 kin Museum piece. A drawing from the former col-
 lection of Dumont, engraved by Jacques Louis Jules
 David in 1882, is also known.

 Provenance: from 1805 The N. Demidov Collection,
 St Petersburg (acquired in Paris); The A. de Mont-
 ferrand Collection, St Petersburg; 1861 The P. Usha-
 kov Collection, St Petersburg; The K. Gortkevich
 Collection, St Petersburg; until 1900 The I. Vasilyev
 Collection, St Petersburg; 1900—27 The Hermitage,
 St Petersburg — Leningrad; since 1927 The Pushkin
 Museum of Fine Arts, Moscow

 Exhibitions: 1861 St Petersburg, Cat. 152; 1955 Mos-
 cow, Cat., p. 29; 1956 Leningrad, Cat., p. 19; 1964
 Leningrad, Cat., p. 14

 Bibliography: Кат. ГМИИ 1948, p. 24; Кат. ГМИИ
 1957, p. 45; Кат. ГМИИ 1961, p. 65; Dussieux 1856,
 p. 444; Сомов 1900, No 1883; Кат. Эрмитажа 1916,
 No 1883; Réau 1929, No 485; R. Continelli, *L. David*,
 Paris, 1930, p. 102, No 35; А. Замятина, *Давид*, Mos-
 cow, 1936, pp. 30—31, ill.; K. Holma, *David, son évo-
 lution et son style*, Paris, 1940, p. 42; L. Hautecœur,
 Louis David, Paris, 1954, p. 66; Sterling 1957, ill. 49,
 p. 65; Прокофьев 1962, ill. 84; И. Кузнецова, *Луи
 Давид*, Moscow, 1965, p. 44, ill.

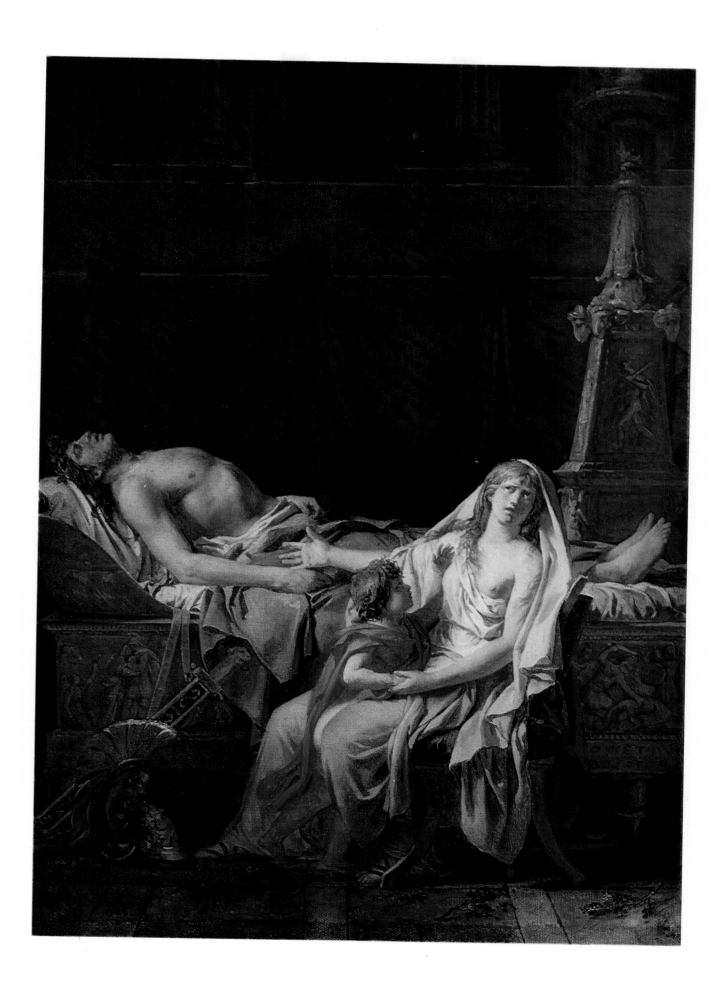

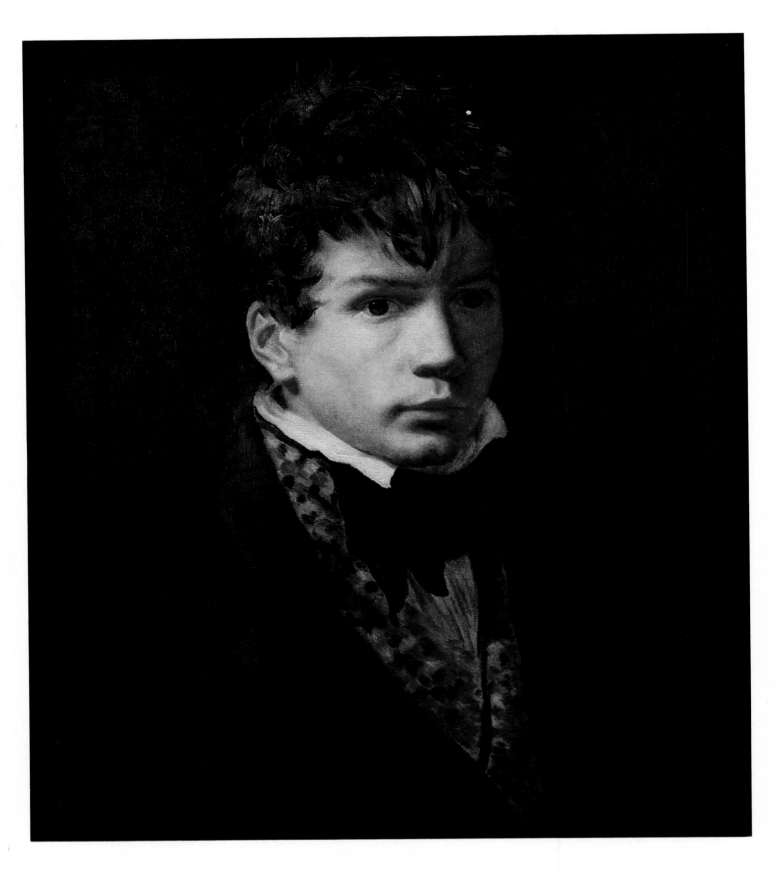

82 PORTRAIT OF INGRES AS A YOUNG MAN (?)
Oil on canvas. 54 × 46 cm. Inv. No 844
The traditional iconographic identification of the model as the painter Ingres at the time of his apprenticeship to David in 1798 is refuted now by almost all French students of David because of a very doubtful resemblance to other portraits of Ingres. It is possible that this portrait belongs to David's latest period.

Provenance: until 1882 The E. Fould Collection, Paris; 1882—88 The A. Goupil Collection, Paris; until 1892 The S. Tretyakov Collection, Moscow; 1892—1925 The Tretyakov Gallery, Moscow; since 1925 The Pushkin Museum of Fine Arts, Moscow

Exhibitions: 1874 Paris, Alsace-Lorrains, Cat. 91; 1883 Paris, Cat. 46; 1955 Moscow, Cat., p. 29; 1956 Leningrad, Cat., p. 19; 1965 Bordeaux, Cat. 51; 1965—66 Paris, Cat. 52; 1972 Dresden, Cat. 12

Bibliography: Кат. ГМИИ 1948, p. 25; Кат. ГМИИ 1957, p. 45; Кат. ГМИИ 1961, p. 65, ill.; Опись галереи Третьяковых 1894, No 81; Кат. галереи Третьяковых 1917, No 3871; Réau 1929, No 486; А. Замятина, Давид, Moscow, 1936, p. 109, ill.; K. Holma, David, son évolution et son style, Paris, 1940, p. 130, ill. 44; L. Hautecœur, Louis David, Paris, 1954, pp. 190, 334; Sterling 1957, ill. 50, p. 66; Прокофьев 1962, ill. 87; Musée de Moscou 1963, p. 149, ill. [the self-portrait of David was included in the album instead of the portrait of David by Ingres]; И. Кузнецова, Луи Давид, Moscow, 1965, p. 161, ill.; ГМИИ 1966, No 75

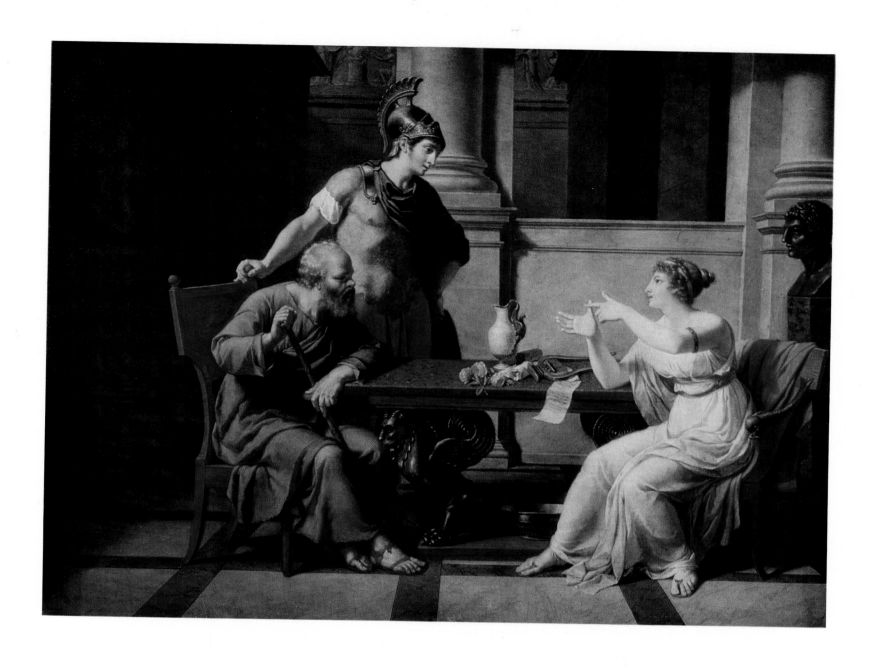

83 SOCRATES AND ASPASIA. 1801
Oil on canvas. 65 × 81 cm. Inv. No 1248
Signed and dated lower left: *Monsiau 1801*
Provenance: since 1927 The Pushkin Museum of Fine
Arts, Moscow (received from the State Museum Re-
serve)
Bibliography: Кат. ГМИИ 1961, p. 130; Réau 1929,
No 600

84 HEAD OF THE VIRGIN
 FROM THE ANNUNCIATION. 1811
Oil on canvas. 50 × 45 cm. Inv. No 1044
Signed and dated lower left: *P. P. Prudhon 1811*
The picture is a companion piece to *Head of the Archangel Gabriel* by Constance Mayer (The Pushkin Museum of Fine Arts, Inv. No 1012). It is a replica of *Head of the Virgin* that was exhibited in the Salon of 1810 (No 665) and purchased by Empress Marie-Louise. There are at least two other replicas of the same original. A drawing for this picture is in the Dijon Museum (No 642).

Provenance: 1827—1924 The Yusupovs Collection, Arkhangelskoye (near Moscow) and St Petersburg —

Petrograd; 1924—27 The Hermitage, Leningrad; since 1927 The Pushkin Museum of Fine Arts, Moscow

Exhibitions: 1912 St Petersburg, Cat. 492; 1955 Moscow, Cat., p. 51; 1956 Leningrad, Cat., p. 48

Bibliography: Кат. ГМИИ 1948, p. 62; Кат. ГМИИ 1957, p. 112; Кат. ГМИИ 1961, p. 150; F. P. Guisot, *Salon de 1810*, in: *Etudes sur les Beaux-Arts*, Paris, 1852, p. 93; Musée Youssoupoff 1839, No 142; А. Прахов 1907, pp. 8, 10, ill. 7; С. Яремич, "Классики и романтики на выставке *Сто лет французской живописи*", *Старые годы*, 1912, February, p. 47; Кат. Юсуповской галереи 1920, No 146; Эрнст 1924, p. 182, ill.; J. Guiffrey, *L'Œuvre de P. P. Prud'hon*, Paris, 1924, p. 110, No 308; Réau 1929, No 619

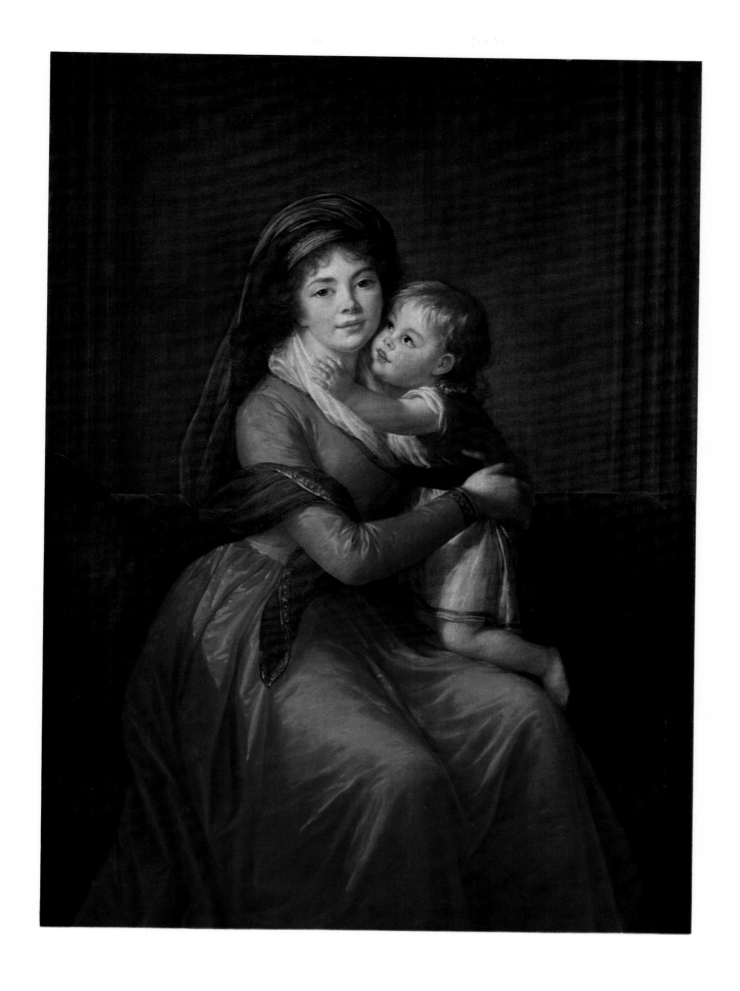

85 PORTRAIT OF PRINCESS
← ALEXANDRA GOLITSYNA
AND HER SON. 1794
Oil on canvas. 137 × 101 cm. Inv. No 1227
Signed and dated lower right: *L. E. Vigée Le Brun*
Vienne 1794
Alexandra Golitsyna, née Protasova, was the wife of
Prince Alexei Golitsyn, Equerry to the Court. Their
son was Piotr Golitsyn (1792—1842).

Provenance: from the late 18th century The A. Go-
litsyn Collection, St Petersburg; 1870 The N. Stroga-
nov Collection, St Petersburg; 1902 The P. Golitsyn
Collection, Moscow; 1905 The S. Vasilchikov Collec-
tion, St Petersburg; 1918—28 The Russian Museum,
Leningrad; since 1928 The Pushkin Museum of Fine
Arts, Moscow

Exhibition: 1905 St Petersburg, Cat. 240

Bibliography: Русские портреты 1905—9, vol. II,
No 24, ill.; Н. Врангель, "Иностранцы в России",
Старые годы, 1911, July — September, p. 25; P. de
Nolhac, *Madame Vigée le Brun, peintre de Marie-
Antoinette*, Paris, 1912, pp. 197, 264; Réau 1929,
No 578; L. Nikolenko, "The Russian Portraits of Ma-
dame Vigée Lebrun", *Gazette des Beaux-Arts*, 70,
1967, p. 107, No 24

MARGUERITE GÉRARD. 1761—1837

86 MOTHERHOOD
Oil on panel. 49 × 37 cm. Inv. No 919
Signed lower left: *M te Gerard*
The picture was painted in the early 1800s. It was
brought to St Petersburg with the collection of the
Dukes of Leuchtenberg, and from 1884 to 1919 was
exhibited with the other pictures of this collection at
the Academy of Arts.

Provenance: until 1824 The Collection of Eugène Beau-
harnais, Munich; 1824—1918 The Collection of Dukes of
Leuchtenberg, Munich (until 1853) and St Petersburg
(since 1853); 1919—24 The Hermitage, Petrograd;
since 1924 The Pushkin Museum of Fine Arts, Moscow

Bibliography: Кат. ГМИИ 1961, p. 82; Dussieux 1856,
p. 444; J. D. Passavant, *Galerie Leuchtenberg. Ge-
mäldesammlung des Herzogs von Leuchtenberg in
München*, Frankfort on the Main, 1857, p. 43, ill.; *Ка-
талог картинной галереи герцога Николая Макси-
милиановича Лейхтенбергского, выставленной в за-
лах Императорской Академии художеств*, St Pe-
tersburg, 1884, No 222

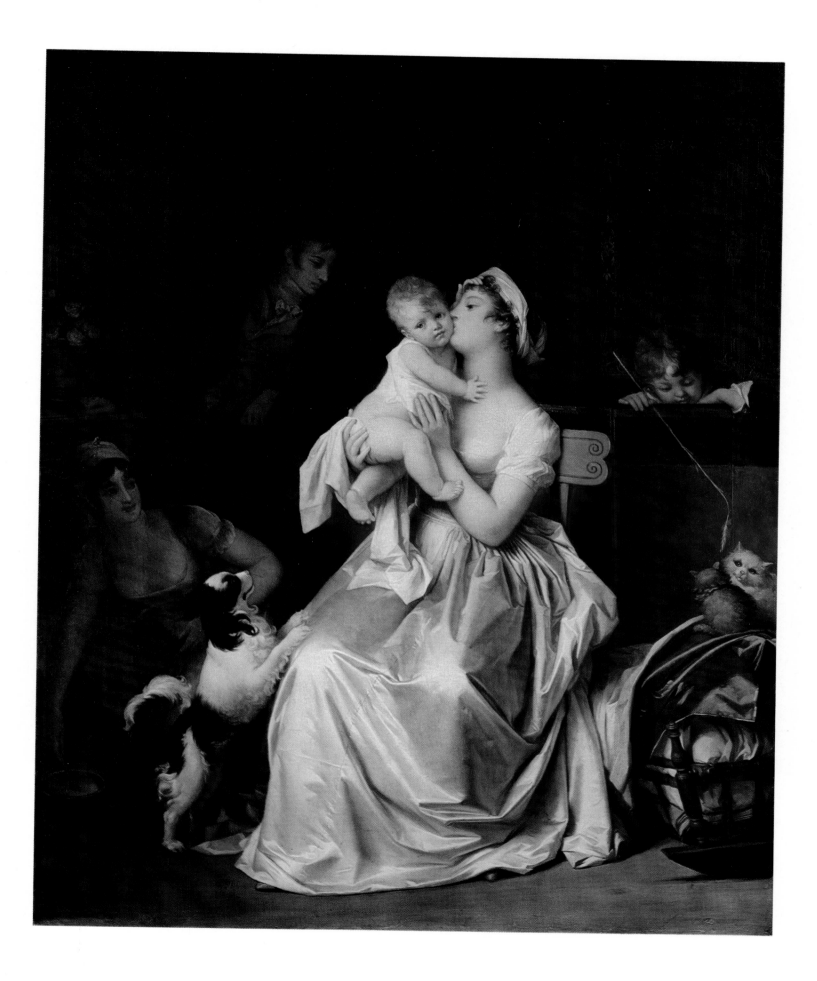

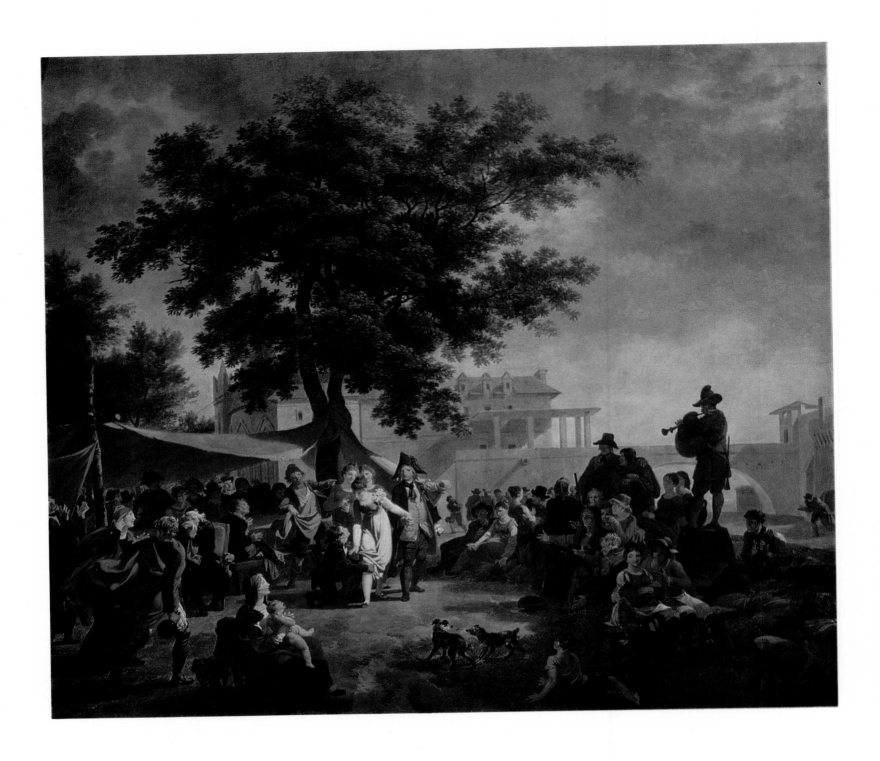

87 VILLAGE WEDDING
 (THE BRIDE'S GARTER)
 Oil on panel. 46 × 58 cm. Inv. No 1106
 The picture was painted in 1808. A finished drawing
 for it was put up at the auction of the Bruun Neer-
 gard Collection in Paris.
 Provenance: 1809—1924 The Yusupovs Collection, Ar-
 khangelskoye (near Moscow) and St Petersburg —

Petrograd; 1924—28 The Hermitage, Leningrad; since
1928 The Pushkin Museum of Fine Arts, Moscow

Exhibition: 1808 Paris (Salon)

Bibliography: Кат. ГМИИ 1948, p. 77; Кат. ГМИИ
1957, p. 175; Кат. ГМИИ 1961, p. 180; A. D'Escra-
gnolle, "Антуан Тоне", Старые годы, 1910, Decem-
ber, p. 27; Кат. Юсуповской галереи 1920, No 119;
Эрнст 1924, p. 166, ill.; Réau 1929, No 653

88 PORTRAIT
OF PRINCE BORIS GOLITSYN

Oil and gouache on ivory plate set in a panel.
27 × 20 cm. Inv. No 933

Boris Golitsyn (1769—1813), lieutenant-general, participated in the 1812 War and died of battle wounds in Wilna. The face is drawn in gouache on an ivory plate set in a wooden panel on which is painted a landscape. The Pushkin Museum portrait may be dated to the early 1800s.

Provenance: 1905 The N. Obolensky Collection, Moscow; since 1925 The Pushkin Museum of Fine Arts, Moscow (received from the State Museum Reserve)

Exhibitions: 1905 St Petersburg, Cat. 2027; 1955 Moscow, Cat., p. 36; 1956 Leningrad, Cat., p. 27

Bibliography: Кат. ГМИИ 1961, p. 83

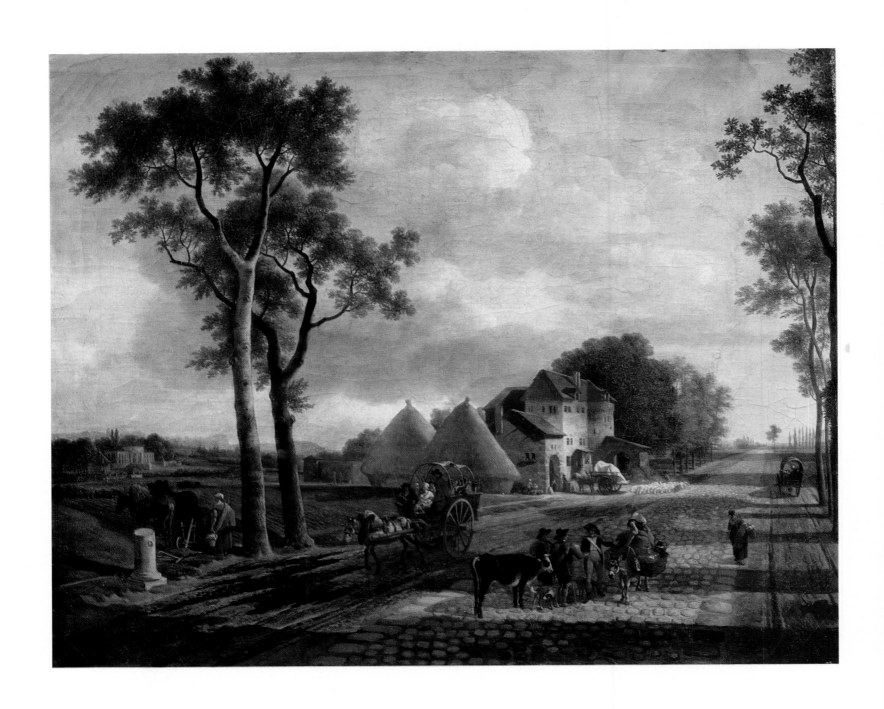

89 AT A TURNPIKE
Oil on canvas. 50 × 62 cm. Inv. No 1231
The picture belongs to the series of the so-called
Grandes Routes which de Marne exhibited in the
Salons of 1801 and 1802.

Provenance: 1818, March 30 Auction of the A. E. Mi-
challon Collection, Paris; 1818, September 15 Auction
of the Loria Collection, Paris; 1860 Auction of the
Lord Seymour Collection, Paris; until 1927 The A. Tol-
staya Collection, Moscow; since 1927 The Pushkin
Museum of Fine Arts, Moscow (received from the
State Museum Reserve)

Exhibition: 1939 Moscow, Cat., p. 31

Bibliography: Кат. ГМИИ 1957, p. 49; Кат. ГМИИ
1961, p. 70; J. Waterlin, *Le Peintre J. L. de Marne*,
Paris — Lausanne, 1962, p. 148

90 ITINERANT ACTORS. 1806
Oil on canvas. 32 × 39 cm. Inv. No 1093
Signed and dated lower center: *Sw 1806*

Provenance: until 1924 The Yusupovs Collection, Arkhangelskoye (near Moscow) and St Petersburg — Petrograd; since 1925 The Pushkin Museum of Fine Arts, Moscow

Exhibition: 1939 Moscow, Cat., p. 32

Bibliography: Кат. ГМИИ 1957, p. 174; Кат. ГМИИ 1961, p. 167; А. Прахов 1907, p. 36, ill. 18; Эрнст 1924, p. 216, ill.; Réau 1929, No 645

91 EQUESTRIAN PORTRAIT
OF PRINCE BORIS YUSUPOV. 1809
Oil on canvas. 321 × 266 cm. Inv. No 835
Signed and dated lower left: *Gros 1809*
The portrait of Boris Yusupov (1794—1849) was commissioned by his father, Nikolai Yusupov, during his stay in Paris. It was modelled on Gros's equestrian portrait of Jérôme Bonaparte, King of Westphalia, which greatly impressed Yusupov in the Salon of 1808.

Provenance: 1809—1924 The Yusupovs Collection, Arkhangelskoye (near Moscow) and St Petersburg — Petrograd; 1924—27 The Hermitage, Leningrad; since 1927 The Pushkin Museum of Fine Arts, Moscow

Exhibitions: 1936 Paris, Cat. 52; 1955 Moscow, Cat., p. 28

Bibliography: Кат. ГМИИ 1957, p. 44; Кат. ГМИИ 1961, p. 63; Musée Youssoupoff 1839, No 352; J.-B. Delestre, *Gros, sa vie et ses ouvrages*, Paris, 1854, ill. 43; 2nd ed., 1867, p. 273; Dussieux 1856, p. 426; J. Tripier Le Franc, *Histoire de la vie et de la mort du baron Gros*, Paris, 1880, p. 273; G. Dargenty, *Le Baron Gros*, Paris — London, 1887, p. 337, ill.; Кат. Юсуповской галереи 1920, No 98; Эрнст 1924, p. 228, ill.; Réau 1929, No 542; Sterling 1957, ill. 52, p. 69; Musée de Moscou 1963, p. 150, ill.

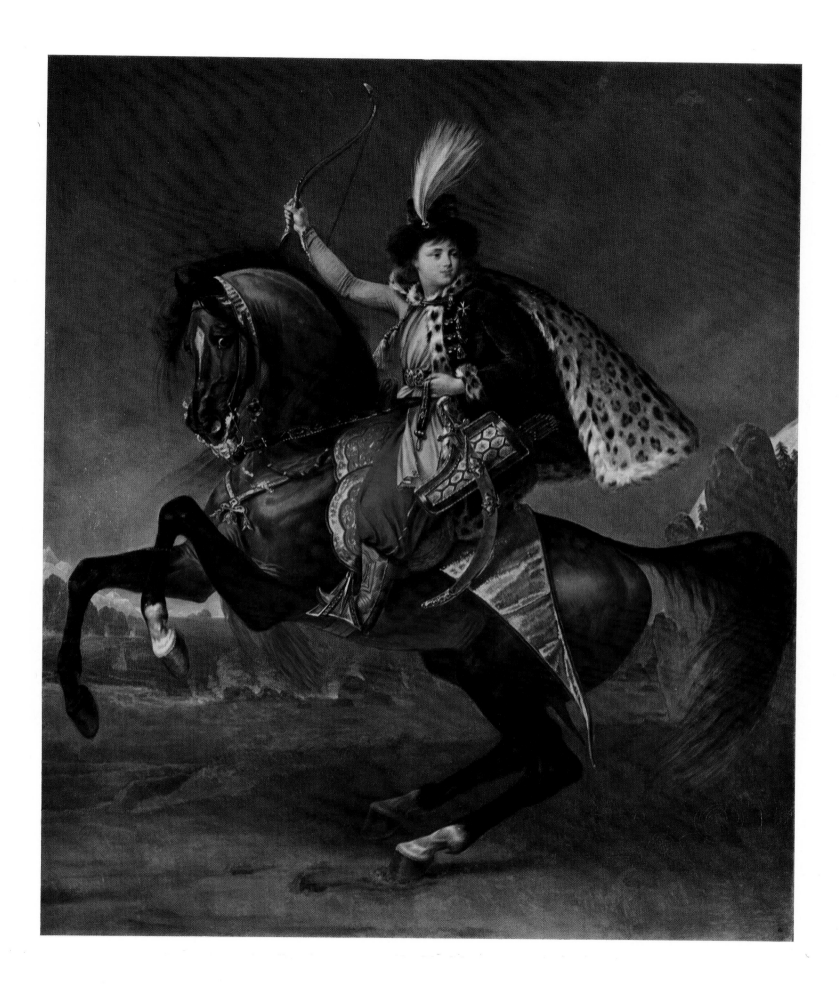

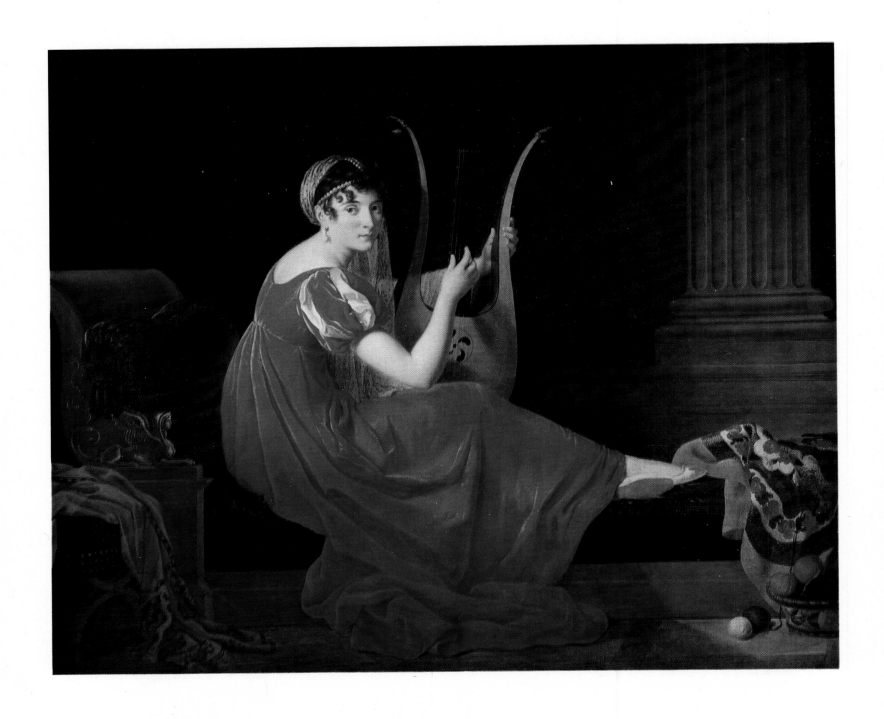

92 PORTRAIT OF A LADY WITH A LYRE. 1806
Oil on canvas. 152 × 185 cm. Inv. No 3920
Signed and dated lower left: *Rivière 1806*
Provenance: since 1964 The Pushkin Museum of Fine
Arts, Moscow (purchased from V. Vaker)
Exhibition: 1970 Moscow, Cat. 70
Bibliography: Кат. ГМИИ 1948, p. 31

93 PORTRAIT
OF PRINCESS MARIA KOCHUBEI
Oil on canvas. 65 × 56 cm. Inv. No 2772
Maria Kochubei (1779—1844), née Vasilchikova, lady of honour, was the wife of Chancellor Victor Kochubei (1768—1834), who was head of the Ministry of Home Affairs (1801—12 and 1819—25).
This portrait, a pendant to the portrait of Prince Victor Kochubei (The Hermitage, Inv. No 4645), was painted around 1809.

Provenance: from the early 1800s The V. Kochubei Collection, St Petersburg; 1908 The Durnovo Collection, St Petersburg; until 1923 The Stroganov Palace Museum, Petrograd; 1923—30 The Hermitage, Leningrad; since 1930 The Pushkin Museum of Fine Arts, Moscow
Exhibitions: 1908 St Petersburg, Cat. 253; 1955 Moscow, Cat., p. 35
Bibliography: Кат. ГМИИ 1957, p. 57; Кат. ГМИИ 1961, p. 82; Прокофьев 1962, ill. 90

94 PORTRAIT OF EKATERINA MURAVYOVA
AND HER SON NIKITA. 1802
Oil on canvas. 127 × 98 cm. Inv. No 1026
Signed and dated lower left: *J. L. Monier f. 1802*
Ekaterina Muravyova (1771—1848), née Kolokoltseva,
was the wife of Mikhail Muravyov, statesman and
writer, curator of Moscow University. Nikita Muravyov
(1796—1843) was a participant in the Decembrists'
uprising. He was condemned to death, but the death
penalty was commuted to hard labor in Siberia.
The picture was formerly believed to portray Anna
Muravyova-Apostol and her son. The present iden-
tification of the models was made on the basis of
Matvei Muravyov-Apostol's *Reminiscences* (see: *Rus-
sky Archiv*, vol. 2, St Petersburg, 1888, p. 369).

Provenance: in the early 19th century The M. Mu-
ravyov Collection, St Petersburg; until 1917 The O.
and L. Zubalovs Collection, Moscow; 1917—24 The
Rumiantsev Museum, Moscow (gift of the Zubalovs);
since 1924 The Pushkin Museum of Fine Arts, Moscow

Exhibitions: 1955 Moscow, Cat., p. 48; 1956 Leningrad,
Cat., p. 42; 1972 Moscow, Cat., p. 121

Bibliography: Кат. ГМИИ 1948, p. 53; Кат. ГМИИ
1957, p. 97; Кат. ГМИИ 1961, p. 131; Réau 1929,
No 604

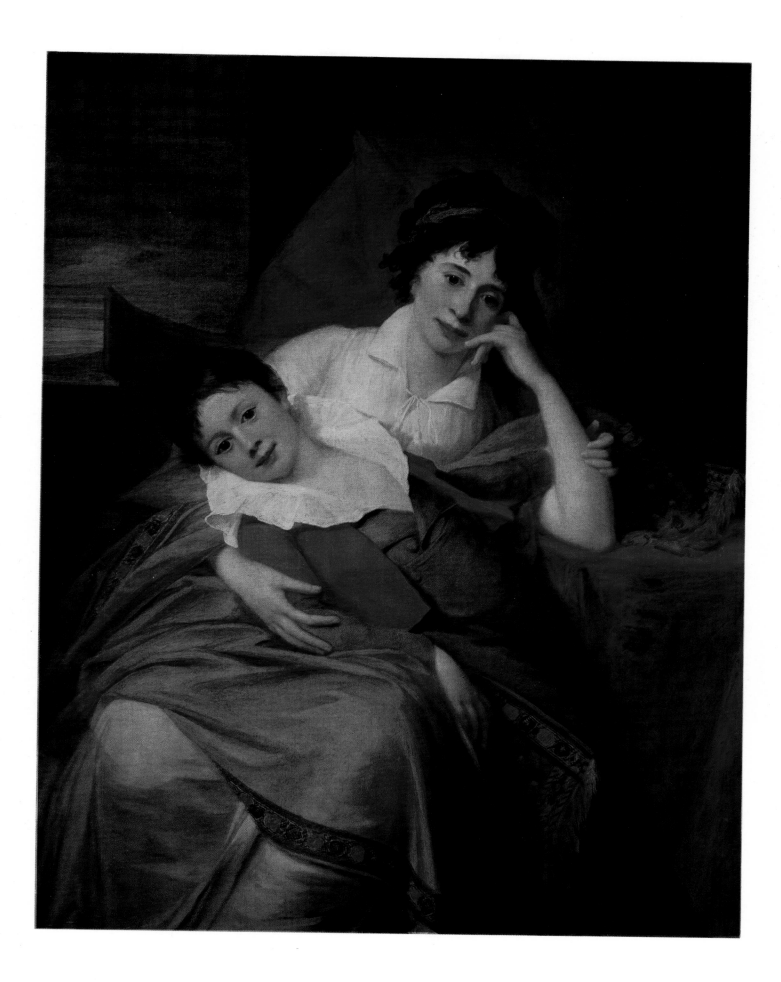

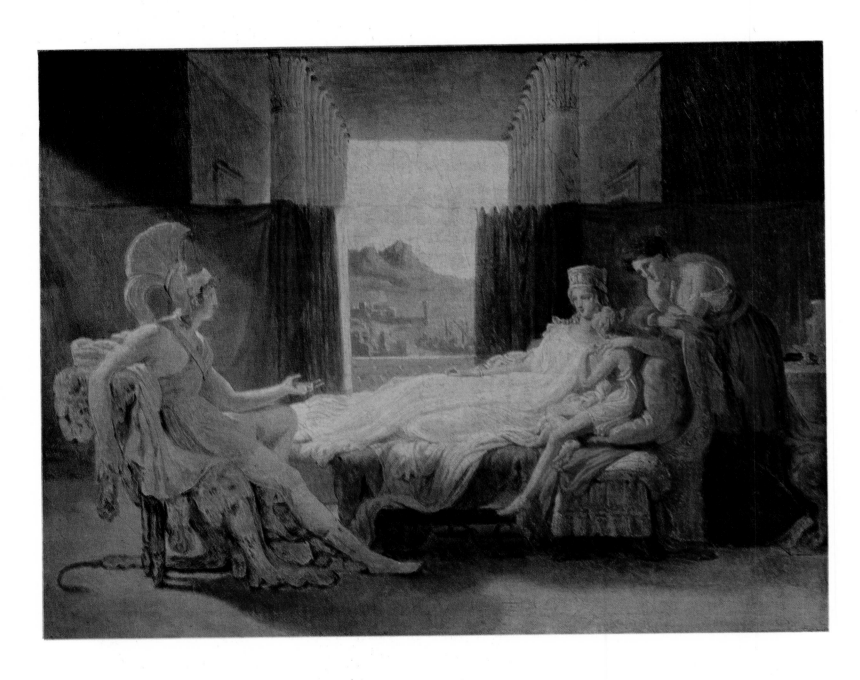

95 AENEAS AND DIDO
Oil on canvas. 31 × 40 cm. Inv. No 809
The subject is taken from Virgil's *Aeneid* (2—3).
The picture is a sketch for *Aeneas and Dido* (1813)
which was exhibited in the Salon of 1817 and now
is in the possession of The Louvre (Inv. No 5184).

Provenance: 1827—1924 The Yusupovs Collection, Ar-
khangelskoye (near Moscow) and St Petersburg —
Petrograd; since 1924 The Pushkin Museum of Fine
Arts, Moscow

Exhibitions: 1912 St Petersburg, Cat. 100; 1955 Moscow,
Cat., p. 26; 1956 Leningrad, Cat., p. 15

Bibliography: Кат. ГМИИ 1948, p. 22; Кат. ГМИИ
1957, p. 37; Кат. ГМИИ 1961, p. 52; Musée Yous-
soupoff 1839, No 70; А. Прахов 1907, pp. 27, 28,
ill. 15; С. Яремич, "Классики и романтики на выстав-
ке *Сто лет французской живописи*", *Старые го-
ды*, 1912, February, p. 49; Кат. Юсуповской гале-
реи 1920, No 124; Эрнст 1924, p. 234, ill.; Réau 1929,
No 544

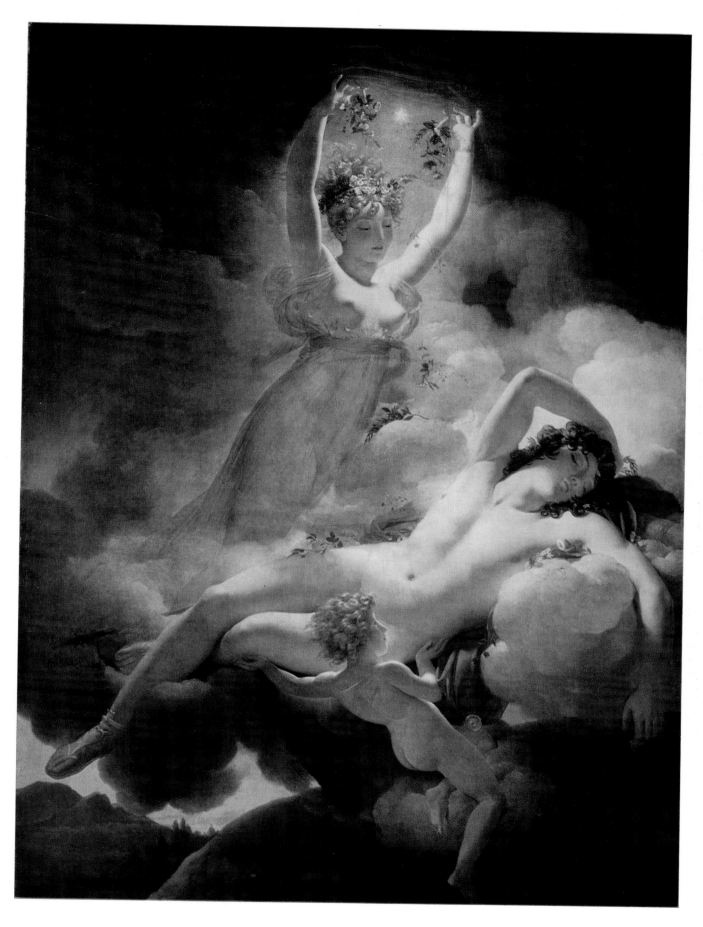

96 AURORA AND CEPHALUS. 1811

Oil on canvas. 251 × 178 cm. Inv. No 1008

Signed and dated lower right: *P. Guerin 1811*

The subject is taken from Ovid's *Metamorphoses* (7: 702—707). The canvas is a replica of the picture exhibited in the Salon of 1810 and now in the possession of The Louvre (No RF 513). It is a companion piece to *Morpheus and Iris* (The Hermitage, Inv. No 5675).

Provenance: 1811—1924 The Yusupovs Collection, Arkhangelskoye (near Moscow) and St Petersburg — Petrograd; 1924 The Hermitage, Petrograd; since 1925 The Pushkin Museum of Fine Arts, Moscow

Exhibition: 1814 Paris (Salon), Cat. 387

Bibliography: Кат. ГМИИ 1961, p. 52; Musée Youssoupoff 1839, No 79; E. Bellier de la Chavignerie, L. Auvray, *Dictionnaire général des artistes de l'école française depuis l'origine des arts du dessin jusqu'à nos jours*, 2 vols., Paris, 1882—85; Réau 1929, No 543

97 THE PAINTER JACQUES STELLA
IN PRISON. 1810
Oil on canvas. 194 × 144 cm. Inv. No 2740
Signed and dated lower right: *Granet Roma 1810*
A preparatory drawing for this picture, made in pen
and watercolors, is now in The Louvre. The picture
was in the collection of the Dukes of Leuchtenberg.
In 1853, after the death of Maximilian, Duke of Leuch-
tenberg, husband of the Grand Duchess Maria Ni-
kolayevna, the picture was brought to St Petersburg.
From 1884 to 1919 it was exhibited together with the
other pictures of this collection in the halls of the
Academy of Arts in St Petersburg.

Provenance: 1810—14 The Collection of Empress Jose-
phine, Paris; 1814—24 The Collection of Eugène Beau-
harnais, Munich; 1824—1918 The Collection of the
Dukes of Leuchtenberg, Munich (until 1853) and St
Petersburg — Petrograd (since 1853); 1920—24 The
Rumiantsev Museum, Moscow; since 1924 The Pushkin
Museum of Fine Arts, Moscow

Exhibitions: 1810 Paris (Salon), Cat. 387; 1814 (?)
Paris (Salon), Cat. 464 (?); 1955 Moscow, Cat., p. 28;
1974—75 Paris, Cat. 82

Bibliography: Кат. ГМИИ 1957, p. 42; Кат. ГМИИ
1961, p. 60; F. P. Guisot, *Salon de 1810*, in: *Etudes
sur les Beaux-Arts*, Paris, 1852, pp. 74—76; Dus-
sieux 1856, pp. 324, 444; J. D. Passavant, *Galerie
Leuchtenberg. Gemäldesammlung des Herzogs von
Leuchtenberg in München*, Frankfort on the Main,
1857, p. 444, ill.; *Каталог картинной галереи гер-
цога Николая Максимилиановича Лейхтенбергского,
выставленной в залах Императорской Академии
художеств*, St Petersburg, 1884, No 224; Réau 1929,
No 535; Ch. Blanc, *Granet*, in: *Histoire des peintres
de toutes les écoles. Ecole française*, vol. 3, Paris,
1863, pp. 4, 8

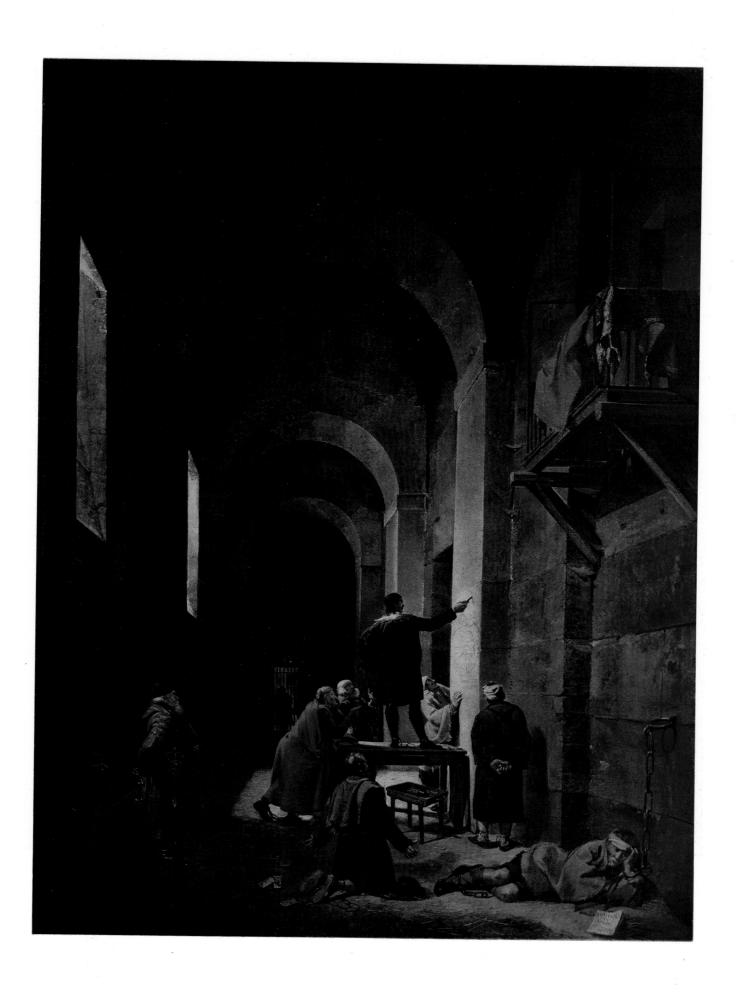

98 STUDY OF A MALE MODEL
Oil on canvas. 64 × 53 cm. Inv. No 922
This study cannot be directly related to any one of
the artist's pictures. It belongs presumably to the
period of 1810—11, when Géricault attended Guérin's
studio and sketched a great deal from live models.
The painterly and plastic treatment of the model,
the contrasts of light and shade, and the inner ten-
sion of the image are characteristic features not only
of the Pushkin Museum study, but of this group of
Géricault's works as a whole.

Provenance: until 1892 The S. Tretyakov Collection,
Moscow; 1892—1925 The Tretyakov Gallery, Moscow;
since 1925 The Pushkin Museum of Fine Arts, Moscow
Exhibitions: 1955 Moscow, Cat., p. 35; 1956 Lenin-
grad, Cat., p. 26

Bibliography: Кат. ГМИИ 1948, p. 32; Кат. ГМИИ
1957, p. 58; Кат. ГМИИ 1961, p. 82, ill.; Опись га-
лереи Третьяковых 1894, No 82; Кат. галереи Третья-
ковых 1917, No 3873; Перцов 1921, p. 13; Réau 1929,
No 534; Прокофьев 1962, ill. 93; В. Прокофьев, Тео-
дор Жерико, Moscow, 1963, pp. 55, 253, ill.

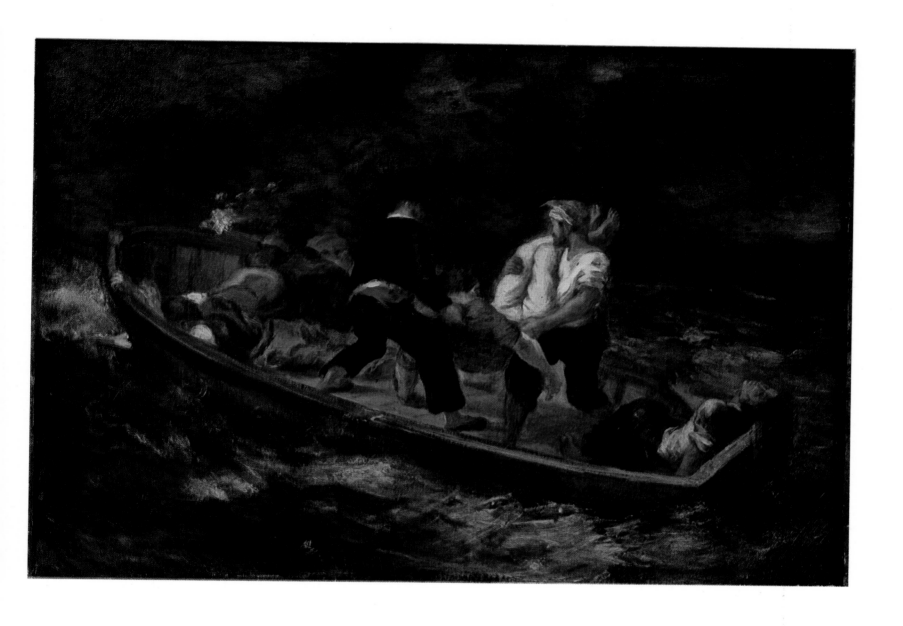

99 AFTER A SHIPWRECK
Oil on canvas. 36 × 57 cm. Inv. No 860
Signed lower left: *Eug. Delacroix*
The picture may be dated around 1847.

Provenance: 1847 Acquired by E. Tyszkiewicz from the painter; 1885 The Hattat Collection, Paris; until 1892 The S. Tretyakov Collection, Moscow; 1892—1925 The Tretyakov Gallery, Moscow; since 1925 The Pushkin Museum of Fine Arts, Moscow

Exhibitions: 1847 Paris (Salon), Cat. 463; 1920 Moscow; 1939 Moscow, Cat., p. 35; 1955 Moscow, Cat., p. 31; 1956 Leningrad, Cat., p. 21; 1963 Paris, Cat. 365; 1964 Leningrad, Cat., p. 15

Bibliography: Кат. ГМИИ 1948, p. 26, ill.; Кат. ГМИИ 1957, p. 49; Кат. ГМИИ 1961, p. 69, ill.; A. Robaut, *L'Œuvre complet d'Eugène Delacroix*, Paris, 1885, No 100; Опись галереи Третьяковых 1894, No 59; Кат. галереи Третьяковых 1917, No 3881; Перцов 1921, p. 13; Réau 1929, No 494; *Journal d'Eugène Delacroix*, vol. 1, Paris, 1950, pp. 218, 225, 228; Sterling 1957, p. 70; Прокофьев 1962, p. 94; R. Escholier, *Eugène Delacroix*, Paris, 1963, pp. 120—121; Musée de Moscou 1963, p. 152, ill.; ГМИИ 1966, No 76

100 THE VIRGIN ADORING THE EUCHARIST.
1841
Oil on canvas. 116 × 84 cm. Inv. No 2761
Signed lower left: *A. J. Ingres pinx*
Dated lower right: *Rome 1841*
The picture was painted in 1841 to the order of the future Russian emperor Alexander II. The subject goes back to Ingres's Virgin in *The Vow of Louis XIII* (1824). There are numerous variants. The one very similar to the present picture is in The Louvre (1854; No 20088). The picture was engraved with a burin by A. Reveil.

Provenance: 1841—45 The Collection of Hereditary Prince Alexander Nikolayevich, St Petersburg; 1845—1919 The Academy of Arts Museum, St Petersburg — Petrograd; 1919—30 The Hermitage, Leningrad; since 1930 The Pushkin Museum of Fine Arts, Moscow

Exhibitions: 1842 St Petersburg; 1861 St Petersburg; 1955 Moscow, Cat., p. 62; 1956 Leningrad, Cat., p. 62

Bibliography: Кат. ГМИИ 1948, p. 87; Кат. ГМИИ 1957, p. 149; Кат. ГМИИ 1961, p. 197; Ch. Lenormant, "*Vierge adorant l'Eucharistie*, tableau de M. Ingres", *L'Artiste*, 1841, p. 194; J. Varnier, "De la Madone exécutée pour Le Grand Duc Héritier de toutes les Russies par M. Ingres", *L'Artiste*, 1841, p. 1; А. Сомов, *Картинная галерея Императорской Академии художеств*, part 2: *Каталог произведений иностранной живописи*, St Petersburg, 1874, No 639; Dussieux 1856, p. 430; М. Далькевич, *Галерея графа Н. А. Кушелева-Безбородко. Императорская Академия художеств*, St Petersburg, s.a. [late 1880s], 4, p. 32, ill.; Boyer d'Agen, *Ingres d'après une correspondance inédite*, Paris, 1909, p. 285; H. Lapauze, *Ingres, sa vie et son œuvre*, Paris, 1911, p. 344; Réau 1929, No 135; Sterling 1957, p. 74; G. Wildenstein, *Ingres*, London, 1959, p. 212, No 234, ill. 179

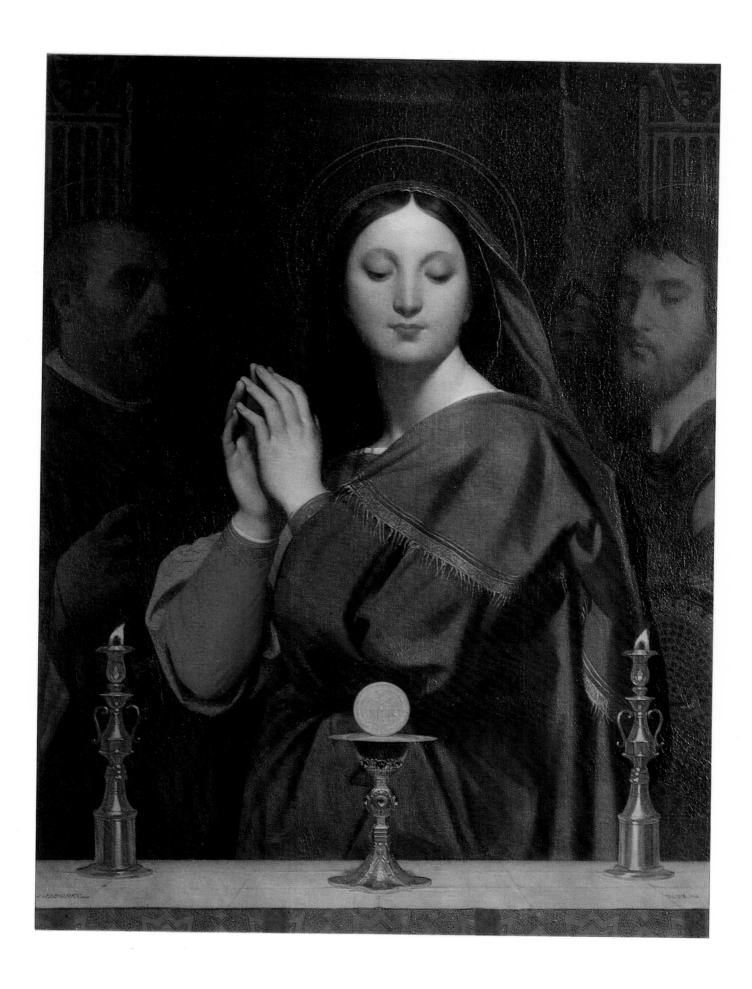

ALEXANDRE GABRIEL DECAMPS. 1803—1860

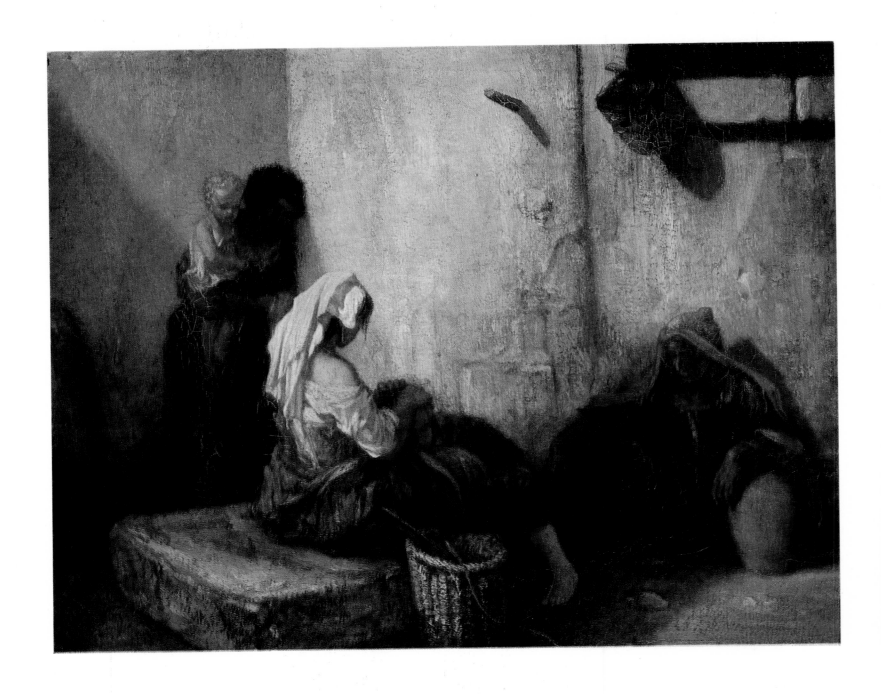

101 STREET SCENE. 1849
Oil on canvas. 45 × 58 cm. Inv. No 2796
Signed and dated lower center: *Decamps 49*
In the collection of Count Kushelev-Bezborodko the picture was listed as *Street Scene, or Italian Family*).
The title *Oriental Street*, mentioned in the 1957 and 1961 catalogues of The Pushkin Museum, is erroneous, as the sitting woman is dressed in Italian costume; this proves that the original title was correct.

Provenance: until 1862 The N. Kushelev-Bezborodko Collection, St Petersburg; 1862—1922 The Academy of Arts Museum, St Petersburg — Petrograd; 1922—

33 The Hermitage, Petrograd — Leningrad; since 1933 The Pushkin Museum of Fine Arts, Moscow

Bibliography: Кат. ГМИИ 1948, p. 26; Кат. ГМИИ 1957, p. 48; Кат. ГМИИ 1961, p. 68; *Картинная галерея Императорской Академии художеств. Картинная галерея графа Н. А. Кушелева-Безбородко*, St Petersburg, 1886, No 180; М. Далькевич, *Галерея графа Н. А. Кушелева-Безбородко. Императорская Академия художеств*, St Petersburg, s.a. [late 1880s], 1, ill. [entitled *Street Scene, or Italian Family*); 4, p. 29; Réau 1929, No 61; Прокофьев 1962, ill. 97 (entitled *An Oriental Street*)

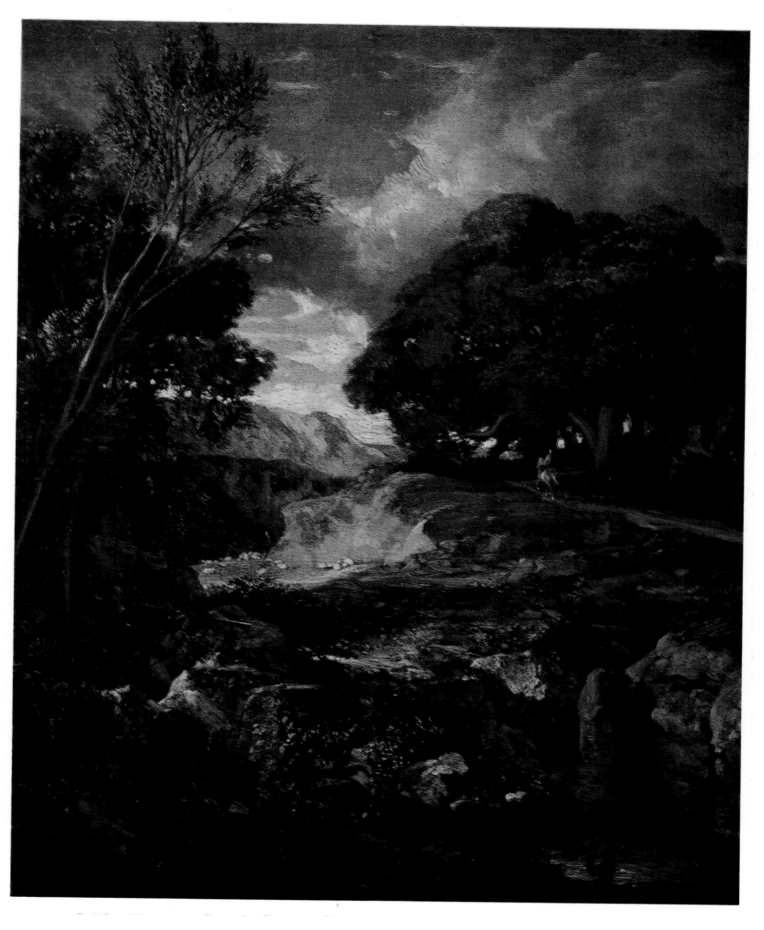

102 HUNTING SCENE IN THE MOUNTAINS. 1843
Oil on canvas. 39 × 31 cm. Inv. No 854
Signed and dated lower right: *Decamps 1843*

Provenance: 1863 Sale of the Demidov Collection, Paris (entitled *Hunting Scene in the Pyrenees*); 1869 Sale of the Collection of Marquis du Lau, Paris (entitled *Sniping*); until 1892 The S. Tretyakov Collection, Moscow; 1892—1925 The Tretyakov Gallery, Moscow; since 1925 The Pushkin Museum of Fine Arts, Moscow

Exhibitions: 1939 Moscow, Cat., p. 36; 1955 Moscow, Cat., p. 30; 1956 Leningrad, Cat., p. 20; 1972 Prague, Cat. 11

Bibliography: Кат. ГМИИ 1948, p. 26; Кат. ГМИИ 1957, p. 48; Кат. ГМИИ 1961, p. 68; A. Moreau, *Decamps et son œuvre*, Paris, 1869, p. 179 (entitled *Hunting Scene in the Pyrenees*); Опись галереи Третьяковых 1894, No 68; Кат. галереи Третьяковых 1917, No 3882; Réau 1929, No 492

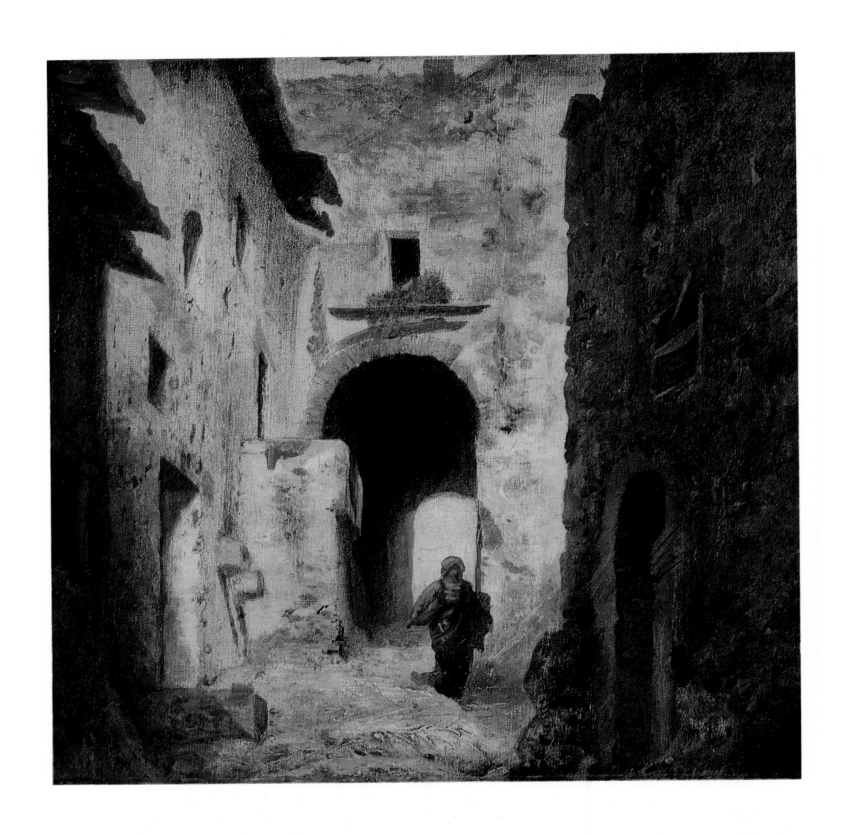

103 MORESQUE GATE. 1835
Oil on canvas. 35 × 38 cm. Inv. No 934
Signed and dated lower right: *E. Isabey 35*

Provenance: 1920—24 The Rumiantsev Museum, Moscow; since 1924 The Pushkin Museum of Fine Arts, Moscow

Exhibitions: 1955 Moscow, Cat., p. 36; 1956 Leningrad, Cat., p. 27

Bibliography: Кат. ГМИИ 1957, p. 58; Кат. ГМИИ 1961, p. 83

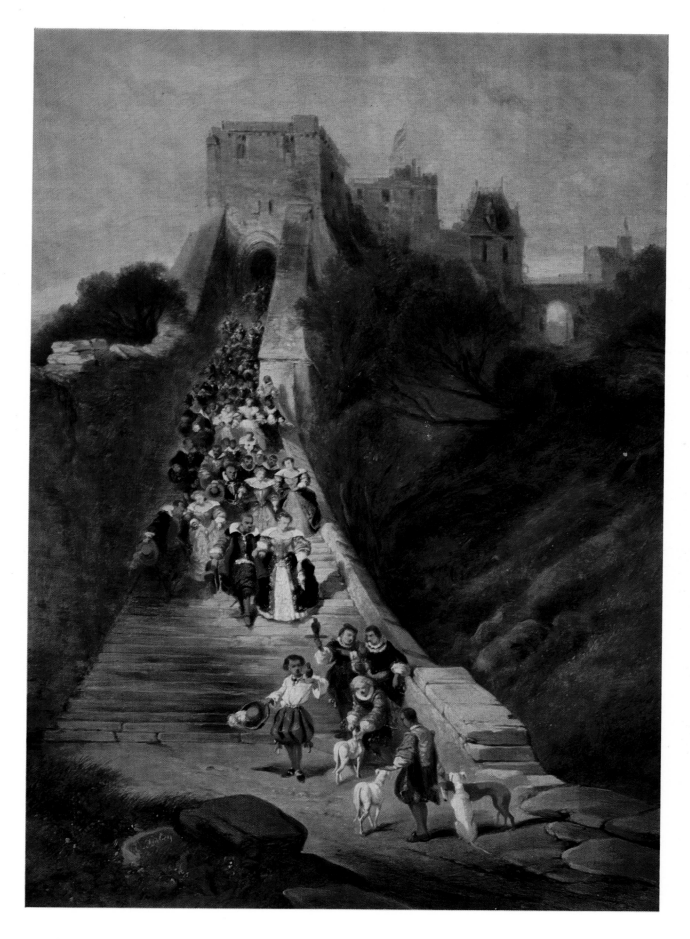

104 LEAVING THE CASTLE
Oil on canvas. 59 × 43 cm. Inv. No 1281
Signed lower left: *E. Isabey*
Formerly entitled *A Party Leaving for a Hunt.*

Provenance: until 1924 The Yusupovs Collection, Arkhangelskoye (near Moscow) and St Petersburg—Petrograd; 1924—27 The Hermitage, Leningrad; since 1927 The Pushkin Museum of Fine Arts, Moscow

Exhibitions: 1955 Moscow, Cat., p. 36; 1956 Leningrad, Cat., p. 27

Bibliography: Кат. ГМИИ 1957, p. 59; Кат. ГМИИ 1961, p. 84; А. Прахов 1907, p. 224 (entitled *A Party Leaving the Castle for a Hunt*); Кат. Юсуповской галереи 1920, No 37; Эрнст 1924, p. 248, ill.; Réau 1929, No 550

105 PROMENADE. 1852
Oil on canvas. 41 × 29.5 cm. Inv. No 937
Signed and dated lower right: *E. Isabey 52*

Provenance: 1893 Auction of the Galerie Petit, Paris
(entitled *La Lecture*, lot 68); until 1918 The P. Khari-
tonenko Collection, Moscow; until 1924 The Rumian-
tsev Museum, Moscow; since 1924 The Pushkin Museum
of Fine Arts, Moscow

Exhibitions: 1937 Circulating Exhibition, Cat. 55;
1960 Moscow, Cat., p. 19

Bibliography: Кат. ГМИИ 1957, p. 59; Кат. ГМИИ
1961, p. 84; Réau 1929, No 551

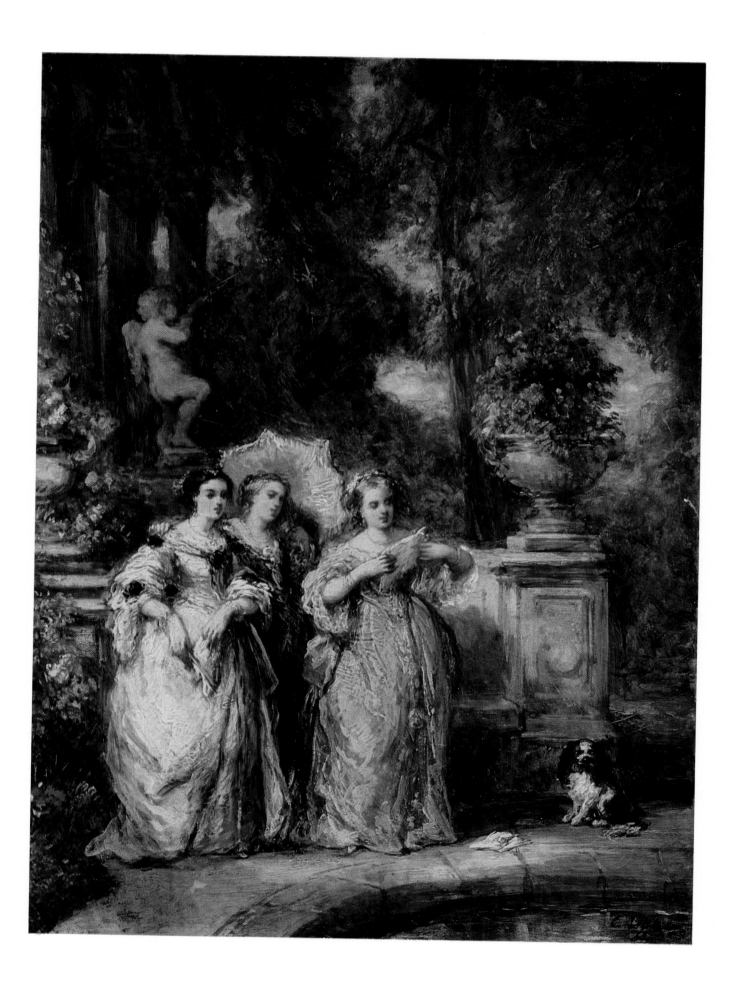

106 CAVALCADE

Oil on canvas. 28 × 22 cm. Inv. No 786

Vernet's *Cavalcade* is a sketch for the picture *Festival at Tsarskoye Selo* (in the possession of the museum in the town of Pushkin, near Leningrad), portraying Nicholas I and his family in fancy dress on horseback. The sketch was made during the artist's second visit to St Petersburg in 1842—43.

Provenance: until 1918 The Bariatinskys Collection, St Petersburg — Petrograd; since 1924 The Pushkin Museum of Fine Arts, Moscow

Bibliography: Кат. ГМИИ 1957, p. 27; Кат. ГМИИ 1961, p. 37; Dussieux 1856, p. 428; E. Bellier de la Chavignerie, L. Auvray, *Dictionnaire général des artistes de l'école française depuis l'origine des arts du dessin jusqu'à nos jours*, 2 vols., Paris, 1882—85, vol. 2, p. 658; Н. Врангель, "Иностранцы в России", *Старые годы*, 1912, July — September, p. 29; M. Beule, *Eloge de M. Horace Vernet*, Paris, 1863, p. 23

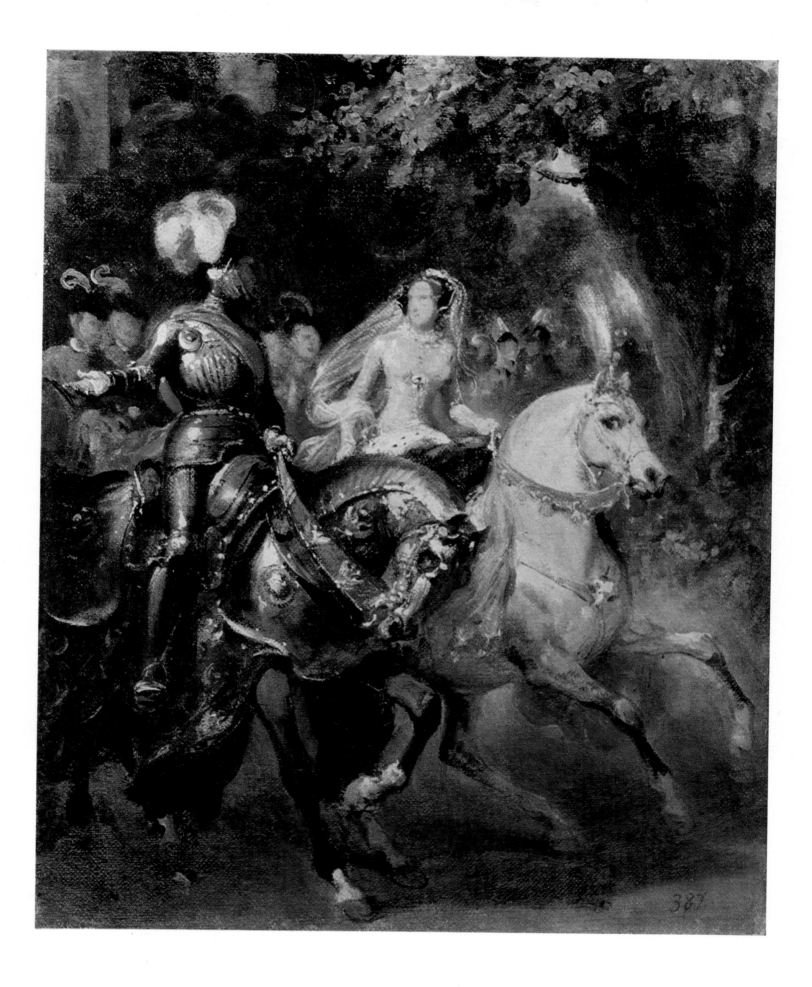

107 THE CHILDREN OF KING EDWARD IV
Oil on canvas. 51 × 60 cm. Inv. No 863
The present work of 1852 is a variant of the simi-
larly entitled picture painted in 1831 (The Louvre,
No 3834). Engraved with a burin by Jules François.
Provenance: 1861 The Merk Collection, Moscow; The
D. Botkin Collection, Moscow; since 1925 The Pushkin
Museum of Fine Arts, Moscow
Bibliography: Кат. ГМИИ 1957, p. 49; Кат. ГМИИ
1961, p. 69; *Каталог картин, составляющих собра-
ние Д. П. Боткина в Москве*, St Petersburg, 1875,
No 13; Réau 1929, No 495; Ch. Blanc, *Paul Delaroche*,
in: *Histoire des peintres de toutes les écoles. Ecole
française*, vol. 3, Paris, 1863, p. 19

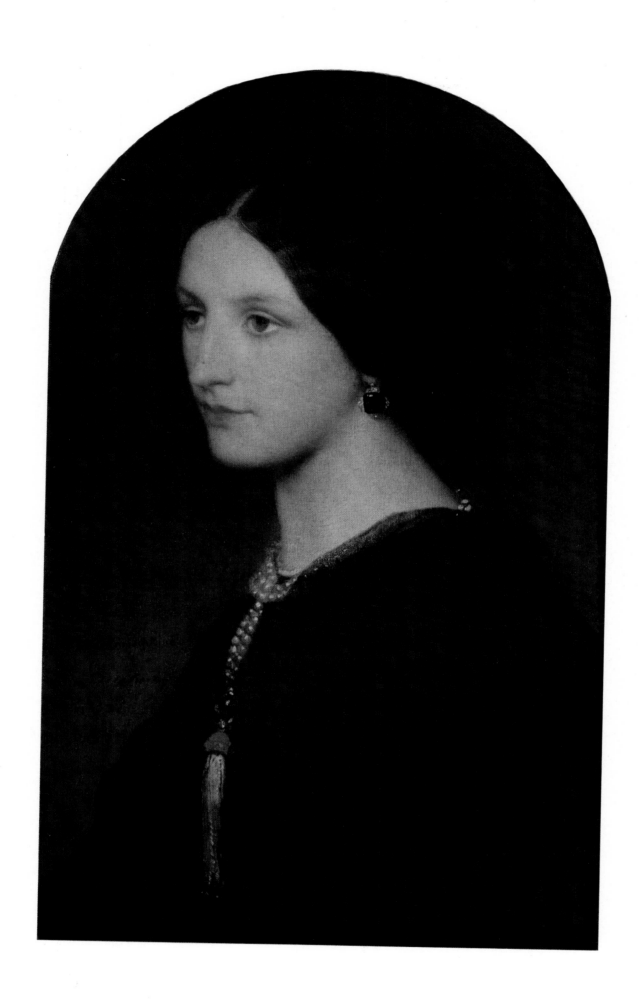

108 PORTRAIT OF COUNTESS
← SOPHIA SHUVALOVA. 1853
Oil on canvas. 66 × 41 cm. Inv. No 861
Signed and dated left, in the background: *a Mme de
Narischkine Paul De la Roche 1853*
Sophia Shuvalova (1829—1894) was the daughter of
Lev Naryshkin and from 1846 wife of Count Shuvalov
(1819—1900), Marshal of the Nobility in the St Peters-
burg Province and Chairman of the Free Economic
Society under Alexander II.

Provenance: 1861 The P. Shuvalov Collection, St Pe-
tersburg; until 1918 The Shuvalovs Collection, St Pe-
tersburg — Petrograd; 1918—24 The Shuvalov Memo-
rial Museum, Petrograd; since 1927 The Pushkin
Museum of Fine Arts, Moscow

Exhibitions: 1861 St Petersburg, Cat. 323; 1905 St Pe-
tersburg, Cat. 1303; 1914 Petrograd, Cat. 216; 1955
Moscow, Cat., p. 31

Bibliography: Кат. ГМИИ 1957, p. 49; Кат. ГМИИ
1961, p. 69; М. Коноплева, *Дом-музей бывшей гра-
фини Шуваловой. Путеводитель*, St Petersburg,
1923, p. 23, No 29

109 CHÂTEAU DE PIERREFONDS
Oil on panel. 47 × 38 cm. Inv. No 958
Signed lower left: *Corot*
The picture is dated to the 1860s. The Château de
Pierrefonds appears in many of Corot's pictures.
A smaller variant of the present work (oil on panel,
35 × 26.5 cm) is in the Saratov Art Museum.

Provenance: 1874 The Sennegon and Lemarinier Col-
lection, Paris; until 1892 The S. Tretyakov Collection,
Moscow; 1892—1925 The Tretyakov Gallery, Moscow;
since 1925 The Pushkin Museum of Fine Arts, Moscow

Exhibitions: 1939 Moscow, Cat., p. 34; 1955 Moscow,
Cat., p. 38; 1956 Leningrad, Cat., p. 28; 1960 Moscow,
Cat., p. 21

Bibliography: Кат. ГМИИ 1948, p. 40; Кат. ГМИИ
1957, p. 71; Кат. ГМИИ 1961, p. 99; Опись галереи
Третьяковых 1894, No 20; Robaut 1905, vol. 2, No 964
bis, ill.; Кат. галереи Третьяковых 1917, No 3878;
Алпатов 1936, pp. 53—55, ill.; Разумовская 1938, p. 2,
ill.; Sterling 1957, ill. 61, p. 83; Прокофьев 1962,
ill. 107

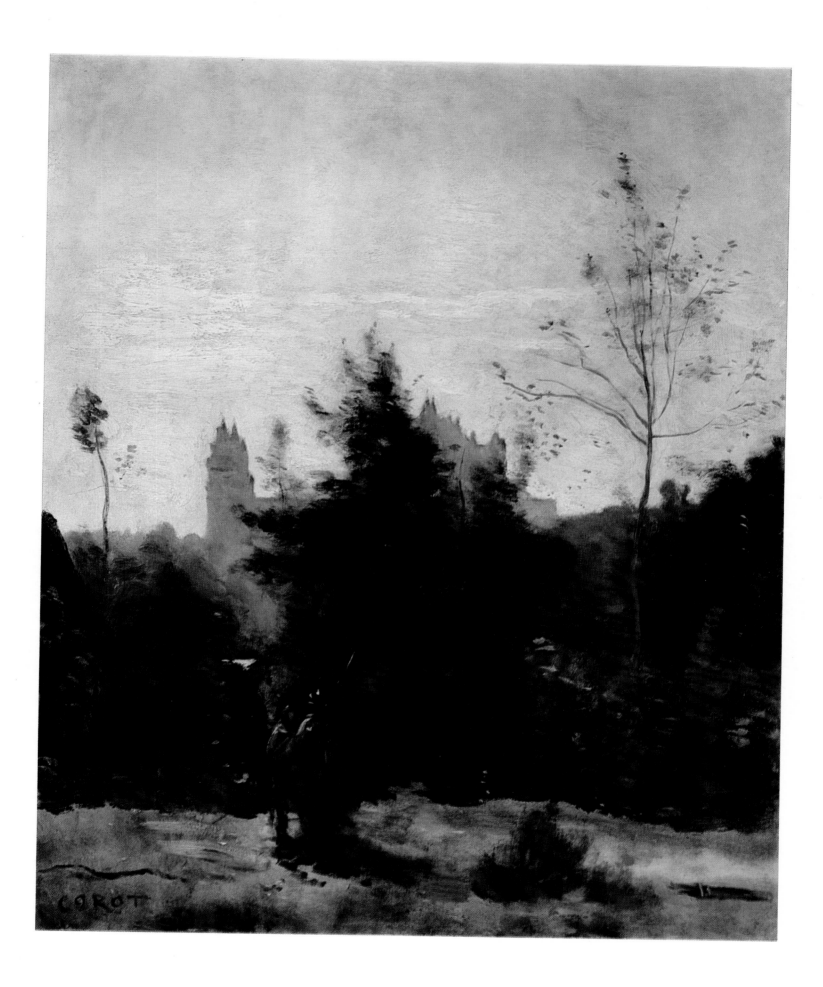

110 MORNING IN VENICE
(PIAZZETTA ON A SUNNY DAY)
Oil on canvas. 27.5 × 40 cm. Inv. No 3148
There are five variants of this picture which the artist painted in 1828, 1834 and in 1845. The canvas housed in The Pushkin Museum is the best. A. Robaut dates it 1834.

Provenance: 1875 Posthumous sale of Corot's pictures, Paris; until 1891 The A. Arosat Collection, Paris; from 1891 The Bernheim Jeune Collection, Paris; 1895—1908 The P. A. Cheramy Collection, Paris; from 1908 The I. Tereshchenko Collection, Kiev; until 1938 The P. Deineka Collection, Kiev; since 1938 The Pushkin Museum of Fine Arts, Moscow

Exhibitions: 1895 Paris; 1939 Moscow, Cat., p. 34; 1955 Moscow, Cat., p. 38; 1956 Leningrad, Cat., p. 28; 1960 Moscow, Cat., p. 20

Bibliography: Кат. ГМИИ 1948, p. 40; Кат. ГМИИ 1957, p. 71; Кат. ГМИИ 1961, p. 99; Robaut 1905, vol. 2, No 318, ill.; *Catalogue des tableaux anciens et modernes composant la collection de P. A. Cheramy*, Paris, 1908, No 132, ill.; F. Fosca, *Corot*, Paris, 1930, ill. (entitled *Venice*); Разумовская 1938, p. 21, ill.; G. Bazin, *Corot*, Paris, 1956, pp. 119—120; M. Alpatov, *Corot à Venise*, in: *Art de France*, 1961, p. 172; Прокофьев 1962, ill. 106; М. Алпатов, *Этюды по истории западноевропейского искусства*, Moscow, 1963, p. 352, ill.

111 HEATHERY HILLS NEAR VIMOUTIERS
(SANDY LAND)
Oil on canvas. 32 × 48 cm. Inv. No 957
Signed lower right: *Corot*
Corot's letter to Alexandre Dumas of August 6, 1865, in which the artist writes of his intention to visit Normandy (Vimoutiers), as well as G. Bazin's statement about Corot's sojourn in Vimoutiers allow for the assumption that the picture was painted in 1865.

Provenance: 1875 Auction of the Verdier and E. Hoschedé Collection, Paris; until 1892 The S. Tretyakov Collection, Moscow; 1892—1925 The Tretyakov Gal-

lery, Moscow; since 1925 The Pushkin Museum of Fine Arts, Moscow

Exhibitions: 1875 Paris; 1939 Moscow, Cat., p. 34; 1955 Moscow, Cat., p. 38; 1956 Leningrad, Cat., p. 28; 1960 Moscow, Cat., p. 21

Bibliography: Кат. ГМИИ 1948, p. 40; Кат. ГМИИ 1957, p. 72; Кат. ГМИИ 1961, p. 99; Опись галереи Третьяковых 1894, No 19 (entitled *Sandy Land*); Robaut 1905, vol. 2, No 948, ill.; Кат. галереи Третьяковых 1917, No 3876 (entitled *Sandy Land*); Разумовская 1938, p. 4, ill.; Яворская 1962, pp. 78—79, ill.; ГМИИ 1966, No 78

112 A GUST OF WIND

Oil on canvas. 48 × 66 cm. Inv. No 956

Signed lower left: *Corot*

The picture is dated to the late 1860s or early 1870s.
The motif is present in several of Corot's pictures.
The most widely known include *A Gust of Wind over
the English Channel* (1869—72, private collection,
Paris) and *A Gust of Wind* (The Louvre, No RF 2038).
There is also an autolithograph of the same name.

Provenance: until 1892 The S. Tretyakov Collection,
Moscow; 1892—1925 The Tretyakov Gallery, Moscow;
since 1925 The Pushkin Museum of Fine Arts, Moscow

Exhibitions: 1939 Moscow, Cat., p. 34; 1955 Moscow,
Cat., p. 38; 1956 Leningrad, Cat., p. 29; 1960 Moscow,
Cat., p. 21

Bibliography: Кат. ГМИИ 1948, p. 40; Кат. ГМИИ
1957, p. 72; Кат. ГМИИ 1961, p. 100; Опись галереи
Третьяковых 1894, No 21; Алпатов 1936, p. 35, ill.
(entitled *The Storm*); Разумовская 1938, p. 17, ill.;
Прокофьев 1962, ill. 111; Sterling 1957, ill. 60, p. 83

113 HAYCART
Oil on canvas. 32 × 45 cm. Inv. No 955
Signed lower right: *Corot*
N. Yavorskaya dates the picture to the 1860s. There
are several pictures on this subject, of which the
landscape *In the Dunes* (The Kunsthalle, Mannheim)
is most closely related to the present work.

Provenance: 1891 The Forbes Collection, Paris; until
1918 The P. Kharitonenko Collection, Moscow; until
1924 The Rumiantsev Museum, Moscow; since 1924
The Pushkin Museum of Fine Arts, Moscow

Exhibitions: 1920 Moscow; 1939 Moscow, Cat., p. 34;
1955 Moscow, Cat., p. 38; 1956 Leningrad, Cat., p. 29;
1960 Moscow, Cat., p. 21

Bibliography: Кат. ГМИИ 1948, p. 40; Кат. ГМИИ
1957, p. 72, ill.; Кат. ГМИИ 1961, p. 100, ill.; Robaut
1905, vol. 3, No 1949, ill.; Алпатов 1936, pp. 36, 38,
ill.; Разумовская 1938, p. 12, ill.; Прокофьев 1962,
ill. 109; Яворская 1962, p. 76, ill.; ГМИИ 1966, No 77

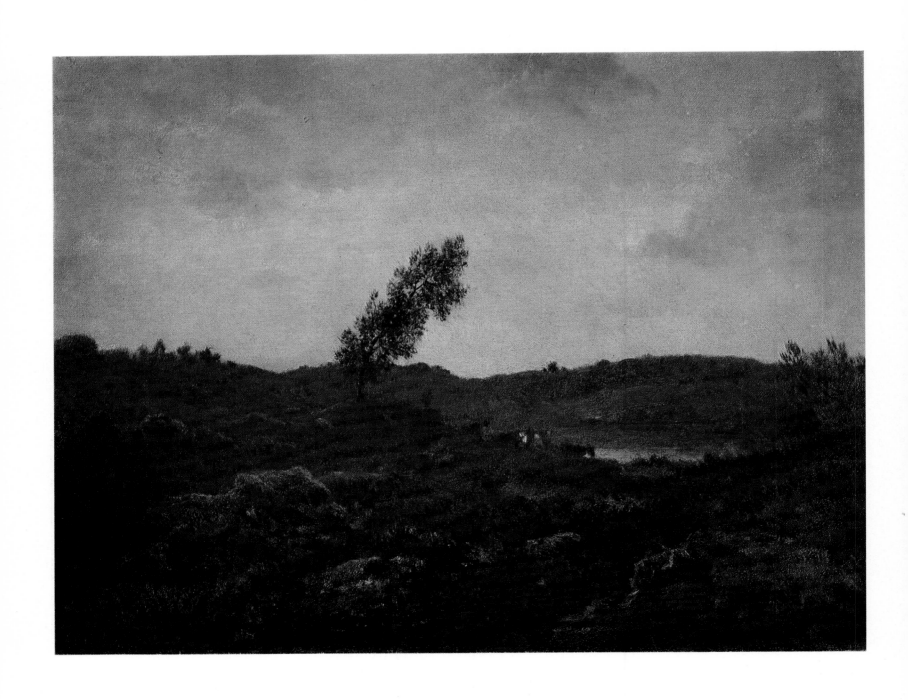

114 A BARBIZON VIEW
Oil on panel. 24 × 32 cm. Inv. No 1088
Signed lower left: *Th. Rousseau*

Provenance: until 1892 The S. Tretyakov Collection, Moscow; 1892—1925 The Tretyakov Gallery, Moscow; since 1925 The Pushkin Museum of Fine Arts, Moscow

Exhibitions: 1955 Moscow, Cat., p. 55; 1956 Leningrad, Cat., p. 54; 1960 Moscow, Cat., p. 33

Bibliography: Кат. ГМИИ 1948, p. 71; Кат. ГМИИ 1957, p. 125; Кат. ГМИИ 1961, p. 165; Опись галереи Третьяковых 1894, No 8; Кат. галереи Третьяковых 1917, No 3898; Réau 1929, No 637

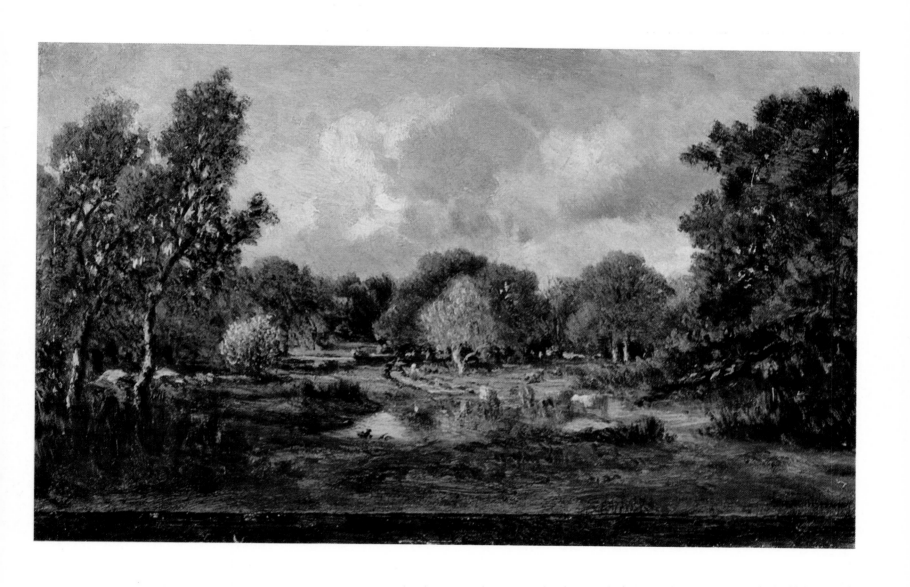

115 COWS AT A WATERING PLACE
Oil on panel. 14.5 × 23 cm. Inv. No 1090
Signed lower right: *Th. Rousseau*
The picture may be dated the mid-1850s.

Provenance: 1892 Sale of the Daupias Lisbon Collection, Paris; until 1924 The Rumiantsev Museum, Moscow; since 1924 The Pushkin Museum of Fine Arts, Moscow

Exhibitions: 1920 Moscow; 1939 Moscow, Cat., p. 40; 1955 Moscow, Cat., p. 56; 1956 Leningrad. Cat., p. 54; 1960 Moscow, Cat., p. 33

Bibliography: Кат. ГМИИ 1948, p. 71, ill.; Кат. ГМИИ 1957, p. 125; Кат. ГМИИ 1961, p. 165; Яворская 1962, p. 127, ill.

JULES DUPRÉ. 1811—1889

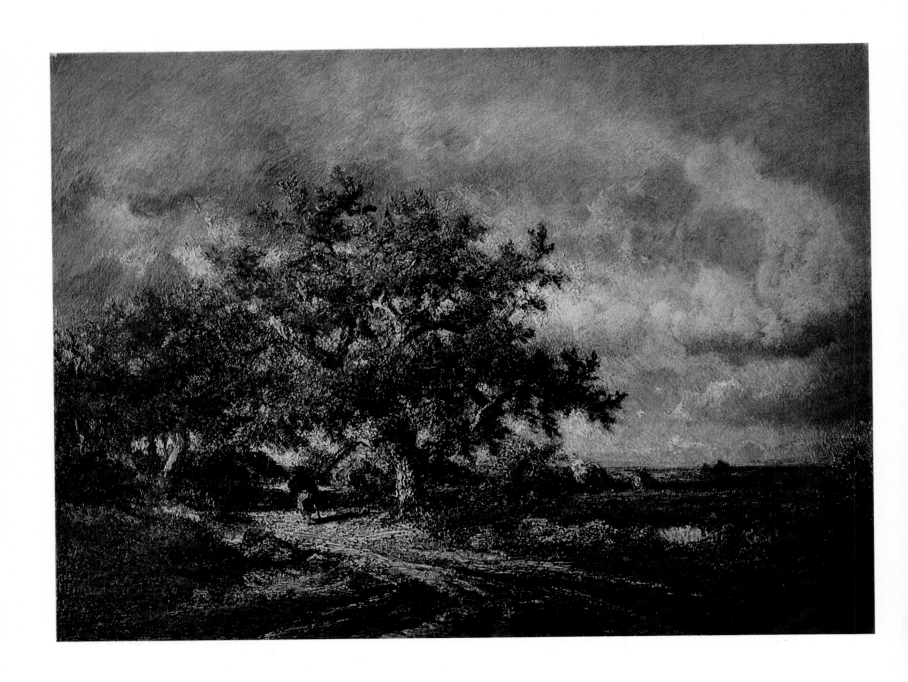

116 OAKS BY THE ROAD
Oil on canvas. 74 × 58 cm. Inv. No 907
Signed lower right: *Jules Dupré*
The picture shows the influence of Constable, which permits its dating to the 1830s.

Provenance: until 1918 The P. Kharitonenko Collection, Moscow; until 1924 The Rumiantsev Museum, Moscow; since 1924 The Pushkin Museum of Fine Arts, Moscow

Exhibitions: 1920 Moscow; 1939 Moscow, Cat., p. 39; 1955 Moscow, Cat., p. 34; 1956 Leningrad, Cat., p. 25; 1960 Moscow, Cat., p. 17

Bibliography: Кат. ГМИИ 1948, p. 34; Кат. ГМИИ 1957, p. 57; Кат. ГМИИ 1961, p. 81; Яворская 1962, p. 153, ill.; ГМИИ 1966, No 79

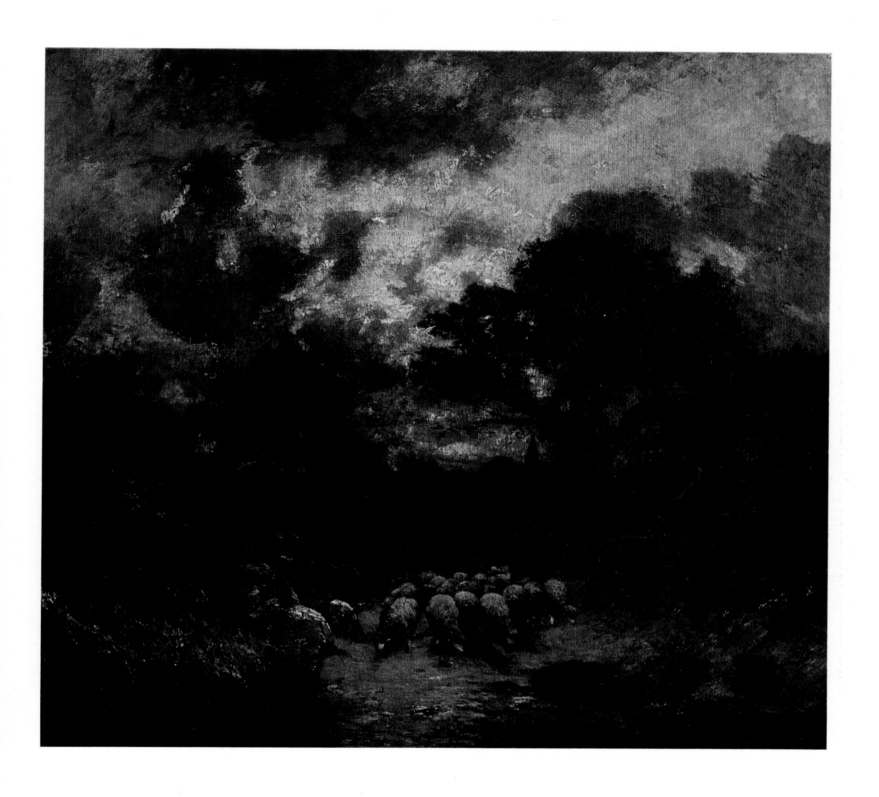

117 EVENING
Oil on canvas. 31 × 35 cm. Inv. No 904
Signed lower left: *Jules Dupré*
N. Yavorskaya dates the picture to the 1840s.

Provenance: until 1892 The S. Tretyakov Collection,
Moscow; 1892—1925 The Tretyakov Gallery, Moscow;
since 1925 The Pushkin Museum of Fine Arts, Moscow

Exhibitions: 1939 Moscow, Cat., p. 39; 1955 Moscow,
Cat., p. 34; 1956 Leningrad, Cat., p. 25; 1960 Moscow,
Cat., p. 17

Bibliography: Кат. ГМИИ 1948, p. 31; Кат. ГМИИ
1957, p. 57; Кат. ГМИИ 1961, p. 80; Опись галереи
Третьяковых 1894, No 32; Кат. галереи Третьяковых
1917, No 3896; Réau 1929, No 523; Яворская 1962,
p. 150

NARCISSE VIRGILE DÍAZ DE LA PEÑA. 1807—1876

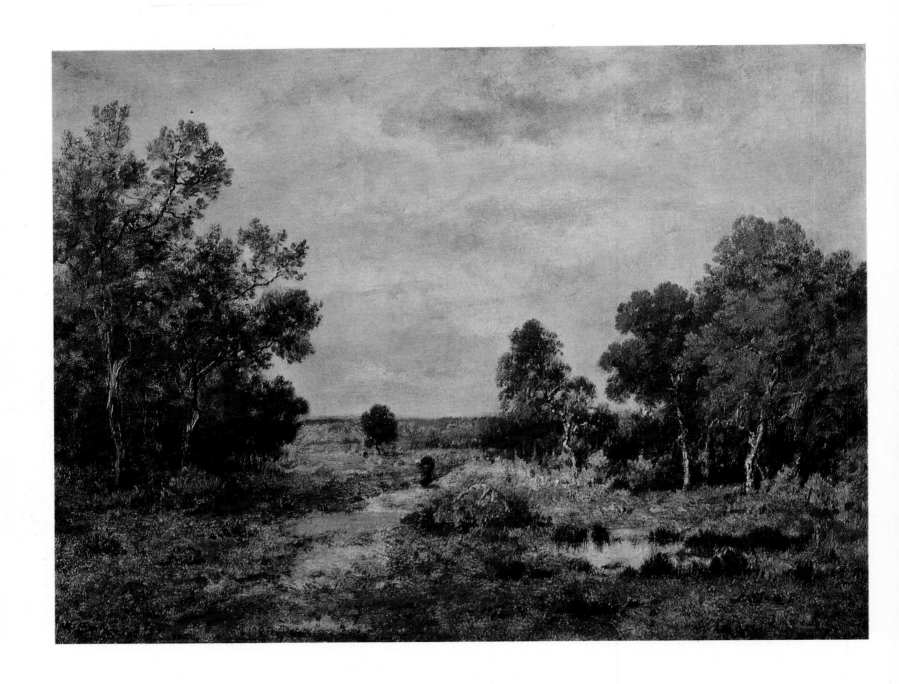

118 AUTUMN IN FONTAINEBLEAU. 1872
Oil on panel. 42 × 56 cm. Inv. No 875
Signed and dated lower left: *Diaz 72*

Provenance: until 1892 The S. Tretyakov Collection,
Moscow; 1892—1925 The Tretyakov Gallery, Moscow;
since 1925 The Pushkin Museum of Fine Arts, Moscow

Exhibitions: 1939 Moscow, Cat., p. 14; 1955 Moscow,
Cat., p. 32; 1956 Leningrad, Cat., p. 22; 1960 Moscow,
Cat., p. 15

Bibliography: Кат. ГМИИ 1948, p. 28; Кат. ГМИИ
1957, p. 52; Кат. ГМИИ 1961, p. 74; Опись галереи
Третьяковых 1894, No 27; Кат. галереи Третьяковых
1917, No 3887; Réau 1929, No 506; Яворская 1962,
p. 166, ill.

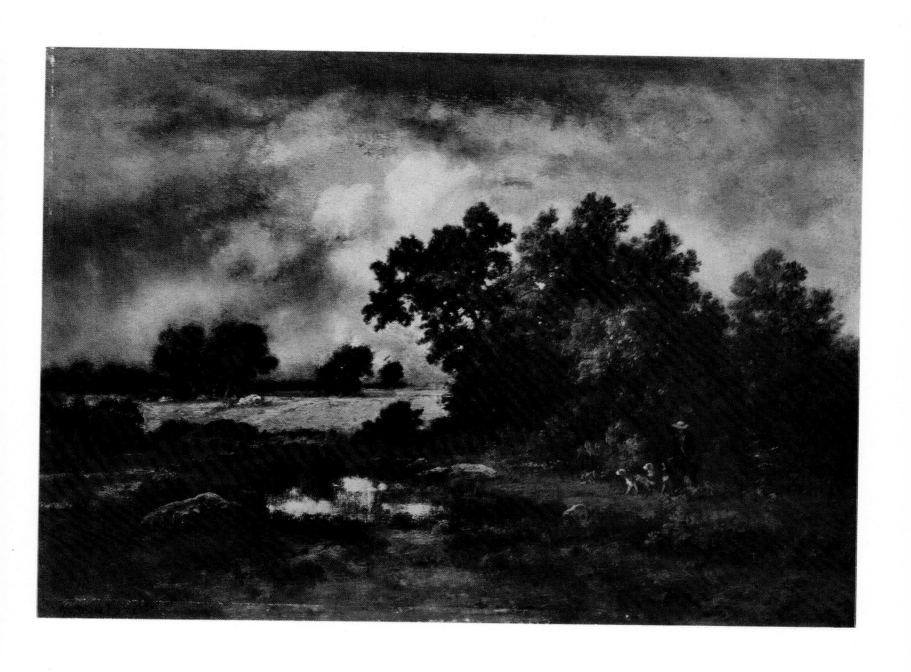

119 RAINY DAY. 1872
Oil on canvas. 44 × 61 cm. Inv. No 874
Signed and dated lower left: *N Diaz 72*

Provenance: 1920—24 The Rumiantsev Museum, Moscow; since 1924 The Pushkin Museum of Fine Arts, Moscow

Exhibitions: 1907 London; 1939 Moscow, Cat., p. 37; 1955 Moscow, Cat., p. 32; 1956 Leningrad, Cat., p. 22; 1960 Moscow, Cat., p. 15

Bibliography: Кат. ГМИИ 1948, p. 28; Кат. ГМИИ 1957, p. 52; Кат. ГМИИ 1961, p. 74; Яворская 1962, p. 167, ill.

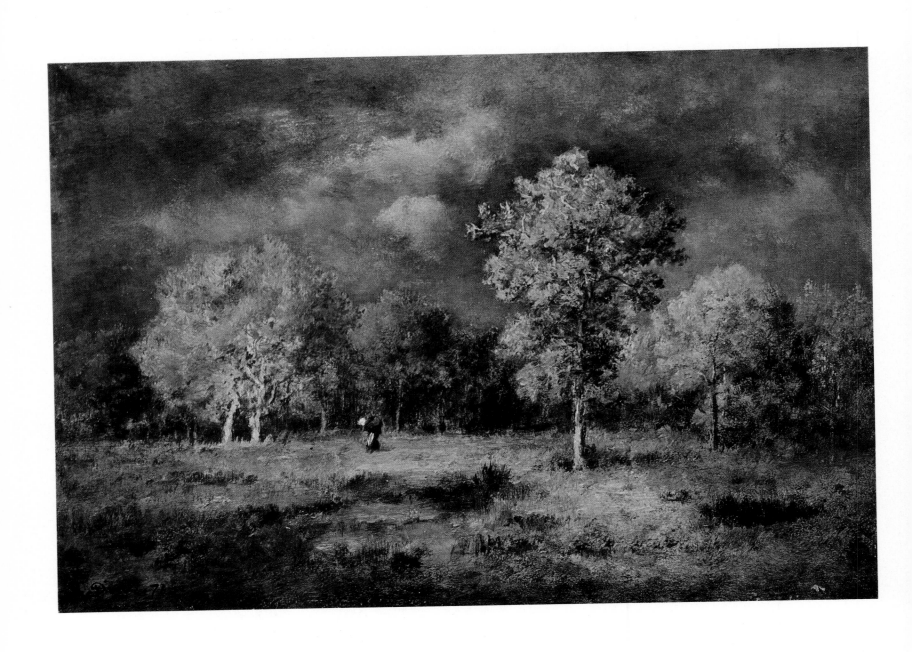

120 APPROACHING STORM. 1871
Oil on panel. 21 × 30 cm. Inv. No 873
Signed and dated lower left: *Diaz 71*

Provenance: until 1918 The P. Kharitonenko Collection,
Moscow; until 1924 The Rumiantsev Museum, Moscow;
since 1924 The Pushkin Museum of Fine Arts, Moscow

Exhibitions: 1920 Moscow; 1955 Moscow, Cat., p. 32;
1956 Leningrad, Cat., p. 22; 1960 Moscow, Cat., p. 15

Bibliography: Кат. ГМИИ 1948, p. 28; Кат. ГМИИ
1957, p. 51; Кат. ГМИИ 1961, p. 74, ill.; Réau 1929,
No 507; Прокофьев 1962, ill. 104; Яворская 1962,
p. 168, ill.; Musée de Moscou 1963, p. 155, ill.; ГМИИ
1966, No 80

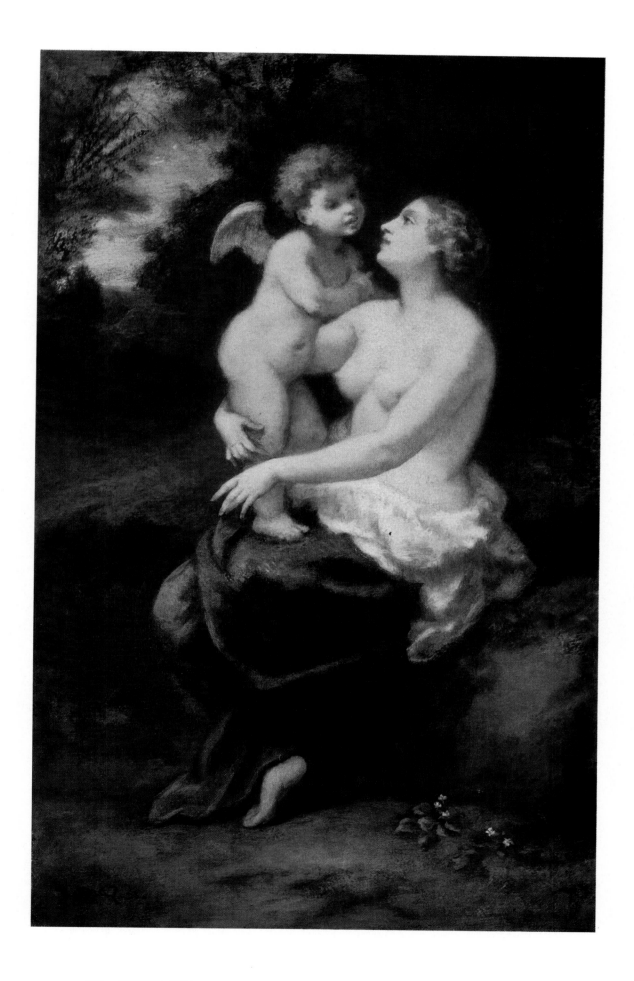

121 VENUS WITH CUPID IN HER LAP. 1851
Oil on panel. 45 × 28 cm. Inv. No 871
Signed and dated lower left: *N. Diaz 1851*

Provenance: The A. Stevens Collection, Paris; 1886 Sale of the Defoer Collection, Paris (entitled *Les Confidences de l'Amour*, lot 13); until 1918 The P. Kharitonenko Collection, Moscow; until 1924 The Rumian- tsev Museum, Moscow; since 1924 The Pushkin Museum of Fine Arts, Moscow

Exhibitions: 1920 Moscow; 1955 Moscow, Cat., p. 32; 1956 Leningrad, Cat., p. 23; 1960 Moscow, Cat., p. 15; 1972 Prague, Cat. 13

Bibliography: Кат. ГМИИ 1957, p. 51; Кат. ГМИИ 1961, p. 71

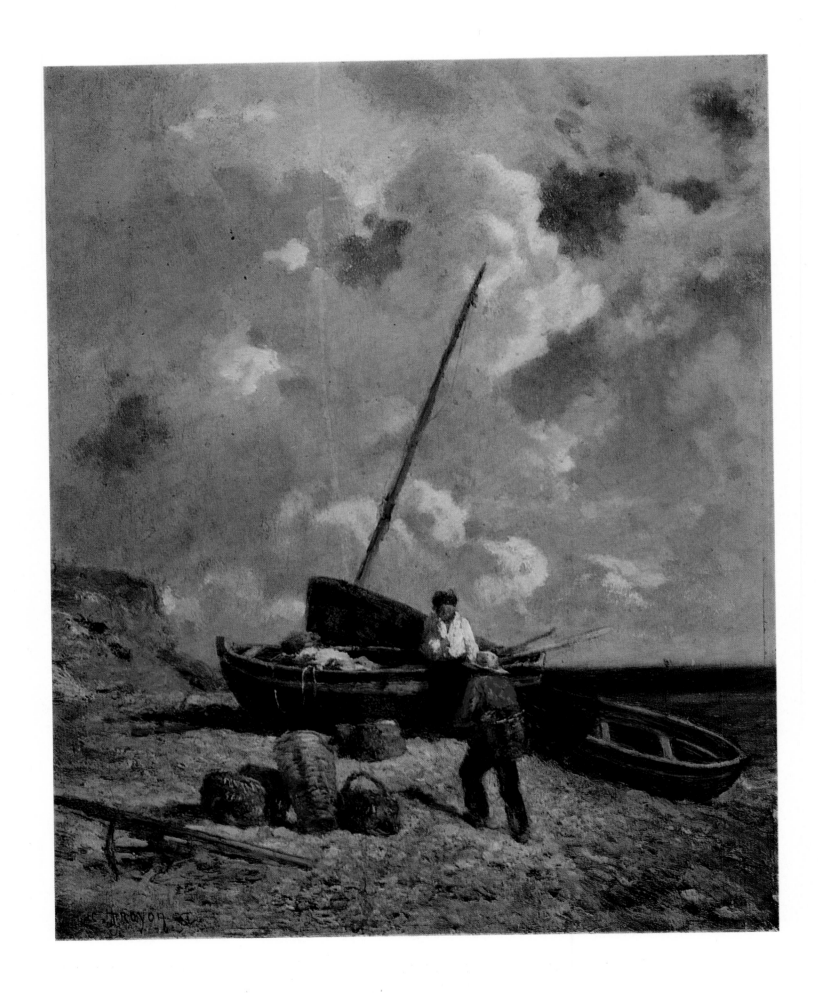

122 FISHERMEN

← Oil on panel. 41 × 32.5 cm. Inv. No 1111

Signed lower left: *C. Troyon*

According to G. Réau, the picture was painted in 1860 in Normandy.

Provenance: The Grechanova Collection, Moscow; since 1925 The Pushkin Museum of Fine Arts, Moscow

Exhibitions: 1955 Moscow, Cat., p. 58; 1956 Leningrad, Cat., p. 57; 1960 Moscow, Cat., p. 37

Bibliography: Кат. ГМИИ 1948, p. 77; Кат. ГМИИ 1957, p. 137; Кат. ГМИИ 1961, p. 181; Réau 1929, No 659

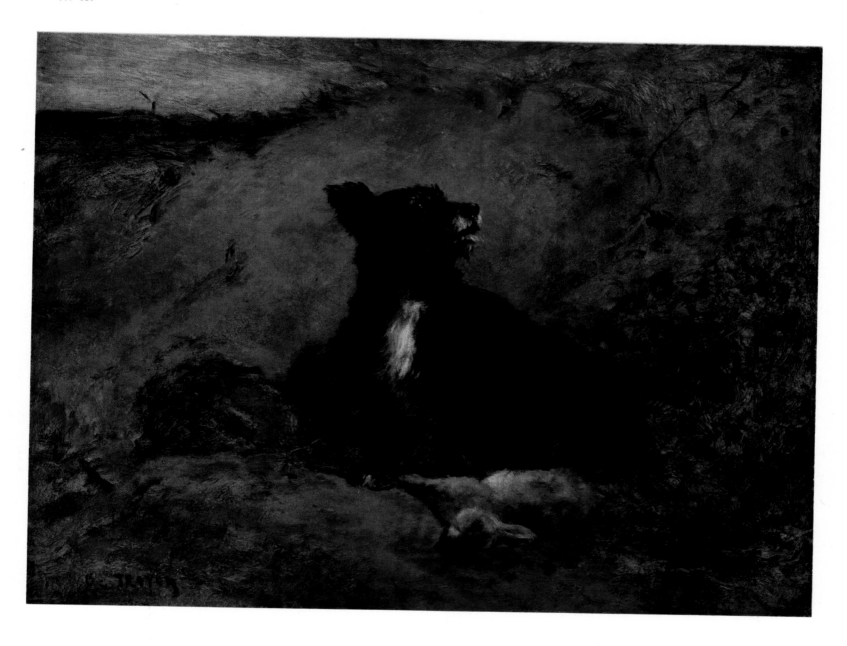

123 DOG AND RABBIT

Oil on panel. 50 × 66 cm. Inv. No 1109

Signed lower left: *C. Troyon*

Provenance: until 1892 The S. Tretyakov Collection, Moscow; 1892—1925 The Tretyakov Gallery, Moscow; since 1925 The Pushkin Museum of Fine Arts, Moscow

Exhibitions: 1955 Moscow, Cat., p. 58; 1956 Leningrad, Cat., p. 58; 1960 Moscow, Cat., p. 37

Bibliography: Кат. ГМИИ 1957, p. 137; Кат. ГМИИ 1961, p. 181; Опись галереи Третьяковых 1894, No 4; Кат. галереи Третьяковых 1917, No 3891; Перцов 1921, p. 19; Réau 1929, No 662

124 APPROACHING STORM. 1851
Oil on panel. 53 × 38.2 cm. Inv. No 1115
Signed and dated lower left: *C. Troyon 1851*

Provenance: until 1892 The S. Tretyakov Collection,
Moscow; 1892—1925 The Tretyakov Gallery, Moscow;
since 1925 The Pushkin Museum of Fine Arts. Moscow

Exhibitions: 1939 Moscow, Cat., p. 38; 1955 Moscow,
Cat., p. 58; 1956 Leningrad, Cat., p. 57; 1960 Moscow,
Cat., p. 36

Bibliography: Кат. ГМИИ 1948, p. 77; Кат. ГМИИ
1957, p. 137; Кат. ГМИИ 1961, p. 181; Опись гале-
реи Третьяковых 1894, No 6; Кат. галереи Третья-
ковых 1917, No 3890; Перцов 1921, p. 18; Réau 1929,
No 699; Яворская 1962, p. 234, ill.

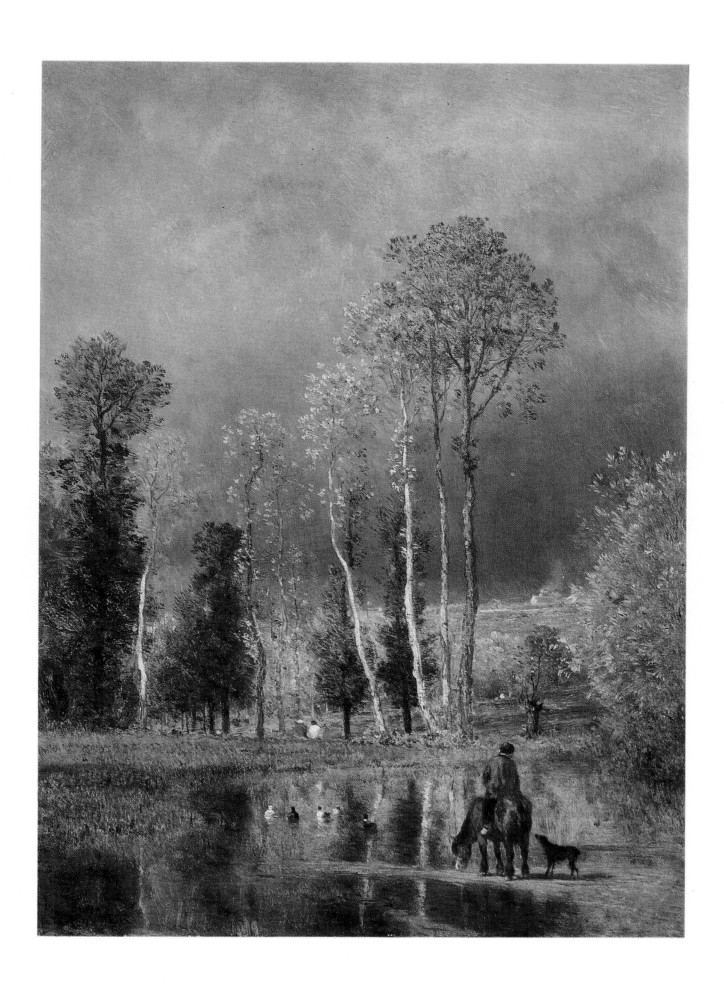

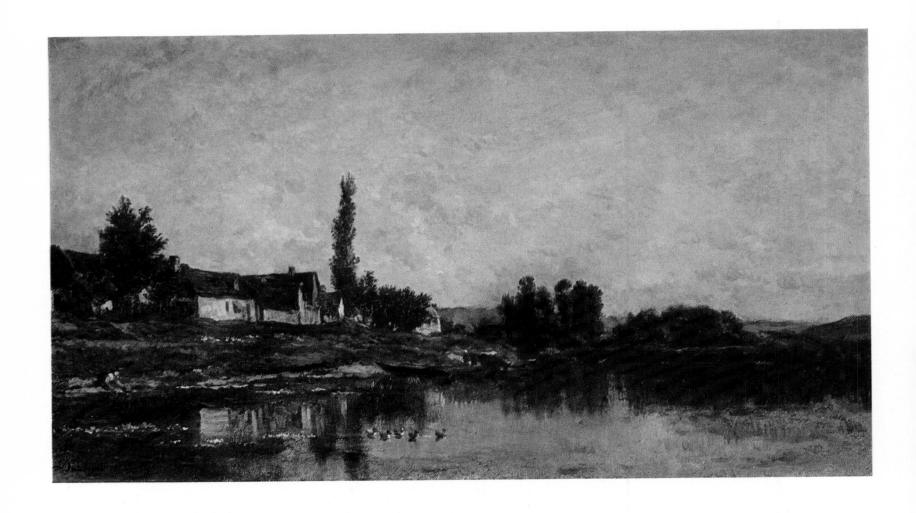

**125 PORTEJOIE VILLAGE ON THE BANK
OF THE SEINE (VILLAGE ON THE BANK
OF THE OISE). 1868**
Oil on panel. 37 × 66 cm. Inv. No 881
Signed and dated lower left: *Daubigny 1868*
A comparison with a landscape in the Metropolitan
Museum of Art (No 30.95.275), almost identical in
composition and dated the same year, 1868, justifies the
changing of the picture's traditional title, *Village on
the Bank of the Oise*. The Pushkin Museum painting
actually depicts the village of Portejoie on the Seine.
A preliminary drawing for the picture made in san-
guine is in The Louvre. The name of the village has
been established by Moreau-Nélaton.

Provenance: until 1892 The S. Tretyakov Collection,
Moscow; 1892—1925 The Tretyakov Gallery, Moscow;
since 1925 The Pushkin Museum of Fine Arts, Moscow

Exhibitions: 1939 Moscow, Cat., p. 42; 1955 Moscow,
Cat., p. 33; 1956 Leningrad, Cat., p. 23; 1960 Moscow,
Cat., p. 16

Bibliography: Кат. ГМИИ 1948, p. 28; Кат. ГМИИ
1957, p. 53; Кат. ГМИИ 1961, p. 76; Опись галереи
Третьяковых 1894, No 13; Кат. галереи Третьяковых
No 3906; Перцов 1921, p. 18; Réau 1929, No 478;
Прокофьев 1962, ill. 113; Яворская 1962, pp. 222—
223; Musée de Moscou 1963, p. 154, ill.; ГМИИ 1966,
No 81 (entitled *Village on the Bank of the Oise*)

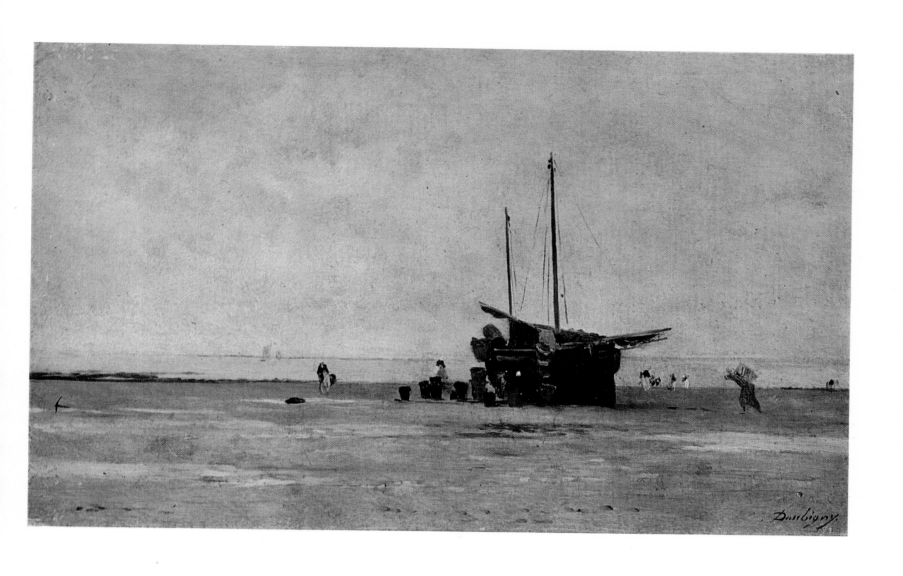

126 THE SEASHORE
Oil on panel. 20 × 34 cm. Inv. No 887
Signed lower right: *Daubigny*
The picture was painted in the 1860s.

Provenance: until 1892 The S. Tretyakov Collection;
1892—1925 The Tretyakov Gallery, Moscow; since
1925 The Pushkin Museum of Fine Arts, Moscow

Exhibitions: 1939 Moscow, Cat., p. 43; 1955 Moscow,
Cat., p. 33; 1956 Leningrad, Cat., p. 24; 1960 Moscow,
Cat., p. 15

Bibliography: Кат. ГМИИ 1948, p. 29; Кат. ГМИИ
1957, p. 53; Кат. ГМИИ 1961, p. 76, ill.; Опись га-
лереи Третьяковых 1894, No 15; Кат. галереи Третья-
ковых 1917, No 3907; Réau 1929, No 480; Прокофьев
1962, ill. 114

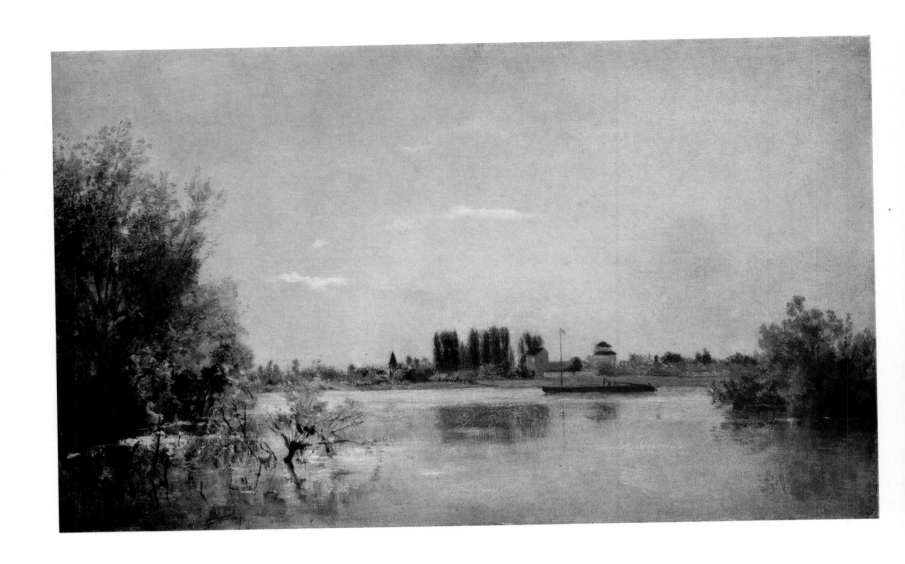

127 THE BANKS OF THE OISE
Oil on panel. 24 × 46 cm. Inv. No 884
Signed lower left: *Daubigny*
The picture was painted around 1860.

Provenance: The J. Güntzburg Collection, Paris; 1886 Sale of the Defoer Collection, Paris; until 1892 The S. Tretyakov Collection, Moscow; 1892—1925 The Tretyakov Gallery, Moscow; since 1925 The Pushkin Museum of Fine Arts, Moscow

Exhibitions: 1939 Moscow, Cat., p. 42; 1955 Moscow, Cat., p. 33; 1956 Leningrad, Cat., p. 23; 1960 Moscow, Cat., p. 16

Bibliography: Кат. ГМИИ 1948, p. 29; Кат. ГМИИ 1957, p. 53; Кат. ГМИИ 1961, p. 75; Опись галереи Третьяковых 1894, No 14; Кат. галереи Третьяковых 1917, No 3909; Яворская 1962, p. 223, ill.

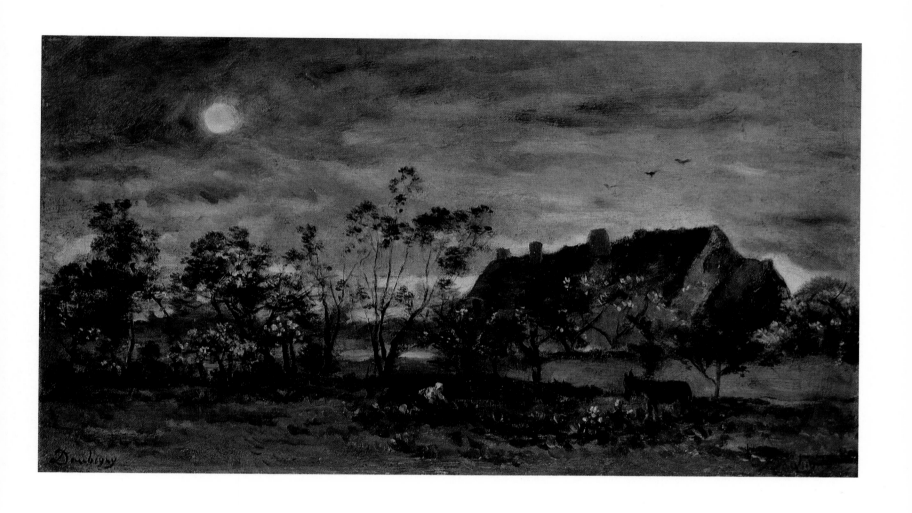

128 EVENING IN HONFLEUR
 Oil on panel. 19 × 34 cm. Inv. No 886
 Signed lower left: *Daubigny*
 The picture was painted in the 1860s.

 Provenance: until 1892 The S. Tretyakov Collection,
 Moscow; 1892—1925 The Tretyakov Gallery, Moscow;
 since 1925 The Pushkin Museum of Fine Arts, Moscow

 Exhibitions: 1955 Moscow, Cat., p. 33; 1956 Lenin-
 grad, Cat., p. 24; 1960 Moscow, Cat., p. 17

 Bibliography: Кат. ГМИИ 1948, p. 29; Кат. ГМИИ
 1957, p. 53; Кат. ГМИИ 1961, p. 76; Опись галереи
 Третьяковых 1894, No 18; Кат. галереи Третьяковых
 1917, No 3908; Réau 1929, No 483

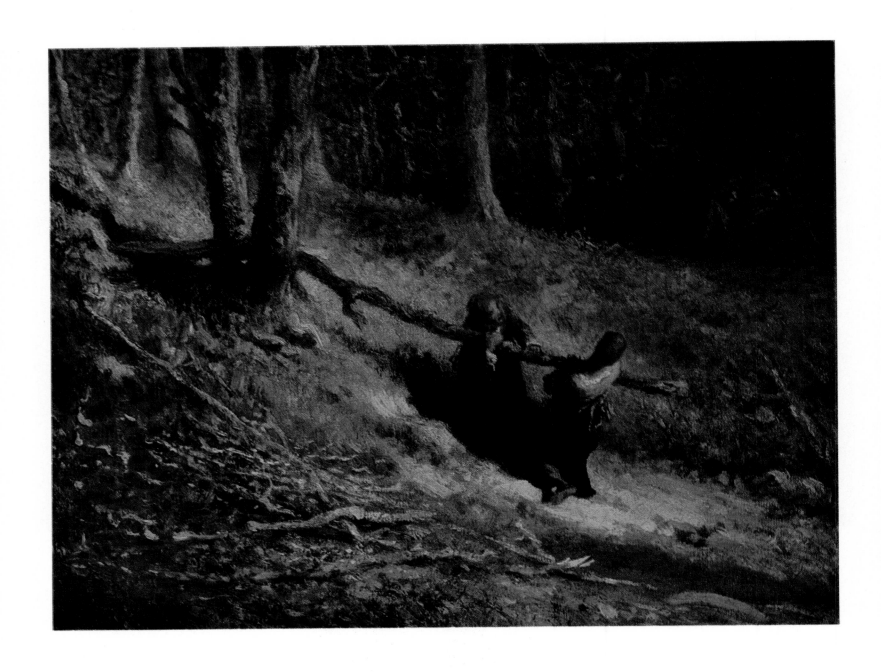

129 BRUSHWOOD GLEANERS
(CHARCOAL BURNERS)
Oil on canvas. 37 × 45 cm. Inv. No 1019
Signed lower right: *J. F. Millet*
The picture was painted in the 1860s.

Provenance: until 1892 The S. Tretyakov Collection,
Moscow; 1892—1925 The Tretyakov Gallery, Moscow;
since 1925 The Pushkin Museum of Fine Arts, Moscow

Exhibitions: 1939 Moscow, Cat., p. 41; 1955 Moscow,
Cat., p. 46; 1956 Leningrad, Cat., p. 40; 1960 Moscow,
Cat., p. 27

Bibliography: Кат. ГМИИ 1948, p. 51; Кат. ГМИИ
1957, p. 93; Кат. ГМИИ 1961, p. 126; Опись галереи
Третьяковых 1894, No 52; Кат. галереи Третьяковых
1917, No 3901; Перцов 1921, p. 18; Прокофьев 1962,
ill. 117; Яворская 1962, p. 183, ill.; ГМИИ 1966, No 82

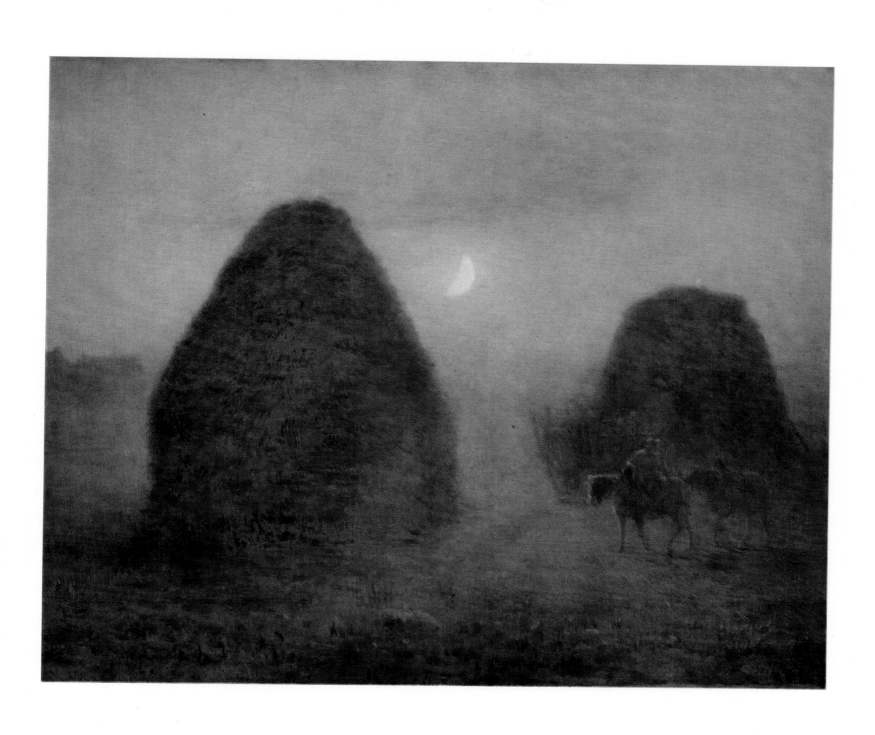

130 HAYSTACKS. 1875

Oil on canvas. 46 × 55 cm. Inv. No 1020

Signed and dated lower right: *F. Millet 1875*

Provenance: 1899 The Rodokonaki Collection, St Petersburg; until 1927 The Hermitage, Leningrad; since 1927 The Pushkin Museum of Fine Arts, Moscow

Exhibitions: 1955 Moscow, Cat., p. 46; 1956 Leningrad, Cat., p. 40; 1960 Moscow, Cat., p. 127

Bibliography: Кат. ГМИИ 1957, p. 93; Кат. ГМИИ 1961, p. 126

131 IN A HAMMOCK
Oil on canvas. 42 × 32 cm. Inv. No 970
Signed lower right: *G. Courbet*
This picture is one of the artist's early works painted before 1850.

Provenance: since 1926 The Pushkin Museum of Fine Arts, Moscow

Bibliography: Réau 1929, No 465; А. Тихомиров, *Гюстав Курбе*, Moscow, 1965, p. 170

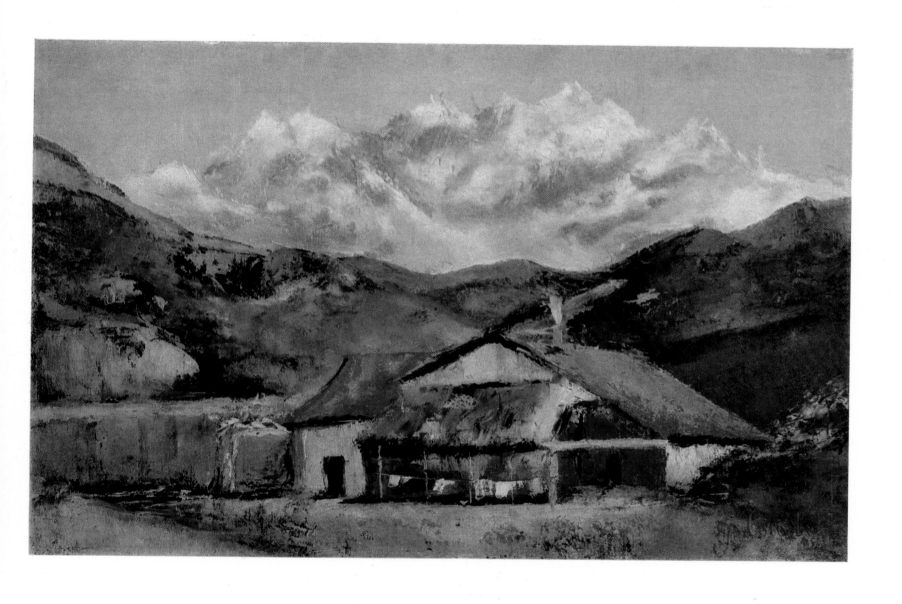

132 A HUT IN THE MOUNTAINS
Oil on canvas. 33 × 49 cm. Inv. No 3542
Signed lower right: *G. Courbet*
The picture was painted in Switzerland, during the last years of the artist's life.

Provenance: until 1918 The S. Shchukin Collection, Moscow; 1918—26 The Museum of Modern Western Art, Moscow; 1926—38 The Pushkin Museum of Fine Arts, Moscow; 1938—48 The Museum of Modern Western Art, Moscow; since 1948 The Pushkin Museum of Fine Arts, Moscow

Exhibitions: 1920 Moscow; 1939 Moscow, Cat., p. 44; 1955 Moscow, Cat., p. 39; 1956 Leningrad, Cat., p. 30; 1960 Moscow, Cat., p. 23; 1965 Bordeaux, Cat., p. 49; 1965—66 Paris, Cat., p. 52

Bibliography: Кат. ГМИИ 1957, p. 76, ill; Кат. ГМИИ 1961, p. 105; Кат. собр. С. Щукина 1913, No 70, p. 18; Тугендхольд 1914, p. 8; Перцов 1921, p. 110, No 70; Тугендхольд 1923, p. 16, ill. 9; Ternovetz 1925, p. 456, ill.; Réau 1929, No 466; Sterling 1957, ill. 64, p. 85; K. Klingenburg, *Gustave Courbet*, Berlin, 1960, p. 42, ill.; Прокофьев 1962, ill. 120; Musée de Moscou 1963, p. 159, ill.; ГМИИ 1966, No 83

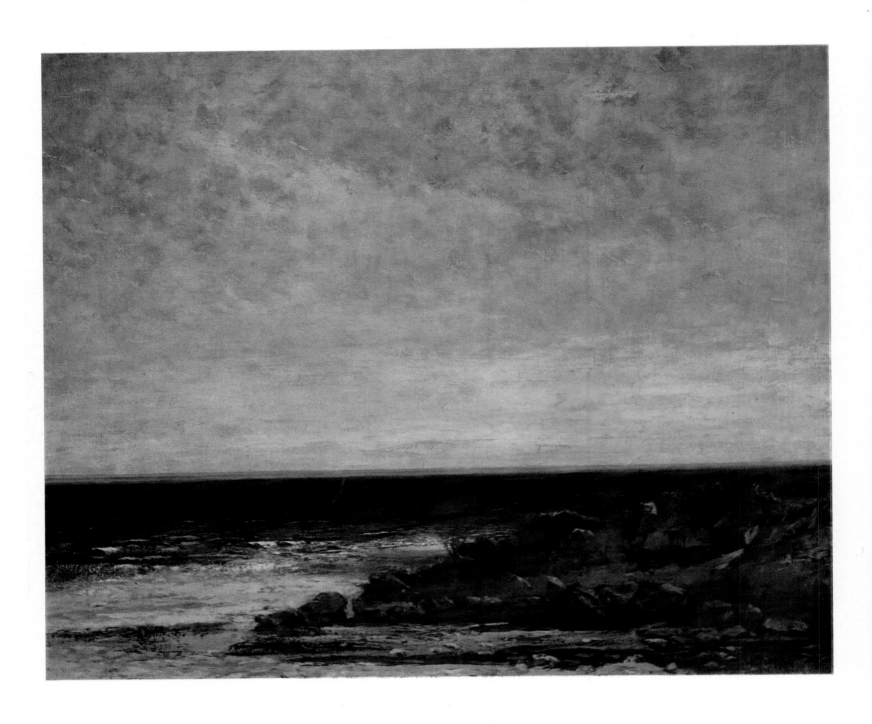

133 THE SEA. 1867

Oil on canvas. 103 × 126 cm. Inv. No 969
Signed and dated lower right: *G. Courbet 67*
In the collection of S. Tretyakov the picture was list-
ed as *Sea View in Brittany*. In the Pushkin Museum
Catalogue (1961), the painting was entitled *The Sea:
the Coast of Normandy* on the basis of its date, for
it was in Normandy that Courbet worked in the late
1860s.

According to P. Fernier, the Pushkin Museum picture
was exhibited as *View of the Mediterranean. Ma-
guelonne, near Montpellier*, at the Ecole des Beaux-
Arts in Paris in 1882, and is a replica of the 1858
canvas, now in the possession of the Musée des Arts
at Saint-Gall in Switzerland.

Provenance: until 1892 The S. Tretyakov Collection,
Moscow (acquired in Paris through the agency of the
painter A. Bogoliubov); 1892—1925 The Tretyakov Gal-
lery, Moscow; since 1925 The Pushkin Museum of
Fine Arts, Moscow

Exhibitions: 1882 Paris (entitled *View of the Medi-
terranean. Maguelonne, near Montpellier*); 1939 Mos-
cow, Cat., p. 43; 1955 Moscow, Cat., p. 39; 1956 Len-
ingrad, Cat., p. 30; 1960 Moscow, Cat., p. 23

Bibliography: Кат. ГМИИ 1948, p. 43 (entitled *The
Sea at the Shore of Brittany*); Кат. ГМИИ 1957,
p. 76; Кат. ГМИИ 1961, p. 105; Опись галереи Тре-
тьяковых 1894, No 132 (entitled *Sea View in Brit-
tany*); Кат. галереи Третьяковых 1917, No 3910 (en-
titled *The Sea by the Shores of Brittany*); Th. Duret,
Courbet, 1918, p. 148; Перцов 1921, p. 18; Réau 1929,
No 464, ill.; Sterling 1957, ill. 63, p. 84; K. Klin-
genburg, *Gustave Courbet*, Berlin, 1960, p. 36, ill.;
Прокофьев 1962, ill. 119; Яворская 1962, p. 249, ill.;
А. Тихомиров, *Гюстав Курбе*, Moscow, 1965, pp. 170—
171, ill.

134 WAITING FOR THE FERRYBOAT ACROSS THE
NILE. 1872
Oil on canvas. 79 × 111 cm. Inv. No 1134
Signed lower left: *Eug. Fromentin*
Dated lower right: *1872*

Provenance: The S. Tretyakov Collection, Moscow;
1894—1925 The Tretyakov Gallery, Moscow; since
1925 The Pushkin Museum of Fine Arts, Moscow

Exhibitions: 1955 Moscow, Cat., p. 60; 1956 Lenin-
grad, Cat., p. 61

Bibliography: Кат. ГМИИ 1948, p. 83; Кат. ГМИИ
1957, p. 146; Кат. ГМИИ 1961, p. 192; Опись гале-
реи Третьяковых 1894, No 11; Кат. галереи Третья-
ковых 1911, No 50; Кат. галереи Третьяковых 1917,
No 3913; Réau 1929, No 530

135 AN ORIENTAL BARBERSHOP. 1872
Oil on canvas. 100 × 60 cm. Inv. No 3490
Signed and dated lower right: *L. Bonnat. 1872*

Provenance: until 1892 The S. Tretyakov Collection, Moscow; 1892—1925 The Tretyakov Gallery, Moscow; 1925—30 The Museum of Fine Arts, Moscow; 1930—48 The Museum of Modern Western Art, Moscow; since 1948 The Pushkin Museum of Fine Arts, Moscow

Exhibitions: 1873 Paris (Salon), Cat. 5; 1960 Moscow, Cat., p. 10

Bibliography: *Catalogue du Salon*, Paris, 1873, No 5, ill. 5 (entitled *Barbier turc*); Опись галереи Третьяковых 1894, No 1; Кат. галереи Третьяковых 1911, No 64; Кат. галереи Третьяковых 1917, No 3926; Réau 1929, No 434 (entitled *Boutique de barbier en Orient*)

PASCAL ADOLPHE JEAN DAGNAN-BOUVERET. 1852—1929

136 THE NUPTIAL BENEDICTION. 1880—81
Oil on canvas. 99 × 143 cm. Inv. No 3481
Signed and dated: *P. A. J. Dagnan-B' Corre 1880—1881*
On the reverse, on the right, is the inscription in black paint: *La figure de la Mariée est le portrait de ma femme... P. A. J. Dagnan*

Provenance: until 1892 The S. Tretyakov Collection, Moscow; 1892—1930 The Tretyakov Gallery, Moscow; 1930 The Museum of Fine Arts, Moscow; 1930—48 The Museum of Modern Western Art, Moscow; since 1948 The Pushkin Museum of Fine Arts, Moscow

Exhibitions: 1882 Paris (Salon); 1955 Moscow, Cat., p. 29; 1956 Leningrad, Cat., p. 52; 1960 Moscow, Cat., pp. 4, 13

Bibliography: Кат. ГМИИ 1957, p. 46; Кат. ГМИИ 1961, p. 65; Опись галереи Третьяковых 1894, No 12; Кат. галереи Третьяковых 1911, No 84; Кат. галереи Третьяковых 1917, No 3948; Réau 1929, No 477

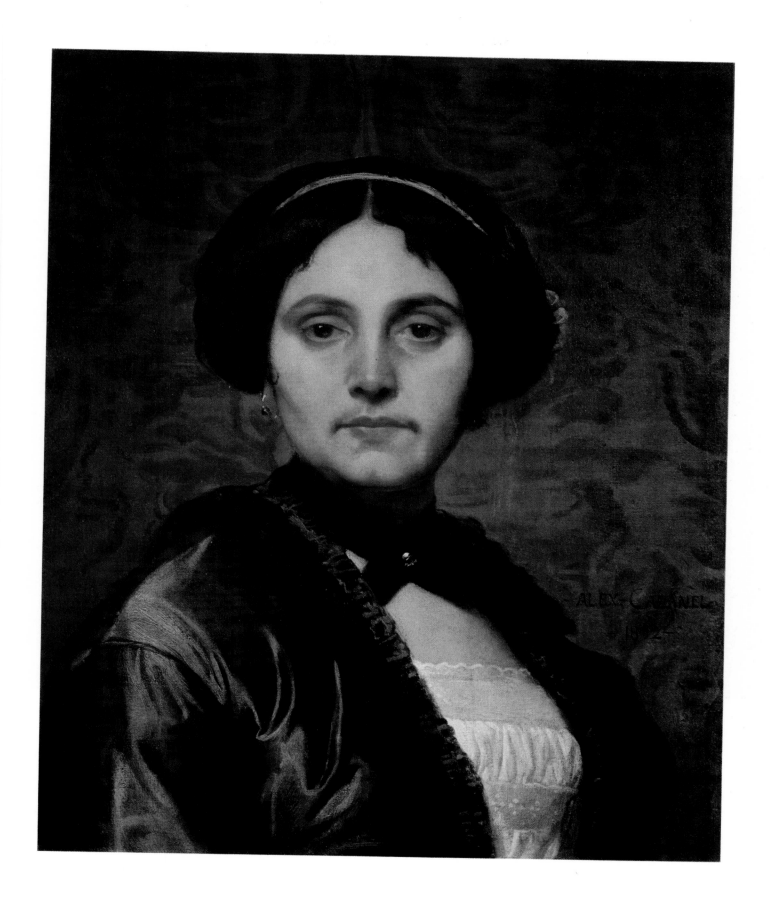

137 FEMALE PORTRAIT. 1852
Oil on canvas. 55 × 46 cm. Inv. No 3496
Signed and dated lower right: *Alex. Cabanel. 1852*
Provenance: until 1930 The Museum of Fine Arts, Moscow; 1930—48 The Museum of Modern Western Art, Moscow; since 1948 The Pushkin Museum of Fine Arts, Moscow

Exhibition: 1960 Moscow, Cat., p. 20

138 THE KING CANDAULES
Oil on canvas. 68 × 198 cm. Inv. No 3543
Signed lower left: *J. L. Gerome*
Auctioned with the Wilson Collection in the Georges
Petit Gallery in Paris in 1881 was a small Gérôme
picture of the same name (lot 162, 20 × 32 cm), which
probably represents a sketch for the Pushkin Museum piece. Another similarly entitled canvas in the
Pereire Collection was listed in the catalogue of the
1891 sale in Paris.

Provenance: The Chaman Collection, Paris; until 1918
The Hermitage, St Petersburg — Petrograd; 1918—38
The Museum of Fine Arts, Moscow; 1938—48 The Museum of Modern Western Art, Moscow; since 1948
The Pushkin Museum of Fine Arts, Moscow

Exhibition: 1960 Moscow, Cat., pp. 5, 19

Bibliography: P. Mantz, "Salon de 1859", *Gazette des Beaux-Arts*, 2, 1859, pp. 196—198

139 **AFTER THE MASQUERADE**
Oil on canvas. 32 × 41 cm. Inv. No 968

Provenance: 1881 Sale of the Wilson Collection, Paris;
until 1892 The S. Tretyakov Collection, Moscow;
1892—1925 The Tretyakov Gallery, Moscow; since
1925 The Pushkin Museum of Fine Arts, Moscow

Exhibition: 1960 Moscow, Cat., p. 23

Bibliography: Кат. ГМИИ 1957, p. 77; Кат. ГМИИ
1961, p. 105; Опись галереи Третьяковых 1894, No 58;
Кат. галереи Третьяковых 1911, No 35; Кат. галереи
Третьяковых 1917, No 3902; Réau 1929, No 474

140 VILLAGE LOVERS. 1882
Oil on canvas. 194 × 180 cm. Inv. 3482
Signed and dated lower left: *J. Bastien-Lepage Dam-
villers 1882*

Provenance: 1885—92 The S. Tretyakov Collection,
Moscow; 1892—1925 The Tretyakov Gallery, Moscow;
1925—30 The Museum of Fine Arts, Moscow; 1930—
48 The Museum of Modern Western Art, Moscow;
since 1948 The Pushkin Museum of Fine Arts, Moscow

Exhibitions: 1883 Paris (Salon); 1885 Paris; 1892
Moscow, Cat., p. 14; 1955 Moscow, Cat., p. 21; 1960
Moscow, Cat., pp. 4, 8

Bibliography: Кат. ГМИИ 1957, p. 11; Кат. ГМИИ
1961, p. 13; Ch. Bigot, *Peintres contemporains*, Paris,
1888, p. 169; Опись галереи Третьяковых 1894, No 53;
L. Fourcaud, *Bastien-Lepage*, Paris, s.a. [1890s],
pp. 33—34, ill.; Кат. галереи Третьяковых 1911, No 79;
Кат. галереи Третьяковых 1917, No 3940; Прокофьев
1962, ill. 121; Antonova 1977, No 95

LÉON LHERMITTE. 1844—1925

142 YOUNG GIRL. 1892
Oil on canvas. 50 × 65 cm. Inv. No. 3480
Signed and dated lower right: *J. E. Blanche 92*

Provenance: The Z. Ratkova-Rozhnova Collection, Moscow; until 1925 The Rumiantsev Museum, Moscow; 1925—30 The Museum of Fine Arts, Moscow; 1930—48 The Museum of Modern Western Art, Moscow; since 1948 The Pushkin Museum of Fine Arts, Moscow

Exhibition: 1960 Moscow, Cat., p. 9

143 TOILERS OF THE SEA. 1897

Oil on cardboard. 54 × 64 cm. Inv. No 3445
Signed and dated lower left: *Ch. Cottet. 97*
This scene with two figures is reproduced by Cottet, though in a slightly altered form, in the central panel of his triptych *The World of the Sea* (Musée national d'art moderne, Paris). The Pushkin Museum picture has long been considered a sketch for the central part of the triptych, but the completeness of its compositional and artistic solution, a more detailed delineation of the figures (compared to the triptych), and an entirely different rendering of the still life, combined with the author's signature and date, allow us to regard the canvas as a work of art in its own right. A variant of the triptych is in the Padua Museum. The triptych *The World of the Sea* was exhibited in the 1898 Salon in Paris (No 311).

Provenance: until 1910 The M. Morozov Collection, Moscow; 1910—25 The Tretyakov Gallery, Moscow; 1925—48 The Museum of Modern Western Art, Moscow; since 1948 The Pushkin Museum of Fine Arts, Moscow

Exhibition: 1960 Moscow, Cat., p. 22

Bibliography: Кат. галереи Третьяковых 1911, No 108; Кат. галереи Третьяковых 1917, No 3950; Кат. ГМНЗИ 1928, No 218; Réau 1929, No 759

144 STILL LIFE
Oil on canvas. 38 × 46 cm. Inv. No 3470
Signed lower right: *A. Vollon*

Provenance: until 1918 The I. Ostroukhov Collection, Moscow; 1918—29 The Museum of Icons and Paintings, Moscow; 1929—48 The Museum of Modern Western Art, Moscow; since 1948 The Pushkin Museum of Fine Arts, Moscow

Exhibition: 1960 Moscow, Cat., p. 11

Bibliography: Кат. галереи Третьяковых 1911, No 63

145 THE BEACH AT TROUVILLE. 1871
Oil on panel. 19 × 46 cm. Inv. No 3567
Signed and dated left: *E. Boudin 1871*
Inscribed lower right: *Trouville*
There are numerous variants of this picture, which
differ one from another in the position of the human
figures on the beach.

Provenance: until 1950 The P. Ettinger Collection,
Moscow; since 1950 The Pushkin Museum of Fine
Arts, Moscow

Exhibitions: 1955 Moscow, Cat., p. 22; 1956 Lenin-
grad, Cat., p. 8; 1960 Moscow, Cat., p. 10

Bibliography: Кат. ГМИИ 1957, p. 19; Кат. ГМИИ
1961, p. 28; Musée de Moscou 1963, p. 161, ill.

146 LANDSCAPE IN FONTAINEBLEAU
Oil on panel. 39 × 60 cm. Inv. No 2806
Signed lower right: *Monticelli*

Provenance: until 1935 The Saratov Art Museum;
since 1935 The Pushkin Museum of Fine Arts, Moscow

Exhibitions: 1955 Moscow, Cat., p. 48; 1956 Lenin-
grad, Cat., p. 42; 1960 Moscow, Cat., p. 27; 1965
Bordeaux, Cat. 54; 1965—66 Paris, Cat. 66

Bibliography: Кат. ГМИИ 1948, p. 53; Кат. ГМИИ
1957, pp. 96—97; Кат. ГМИИ 1961, p. 131; Sterling
1957, ill. 62, p. 79; Прокофьев 1962, ill. 123; ГМИИ
1966, No 86

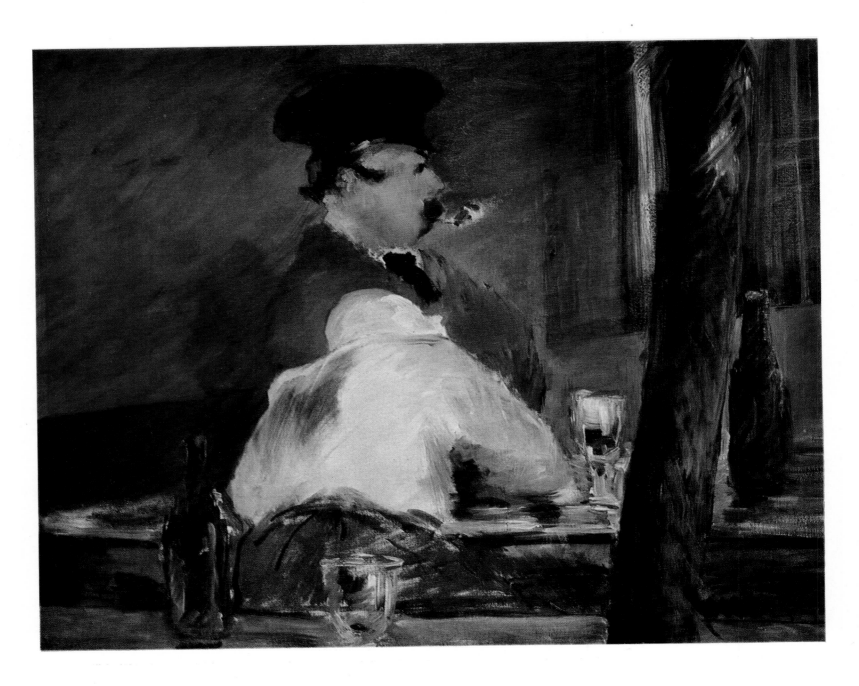

147 THE BAR

Oil on canvas. 72 × 92 cm. Inv. No 3443

Inscribed lower right on the canvas: *Certifié d'Ed. Manet, V^{ve} Ed. Manet*

The picture was bought by Sergei Shchukin from Ad. Tavernier for 4,800 francs in 1900 in Paris. Evidently in 1903 Shchukin sold the canvas to Mikhail Morozov in whose collection it remained until 1910. There are two drawings relating to the picture: one, made in pencil in 1878 (the Carroll Ann Statkin Collection, New York), almost exactly reproduces its central and right-hand parts; the other, in India ink, wash and pencil (according to F. Mathey it is in the L. Rouart and Barillon Collection in Paris), almost completely coincides with the Pushkin Museum canvas. Both drawings differ from the latter only in that the tree is depicted in them on the other side of the counter. The picture was apparently painted in 1878—79. According to Jamot-Wildenstein, it shows a bar in Place Moncey in Paris. Tabarant states that the bar depicted is situated near the Porte Clichy. The fact that Manet repeatedly turned to the motif of the male figure sitting by the table suggests that he intended to use it in one of his pictures.

Provenance: until 1900 The Ad. Tavernier Collection, Paris; since 1900 The S. Shchukin Collection, Moscow; 1903—10 The M. Morozov Collection, Moscow; 1910—25 The Tretyakov Gallery, Moscow; 1925—48 The Museum of Modern Western Art, Moscow; since 1948 The Pushkin Museum of Fine Arts, Moscow

Exhibitions: 1955 Moscow, Cat., p. 43; 1960 Moscow, Cat., p. 26; 1966—67 Tokyo, Kyoto, Cat. 49; 1974 Leningrad, Cat. 17; 1974—75 Moscow, Cat. 7

Bibliography: Кат. ГМИИ 1957, p. 84; Кат. ГМИИ 1961, p. 115; *Vente de la collection Tavernier*, Paris, 1900, March 6, No 54, ill.; Кат. галереи Третьяковых 1917, No 3924, p. 289; Ternovetz 1925, p. 457; E. Moreau-Nélaton, *Manet raconté par lui-même*, vol. I, Paris, 1926, p. 52, ill. 242; Кат. ГМНЗИ 1928, No 282; Réau 1929, No 900; Jamot-Wildenstein, *Monet*, Paris, 1932, No 292, ill. 333; Sterling 1957, ill. 65; Ревалд 1959, pp. 140—141; Прокофьев 1962, ill. 124; F. Mathey, *Graphisme de Manet*, vol. 2, Paris, 1963, No 64; Antonova 1977, No 96

148 PORTRAIT OF ANTONIN PROUST
Oil on canvas. 65 × 54 cm. Inv. No 3469
Signed right: *E M*.
Antonin Proust (1832—1905), uncle of the novelist Marcel Proust, was Minister of the Interior and, from 1881, Minister of Fine Arts in France. A schoolmate of Manet, he later wrote reminiscences about the artist. A. Tabarant mentions five portraits of Proust painted by Manet and dates the Pushkin Museum work to 1877.

Provenance: until 1918 The I. Ostroukhov Collection, Moscow; 1918—29 The Museum of Icons and Paintings, Moscow; 1929—48 The Museum of Modern Western Art, Moscow; since 1848 The Pushkin Museum of Fine Arts, Moscow

Exhibitions: 1955 Moscow, Cat., p. 43; 1960 Moscow, Cat., p. 26; 1965 Bordeaux, Cat. 64; 1965—66 Paris, Cat. 66; 1974—75 Moscow, Cat. 8

Bibliography: Кат. ГМИИ 1957, p. 84; Кат. ГМИИ 1961, p. 115; Кат. галереи Третьяковых 1911, No 89; Réau 1929, No 901; A. Tabarant, *Manet et ses œuvres*, Paris, 1947, p. 313; Sterling 1957, p. 88; Ревалд 1959, pp. 310—311

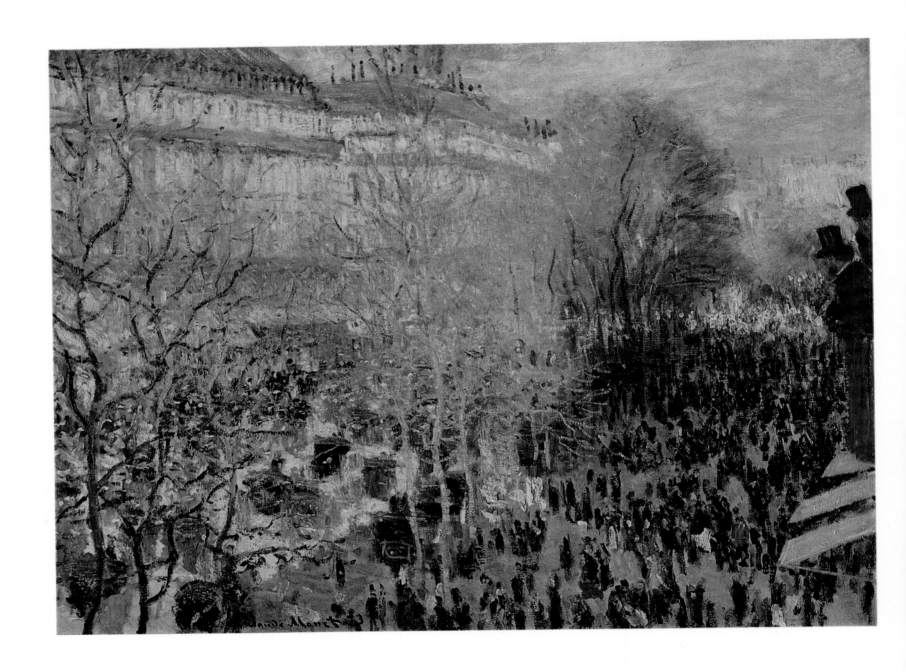

149　BOULEVARD DES CAPUCINES. 1873
Oil on canvas. 61 × 80 cm. Inv. No 3397
Signed and dated lower, center: *Claude Monet 73*
The picture was bought by Ivan Morozov in 1907 in Paris from Durand-Ruel for 40,000 francs. There is probably an earlier variant in the collection of the Nelson Gallery and Atkins Museum of Fine Arts, Kansas City (USA).

Provenance: The J.-B. Faure Collection, Paris; until 1907 The P. Durand-Ruel Collection, Paris; 1907—18 The I. Morozov Collection, Moscow; 1918—48 The Museum of Modern Western Art, Moscow; since 1948 The Pushkin Museum of Fine Arts, Moscow

Exhibitions: 1874 Paris, Cat. 97; 1883 Paris (Durand-Ruel Gallery), Cat. 31; 1889 Paris, Cat. 19; 1906 Berlin, Cat. 32; 1906 Paris, Cat. 7; 1906 Berlin, Stuttgart, Cat. 25; 1907 Mannheim, Cat. 582 f.; 1939 Moscow, Cat., p. 37; 1955 Moscow, Cat., p. 47; 1960 Moscow, Cat., p. 28; 1974 Leningrad, Cat. 20; 1974—75 Moscow, Cat. 11

Bibliography: Кат. ГМИИ 1957, p. 95, ill.; Кат. ГМИИ 1961, p. 129, ill.; Маковский 1912, p. 9; Geffroy 1922, pp. 76, 118, ill. pp. 76—77; Ternovetz 1925, p. 456, ill.; Ettinger 1926, part 1, p. 22, ill.; Кат. ГМНЗИ 1928, No 380; Réau 1929, No 987; Reuterswärd 1948, p. 83, ill. 30; G. Bazin, *L'Epoque impressionniste*, Paris, 1957, p. 35; Sterling 1957, ill. 74, pp. 96—97; Ревалд 1959, pp. 124—125; Прокофьев 1962, ill. 134; Моне 1969, No 4; Моне 1974, ill. 5; Antonova 1977, No 84

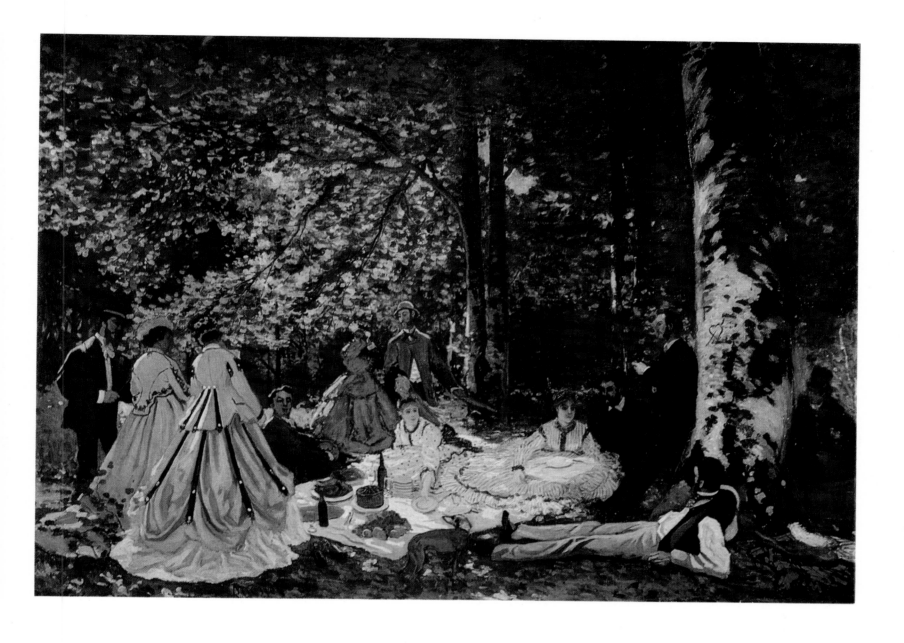

150 LUNCHEON ON THE GRASS. 1866
Oil on canvas. 130 × 181 cm. Inv. No 3307
Signed and dated lower left: *Claude Monet 66*

In the 1860s many future Impressionists, such as Frédéric Bazille, executed large-size pictures pursuing but one aim — the depiction of the human figure (or figures) *en plein air*. It was with the same aim in mind that Monet began work on his large canvas, *Luncheon on the Grass*, at Chailly-en-Bière in the summer of 1865. He intended it for the 1866 Salon exhibition but was dissatisfied with the final result and, in all probability, later cut the picture into three parts, two of which have survived to the present day (the left-hand part is in The Louvre, the central part in the Eknayan Collection in Paris). All trace of the right-hand part has been lost.

It is possible that his failure with the large composition prompted Monet to make a smaller version of it, although there are differences of opinion on this matter. Some scholars think it is a sketch for the large painting (H. Adhémar, G. Bazin), while others see it as a second version made by the painter (Ch. Sterling, N. Yavorskaya). The author's dating of the Pushkin Museum picture, comparisons with the surviving parts of the large canvas and, finally, X-ray photographs of this picture taken in 1963 and 1973, all tend to support the conclusion that this is a smaller replica of the original large version of *Luncheon on the Grass*. The model for the female figures in the composition was Camille Doncieux, Monet's fiancée whom he married in 1870; several male figures were painted from Monet's friend Frédéric Bazille. Monet apparently realized his initial concept of the picture in a pencil drawing, which in 1947 was in the collection of F. Bazille, the artist's cousin. Monet had several times painted the landscape without figures (as can be seen from *Chailly-en-Bière*, 1865, Statens Museum for Kunst, Copenhagen), and then started work on the scene as a whole. Soon after its completion (according to G. Wildenstein, already in 1874)

the Moscow picture was in the collection of the French opera singer J.-B. Faure, who sold it to Paul Durand-Ruel for 18,000 francs on February 12, 1901; he, in turn, sold it to Paul Cassirer for 30,000 francs in Berlin, and it was probably there that it was bought by Sergei Shchukin (between 1901 and 1908).

Provenance: until 1901 The J.-B. Faure Collection, Paris; 1901 The P. Durand-Ruel Collection, Paris; from 1901, February 12, The P. Cassirer Collection, Berlin; until 1918 The S. Shchukin Collection, Moscow; 1918—48 The Museum of Modern Western Art, Moscow; since 1948 The Pushkin Museum of Fine Arts, Moscow

Exhibitions: 1900 Paris (?); 1903 Vienna, Cat. 44; 1955 Moscow, Cat., p. 46; 1960 Moscow, Cat., p. 27; 1974—75 Moscow, Cat. 9; 1974—75 Paris, New York, Cat. 24

Bibliography: Кат. ГМИИ 1957, p. 95; Кат. ГМИИ 1961, p. 129; Heilbut 1903, p. 177, ill.; Кат. собрания С. Щукина 1913, No 133, pp. 30—31; Тугендхольд 1914, ill., p. 6; Перцов 1921, No 133, p. 112; Geffroy 1922, pp. 28, 29, ill.; Тугендхольд 1923, p. 20, ill., p. 12; Ternovetz 1925, p. 458, ill.; Ettinger 1926, part 1, p. 16, ill.; R. Régamey, "La Formation de Claude Monet", *Gazette des Beaux-Arts*, XV, 1927, pp. 65—84, ill. p. 69; Кат. ГМНЗИ 1928, No 367; Réau 1929, No 974; Reuterswärd 1948, p. 17, ill.; G. Bazin, *L'Epoque impressionniste*, Paris, 1957, p. 24; Sterling 1957, ill. 69, p. 92; H. Adhémar, "Modifications apportées par Monet à son *Déjeuner sur l'herbe* de 1865 à 1866", *Bulletin du laboratoire du Musée du Louvre*, 1958, 3, p. 37, ill. p. 46; G. Sarraute, "Contribution à l'étude du *Déjeuner sur l'herbe* de Monet", *Bulletin du laboratoire du Musée du Louvre*, 1958, 3, p. 41, ill. p. 49; Ревалд 1959, pp. 96—97; Cat. Impressionnistes 1959, p. 124; Прокофьев 1962, ill. 133; Musée de Moscou 1963, p. 172, ill.; Моне 1969, No 1; J. Isaacson, *Monet. "Le Déjeuner sur l'herbe"*, New York, 1972, pp. 70—72, 77, 100, ill.; K. S. Champa, *Studies in Early Impressionism*, London, 1973, p. 30, ill. 50; Моне 1974, ill. 1—4

151 ROUEN CATHEDRAL AT NOON. 1894
Oil on canvas. 100 × 65 cm. Inv. No 3312
Signed and dated lower left: *Claude Monet 94*
The picture was bought by Sergei Shchukin from Durand-Ruel in Paris in 1902. Monet worked on this motif from 1892 to 1894. Other canvases from this series, similar in composition and style, all dated 1894, are in The Louvre.

Provenance: until 1898 The artist's collection, Paris; 1898—1902 The P. Durand-Ruel Collection, Paris; 1902—18 The S. Shchukin Collection, Moscow; 1918—48 The Museum of Modern Western Art, Moscow; since 1948 The Pushkin Museum of Fine Arts, Moscow

Exhibitions: 1895 Paris (Durand-Ruel Gallery); 1955 Moscow, Cat., p. 47; 1960 Moscow, Cat., p. 28; 1974 Leningrad, Cat. 26; 1974—75 Moscow, Cat. 20

Bibliography: Кат. ГМИИ 1957, p. 95; Кат. ГМИИ 1961, p. 129; Искусство 1905, ill. p. 18; Кат. собр. С. Щукина 1913, No 138, pp. 32—33; Перцов 1921, No 138, pp. 41, 112; Ternovetz 1925, p. 459; Кат. ГМНЗИ 1928, No 374; Réau 1929, No 981; Reuterswärd 1948, p. 278; Моне 1969, No 13; Моне 1974, ill. 11; Antonova 1977, No 83

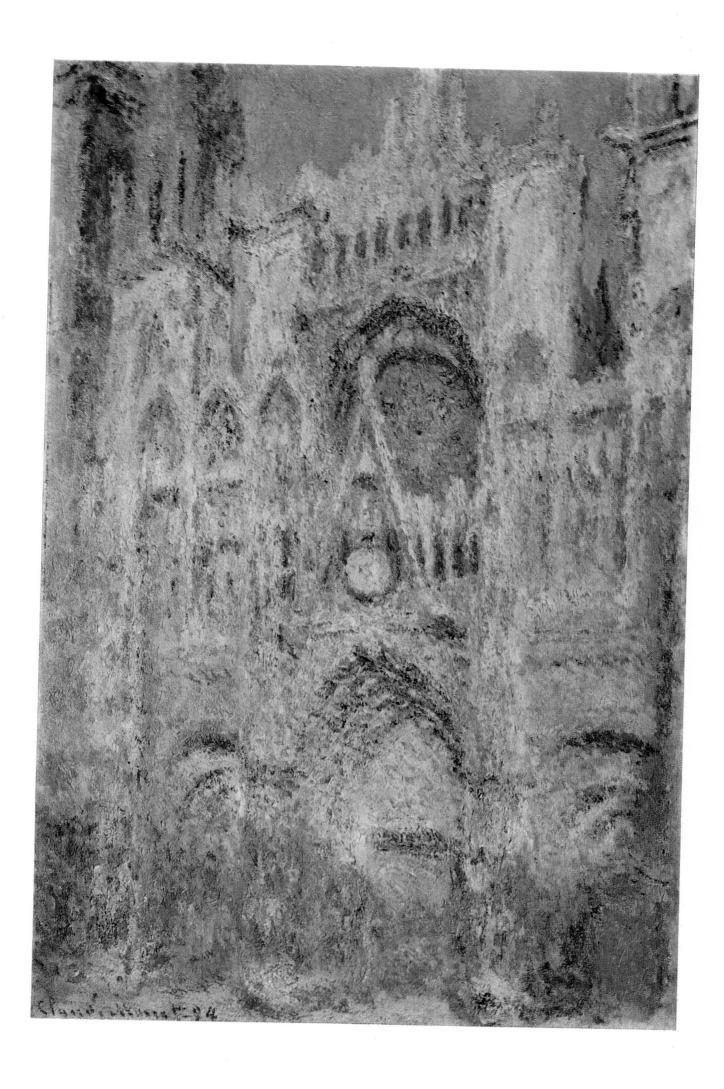

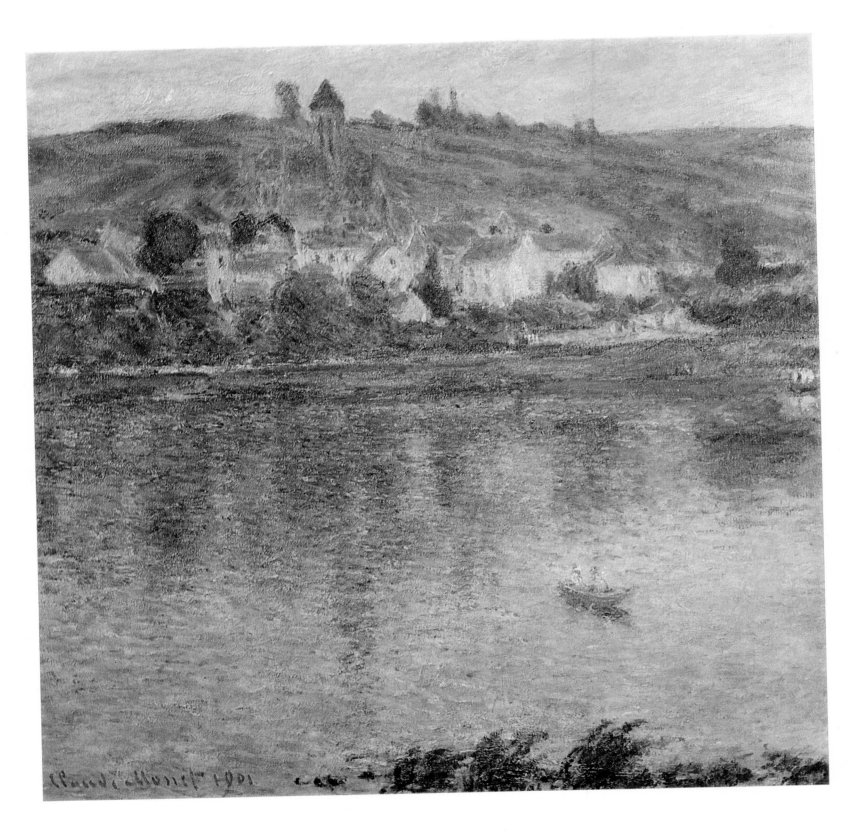

152 VÉTHEUIL. 1901
Oil on canvas. 90 × 92 cm. Inv. No 3314
Signed and dated lower left: *Claude Monet 1901*
Monet painted most of his views of Vétheuil in 1878—
82, but frequently returned to these motifs later on.
The Moscow picture was done in 1901, during one of
the artist's sojourns at Vétheuil. Two landscapes of
Vétheuil of the same year are in the Art Institute
of Chicago. The Pushkin Museum canvas was bought
by Sergei Shchukin from Durand-Ruel in Paris on
May 13, 1902.
Provenance: until 1902 The Bernheim Jeune Collection,
Paris; 1902, February 5 — May 13 The P. Durand-
Ruel Collection, Paris; 1902—18 The S. Shchukin Col-
lection, Moscow; 1918—48 The Museum of Modern
Western Art, Moscow; since 1948 The Pushkin Mu-
seum of Fine Arts, Moscow

Exhibitions: 1939 Moscow, Cat., p. 48; 1960 Moscow,
Cat., p. 29; 1973 Washington, Cat. 28; 1974—75 Mos-
cow, Cat. 23

Bibliography: Кат. ГМИИ 1957, p. 173; Кат. ГМИИ
1961, p. 130; Искусство 1905, ill. p. 15; Кат. собр.
С. Щукина 1913, No 144, pp. 32—33; Тугендхольд
1914, ill. p. 43; Grautoff 1919, ill. p. 86; Перцов 1921,
No 144, p. 112; Ternovetz 1925, p. 459; Кат. ГМНЗИ
1928, No 378; Réau 1929, No 985; Reuterswärd 1948,
p. 283; Musée de Moscou 1963, p. 174, ill.; ГМИИ
1966, No 88; Моне 1969, No 18; Моне 1974, ill. 16—18

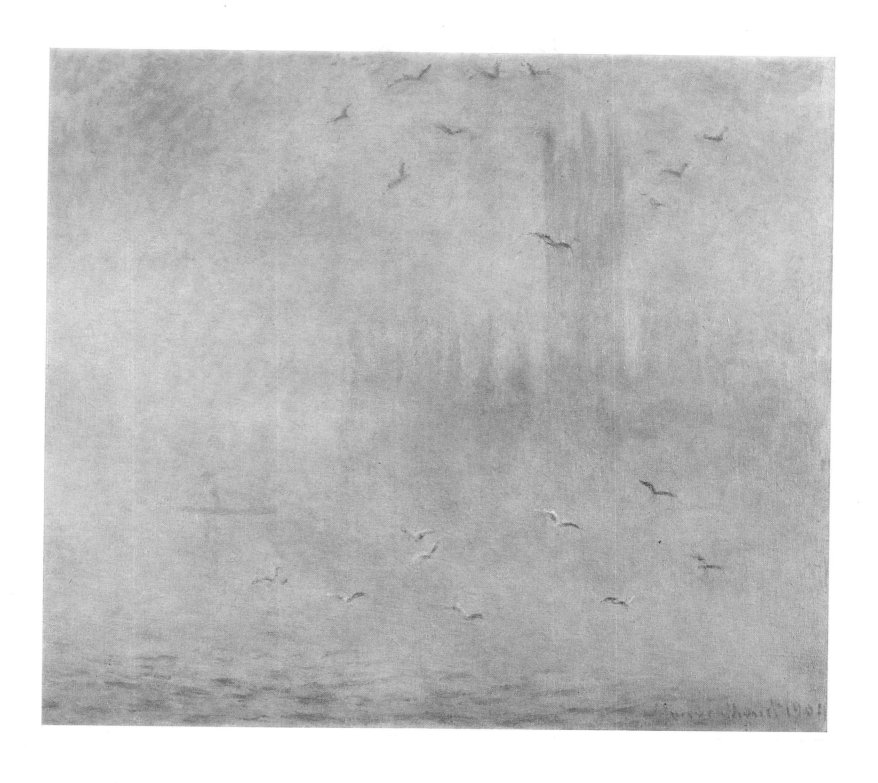

153 SEA GULLS. THE THAMES IN LONDON. THE HOUSES OF PARLIAMENT. 1904
Oil on canvas. 82 × 92 cm. Inv. No 3306
Signed and dated lower right: *Claude Monet 1904*
Monet painted this picture after his second visit to London (1901—3). The canvas of 1904 of the same subject is in The Louvre. The Moscow picture was bought by Sergei Shchukin from Durand-Ruel in Paris in November 1904.

Provenance: until 1904, May 11, The artist's collection, Paris; 1904, May 11 — November 24, The P. Durand-Ruel Collection, Paris; 1904—18 The S. Shchukin Collection, Moscow; 1918—48 The Museum of Modern Western Art, Moscow; since 1948 The Pushkin Museum of Fine Arts, Moscow

Exhibitions: 1904 Paris; 1939 Moscow, Cat., p. 48; 1955 Moscow, Cat., p. 48; 1960 Moscow, Cat., p. 29; 1974 Leningrad, Cat. 31; 1974—75 Moscow, Cat. 25

Bibliography: Кат. ГМИИ 1957, p. 96; Кат. ГМИИ 1961, p. 130; Кат. собр. С. Щукина 1913, No 132, pp. 30—31; Перцов 1921, No 132, p. 112; Ternovetz 1925, p. 459; Кат. ГМНЗИ 1928, No 379; Réau 1929, No 986; Reuterswärd 1948, p. 287; Моне 1969, No 20; Моне 1974, ill. 19; Antonova 1977, No 85

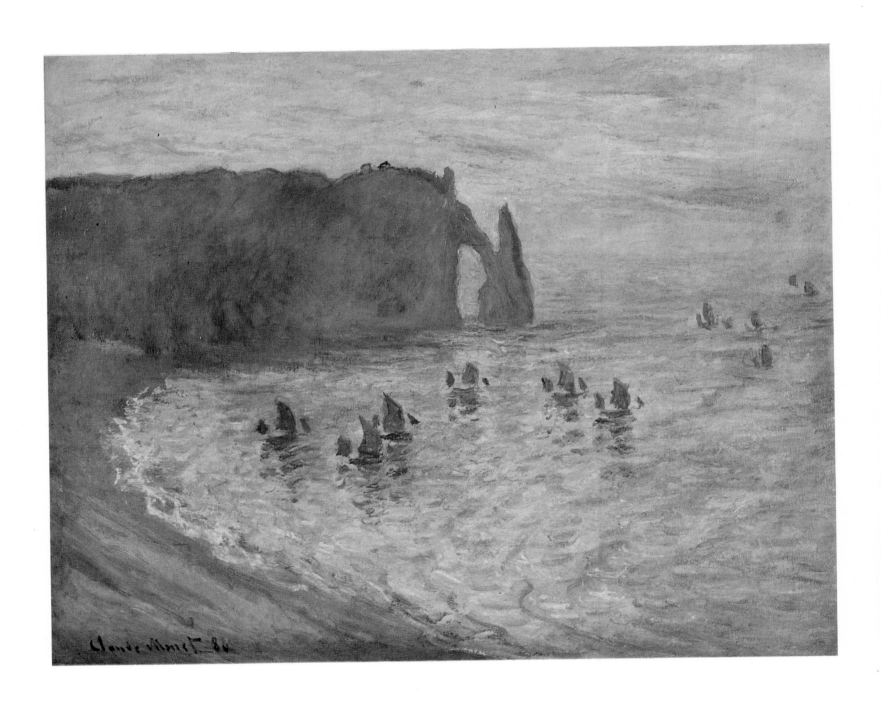

154 THE ROCKS AT ÉTRETAT. 1886
Oil on canvas. 66 × 81 cm. Inv. No 3308
Signed and dated lower left: *Claude Monet 86*
There are many seascapes painted by Monet at Et-
retat. Closest to the Moscow canvas is *Etretat*
dated the same year, in the Metropolitan Museum
of Art, New York. The canvas was bought by Ser-
gei Shchukin from Durand-Ruel on June 24, 1898, in
Paris.
Provenance: until 1894 The Collection of G. de Chol-
let, Paris; 1894—98 The P. Durand-Ruel Collection,
Paris; 1898—1918 The S. Shchukin Collection, Mos-
cow; 1918—48 The Museum of Modern Western Art,

Moscow; since 1948 The Pushkin Museum of Fine Arts,
Moscow

Exhibitions: 1939 Moscow, Cat., p. 47; 1955 Moscow,
Cat., p. 47; 1960 Moscow, Cat., p. 28; 1966—67 Tokyo,
Kyoto, Cat. 51; 1972 Otterloo, Cat. 38; 1974—75 Mos-
cow, Cat. 16

Bibliography: Кат. ГМИИ 1957, p. 173; Кат. ГМИИ
1961, p. 129; Кат. собр. С. Щукина 1913, No 134,
pp. 30—31; Перцов 1921, No 134, pp. 41, 112; Geffroy
1922, pp. 200—201, ill.; Ternovetz 1925, p. 459; Кат.
ГМНЗИ 1928, No 370; Réau 1929, No 977; Reuters-
wärd 1948, p. 284; Sterling 1957, ill. 72, p. 102; Моне
1969, No 8; Моне 1974, ill. 8; Antonova 1977, No 86

155 HAYSTACK AT GIVERNY
Oil on canvas. 64.5 × 87 cm. Inv. No 3398
Signed lower left: *Claude Monet*
The earliest pictures of the Giverny series were painted by Monet in the mid-1880s. Although this canvas is not dated by the artist, it is known that in the catalogue of the exhibition of Monet's works from the Faure Collection, held at Durand-Ruel's in 1906, it was dated 1889. *Haystack at Giverny* was bought by Ivan Morozov from Durand-Ruel in 1907. The 1886 picture on the same theme is in The Hermitage, Leningrad.

Provenance: The J.-B. Faure Collection, Paris; until 1907 The P. Durand-Ruel Collection, Paris; 1907—18 The I. Morozov Collection, Moscow; 1918—48 The Museum of Modern Western Art, Moscow; since 1948 The Pushkin Museum of Fine Arts, Moscow

Exhibitions: 1906 Paris, Cat. 17; 1939 Moscow, Cat., p. 48; 1955 Moscow, Cat., p. 47; 1960 Moscow, Cat., p. 29; 1972 Otterloo, Cat. 39; 1972 Prague, Cat. 26; 1974—75 Moscow, Cat. 19

Bibliography: Кат. ГМИИ 1961, p. 129; Маковский 1912, p. 9; Перцов 1921, No 141, p. 112; Ternovetz 1925, p. 459; Кат. ГМНЗИ 1928, No 383; Réau 1929, No 990; Reuterswärd 1948, p. 286; Sterling 1957, ill. 73; Прокофьев 1962, ill. 136; Моне 1969, No 12; Моне 1974, ill. 15; Antonova 1977, No 87

156　THE ROCKS AT BELLE-ILE. 1886
Oil on canvas. 65 × 81 cm. Inv. No 3310
Signed and dated lower right: *Claude Monet 86*
Monet painted a large number of landscapes at Belle-Ile.
There are views of Belle-Ile, similar to the Moscow
picture, in The Louvre (*The Rocks at Belle-Ile*, 65
× 81 cm; *Storm. The Shores at Belle-Ile*, 65 × 81 cm)
and in Copenhagen Statens Museum for Kunst, the
Box Collection (*The Pyramid at Port-Coton*, 1886).
The picture was bought by Sergei Shchukin from Du-
rand-Ruel in Paris on November 10, 1898.

Provenance: until 1897 The Aubry Collection, Paris;
1897—98 The P. Durand-Ruel Collection, Paris; 1898—

1918 The S. Shchukin Collection, Moscow; 1918—48
The Museum of Modern Western Art, Moscow; since
1948 The Pushkin Museum of Fine Arts, Moscow

Exhibitions: 1939 Moscow, Cat., p. 47; 1955 Moscow,
Cat., p. 47; 1960 Moscow, Cat., p. 28; 1974—75 Mos-
cow, Cat. 15

Bibliography: Кат. ГМИИ 1957, p. 95; Кат. ГМИИ
1961, p. 129; Кат. собр. С. Щукина 1913, No 136,
pp. 30—31; Тугендхольд 1914, p. 43, ill. p. 26; Пер-
цов 1921, No 136, pp. 41, 112; Ternovetz 1925, p. 459;
Кат. ГМНЗИ 1928, No 371; Réau 1929, No 978; Reu-
terswärd 1948, p. 286; Прокофьев 1962, ill. 137; Моне
1969, No 7; Моне 1974, ill. 9, 10

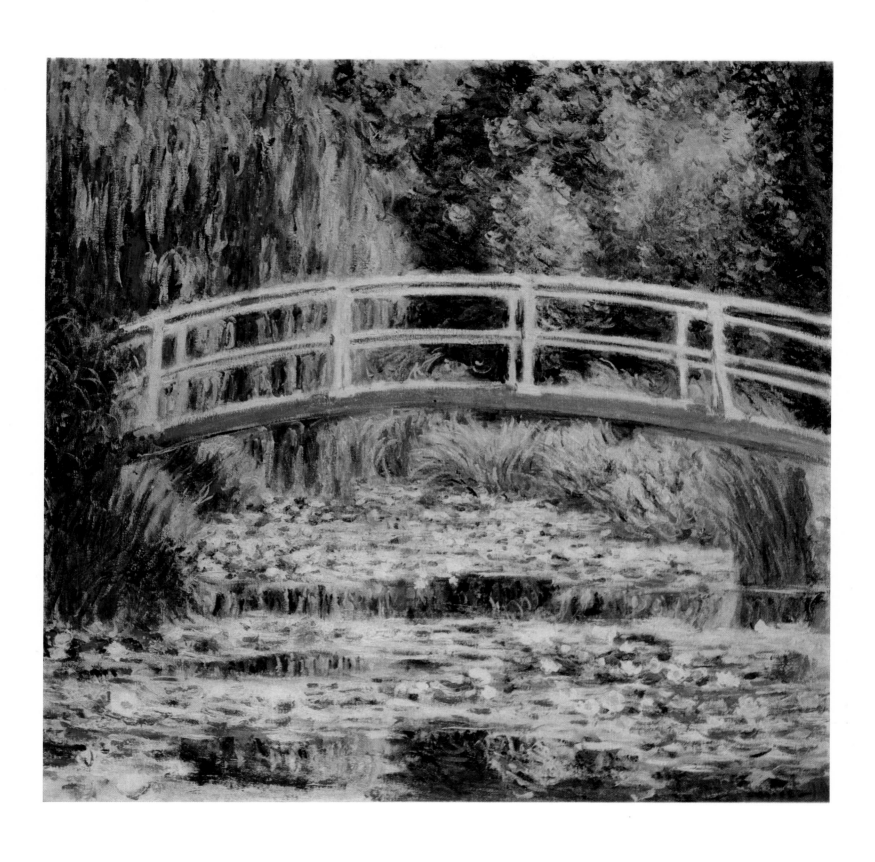

157　WATER LILIES. 1899

Oil on canvas. 89 × 93 cm. Inv. No 3309

Signed and dated lower right: *Claude Monet 99*

The series *Water Lilies. Water Landscapes* was painted at Giverny between 1898 and 1908. The Push-kin Museum picture is one of the first works of the series. A compositionally similar variant of the same year (*Pond with Water Lilies. Green Harmony*, 89 × 93.5 cm) is in The Louvre.

Provenance: 1908—18 The S. Shchukin Collection, Moscow; 1918—48 The Museum of Modern Western Art, Moscow; since 1948 The Pushkin Museum of Fine Arts, Moscow

Exhibitions: 1909 Paris (Durand-Ruel Gallery); 1939 Moscow, Cat., p. 48; 1955 Moscow, Cat., p. 48; 1960 Moscow, Cat., p. 29; 1974—75 Moscow, Cat. 22

Bibliography: Кат. ГМИИ 1957, p. 96; Кат. ГМИИ 1961, p. 130; Кат. собр. С. Щукина 1913, No 135, pp. 30—31; Тугендхольд 1914, ill. p. 43; Перцов 1921, No 135, p. 112; Тугендхольд 1923, p. 26, ill. p. 18; Ternovetz 1925, p. 459; Кат. ГМНЗИ 1928, No 377; Réau 1929, No 984; Reuterswärd 1948, p. 288; Моне 1969, No 17; Моне 1974, ill. 13, 14; Antonova 1977, No 88

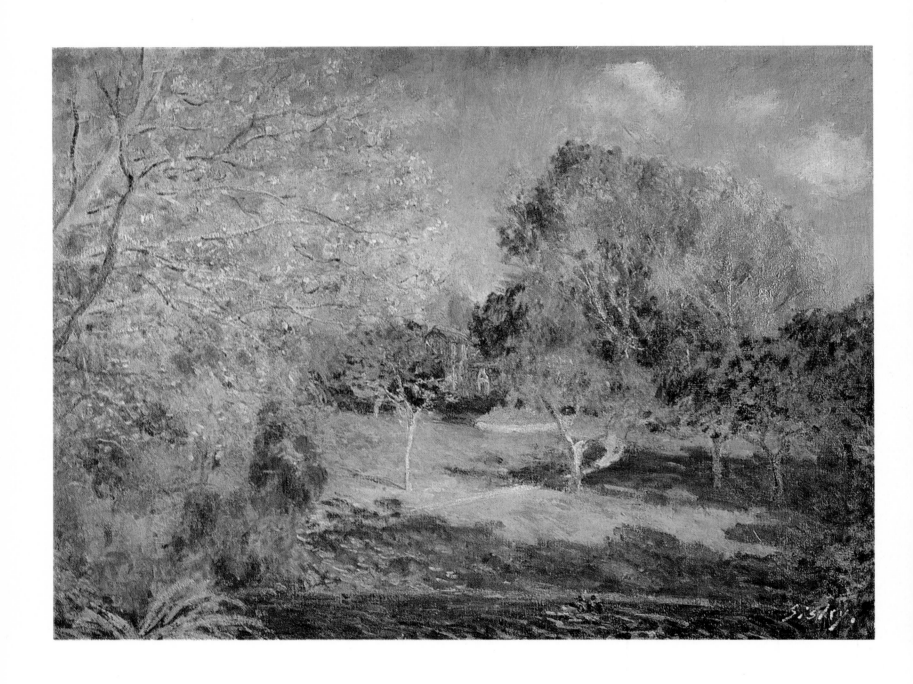

158 THE GARDEN OF HOSCHEDÉ

Oil on canvas. 56 × 74 cm. Inv. No 3421

Signed lower right: *Sisley*

F. Daulte refers to the Pushkin Museum picture as *The Garden of Hoschedé at Montgeron* and states that it was executed in 1881 and is Sisley's only view of Montgeron, where Ernest Hoschedé, a well-known Parisian banker and one of the first collectors and enthusiasts of Impressionist painting, had his estate. The picture was bought by Ivan Morozov from Durand-Ruel for 40,000 francs in Paris on November 20, 1904.

Provenance: until 1900 The J.-B. Faure Collection, Paris; 1900—4 The P. Durand-Ruel Collection, Paris (No 5710); 1904—18 The I. Morozov Collection, Moscow; 1918—48 The Museum of Modern Western Art, Moscow; since 1948 The Pushkin Museum of Fine Arts, Moscow

Exhibitions: 1939 Moscow, Cat., p. 46; 1960 Moscow, Cat., p. 35; 1974 Leningrad, Cat. 61; 1974—75 Moscow, Cat. 50

Bibliography: Кат. ГМИИ 1957, p. 129; Кат. ГМИИ 1961, p. 171; Маковский 1912, p. 24; Кат. ГМНЗИ 1928, No 580; Réau 1929, No 1108; F. Daulte, *Sisley*, Lausanne, 1959, No 444

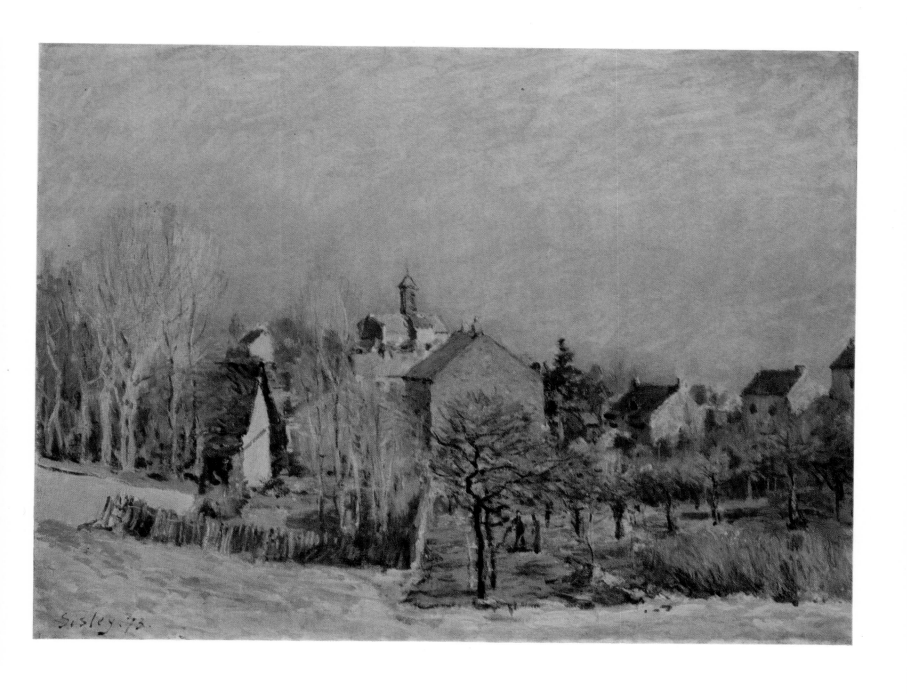

159 FROSTY MORNING
IN LOUVECIENNES. 1873
Oil on canvas. 46 × 61 cm. Inv. No 3420
Signed and dated lower left: *Sisley 73*
In 1873 Sisley painted several views of Louveciennes
and its suburbs, all of which, however, greatly dif-
fer from the Moscow picture. The latter was bought
by Ivan Morozov from Durand-Ruel in Paris in 1903
for 11,500 francs. Durand-Ruel purchased the land-
scape for 9,300 francs at the sale of the Strauss Col-
lection at the Hôtel Drouot on May 3, 1902.

Provenance: until 1902, May 3, The G. Strauss Col-
lection, Paris; 1902, May 3 — 1903 The P. Durand-
Ruel Collection, Paris; 1903—18 The I. Morozov Col-
lection, Moscow; 1918—48 The Museum of Modern
Western Art, Moscow; since 1948 The Pushkin Mu-
seum of Fine Arts, Moscow

Exhibitions: 1939 Moscow, Cat., p. 46; 1955 Moscow,
Cat., p. 57; 1960 Moscow, Cat., p. 35; 1974—75 Mos-
cow, Cat. 49

Bibliography: Кат. ГМИИ 1957, p. 129; Кат. ГМИИ
1961, p. 171; Маковский 1912, p. 24; Ternovetz 1925,
p. 460, ill. p. 457; Кат. ГМНЗИ 1928, No 579, ill.;
Réau 1929, No 1107; Ревалд 1959, pp. 188—189, 195;
F. Daulte, *Sisley*, Lausanne, 1959, No 57, ill.; Про-
кофьев 1962, ill. 146; Antonova 1977, No 94

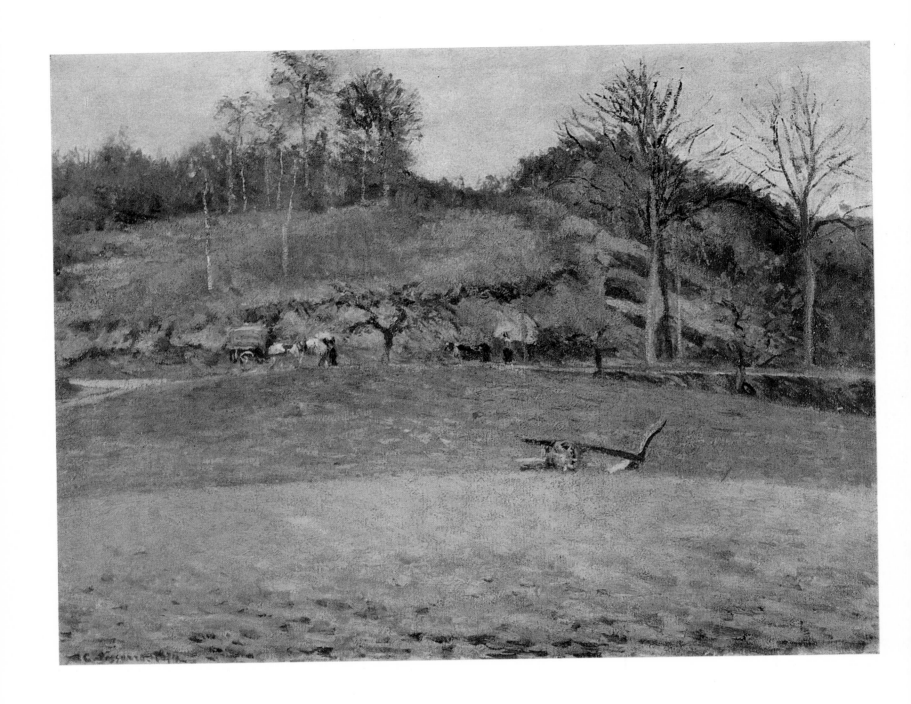

160 PLOUGHLAND. 1874
Oil on canvas. 49 × 64 cm. Inv. No 3402
Signed and dated lower left: *C. Pissarro 1874*

Provenance: The Martin Collection, Paris; until 1904
The A. Vollard Collection, Paris; 1904—18 The I. Mo-
rozov Collection, Moscow; 1918—48 The Museum of
Modern Western Art, Moscow; since 1948 The Push-
kin Museum of Fine Arts, Moscow

Exhibitions: 1874 Paris; 1939 Moscow, Cat., p. 45;
1960 Moscow, Cat., p. 29; 1974—75 Moscow, Cat. 26

Bibliography: Кат. ГМИИ 1957, p. 110; Кат. ГМИИ
1961, p. 148; Маковский 1912, p. 22; Кат. ГМНЗИ
1928, No 464; Réau 1929, No 1050; L. R. Pissarro,
L. Venturi, *Camille Pissarro. Son art, son œuvre*,
2 vols., Paris, 1939, vol. 1, p. 116, No 258; vol. 2,
ill. No 258; Ревалд 1959, p. 201; *Камиль Писсарро.
Письма. Критика. Воспоминания современников*,
Moscow, 1974, p. 17; Antonova 1977, No 101

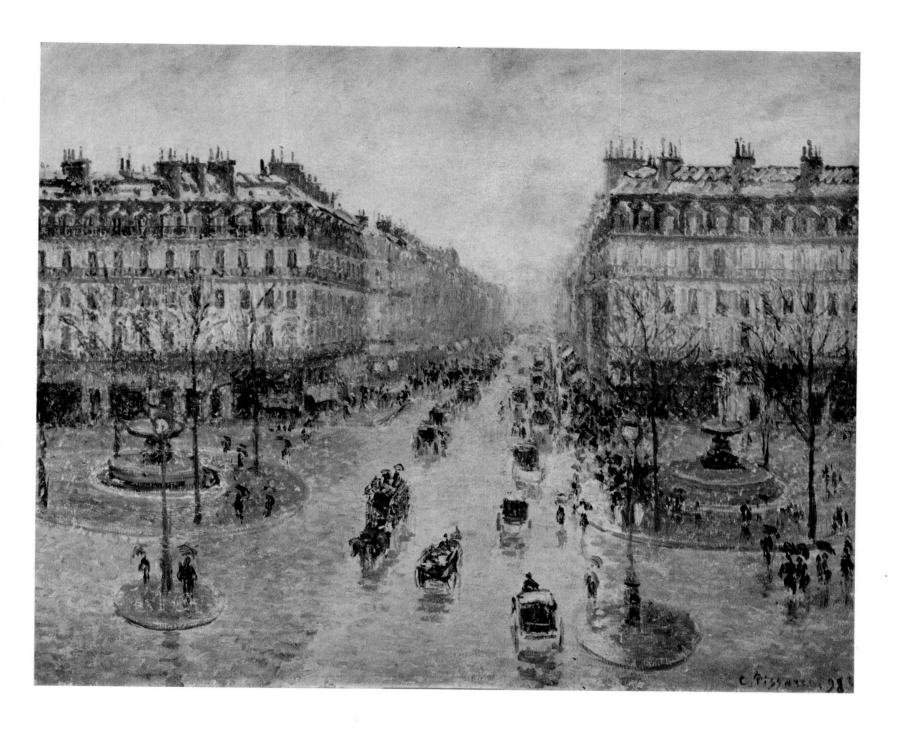

161 AVENUE DE L'OPÉRA. 1898
Oil on canvas. 65 × 82 cm. Inv. No 3323
Signed and dated lower right: *C. Pissarro 98* (the figures *98* are outlined twice)
The picture was painted from the window of the Hôtel du Louvre in the winter of 1898. There are several cityscapes by Pissarro on the same subject. The closest analogies to the Moscow canvas are a view in the Rheims Museum (1898, 73 × 92 cm) and one in the Philadelphia Museum of Art (*Morning Sun*, 65 × 81 cm, the Carroll S. Tyson Collection).

Provenance: The P. Durand-Ruel Collection, Paris (No 4632); until 1918 The S. Shchukin Collection, Moscow; 1918—48 The Museum of Modern Western Art, Moscow; since 1948 The Pushkin Museum of Fine Arts, Moscow

Exhibitions: 1898 Paris, Cat. 10; 1939 Moscow, Cat., p. 46; 1960 Moscow, Cat., p. 30; 1974 Leningrad, Cat. 33; 1974—75 Moscow, Cat. 30

Bibliography: Кат. ГМИИ 1957, p. 110, ill.; Кат. ГМИИ 1961, p. 148, ill.; Кат. собр. С. Щукина 1913, No 184, pp. 40—41; Тугендхольд 1914, p. 44; Тугендхольд 1923, ill. p. 20; A. Tabarant, *Pissarro*, Paris, 1924, ill. 37; Кат. ГМНЗИ 1928, No 463; Réau 1929, No 1049; L. R. Pissarro, L. Venturi, *Camille Pissarro. Son art, son œuvre*, 2 vols., Paris, 1939, vol. 1, p. 22, No 1029; vol. 2, No 1029; Прокофьев 1962, ill. 147; Musée de Moscou 1963, p. 162, ill.; ГМИИ 1966, No 89; М. Герман, *Писсарро*, Leningrad, 1973, p. 28, ill.; *Камиль Писсарро. Письма. Критика. Воспоминания современников*, Moscow, 1974, p. 38, ill. 61; Antonova 1977, No 102

162 LADY IN WHITE
Oil on canvas. 82 × 66 cm. Inv. No 3433
Signed lower right: *Helleu*
The picture may be dated to the mid-1890s.
Provenance: The Dede Collection, Paris; The P.
Shchukin Collection, Moscow; until 1922 The History
Museum, Moscow; 1922—48 The Museum of Modern
Western Art, Moscow; since 1948 The Pushkin Museum of Fine Arts, Moscow
Exhibition: 1960 Moscow, Cat., p. 39
Bibliography: Кат. ГМНЗИ 1928, No 666

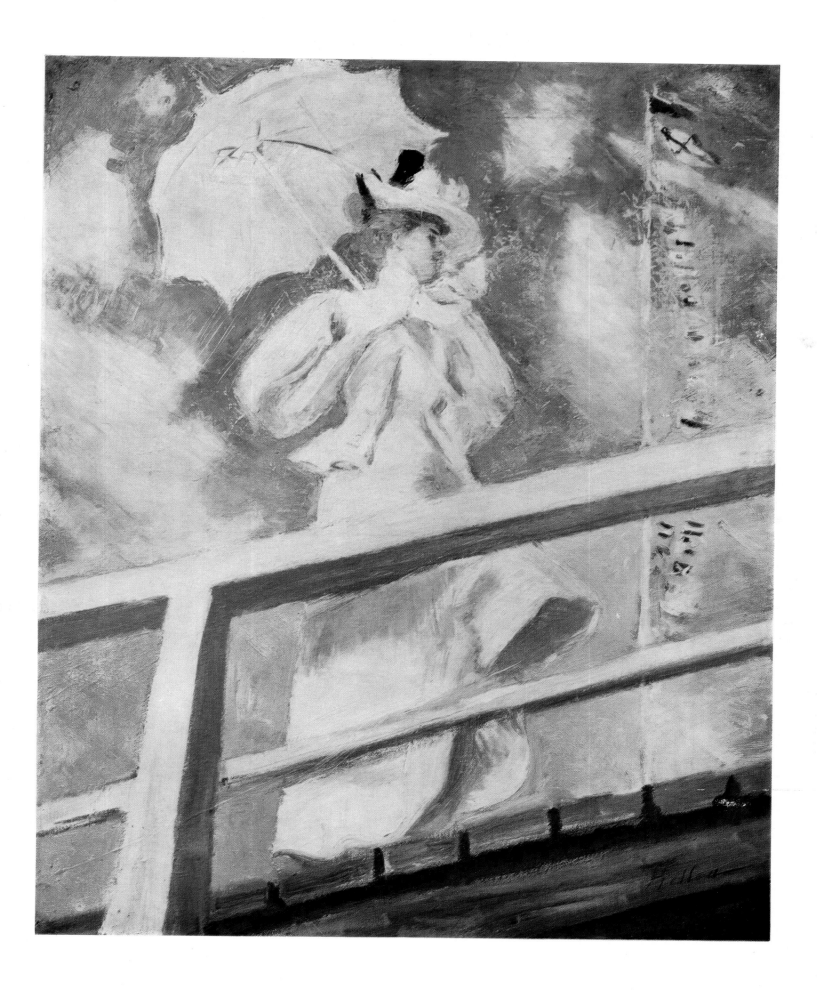

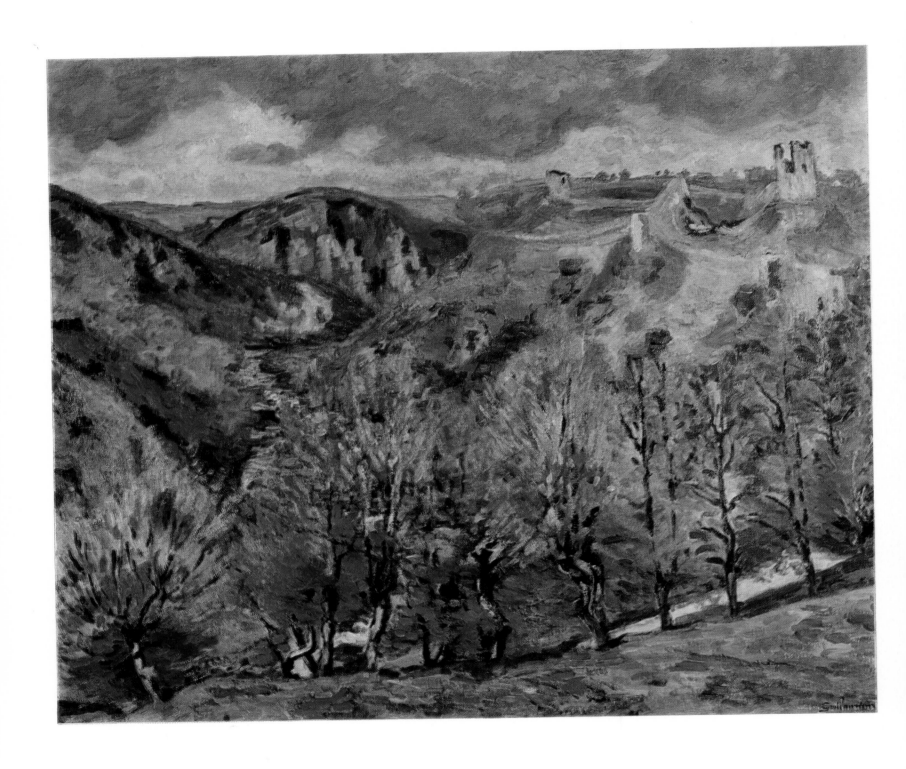

163 LANDSCAPE WITH RUINS
Oil on canvas. 79 × 93 cm. Inv. No 3262
Signed lower right: *Guillaumin*
After 1891 Guillaumin often worked at Crozant, painting the ruins of the castle. The Moscow picture was probably done there in the early 1890s.

Provenance: until 1918 The S. Shchukin Collection, Moscow; 1918—48 The Museum of Modern Western Art, Moscow; since 1948 The Pushkin Museum of Fine Arts, Moscow

Exhibitions: 1939 Moscow, Cat., p. 48; 1960 Moscow, Cat., p. 12; 1972 Otterloo, Cat. 25

Bibliography: Кат. собр. С. Щукина 1913, No 15, pp. 6—7; Тугендхольд 1914, p. 38; Перцов 1921, No 15, p. 107; Кат. ГМНЗИ 1928, No 75; Réau 1929, No 870

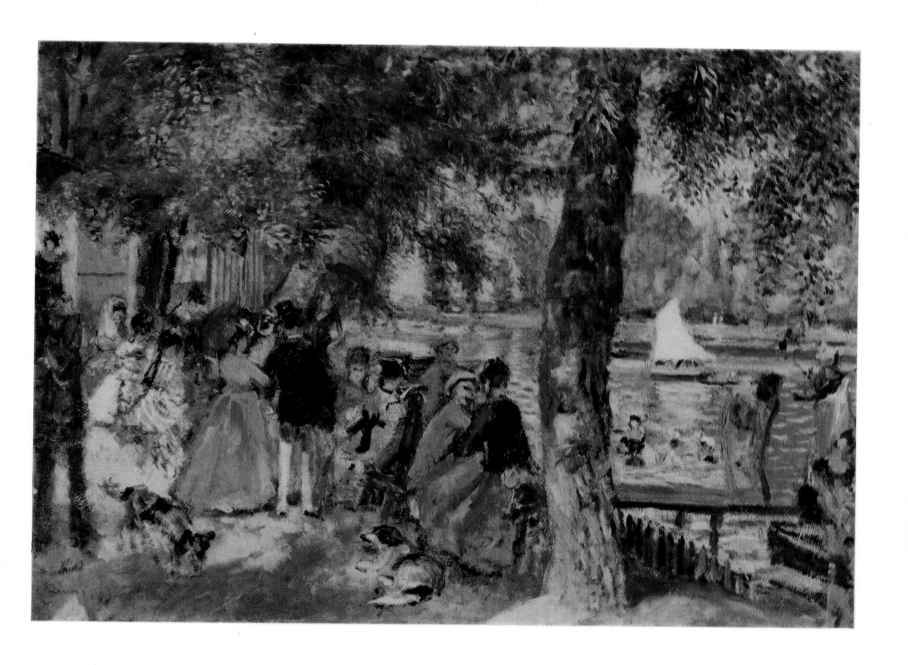

164 BAIGNADE DANS LA SEINE

Oil on canvas. 59 × 80 cm. Inv. No 3407
Signed lower left: *Renoir*

Renoir often painted this place at Bougival, known as La Grenouillère. According to D. Rouart and J. Rewald, the Moscow canvas was painted in 1869. There are three similar paintings on the same subject — in Stockholm (Nationalmuseum), Hamburg (the E. Berens Collection) and in Winterthur (the O. Reinhart Collection); one more, entitled *La Grenouillère* (1879), is in The Louvre. *Baignade dans la Seine* is the earliest Renoir in The Pushkin Museum. It was bought by Ivan Morozov from Ambroise Vollard for 20,000 francs in Paris in 1908.

Provenance: until 1908 The A. Vollard Collection, Paris; 1908—18 The I. Morozov Collection, Moscow; 1918—48 The Museum of Modern Western Art, Moscow; since 1948 The Pushkin Museum of Fine Arts, Moscow

Exhibitions: 1939 Moscow, Cat., p. 49; 1941 Moscow; 1955 Moscow, Cat., p. 53; 1960 Moscow, Cat., p. 31; 1974 Leningrad, Cat. 35; 1974—75 Moscow, Cat. 33

Bibliography: Кат. ГМИИ 1957, p. 118; Кат. ГМИИ 1961, p. 157; Маковский 1912, pp. 9, 23; Ettinger 1926, p. 22, ill.; Кат. ГМНЗИ 1928, No 502; Réau 1929, No 1072; Sterling 1957, ill. 80; Feist 1961, p. 61; Прокофьев 1962, ill. 143; Musée de Moscou 1963, p. 168, ill.; K. S. Champa, *Studies in Early Impressionism*, London, 1973, p. 64, ill. 84; Antonova 1977, No 89

165 IN THE GARDEN
Oil on canvas. 81 × 65 cm. Inv. No 3406
Signed lower right: *Renoir*
The picture was completed in 1875, when Renoir
hired a studio in the Rue Cortot in Montmartre and
often painted in the Moulin de la Galette. This and
the canvas *La Balançoire* (*The Swing*) (Musée de
l'Impressionnisme, Paris) apparently served as pre-
paratory works for Renoir's large picture of 1876,
Le Moulin de la Gallette (Musée de l'Impressionnisme,
Paris). Depicted in the Moscow canvas are Renoir's
model Nini, standing on the left; behind her is Claude
Monet, seated; in the background is the painter Lami;
standing on the right is the artist Charles Cordier.
The man standing in the background is sometimes
identified as Alfred Sisley, and the man seated at
the table as Norbert Goeneutte. The picture was
bought by Ivan Morozov at the auction of the G. Viau
Collection in Paris in 1907 (lot 17).

Provenance: The E. Mürer Collection, Paris; 1896—1907
The G. Viau Collection, Paris; 1907—18 The I. Mo-
rozov Collection, Moscow; 1918—48 The Museum of
Modern Western Art, Moscow; since 1948 The Push-
kin Museum of Fine Arts, Moscow

Exhibitions: 1900 Paris, Cat. 25; 1903 Vienna; 1904
Paris (Salon d'Automne); 1941 Moscow; 1955 Moscow,
Cat., p. 53; 1960 Moscow, Cat., p. 31; 1965 Bordeaux,
Cat. 68; 1965—66 Paris, Cat. 69; 1966—67 Tokyo,
Kyoto, Cat. 53; 1972 Otterloo, Cat. 49; 1972 Prague,
Cat. 31; 1973 Washington, Cat. 36; 1974 Leningrad,
Cat. 36; 1974—75 Moscow, Cat. 34

Bibliography: Кат. ГМИИ 1957, p. 118; Кат. ГМИИ
1961, p. 157; Heilbut 1903, p. 184, ill.; *Vente de la
collection Georges Viau*, Paris, 1907, No 17; Маков-
ский 1912, pp. 9, 23; Кат. ГМНЗИ 1928, No 503; Réau
1929, No 1073; M. Drucker, *Renoir*, Paris, 1955, ill.
36; Sterling, 1957, ill. 82, p. 108; Daulte 1971, No 197;
Antonova 1977, No 90

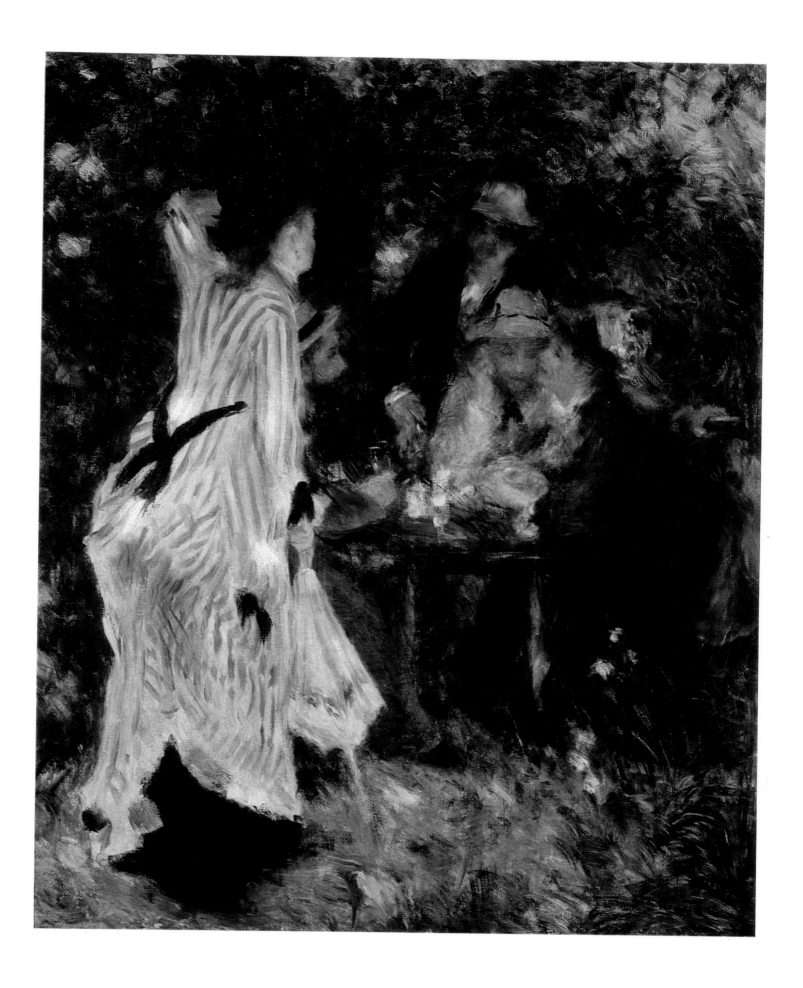

166 NUDE. 1876
Oil on canvas. 92 × 73 cm. Inv. No 3330
Signed and dated lower right: *Renoir 76*
Many scholars think that the same model sat for the
artist as for Manet's *Nana*. According to other au-
thors (Jamot, Drucker), *Nude* was painted from a mod-
el named Anna. A sketch of the same model (*Torso
of a Woman in the Sun*, 1875—76, 80 × 64 cm) is in
The Louvre. A variant of the Moscow canvas, dated
the same year and of the same dimensions, is in the
Kunsthistorisches Museum in Vienna.

Provenance: until 1896 The E. Chabrier Collection,
Paris; 1896—98 The P. Durand-Ruel Collection, Paris;
1898—1912 The P. Shchukin Collection, Moscow; 1912—
18 The S. Shchukin Collection, Moscow; 1918—48 The
Museum of Modern Western Art, Moscow; since 1948
The Pushkin Museum of Fine Arts, Moscow

Exhibitions: 1941 Moscow; 1955 Moscow, Cat., p. 53;
1956 Leningrad, Cat., p. 51; 1960 Moscow, Cat., p. 31;
1974—75 Moscow, Cat. 36

Bibliography: Кат. ГМИИ 1957, p. 118, ill.; Кат. ГМИИ
1961, p. 157, ill.; Кат. собр. С. Щукина 1913, No 194,
pp. 42—43; Тугендхольд 1914, p. 45, ill. p. 14; Grau-
toff 1919, ill. p. 87; Перцов 1921, No 194, p. 114;
Тугендхольд 1923, pp. 31—32, ill. p. 26; F. Fosca, *Re-
noir*, Paris, 1924, p. 25, ill.; Ettinger 1926, part 1,
p. 21, ill.; Кат. ГМНЗИ 1928, No 500; Réau 1929,
No 1070; *Gazette des Beaux-Arts*, XI, 1934, p. 192;
D. Rouart, *Renoir. Etude biographique et critique*,
Geneva, 1954, p. 35, ill.; M. Drucker, *Renoir*, Paris,
1955, ill. 26; Sterling 1957, ill. 83, p. 108; Cat. Impres-
sionnistes 1959, p. 178; Feist 1961, p. 62, ill. 21;
Прокофьев 1962, ill. 139; ГМИИ 1966, No 92; Ренуар
1970, ill. 11; Daulte 1971, No 213; Antonova 1977,
No 92

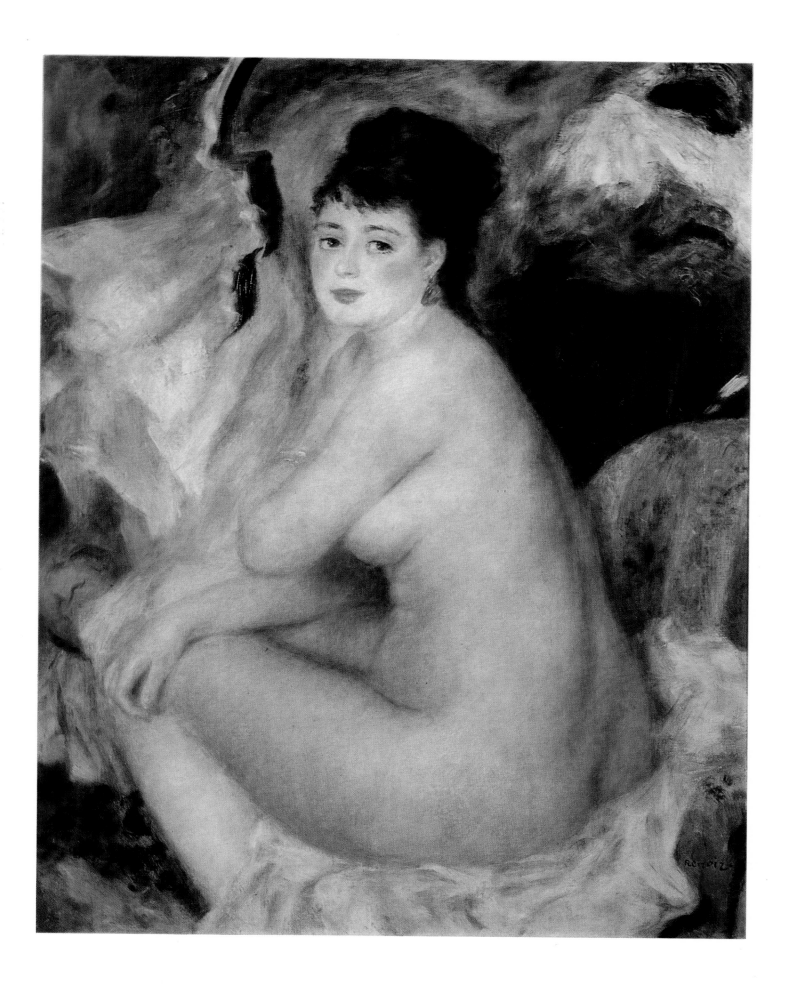

167 PORTRAIT OF THE ACTRESS
JEANNE SAMARY. Study. 1877
Oil on canvas. 56 × 47 cm. Inv. No 3405
Signed and dated upper left: *Renoir 77*
In the course of 1877 and 1878 Renoir painted Jeanne
Samary several times. Her half-length portrait is now
in the collection of the Comédie-Française in Paris
where the actress played. The Hermitage in Leningrad
possesses a full-length portrait of Samary completed
in 1878. The Moscow canvas is generally considered to
be a sketch for the Hermitage portrait, but it would
be more proper to regard the former as an independ-
ent work of art. Many scholars agree that the Moscow
canvas is the finest Impressionist portrait ever done
by Renoir. The canvas was bought by Ivan Morozov
from Durand-Ruel in Paris in 1904 for 25,000 francs.

Provenance: The Collection of P. Lagard (husband of
Samary), Paris; since 1903 The P. Durand-Ruel Col-
lection, Paris; 1904—18 The I. Morozov Collection,
Moscow; 1918—48 The Museum of Modern Western
Art, Moscow; since 1948 The Pushkin Museum of Fine
Arts, Moscow

Exhibitions: 1877 Paris; 1930 Moscow; 1937 Paris,
Cat. 394; 1941 Moscow; 1955 Moscow, Cat., p. 54;
1960 Moscow, Cat., p. 31; 1974 Leningrad, Cat. 39;
1974—75 Moscow, Cat. 37

Bibliography: Кат. ГМИИ 1957, p. 118; Кат. ГМИИ
1961, p. 157, ill.; Кат. галереи Третьяковых 1911,
No 92; Маковский 1912, p. 9, 23; G. Rivière, *Renoir
et ses amis*, Paris, 1921, p. 157; F. Fosca, *Renoir*, Par-
is, 1924, p. 13, ill. (entitled *Rêverie*); Ternovetz 1925,
p. 463, ill. p. 462; Ettinger 1926, part 1, p. 25, ill.;
Кат. ГМНЗИ 1928, No 509; Réau 1929, No 1075; Ster-
ling 1957, ill. 79, p. 103; Feist 1961, p. 63, ill. 29;
Прокофьев 1962, ill. 141; Musée de Moscou 1963,
p. 170, ill.; ГМИИ 1966, No 91; Ренуар 1970, ill. 15;
Daulte 1971, No 229; Antonova 1977, No 91

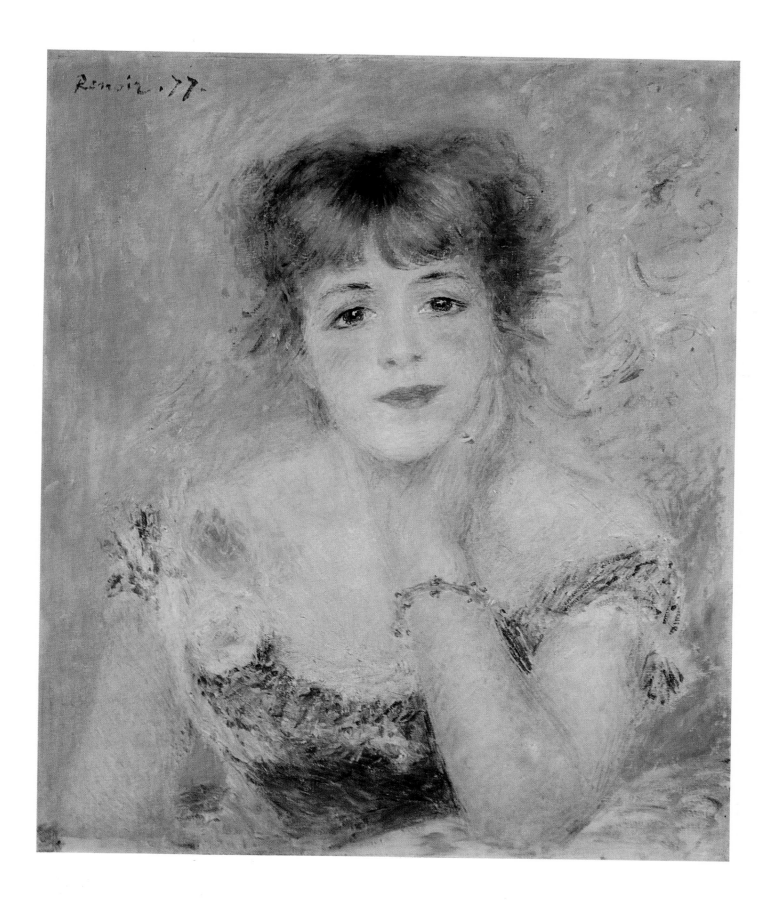

168 GIRLS IN BLACK

Oil on canvas. 81.3 × 65.2 cm. Inv. No 3329
Monogrammed lower right: *A. R.*

P. Feist dates the picture to 1880—82. A sketch of the girl's figure on the left is in the F. Hirschland Collection in New York. There is a certain similarity between this same figure and *Woman with a Muff* in pastel, in the Pushkin Museum collection.

Provenance: 1908—18 The S. Shchukin Collection, Moscow; 1918—48 The Museum of Modern Western Art, Moscow; since 1948 The Pushkin Museum of Fine Arts, Moscow

Exhibitions: 1955 Moscow, Cat., p. 54; 1956 Leningrad, Cat., p. 32; 1960 Moscow, Cat., p. 32; 1974 Leningrad, Cat. 42; 1974—75 Moscow, Cat. 40

Bibliography: Кат. ГМИИ 1957, p. 118; Кат. ГМИИ 1961, p. 157; Кат. собр. С. Щукина 1913, No 193, pp. 42—43; Тугендхольд 1914, p. 45, ill. p. 14; Перцов 1921, No 193, p. 114; Тугендхольд 1923, pp. 30—31, ill. p. 22; Кат. ГМНЗИ 1928, No 501; Réau 1929, No 1071; Sterling 1957, ill. 81; Feist 1961, p. 64; Прокофьев 1962, ill. 140; Ренуар 1970, ill. 38; Daulte 1971, No 375; Antonova 1977, No 93

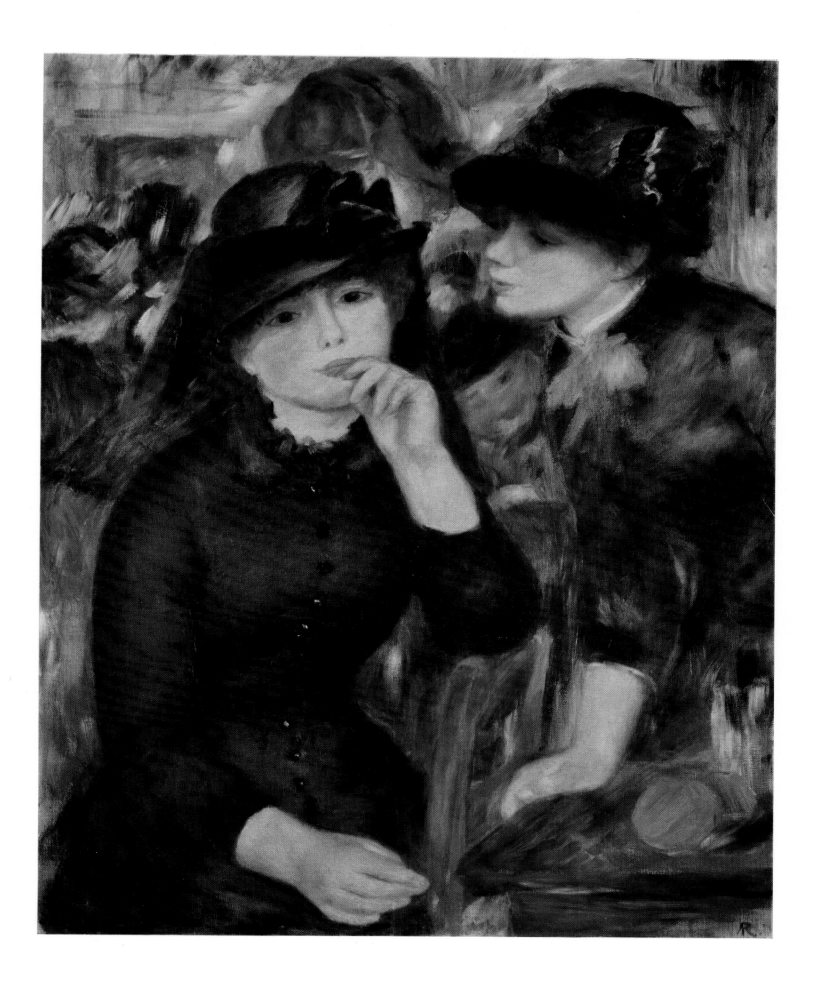

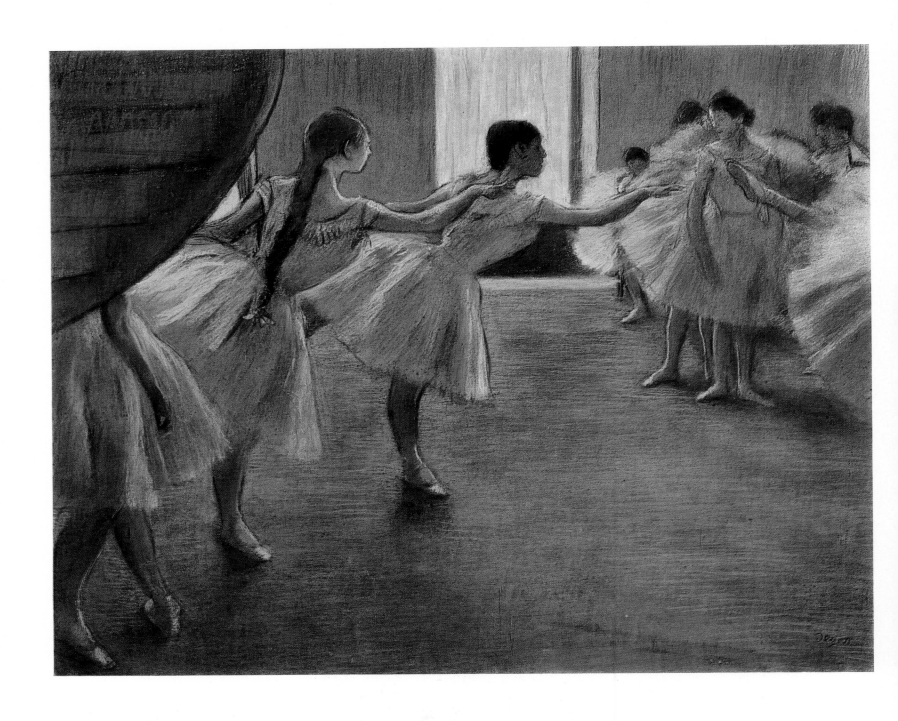

169 DANCERS AT THE REHEARSAL
Pastel on cardboard. 50 × 63 cm. Inv. No 3276
Signed lower right: *Degas*
A version painted in 1875—77, reproducing the left-
hand part of the Moscow picture, is now at the Tate
Gallery in London.

Provenance: until 1918 The S. Shchukin Collection,
Moscow; 1918—48 The Museum of Modern Western
Art, Moscow; since 1948 The Pushkin Museum of
Fine Arts, Moscow

Exhibitions: 1955 Moscow, Cat., p. 30; 1960 Moscow,
Cat., p. 14; 1974 Leningrad, Cat. 10; 1974—75 Moscow,
Cat. 5

Bibliography: Кат. ГМИИ 1957, p. 47; Кат. ГМИИ
1961, p. 67; Кат. собр. С. Щукина 1913, No 41, pp. 10—
11; Тугендхольд 1914, p. 39, ill. p. 20; Перцов 1921,
No 41, p. 108; Тугендхольд 1923, p. 37, ill. p. 32;
Кат. ГМНЗИ 1928, No 122; Réau 1929, No 765; Ре-
валд 1959, p. 186; Прокофьев 1962, ill. 128; Antonova
1977, No 99

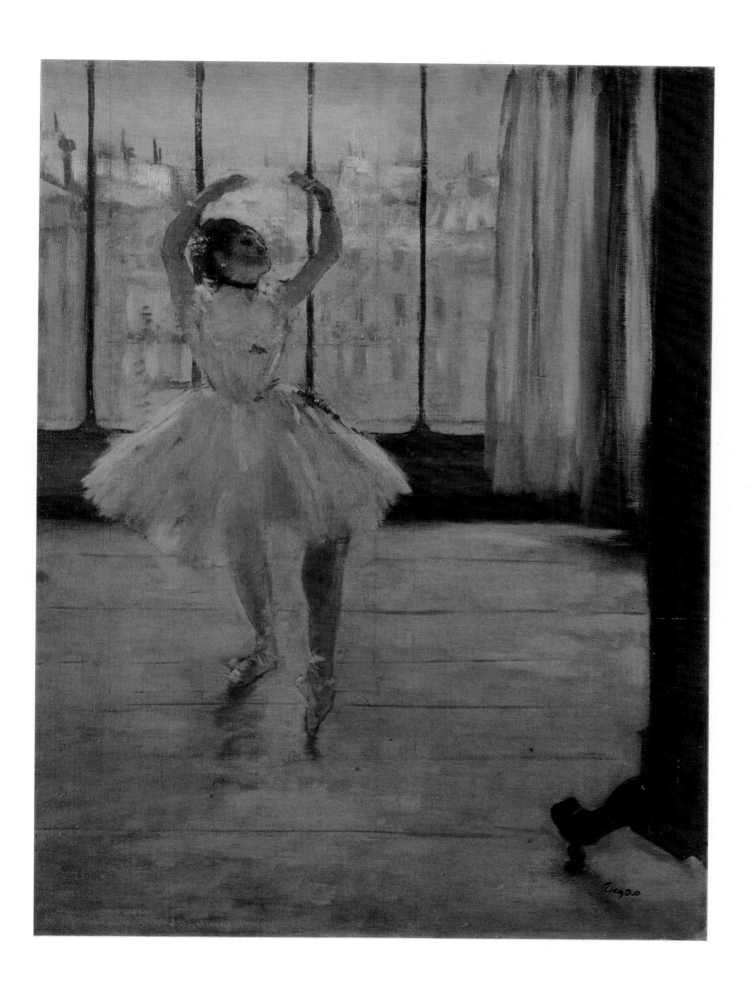

170 DANCER AT THE PHOTOGRAPHER'S
← Oil on canvas. 65 × 50 cm. Inv. No 3274
Signed lower right: *Degas*
The same interior is depicted in a canvas of 1873, *Three Dancers*, now in a private collection in Paris; the pose of the dancer on the extreme left is similar to that of the dancer in the Moscow picture. A pencil drawing for this picture (present location unknown) was published in *The Burlington Magazine*. Pickvance dates the Pushkin Museum piece to 1874.

Provenance: The G. Bram Collection, Paris; The A. Doria Collection, Paris; 1901 The P. Durand-Ruel Collection, Paris; The P. Cassirer Collection, Berlin; 1901 The S. Shchukin Collection, Moscow; 1918—48 The Museum of Modern Western Art, Moscow; since 1948 The Pushkin Museum of Fine Arts, Moscow

Exhibitions: 1879 Paris, Cat. 72; 1955 Moscow, Cat., p. 30; 1960 Moscow, Cat., p. 14; 1974 Leningrad, Cat. 8; 1974—75 Moscow, Cat. 5

Bibliography: Кат. ГМИИ 1957, p. 47; Кат. ГМИИ 1961, p. 67; Муратов 1908, p. 120; Кат. собр. С. Щукина 1913, No 39, pp. 10—11; Тугендхольд 1914, p. 39, ill. p. 21; Grautoff 1919, ill. p. 85; Перцов 1921, No 39, p. 108; Тугендхольд 1923, pp. 36—37, ill. p. 31; Кат. ГМНЗИ 1928, No 120; Réau 1929, No 763; Sterling 1957, ill. 66, p. 88; Ревалд 1959, p. 149, ill.; Прокофьев 1962, ill. 129; A. Pickvance, "Degas's Dancers. 1872—6", *The Burlington Magazine*, 1963, June, pp. 260—261, ill. 18; *Apollo*, 1967, 1, ill.; *Эдгар Дега. Письма. Воспоминания современников*, Moscow, 1971, ill. 33; Antonova 1977, No 98

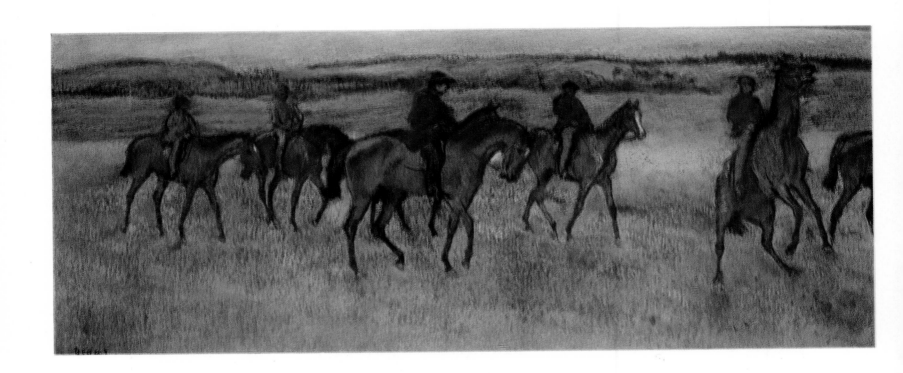

171 EXERCISING RACEHORSES
Pastel on paper. 36 × 86 cm. Inv. No 3275
Signed lower right and left: *degas*
From the 1860s on Degas frequently painted horse-racing scenes. There is another pastel similar to that of The Pushkin Museum (see Lemoisne 1946—49, No 597 bis).

Provenance: until 1894 The T. Duret Collection, Paris; until 1918 The S. Shchukin Collection, Moscow; 1918—48 The Museum of Modern Western Art, Moscow; since 1948 The Pushkin Museum of Fine Arts, Moscow

Exhibitions: 1955 Moscow, Cat., p. 30; 1960 Moscow, Cat., p. 14; 1974 Leningrad, Cat. 9; 1974—75 Moscow, Cat. 3

Bibliography: Кат. ГМИИ 1957, p. 47; Кат. ГМИИ 1961, p. 67, ill.; Муратов 1908, p. 125; Кат. собр. С. Щукина 1913, No 40, pp. 10—11; Перцов 1921, No 40, p. 108; Тугендхольд 1923, ill. p. 33; Ettinger 1926, part 1, p. 26, ill.; Кат. ГМНЗИ 1928, No 121; Réau 1929, No 764; Ревалд 1959, p. 135, ill.; Прокофьев 1962, ill. 126; Antonova 1977, No 97

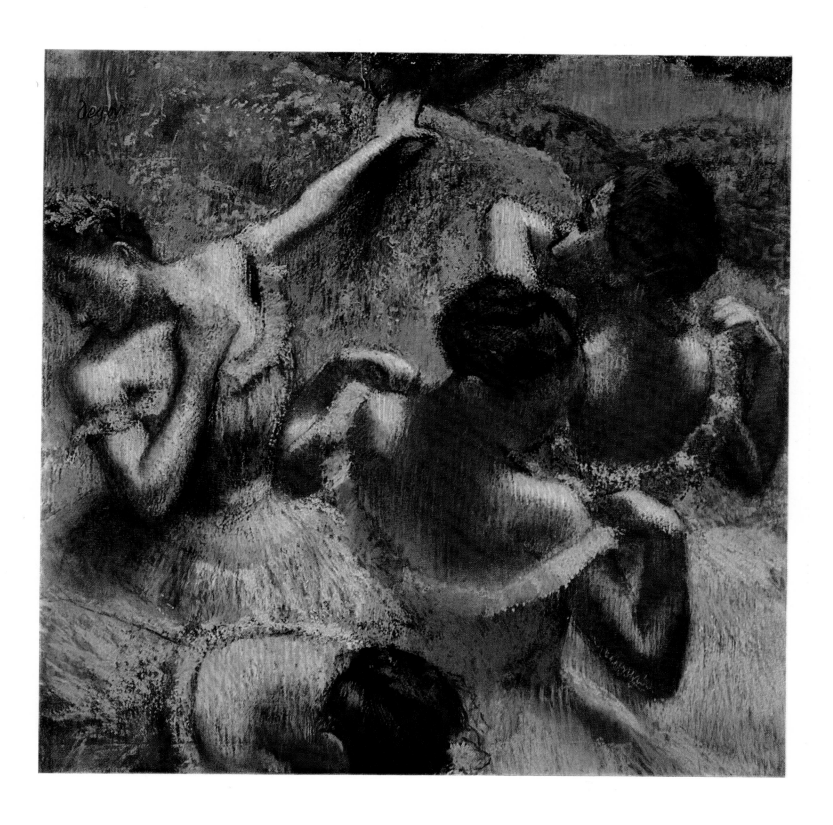

172 DANCERS IN BLUE

Pastel on paper. 65 × 65 cm. Inv. No 3273

The picture may be dated approximately 1898 (Lemoisne dates it 1897). An earlier work on the same theme, painted in oils around 1890 (in the Musée de l'Impressionnisme in Paris), is similar to the Pushkin Museum pastel in its use of color. Another pastel of 1899 is now in the Paul Durand-Ruel Collection.

Provenance: 1898—1903 The P. Durand-Ruel Collection, Paris; 1903—18 The S. Shchukin Collection, Moscow; 1918—48 The Museum of Modern Western Art, Moscow; since 1948 The Pushkin Museum of Fine Arts, Moscow

Exhibitions: 1955 Moscow, Cat., p. 30; 1960 Moscow, Cat., p. 14; 1974—75 Moscow, Cat. 6

Bibliography: Кат. ГМИИ 1957, p. 47, ill.; Кат. ГМИИ 1961, p. 67, ill.; Муратов 1908, p. 129; Кат. собр. С. Щукина 1913, No 38, pp. 10—11; Тугендхольд 1914, p. 39, ill. p. 22; Перцов 1921, No 38, p. 108; Тугендхольд 1923, ill. p. 28; Кат. ГМНЗИ 1928, No 123; Réau 1929, No 766; D. Rouart, *Degas. A la recherche de sa technique*, Paris, 1945, ill.; Ревалд 1959, pp. 360—361; Прокофьев 1962, ill. 127; ГМИИ 1966, No 93; *Эдгар Дега. Письма. Воспоминания современников*, Moscow, 1971, ill. (on the dust-cover); Antonova 1977, No 100

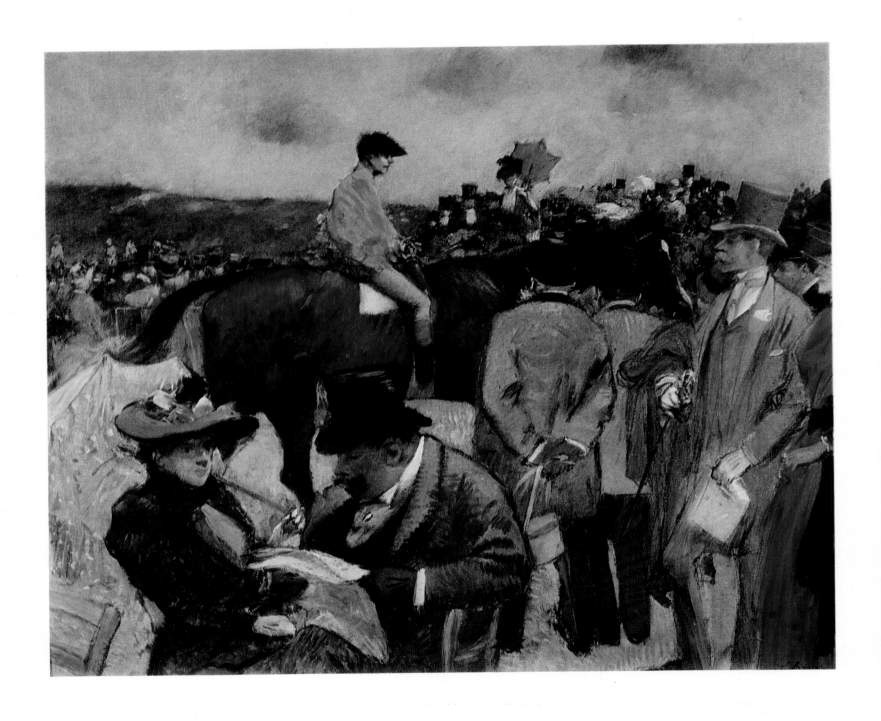

173 THE HORSE RACE
Oil on canvas. 38 × 45 cm. Inv. No 3347
Signed lower right: *J. L. Forain*
The picture may be dated to the late 1880s.

Provenance: 1899—1918 The S. Shchukin Collection,
Moscow; 1918—48 The Museum of Modern Western
Art, Moscow; since 1948 The Pushkin Museum of Fine
Arts, Moscow

Exhibitions: 1899 Moscow, Cat. 282; 1955 Moscow,
Cat., p. 59; 1960 Moscow, Cat., pp. 7, 38; 1967—68
Odessa, Kharkov, Cat. 36; 1972 Otterloo, Cat. 12;
1972 Prague, Cat. 16; 1974—75 Moscow, Cat. 56

Bibliography: Кат. собр. С. Щукина 1913, No 221,
pp. 50—51; Тугендхольд 1914, p. 49, ill. p. 24; Пер-
цов 1921, No 221, p. 116; Кат. ГМНЗИ 1928, No 633;
Réau 1929, No 815

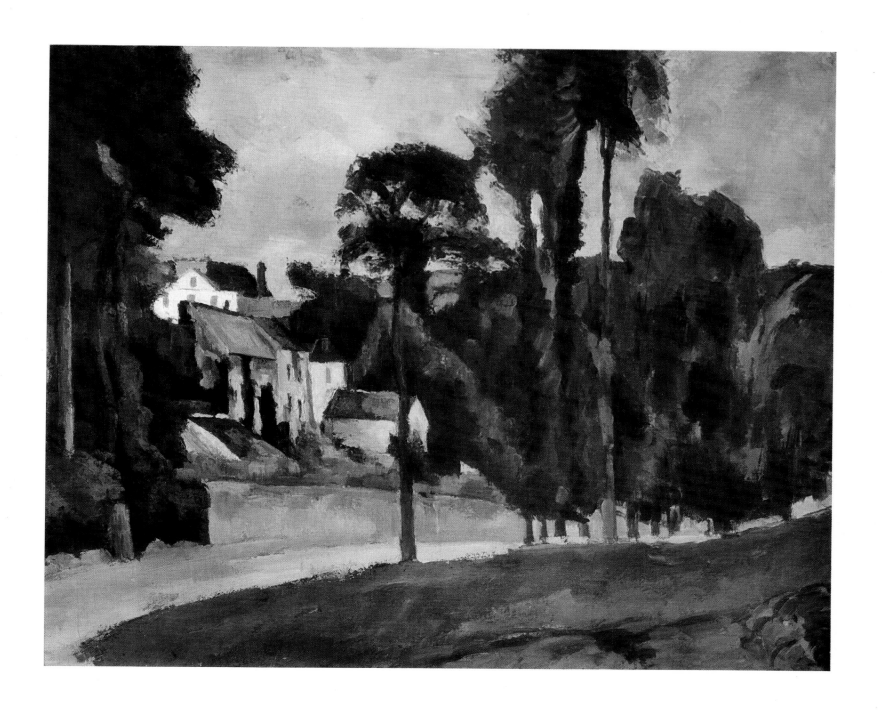

174 ROAD TO PONTOISE. 1875—77
Oil on canvas. 58 × 71 cm. Inv. No 3410
In 1872 Cézanne came to join Pissarro and Guillau-
min at Auvers-sur-Oise and lived there for two years.
Road to Pontoise depicts the same locality as *The
Hermitage Pavilion at Pontoise* (1875) by Pissarro.
The canvas was in the Viau sale at Durand-Ruel's
in Paris on March 4, 1907 (lot 12).
Provenance: until 1907 The G. Viau Collection, Par-
is; until 1909 The E. Druet Collection, Paris; 1909—
18 The I. Morozov Collection, Moscow; 1918—48 The
Museum of Modern Western Art, Moscow; since 1948
The Pushkin Museum of Fine Arts, Moscow

Exhibitions: 1903 Vienna, Cat. 58; 1926 Moscow,
Cat. 6; 1956 Leningrad (Paul Cézanne), Cat. 3; 1960
Moscow, Cat., p. 34; 1974 Moscow, Cat. 44
Bibliography: Кат. ГМИИ 1957, p. 127; Кат. ГМИИ
1961, p. 168; Кат. ГМНЗИ 1928, No 556; *Аполлон*,
1912, March, pp. 36—37; T. L. Klingsor, *Cézanne*,
Paris, 1923, ill. 21; Н. Яворская, *Сезанн*, Moscow,
1933, ill.; А. Воллар, *Сезанн*, Leningrad, 1934, ill.;
Venturi 1936, No 172, ill.; J. Rewald, *Cézanne, sa
vie, son œuvre*, Paris, 1936, ill. 33; Dorival 1948,
p. 43; P. Feist, *Paul Cézanne*, Leipzig, 1963, ill. 19;
Сезанн 1975, No 5

175 INTERIOR WITH TWO WOMEN
AND A CHILD (SCÈNE D'INTÉRIEUR)
Oil on canvas. 91 × 72 cm. Inv. No 3409
The picture was painted at the beginning of the 1860s.
According to Venturi, it depicts the artist's sisters
Marie and Rose. The picture was bought by Ivan
Morozov from Ambroise Vollard in Paris in 1913.

Provenance: until 1913 The A. Vollard Collection,
Paris; 1913—18 The I. Morozov Collection, Moscow;
1918—48 The Museum of Modern Western Art, Mos-
cow; since 1948 The Pushkin Museum of Fine Arts,
Moscow

Exhibitions: 1926 Moscow, Cat. 1; 1956 Leningrad
(Paul Cézanne), Cat., p. 4; 1960 Moscow, Cat., p. 34

Bibliography: Кат. ГМИИ 1961, p. 168; Ternovetz
1925, p. 464; Ettinger 1926, part 2, p. 114, ill.; Кат.
ГМНЗИ 1928, No 553; Réau 1929, No 735; Venturi
1936, No 24, ill.; Dorival 1948, pp. 19, 133, ill. 5;
Sterling 1957, ill. 87; Сезанн 1975, No 1; Antonova
1977, No 108

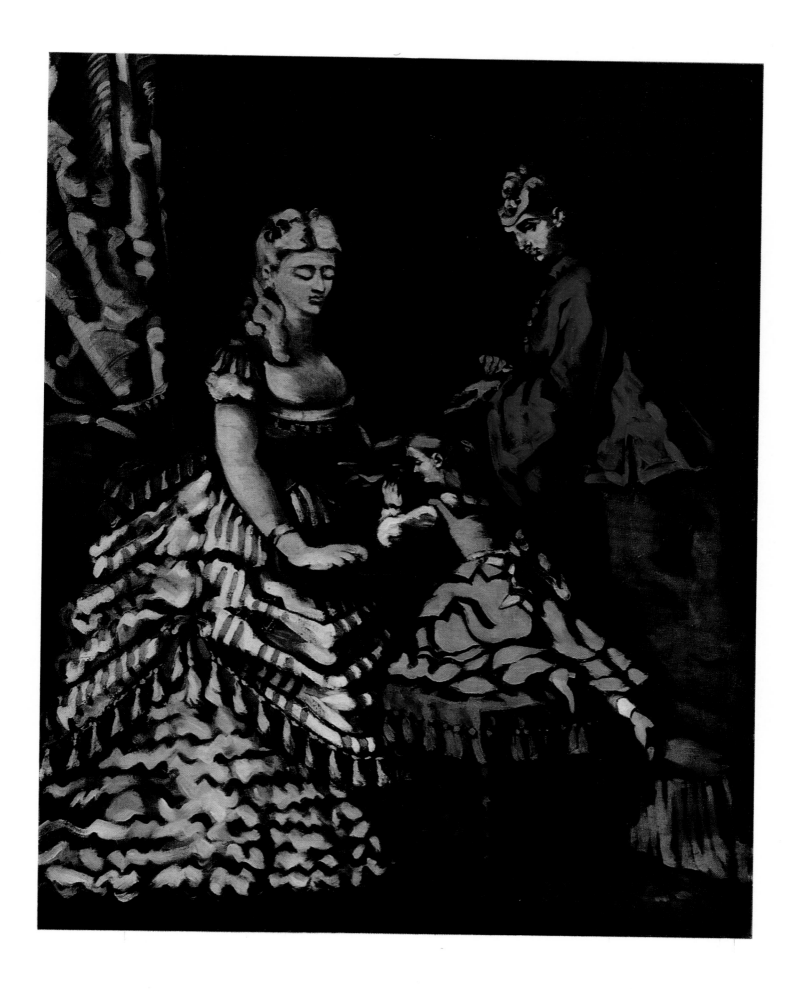

176 BATHERS. Study
Oil on canvas. 26 × 40 cm. Inv. No 3414
This is one of Cézanne's numerous studies for an un-
realized picture on the same theme. A pencil sketch
(1875—77) for the central figure with a towel in his
hand is in the collection of the artist's son. A sketch,
dated 1885, for the standing figure with raised arms
is in the A. Chappuis Collection in Paris. The light
palette and the abundance of blue tones permit the
Moscow canvas to be dated to the early 1890s.
Provenance: until 1910 The A. Vollard Collection,
Paris; 1910—18 The I. Morozov Collection, Moscow;

1918—48 The Museum of Modern Western Art, Mos-
cow; since 1948 The Pushkin Museum of Fine Arts,
Moscow

Exhibitions: 1926 Moscow, Cat. 12; 1956 Leningrad
(Paul Cézanne), Cat. 16; 1972 Otterloo, Cat. 3; 1973
Washington, Cat. 3

Bibliography: Кат. ГМИИ 1961, p. 169; Маковский
1912, p. 23; Ternovetz 1925, p. 466, ill.; Кат. ГМНЗИ
1928, No 565; Réau 1929, No 747; Venturi 1936,
No 588; Sterling 1957, ill. 94, p. 118; Сезанн 1975,
No 15; Antonova 1977, No 107

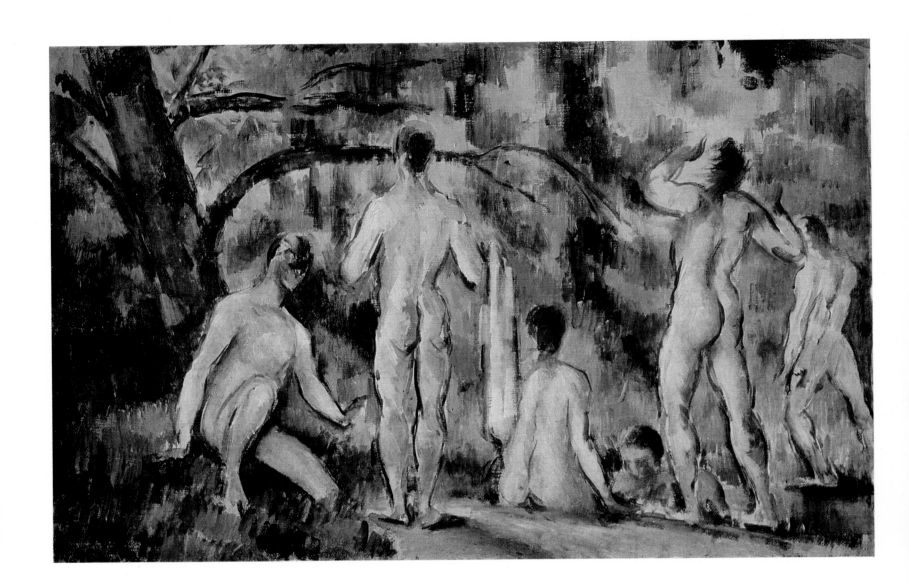

177 THE AQUEDUCT
→ Oil on canvas. 91 × 72 cm. Inv. No 3337
 From 1885 on Cézanne often worked at Bellevue, not
 far from Aix, where Maxim Conil, his brother-in-law,
 had bought an estate. According to A. Barskaya,
 the Moscow picture presents a view of the aqueduct
 and Mount Sainte-Victoire from Bellevue. The same
 locality is depicted in Cézanne's *Mount Sainte-
 Victoire* of 1885—87 (The Metropolitan Museum of Art,
 New York). The Moscow canvas was obviously
 completed in 1885—87.
 Provenance: The A. Vollard Collection, Paris; 1913—
 18 The S. Shchukin Collection, Moscow; 1918—48
 The Museum of Modern Western Art, Moscow; since
 1948 The Pushkin Museum of Fine Arts, Moscow

Exhibitions: 1904 Paris (Salon d'Automne), Cat. 15;
1926 Moscow, Cat. 21; 1936 Paris (Orangerie), Cat.
103; 1939 Moscow, Cat., p. 46; 1955 Moscow, Cat.,
p. 56; 1956 Leningrad (Paul Cézanne), Cat. 10; 1966—
67 Tokyo, Kyoto, Cat. 57; 1972 Otterloo, Cat. 1; 1972
Prague, Cat. 6; 1973 Washington, Cat. 2

Bibliography: Кат. ГМИИ 1957, p. 127; Кат. ГМИИ
1961, p. 168; R. Marx, "Le Salon d'Automne", *Ga-
zette des Beaux-Arts*, 32, 1904, ill. p. 464; Кат. собр.
С. Щукина 1913, No 206, pp. 46—47; Vollard 1914,
ill. 45; Перцов 1921, No 206, p. 115; Тугендхольд
1923, ill. p. 91; Ternovetz 1925, p. 471; Кат. ГМНЗИ
1928, No 548; Réau 1929, No 730; Venturi 1936, No 477;
Sterling 1957, ill. 85, p. 116; Прокофьев 1962, ill. 160;
Сезанн 1975, No 10

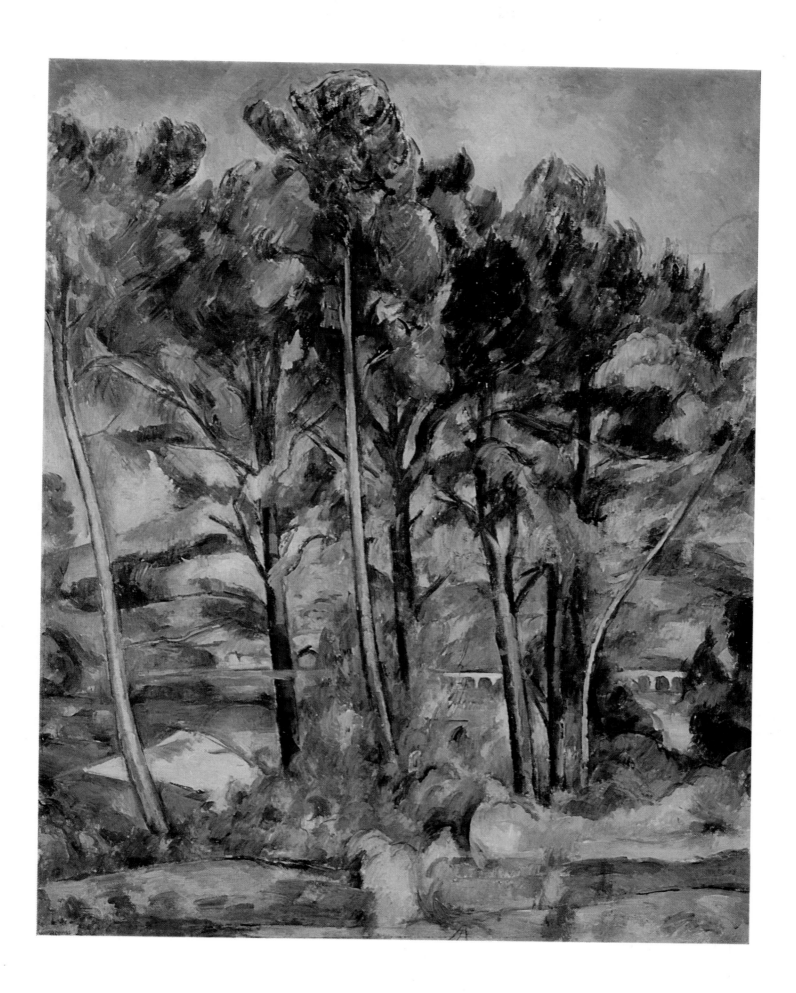

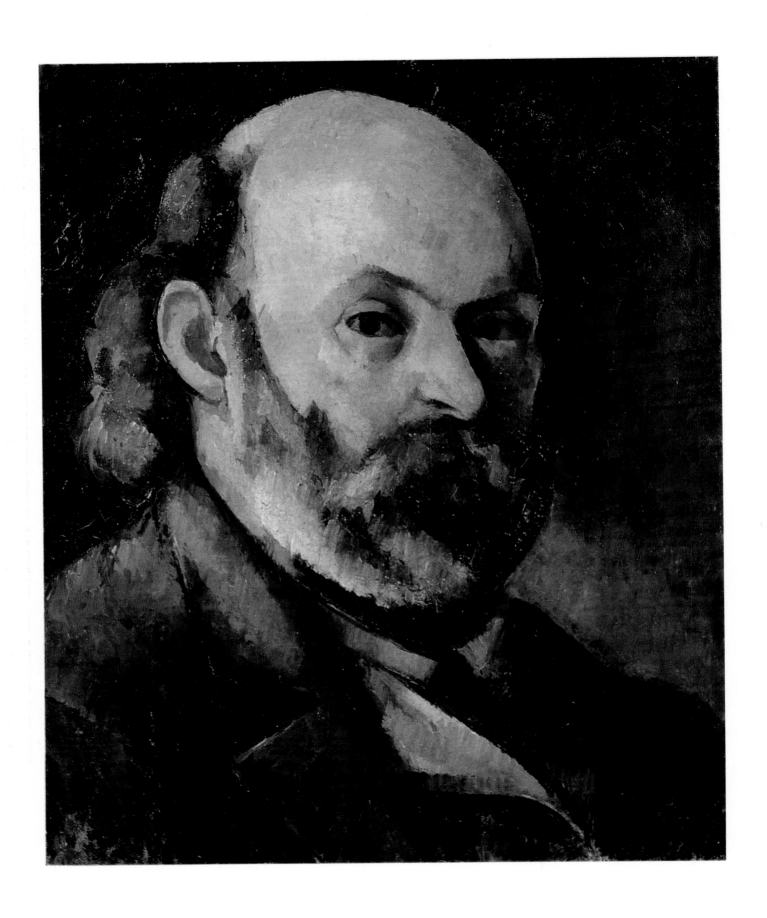

178 SELF-PORTRAIT
Oil on canvas. 45 × 37 cm. Inv. No 3338
Signed lower right: *P. Cézanne*
Various scholars date this self-portrait 1879—82.
Most probably it was painted in the early 1880s.

Provenance: The A. Vollard Collection, Paris; 1908—
18 The S. Shchukin Collection, Moscow; 1918—48
The Museum of Modern Western Art, Moscow; since
1948 The Pushkin Museum of Fine Arts, Moscow

Exhibitions: 1895 Paris (Vollard Gallery); 1926 Mos-
cow, Cat. 7; 1955 Moscow, Cat., p. 56; 1956 Lenin-
grad, Cat., p. 55; 1956 Leningrad (Paul Cézanne),
Cat. 7; 1974—75 Moscow, Cat. 45

Bibliography: Кат. ГМИИ 1957, p. 127; Кат. ГМИИ
1961, p. 168; Кат. собр. С. Щукина 1913, No. 207,
pp. 46—47; Тугендхольд 1914, p. 45, ill. (on the fron-
tispiece); Vollard 1914, p. 58, ill. 19; Перцов 1921,
No 207, p. 115; Тугендхольд 1923, ill. p. 7; Ternovetz
1925, p. 468, ill.; Кат. ГМНЗИ 1928, No 547; Réau
1929, No 729; Venturi 1936, No 368, ill.; Прокофьев
1962, ill. 158; Сезанн 1975, No 7; Antonova 1977,
No 110

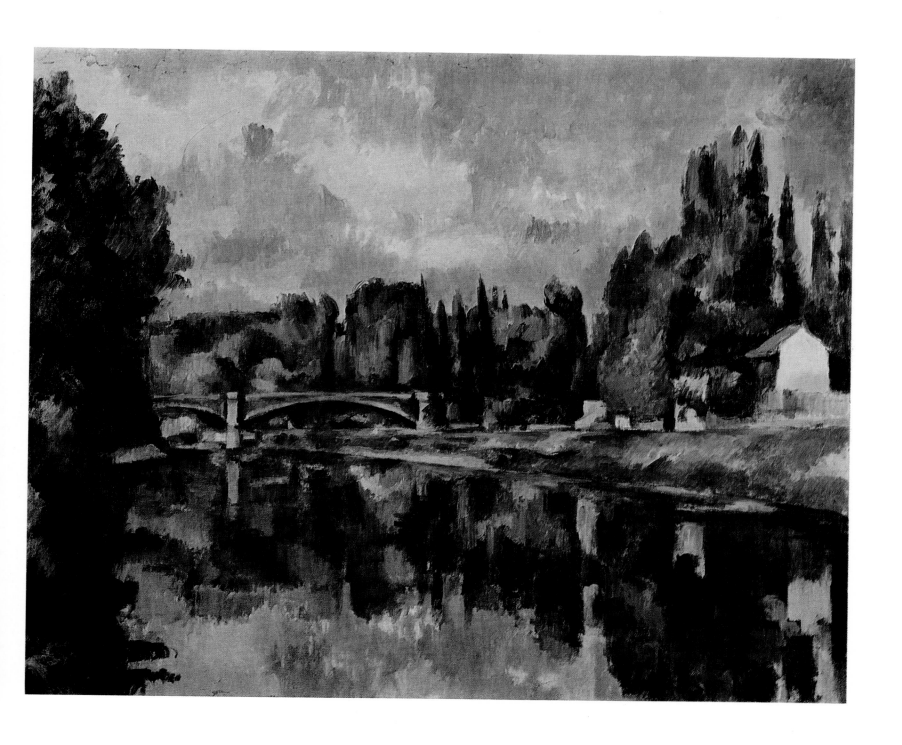

179 THE BANKS OF THE MARNE

Oil on canvas. 71 × 90 cm. Inv. No 3416

Cézanne painted this place on more than one occasion. A similar picture of the same title is in The Hermitage in Leningrad; the same locality is depicted in the landscapes which are in the collections of Lecomte and Goldschmidt-Rothschild in Paris. On Vollard's evidence, cited by Henri Perruchot, the Moscow landscape was hung at Cézanne's exhibition in the Vollard Gallery in November — December 1895 in Paris. Completed around 1888, it is regarded as the finest representation of this subject.

Provenance: The A. Pellerin Collection, Paris; until 1912 The A. Vollard Collection, Paris; 1912—18 The I. Morozov Collection, Moscow; 1918—48 The Museum of Modern Western Art, Moscow; since 1948 The Pushkin Museum of Fine Arts, Moscow

Exhibitions: 1895 Paris (Vollard Gallery); 1912 St Petersburg; 1936 Paris (Orangerie); 1937 Paris, Cat. 254; 1939 Moscow, Cat., p. 46; 1955 Moscow, Cat., p. 56; 1956 Leningrad, Cat., p. 55; 1956 Leningrad (Paul Cézanne), Cat. 13; 1960 Moscow, Cat., p. 34; 1974 Leningrad, Cat. 50; 1974—75 Moscow, Cat. 46

Bibliography: Кат. ГМИИ 1957, p. 127; Кат. ГМИИ 1961, p. 169; *Die Kunst*, 1910, No 1, ill. p. 164; Я. Ту-гендхольд, "Пейзаж во французской живописи", *Аполлон*, 1911, No 7, p. 10; Маковский 1912, p. 23; Vollard 1914, pp. 25, 58; Ternovetz 1925, p. 468, ill. p. 472; Кат. ГМНЗИ 1928, No 559; Réau 1929, No 741; Venturi 1936, No 631, ill.; Dorival 1948, p. 137, ill. 160; Sterling 1957, ill. 98, p. 116; Cat. Impression-nistes 1959, p. 22; Прокофьев 1962, ill. 161; ГМИИ 1966, No 100; Сезанн 1972, ill. 36; Сезанн 1975, No 11

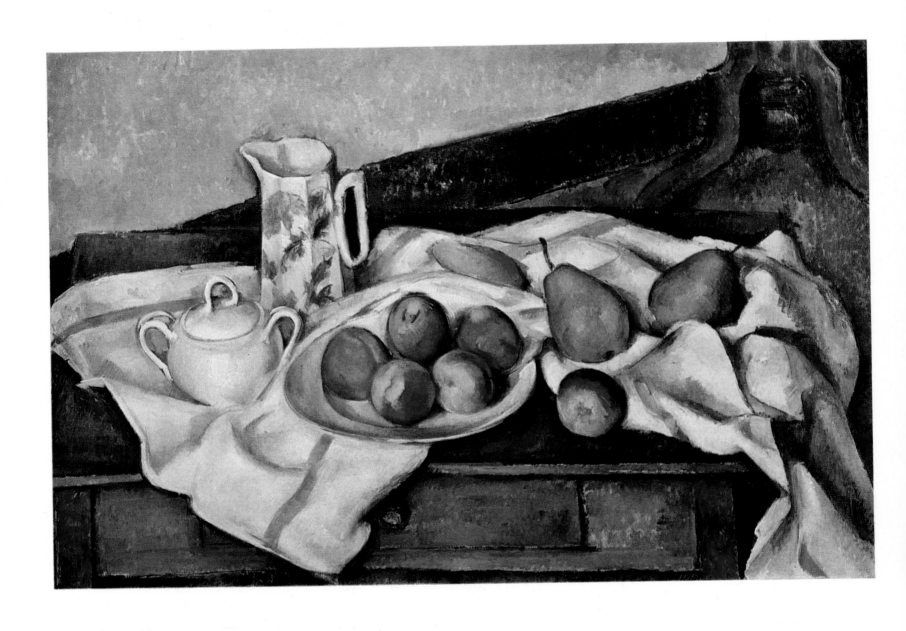

180 PEACHES AND PEARS

Oil on canvas. 61 × 90 cm. Inv. No 3415

The picture was presumably painted in 1888—90. A canvas of the same year, similar to this still life, is in the Nasjonalmuseet, Oslo.

Provenance: until 1912 The A. Vollard Collection, Paris; 1912—18 The I. Morozov Collection, Moscow; 1918—48 The Museum of Modern Western Art, Moscow; since 1948 The Pushkin Museum of Fine Arts, Moscow

Exhibitions: 1926 Moscow, Cat. 10; 1936 Paris (Orangerie), Cat. 68; 1955 Moscow, Cat., p. 57; 1956 Leningrad, Cat., p. 55; 1956 Leningrad (Paul Cézanne), Cat. 15

Bibliography: Кат. ГМИИ 1957, p. 128, ill.; Кат. ГМИИ 1961, p. 169; Маковский 1912, p. 23; Ternovetz 1925, p. 465; G. Charensol, "Les Détracteurs de Cézanne", *L'Art Vivant*, 37, 1926, p. 494, ill.; Кат. ГМНЗИ 1928, No 562; Réau 1929, No 744; Venturi 1936, No 619; Sterling 1957, ill. 92; Прокофьев 1962, ill. 159; ГМИИ 1966, No 101; Сезанн 1975, No 16; Antonova 1977, No 109

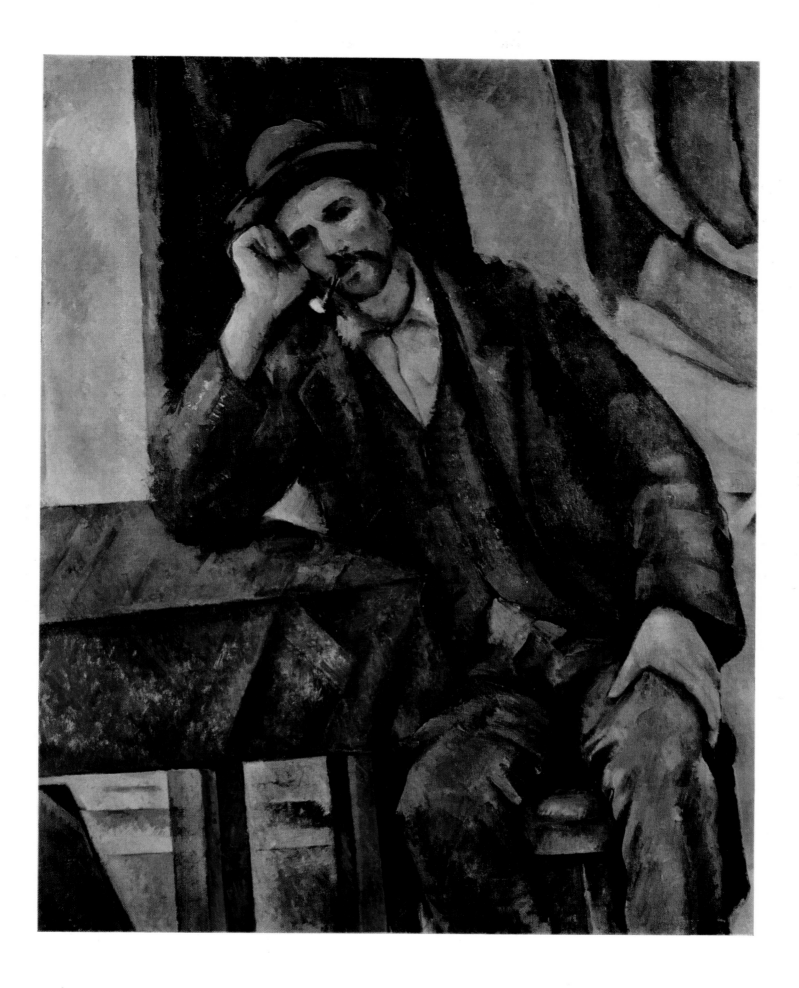

181 MAN SMOKING A PIPE

← Oil on canvas. 91 × 72 cm. Inv. No 3336
Cézanne turned to this theme several times. There is a painting entitled *The Smoker* in The Hermitage in Leningrad. The Moscow canvas may be dated to 1895—1900.

Provenance: The A. Vollard Collection, Paris; 1913—18 The S. Shchukin Collection, Moscow; 1918—48 The Museum of Modern Western Art, Moscow; since 1948 The Pushkin Museum of Fine Arts, Moscow

Exhibitions: 1926 Moscow, Cat. 17; 1955 Moscow, Cat., p. 57; 1956 Leningrad, Cat., p. 56; 1956 Leningrad (Paul Cézanne), Cat. 19; 1965 Bordeaux, Cat. 56; 1965—66 Paris, Cat. 48; 1970 Osaka, Cat., p. 254

Bibliography: Кат. ГМИИ 1961, p. 169; Кат. собр. С. Щукина 1913, No 205, pp. 46—47; Тугендхольд 1914, p. 45, ill. p. 39; Grautoff 1919, ill. p. 89; Перцов 1921, No 205, p. 115; Тугендхольд 1923, ill. p. 87; Ternovetz 1925, p. 470, ill.; Кат. ГМНЗИ 1928, No 551; Réau 1929, No 733; Venturi 1936, No 688; Dorival 1948, p. 61; Сезанн 1975, No 18

182 MARDI GRAS (PIERROT AND HARLEQUIN)

Oil on canvas. 102 × 81 cm. Inv. 3335
The models who sat for the picture were Louis Guillaume as Pierrot and Paul Cézanne, the artist's son, as Harlequin. On the evidence of the latter the work was painted in 1888 in Cézanne's studio in the Rue du Val-de-Grâce in Paris. There are three oil studies and numerous drawings relating to this picture. The study closest to it is in the Auguste Pellerin Collection in Paris.

Provenance: 1888—89 The V. Chocquet Collection, Paris; 1899—1904 The P. Durand-Ruel Collection, Paris; 1904—18 The S. Shchukin Collection, Moscow; 1918—48 The Museum of Modern Western Art, Moscow; since 1948 The Pushkin Museum of Fine Arts, Moscow

Exhibitions: 1903 Vienna; 1904 Paris (Salon d'Automne), Cat. 19; 1926 Moscow, Cat. 13; 1936 Paris (Orangerie), Cat. 72; 1955 Moscow, Cat., p. 57; 1956 Leningrad, Cat., p. 55; 1956 Leningrad (Paul Cézanne), Cat. 11; 1974 Leningrad, Cat. 52; 1974—75 Moscow, Cat. 47

Bibliography: Кат. ГМИИ 1957, p. 127; Кат. ГМИИ 1961, p. 169; *Vente de la collection Mme Chocquet*, Paris, 1899, July 1—4, No 1, ill.; Heilbut 1903, p. 191, ill.; Искусство 1905, ill. p. 7; Кат. собр. С. Щукина 1913, No 204, pp. 46—47; Тугендхольд 1914, p. 45, ill. p. 36; Перцов 1921, No 204, p. 115; Тугендхольд 1923, p. 90, ill. p. 80; Ternovetz 1925, p. 469, ill.; Ettinger 1926, part 2, p. 113, ill.; Кат. ГМНЗИ 1928, No 549; Réau 1929, No 731; R. Huyghe, "Cézanne", *L'Amour de l'Art*, 1936, I, ill. 57; V, p. 176, ill. 157; Venturi 1936, No 552; Dorival 1948, p. 137, ill. 123; Sterling 1957, ill. 89, p. 116; Прокофьев 1962, ill. 162; ГМИИ 1966, No 102; Сезанн 1972, ill. 38; Сезанн 1975, No 13; Antonova 1977, No 106

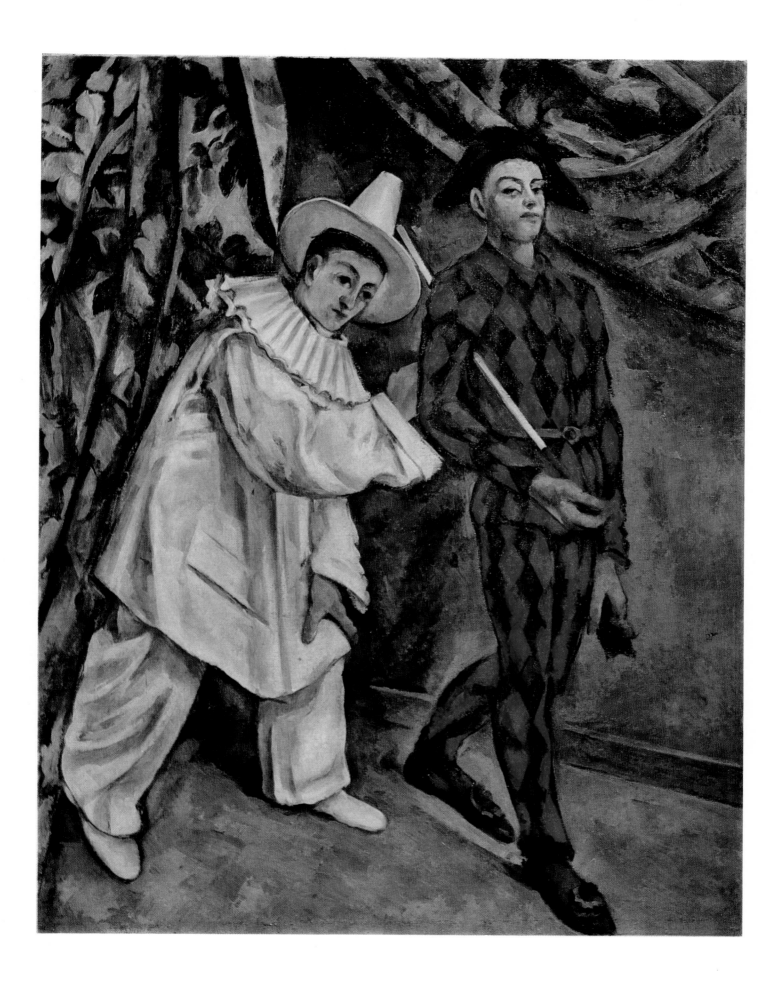

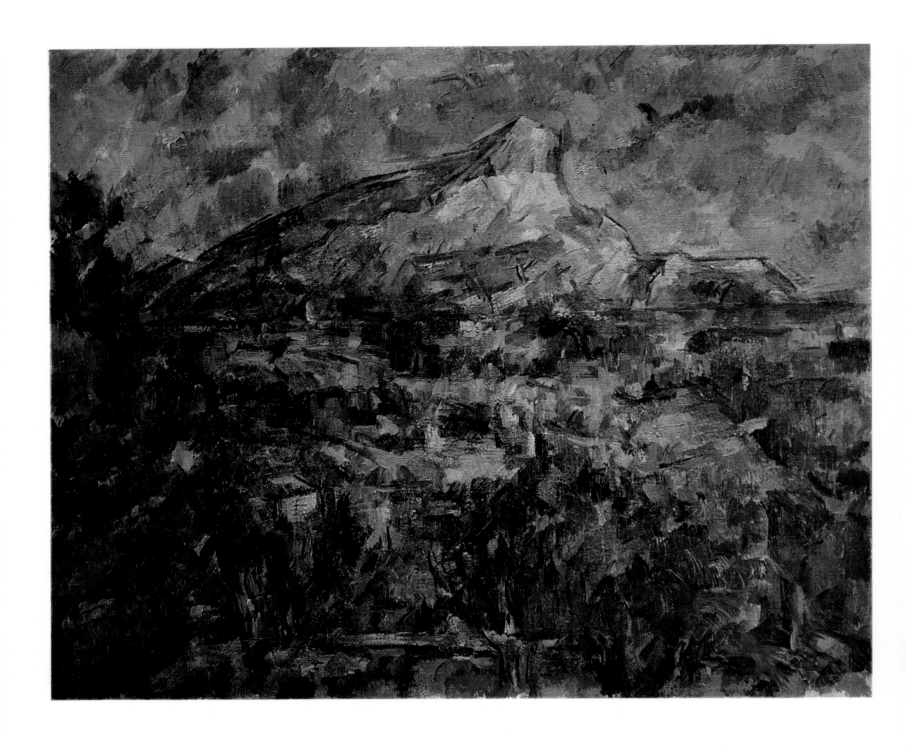

183 LANDSCAPE AT AIX
 (MOUNT SAINTE-VICTOIRE)
 Oil on canvas. 60 × 73 cm. Inv. No 3339
 According to M. Raynal, Cézanne painted or drew
 Mount Sainte-Victoire almost fifty times; it was one
 of his favorite subjects. The Moscow picture is dated
 about 1905 and is one of the finest views of Sainte-
 Victoire. It is reproduced in *Portrait of Cézanne
 with His Son and the Artist K. X. Roussel*, painted
 by Maurice Denis at Aix in 1905.

 Provenance: 1905 The artist's collection, Aix; the
 A. Vollard Collection, Paris; 1913—18 The S. Shchu-
 kin Collection, Moscow; 1918—48 The Museum of
 Modern Western Art, Moscow; since 1948 The Push-
 kin Museum of Fine Arts, Moscow

Exhibitions: 1926 Moscow, Cat. 25; 1956 Leningrad
(Paul Cézanne), Cat. 25; 1965 Bordeaux, Cat. 58;
1965—66 Paris, Cat. 50; 1972 Otterloo, Cat. 7

Bibliography: Кат. ГМИИ 1961, p. 169; Кат. собр.
С. Щукина 1913, No 210, pp. 46—47; Маковский 1912,
p. 23; Тугендхольд 1914, p. 45; Перцов 1921, No 210,
p. 115; Кат. ГМНЗИ 1928, No 552; Réau 1929, No 734;
Venturi 1936, No 803; Sterling 1957, p. 116; Сезанн
1972, ill. 56; Сезанн 1975, No 25

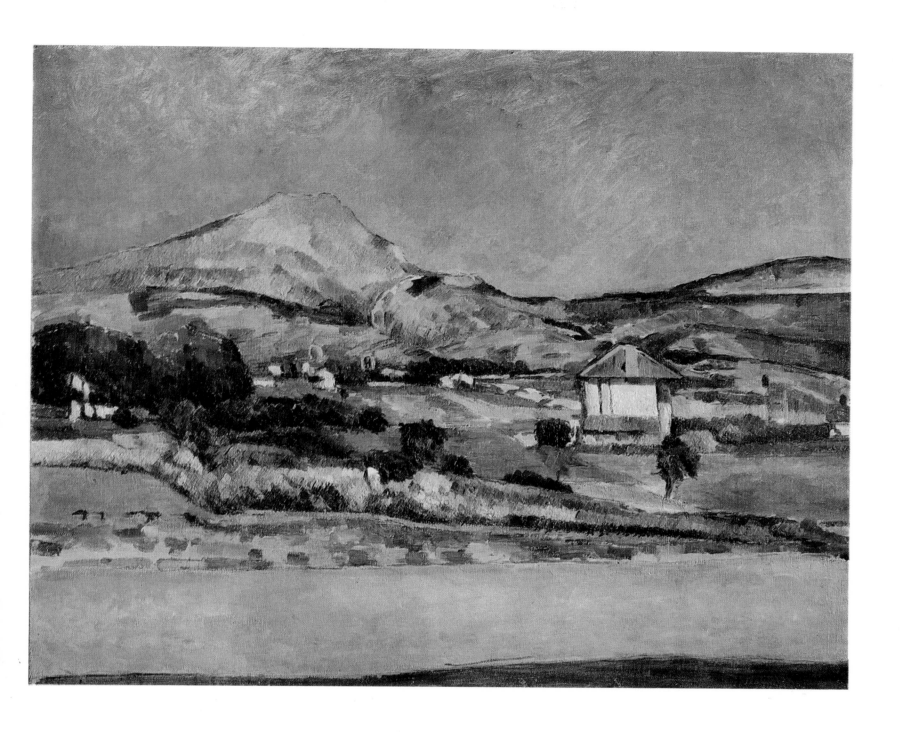

184 FIELD BY MOUNT SAINTE-VICTOIRE
Oil on canvas. 58 × 72 cm. Inv. No 3412
The picture may be dated to 1882—85. A pencil draw-
ing done for the right-hand part of the canvas is now
in the Kunstmuseum, Basel.

Provenance: until 1907 The A. Vollard Collection,
Paris; 1907—18 The I. Morozov Collection, Moscow;
1918—48 The Museum of Modern Western Art, Mos-
cow; since 1948 The Pushkin Museum of Fine Arts,
Moscow

Exhibitions: 1904 Paris (Salon d'Automne), Cat. 7;
1926 Moscow, Cat. 8; 1956 Leningrad (Paul Cézanne),
Cat. 8; 1967—68 Odessa, Kharkov, Cat. 32; 1972
Prague, Cat. 5

Bibliography: Кат. ГМИИ 1961, p. 168; Маковский
1912, p. 23; M. Denis, "Cézanne", *Kunst und Künstler*,
1914, 4, ill. p. 211; Vollard, 1914, ill. 45; Ternovetz
1925, p. 465; Кат. ГМНЗИ 1928, No 557; Réau 1929,
No 739 (entitled *La Montagne de Sainte-Victoire*);
Venturi 1936, No 423; Прокофьев 1962, ill. 165; Се-
занн 1975, No 8; Antonova 1977, No 103

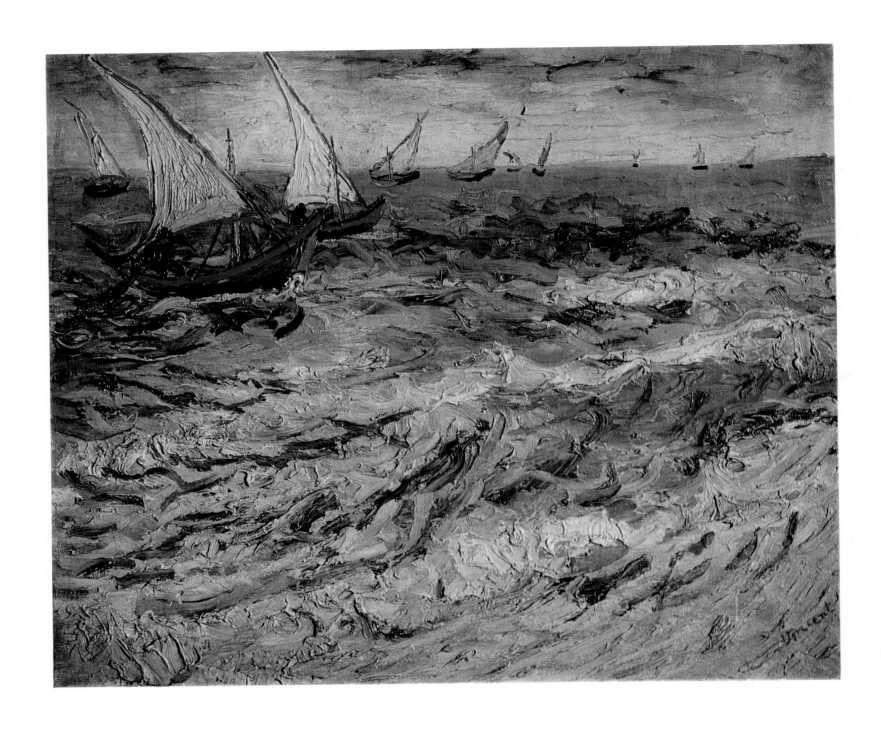

185 SEASCAPE AT SAINTES-MARIES

Oil on canvas. 44 × 53 cm. Inv. No 3438
Signed lower right: *Vincent*

The picture was painted in June 1888 at Saintes-Ma-
ries-de-la-Mer on the Mediterranean, not far from
Arles. In addition to the Moscow picture, Dr De La
Faille mentions two more seascapes done by Van
Gogh at Saintes-Maries, one of which is in the Van
Gogh Museum in Amsterdam. There exist several
drawings on the same theme. The one bearing the
strongest resemlance to the Pushkin Museum canvas
(pen and India ink) is in the Musées Royaux des
Beaux-Arts in Brussels.

Provenance: until 1910 The M. Morozov Collection, Mos-
cow; 1910—25 The Tretyakov Gallery, Moscow; 1925—
48 The Museum of Modern Western Art, Moscow;
since 1948 The Pushkin Museum of Fine Arts, Moscow

Exhibitions: 1926 Moscow, Cat. 3; 1939 Moscow, Cat.,
p. 50; 1960 Moscow, Cat., p. 11

Bibliography: Кат. ГМИИ 1957, p. 37; Кат. ГМИИ
1961, p. 53; Кат. Галереи Третьяковых 1911, No 99;
Кат. ГМНЗИ 1928, No 86; De La Faille 1928, vol. 1,
p. 117, No 417, vol. 2, ill. 63; Réau 1929, No 1149;
Van Gogh 1937, No 499, p. 195; Sterling 1957, ill. 113,
p. 138; Ван Гог 1966, No 499, p. 360, ill. p. 176; De
La Faille 1970, No 417, p. 195; Antonova 1977, No 117

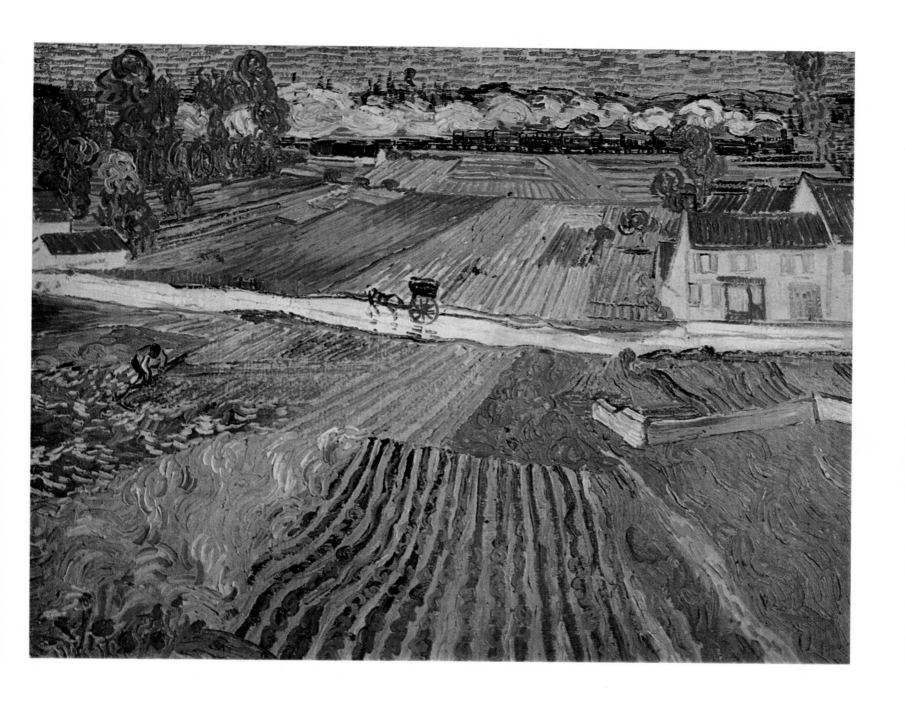

186 LANDSCAPE WITH CARRIAGE AND TRAIN
Oil on canvas. 72 × 90 cm. Inv. No 3374
The picture was painted at Auvers in July 1890, one
month before Van Gogh's death. A similar variant,
La Route près d'Auvers, is now in a private collec-
tion in New York.

Provenance: The Jo Van Gogh-Bönger Collection,
Amsterdam; The Bernheim Jeune Collection, Paris;
1909 The E. Druet Collection, Paris; 1909—18 The
I. Morozov Collection, Moscow; 1918—48 The Museum
of Modern Western Art, Moscow; since 1948 The
Pushkin Museum of Fine Arts, Moscow

Exhibitions: 1905 Amsterdam, Cat. 227; 1909 Paris;
1926 Moscow, Cat. 10; 1939 Moscow, Cat., p. 51;
1956 Leningrad, Cat., p. 12; 1960 Moscow, Cat., p. 11

Bibliography: Кат. ГМИИ 1957, p. 37; Кат. ГМИИ
1961, p. 53; Маковский 1912, pp. 15, 19; Ternovetz
1925, p. 478, ill. 481; Кат. ГМНЗИ 1928, No 85; De
La Faille 1928, vol. 1, p. 125, No 760, vol. 2, ill. 212;
Réau 1929, No 1148; Van Gogh 1937, No 651, p. 320;
Sterling 1957, ill. 120, pp. 148, 158; Прокофьев 1962,
ill. 150; Ван Гог 1966, No 641, p. 521, ill. p. 520;
ГМИИ 1966, No 97; De La Faille 1970, No 760, p. 293

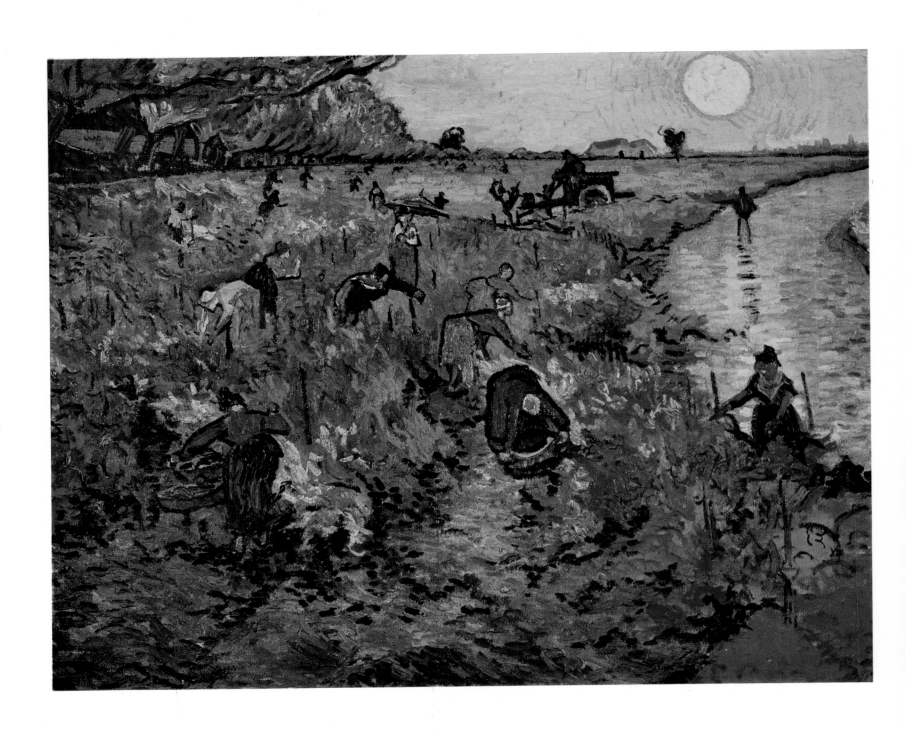

187 THE RED VINEYARD

Oil on canvas. 73 × 91 cm. Inv. No 3372

The picture was painted at Arles in November 1888. This dating is supported by Van Gogh's letters to his brother Théo (Nos 559, 561). A little earlier, in October 1888, the artist completed his *Champ de vignes (La Vigne verte)* (in the Kröller-Müller Museum, Otterloo), which differs from the Moscow canvas primarily in its color scale, dominated by green tones.

Provenance: The J. Tanguy Collection, Paris; 1891—1906/7 The A. Boch Collection, Brussels; The Collection of Prince de Wagram, Paris; The E. Druet Collection, Paris; 1909—18 The I. Morozov Collection, Moscow; 1918—48 The Museum of Modern Western Art, Moscow; since 1948 The Pushkin Museum of Fine Arts, Moscow

Exhibitions: 1890 Brussels; 1926 Moscow, Cat. 5; 1939 Moscow, Cat., p. 50; 1960 Moscow, Cat., p. 11; 1960 Paris (Musée Jacquemart-André)

Bibliography: Кат. ГМИИ 1957, p. 37; Кат. ГМИИ 1961, p. 53; Маковский 1912, p. 19; Ettinger 1926, part 2, p. 118, ill.; Кат. ГМНЗИ 1928, No 82; De La Faille 1928, vol. 1, p. 142, No 495, vol. 2, ill. 221; Réau 1929, No 1145; Van Gogh 1937, No 544, p. 247, No 559, p. 258, No 561, p. 259; Cahiers d'Art 1950, p. 348; Sterling 1957, ill. 115; Прокофьев 1962, ill. 152; Ван Гог 1966, No 544, p. 409, No 558, p. 424, No 561, p. 427, ill. p. 304; ГМИИ 1966, No 96; De La Faille 1970, No 495, p. 221; Antonova 1977, No 119

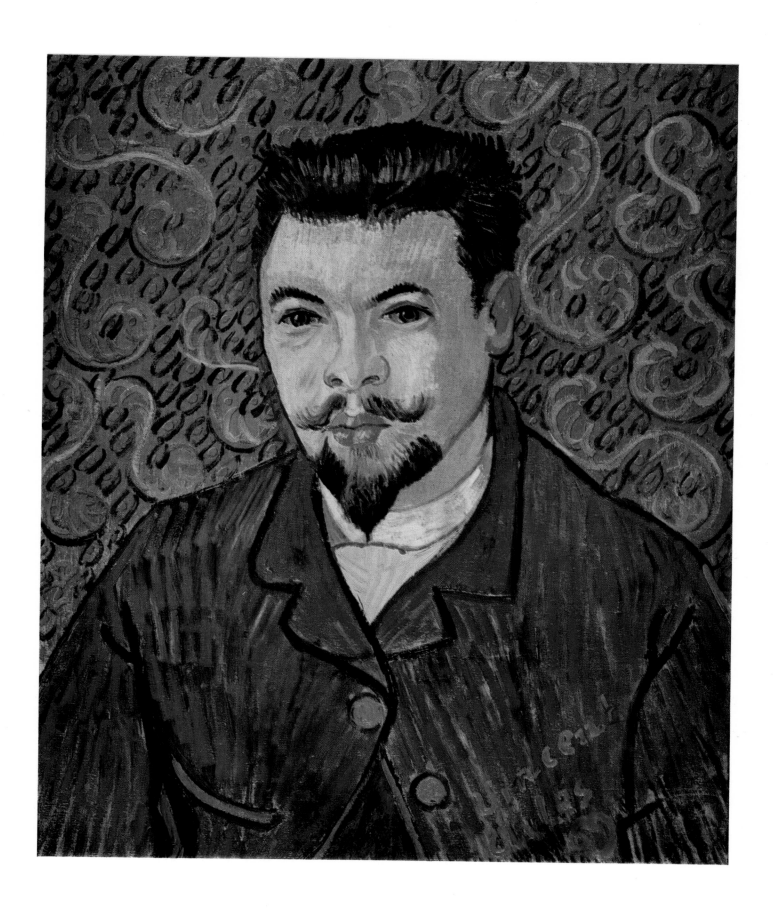

188 PORTRAIT OF DR REY. 1889
Oil on canvas. 64 × 53 cm. Inv. No 3272
Signed and dated lower right: *Vincent Arles 89*
Van Gogh painted this portrait in January 1889 at
Arles and presented it to Dr Félix Rey, who sold it
in 1900 to Ambroise Vollard. Van Gogh mentions
the portrait in his letters to Théo (Nos 568, 571).
In 1926 V. Sidorova identified the model as Dr Rey.

Provenance: 1889—1900 In the possession of Dr Rey,
Arles; 1900 The Ch. Camoin Collection, Paris; 1900
The A. Vollard Collection, Paris; The P. Cassirer
Collection, Berlin (No 3487); until 1908 The E. Druet
Collection, Paris (No 4285); 1908—18 The S. Shchu-
kin Collection, Moscow; 1918—48 The Museum of
Modern Western Art, Moscow; since 1948 The Push-
kin Museum of Fine Arts, Moscow

Exhibitions: 1909 Paris; 1926 Moscow, Cat. 7; 1956 Leningrad, Cat., p. 11; 1960 Paris (Musée Jacquemart-André), Cat. 49a; 1965 Bordeaux, Cat. 64; 1965—66 Paris, Cat. 61; 1966—67 Tokyo, Kyoto, Cat. 63

Bibliography: Кат. ГМИИ 1957, p. 37; Кат. ГМИИ 1961, p. 53; Кат. собр. С. Щукина 1913, No 33, pp. 8—9; Тугендхольд 1914, p. 39, ill. p. 52; Перцов 1921, No 33, p. 108; Тугендхольд 1923, ill. p. 38; Ternovetz 1925, p. 473, ill. 479; Ettinger 1926, part 2, p. 117, ill.; Кат. ГМНЗИ 1928, No 80; De La Faille 1928, vol. 1, p. 143, No 500, vol. 2, ill. 87; Réau 1929, No 1143; Van Gogh 1937, No 568, p. 265, No 571, p. 269; Cahiers d'Art 1950, p. 348; Sterling, 1957, ill. 117; Прокофьев 1962, ill. 149; Ван Гог 1966, No 568, p. 432, No 571, p. 435, ill. p. 368; De La Faille 1970, No 500, pp. 223, 631; Antonova 1977, No 120

189 THE PRISON COURTYARD

Oil on canvas. 80 × 64 cm. Inv. No 3373

The picture was painted by Van Gogh in February 1890 at Saint-Rémy, where he stayed in an asylum. It represents a free copy of Gustave Doré's drawing for the book *London* (the drawing was engraved for the book by N. Pisan). Van Gogh writes about his copying of *Newgate: The Exercise Yard* by Doré in his letter to Théo (No 626).

Provenance: The Jo Van Gogh-Bönger Collection, Amsterdam; The Mme Slavona Collection, Paris; The M. Fabre Collection, Paris; 1906 The E. Druet Collection, Paris (No 542); 1909 The Collection of Prince de Wagram, Paris; 1909 The E. Druet Collection, Paris; The I. Morozov Collection, Moscow; 1918—48 The Museum of Modern Western Art, Moscow; since 1948 The Pushkin Museum of Fine Arts, Moscow

Exhibitions: 1905 Paris, Cat. 14; 1909 Paris; 1926 Moscow, Cat. 8; 1956 Leningrad, Cat., p. 11; 1958 Brussels, Cat. 108; 1960 Paris (Musée Jacquemart-André), Cat. 6

Bibliography: Кат. ГМИИ 1957, p. 37, ill.; Кат. ГМИИ 1961, p. 53; Маковский 1912, pp. 15, 19; Ternovetz 1925, p. 476; Кат. ГМНЗИ 1928, No 83; De La Faille 1928, vol. 1, p. 190, No 669, vol. 2, ill. 187; Réau 1929, No 1146; Van Gogh 1937, No 623, p. 312, No 626, p. 313; Cahiers d'Art 1950, p. 348; Sterling 1957, ill. 118; Прокофьев 1962, ill. 148; Ван Гог 1966, No 626, p. 510, ill. p. 448; De La Faille 1970, No 669, p. 203; Antonova 1977, No 118

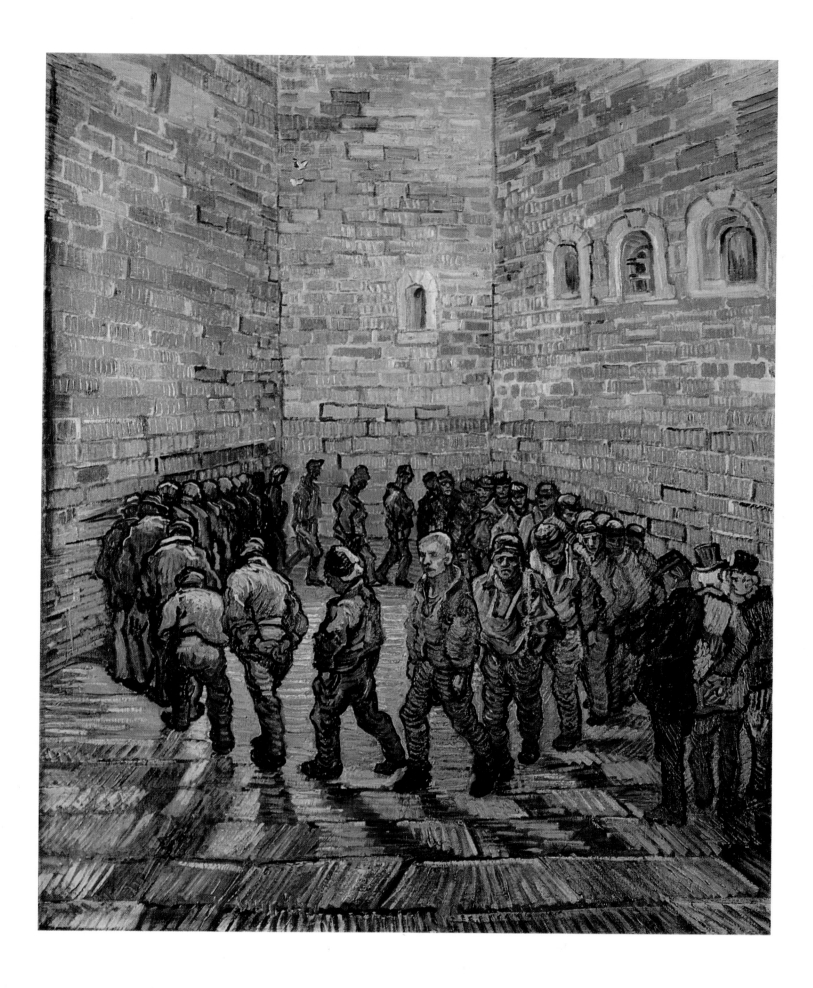

190 THE SINGER YVETTE GUILBERT.
Sketch. 1894
Tempera on cardboard. 57 × 42 cm. Inv. No 3446
Signed and dated lower left: *Lautrec 94*
Above the signature is a half-obliterated inscription:
A Arsène Alexandre

Yvette Guilbert (1867—1944) was one of Lautrec's favorite models. The Moscow work, which shows the actress performing the song *Linger, longer, loo*, was the first sketch for her portrait to be published in the review *Le Rire*. The portrait itself appeared in *Le Rire* (1894, No 7); printed in a small number of copies, it was sent as a bonus to the review's subscribers. The Moscow sketch was intended for Arsène Alexandre, the editor of the review, and remained with him until May 8, 1903, when his collection was sold at the Georges Petit Gallery. The sketch was acquired for the Bernheim Jeune Gallery (No 13183), and later was bought by Mikhail Morozov. In 1910 Morozov's widow presented the sketch to the Tretyakov Gallery in Moscow.

Provenance: until May 8, 1903 The A. Alexandre Collection, Paris; from May 8, 1903 The Bernheim Jeune Collection, Paris (No 13183); until 1910 The M. Morozov Collection, Moscow; 1910—25 The Tretyakov Gallery, Moscow; 1925—48 The Museum of Modern Western Art, Moscow; since 1948 The Pushkin Museum of Fine Arts, Moscow

Exhibitions: 1925 Moscow, Cat. 44; 1960 Moscow, Cat., p. 37

Bibliography: Кат. ГМИИ 1961, p. 182; Кат. галереи Третьяковых 1911, No 102; Кат. галереи Третьяковых 1917, No 3952; Кат. ГМНЗИ 1928, No 620; Réau 1929, No 1122; G. Mack, *Toulouse-Lautrec*, New York, 1938, p. 68; Cahiers d'Art 1950, p. 348; J. Lassaigne, *Toulouse-Lautrec*, Paris, 1953, p. 68; *Dictionnaire de la peinture moderne*, Paris, 1954, p. 294; Прокофьев 1962, ill. 167; Musée de Moscou 1963, p. 164, ill.; Antonova 1977, No 111

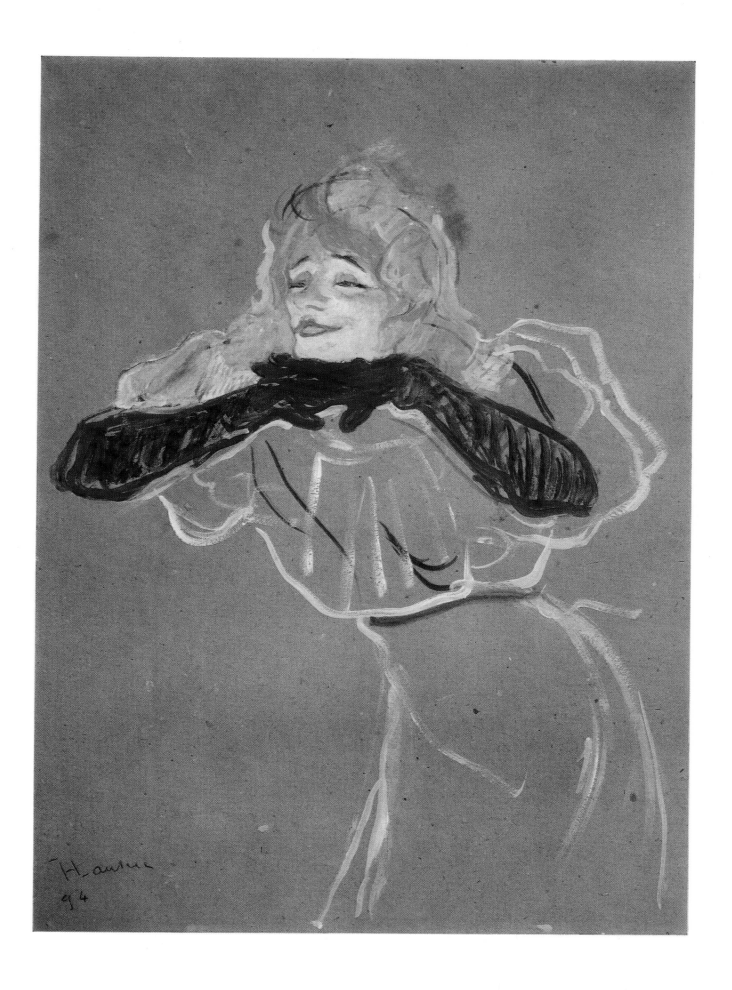

LOUIS LEGRAND. 1863—1951

191 THE APACHE'S SUPPER. 1901
Pastel and charcoal on paper. 63 × 49 cm. Inv. No 3388
Signed, dated and monogrammed upper right: *Louis Legrand, 1901*
The pastel of The Pushkin Museum was bought by Ivan Morozov in 1903 for 1,500 francs at the Salon de la Société Nationale des Beaux-Arts in Paris (No 350). Legrand made an engraving from this picture (in reverse) in the etching and dry-point technique.
Provenance: 1903—18 The I. Morozov Collection, Moscow; 1918—48 The Museum of Modern Western Art, Moscow; since 1948 The Pushkin Museum of Fine Arts, Moscow
Exhibitions: 1903 Paris (Salon des Indépendants), Cat. 350; 1925 Moscow, Cat. 41; 1960 Moscow, Cat., p. 24
Bibliography: Кат. ГМНЗИ 1928, No 239; Réau 1929, No 888

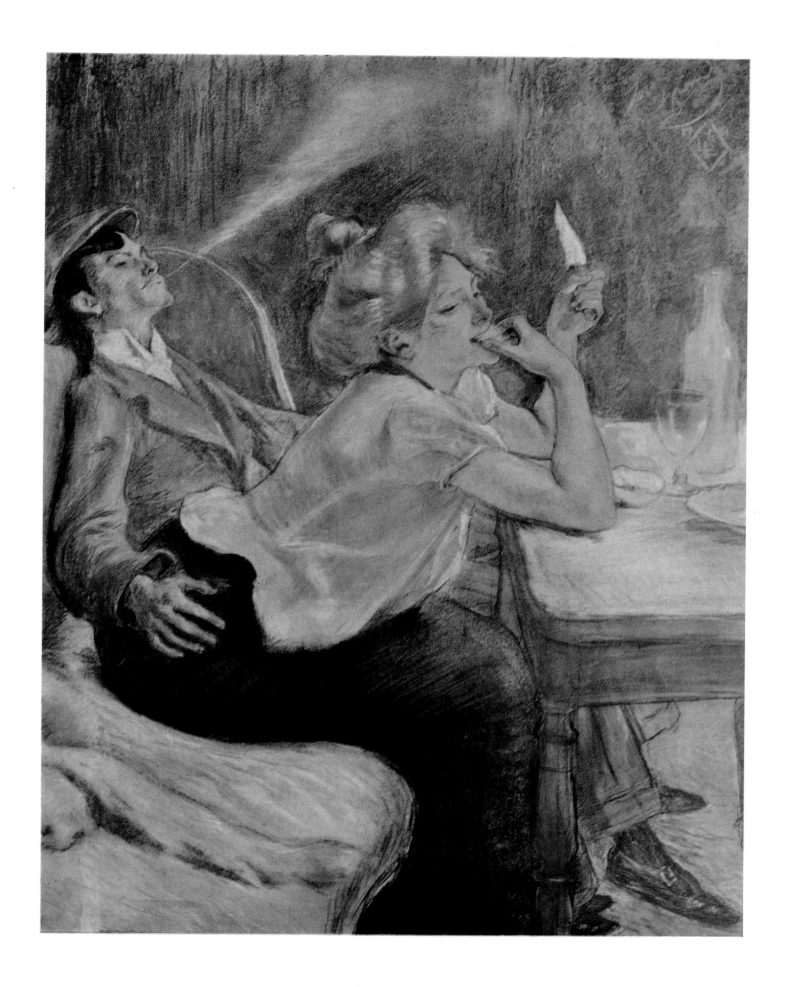

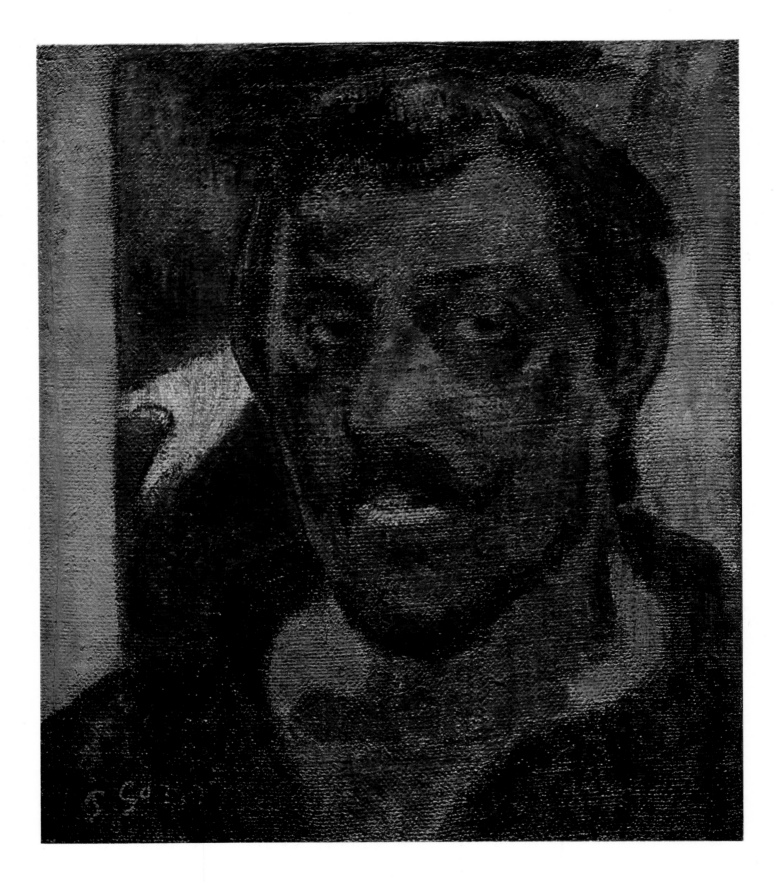

192 SELF-PORTRAIT
Oil on canvas. 46 × 37 cm. Inv. No 3264
Signed lower left: *PG O*
In 1903 Gauguin sent this picture to Daniel de Monfreid in Paris, asking him to show and sell it to Gustave Fayet. The picture is painted on the coarse, thick-grained canvas frequently used by Gauguin in the 1890s. Wildenstein and Rewald date it to 1888—90, F. Cachin to 1888. However, the picture is stylistically closer to Gauguin's works of the 1890s.

Provenance: The G. Fayet Collection, Paris (probably from 1903); until 1918 The S. Shchukin Collection, Moscow; 1918—48 The Museum of Modern Western Art, Moscow; since 1948 The Pushkin Museum of Fine Arts, Moscow

Exhibitions: 1906 Paris (Salon d'Automne); 1926 Moscow (Paul Gauguin), Cat. 2; 1966—67 Tokyo, Kyoto, Cat. 61

Bibliography: Кат. ГМИИ 1961, p. 54; Кат. собр. С. Щукина 1913, No 18, pp. 6—7; Тугендхольд 1914, p. 38, ill. p. 40; Перцов 1921, No 18, p. 108; Тугендхольд 1923, ill. p. 49; Ternovetz 1925, p. 472; Кат. ГМНЗИ 1928, No 88; Réau 1929, No 830; Cahiers d'Art 1950, p. 341; Wildenstein 1964, p. 110, No 297, ill.; Кантор-Гуковская 1965, ill.; Cachin 1968, p. 364

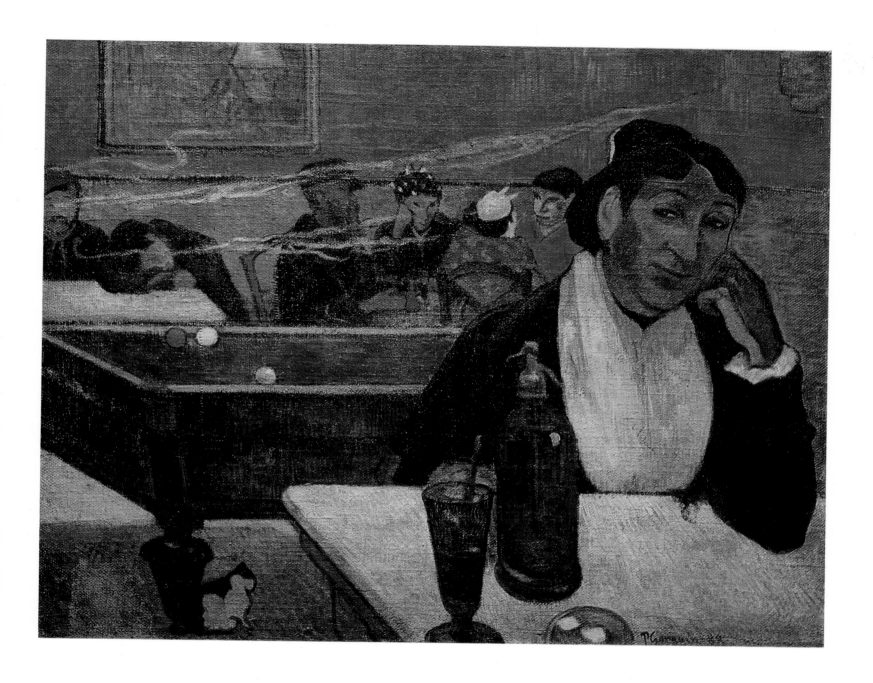

193 CAFÉ AT ARLES. 1888
 Oil on canvas. 72 × 92 cm. Inv. No 3367
 Signed and dated twice, lower right and lower left:
 P. Gauguin 88
 The picture was painted in November 1888 at Arles
 where Gauguin arrived on Van Gogh's invitation. It
 depicts the interior of a café owned by J. Ginoux,
 whose wife is also portrayed here. A preliminary
 drawing for the Moscow canvas portraying Mme Gi-
 noux is in the Hanley Collection (Bradford, Penn.,
 USA). Several oil copies of this drawing were made
 by Van Gogh. Gauguin describes *Café at Arles* in
 a letter to Emile Bernard dated November 1888, in
 which he mentions all the persons depicted, except
 for the postman Roulin, seated on the right; he can
 be recognized from a portrait painted by Van Gogh.
 An Arlésienne resembling Mme Ginoux figures in Gau-
 guin's picture of 1888, *An Old Arlésienne* (The Art
 Institute of Chicago), and the zincograph *The Spin-
 sters* (1889).

There are many sketches of Arlesian women resembl-
ing Mme Ginoux in Gauguin's notebooks (R. Huyghe,
Carnets de Gauguin, Paris, 1952, p. 19).

Provenance: until 1908 The A. Vollard Collection,
Paris; 1908—18 The I. Morozov Collection, Moscow;
1918—48 The Museum of Modern Western Art, Mos-
cow; since 1948 The Pushkin Museum of Fine Arts,
Moscow

Exhibitions: 1906 Berlin, Cat. 80; 1926 Moscow (Paul
Gauguin), Cat. 1; 1955 Moscow, Cat., p. 27; 1956
Leningrad, Cat., p. 16; 1960 Moscow, Cat., p. 12

Bibliography: Кат. ГМИИ 1957, p. 38; Кат. ГМИИ
1961, p. 53; Маковский 1912, pp. 15, 19; Ternovetz
1925, p. 471; Кат. ГМНЗИ 1928, 103; Réau 1929,
No 845; Malingue 1946, No LXXV; Cahiers d'Art 1950,
p. 341; Sterling 1957, ill. 101, p. 126; Прокофьев 1962,
ill. 153; Wildenstein 1964, pp. 113, 114, No 305, ill.;
Кантор-Гуковская 1965, pp. 71—73, ill.; Cachin 1968,
pp. 133—134, 364, ill. 61; Antonova 1977, No 112

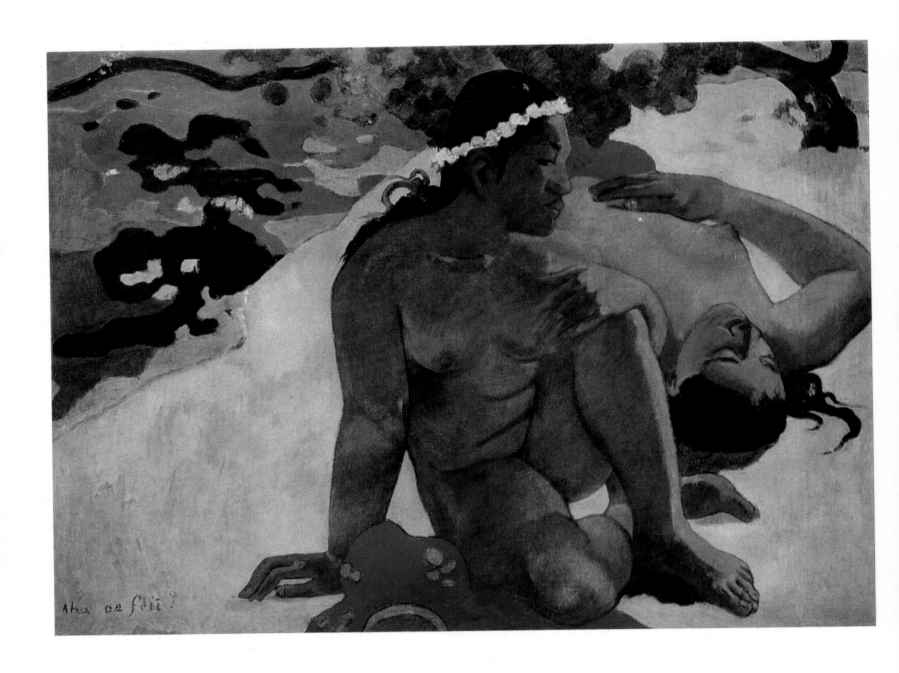

194 ARE YOU JEALOUS?
(AHA OE FEII?). 1892

Oil on canvas. 66 × 89 cm. Inv. No 3269
Signed and dated center right: *P. Gauguin 92*
Inscribed lower left: *Aha oe feii?*

Gauguin painted this picture during his first visit to
Tahiti. In December 1892 he sent it with several other
pictures to an exhibition in Denmark. In his letter of
December 8, 1892 Gauguin begs his wife not to sell
this canvas for less than 800 francs.

Gauguin describes this picture in his diary *Noa Noa*:
"On the shore, despite the heat, two sisters are lying
after bathing in the graceful poses of resting animals;
they speak of yesterday's love and the morrow's vic-
tories. The recollection causes them to quarrel: 'What!
Are you jealous?' "

Provenance: from 1895 The Leclanché Collection,
Paris; 1908—18 The S. Shchukin Collection, Moscow;
1918—48 The Museum of Modern Western Art, Mos-
cow; since 1948 The Pushkin Museum of Fine Arts,
Moscow

Exhibitions: 1893 Paris, Cat. 18; 1895 Paris (Hôtel
Drouot), Cat. 19; 1926 Moscow (Paul Gauguin), Cat. 7;
1955 Moscow, Cat., p. 27; 1956 Leningrad, Cat. p. 16;
1960 Moscow, Cat., p. 13

Bibliography: Кат. ГМИИ 1957, p. 38, ill; Кат. ГМИИ
1961, p. 54, ill.; Rotonchamp 1906, pp. 110, 114, 119
(No 18), 135; С. Маковский, "Проблемы 'тела' в жи-
вописи", *Аполлон*, 1910, p. 17; Кат. собр. С. Щукина
1913, No 26, pp. 26—27; Гоген 1914, p. 27; P. Gauguin,
Briefe an Georges Daniel de Monfreid, Potsdam,
1920, p. 99; Перцов 1921, No 26, p. 108; Тугендхольд
1923, p. 52, ill. p. 53; Ternovetz 1925, pp. 472, 476;
Кат. ГМНЗИ 1928, No 90; Réau 1929, No 832; Malin-
gue 1946, pp. 236—237; Sterling 1957, ill. 103; Про-
кофьев 1962, ill. 154; Wildenstein 1964, p. 186, No 461;
Кантор-Гуковская 1965, pp. 111—113, ill.; П. Гоген,
Письма. "Ноа-Ноа". Из книги "Прежде и потом",
Leningrad, 1972, ill. 8

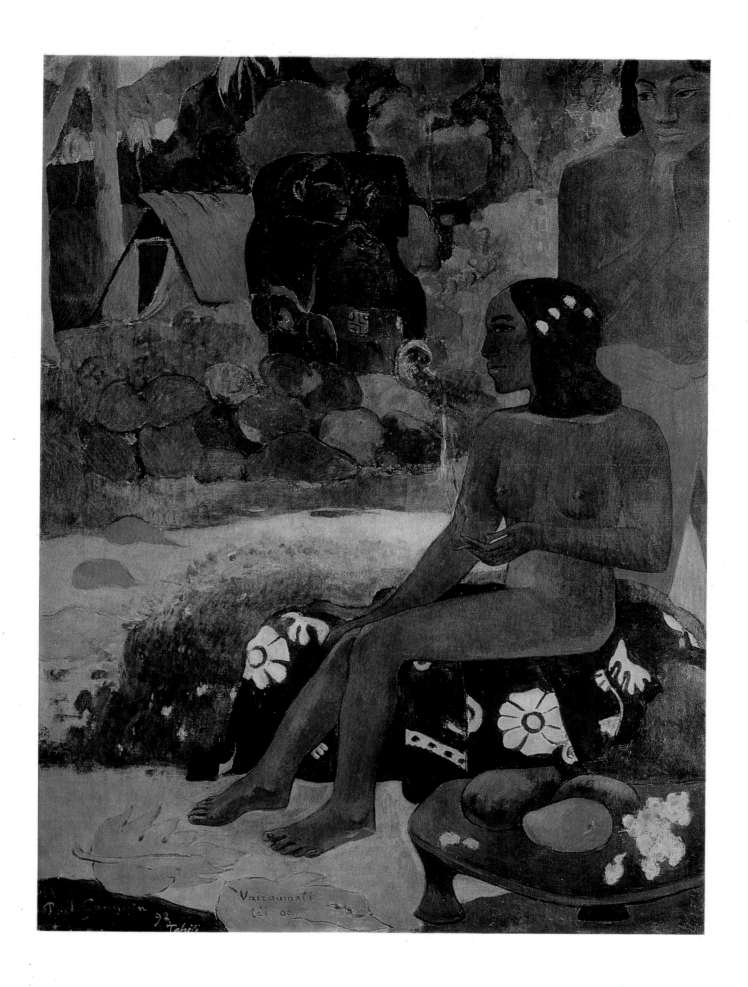

195 HER NAME IS VAÏRAUMATI
← (VAÏRAUMATI TEI OA). 1892
Oil on canvas. 91 × 68 cm. Inv. No 3266
Signed and dated lower left: *Paul Gauguin 92 Tahiti*
Inscribed bottom center: *Vaïraumati tei oa*
The picture was painted during Gauguin's first Ta-
hitian period. Vaïraumati is the heroine of a Maori
legend which Gauguin retells in *Noa Noa*. A variant
of the Moscow picture, dated the same year, is in
the William S. Paley Collection in New York. On the
evidence of John Rewald, the model for the New York
picture was Tehura, Gauguin's *vahiné*. The same
woman is apparently depicted in the Moscow picture.
Provenance: until 1918 The S. Shchukin Collection,
Moscow; 1918—48 The Museum of Modern Western
Art, Moscow; since 1948 The Pushkin Museum of Fine
Arts, Moscow

Exhibitions: 1893 Paris, Cat. 13; 1895 Paris (Hôtel
Drouot), Cat. 15; 1926 Moscow (Paul Gauguin), Cat. 6;
1955 Moscow, Cat., p. 27; 1956 Leningrad, Cat., p. 16;
1960 Moscow, Cat., p. 13

Bibliography: Кат. ГМИИ 1957, p. 38; Кат. ГМИИ
1961, p. 54; Rotonchamp 1906, pp. 119, 135; Кат.
собр. С. Щукина 1913, No 21, pp. 6—7; Гоген 1914,
pp. 106—109; Тугендхольд 1914, p. 38, ill. p. 49;
Перцов 1921, No 21, p. 108; Кат. ГМНЗИ 1928, No 89;
Réau 1929, No 831; Cahiers d'Art 1950, p. 341; Wil-
denstein 1964, pp. 179—180, No 450, ill.; Cachin 1968,
p. 364

196 LANDSCAPE WITH PEACOCKS. 1892
Oil on canvas. 115 × 86 cm. Inv. No 3369
Signed, inscribed and dated lower right: *Matamoe
P. Gauguin 92*

The picture was painted during Gauguin's first Tahi-
tian period. The Tahitian word *Matamoe* is usually
translated as *dead* or *alien*; in this latter meaning it
probably refers to the peacocks, which, according to
Maori legends, were not original inhabitants of the
islands. This is the first of Gauguin's works bought
by Ivan Morozov.

Provenance: 1895 The Collection of Paul Gauguin
and J. de Rotonchamp, Paris; The A. Seguin Collec-
tion, Paris; until 1907 The A. Vollard Collection,
Paris; 1907—18 The I. Morozov Collection, Moscow;
1918—48 The Museum of Modern Western Art, Mos-
cow; since 1948 The Pushkin Museum of Fine Arts,
Moscow

Exhibitions: 1893 Paris, Cat. 2; 1895 Paris (Hôtel
Drouot), Cat. 4; 1906 Paris (Salon d'Automne), Cat.
76; 1926 Moscow (Paul Gauguin), Cat. 8; 1939 Mos-
cow, Cat., pp. 21, 49; 1955 Moscow, Cat., p. 27; 1956
Leningrad, Cat., p. 16; 1967 Montreal, Cat. 89; 1974—
75 Paris (Grand Palais), Cat. 190 bis; 1975 Moscow

Bibliography: Кат. ГМИИ 1957, p. 38; Кат. ГМИИ
1961, p. 54; Rotonchamp 1906, pp. 119, 134; Гоген
1914, pp. 29—31; Маковский 1912, p. 20; Ternovetz
1925, p. 471, ill. p. 476; Кат. ГМНЗИ 1928, No 107;
Réau 1929, No 849; Cahiers d'Art 1950, p. 341; Musée
de Moscou 1963, p. 182, ill.; Wildenstein, 1964, pp.
195—196, No 484, ill.

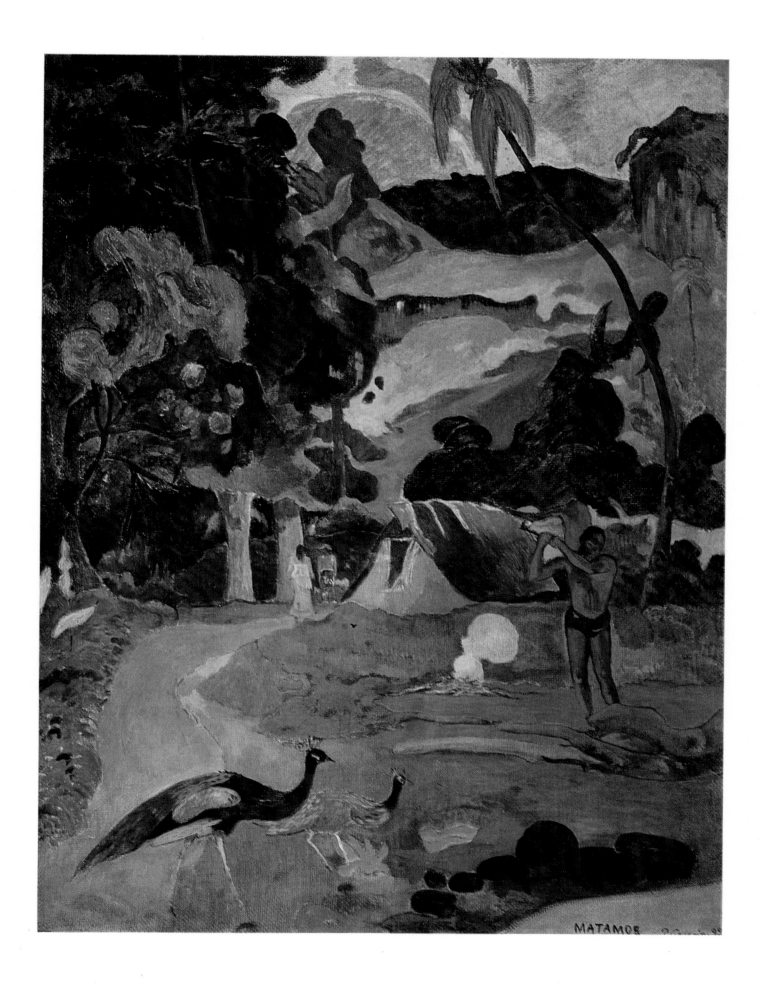

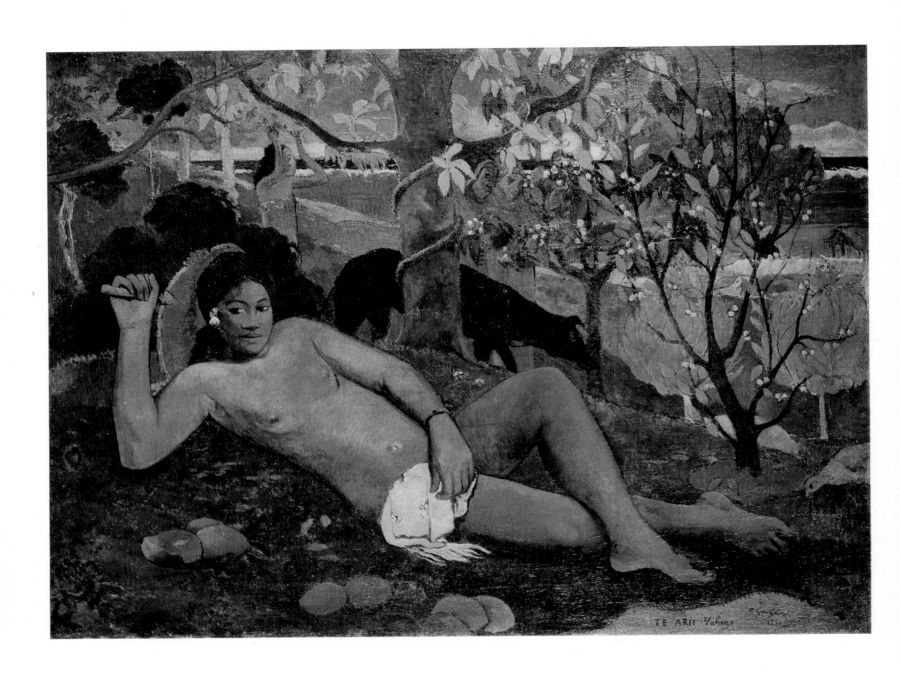

197 THE KING'S WIFE
(TE ARII VAHINÉ). 1896
Oil on canvas. 97 × 130 cm. Inv. No 3265
Signed, inscribed and dated lower right: *Te Arii Vahine. P. Gauguin 1896*
The picture was painted during Gauguin's second Tahitian period. According to Perruchot, the model for this canvas was Gauguin's *vahiné* Pau'ura. Describing the picture to Daniel de Monfreid, Gauguin wrote: "I think that in color I have never before achieved anything of such a majestic deep sonority." There is a watercolor done from the Moscow picture in the W. Chaney Collection in New York. A variant of the work (according to Wildenstein, a study for the Pushkin Museum canvas) is in the J. Thannhauser Collection in New York. Gauguin used the same subject in his woodcuts and wood sculptures.

Provenance: from 1903 The G. Fayet Collection, Paris; 1910—18 The S. Shchukin Collection, Moscow; 1918—48 The Museum of Modern Western Art, Moscow; since 1948 The Pushkin Museum of Fine Arts, Moscow

Exhibitions: 1906 Paris (Salon d'Automne), Cat. 13; 1926 Moscow (Paul Gauguin), Cat. 13; 1955 Moscow, Cat., p. 27; 1956 Leningrad, Cat., p. 17; 1958 Brussels, Cat. 98; 1960 Moscow, Cat., p. 13

Bibliography: Кат. ГМИИ 1957, p. 38; Кат. ГМИИ 1961, p. 54; Rotonchamp 1906, p. 138, ill. p. 170; С. Маковский, "Проблемы 'тела' в живописи", *Аполлон*, 1910, pp. 25—26; Кат. собр. С. Щукина 1913, No 19, pp. 6—7; Тугендхольд 1923, ill. p. 51; Ternovetz 1925, p. 472, ill. p. 477; Кат. ГМНЗИ 1928, No 91; Réau 1929, No 833; Malingue 1946, ill. 206; Cahiers d'Art 1950, p. 341; Sterling 1957, ill. 106; Прокофьев 1962, ill. 156; Musée de Moscou 1963, p. 184, ill.; Wildenstein 1964, pp. 223, 224, No 542, ill.; Кантор-Гуковская 1965, pp. 144—145, ill.; ГМИИ 1966, No 98; Cachin 1968, p. 332, ill. 196; П. Гоген, *Письма. "Ноа-Ноа". Из книги "Прежде и потом"*, Leningrad, 1972, pp. 74, 234; Antonova 1977, No 113

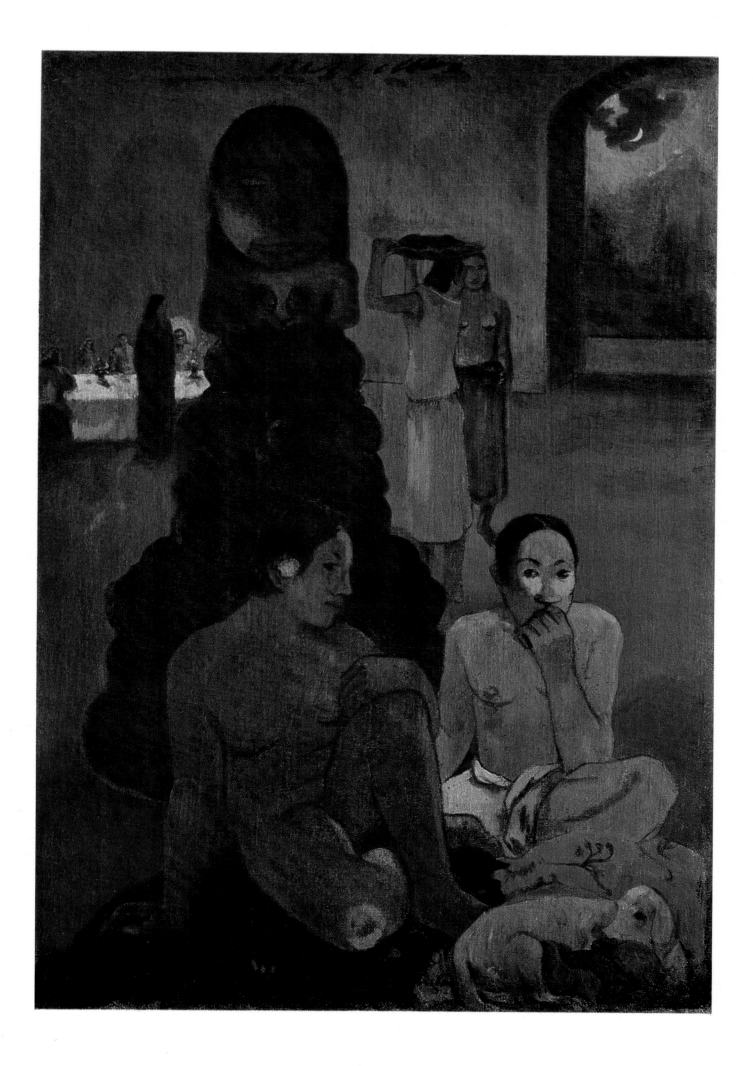

198 THE GREAT BUDDHA. 1899

← Oil on canvas. 134 × 95 cm. Inv. No 3368
Signed and dated lower left: *P. Gauguin/99*
The picture is stylistically typical of Gauguin's works
of the 1890s. After 1898 the artist frequently painted
many-figure scenes of a religious and philosophical
character (*The Last Supper*, 1899, in the Kathie Gra-
noff Collection, Paris). *The Great Buddha* was bought
by Ivan Morozov from Ambroise Vollard for 20,000
francs.

Provenance: The G. Fayet Collection, Paris; until 1908
The A. Vollard Collection, Paris; 1908—18 The I. Mo-
rozov Collection, Moscow; 1918—48 The Museum of
Modern Western Art, Moscow; since 1948 The Push-
kin Museum of Fine Arts, Moscow

Exhibitions: 1906 Paris (Salon d'Automne); 1926 Mos-
cow (Paul Gauguin), Cat. 25

Bibliography: Кат. ГМИИ 1961, p. 55; Маковский
1912, p. 20; Тугендхольд 1923, p. 54; Ternovetz 1925,
pp. 472, 473, ill.; Кат. ГМНЗИ 1928, No 112; Réau
1929, No 854; Cahiers d'Art 1950, p. 342; Wildenstein
1964, p. 243, No 579, ill.; В. Зиновьева, "Реставра-
ция картины П. Гогена *Великий Будда*", *Сообще-
ния ГМИИ*, 1966, 3, pp. 80—83; Cachin 1968, p. 364

199 LANDSCAPE. 1899

Oil on canvas. 94 × 73 cm. Inv. No 3263
Signed and dated lower left: *Paul Gauguin 99*
This picture was among the works Gauguin sent
from the island of Dominique to Europe shortly be-
fore his death.

Provenance: 1903 The A. Vollard Collection, Paris;
1905—18 The S. Shchukin Collection, Moscow; 1918—
48 The Museum of Modern Western Art, Moscow;
since 1948 The Pushkin Museum of Fine Arts, Moscow

Exhibitions: 1926 Moscow (Paul Gauguin), Cat. 21;
1965 Bordeaux, Cat. 61; 1965—66 Paris, Cat. 58

Bibliography: Кат. ГМИИ 1961, p. 54; Rotonchamp
1906, p. 189 (No 5); Кат. собр. С. Щукина 1913,
No 17, pp. 6—7; Тугендхольд 1914, p. 38, ill. p. 48;
Grautoff 1919, ill. p. 91; Перцов 1921, No 17, p. 108;
Тугендхольд 1923, ill. p. 55; Ternovetz 1925, p. 41;
Кат. ГМНЗИ 1928, No 97; Réau 1929, No 839; Cahiers
d'Art 1950, p. 341; Wildenstein 1964, p. 249, No 589,
ill.; Cachin 1968, p. 364

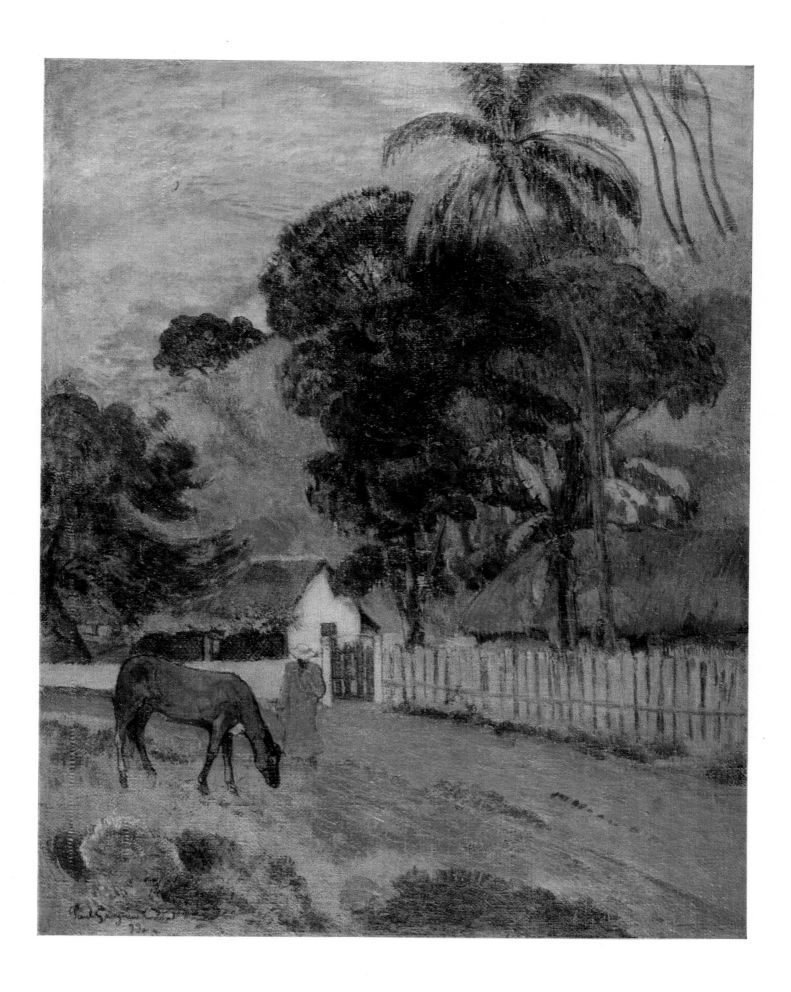

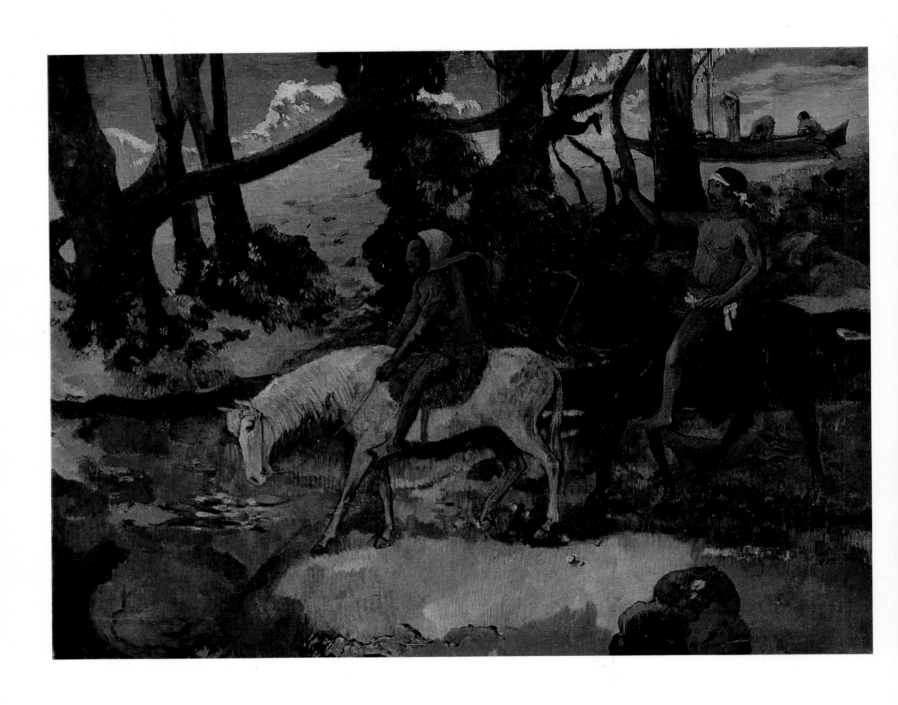

200 THE FORD (FLIGHT). 1901
Oil on canvas. 76 × 95 cm. Inv. No 3270
Signed and dated lower right: *Paul Gauguin 1901*
The picture was painted on the island of Dominique and sent by Gauguin in April 1903 to Daniel de Monfreid to be sold.

Provenance: until 1906 The D. de Monfreid Collection, Paris; 1906 The G. Fayet Collection, Paris; until 1918 The S. Shchukin Collection, Moscow; 1918—48 The Museum of Modern Western Art, Moscow; since 1948 The Pushkin Museum of Fine Arts, Moscow

Exhibitions: 1906 Paris (Salon d'Automne), Cat. 22; 1926 Moscow (Paul Gauguin), Cat. 28; 1958 Brussels, Cat. 99; 1960 Moscow, Cat., p. 13

Bibliography: Кат. ГМИИ 1957, p. 38; Кат. ГМИИ 1961, p. 55; Кат. собр. С. Щукина 1913, No 31, pp. 8—9; Тугендхольд 1914, p. 39, ill. p. 46; Grautoff 1919, ill. p. 92; Перцов 1921, No 31, p. 108; Тугендхольд 1923, ill. p. 54; Ternovetz 1925, pp. 472, 475, ill.; Кат. ГМНЗИ 1928, No 102; Réau 1929, No 844; Wildenstein 1964, p. 254, No 597, ill.; Кантор-Гуковская 1965, p. 173, ill.; ГМИИ 1966, No 99; Cachin 1968, p. 364; Antonova 1977, No 115

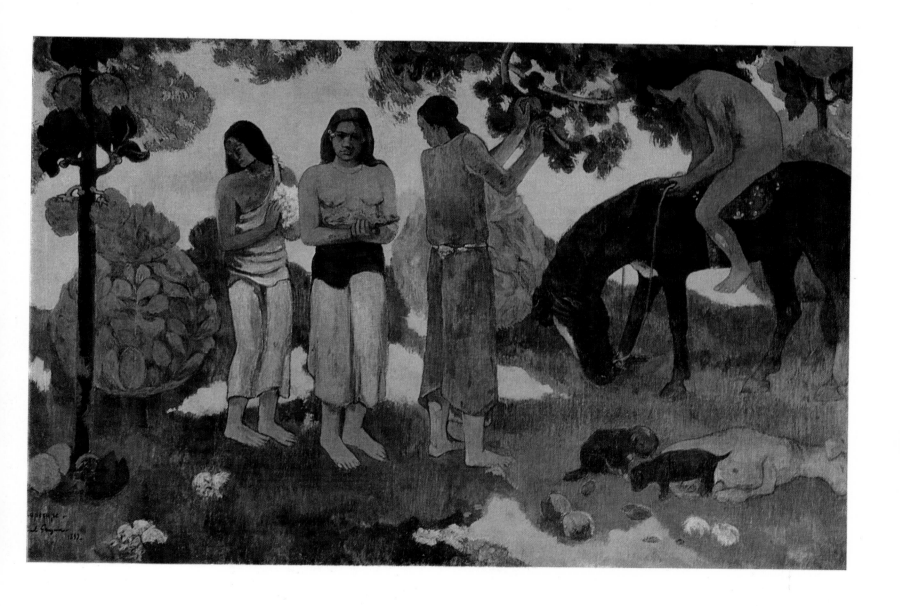

201 GATHERING FRUIT. 1899

Oil on canvas. 130 × 190 cm. Inv. No 3268

Signed, inscribed and dated lower left: *Ruperure, Paul Gauguin 1899*

The picture in part repeats the large panel of 1898, *Preparations for a Feast* (Tate Gallery, London). Gauguin also used this subject in his woodcuts, monotypes and drawings (the latter for his manuscript *Avant et après*). In 1903 the artist sent *Gathering Fruit* to Daniel de Monfreid in Paris, asking him to sell it to Georges Fayet (Gauguin's letter to Monfreid, December 21, 1903).

Provenance: The G. Fayet Collection, Paris (evidently from 1903); 1913—18 The S. Shchukin Collection, Moscow; 1918—48 The Museum of Modern Western Art, Moscow; since 1948 The Pushkin Museum of Fine Arts, Moscow

Exhibitions: 1926 Moscow (Paul Gauguin), Cat. 22; 1955 Moscow, Cat., p. 27; 1956 Leningrad, Cat., p. 17

Bibliography: Кат. ГМИИ 1957, p. 38; Кат. ГМИИ 1961, p. 54; Кат. собр. С. Щукина 1913, No 24, pp. 8—9; Тугендхольд 1914, p. 38, ill. p. 50; Grautoff 1919, ill. p. 90; Перцов 1921, No 24, p. 108; Тугендхольд 1914, p. 48; Ternovetz 1925, ill. p. 475; Кат. ГМНЗИ 1928, No 98; Réau 1929, No 840; Cahiers d'Art 1950, p. 341; Wildenstein 1964, p. 247, No 585, ill.

202 PARROTS. 1902
Oil on canvas. 62 × 76 cm. Inv. No 3371
Signed and dated: *Paul Gauguin 1902*
The picture was painted on the island of Dominique.
A variant of the same year is in the collection of
E. von der Heidt at Ascona (Switzerland). Bengt
Danielsson believes that the still life was painted
during the artist's illness, when he was not able
to leave the house, and that the sculpture of Buddha
depicted in it is an earlier work by Gauguin.

Provenance: The G. Fayet Collection, Paris; until 1910
The E. Druet Collection, Paris; 1910—18 The I. Mo-
rozov Collection, Moscow; 1918—48 The Museum of
Modern Western Art, Moscow; since 1948 The Push-
kin Museum of Fine Arts, Moscow

Exhibitions: 1906 Paris (Salon d'Automne), Cat. 15;
1926 Moscow (Paul Gauguin), Cat. 29; 1955 Moscow,
Cat., p. 28; 1956 Leningrad, Cat., p. 17

Bibliography: Кат. ГМИИ 1957, p. 39; Кат. ГМИИ
1961, p. 55; Тугендхольд 1923, p. 50; Ternovetz 1925,
pp. 472, 474, ill.; Кат. ГМНЗИ 1928, No 113; Réau
1929, No 855; Cahiers d'Art 1950, p. 342; Sterling
1957, ill. 110; Musée de Moscou 1963, p. 185, ill.;
Wildenstein 1964, p. 267, No 629; Cachin 1968, p. 364

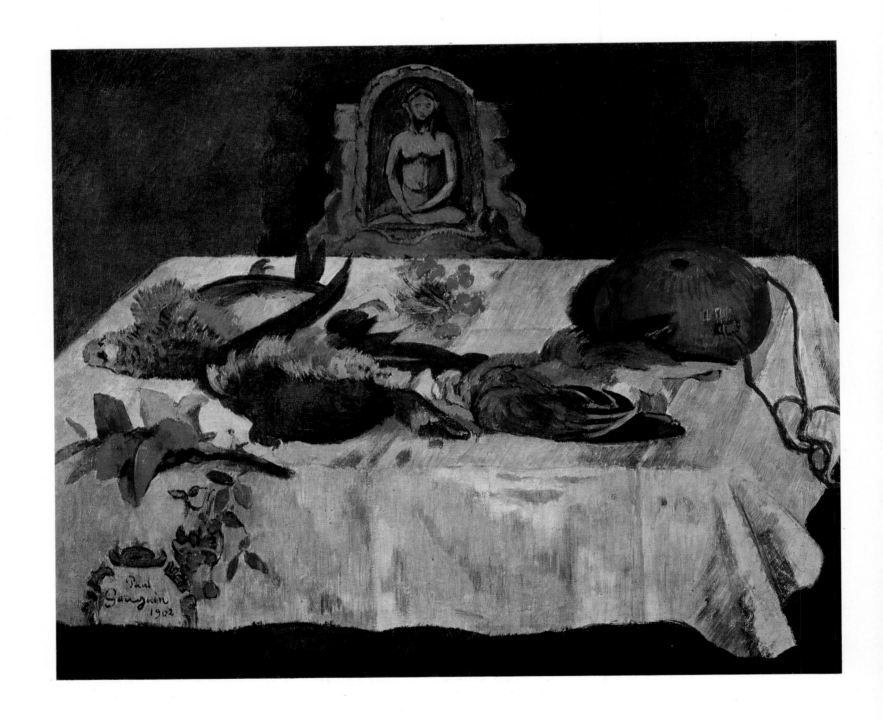

203 TWO CATS
Tempera on unprimed canvas. 61 × 64 cm. Inv. No 3463
Signed lower left: *Steinlen*
This canvas represents a sketch for the poster for
the Steinlen exhibition of 1894 and is also a variant
of a color lithograph. It may be dated 1894.

Provenance: until 1918 The Z. Domashneva Collection,
Moscow; 1921—28 The Tretyakov Gallery, Moscow;
1928—48 The Museum of Modern Western Art, Mos-
cow; since 1948 The Pushkin Museum of Fine Arts,
Moscow

Exhibition: 1960 Moscow, Cat., p. 35

204 SPRING IN PROVENCE. 1903
 Oil on canvas mounted on cardboard. 26.5 × 35 cm.
 Inv. No 3419
 Signed and dated lower left: *P. Signac. 03*
 This picture is also known as *A Cottage* and is close
 to *Almond Trees in Blossom*, in the G. Signac Col-
 lection. M. J. Chartrain-Hebbelinck points out that the
 Moscow canvas, under the title *A Cottage at Saint-
 Tropez*, was included in the exhibition *The Inter-
 pretation of the South* in Brussels in 1913.
 Provenance: 1906—18 The I. Morozov Collection, Mos-
 cow; 1918—48 The Museum of Modern Western Art,
 Moscow; since 1948 The Pushkin Museum of Fine Arts,
 Moscow

 Exhibitions: 1906 Paris (Salon des Indépendants);
 1913 Brussels; 1939 Moscow, Cat. 78; 1960 Moscow,
 Cat., p. 35

 Bibliography: Маковский 1912, p. 23; Кат. ГМНЗИ
 1928, No 576; Réau 1929, No 1102; M. J. Chartrain-
 Hebbelinck, "Les Lettres de Paul Signac à Octave
 Maus", *Bulletin des Musées Royaux des Beaux-Arts
 de Belgique*, 1969, 1—2, p. 93, ill. 20

205 THE PINE TREE. SAINT-TROPEZ. 1909
Oil on canvas. 72 × 92 cm. Inv. No 3341
Signed and dated lower right in green paint: *P. Signac 1909*

During 1907—9 Signac often turned to this motif. A slightly different landscape, *The Bay*, was painted in 1907. There are two watercolors and pencil sketches of *Le Pin Bertaud* in private collections in Paris.

Provenance: 1913—18 The S. Shchukin Collection, Moscow; 1918—48 The Museum of Modern Western Art, Moscow; since 1948 The Pushkin Museum of Fine Arts, Moscow

Exhibitions: 1910 Paris (Salon des Indépendants), Cat. 4753; 1939 Moscow, Cat., p. 52; 1960 Moscow, Cat., p. 35

Bibliography: Кат. ГМИИ 1957, p. 129; Кат. ГМИИ 1961, p. 170; Кат. собр. С. Щукина 1913, No 212, pp. 48—49; Тугендхольд 1914, p. 46; Перцов 1921, No 212, p. 115; Кат. ГМНЗИ 1928, No 575; Réau 1929, No 1101; Прокофьев 1962, ill. 169; M. J. Chartrain-Hebbelinck, "Les Lettres de Paul Signac à Octave Maus", *Bulletin des Musées Royaux des Beaux-Arts de Belgique*, 1969, 1—2, p. 87, ill. 16 (entitled *Le Pin Bertaud — Saint-Tropez*)

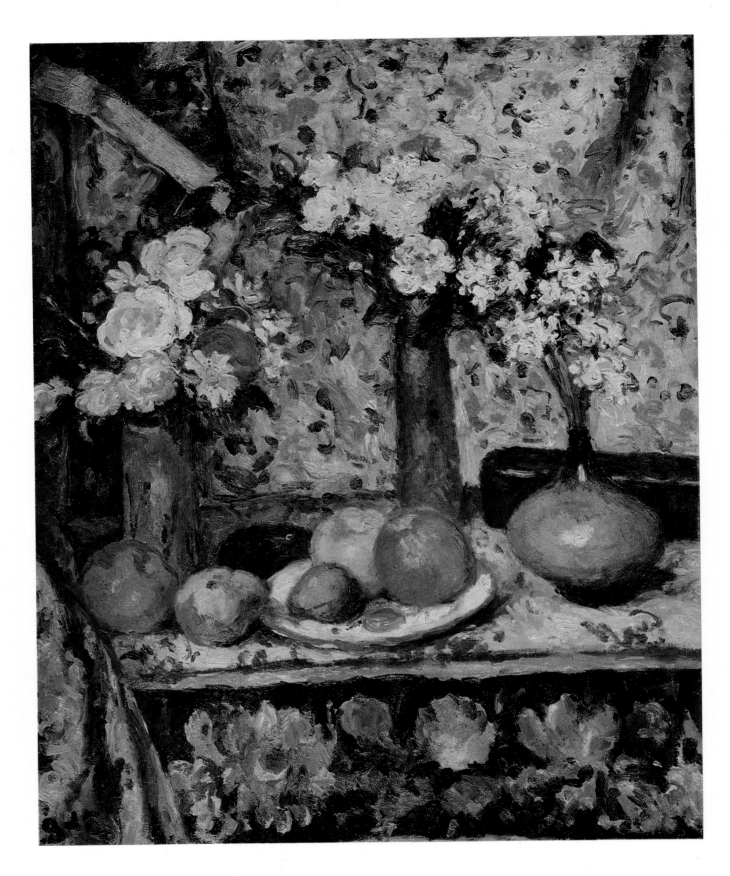

206 FLOWERS AND FRUIT
Oil on canvas. 81 × 65 cm. Inv. No 3425
Monogrammed left: *GdE*

Provenance: until 1907 The P. Durand-Ruel Collection, Paris; 1907—18 The I. Morozov Collection, Moscow; 1918—48 The Museum of Modern Western Art, Moscow; since 1948 The Pushkin Museum of Fine Arts, Moscow

Exhibitions: 1907 Paris (Salon d'Automne); 1939 Circulating Exhibition, Cat. 84

Bibliography: Маковский 1912, p. 24; Кат. ГМНЗИ 1928, No 671; Réau 1929, No 811

207 LANDSCAPE WITH A HOUSE
Oil on canvas. 61 × 79 cm. Inv. No 3384
Signed lower right: *Henri Edmond Cross*
The picture was bought by Ivan Morozov from Bernheim Jeune in Paris in 1907.

Provenance: until 1907 The Bernheim Jeune Collection, Paris; 1907—18 The I. Morozov Collection, Moscow; 1918—48 The Museum of Modern Western Art, Moscow; since 1948 The Pushkin Museum of Fine Arts, Moscow

Exhibition: 1907 Paris

Bibliography: Маковский 1912, p. 21; Кат. ГМНЗИ 1928, No 220; Réau 1929, No 761 (entitled *Autour de la maison*)

208 A SQUARE IN PARIS. 1907
Oil on cardboard. 104 × 80 cm. Inv. No 3381
Signed and dated lower left: *Dufrenoy 1907*
The picture was bought by Ivan Morozov from the
Golden Fleece exhibition in Moscow in 1908.

Provenance: 1908—18 The I. Morozov Collection, Moscow; 1918—43 The Museum of Modern Western Art, Moscow; since 1948 The Pushkin Museum of Fine Arts, Moscow

Exhibition: 1908 Moscow, Cat. 61

Bibliography: Золотое Руно 1908, p. 17, ill.; Кат. ГМНЗИ 1928, No 185; Réau 1929, No 809

CHARLES GUÉRIN. 1875—1939

209 ON THE TERRACE
Oil on canvas mounted on cardboard. 17 × 29 cm.
Inv. No 3557
Signed lower right: *Ch G*
The picture was apparently painted around 1904—7,
during Guérin's association with the Fauves.

Provenance: until 1945 The Z. Beloborodova Collection,
Moscow; 1945—48 The Museum of Modern Western
Art, Moscow; since 1948 The Pushkin Museum of
Fine Arts, Moscow

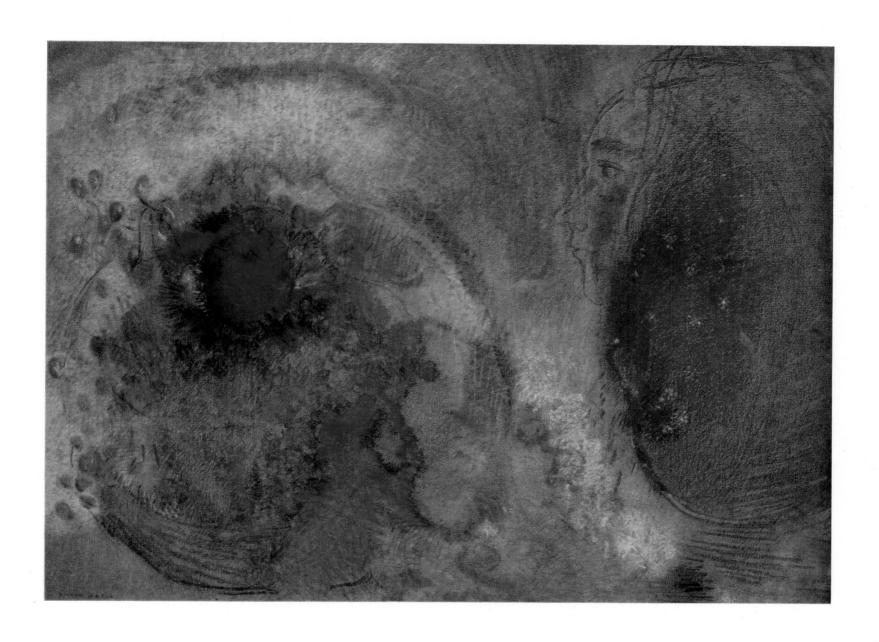

210 NIGHT AND DAY
Pastel on cardboard. 47 × 61 cm. Inv. No 3451
Signed lower left: *Odilon Redon*

Provenance: The Tolstoi Collection, Moscow(?); until
1925 The A. Strelkov Collection, Moscow; 1925—48
The Museum of Modern Western Art, Moscow; since
1948 The Pushkin Museum of Fine Arts, Moscow

Bibliography: Кат. ГМНЗИ 1928, No 496; Réau 1929,
No 1067

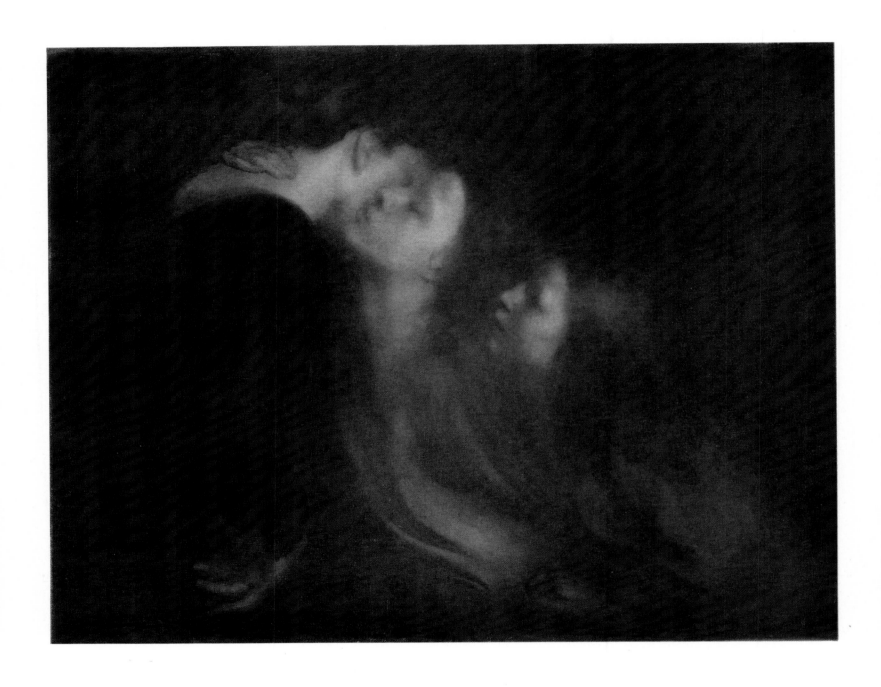

211 THE MOTHER'S KISS
Oil on canvas. 94 × 120 cm. Inv. No 3444
Signed lower left: *Eugène Carrière*

Provenance: until 1910 The M. Morozov Collection, Moscow; 1910—25 The Tretyakov Gallery, Moscow; 1925—48 The Museum of Modern Western Art, Moscow; since 1948 The Pushkin Museum of Fine Arts, Moscow

Exhibition: 1960 Moscow, Cat., p. 20

Bibliography: *Мир искусства*, 1903, 1—2, p. 65, ill.; Кат. галереи Третьяковых 1911, No 98; Кат. галереи Третьяковых 1917, No 3944; Кат. ГМНЗИ 1928, No 205; Réau 1929, No 724 (entitled *Caresse*)

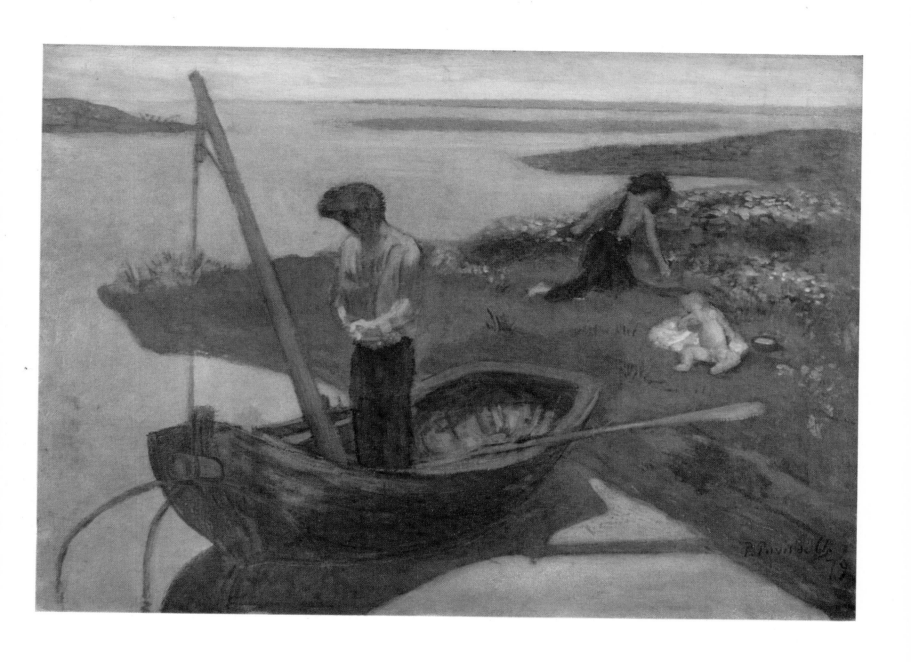

212 THE POOR FISHERMAN. Sketch. 1879
Oil on canvas. 66 × 91 cm. Inv. No 3324
Signed and dated lower right: *P. Puvis de Ch. 79*
The picture represents a sketch for the similarly en-
titled composition of 1831, now in The Louvre, Paris
(No RF 506).

Provenance: 1891—1900 The P. Durand-Ruel Collec-
tion, Paris; 1900—18 The S. Shchukin Collection,
Moscow; 1918 — 48 The Museum of Modern Western
Art, Moscow; since 1948 The Pushkin Museum of
Fine Arts, Moscow

Exhibitions: 1955 Moscow, Cat., p. 53; 1956 Lenin-
grad, Cat., p. 51; 1960 Moscow, Cat., p. 30

Bibliography: Кат. собр. С. Щукина 1913, No 185,
pp. 40—41; Тугендхольд 1914, p. 44, ill. p. 8; Пер-
цов 1921, No 185, p. 114; Тугендхольд 1923, p. 60,
ill. p. 59; Кат. ГМНЗИ 1928, No 469; Réau 1929,
No 1054

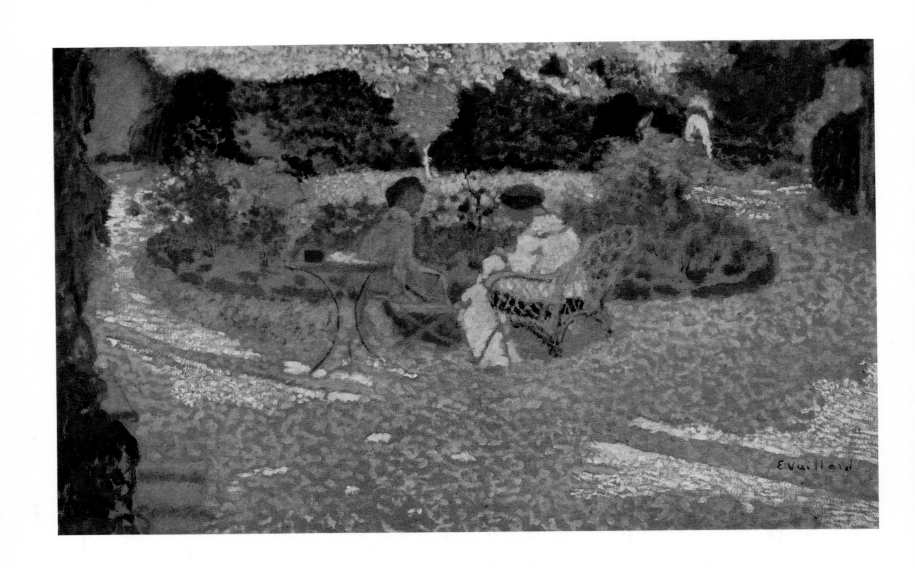

213 IN THE GARDEN
Tempera on cardboard. 51 × 83 cm. Inv. No 3447
Signed lower right: *E. Vuillard*
The Pushkin Museum picture can be dated to 1894—
95, a period when Vuillard worked on the *Gardens
of Paris* series, having painted nine decorative pan-
els on this subject for the house of Alexandre Na-
tanson in Paris.

Provenance: until 1918 The S. Shcherbatov Collection,
Moscow; 1918—24 The Rumiantsev Museum, Moscow;
1924—25 The Museum of Fine Arts, Moscow; 1925—
48 The Museum of Modern Western Art, Moscow;
since 1948 The Pushkin Museum of Fine Arts, Moscow

Exhibitions: 1939 Moscow, Cat., p. 52; 1968 Paris,
Cat. 55

Bibliography: Кат. ГМИИ 1961, p. 46; Кат. ГМНЗИ
1928, No 58; Réau 1929, No 1159; Cahiers d'Art 1950,
p. 348; Musée de Moscou 1963, p. 194, ill.

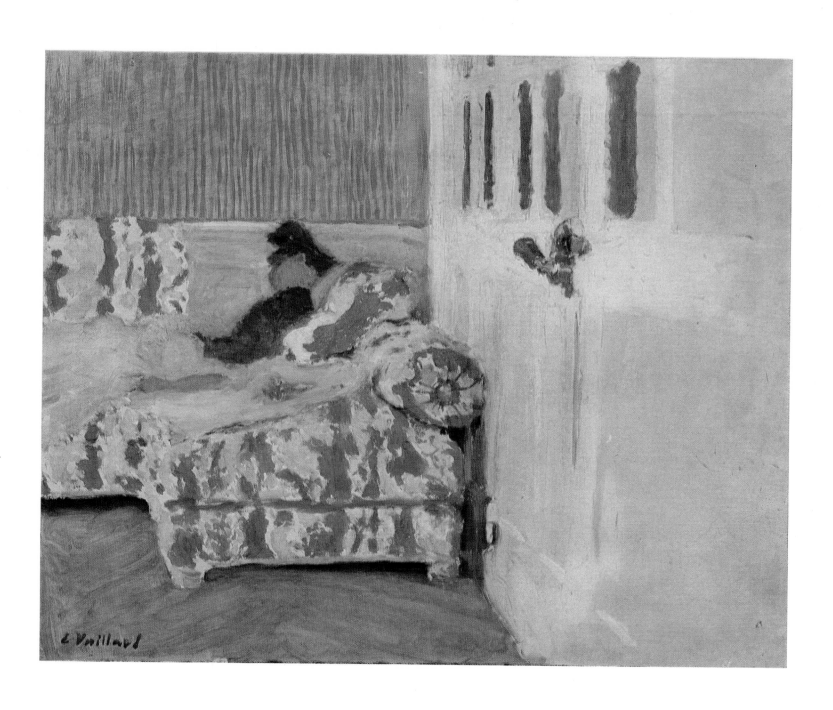

214 ON THE SOFA (THE WHITE ROOM)
Oil on cardboard mounted on panel. 32 × 38 cm.
Inv. No 3441
Signed lower left: *E. Vuillard*

Provenance: The Bernheim Jeune Collection, Paris;
until 1918 The A. Liapunov Collection, Moscow; 1918—
25 The Tretyakov Gallery, Moscow; 1925—48 The
Museum of Modern Western Art, Moscow; since 1948
The Pushkin Museum of Fine Arts, Moscow

Bibliography: Кат. ГМИИ 1961, p. 46; Золотое Руно
1908, p. 23, ill.; Кат. ГМНЗИ 1928, No 59; Réau
1929, No 1160; Cahiers d'Art 1950, p. 348; Sterling
1957, ill. 134

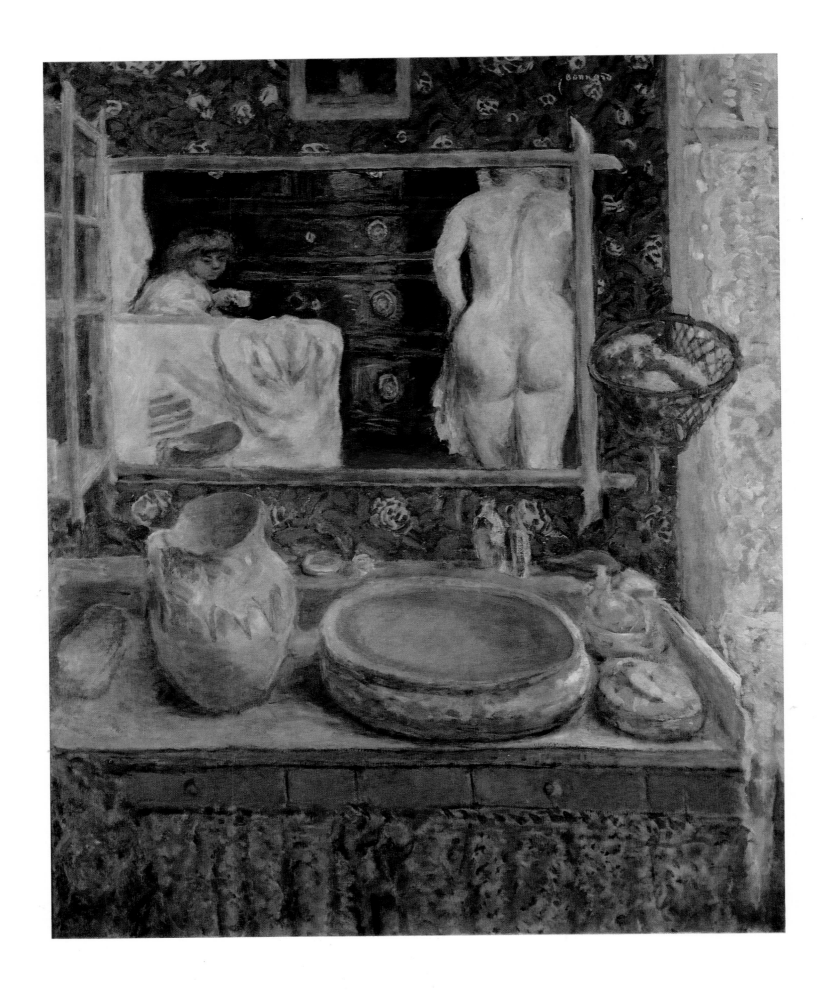

215 MIRROR IN THE DRESSING ROOM
← Oil on canvas. 120 × 97 cm. Inv. No 3355
Signed upper right: *Bonnard*
Inscribed on the reverse: *Glace cabinet de toilette.
Ne pas vernir. P. Bonnard*
According to a note in the manuscript catalogue of
The Museum of Modern Western Art compiled by Ter-
novetz, this was one of the favorite works of the
Russian painter Valentin Serov. The canvas may be
dated around 1908. A picture on the same motif en-
titled *Mirror in a Green Room* (1909) is in the
John Herron Art Museum, Indianapolis (USA). The
interior depicted in the Moscow canvas is close to

that in *Nude against the Light. Eau-de-Cologne*
(Musées Royaux des Beaux-Arts, Brussels).

Provenance: 1908 The Bernheim Jeune Collection, Par-
is; 1908—18 The I. Morozov Collection, Moscow; 1918—
48 The Museum of Modern Western Art, Moscow;
since 1948 The Pushkin Museum of Fine Arts, Moscow

Exhibitions: 1908 Paris (Salon d'Automne), Cat. 184;
1965 Bordeaux, Cat. 75; 1965—66 Paris, Cat. 73

Bibliography: Кат. ГМИИ 1961, p. 21; Маковский
1912, p. 19; Кат. ГМНЗИ 1928, No 21; Réau 1929,
No 705; Cahiers d'Art 1950, p. 192, ill.; Antonova
1977, No 126

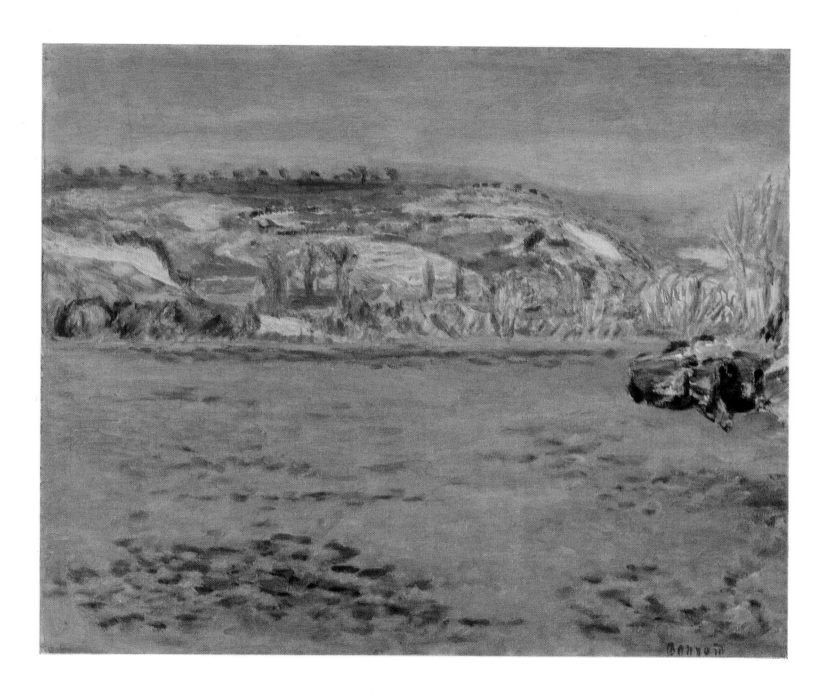

216 THE SEINE AT VERNON
Oil on canvas. 51 × 60.5 cm. Inv. No 3357
Signed lower right: *Bonnard*
The picture was painted around 1911.

Provenance: until 1913 The Bernheim Jeune Collection,
Paris; 1913—18 The I. Morozov Collection, Moscow;
1918—48 The Museum of Modern Western Art, Mos-
cow; since 1948 The Pushkin Museum of Fine Arts,
Moscow

Bibliography: Кат. ГМИИ 1961, p. 21; Кат. ГМНЗИ
1928, No 25; Réau 1929, No 708

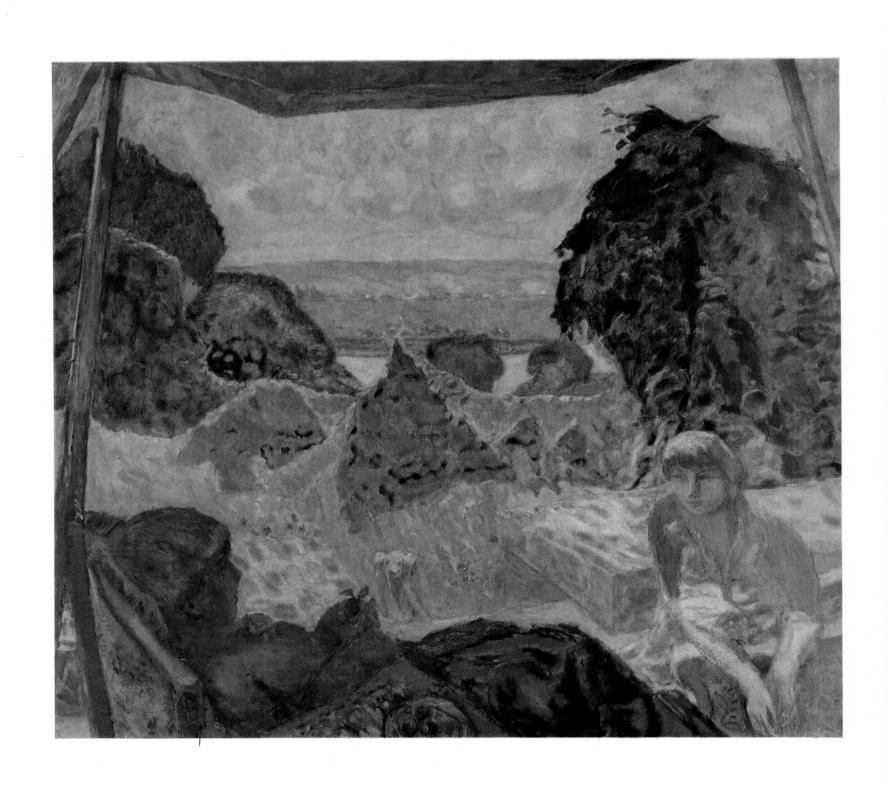

217 SUMMERTIME IN NORMANDY

Oil on canvas. 114 × 128 cm. Inv. No 3356

Signed lower right: *Bonnard*

Painted around 1911—12, the picture was bought by Ivan Morozov from E. Druet for 6,000 francs.

Provenance: until 1913 The E. Druet Collection, Paris; 1913—18 The I. Morozov Collection, Moscow; 1918—48 The Museum of Modern Western Art, Moscow; since 1948 The Pushkin Museum of Fine Arts, Moscow

Exhibitions: 1913 Paris; 1939 Moscow, Cat., p. 52; 1972 Prague, Cat. 2

Bibliography: Кат. ГМИИ 1961, p. 21; Réau 1929, No 706; ГМИИ 1966, No 111; Antonova 1977, No 125

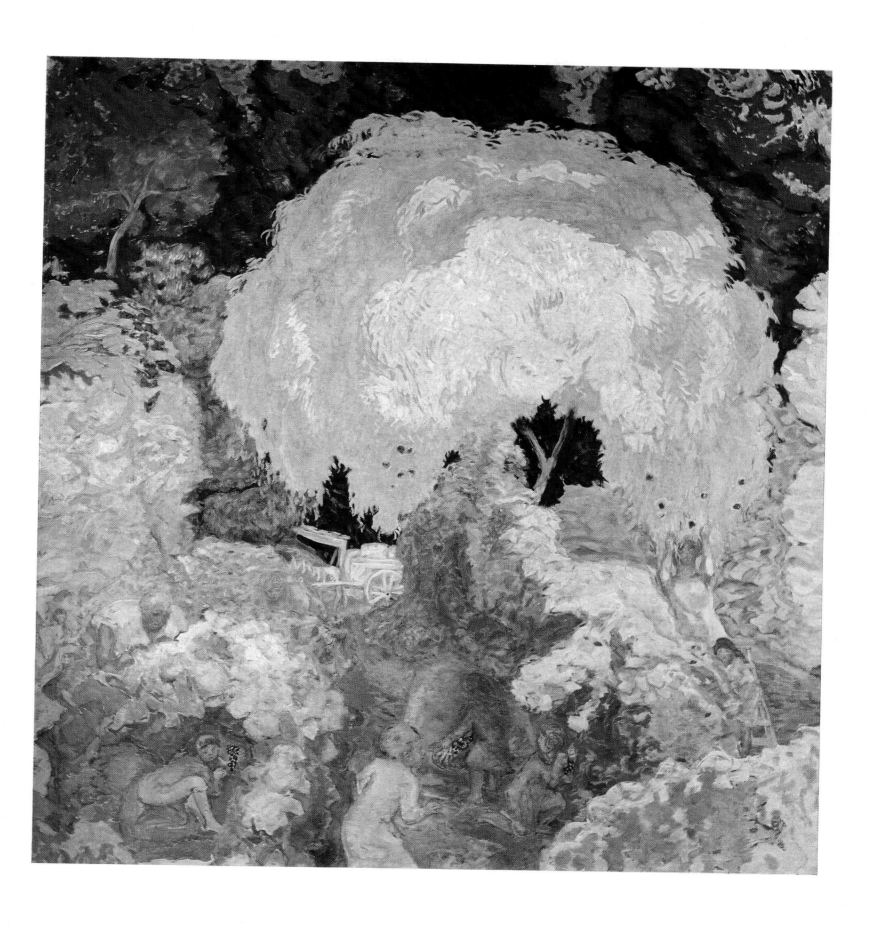

218 AUTUMN (FRUIT PICKING). Panel
Oil on canvas. 365 × 347 cm. Inv. No 3360
Together with its companion piece *Early Spring in the Country*, now in The Pushkin Museum of Fine Arts (Inv. No 3359), this panel was painted in 1912 for Ivan Morozov's mansion in Moscow. Morozov paid 25,000 francs to Bonnard for both panels.

Provenance: 1912—18 The I. Morozov Collection, Moscow; 1918—48 The Museum of Modern Western Art, Moscow; since 1948 The Pushkin Museum of Fine Arts, Moscow

Exhibition: 1913 Paris, Cat. 5

Bibliography: Réau 1929, No 714; Musée de Moscou 1963, p. 191, ill.

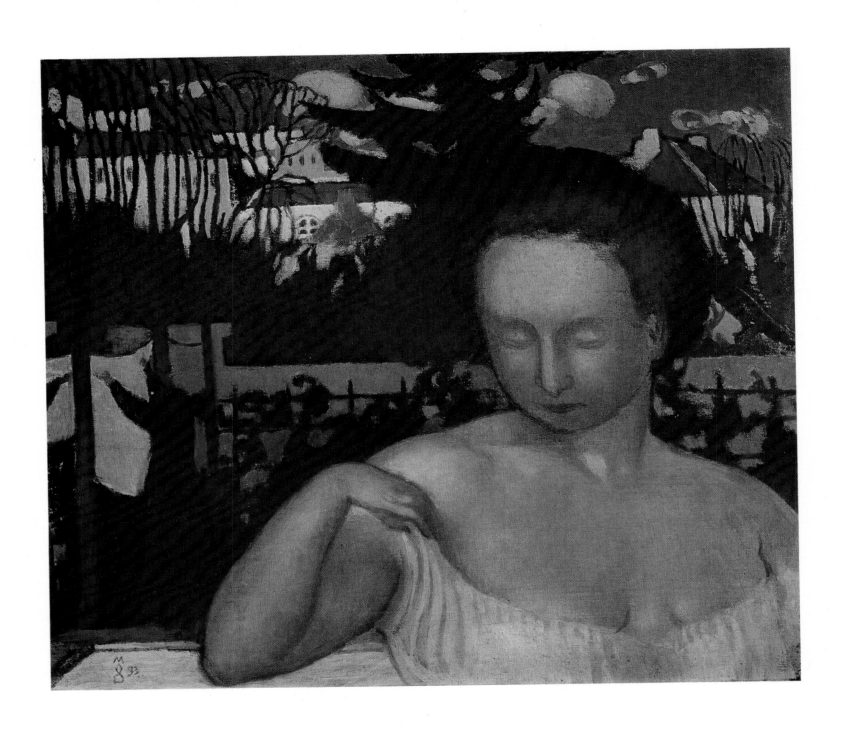

219 PORTRAIT OF THE ARTIST'S WIFE. 1893
Oil on canvas. 45 × 54 cm. Inv. No 3277
Signed and dated in monogram lower left: *M 93*
This is the earliest Denis now in The Pushkin Museum.

Provenance: until 1918 The S. Shchukin Collection, Moscow; 1918—48 The Museum of Modern Western Art, Moscow; since 1948 The Pushkin Museum of Fine Arts, Moscow

Exhibition: 1972 Otterloo, Cat. 9

Bibliography: Кат. ГМИИ 1961, p. 71; Тугендхольд 1914, p. 39, ill. p. 28; Перцов 1921, No 45, p. 108; Тугендхольд 1923, ill. p. 58; Кат. ГМНЗИ 1928, No 130; Réau 1929, No 772

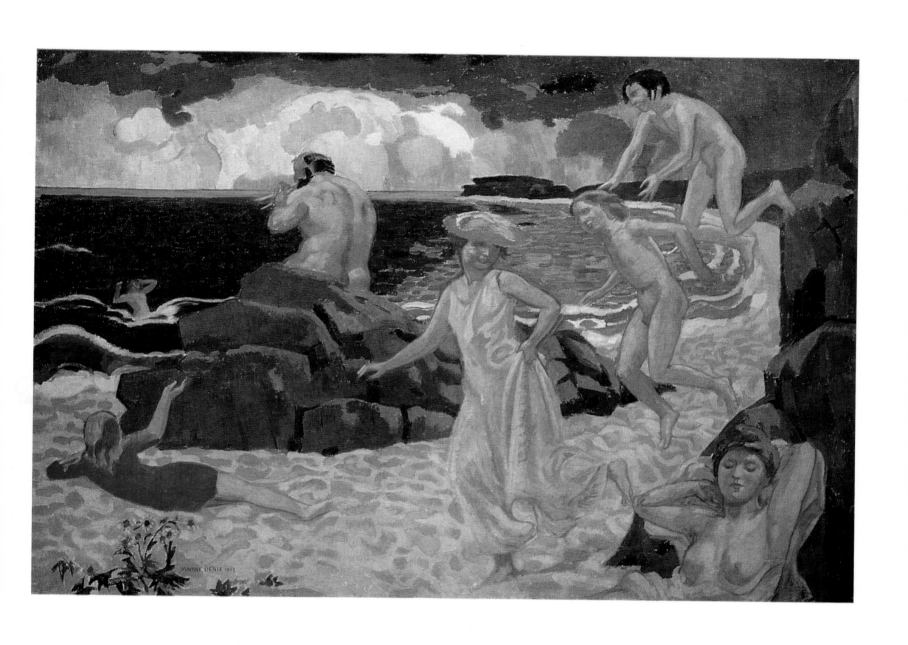

220 POLYPHEMUS. 1907
Oil on canvas. 81 × 116 cm. Inv. No 3375
Signed and dated lower left: *Maurice Denis 1907*

Provenance: 1907—18 The I. Morozov Collection, Moscow; 1918—48 The Museum of Modern Western Art, Moscow; since 1948 The Pushkin Museum of Fine Arts, Moscow

Exhibition: 1967—68 Odessa, Kharkov, Cat. 9

Bibliography: Кат. ГМИИ 1961, p. 71; Кат. ГМНЗИ 1928, No 136; Réau 1929, No 778

221 THE POET AND HIS MUSE.
PORTRAIT OF APOLLINAIRE
AND MARIE LAURENCIN. 1909
Oil on canvas. 131 × 97 cm. Inv. No 3334
Signed and dated lower right: *H. Rousseau 1909*
The models for the picture were the poet Guillaume
Apollinaire and the artist Marie Laurencin. A va-
riant (146 × 97), now in the Kunstmuseum in Basle,
was also painted in 1909. The Pushkin Museum pic-
ture was bought by Apollinaire from the artist for
300 francs.

Provenance: from 1909 The G. Apollinaire Collection,
Paris; until 1918 The S. Shchukin Collection, Moscow;
1918—48 The Museum of Modern Western Art, Mos-
cow; since 1948 The Pushkin Museum of Fine Arts,
Moscow

Exhibitions: 1911 Paris (Salon des Indépendants), Cat.
43; 1964 Rotterdam

Bibliography: Кат. собр. С. Щукина 1913, No 202,
pp. 44—45; Тугендхольд 1914, p. 45; Перцов 1921,
No 202, p. 115; Réau 1929, No 1093; W. Uhde, "Henri
Rousseau et les primitifs modernes", *L'Amour de
l'Art*, 1933, 8, p. 140; Cahiers d'Art 1950, p. 347;
Musée de Moscou 1963, p. 186, ill.; *L'Opera completa
di Rousseau il Doganiere*, presentazione di G. Artieri,
apparati critici et filologici di D. Vallier, Milano,
1969, ill. 133

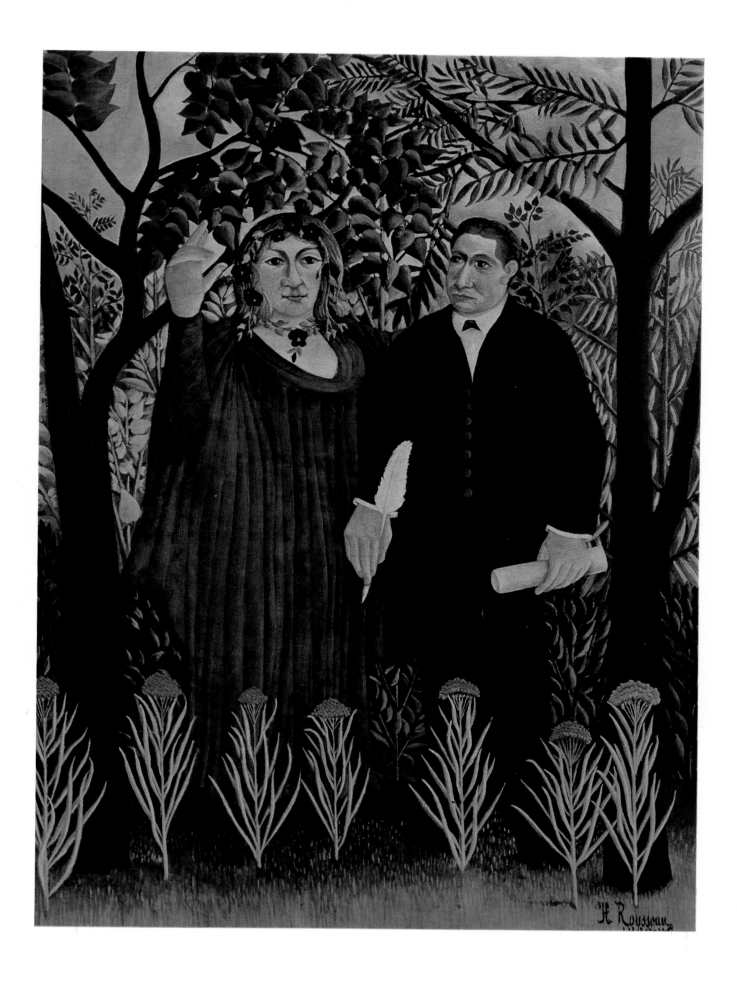

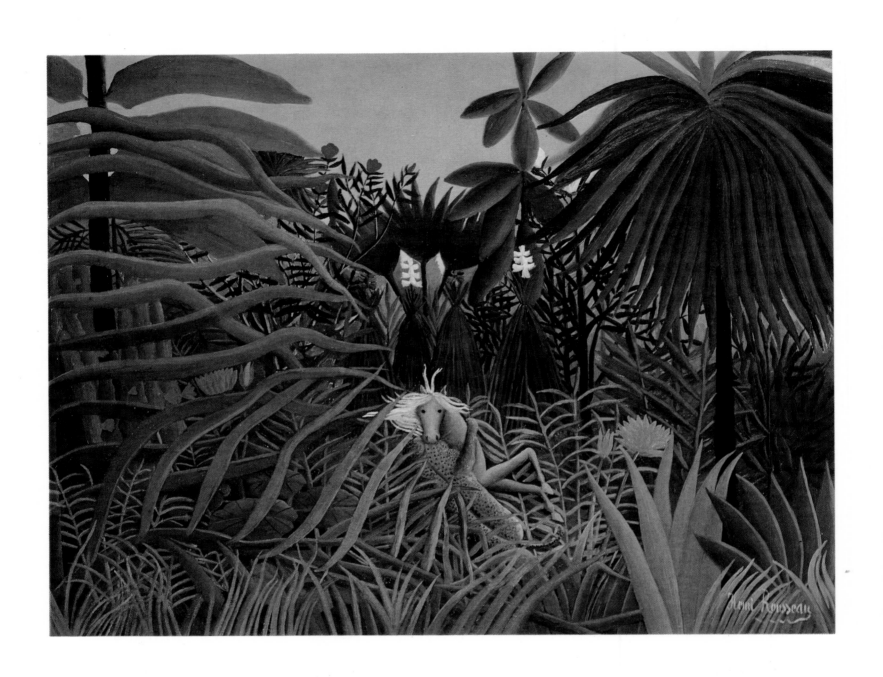

222 JAGUAR ATTACKING A HORSE
Oil on canvas. 90 × 116 cm. Inv. No 3351
Signed lower right: *Henri Rousseau*

Provenance: until 1918 The S. Shchukin Collection,
Moscow; 1918—48 The Museum of Modern Western
Art, Moscow; since 1948 The Pushkin Museum of Fine
Arts, Moscow

Exhibitions: 1964 Rotterdam, Cat. 111; 1972 Otterloo,
Cat. 52

Bibliography: Кат. собр. С. Щукина 1913, No 231,
pp. 44—45; Тугендхольд 1914, p. 45; Перцов 1921,
No 231, p. 115; Ternovetz 1925, p. 484, ill.; Réau 1929,
No 1094; Cahiers d'Art 1950, p. 347; *L'Opera com-
pleta di Rousseau il Doganiere*, presentazione di G. Ar-
tieri, apparati critici et filologici di D. Vallier, Milano,
1969, ill. 169

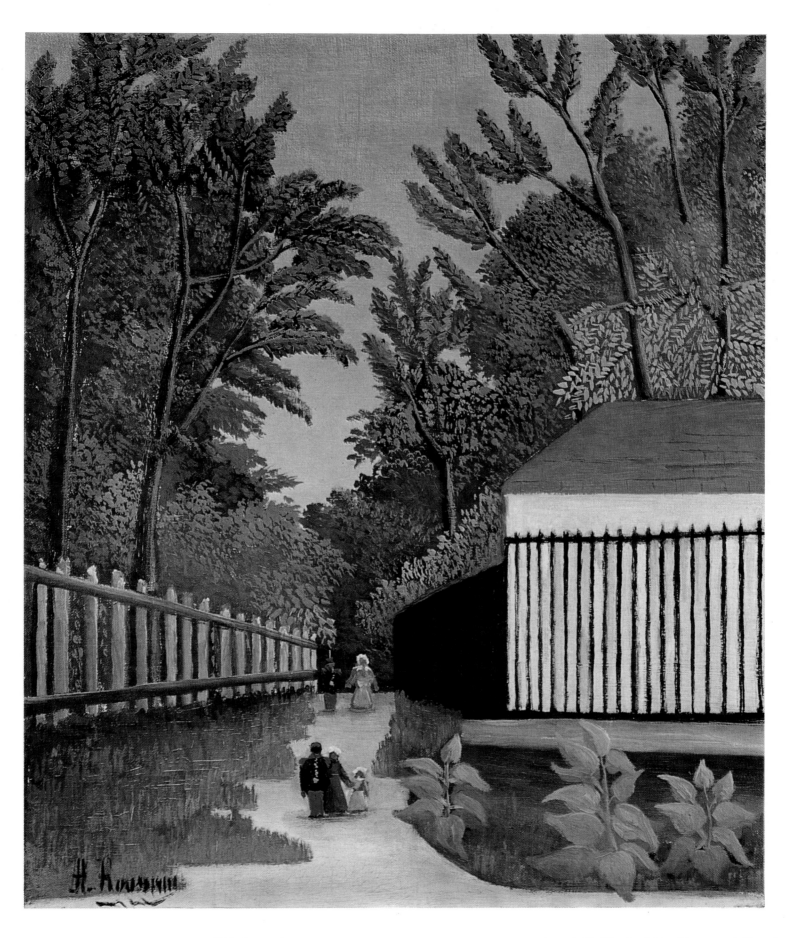

223 VIEW OF THE MONTSOURIS PARK
Oil on canvas. 46 × 38 cm. Inv. No 3332
Signed lower left: *H. Rousseau*

Rousseau repeatedly painted the Montsouris Park.
Most of his landscapes with this motif date from about
1895. In all probability, the Moscow picture relates
to the same period.

Provenance: 1918 The S. Shchukin Collection, Moscow;
1918—48 The Museum of Modern Western Art, Mos-

cow; since 1948 The Pushkin Museum of Fine Arts,
Moscow

Exhibition: 1967—68 Odessa, Kharkov, Cat. No 30

Bibliography: Кат. собр. С. Щукина 1913, No 199,
pp. 44—45; Тугендхольд 1914, p. 45; Перцов 1921,
No 199, p. 115; Réau 1929, No 1095; W. Uhde, "Henri
Rousseau et les primitifs modernes", *L'Amour de
l'Art*, 1933, 8, p. 201; Cahiers d'Art 1950, p. 347;
Musée de Moscou 1963, p. 188, ill.

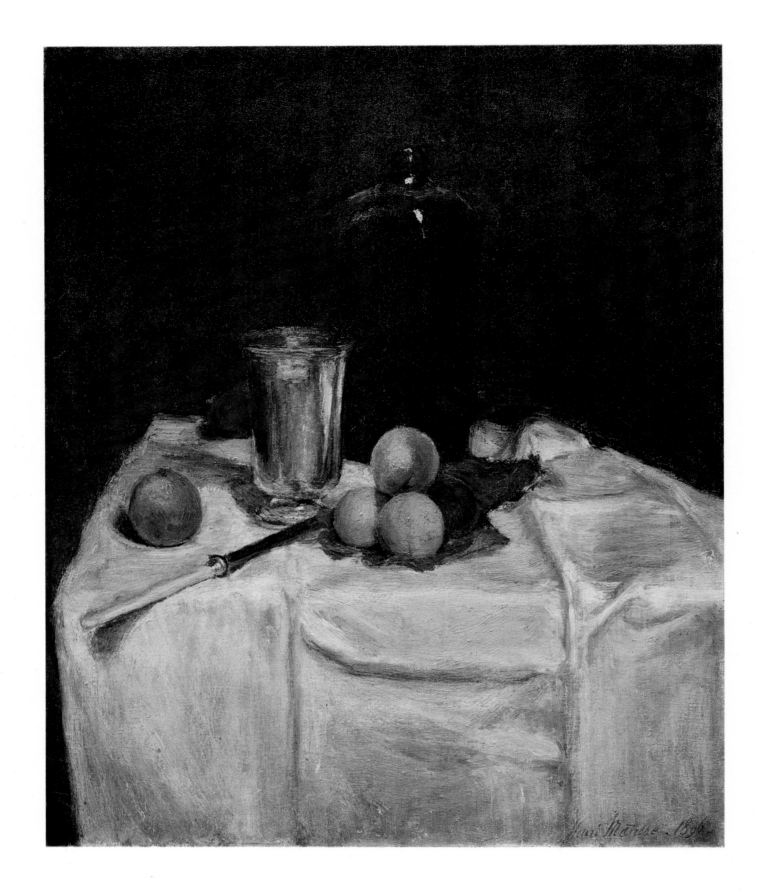

224 THE BOTTLE OF SCHIEDAM. 1896
Oil on canvas. 73.2 × 60.3 cm. Inv. No 3392
Signed and dated lower right: *Henri Matisse. 1896.*
The picture was bought by Ivan Morozov from Bernheim Jeune in Paris in 1911 for 1,500 francs. It is the earliest Matisse to be found in Soviet museums. The canvas was painted in 1896, when Matisse worked extensively in The Louvre, copying the Old Masters.

Provenance: until 1911 The Bernheim Jeune Collection, Paris; 1911—18 The I. Morozov Collection, Moscow; 1918—48 The Museum of Modern Western Art, Moscow; since 1948 The Pushkin Museum of Fine Arts, Moscow

Exhibitions: 1955 Moscow, Cat., p. 44; 1956 Leningrad, Cat., p. 37; 1969 Moscow, Leningrad, Cat. 1

Bibliography: Кат. ГМИИ 1957, p. 88; Кат. ГМИИ 1961, p. 120; Маковский 1912, p. 22; Ternovetz 1925, p. 484; Кат. ГМНЗИ 1928, No 345; Réau 1929, No 957; Cahiers d'Art 1950, p. 343; Кат. выст. Матисса 1969, p. 62, No 1, ill. p. 21

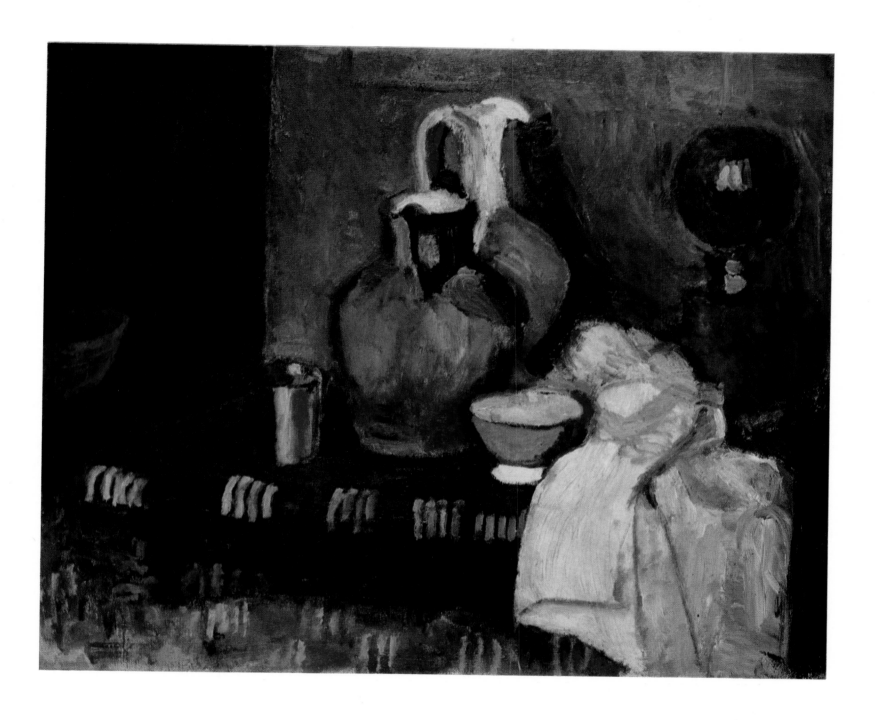

225 BLUE JUG
Oil on canvas. 59.5 × 73.5 cm. Inv. No 3393
In the early 1900s several still lifes by Matisse with the blue jug motif were exhibited in the Salon des Indépendants and at Vollard's. The Moscow picture was painted apparently in 1899—1900. It was bought by Ivan Morozov from Ambroise Vollard in Paris in 1909 for 2,000 francs.

Provenance: until 1909 The A. Vollard Collection, Paris; 1909—18 The I. Morozov Collection, Moscow; 1918—48 The Museum of Modern Western Art, Mos-cow; since 1948 The Pushkin Museum of Fine Arts, Moscow

Exhibitions: 1955 Moscow, Cat., p. 44; 1956 Leningrad, Cat., p. 38; 1967—68 Odessa, Kharkov, Cat. 26; 1969 Moscow, Leningrad, Cat. 5; 1969—70 Prague, Cat. 2

Bibliography: Кат. ГМИИ 1957, p. 88; Кат. ГМИИ 1961, p. 120; Кат. ГМНЗИ 1928, No 348; Réau 1929, No 960; Cahiers d'Art 1950, p. 343; Diehl 1954, pp. 116, (401), (402); Кат. выст. Матисса 1969, p. 62, No 5, ill. p. 22

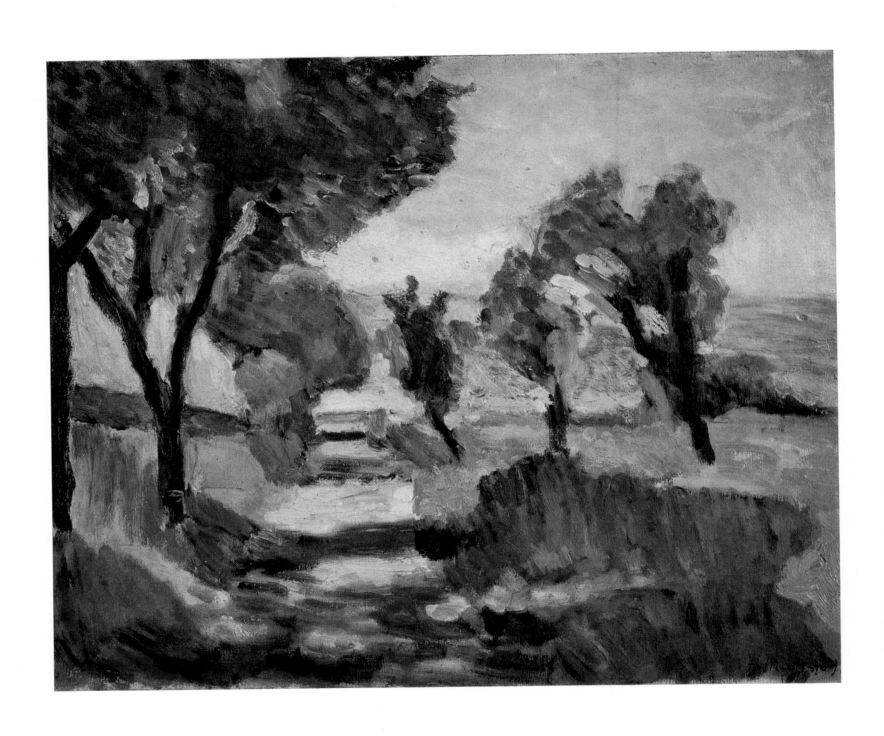

226 CORSICAN LANDSCAPE
WITH OLIVES. 1898
Oil on canvas. 38 × 46 cm. Inv. No 4108
Signed and dated lower right: *H. Matisse. 98*
The landscape was painted during Matisse's travels
in Corsica in 1898. Its light color scheme and brisk
dynamic brushstrokes, combined with an evident in-
terest in conveying the play of sunlight, are a tribute
to Impressionism. The radiant contrasts of bright col-
or patches are already indicative of Fauvism. The
picture was presented to The Pushkin Museum by Ly-
dia Délectorskaya in 1970.

Provenance: until 1947 The Vassaux Collection, Saint-
Saëns; 1947—70 The L. Délectorskaya Collection, Par-
is; since 1970 The Pushkin Museum of Fine Arts,
Moscow

Exhibitions: 1958 Paris; 1970 Paris, Cat. 22

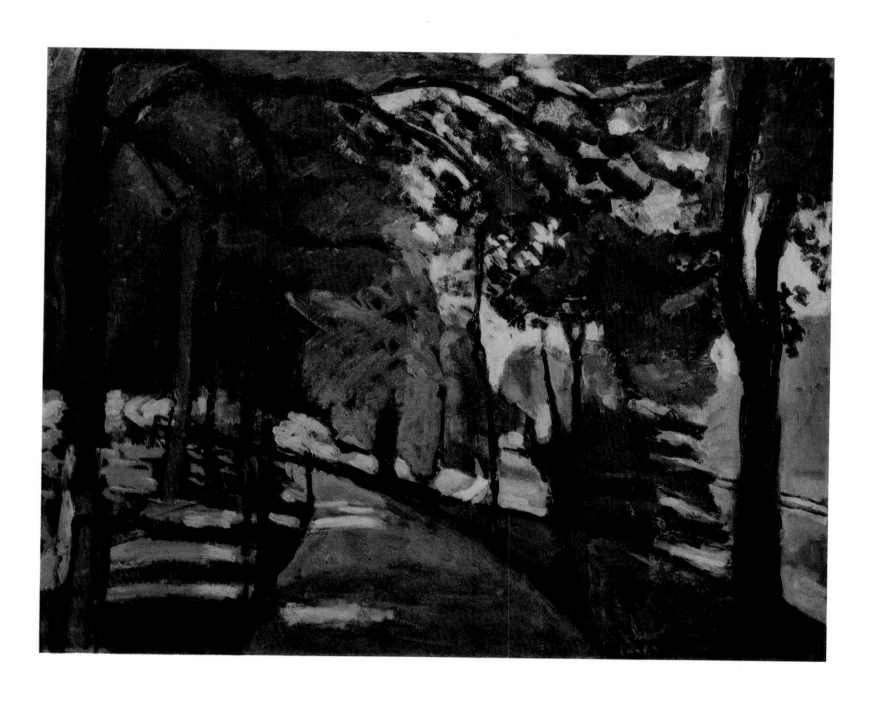

227 BOIS DE BOULOGNE. 1902

Oil on canvas. 65 × 81.5 cm. Inv. No 3320

Signed and dated lower left: *Henri-Matisse 1902*

In 1902—4 Matisse painted several views of the Bois de Boulogne which figured more than once in the exhibitions of the Salon d'Automne, the Salon des Indépendants and in the Vollard Gallery.

Provenance: until 1918 The S. Shchukin Collection, Moscow; 1918—48 The Museum of Modern Western Art, Moscow; since 1948 The Pushkin Museum of Fine Arts, Moscow

Exhibitions: 1939 Moscow, Cat., p. 53; 1955 Moscow, Cat., p. 44; 1956 Leningrad, Cat., p. 38; 1965 Bordeaux, Cat. 87; 1965—66 Paris, Cat. 86; 1968 London, Cat. 85; 1969 Moscow, Leningrad, Cat. 9; 1970 Paris, Cat. 48

Bibliography: Кат. ГМИИ 1961, p. 120; Кат. собр. С. Щукина 1913, No 118, pp. 28—29; Тугендхольд 1914, ill. p. 56; Кат. ГМНЗИ 1928, No 308, p. 11; Перцов 1921, No 118; Réau 1929, No 922; Cahiers d'Art 1950, p. 343; Barr 1951, pp. 44, 51, 106, ill. 308; Diehl 1954, p. 26, 116, (403), 117 (37); Кат. выст. Матисса 1969, p. 63, No 9, ill. p. 26

228 SPANISH WOMAN
WITH A TAMBOURINE. 1909
Oil on canvas. 91.6 × 73.2 cm. Inv. No 3297
Signed and dated lower left: *Henri Matisse 1909*

Provenance: The Bernheim Jeune Collection, Paris; until 1918 The S. Shchukin Collection, Moscow; 1918—48 The Museum of Modern Western Art, Moscow; since 1948 The Pushkin Museum of Fine Arts, Moscow

Exhibitions: 1911 Paris (Salon des Indépendants), Cat. 6740; 1955 Moscow, Cat., p. 45; 1956 Leningrad, Cat., p. 38; 1966—67 Tokyo, Kyoto, Cat. 68; 1967—68 Odessa, Kharkov, Cat. 25; 1969 Moscow, Leningrad, Cat. 23; 1970 Paris, Cat. 92; 1974—75 Paris (Grand Palais), Cat. 188; 1975 Moscow

Bibliography: Кат. ГМИИ 1957, p. 88; Кат. ГМИИ 1961, p. 120; Кат. собр. С. Щукина 1913, No 102, pp. 24—25; Перцов 1921, No 102, p. 111; J. Elias, "Nach der Heroischen Zeit", *Kunst und Künstler*, 1918—19, ill. p. 230; Ternovetz 1925, p. 483, ill.; Кат. ГМНЗИ 1928, No 322; Réau 1929, No 936; Ромм 1935, p. 53, ill.; Cahiers d'Art 1950, p. 343; Barr 1951, pp. 106, 130, 134, No 6, ill. 352; Diehl 1954, p. 46; Sterling 1957, ill. 145; Матисс 1958, ill.; Прокофьев 1962, ill. 180; Кат. выст. Матисса 1969, p. 65, No 23, ill. p. 40

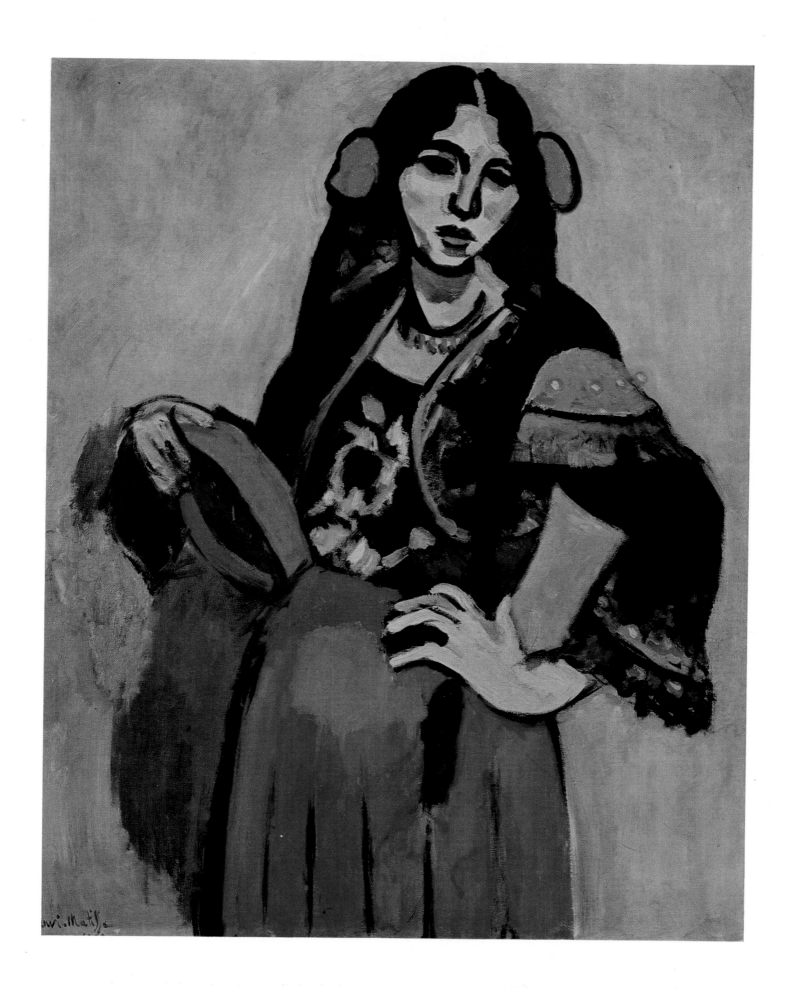

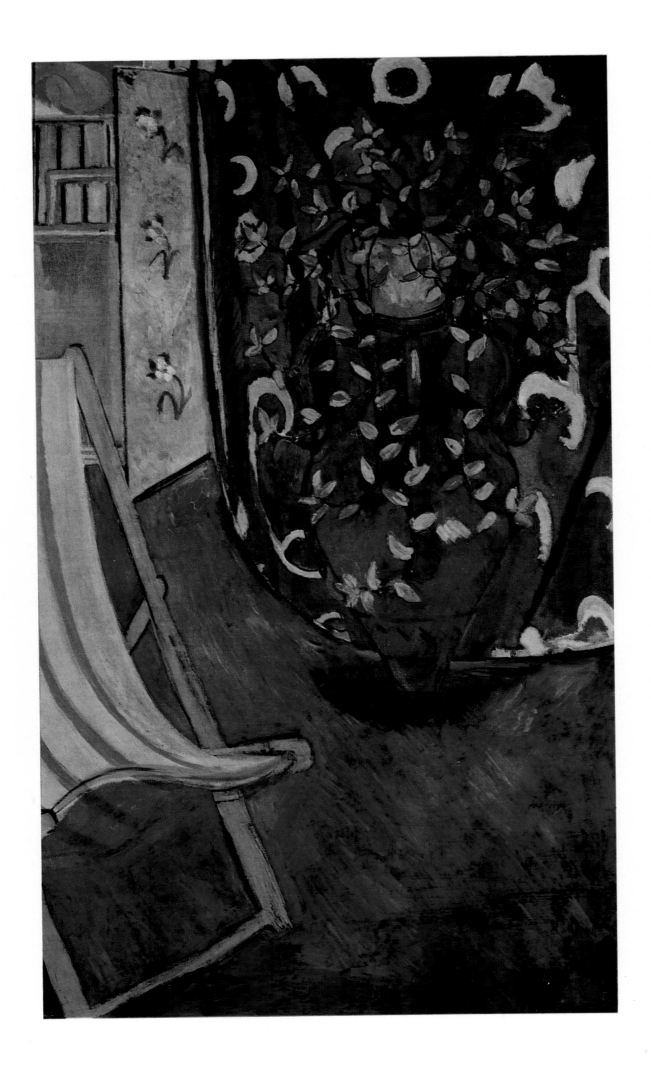

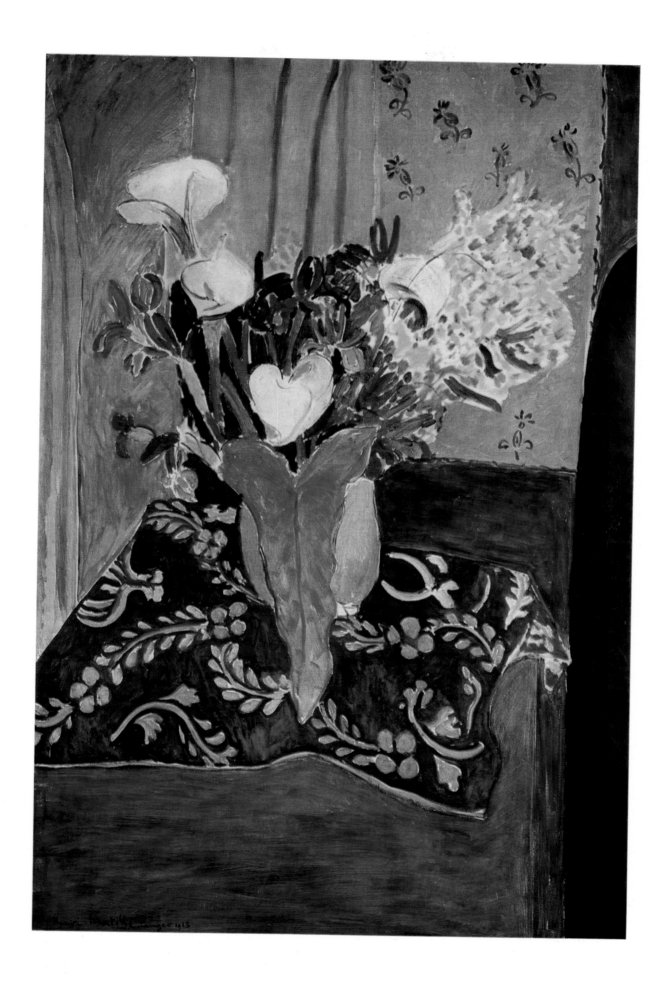

229 CORNER OF THE STUDIO
← Oil on canvas. 191.5 × 114 cm. Inv. No 3302
A companion piece to *The Studio with "La Danse"*
(see plate 231), this picture was painted in 1912.

Provenance: 1912—18 The S. Shchukin Collection,
Moscow; 1918—48 The Museum of Modern Western
Art, Moscow; since 1948 The Pushkin Museum of
Fine Arts, Moscow

Exhibitions: 1969 Moscow, Leningrad, Cat. 42; 1972
Prague, Cat. 25

Bibliography: Кат. ГМИИ 1961, p. 121; Кат. собр.
С. Щукина 1913, No 123, pp. 28—29; Тугендхольд
1914, p. 42; Перцов 1921, No 123, p. 112; Кат. ГМНЗИ
1928, No 332; Réau 1929, No 946; Cahiers d'Art 1950,
p. 343; Barr 1951, p. 157; Кат. выст. Матисса 1969,
p. 69, No 42, ill. p. 56

230 IRISES, ARUMS AND MIMOSAS. 1913
← Oil on canvas. 145.5 × 97 cm. Inv. No 3303
Signed and dated lower left: *Henri Matisse tanger
1913*
As follows from the date and signature on the pic-
ture, this still life was painted at Tangier in 1913.

Provenance: 1913—18 The S. Shchukin Collection,
Moscow; 1918—48 The Museum of Modern Western
Art, Moscow; since 1948 The Pushkin Museum of
Fine Arts, Moscow

Exhibitions: 1913 Paris (Bernheim Jeune Gallery);
1955 Moscow, Cat., p. 45; 1956 Leningrad, Cat., p. 39;
1969 Moscow, Leningrad, Cat. 48; 1969—70 Prague,
Cat. 13

Bibliography: Кат. ГМИИ 1957, p. 89; Кат. ГМИИ
1961, p. 121; Кат. собр. С. Щукина 1913, No 125,
pp. 28—29; Перцов 1921, No 125, p. 112; Кат. ГМНЗИ
1928, No 334; Réau 1929, No 948; Cahiers d'Art 1950,
p. 343; Barr 1951, pp. 159, 206, 215, ill. 389; Diehl
1954, pp. 69, 117; Алпатов 1969, p. 48; Кат. выст.
Матисса 1969, p. 70, No 48, ill. p. 57; Antonova 1977,
No 141

231 THE STUDIO WITH "LA DANSE"
Oil on canvas. 190.5 × 114.5 cm. Inv. No 3301
Signed lower right: *Henri Matisse*
In the summer of 1912 Matisse painted two panels on
this theme in his studio at Issy-les-Moulineaux, one
of which is the Moscow canvas; the other is in the
Worcester Museum, Mass. (USA). The picture now
in The Pushkin Museum was bought by Sergei Shchu-
kin from Matisse in 1912.

Provenance: The artist's collection, Paris; 1912—18
The S. Shchukin Collection, Moscow; 1918—48 The
Museum of Modern Western Art, Moscow; since 1948
The Pushkin Museum of Fine Arts, Moscow

Exhibitions: 1912 Paris (Salon d'Automne), Cat. 769;
1958 Brussels, Cat. 210; 1965 Bordeaux, Cat. 90;
1965—66 Paris, Cat. 90; 1967 Montreal, Cat. 138;
1969 Moscow, Leningrad, Cat. 41; 1969—70 Prague,
Cat. 12; 1972 Otterloo, Cat. 34; 1973 Washington,
Cat. 25

Bibliography: Кат. ГМИИ 1961, p. 121; Кат. собр.
С. Щукина 1913, No 121, pp. 28—29; Перцов 1921,
No 121, p. 112; Кат. ГМНЗИ 1928, No 331; Réau 1929,
No 945 (entitled *La Danse autour des capucines*);
Ромм 1935, p. 29; Cahiers d'Art 1950, p. 343; Barr
1951, pp. 127, 144, 148, 156, 157, 537, 555, ill. 382;
Diehl 1954, pp. 68, 138, 154, ill. 57; Musée de Moscou
1963, p. 206, ill.; Алпатов 1969, p. 47; Кат. выст.
Матисса 1969, p. 69, No 41, ill. p. 57; Antonova 1977,
No 139

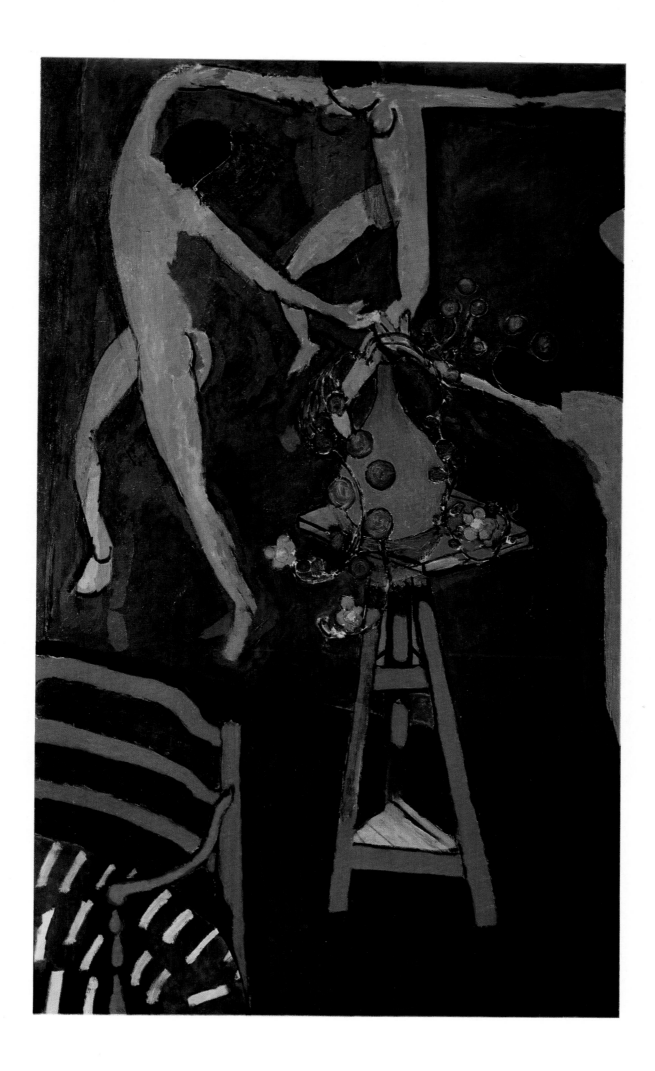

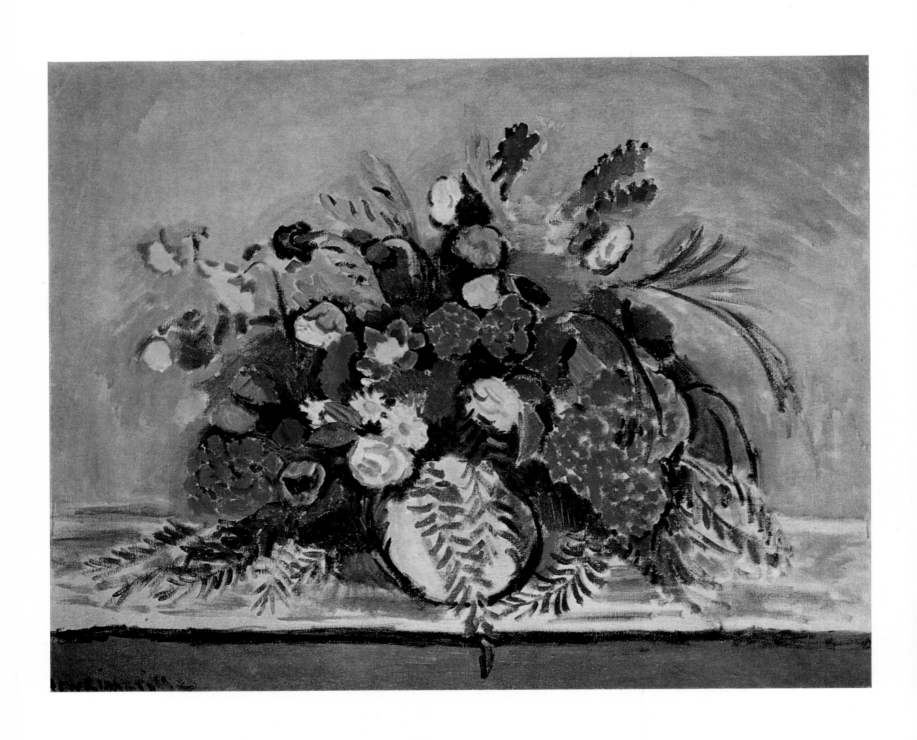

232 FLOWERS IN A WHITE VASE
Oil on canvas. 81.5 × 100.5 cm. Inv. No 3298
Signed lower left: *Henri Matisse*
The picture was painted in 1909.

Provenance: The F. Fénéon Collection, Paris (?); until
1918 The S. Shchukin Collection, Moscow; 1918—48
The Museum of Modern Western Art, Moscow; since
1948 The Pushkin Museum of Fine Arts, Moscow

Exhibitions: 1955 Moscow, Cat., p. 45; 1956 Lenin-
grad, Cat., p. 49; 1966—67 Tokyo, Kyoto, Cat. 69;
1969 Moscow, Leningrad, Cat. 22; 1969—70 Prague,
Cat. 9

Bibliography: Кат. ГМИИ 1957, p. 89; Кат. ГМИИ
1961, p. 120; Кат. собр. С.Щукина 1913, No 107,
pp. 26—27; Кат. ГМНЗИ 1928, No 339; Réau 1929,
No 954; Cahiers d'Art 1950, p. 343; Кат. выст. Ма-
тисса 1969, p. 65, No 22, ill. p. 37

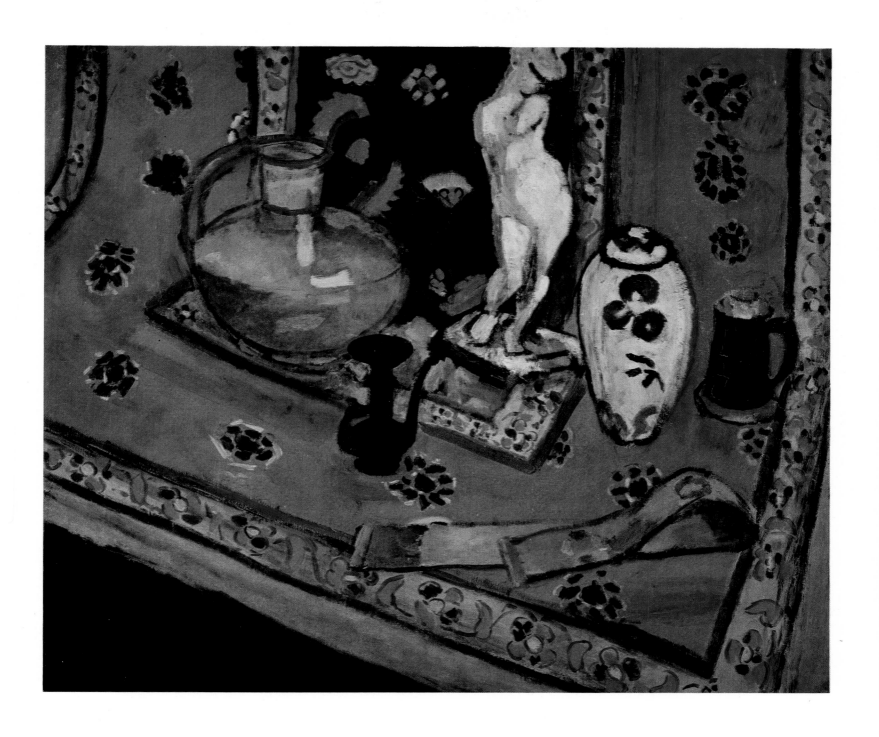

233 STATUETTE AND VASE
ON AN ORIENTAL CARPET. 1908
Oil on canvas. 88.5 × 105 cm. Inv. No 3296
Signed and dated lower left: *Henri Matisse 1908*
The sculpture *Madeleine I* depicted here is the work
of Matisse, who frequently introduced his earlier
sculptures and paintings into his pictures. It is a
study for *The Red Room* (The Hermitage, Leningrad).
Provenance: 1908—18 The S. Shchukin Collection,
Moscow; 1918—48 The Museum of Modern Western
Art, Moscow; since 1948 The Pushkin Museum of
Fine Arts, Moscow

Exhibitions: 1908 Paris (Salon d'Automne), Cat. 897;
1955 Moscow, Cat. 45; 1956 Leningrad, Cat., p. 38;
1969 Moscow, Leningrad, Cat. 18; 1970 Paris, Cat. 90
Bibliography: Кат. ГМИИ 1957, p. 88; Кат. ГМИИ
1961, p. 120; Кат. собр. С. Щукина 1913, No 101,
pp. 24—25; Тугендхольд 1914, p. 42, ill. p. 56; Пер-
цов 1921, No 101, p. 111; Тугендхольд 1923, ill. p. 71;
Кат. ГМНЗИ 1928, No 316; Réau 1929, No 933; Ca-
hiers d'Art 1950, p. 343; Barr 1951, pp. 106, 124, 129,
ill. 343; Diehl 1954, p. 138; Sterling 1957, ill. 136,
p. 178; ГМИИ 1966, No 105; Кат. выст. Матисса
1969, p. 64, No 18, ill. p. 33

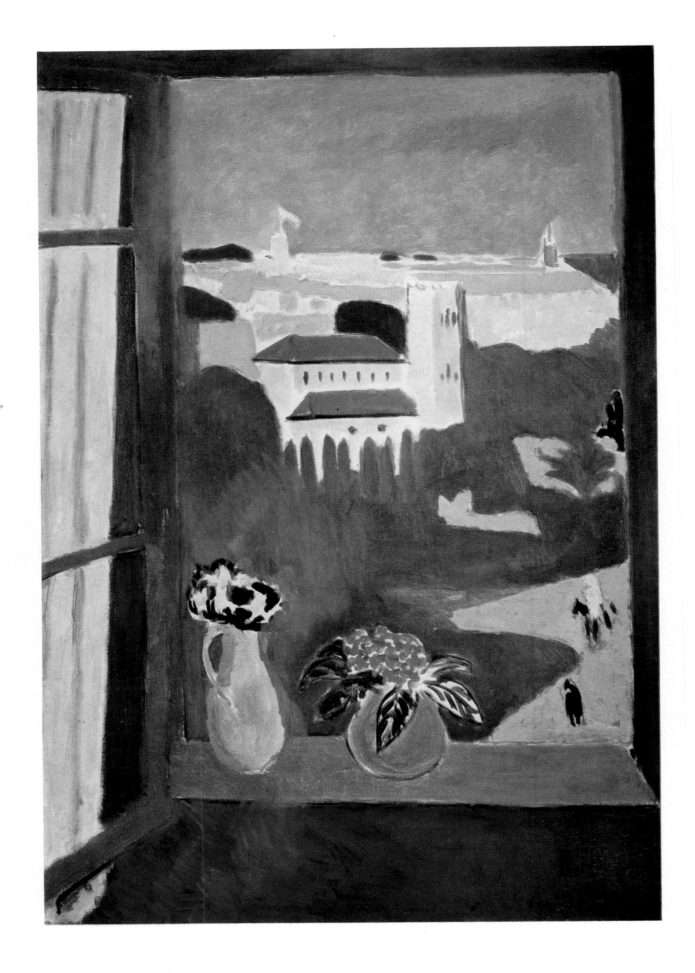

234 VIEW FROM THE WINDOW. TANGIER

← Oil on canvas. 115 × 80 cm. Inv. No 3395

Painted at Tangier at the beginning of 1912, this picture presents a view from the window of the Hôtel de France where Matisse was staying. The landscape constitutes the left-hand part of what is known as *The Moroccan Triptych* (The Pushkin Museum of Fine Arts, Inv. Nos 3396, 4058). Art historians do not usually believe that Matisse conceived the three paintings as a single whole; their inclusion in a triptych was often ascribed to Ivan Morozov. However, in his letter to Morozov of April 19, 1913, preserved in the Archives of The Pushkin Museum, Matisse points out that the pictures are conceived so as to hang together and in a definite order. In the same letter the artist made a pen drawing of how the pictures should be placed on the wall. All three parts of the triptych were bought by Morozov from Matisse in 1913 for 8,000 francs each. There is a drawing of 1912 (pen and ink) for *View from the Window. Tangier*, depicting the same motif.

Provenance: until 1913 The artist's collection, Paris; 1913—18 The I. Morozov Collection, Moscow; 1918—48 The Museum of Modern Western Art, Moscow; since 1948 The Pushkin Museum of Fine Arts, Moscow; from 1956 to 1962 was on a permanent display in The Hermitage, Leningrad

Exhibitions: 1913 Paris (Bernheim Jeune Gallery); 1913 Berlin; 1969 Moscow, Leningrad, Cat. 43, 44, 45; 1970 Paris, Cat. 116a, 116b, 116c

Exhibitions where *View from the Window. Tangier* was shown: 1939 Moscow, Cat., p. 53; 1955 Moscow, Cat., p. 45; 1962 Venice, Cat. 16; 1968 London, Cat. 47

Bibliography: Кат. ГМИИ 1957, p. 89; Кат. ГМИИ 1961, p. 121; Ternovetz 1925, p. 484; Кат. ГМНЗИ 1928, No 353; Réau 1929, No 965; Cahiers d'Art 1950, p. 343; Barr 1951, pp. 145, 154, 159, 165, ill. p. 386; Матисс 1958, ill.; Алпатов 1969, p. 57; Кат. выст. Матисса 1969, p. 69, No 43, ill. p. 54; Antonova 1977, No 140

235 ZORAH ON THE TERRACE

← Oil on canvas. 115.8 × 100.5 cm. Inv. No 3396

The picture constitutes the central part of *The Moroccan Triptych* and was painted during Matisse's second sojourn in Tangier in the autumn of 1912. The Moroccan woman Zorah, who had frequently posed for the artist, served as a model for this picture.

Provenance: until 1913 The artist's collection, Paris; 1913—18 The I. Morozov Collection, Moscow; 1918—48 The Museum of Modern Western Art, Moscow; since 1948 The Pushkin Museum of Fine Arts, Moscow; from 1956 to 1962 was on a permanent display in The Hermitage, Leningrad

Exhibition where *Zorah on the Terrace* was shown: 1939 Circulating Exhibition, Cat. 81

Exhibitions of the whole triptych, see note to plate 234

Bibliography: Кат. ГМИИ 1961, p. 121; Ternovetz 1925, p. 484; Кат. ГМНЗИ 1928, No 354; Réau 1929, No 966; Ромм 1935, pp. 45, 63; Cahiers d'Art 1950, p. 343; Barr 1951, pp. 145, 147, 154, 159, 203, ill. 387; Diehl 1954, pp. 62, 117, ill. 61; Матисс 1958, p. 106, 107; Алпатов 1969, p. 48; Кат. выст. Матисса 1969, p. 69, No 44, ill. p. 54; Antonova 1977, No 137

236 ENTRANCE TO THE CASBAH

← Oil on canvas. 115 × 80 cm. Inv. No 4058

This is the right-hand part of *The Moroccan Triptych*. It was painted in Tangier in the autumn of 1912.

Provenance: until 1913 The artist's collection, Paris; 1913—18 The I. Morozov Collection, Moscow; 1918—48 The Museum of Modern Western Art, Moscow; 1948—68 The Hermitage, Leningrad; since 1968 The Pushkin Museum of Fine Arts, Moscow

Exhibitions of the whole triptych, see note to plate 234

Bibliography: Ternovetz 1925, p. 484; Кат. ГМНЗИ 1928, No 355; Réau 1929, No 967; Ромм 1935, p. 45; Cahiers d'Art 1950, p. 343; Barr 1951, pp. 145, 154, 156, 159, ill. 386; Diehl 1954, pp. 69, 117 (139), ill. 62; Кат. выст. Матисса 1969, p. 69, No 45, ill. p. 55

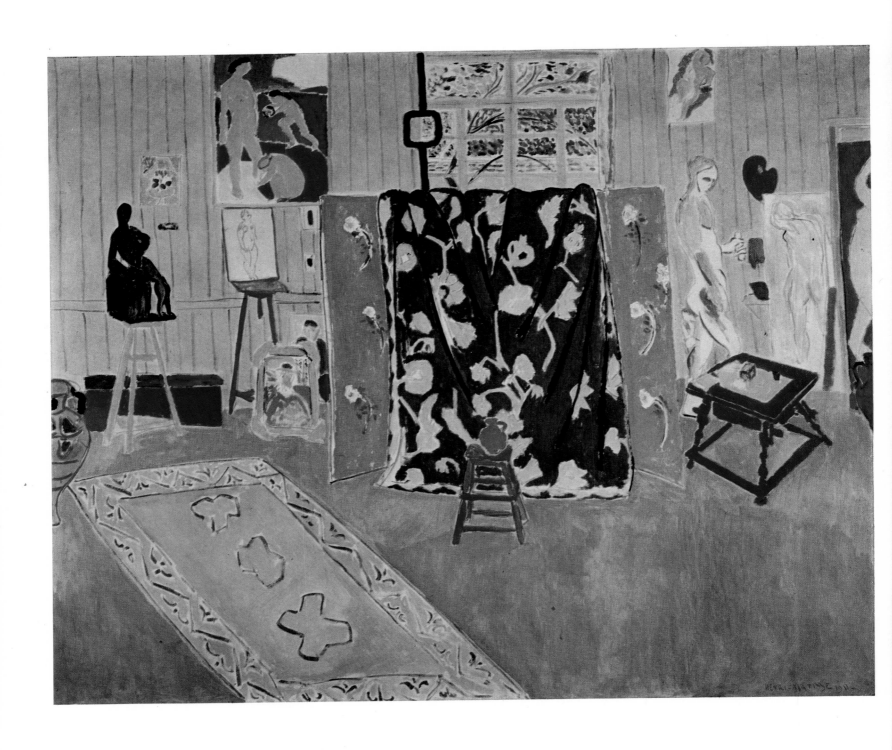

237 THE LARGE STUDIO. 1911
Oil on canvas. 179.5 × 221.3 cm. Inv. No 3295
Signed and dated lower right: *Henri-Matisse 1911*
In the period between 1911 and 1913 Matisse often
painted large interior scenes, especially of his studio,
introducing into them many of his own paintings
and sculptures. The canvas in The Pushkin Museum
depicts the right-hand part of the artist's studio at
Issy-les-Moulineaux; the left-hand section is repre-
sented in his well-known canvas *The Red Studio*
(1911, the Museum of Modern Art, New York).

Provenance: until 1912 The artist's collection, Paris;
1912—18 The S. Shchukin Collection, Moscow; 1918—
48 The Museum of Modern Western Art, Moscow;

since 1948 The Pushkin Museum of Fine Arts, Moscow
Exhibitions: 1912 Paris (Salon d'Automne), Cat. 770;
1958 Brussels, Cat. 212; 1969 Moscow, Leningrad, Cat.
37; 1970 Paris, Cat. 106

Bibliography: Кат. ГМИИ 1961, p. 121; Кат. собр.
С. Щукина 1913, No 94, pp. 22—23; Тугендхольд
1914, p. 41; Перцов 1921, No 94, p. 111; Ternovetz
1925, p. 484; Кат. ГМНЗИ 1928, No 327; Réau 1929,
No 941; Ромм 1935, p. 28; Cahiers d'Art 1950, p. 343;
Barr 1951, pp. 100, 142—144, 148, 151—153, 539 (152),
ill. 375; Diehl 1954, p. 68, 138; Musée de Moscou 1963,
p. 204, ill.; Алпатов 1969, p. 58; Кат. выст. Матисса
1969, p. 68, No 37, ill. p. 49

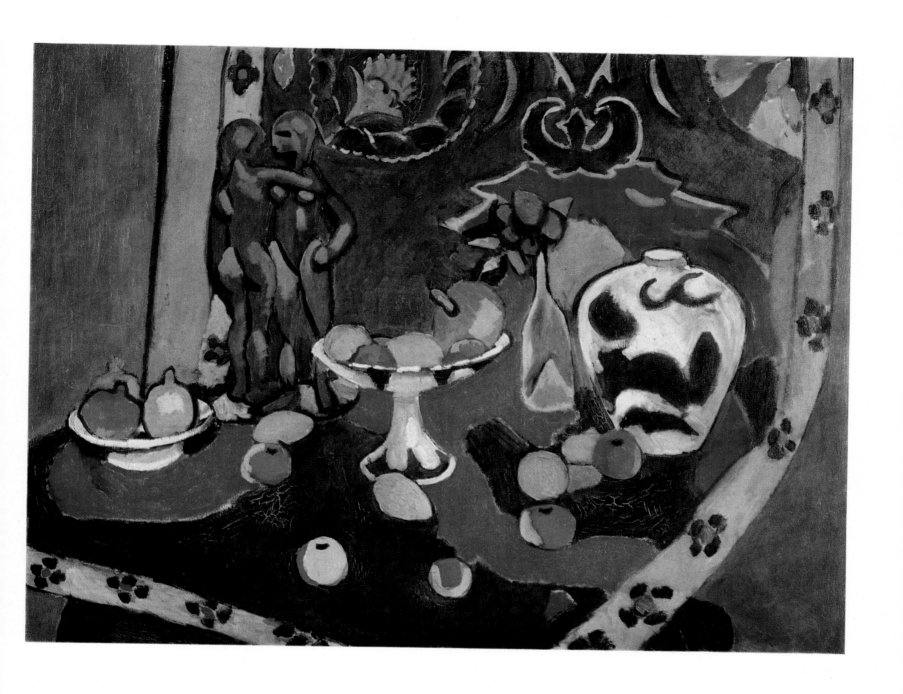

238 FRUIT AND BRONZES. 1910
Oil on canvas. 89.5 × 116.5 cm. Inv. No 3394
Signed and dated lower center: *Henri Matisse 1910*
The picture was bought by Ivan Morozov from Matisse in 1910 in Paris for 5,000 francs. Reproduced in the still life is Matisse's sculpture *Two Negro Women* (1908). Valentin Serov used this still life as a background for his portrait of Ivan Morozov painted in 1910 (The Tretyakov Gallery, Moscow).

Provenance: 1910 The artist's collection, Paris; 1910—18 The I. Morozov Collection, Moscow; 1918—48 The Museum of Modern Western Art, Moscow; since 1948 The Pushkin Museum of Fine Arts, Moscow

Exhibitions: 1910 Paris, Cat. 58; 1955 Moscow, Cat., p. 45; 1956 Leningrad, Cat., p. 38; 1969 Moscow, Leningrad, Cat. 30

Bibliography: Кат. ГМИИ 1957, p. 89; Кат. ГМИИ 1961, p. 121; Маковский 1912, p. 22; Кат. ГМНЗИ 1928, No 352; Réau 1929, No 964; Cahiers d'Art 1950, p. 343; Barr 1951, pp. 127, 128, 138 (5); Diehl 1954, ill. 50; Sterling 1957, ill. 139, p. 182; Матисс 1958, p. 102; Прокофьев 1962, ill. 182; Кат. выст. Матисса 1969, pp. 66—67, No 30, ill. p. 44; Antonova 1977, No 138

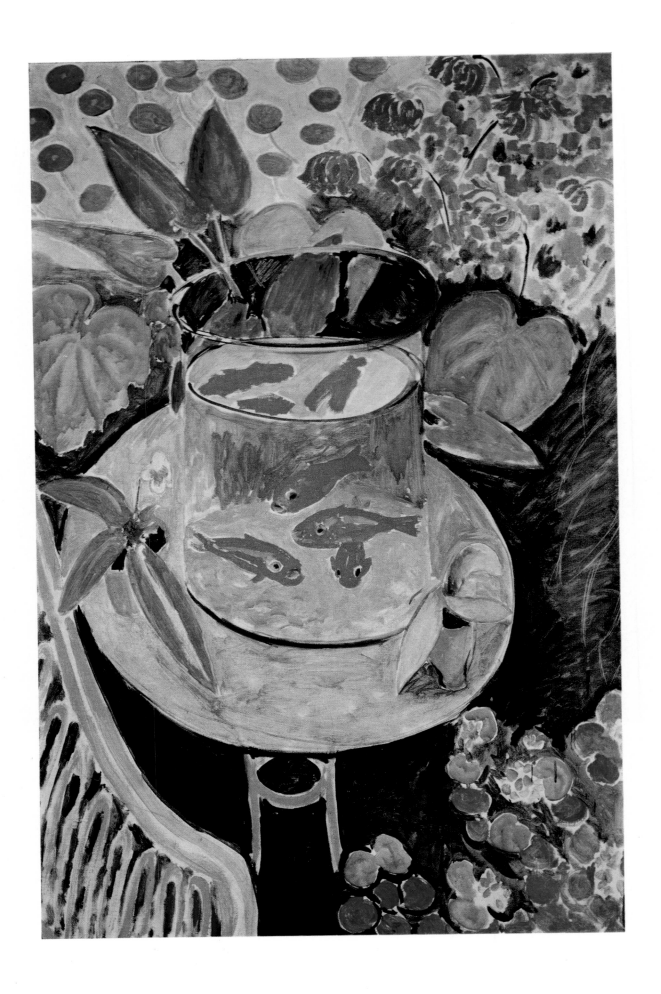

Oil on canvas. 146 × 97 cm. Inv. No 3299
Matisse painted over ten variations on this theme, of which the Moscow picture, completed in 1911 at Issy-les-Moulineaux, is considered the best.

Provenance: until 1912 The artist's collection, Paris; 1912—18 The S. Shchukin Collection, Moscow; 1918—48 The Museum of Modern Western Art, Moscow; since 1948 The Pushkin Museum of Fine Arts, Moscow
Exhibitions: 1955 Moscow, Cat., p. 45; 1956 Leningrad, Cat., p. 39; 1958 Brussels, Cat. 211; 1966—67 Tokyo, Kyoto, Cat. 72; 1969 Moscow, Leningrad, Cat. 36; 1970 Paris, Cat. 107

Bibliography: Кат. ГМИИ 1957, p. 89; Кат. ГМИИ 1961, p. 121; Кат. собр. С. Щукина 1913, No 115, pp. 26—27; Перцов 1921, No 115, p. 111; Ettinger 1926, part 2, p. 119, ill.; Кат. ГМНЗИ 1928, No 330; Réau 1929, No 944; Ромм 1935, p. 32, ill.; R. Escholier, *Henri Matisse*, Paris, 1937, ill. No 11; Cahiers d'Art 1950, p. 343; Barr 1951, pp. 144, 154, 164, 537, 553, ill. 376; Diehl 1954, pp. 68, 139 (59), 154, 161, ill. 59; Sterling 1957, ill. 149; Матисс 1958, ill.; Прокофьев 1962, ill. 183; ГМИИ 1966, No 104; Алпатов 1969, p. 47; Кат. выст. Матисса 1969, p. 68, No 36, ill. p. 51

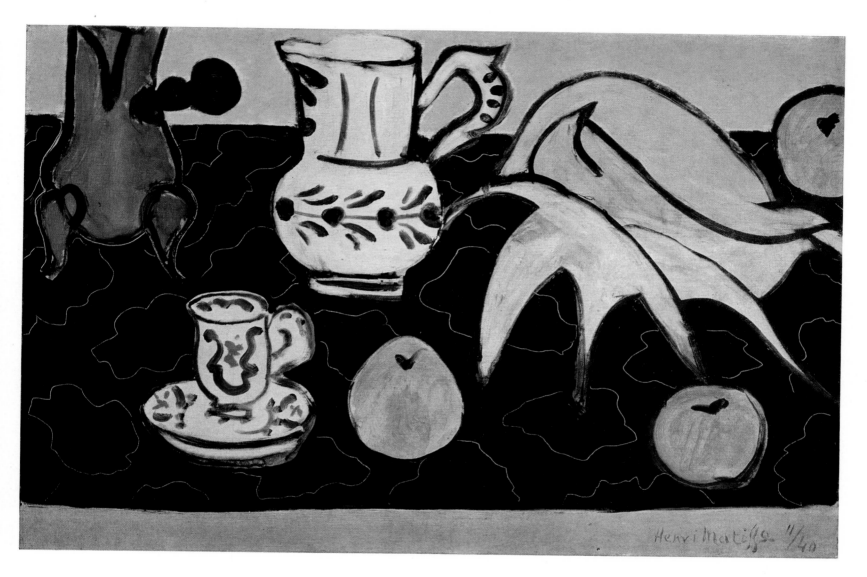

240 STILL LIFE WITH A SEASHELL. 1940
Oil on canvas. 54.8 × 82 cm. Inv. No 3769
Signed and dated lower right: *Henri Matisse 11/40*
The picture was presented to The Pushkin Museum by Lydia Délectorskaya in 1958. Several drawings are known to have been done for the picture. One of these, *A Seashell* (in pen), is in The Pushkin Museum. Matisse repeated the composition of this still life in the collage technique (the Pierre Matisse Collection, New York).

Provenance: until 1952 The artist's collection, Nice; 1952—58 The L. Délectorskaya Collection, Paris; since 1958 The Pushkin Museum of Fine Arts, Moscow

Exhibitions: 1951 Tokyo; 1953—55 Copenhagen; 1969 Moscow, Leningrad, Cat. 51

Bibliography: Кат. ГМИИ 1961, p. 122; *Cahiers d'Art* 1940—44, p. 130, ill.; Diehl 1954, p. 91, ill. 121, p. 146 (121); Алпатов 1969, p. 63; Кат. выст. Матисса 1969, p. 71, No 51, ill. p. 60; J. Cowart, J. D. Flam, D. Fourcade, J. H. Neff, *Henri Matisse. Paper Cut-Outs*, The St Louis Art Museum and Detroit Institute of Arts, 1977, p. 41, ill. 23, p. 98, No 11

ALBERT MARQUET. 1875—1947

241 SUNNY DAY IN PARIS.
THE LOUVRE EMBANKMENT
Oil on canvas. 65 × 82 cm. Inv. No 3391
Signed lower right: *Marquet*
The picture is dated 1905.

Provenance: until 1913 The E. Druet Collection, Paris
(No 7389); 1913—18 The I. Morozov Collection, Moscow; 1918—48 The Museum of Modern Western Art,
Moscow; since 1948 The Pushkin Museum of Fine
Arts, Moscow

Exhibitions: 1955 Moscow, Cat., p. 44; 1956 Leningrad, Cat., p. 37; 1958 Moscow, Cat. 8; 1959 Leningrad,
Kiev, Cat. 10; 1967—68 Odessa, Kharkov, Cat. 23;
1975—76 Bordeaux, Paris, Cat. 28

Bibliography: Кат. ГМИИ 1957, p. 86; Кат. ГМИИ
1961, p. 117; Кат. ГМНЗИ 1928, No 296; Réau 1929,
No 914; Jourdain 1959, p. 111; Леняшина 1975, No 138,
ill. p. 58; Antonova 1977, No 133

242 NOTRE-DAME IN WINTER
Oil on canvas. 65 × 81 cm. Inv. No 3292
Signed lower left: *marquet*
The picture is dated 1908.

Provenance: The E. Druet Collection, Paris (No 4902);
until 1918 The S. Shchukin Collection, Moscow; 1918—
48 The Museum of Modern Western Art, Moscow;
since 1948 The Pushkin Museum of Fine Arts, Moscow

Exhibitions: 1955 Moscow, Cat., p. 44; 1956 Leningrad,
Cat., p. 36; 1958 Moscow, Cat. 2; 1959 Leningrad,
Kiev, Cat. 13

Bibliography: Кат. ГМИИ 1957, p. 86; Кат. ГМИИ
1961, p. 117; Кат. собр. С. Щукина 1913, No 88,
pp. 22—23; Тугендхольд 1914, p. 41, ill. p. 30; Пер-
цов 1921, No 88, p. 111; Тугендхольд 1923, ill. p. 61;
Кат. ГМНЗИ 1928, No 286; Réau 1929, No 908; Ca-
hiers d'Art 1950, p. 342; Прокофьев 1962, ill. 175;
Musée de Moscou 1963, No 93, p. 196; ГМИИ 1966,
No 110; Марке 1969, ill. 14; Леняшина 1975, No 206

243 VESUVIUS
Oil on canvas. 61 × 80 cm. Inv. No 3294
Signed lower right: *marquet*
The picture is dated 1909.

Provenance: The E. Druet Collection, Paris (No 5408);
until 1918 The S. Shchukin Collection, Moscow; 1918—
48 The Museum of Modern Western Art, Moscow;
since 1948 The Pushkin Museum of Fine Arts, Moscow

Exhibitions: 1939 Moscow, Cat., p. 54; 1955 Moscow,
Cat., p. 44; 1956 Leningrad, Cat., p. 37; 1958 Mos-
cow, Cat. 4

Bibliography: Кат. ГМИИ 1957, p. 86; Кат. ГМИИ
1961, p. 117; Кат. собр. С. Щукина 1913, No 92,
pp. 22—23; Тугендхольд 1914, p. 41, ill. p. 30; Пер-
цов 1921, No 92, p. 111; Кат. ГМНЗИ 1928, No 288;
Réau 1929, No 919; Cahiers d'Art 1950, p. 342; Jour-
dain 1959, p. 79; Прокофьев 1962, ill. 179; Марке
1969, ill. 16; Леняшина 1975, No 179, ill. p. 99

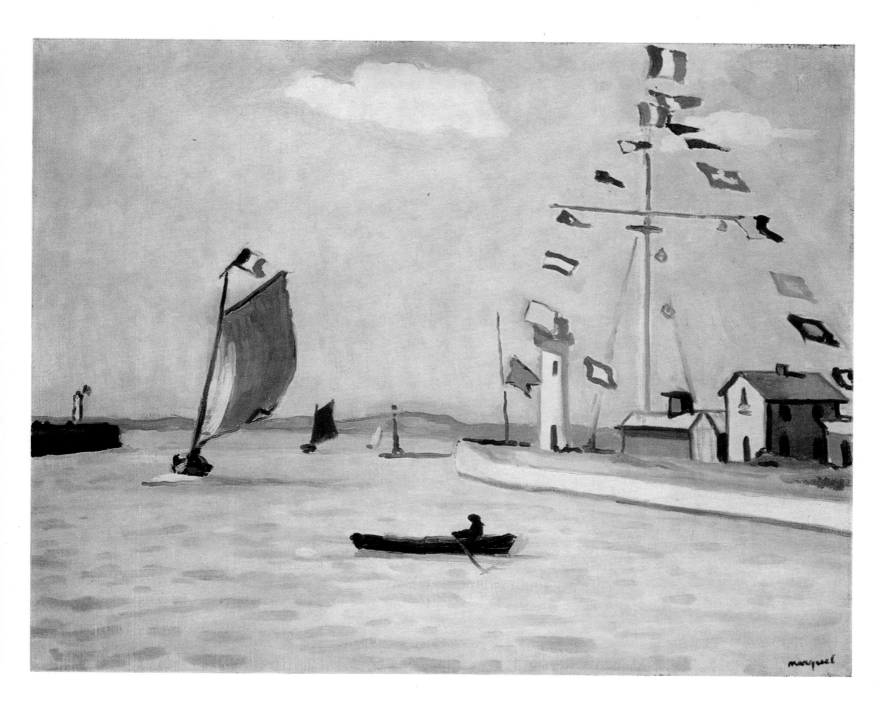

244 HARBOR AT HONFLEUR

Oil on canvas. 65 × 81 cm. Inv. No 3291
Signed lower right: *marquet*
The picture is dated 1911.

Provenance: The E. Druet Collection, Paris (No 6507);
until 1918 The S. Shchukin Collection, Moscow; 1918—
48 The Museum of Modern Western Art, Moscow;
since 1948 The Pushkin Museum of Fine Arts, Moscow

Exhibitions: 1955 Moscow, Cat., p. 44; 1956 Lenin-
grad, Cat., p. 37; 1958 Moscow, Cat. 6; 1959 Lenin-
grad, Kiev, Cat. 15; 1965 Bordeaux, Cat. 85; 1965—
66 Paris, Cat. 85; 1975—76 Bordeaux, Paris, Cat. 49

Bibliography: Кат. ГМИИ 1957, p. 86; Кат. ГМИИ
1961, p. 117; Кат. собр. С. Щукина 1913, No 87,
pp. 22—23; Тугендхольд 1914, p. 41; Кат. ГМНЗИ
1928, No 291; Réau 1929, No 916; Cahiers d'Art 1950,
p. 343; Jourdain 1959, p. 203; Марке 1969, ill. 17;
Леняшина 1975, No 226, ill. p. 103; Antonova 1977,
No 135

245 FLOOD IN PARIS
Oil on canvas. 33 × 41 cm. Inv. No 3290
Signed lower left: *marquet*
The picture is dated 1910.

Provenance: The E. Druet Collection, Paris; until 1918
The S. Shchukin Collection, Moscow; 1918—48 The
Museum of Modern Western Art, Moscow; since 1948
The Pushkin Museum of Fine Arts, Moscow

Exhibitions: 1939 Circulaing Exhibition, Cat. 83; 1958
Moscow, Cat. 5; 1959 Leningrad, Kiev, Cat. 14

Bibliography: Кат. ГМИИ 1961, p. 117; Кат. собр.
С. Щукина 1913, No 85, pp. 22—23; Тугендхольд
1914, p. 41; Перцов 1921, No 85, p. 111; Ettinger 1926,
part 2, p. 127, ill.; Кат. ГМНЗИ 1928, No 289; Réau
1929, No 909; Cahiers d'Art 1950, p. 343; Леняшина
1975, No 212

246 SNOW IN MUNICH. 1909
Oil on canvas. 64 × 80 cm. Inv. No 3424
Signed and dated lower right: *Othon Friesz Munich 09*
In the winter of 1909 Friesz was in Munich and there
painted a series of winter landscapes. The same square
is also depicted in other canvases of this series.

Provenance: 1909 The E. Druet Collection, Paris
(No 5660); 1909—18 The I. Morozov Collection, Mos-
cow; 1918—48 The Museum of Modern Western Art,
Moscow; since 1948 The Pushkin Museum of Fine
Arts, Moscow

Exhibition: 1909 Paris (Druet Gallery), Cat. 40

Bibliography: Маковский 1912, pp. 10, 24; Ternovetz
1925, p. 485; Кат. ГМНЗИ 1928, No 644; Réau 1929,
No 825

LOUIS VALTAT. 1869—1952

247 THE FARM (LANDSCAPE)
Oil on canvas. 82 × 101 cm. Inv. No 3361
Signed lower right: *L. Valtat*
The picture may be dated 1907, the year it was exhibited in the Salon d'Automne.

Provenance: 1907 The A. Vollard Collection, Paris; 1907—18 The I. Morozov Collection, Moscow; 1918—48 The Museum of Modern Western Art, Moscow; since 1948 The Pushkin Museum of Fine Arts, Moscow

Exhibition: 1907 Paris (Salon d'Automne), Cat. 1673

Bibliography: Маковский 1912, p. 19; Кат. ГМНЗИ 1928, No 43; Réau 1929, No 1129

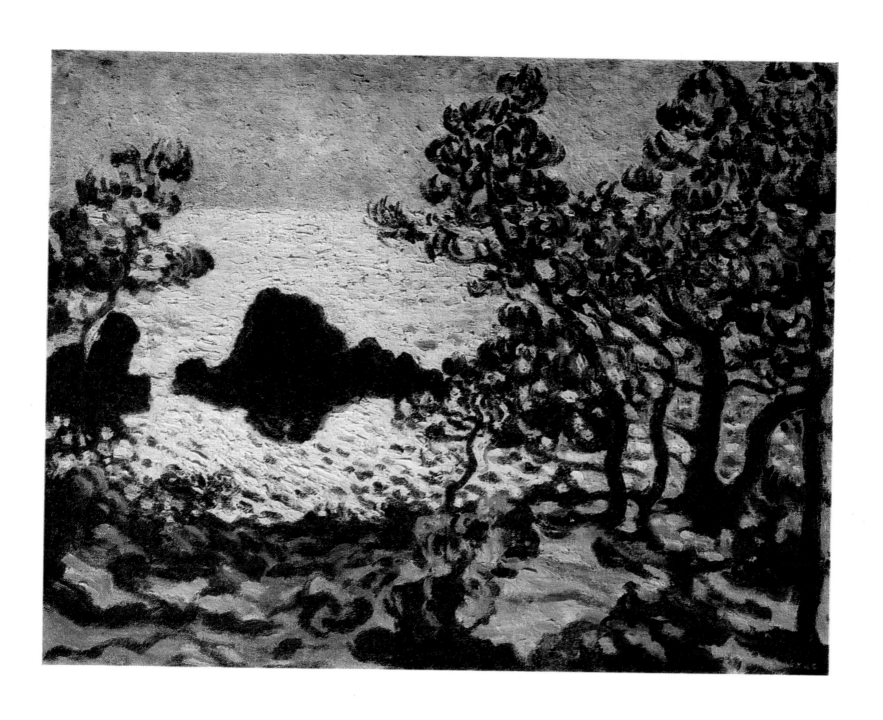

248 THE SEA AT ANTHÉOR
Oil on canvas. 82 × 100 cm. Inv. No 3362
Signed lower left: *L. Valtat*
The picture may be dated 1905—6, when Valtat
worked at Anthéor.

Provenance: until 1907 The A. Vollard Collection,
Paris; 1907—18 The I. Morozov Collection, Moscow;
1918—48 The Museum of Modern Western Art, Moscow; since 1948 The Pushkin Museum of Fine Arts,
Moscow

Exhibitions: 1907 Paris (Salon d'Automne), Cat. 1675;
1967—68 Odessa, Kharkov, Cat. 4

Bibliography: Маковский 1912, p. 19; Кат. ГМНЗИ
1928, No 41; Réau 1929, No 1130

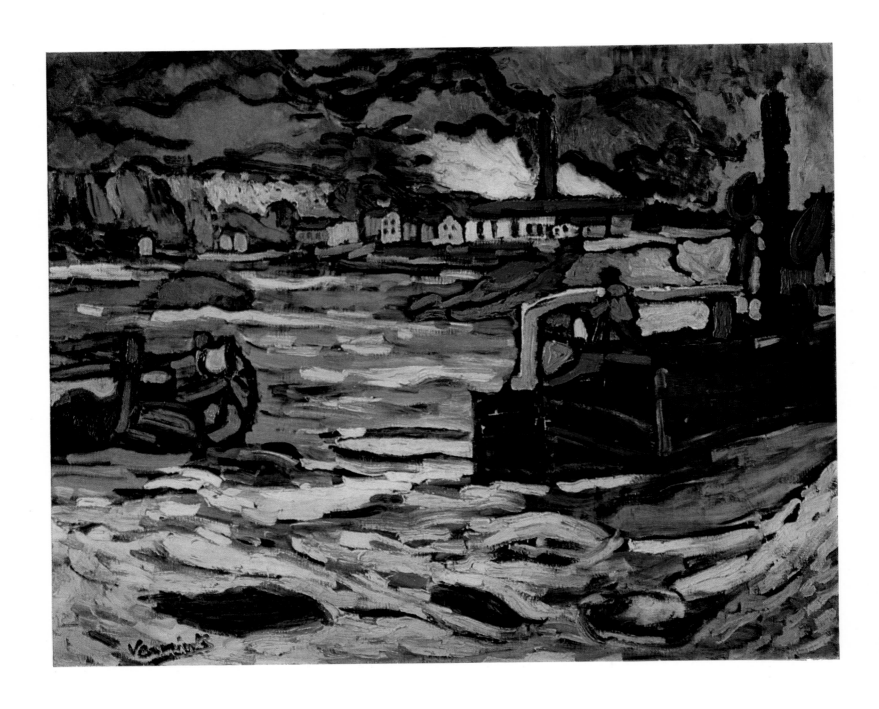

249 BOATS ON THE SEINE
Oil on canvas. 81 × 100 cm. Inv. No 3364
Signed lower left, underlined: *Vlaminck*

Provenance: until 1907 The A. Vollard Collection, Paris; 1907—18 The I. Morozov Collection, Moscow; 1918—48 The Museum of Modern Western Art, Moscow; since 1948 The Pushkin Museum of Fine Arts, Moscow

Exhibition: 1907 Paris (Salon d'Automne), Cat. 1694

Bibliography: Кат. ГМИИ 1961, p. 41; Маковский 1912, p. 19; Кат. ГМНЗИ 1928, No 52; Réau 1929, No 1153; Antonova 1977, No 127

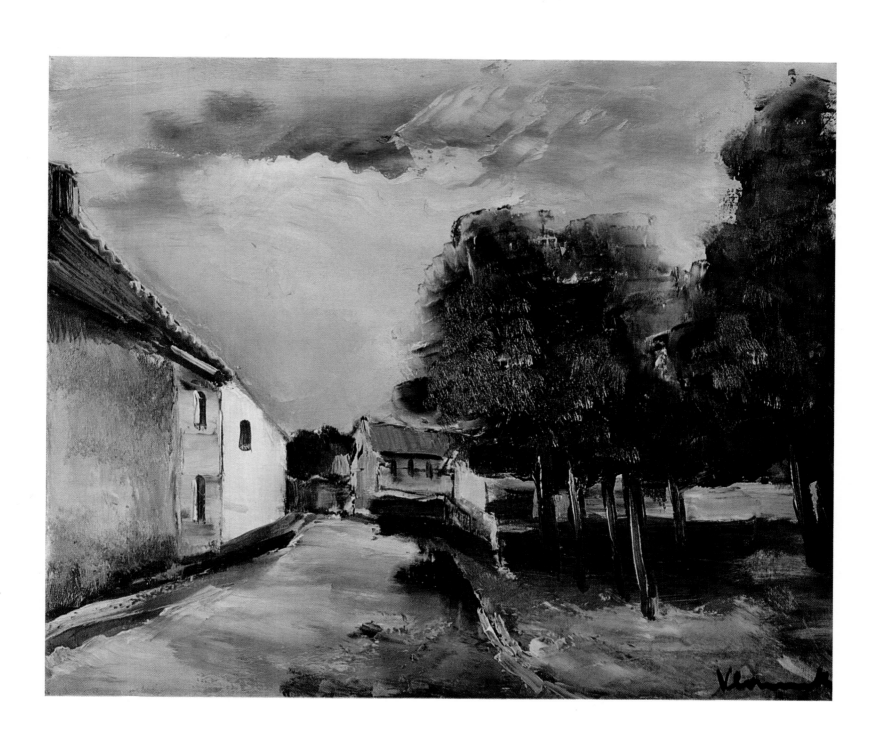

250 LANDSCAPE IN AUVERS
Oil on canvas. 45 × 55 cm. Inv. No 3460
Signed lower right: *Vlaminck*

Provenance: until 1925 The artist's collection, Paris; 1925—48 The Museum of Modern Western Art, Moscow; since 1948 The Pushkin Museum of Fine Arts, Moscow

Exhibition: 1939 Moscow, Cat., p. 54

Bibliography: Кат. ГМИИ 1961, p. 42; Кат. ГМНЗИ 1928, No 55, ill.; Réau 1929, No 1156; Прокофьев 1962, ill. 188

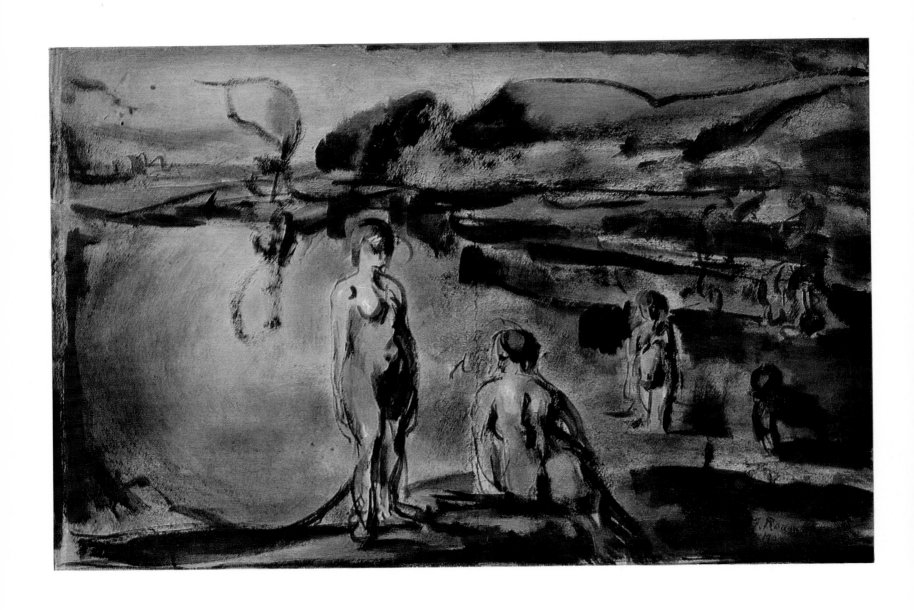

251 BATHING IN A LAKE. 1907
Watercolor and pastel on paper. 65 × 96 cm.
Inv. No 3331
Signed and dated lower right: *G Rouault 1907*

Provenance: The E. Druet Collection, Paris (No 3705);
1913—18 The S. Shchukin Collection, Moscow; 1918—
48 The Museum of Modern Western Art, Moscow;
since 1948 The Pushkin Museum of Fine Arts, Moscow

Exhibition: 1908 Moscow, Cat. 149

Bibliography: Золотое Руно 1908, p. 64, ill.; Кат.
собр. С. Щукина 1913, No 196, pp. 44—45; Тугенд-
хольд 1914, p. 45; Перцов 1921, No 196, p. 115; Ter-
novetz 1925, p. 485; Ettinger 1926, part 2, p. 128, ill.;
Кат. ГМНЗИ 1928, No 526; Réau 1929, No 1086; Ca-
hiers d'Art 1950, p. 347; Musée de Moscou 1963,
p. 198, ill.; Antonova 1977, No 142

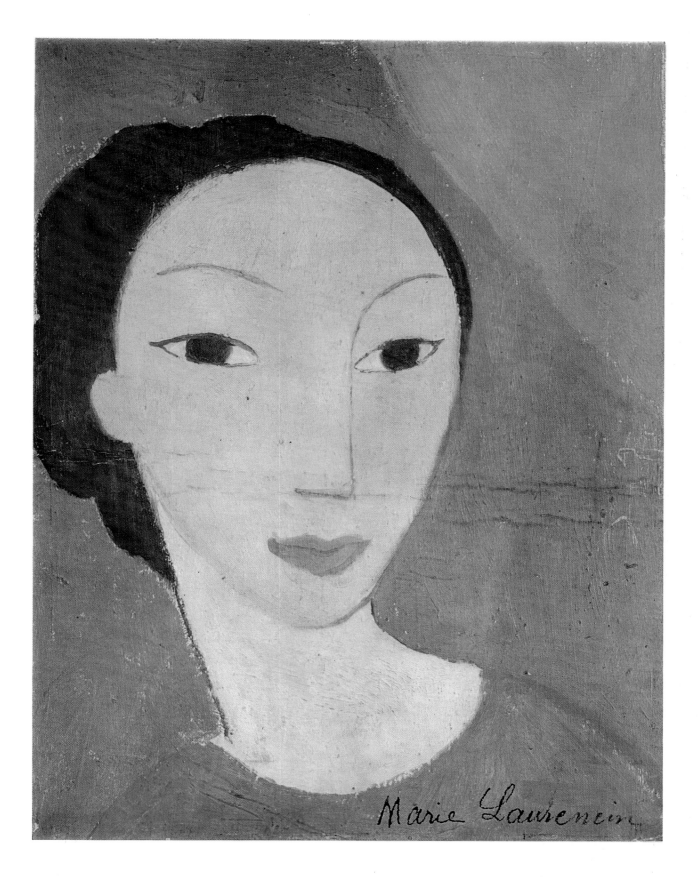

252 WOMAN'S HEAD
Oil on canvas mounted on cardboard. 35 ×27 cm.
Inv. No 3354
Signed lower right: *Marie Laurencin*

Provenance: until 1918 The S. Shchukin Collection,
Moscow; 1918—48 The Museum of Modern Western
Art, Moscow; since 1948 The Pushkin Museum of
Fine Arts, Moscow

Bibliography: Перцов 1921, No 242, p. 110; Кат.
ГМНЗИ 1928, No 264; Réau 1929, No 881; Cahiers
d'Art 1950, p. 342

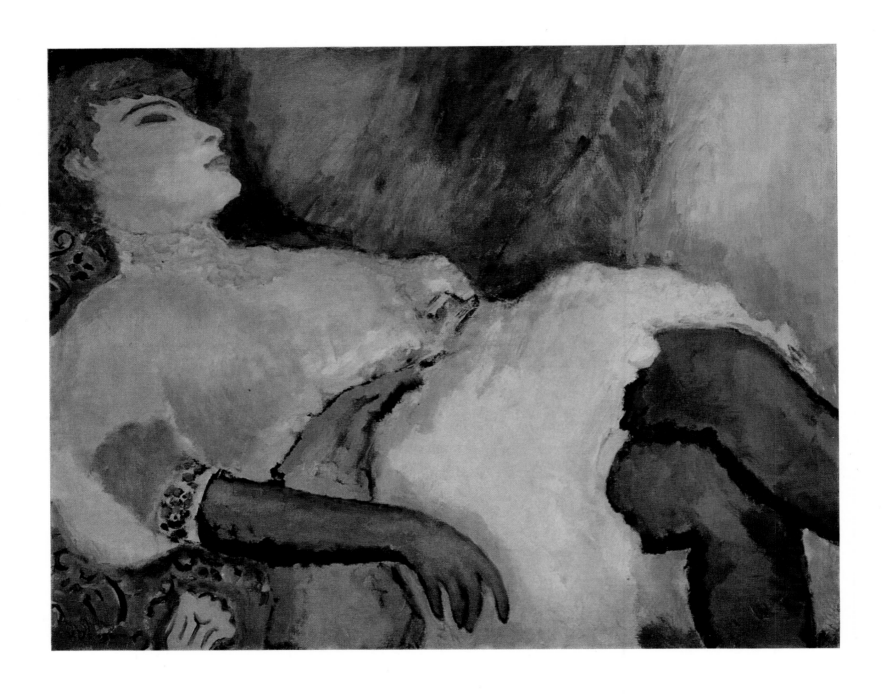

253 LADY IN BLACK GLOVES
Oil on canvas. 73 × 91 cm. Inv. No 3436
Signed lower left: *V. Dongen*

Provenance: 1908—19 The S. Poliakov Collection, Moscow; 1919—25 The Tretyakov Gallery, Moscow; 1925—48 The Museum of Modern Western Art, Moscow; since 1948 The Pushkin Museum of Fine Arts, Moscow

Exhibitions: 1908 Moscow; 1967—68 Paris, Rotterdam, Cat. 53a

Bibliography: Золотое Руно 1908, Nos 7, 8, pp. 39, 64, ill.; Кат. ГМНЗИ 1928, No 179; Réau 1929, No 1138

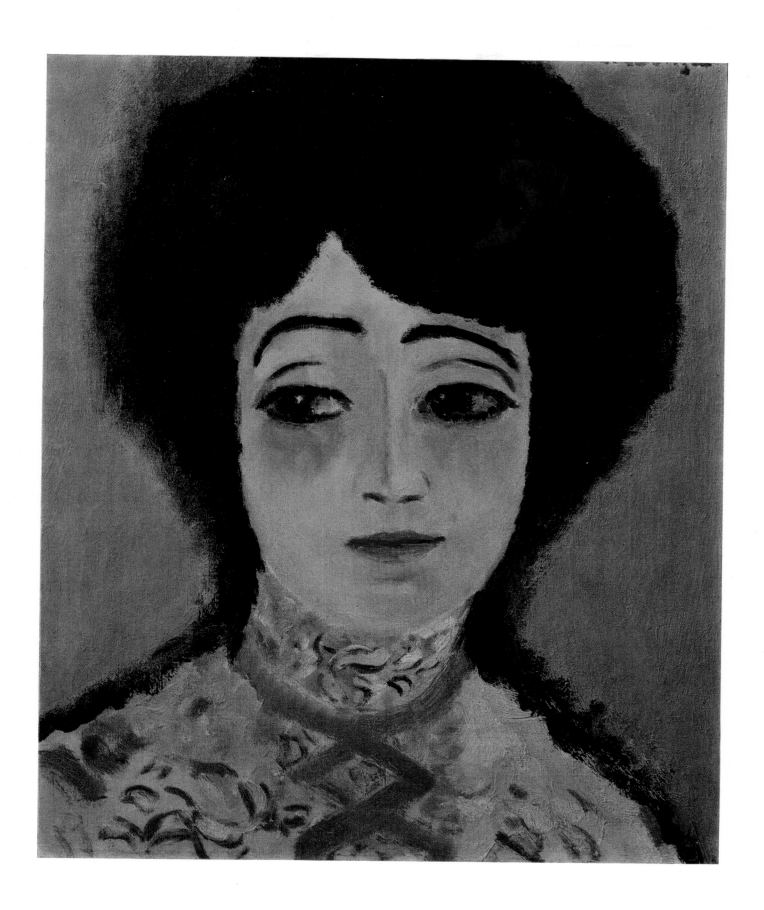

254 SPANISH WOMAN
Oil on canvas. 46 × 39 cm. Inv. No 3972
Signed upper right: *van Dongen*

Provenance: The Ginsburg Collection (?); until 1966
The G. Kostaki Collection, Moscow; since 1966 The
Pushkin Museum of Fine Arts, Moscow (gift of
G. Kostaki)

Exhibition: 1970 Moscow, Cat. 26

Bibliography: "La Chronique des arts", *Gazette des
Beaux-Arts*, 72, 1968, No 465, p. 127

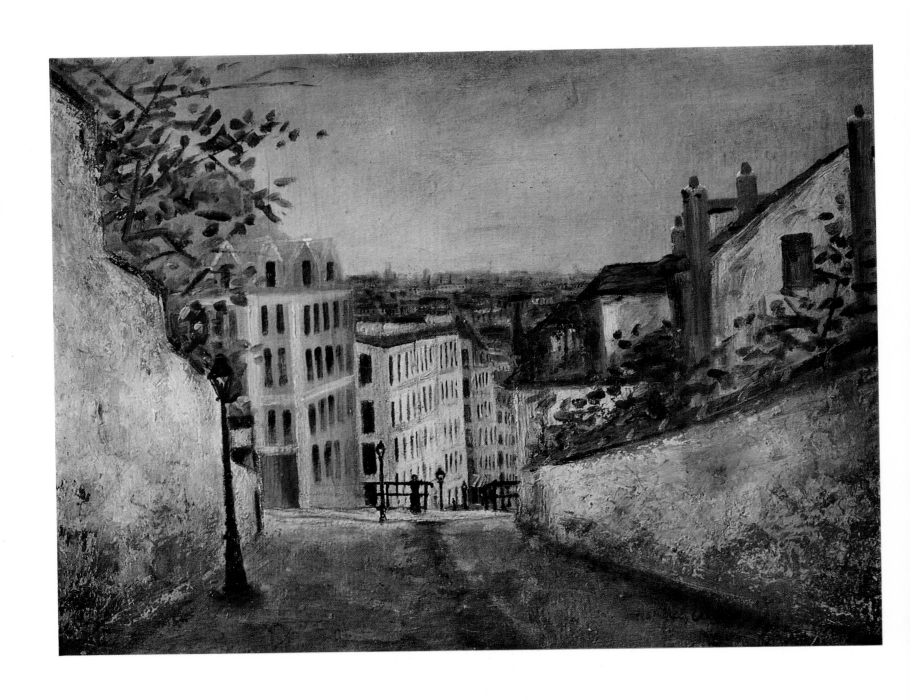

255 LA RUE DU MONT-CENIS
Oil on canvas. 48 × 63 cm. Inv. No 3466
Signed lower right: *Maurice Utrillo V*
This painting was bought through the State Purchasing Commission at the exhibition of Modern Western Art in Moscow in 1928. Utrillo painted the Rue du Mont-Cenis in Montmartre many times. There are landscapes on this theme in a private collection in Bern (*La Rue du Mont-Cenis*, 1911) and in private collections in Zurich (for example, *La Rue du Mont-Cenis*, 1913, in the Pollag Collection).

Provenance: until 1928 The artist's collection, Paris; 1928—48 The Museum of Modern Western Art, Moscow; since 1948 The Pushkin Museum of Fine Arts, Moscow

Exhibitions: 1928 Moscow, Cat., 117; 1939 Moscow, Cat., p. 55

Bibliography: Кат. ГМИИ 1961, p. 185; Б. Терновец, "Выставка современного французского искусства в Москве", *Искусство,* 1928, 3—4, p. 120; B. Ternovetz, "Lettre de Russie. Le développement du Musée d'Art Moderne de Moscou", *Formes,* 1930, 3, pp. 22—23, ill.; *Советский музей,* 1935, 2, pp. 41—53, ill. p. 48; Sterling 1957, ill. 150; Прокофьев 1962, ill. 166; Antonova 1977, No 123

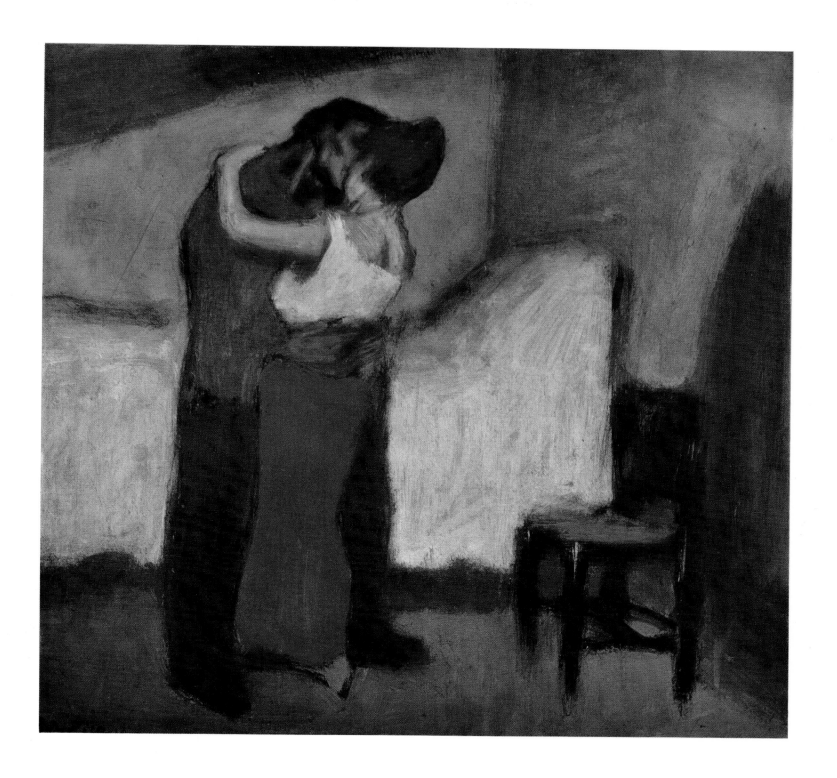

256 THE RENDEZVOUS
Oil on cardboard. 52 × 56 cm. Inv. No 3322
Signed lower right (underlined): *P. R. Picasso*
The picture was painted in 1900 in Paris. On the reverse is a sketch in oil: a seated woman with a book and a red sofa against a brown background.
Provenance: 1913—18 The S. Shchukin Collection, Moscow; 1918—48 The Museum of Modern Western Art, Moscow; since 1948 The Pushkin Museum of Fine Arts, Moscow

Exhibitions: 1954 Paris, Cat. 2; 1955 Moscow, Cat., p. 50; 1956 Leningrad, Cat., p. 46; 1960 London, Cat. 271; 1964 Tokyo, Cat. 2; 1971 Paris, Cat. 1
Bibliography: Кат. ГМИИ 1957, p. 109; Кат. ГМИИ 1961, p. 147; Кат. собр. С. Щукина 1913, No 182, pp. 40—41; Тугендхольд 1914, p. 44; Перцов 1921, No 182, p. 114; Кат. ГМНЗИ 1928, No 419; Réau 1929, No 1006; Zervos 1932—59, vol. 1, No 26, ill. XIII; Cahiers d'Art 1950, p. 344; Daix et Boudaille 1966, p. 123, II/14, ill.

257 THE STROLLING GYMNASTS
Oil on canvas. 73 × 60 cm. Inv. No 3420
Signed lower left (underlined): *Picasso*
Painted in 1901 in Paris, this picture belongs to the
artist's Blue period. It was bought by Ivan Morozov
from Ambroise Vollard in Paris in 1908 for 300 francs.
This was in fact the first Picasso to arrive in Moscow.
Provenance: until 1908 The A. Vollard Collection, Paris; 1908—18 The I. Morozov Collection, Moscow; 1918—48 The Museum of Modern Western Art, Moscow; since 1948 The Pushkin Museum of Fine Arts, Moscow
Exhibitions: 1954 Paris, Cat. 1; 1955 Moscow, Cat., p. 50; 1956 Leningrad, Cat., p. 47; 1967 Montreal; 1971 Paris, Cat. 2

Bibliography: Кат. ГМИИ 1957, p. 109; Кат. ГМИИ 1961, p. 147; Маковский 1912, p. 22; Тугендхольд 1914, p. 44; Ettinger 1926, part 2, p. 122, ill.; Кат. ГМНЗИ 1928, No 458; Réau 1929, No 1045; Zervos 1932—59, vol. 1, No 92, ill. XLVI; Cahiers d'Art 1950, p. 345; Sterling 1957, ill. 152; Прокофьев 1962, ill. 194; ГМИИ 1966, No 112; Daix et Boudaille 1966, p. 199, VI/20, ill.; D. Cooper, *Picasso. Theatre*, London, 1967, ill. 48; Antonova 177, No 144

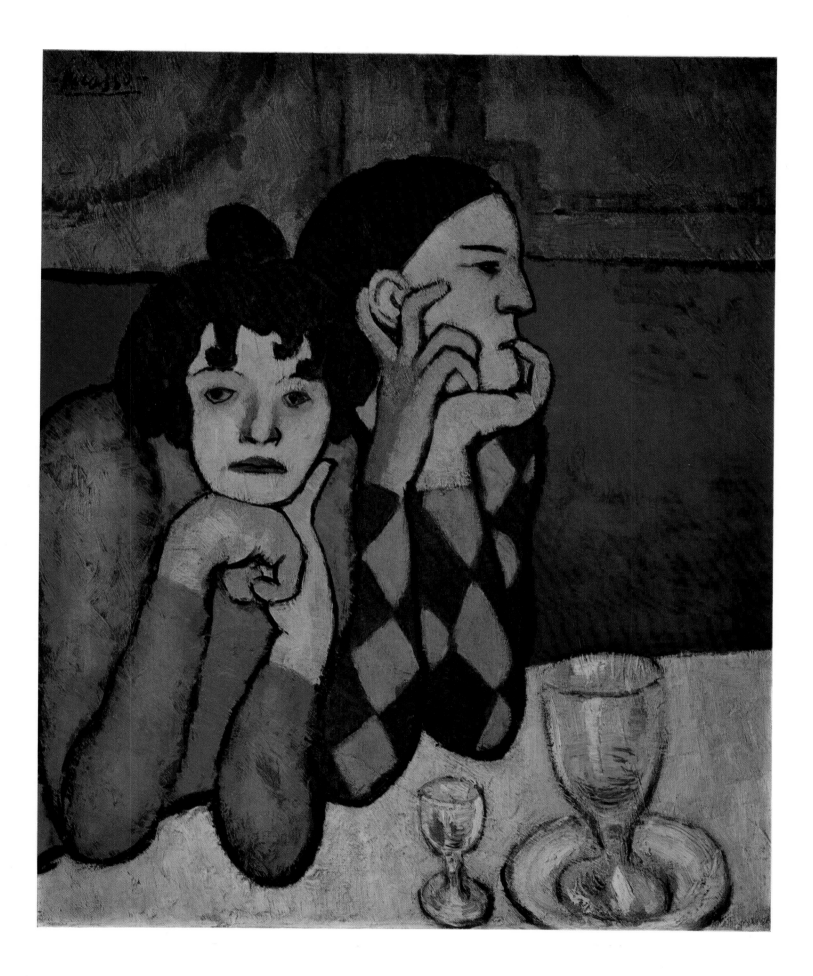

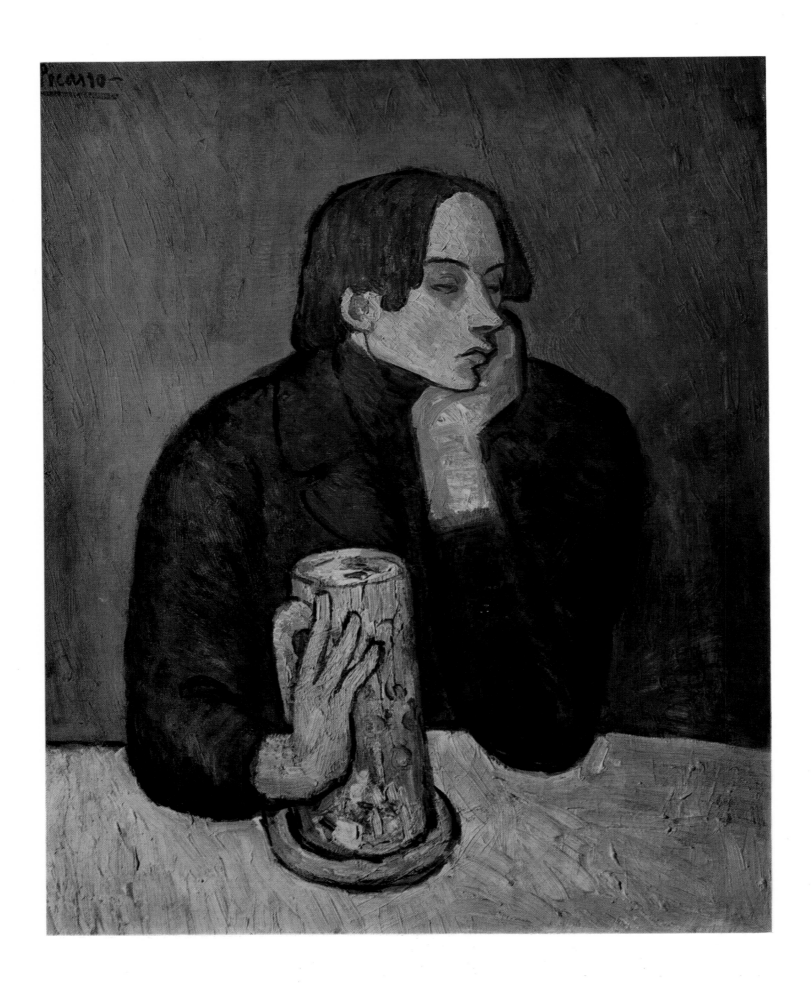

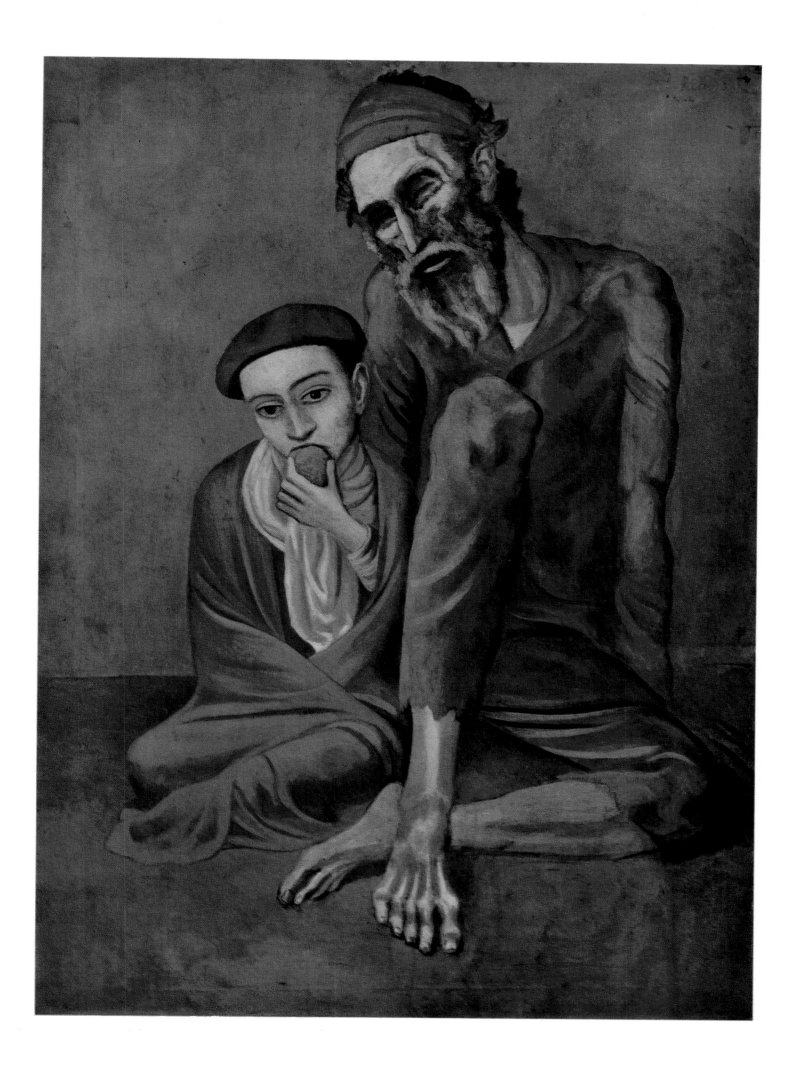

258 PORTRAIT OF THE POET SABARTÉS
← Oil on canvas. 82 × 66 cm. Inv. No 3317
Signed upper left (underlined): *Picasso*
This portrait of the Spanish poet Jaime Sabartés was
painted by Picasso in 1901 during his Blue period.
On the evidence of Sabartés, the artist painted four
portraits of him, of which the one in The Pushkin
Museum is the earliest.

Provenance: The D. H. Kahnweiler Collection, Paris;
1913—18 The S. Shchukin Collection, Moscow; 1918—
48 The Museum of Modern Western Art, Moscow;
since 1948 The Pushkin Museum of Fine Arts, Moscow

Exhibitions: 1954 Paris, Cat. 3; 1955 Moscow, Cat.,
p. 50; 1956 Leningrad, Cat., p. 46; 1966—67 Paris,
Cat. 10

Bibliography: Кат. ГМИИ 1957, p. 109; Кат. ГМИИ
1961, p. 147; Кат. собр. С. Щукина 1913, No 158,
pp. 36—37; Тугендхольд 1914, p. 43; Перцов 1921,
No 158, p. 113; Кат. ГМНЗИ 1928, No 408; Réau 1929,
No 998; Zervos 1932—59, vol. 1, No 97, ill. XLVIII;
A. H. Barr, Picasso. *Fifty Years of His Art*, New
York, 1946, p. 16; J. Sabartés, *Picasso. Portraits et
souvenirs*, Paris, 1946, pp. 70—73, ill. 64; Cahiers
d'Art 1950, p. 344; Daix et Boudaille 1966, p. 199,
VI/19, ill.

259 OLD BEGGAR AND A BOY
← Oil on canvas. 125 × 92 cm. Inv. No 3318
Signed upper right: *Picasso*
The picture was painted in 1903 in Barcelona and
belongs to Picasso's Blue period. There is a prelimi-
nary drawing in pastel (1903) in the Junyer-Vidal
Collection, Barcelona.

Provenance: 1913—18 The S. Shchukin Collection,
Moscow; 1918—48 The Museum of Modern Western
Art, Moscow; since 1948 The Pushkin Museum of Fine
Arts, Moscow

Exhibitions: 1955 Moscow, Cat., p. 50; 1956 Lenin-
grad, Cat., p. 46; 1960 London, Cat. 272; 1971 Paris,
Cat. 5

Bibliography: Кат. ГМИИ 1957, p. 109; Кат. ГМИИ
1961, p. 147; Кат. собр. С. Щукина 1913, No 160,
pp. 36—37; Перцов 1921, No 160, p. 113; Тугенд-
хольд 1923, p. 112, ill. p. 117; Ettinger 1926, part 2,
p. 120, ill.; Кат. ГМНЗИ 1928, No 410; Réau 1929,
No 1000; Zervos 1932—59, vol. 1, No 175, ill. LXXXI;
Cahiers d'Art 1950, p. 344; Sterling 1957, ill. 156;
Прокофьев 1962, ill. 192; Daix et Boudaille 1966,
pp. 62, 228, IX/30, ill.; Antonova 1977, No 143

260 SPANISH WOMAN FROM MALLORCA
Watercolor, tempera and gouache on cardboard.
67 × 51 cm. Inv. No 3316
Signed lower left: *Picasso*
Completed in 1905 in Paris, this work is a study for
Family of Saltimbanques (in the Chester Dale Col-
lection, the National Gallery of Art, Washington).

Provenance: 1913—18 The S. Shchukin Collection,
Moscow; 1918—48 The Museum of Modern Western
Art, Moscow; since 1948 The Pushkin Museum of Fine
Arts, Moscow

Exhibitions: 1955 Moscow, Cat., p. 50; 1956 Lenin-
grad, Cat., p. 46; 1965 Berlin, Cat., p. 147; 1970
Osaka, Cat., p. 262

Bibliography: Кат. ГМИИ 1957, p. 109; Кат. ГМИИ
1961, p. 147; Кат. собр. С. Щукина 1913, No 153,
pp. 34—35; Тугендхольд 1914, p. 43; Перцов 1921,
No 153, p. 113; Тугендхольд 1923, ill. p. 121; Кат.
ГМНЗИ 1928, No 417; Réau 1929, No 1007; Zervos
1932—59, vol. 1, No 288, ill. CXXIII; Cahiers d'Art
1950, p. 345; Sterling 1957, ill. 158; Прокофьев 1962,
ill. 196; Musée de Moscou 1963, p. 210, ill.; ГМИИ
1962, No 114; Daix et Boudaille 1966, pp. 76, 266,
XII/34, ill.; Antonova 1977, No 145

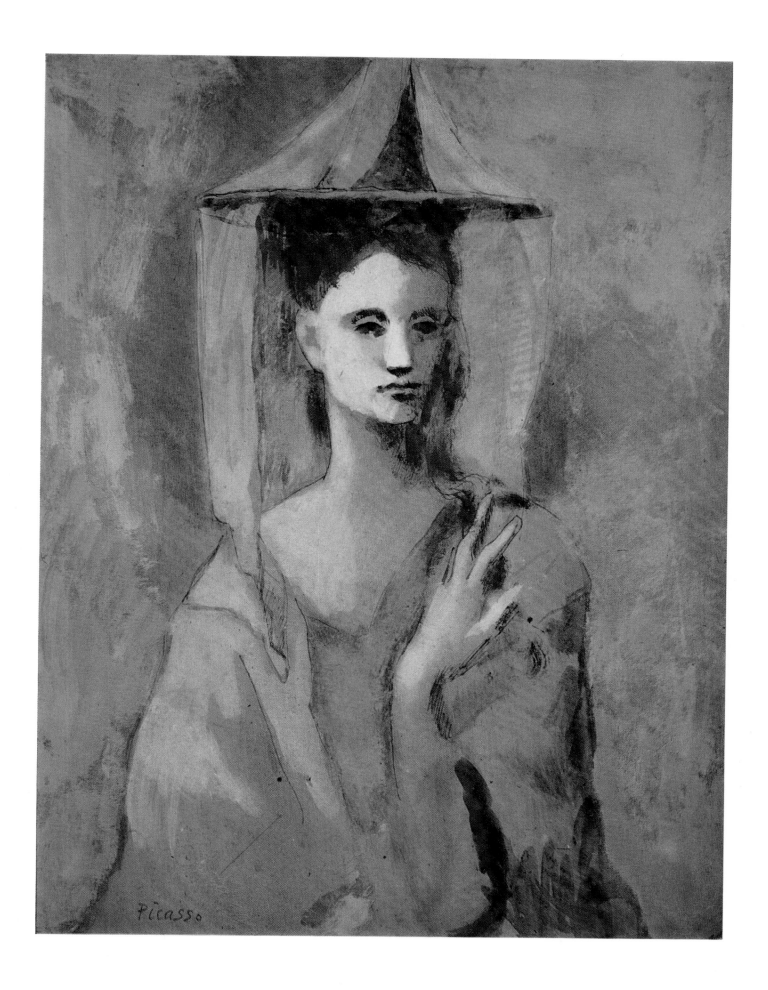

261 YOUNG GIRL ON A BALL
Oil on canvas. 147 × 95 cm. Inv. No 3399
Signed lower right: *Picasso*
The picture was painted in 1905 in Paris and belongs to Picasso's Pink period. The motif of a figure balancing on a ball recurs in Picasso's work. Related to the Pushkin Museum picture are a pen drawing (in a private collection, Paris) and two watercolors (one in the Cone Collection, the Baltimore Museum of Art, the other in a private collection, Paris). The picture was bought by Ivan Morozov from D. H. Kahnweiler in Paris in 1913 for 13,500 francs.

Provenance: 1907 The G. Stein Collection, Paris; until 1913 The D. H. Kahnweiler Collection, Paris; 1913—18 The I. Morozov Collection, Moscow; 1918—48 The Museum of Modern Western Art, Moscow; since 1948 The Pushkin Museum of Fine Arts, Moscow

Exhibitions: 1955 Moscow, Cat., p. 50; 1956 Leningrad, Cat., p. 47; 1958 Brussels, Cat. 255; 1960 London, Cat. 273; 1971 Paris, Cat. 6

Bibliography: Кат. ГМИИ 1957, p. 109, ill.; Кат. ГМИИ 1961, p. 147, ill.; Ternovetz 1925, p. 485, ill.; Кат. ГМНЗИ 1928, No 459; Réau 1929, No 1046; Zervos 1932—59, vol. 1, No 290, ill. CXXIV; Cahiers d'Art 1950, p. 345; Sterling 1957, ill. 157; Прокофьев 1962, ill. 197; Musée de Moscou 1963, p. 208, ill.; ГМИИ 1966, No 113; Daix et Boudaille 1966, pp. 89, 262, XII/19, ill.; D. Cooper, *Picasso. Theatre*, London, 1967, ill. 52; J. Starobinski, *Portrait de l'artiste en saltimbanque*, Geneva, 1970, ill. p. 125; Antonova 1977, No 146

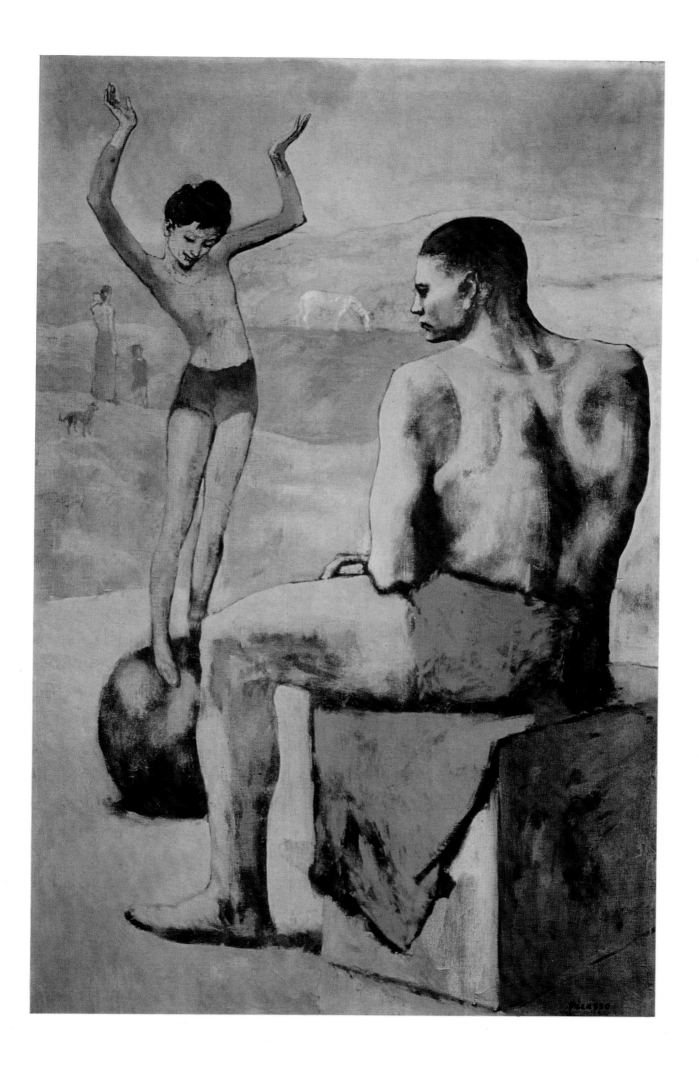

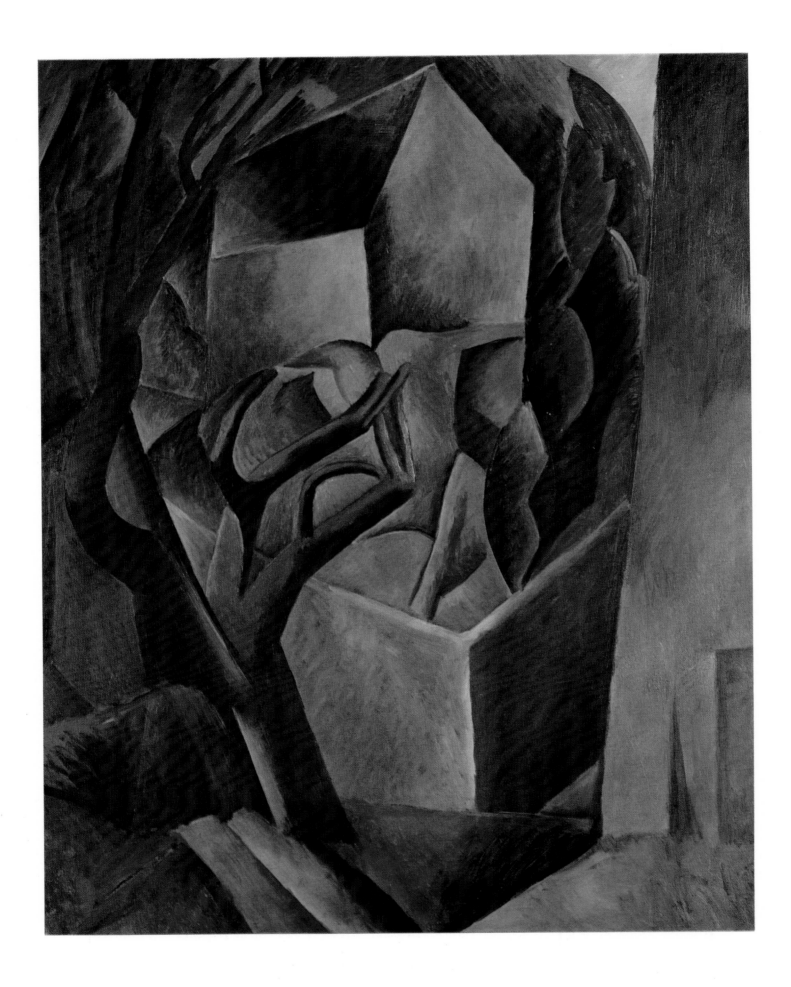

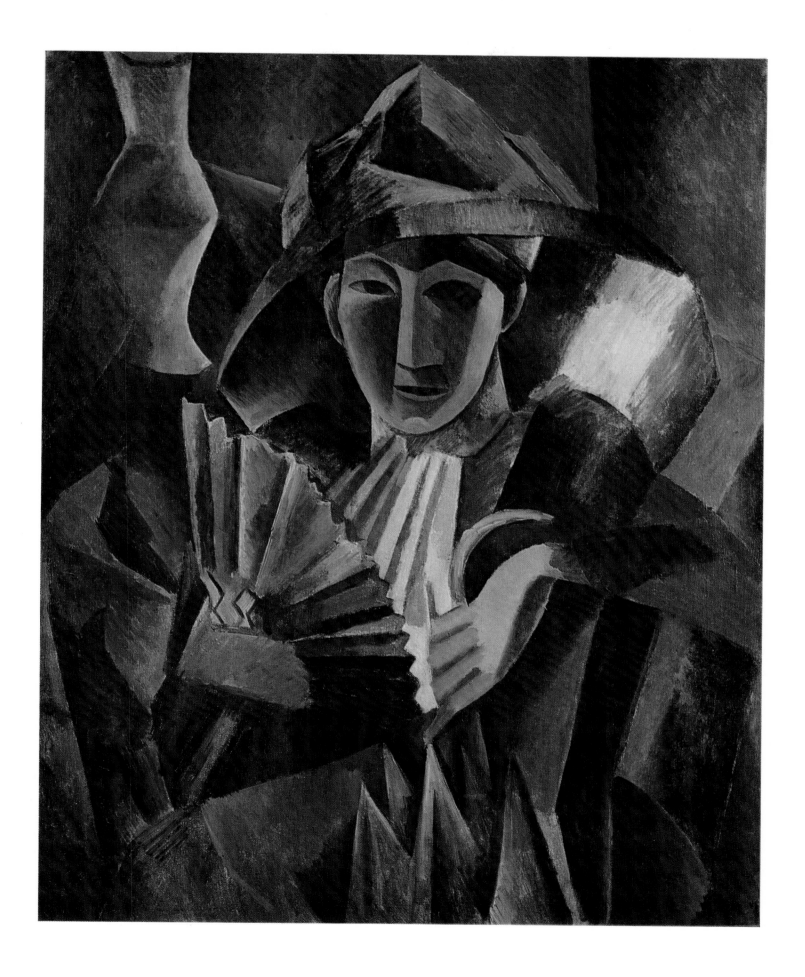

262 A HUT IN THE GARDEN

← Oil on canvas. 92 × 73 cm. Inv. No 3350
The picture was painted in the vicinity of Creil (Oise), in the autumn of 1908. Several other Picasso works on the same theme are known.

Provenance: 1913—18 The S. Shchukin Collection, Moscow; 1918—48 The Museum of Modern Western Art, Moscow; since 1948 The Pushkin Museum of Fine Arts, Moscow

Exhibitions: 1939 Moscow, Cat., p. 55; 1954 Paris, Cat. 6; 1964 Tokyo, Cat. 5

Bibliography: Кат. ГМИИ 1957, p. 109; Кат. ГМИИ 1961, p. 148; Кат. собр. С. Щукина 1913, No 230, pp. 40—41; Тугендхольд 1914, p. 43; Перцов 1921, No 230, p. 114; Кат. ГМНЗИ 1928, No 444; Réau 1929, No 1031; A. H. Barr, *Picasso. Fifty Years of His Art*, New York, 1946, p. 59; Cahiers d'Art 1950, p. 345

263 LADY WITH A FAN

← Oil on canvas. 101 × 81 cm. Inv. No 3320
The picture was painted in 1909. This was the first Picasso to be bought by Sergei Shchukin.

Provenance: 1913—18 The S. Shchukin Collection, Moscow; 1918—48 The Museum of Modern Western Art, Moscow; since 1948 The Pushkin Museum of Fine Arts, Moscow

Exhibitions: 1966—67 Paris, Cat. 58; 1968 Vienna, Cat. 17; 1971 Paris, Cat. 19

Bibliography: Кат. ГМИИ 1957, p. 109; Кат. ГМИИ 1961, p. 147; Кат. собр. С. Щукина 1913, No 176, pp. 38—39; Тугендхольд 1914, p. 44, ill. p. 71; Grautoff 1919, ill. p. 97; Тугендхольд 1923, pp. 121—122, ill. p. 133; Кат. ГМНЗИ 1928, No 441; Réau 1929, No 1028; Zervos 1932—59, vol. 2, No 137; Cahiers d'Art 1950, p. 345; Antonova 177, No 147

264 QUEEN ISABEAU

Oil on canvas. 92 × 73 cm. Inv. No 3319
Queen Isabeau is the heroine of medieval tales of chivalry. The picture was executed in 1909.

Provenance: The D. H. Kahnweiler Collection, Paris; 1913—18 The S. Shchukin Collection, Moscow; 1918—48 The Museum of Modern Western Art, Moscow; since 1948 The Pushkin Museum of Fine Arts, Moscow

Exhibitions: 1954 Paris, Cat. 17; 1956 Leningrad, Cat. 47; 1965 Bordeaux, Cat. 95; 1965—66 Paris, Cat. 94; 1967—68 Odessa, Kharkov, Cat. 27; 1971 Paris, Cat. 18

Bibliography: Кат. ГМИИ 1957, p. 109; Кат. ГМИИ 1961, p. 147; Кат. собр. С. Щукина 1913, No 165, pp. 36—37; Тугендхольд 1914, p. 43; Перцов 1921, No 165, p. 113; Тугендхольд 1923, pp. 121—122, ill. p. 125; Кат. ГМНЗИ 1928, No 440; Réau 1929, No 1027; Zervos 1932—59, vol. 2, No 136; Cahiers d'Art 1950, p. 345

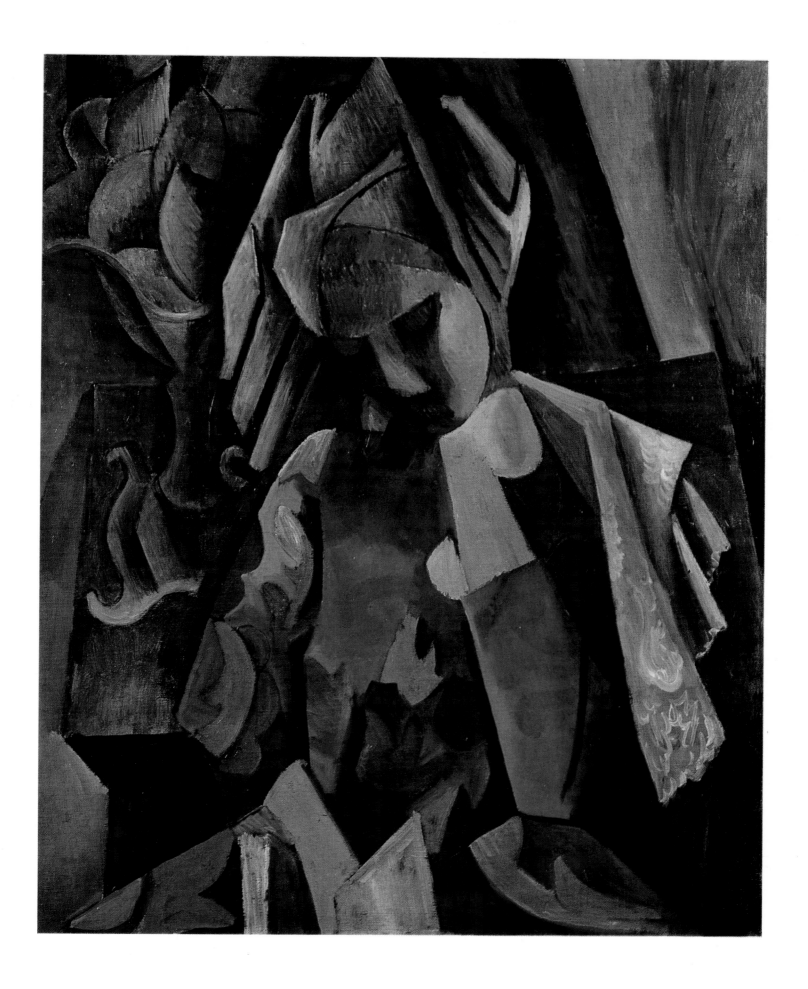

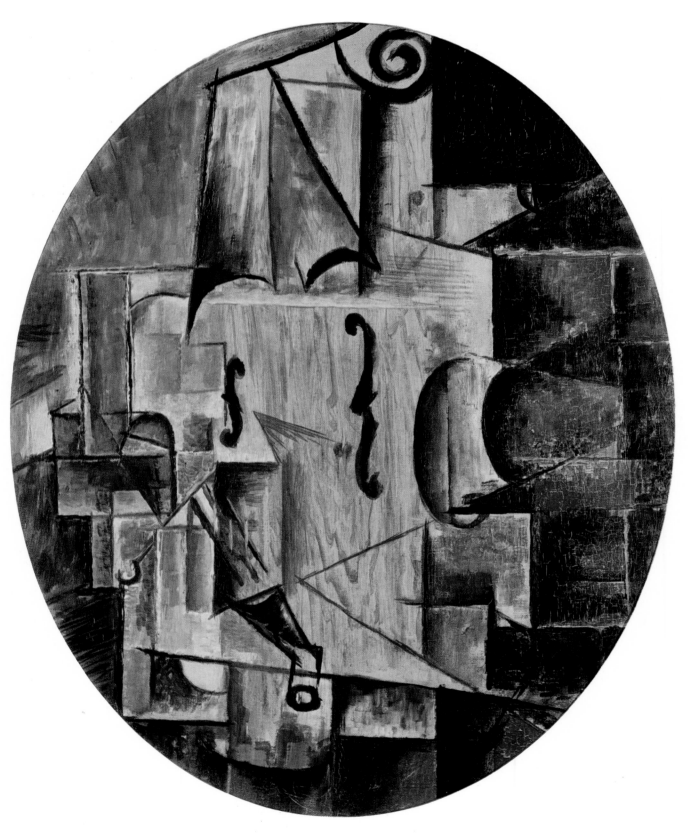

265 STILL LIFE WITH A VIOLIN
Oil on canvas. 55 × 46 cm (oval). Inv. No 3321
Signed on the reverse upper right: *Picasso*
The picture was painted in 1911—12.

Provenance: The D. H. Kahnweiler Collection, Paris;
1913—18 The S. Shchukin Collection, Moscow; 1918—
48 The Museum of Modern Western Art, Moscow;
since 1948 The Pushkin Museum of Fine Arts, Moscow

Exhibition: 1971 Paris, Cat. 24

Bibliography: Кат. собр. С. Щукина 1913, No 178,
pp. 38—39; Тугендхольд 1914, ill. p. 75; Перцов 1921,
No 178, p. 113; Кат. ГМНЗИ 1928, No 452; Réau 1929,
No 1039; Cahiers d'Art 1950, p. 345

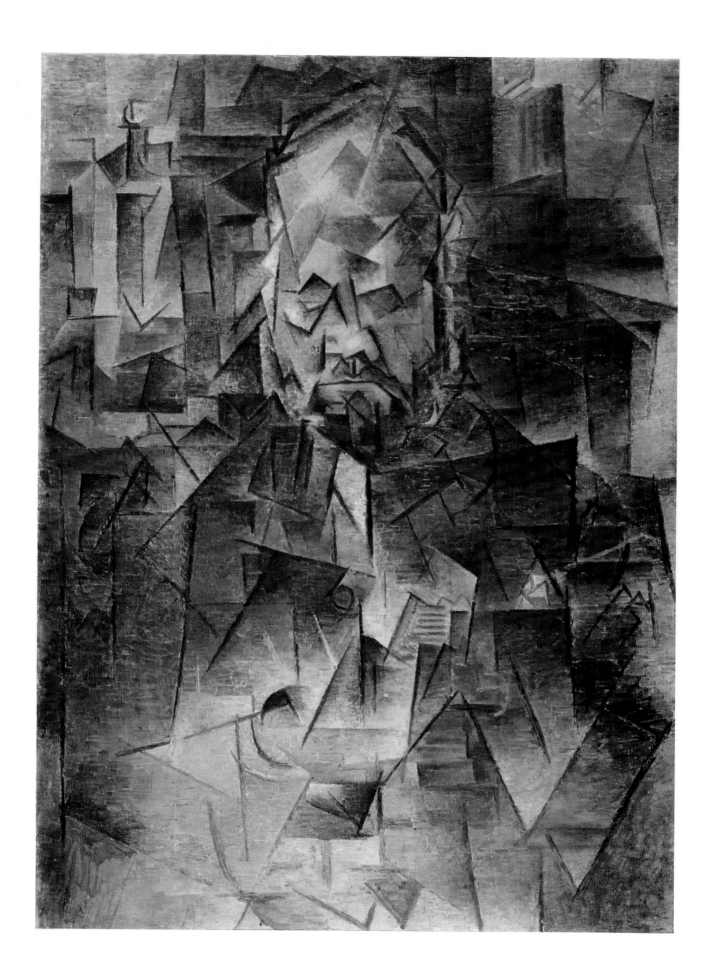

266 PORTRAIT OF AMBROISE VOLLARD

← Oil on canvas. 93 × 66 cm. Inv. No 3401
Picasso painted and drew many portraits of Ambroise
Vollard (1868—1939), the famous Parisian dealer, col-
lector and connoisseur of art. This portrait was done
in Paris in 1909—10, and bought there by Ivan Moro-
zov from Vollard in 1913 for 3,000 francs.

Provenance: until 1913 The A. Vollard Collection,
Paris; 1913—18 The I. Morozov Collection, Moscow;
1918—48 The Museum of Modern Western Art, Mos-
cow; since 1948 The Pushkin Museum of Fine Arts,
Moscow

Exhibitions: 1958 Brussels, Cat. 258; 1964 Tokyo,
Cat. 7; 1965 Bordeaux, Cat. 96; 1965—66 Paris, Cat. 96;
1966—67 Paris, Cat. 67

Bibliography: Ternovets 1925, p. 488, ill.; Кат. ГМНЗИ
1928, No 460; Réau 1929, No 1047; Zervos 1932—59,
vol. 2, No 265, ill.; Cahiers d'Art, 1950, p. 345;
Sterling 1957, ill. 163

GEORGES BRAQUE. 1882—1963

267 THE NEW CASTLE AT LA ROCHE-GUYON
Oil on canvas. 92 × 73 cm. Inv. No 3258
Signed on the reverse: *Braque*
In 1909 Braque worked on his series of landscapes
with views of the castle at La Roche-Guyon. The
Pushkin Museum picture was apparently painted at
the same time.

Provenance: The D. H. Kahnweiler Collection, Paris
(No 342); until 1918 The S. Shchukin Collection, Mos-
cow; 1918—48 The Museum of Modern Western Art,
Moscow; since 1948 The Pushkin Museum of Fine
Arts, Moscow

Exhibitions: 1967—68 Odessa, Kharkov, Cat. 3; 1973
Washington, Cat. 1

Bibliography: Кат. собр. С. Щукина 1913, No 2,
pp. 2—3; Перцов 1921, No 2, p. 107; Тугендхольд
1923, ill. p. 103; Ternovetz 1925, p. 487; Кат. ГМНЗИ
1928, No 32; Réau 1929, No 719; Cahiers d'Art 1950,
p. 338

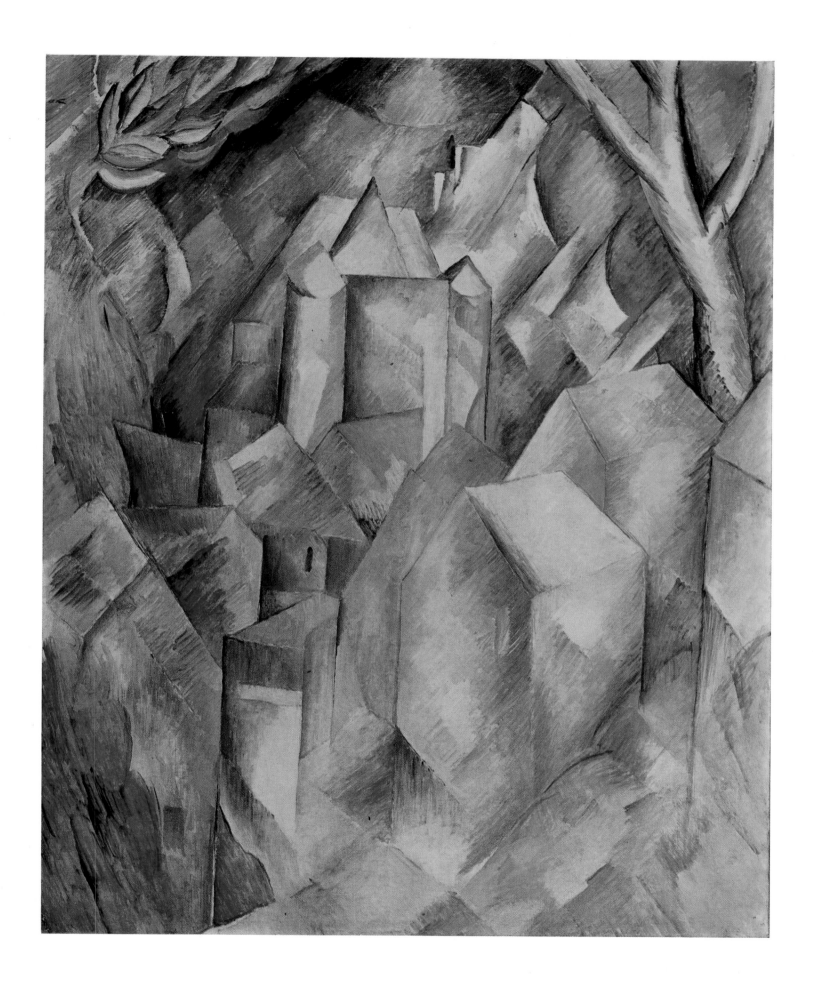

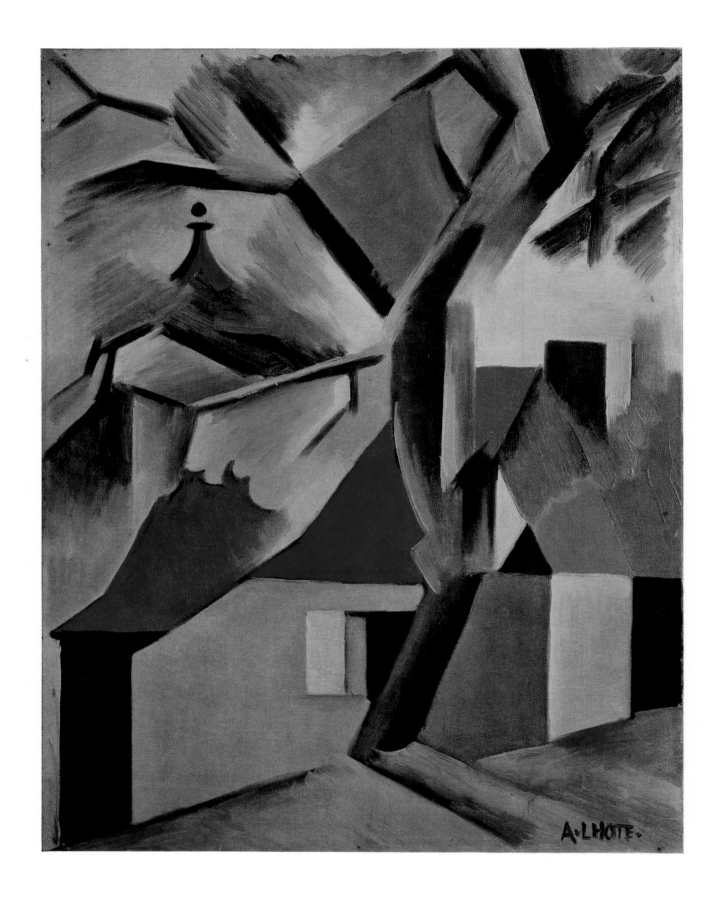

268 LANDSCAPE WITH HOUSES
Oil on canvas. 65 × 50 cm. Inv. No 3462
Signed lower right: *A. Lhote*
The picture was given by André Lhote to S. Romov in Paris in 1927 as a gift for The Museum of Modern Western Art in Moscow.

Provenance: until 1927 The artist's collection, Paris; 1927—48 The Museum of Modern Western Art, Moscow; since 1948 The Pushkin Museum of Fine Arts, Moscow

Bibliography: Кат. ГМНЗИ 1928, No 267; Réau 1929, No 893

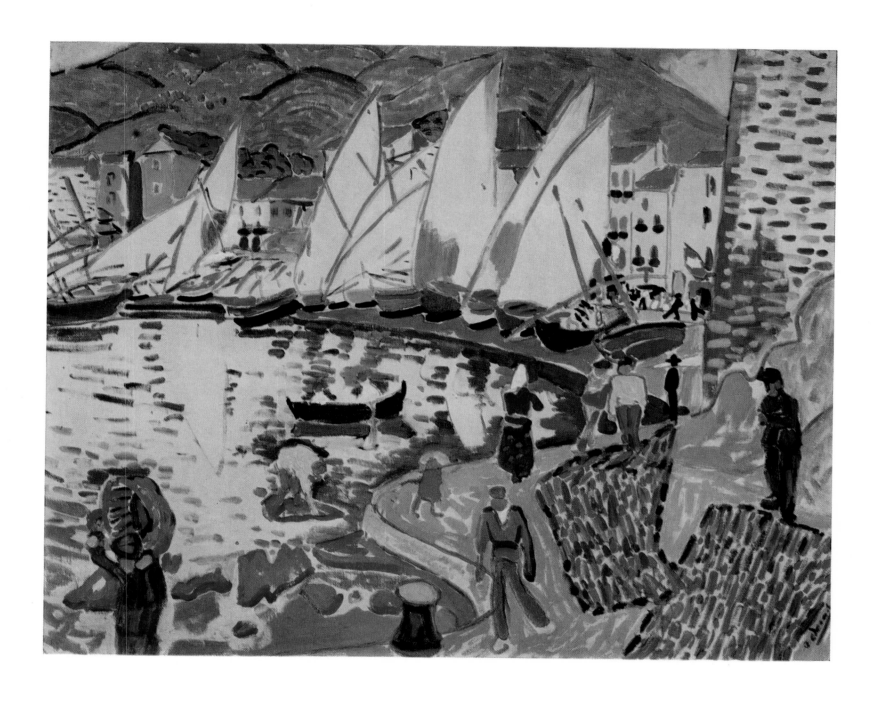

269 DRYING SAILS (SAIL BOATS)
Oil on canvas. 82 × 101 cm. Inv. No 3377
Signed lower right: *a derain*
The picture was painted in 1905 at Collioure, where
Derain worked with Matisse, and was shown at the
first Fauve exhibition in the 1905 Salon d'Automne.
It was previously entitled *Fishing Boats*, and erro-
neously dated 1907.

Provenance: until 1907 The A. Vollard Collection, Par-
is; 1907—18 The I. Morozov Collection, Moscow; 1918—
48 The Museum of Modern Western Art, Moscow;
since 1948 The Pushkin Museum of Fine Arts, Moscow
Exhibition: 1905 Paris (Salon d'Automne), Cat. 440
Bibliography: Кат. ГМИИ 1961, p. 71; Маковский
1912, p. 20; Ternovetz 1925, p. 487; Кат. ГМНЗИ
1928, No 166; Réau 1929, No 800; Cahiers d'Art 1950,
p. 340

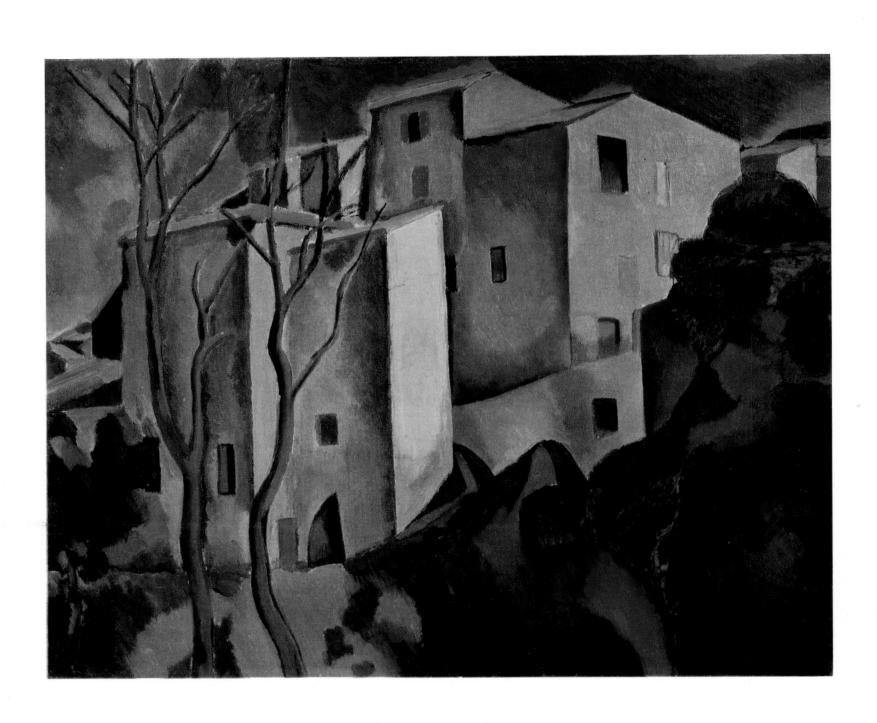

270　THE CASTLE
Oil on canvas. 66 × 82 cm. Inv. No 3279
The picture was painted in 1910 at Cagnes.

Provenance: The D. H. Kahnweiler Collection, Paris;
until 1918 The S. Shchukin Collection, Moscow; 1918—
48 The Museum of Modern Western Art, Moscow;
since 1948 The Pushkin Museum of Fine Arts, Moscow

Exhibitions: 1965 Bordeaux, Cat. 78; 1965—66 Paris,
Cat. 77

Bibliography: Кат. ГМИИ 1961, p. 72; Кат. собр.
С. Щукина 1913, No 52, pp. 12—13; Тугендхольд
1914, p. 39; Перцов 1921, No 52, p. 109; Ternovetz
1925, p. 487; Кат ГМНЗИ 1928, No 153; Réau 1929,
No 788; Cahiers d'Art 1950, p. 340; Прокофьев 1962,
ill. 190; Musée de Moscou 1963, No 95, p. 201

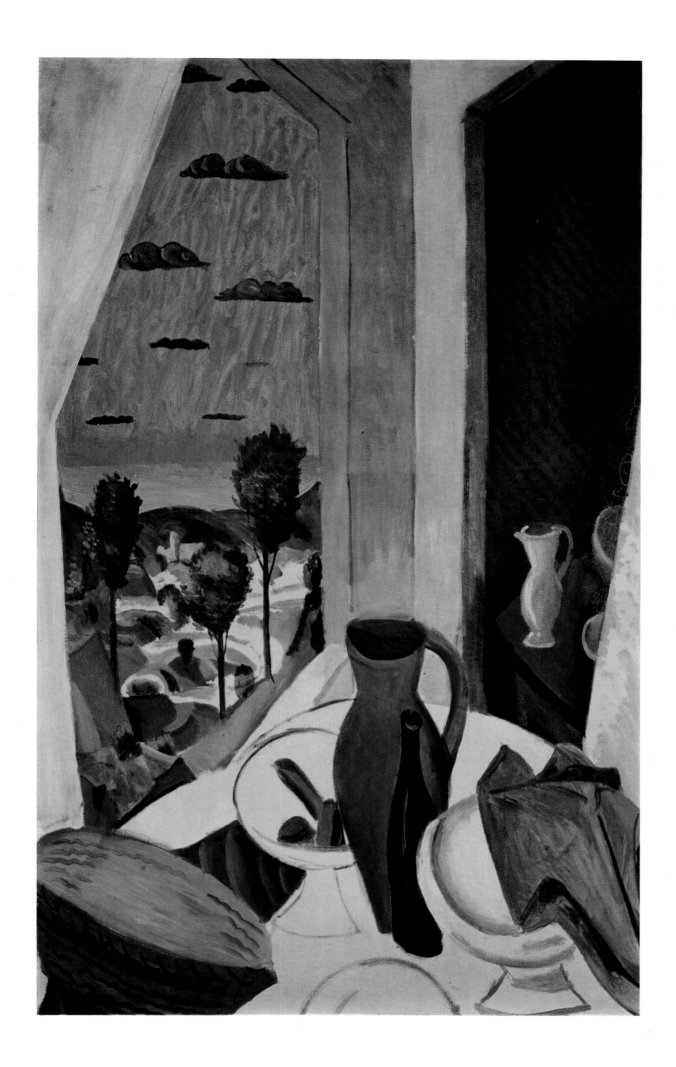

271 TABLE BY THE WINDOW
← Oil on canvas. 128 × 79 cm. Inv. No 3352
Signed on the reverse, upper left: *a derain*
A watercolor *View from the Window*, similar to the Moscow picture, is now in the Flechtheim Collection, Düsseldorf. According to C. Einstein, it represents a sketch for *Table by the Window*. On the evidence of Alice Derain, wife of the artist, the Moscow canvas was painted in 1912 at Cahors. Its other analogues are *Landscape in Provence* (1914) and *The Window* (1913), both in the Kunstmuseum, Basle. The canvas may be dated 1912—13.

Provenance: The D. H. Kahnweiler Collection, Paris (No 1375); 1913—18 The S. Shchukin Collection, Moscow; 1918—48 The Museum of Modern Western Art, Moscow; since 1948 The Pushkin Museum of Fine Arts, Moscow

Bibliography: Кат. ГМИИ 1961, p. 72; Кат. собр. С. Щукина 1913, No 232, pp. 14—15; Тугендхольд 1914, p. 39; Перцов 1921, No 232, p. 109; Кат. ГМНЗИ 1928, No 156; Réau 1929, No 791 (entitled *Vue de la fenêtre*); Cahiers d'Art 1950, p. 340

272 TREE TRUNKS
Oil on canvas. 92 × 73 cm. Inv. No 3378
Signed and dated on the reverse upper left: *a derain*
The picture was painted in 1912 or 1913. Written on the reverse side of the subframe is Derain's address: *Villa Paradis (Le Martigues)*; apparently the canvas was executed here. This is also corroborated by the existence of a similar 1912 variant, entitled *Pine Grove at Le Martigues*. Kahnweiler dates the Pushkin Museum painting to 1913. It was bought by Ivan Morozov from D. H. Kahnweiler in 1913 for 2,500 francs.

Provenance: until 1913 The D. H. Kahnweiler Collection, Paris (No 1474); 1913—18 The I. Morozov Collection, Moscow; 1918—48 The Museum of Modern Western Art, Moscow; since 1948 The Pushkin Museum of Fine Arts, Moscow

Exhibition: 1966—67 Tokyo, Kyoto, Cat. 76

Bibliography: Кат. ГМИИ 1961, p. 72; Ternovetz 1925, p. 487, ill.; Кат. ГМНЗИ 1928, No 170; Réau 1929, No 804 (entitled *La Pinède*); Cahiers d'Art 1950, p. 340

273 THE OLD BRIDGE
Oil on canvas. 73 × 92 cm. Inv. No 3278
Signed on the reverse upper left: *a derain*
It is possible that the Pushkin Museum picture de-
picts a bridge at Cagnes, where Derain worked in 1910.
Another landscape of 1910, entitled *The Old Bridge
at Cagnes* (see: D. Sutton, *André Derain*, Cologne,
1960, p. 12), features a similar locality, so that it is
usually assumed that the Moscow canvas represents
the bridge at Cagnes and refers to 1910. D. H. Kahn-
weiler, however, thinks that it was painted later, in
1912.

Provenance: The D. H. Kahnweiler Collection, Paris;
until 1918 The S. Shchukin Collection, Moscow; 1918—
48 The Museum of Modern Western Art, Moscow;
since 1948 The Pushkin Museum of Fine Arts, Moscow

Bibliography: Кат. ГМИИ 1961, p. 72; Кат. собр.
С. Щукина 1913, No 50, pp. 12—13; Тугендхольд
1914, p. 39; Перцов 1921, No 50, p. 109; Тугендхольд
1923, pp. 106, 139; Кат. ГМНЗИ 1928, No 158; Réau
1929, No 793; Cahiers d'Art 1950, p. 340

274 SATURDAY

Oil on canvas. 181 × 228 cm. Inv. No 3353
Signed lower right: *a derain*
On the evidence of D. Sutton, the picture's title was
suggested by Apollinaire (see: D. Sutton, *André De-
rain*, Cologne, 1960, p. 156). The canvas may be dated
to 1911—14.

Provenance: until 1914 The D. H. Kahnweiler Collection,
Paris; 1914—18 The S. Shchukin Collection, Moscow;
1918—48 The Museum of Modern Western Art, Mos-
cow; since 1948 The Pushkin Museum of Fine Arts,
Moscow

Exhibition: 1964 Leningrad, Cat., p. 16

Bibliography: Кат. ГМИИ 1961, p. 72; Перцов 1921,
No 235, p. 109; Тугендхольд 1923, ill. 109; Ternovetz
1925, p. 486; Ettinger 1926, part 2, p. 127, ill.; Кат.
ГМНЗИ 1928, No 163; Réau 1929, No 798; Cahiers
d'Art 1950, p. 340; Antonova 1977, No 129

275 ORIENTAL LANDSCAPE. 1927
Oil on canvas. 88 × 116 cm. Inv. No 3458
Signed and dated lower right: *Lurçat 27*
The picture was presented to S. Romov in Paris in 1927
as a gift for The Museum of Modern Western Art
in Moscow.

Provenance: The artist's collection, Paris; 1927—48
The Museum of Modern Western Art, Moscow; since
1948 The Pushkin Museum of Fine Arts, Moscow

Exhibition: 1934 Moscow

Bibliography: Кат. ГМНЗИ 1928, No 269; Réau 1929,
No 899

276 GRAPHIC WORK AGAINST
A BLACK BACKGROUND. 1928
Oil on canvas. 97 × 130 cm. Inv. No 3468
Signed and dated lower right: *Ozenfant 1928*
The picture was acquired through the State Purchasing Commission at the Exhibition of Modern Western Art in Moscow in 1928.

Provenance: The artist's collection, Paris; 1928—48 The Museum of Modern Western Art, Moscow; since 1948 The Pushkin Museum of Fine Arts, Moscow

Exhibition: 1928 Moscow, Cat. 81

Bibliography: P. Ettinger, "Neuerwerbungen des Museums moderner Kunst in Moskau", *Der Cicerone*, 1927, 17, p. 546; Б. Терновец, "Выставка современного французского искусства в Москве", *Искусство*, 1928, 3—4, p. 120

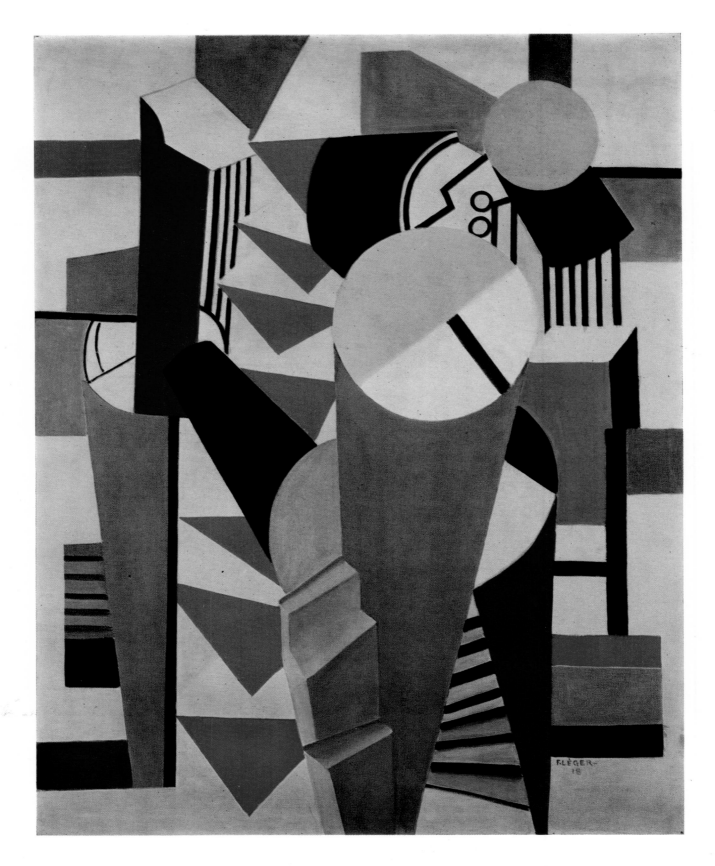

277 COMPOSITION. 1918
Oil on canvas. 146 × 114 cm. Inv. No 3452
Signed and dated lower right: *F. Leger 18*
In 1927 the picture was presented by Léger to S. Romov in Paris as a gift for The Museum of Modern Western Art in Moscow.

Provenance: until 1927 The artist's collection, Paris; 1927—48 The Museum of Modern Western Art, Moscow; since 1948 The Pushkin Museum of Fine Arts, Moscow

Exhibitions: 1965 Bordeaux, Cat. 82; 1965—66 Paris, Cat. 81

Bibliography: Кат. ГМНЗИ 1928, No 246; Réau 1929, No 886; Cahiers d'Art 1950, p. 342

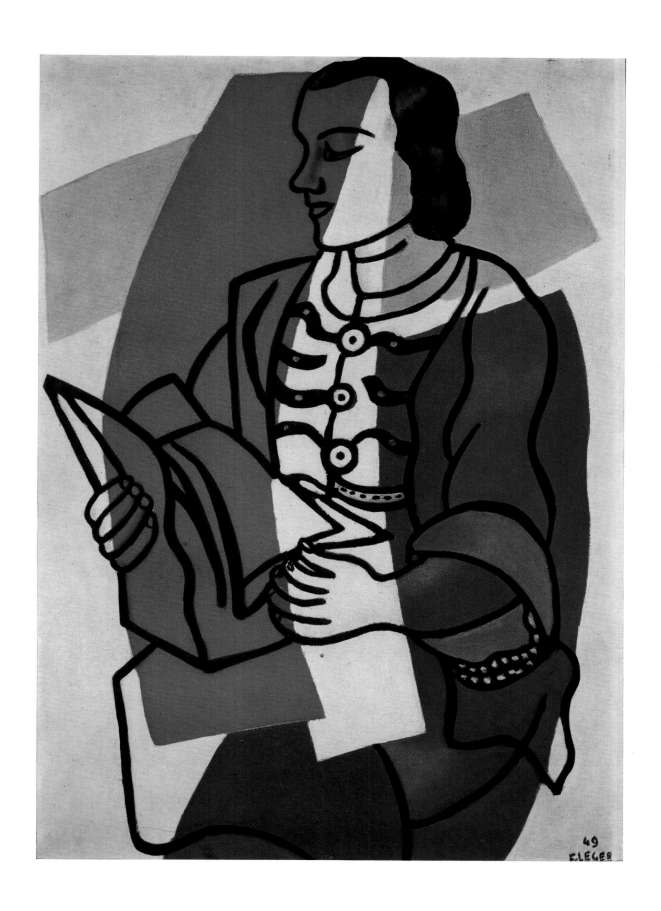

278 READING
(PORTRAIT OF NADIA LÉGER). 1949
Oil on canvas. 92 × 73 cm. Inv. No 4086
Signed and dated lower right: *49 F. Leger*
The picture was presented to The Pushkin Museum
of Fine Arts by Nadia Léger in 1969.

Provenance: until 1969 The N. Léger Collection, Biot
(No 182); since 1969 The Pushkin Museum of Fine
Arts, Moscow

Exhibitions: 1963 Moscow, Cat., p. 47; 1970 Moscow

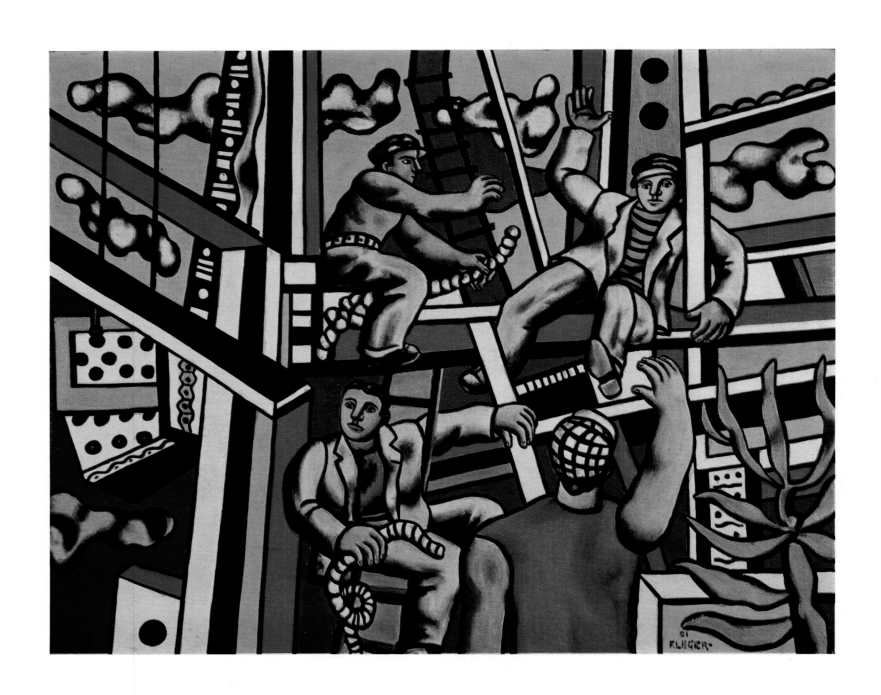

279 BUILDERS (BUILDERS WITH ALOE). 1951
Oil on canvas. 160 × 200 cm. Inv. No 4085
Signed and dated lower right: *51 F. Leger*
The picture was presented to The Pushkin Museum
of Fine Arts by Nadia Léger in 1969.

Provenance: until 1969 The N. Léger Collection, Biot
(No 437); since 1969 The Pushkin Museum of Fine
Arts, Moscow

Exhibitions: 1963 Moscow, Cat., p. 48; 1970 Moscow

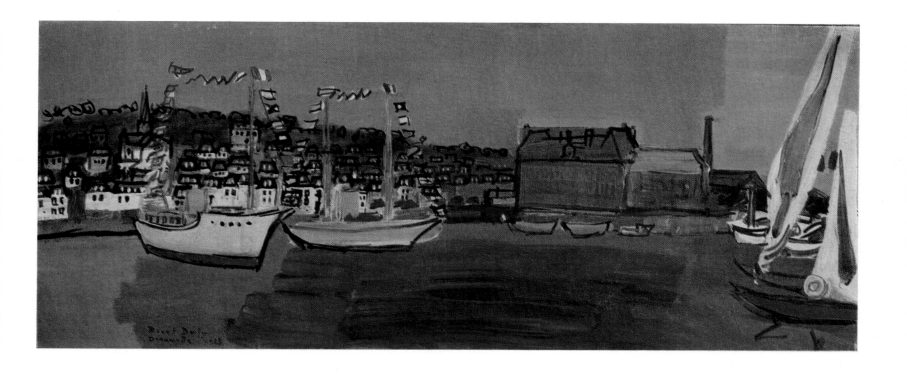

280 JULY 14 IN DEAUVILLE. 1933
Oil on canvas. 38 × 92 cm. Inv. No 4068
Signed, inscribed and dated lower right: *Raoul Dufy
Deauville 1933*
In the 1930s Dufy often painted views of Deauville.
A 1938 variant of the Pushkin Museum picture, *Pool
at Deauville*, is in a private collection in Paris.
The picture was presented to The Pushkin Museum
by M. Kaganovitch in 1969.

Provenance: Private collection, Bern; The Witzin-
ger Collection, Basle; until 1969 The M. Kaganovitch
Collection, Paris; since 1969 The Pushkin Museum
of Fine Arts, Moscow

Exhibitions: 1938 Paris; 1962 Paris; 1963 Rotterdam,
Cat., p. 32; 1970 Moscow, Cat. 28

Bibliography: Antonova 1977, No 131

ANDRÉ FOUGERON. Born 1913

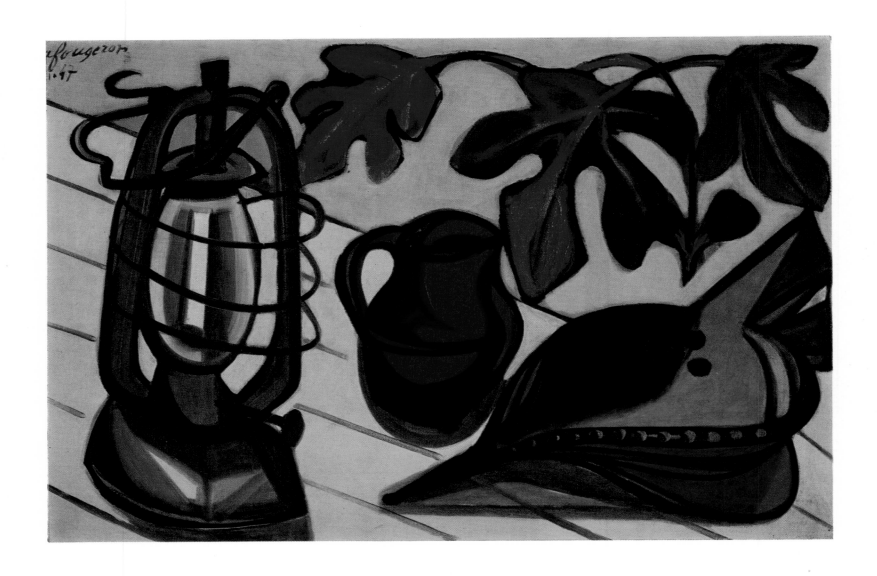

281 PEASANT STILL LIFE. 1947
Oil on canvas. 60 × 92 cm. Inv. No 4066
Signed and dated lower left: *a fougeron, VIII, 47*
The picture was acquired through the State Purchas-
ing Commission at the exhibition of Fougeron's works
in Moscow in 1968.

Provenance: until 1968 The artist's collection, Paris;
since 1968 The Pushkin Museum of Fine Arts, Moscow

Exhibitions: 1968 Moscow; 1970 Moscow, Cat. 81

CATALOGUE
OF FRENCH PAINTINGS
IN THE PUSHKIN MUSEUM
OF FINE ARTS

1

7

11

2

8

14

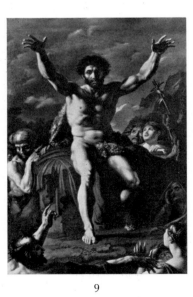

3

9

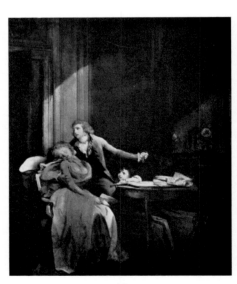

15

ALLEGRAIN — BONNARD

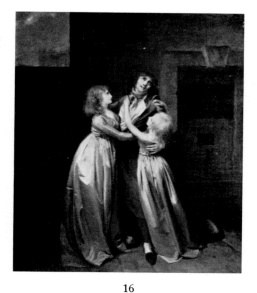

16

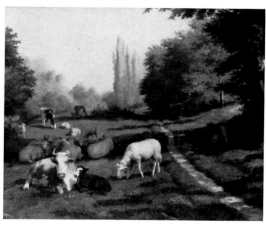

19

17

20

18

25

26

35

41

28

36

42

34

38

44

45

46

48

50

51

52

26 SUMMER (THE DANCE). Panel
Oil on canvas. 202 × 254 cm. Inv No 3358

BONNAT, LÉON JOSEPH FLORENTIN. 1833—1922

27 AN ORIENTAL BARBER SHOP. 1872.
Pl. 135

28 READING. Study
Oil on canvas. 24.5 × 16 cm. Inv. No 4098

BOUCHER, FRANÇOIS. 1703—1770

29 HERCULES AND OMPHALE. *Pl. 45*

30 LANDSCAPE WITH A HERMIT. 1742.
Pl. 46

31 JUPITER AND CALLISTO. 1744. *Pl. 49*

32 THE MILL (THE FARM). 1752. *Pl. 47*

33 A WOMAN'S HEAD. *Pl. 48*

34 THE VIRGIN WITH THE INFANT CHRIST
AND ST JOHN THE BAPTIST
Oil on canvas. 118 × 90 cm. Inv. No 730

35 BACCHANTE PLAYING A REED PIPE
Oil on canvas. 49 × 62 cm (oval). Inv. No 731

36 VENUS SLEEPING
Oil on canvas. 49 × 63 cm (oval). Inv. No 732

BOUDIN, EUGÈNE. 1824—1898

37 THE BEACH AT TROUVILLE. 1871.
Pl. 145

38 SAIL BOATS AT THE SEASHORE. 1880
Oil on panel. 25 × 35 cm. Inv. No 3497

BOULLOGNE THE YOUNGER, LOUIS.
1654—1733

39 THE JUDGMENT OF SOLOMON. 1710.
Pl. 11

BOURDON, SÉBASTIEN. 1616—1671

40 NOAH'S SACRIFICE. *Pl. 12*

BOURDON (?)

41 HORSEMEN BY THE RUINS
Oil on canvas. 52 × 62 cm. Inv. No 2221

BOZE. JOSEPH. *C.* 1744—1826

42 PORTRAIT OF FRANKLIN
Oil on canvas. 64 × 53 cm. Inv. No 3707

BRAQUE, GEORGES. 1882—1963

43 THE NEW CASTLE AT LA ROCHE-GUYON.
Pl. 267

BRASCASSAT, JACQUES RAYMOND. 1804—1867

44 A BULL
Oil on paper mounted on canvas. 66 × 92 cm.
Inv. No 3021

BRETON, JULES. 1827—1906

45 FISHERMEN AT MENTON. 1878
Oil on canvas. 191 × 256 cm. Inv. No 3493

BRUANDET, LAZARE. 1755—1804

46 HUNTING IN THE WOODS
Oil on canvas. 53 × 65 cm. Inv. No 2149

CABANEL, ALEXANDRE. 1823—1889

47 FEMALE PORTRAIT. 1852. *Pl. 137*

CAROLUS-DURAN, ÉMILE AUGUSTE. 1838—1917

48 PORTRAIT OF A YOUNG GIRL
Oil on canvas. 45 × 38 cm. Inv. No 3488

CARRIÈRE, EUGÈNE. 1849—1906

49 THE MOTHER'S KISS. *Pl. 211*

53

67

70

65

68

73

66

69

74

CARRIÈRE — CORNEILLE DE LYON

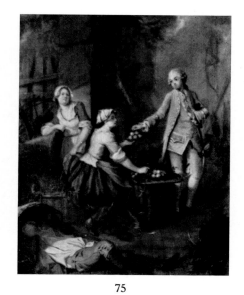

75

84

76

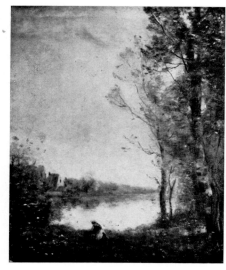

85

78

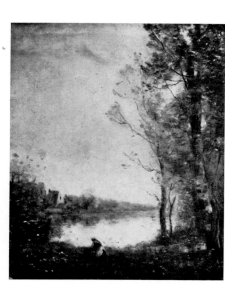

86

50 WOMAN TAKING OUT A SPLINTER
Oil on canvas. 45 × 37 cm. Inv. No 3282

51 HEAD OF A SLEEPING WOMAN
Oil on canvas. 36 × 47 cm. Inv. No 3283

CARRIÈRE-BELLEUSE, PIERRE. 1851—1933

52 PLACE PIGALLE IN PARIS. 1890
Oil on panel. 38 × 46 cm. Inv. No 3428

CAZIN, JEAN CHARLES. 1841—1901

53 VILLAGE
Oil on canvas. 56 × 46 cm. Inv. No 3486

CÉZANNE, PAUL. 1839—1906

54 INTERIOR WITH TWO WOMEN AND A CHILD
(SCÈNE D'INTÉRIEUR). Pl. 175

55 SELF-PORTRAIT. Pl. 178

56 FIELD BY MOUNT SAINTE-VICTOIRE. Pl. 184

57 ROAD AT PONTOISE. Pl. 174

58 THE AQUEDUCT. Pl. 177

59 THE BANKS OF THE MARNE. Pl. 179

60 PEACHES AND PEARS. Pl. 180

61 MARDI GRAS
(PIERROT AND HARLEQUIN). Pl. 182

62 BATHERS. Study. Pl. 176

63 MAN SMOKING A PIPE. Pl. 181

64 LANDSCAPE AT AIX
(MOUNT SAINTE-VICTOIRE). Pl. 183

65 TREES IN THE PARK
(LE JAS DE BOUFFAN)
Oil on canvas. 72 × 91 cm. Inv. No 3413

66 BRIDGE OVER THE POOL. C. 1888
Oil on canvas. 64 × 79 cm. Inv. No 3417

67 FLOWERS
Oil on canvas. 77 × 64 cm. Inv. No 3411

CHANTRIAU, GÉO. Active in the 1940s

68 LIBERATING STAINS IN AUGUST 1944
Oil on canvas. 81 × 54 cm. Inv. No 3615

CHAPLIN, CHARLES. 1825—1891

69 LETTER
Oil on canvas. 41 × 25 cm. Inv. No 3494

70 LADY WITH A PUG-DOG
Oil on canvas. 74 × 50 cm. Inv. No 3495

CHARDIN, JEAN-BAPTISTE SIMÉON. 1699—1779

71 STILL LIFE WITH THE ATTRIBUTES
OF THE ARTS. Pl. 51

72 AUTUMN. After Bouchardon's
bas-relief. 1770. Pl. 52

CHARLET, NICOLAS TOUSSAINT. 1792—1845

73 NIGHT WATCH
Oil on canvas. 40 × 32 cm. Inv. No 1143

CHARPENTIER, JEAN-BAPTISTE. 1728—1806

74 SELLER OF FLOWERS
Oil on panel. 68 × 55 cm. Inv. No 923

75 APPLE SELLER
Oil on panel. 70 × 54 cm. Inv. No 2922

76 LADY BY THE OPEN-AIR CAGE. 1784
Oil on canvas. 76 × 59 cm. Inv. No 2902

CHÉRON, ÉLISABETH SOPHIE. 1648—1711

77 PORTRAIT OF JEANNE MARIE BOUVIER
DE LA MOTTE GUYON. Pl. 29

CORNEILLE DE LYON. 1500/10 — c. 1575

78 FEMALE PORTRAIT (PORTRAIT OF QUEEN
CLAUDE?)
Oil on panel. 11 × 10 cm. Inv. No 949

87

90

88

91

95

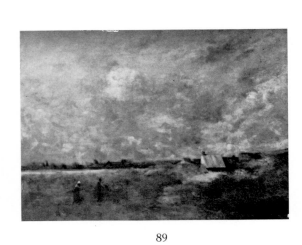

89

92

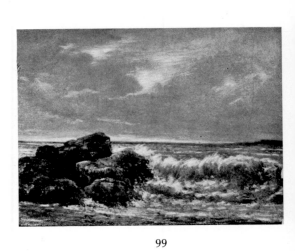

99

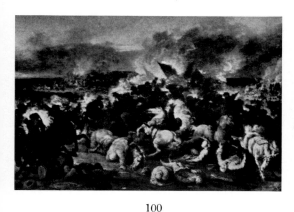

100

101

103

104

105

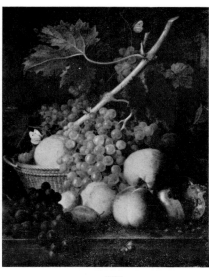

107

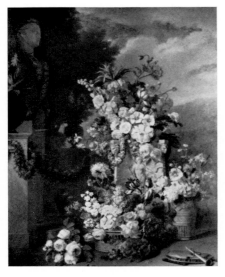

108

116

119

109

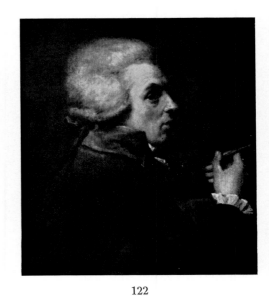

117

122

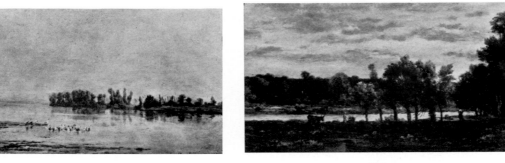

115

118

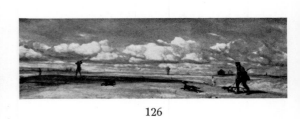

126

127

130

128

131

129

132

DAEL, JEAN FRANÇOIS VAN. 1764—1840

107 FRUIT. 1808
Oil on panel. 56 × 45.5 cm. Inv. No 2168

108 TRIBUTE TO FLORA. 1809
Oil on canvas. 197 × 148 cm. Inv. No 847

DAEL (?)

109 FLOWERS
Oil on canvas. 73.5 × 58 cm. Inv. No 3200

DAGNAN-BOUVERET,
PASCAL ADOLPHE JEAN. 1852—1929

110 THE NUPTIAL BENEDICTION. 1880—81.
Pl. 136

DAUBIGNY, CHARLES FRANÇOIS. 1817—1878

111 THE BANKS OF THE OISE. *Pl. 127*

112 THE SEASHORE. *Pl. 126*

113 PORTEJOIE VILLAGE ON THE BANK
OF THE SEINE (VILLAGE ON THE BANK
OF THE OISE). 1868. *Pl. 125*

114 EVENING IN HONFLEUR. *Pl. 128*

115 MORNING. 1858
Oil on panel. 29 × 47 cm. Inv. No 879

116 LANDSCAPE WITH THE OISE. 1859
Oil on panel. 18 × 36 cm. Inv. No 880

117 OLIVE GARDEN
Oil on canvas. 39 × 65 cm. Inv. No 885

118 RIVER ON A CLOUDY DAY. 1870
Oil on panel. 27 × 43 cm. Inv. No 882

119 LONDON
Oil on panel. 32 × 59.5 cm. Inv. No 2431

DAVID, JACQUES LOUIS. 1748—1825

120 ANDROMACHE MOURNING OVER HECTOR.
1783. *Pl. 81*

121 PORTRAIT OF INGRES AS A YOUNG MAN (?).
Pl. 82

122 SELF-PORTRAIT
Oil on canvas. 63 × 52 cm. Inv. No 842

DEBUCOURT, PHILIBERT LOUIS. 1755—1832

123 CHARLATAN. *Pl. 72*

DECAMPS, ALEXANDRE GABRIEL. 1803—1860

124 HUNTING SCENE IN THE MOUNTAINS.
1843. *Pl. 102*

125 STREET SCENE. 1849. *Pl. 101*

126 FOWLING. 1842
Oil on panel. 13 × 41 cm. Inv. No 855

127 DOGS
Oil on canvas. 21 × 31 cm. Inv. No 856

128 HUNTERS IN A BOAT
Oil on canvas. 9 × 14 cm. Inv. No 857

129 YOUNG BEGGARS
Watercolor on paper. 36 × 47 cm. Inv. No 853

DECAMPS (?)

130 BEGGARS
Oil on canvas. 24 × 16 cm. Inv. No 852

DEDREUX, ALFRED. 1810—1860

131 ORIENTAL HORSEMAN WITH A SERVANT
Oil on canvas. 65.5 × 81 cm. Inv. No 3897

DE GALLARD, MICHEL. Born 1921

132 STUDY FOR A CHILD'S PORTRAIT. 1952
Oil on canvas. 91.5 × 64.5 cm. Inv. No 3819

DEGAS, EDGAR. 1834—1917

133 DANCERS AT THE REHEARSAL. *Pl. 169*

141

145

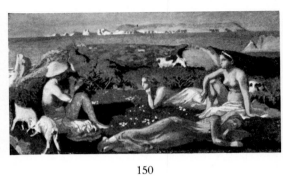

150

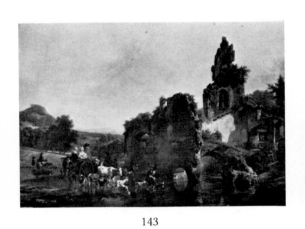

143

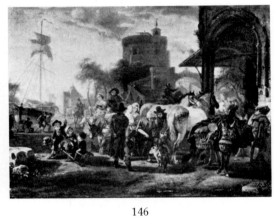

146

157

144

147

159

DEGAS — DÍAZ DE LA PEÑA

160

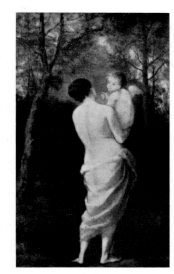

167

161

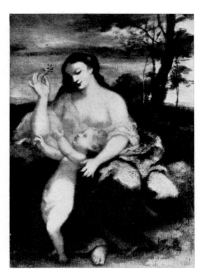

168

162

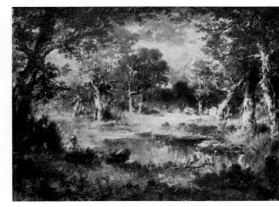

169

170

173

177

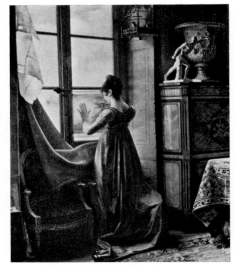

171

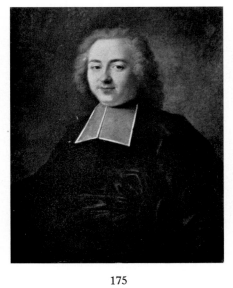

174

183

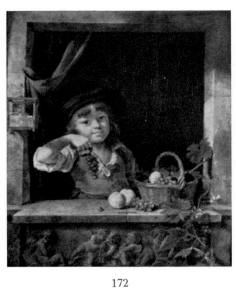

172

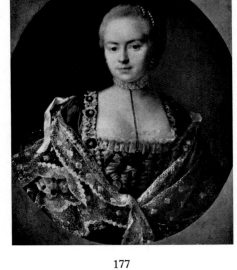

175

184

DÍAZ DE LA PEÑA — DUPRÉ

187

190

188

191

189

192

194

197

201

195

199

203

196

200

204

DUPRÉ — GAUGUIN

205

211

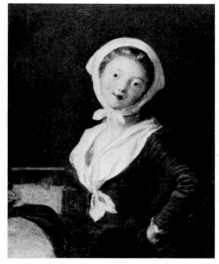

208

213

209

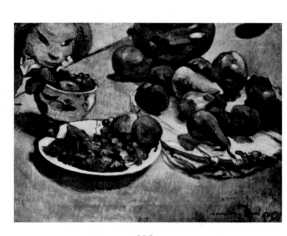

225

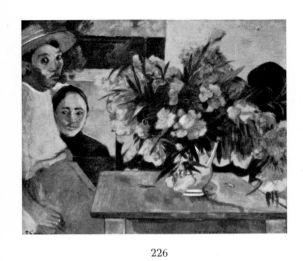

226

230

236

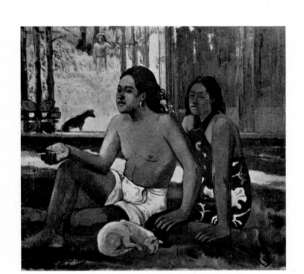

227

232

238

229

235

242

GAUGUIN — GUÉRIN

243

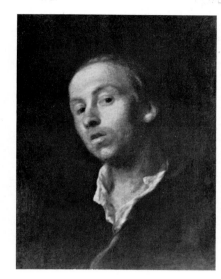

246

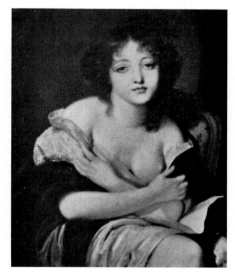

244

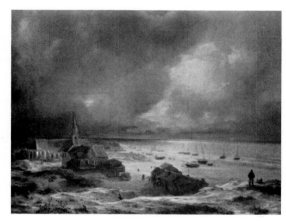

248

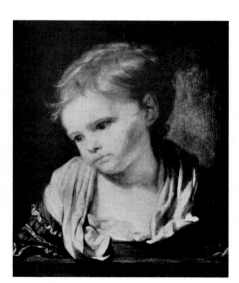

245

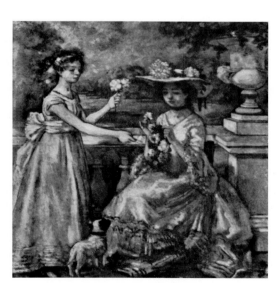

250

253

257

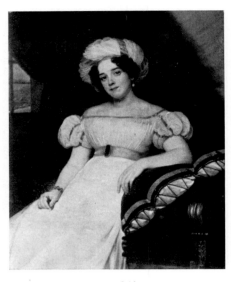

261

255

259

262

256

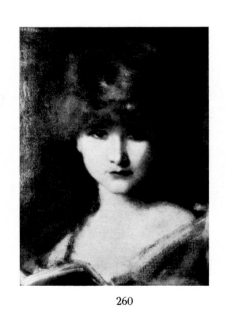

260

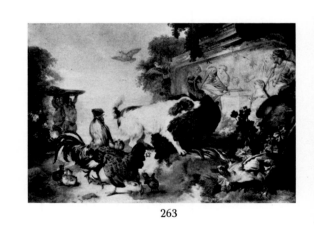

263

GUÉRIN — ISABEY

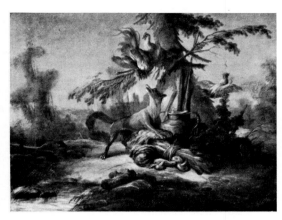

264

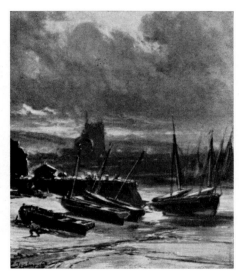

272

270

273

271

274

250 TWO GIRLS ON THE TERRACE
Oil on canvas. 147 × 131 cm. Inv. No 3261

GUÉRIN, PIERRE NARCISSE. 1774—1833

251 AENEAS AND DIDO. *Pl. 95*

252 AURORA AND CEPHALUS. 1811. *Pl. 96*

GUILLAUMET, GUSTAVE. 1840—1887

253 INTERIOR OF A HOUSE IN THE DESERT
OF SAHARA
Oil on canvas. 56.3 × 75 cm. Inv. No 3487

GUILLAUMIN, ARMAND. 1841—1927

254 LANDSCAPE WITH RUINS. *Pl. 163*

GUILLOT, DONAT. Active in the second half
of the 19th century

255 COURBEVOIE
Oil on canvas. 39 × 56 cm. Inv. No 3492

HARPIGNIES, HENRI. 1819—1916

256 AUTUMN
Oil on canvas. 55 × 45 cm. Inv. No 703

257 MOONRISE
Oil on canvas. 29 × 40 cm. Inv. No 704

HELLEU, PAUL. 1859—1927

258 LADY IN WHITE. *Pl. 162*

259 ON THE SOFA
Pastel on paper. 50 × 68 cm. Inv. No 3432

HENNER, JEAN-JACQUES. 1829—1905

260 HEAD OF A GIRL
Oil on canvas. 45 × 32 cm. Inv. No 3491

HERSENT, LOUIS. 1777—1860

261 PORTRAIT OF PRINCESS
NATALIA GOLITSYNA. 1824
Oil on canvas. 123 × 96 cm. Inv. No 810

HILAIR, JEAN-BAPTISTE. 1751 — after 1822

262 TURK AND WOMAN
Oil on canvas. 66 × 84 cm. Inv. No 812

HUET, JEAN-BAPTISTE MARIE. 1745—1811

263 DOG ATTACKING A TURKEY. 1781
Oil on canvas. 65 × 96 cm. Inv. No 840

HUET (?)

264 COCK AND FOX
Oil on panel. 60 × 71 cm. Inv. No 1182

INGRES, JEAN AUGUSTE DOMINIQUE. 1780—1867

265 THE VIRGIN ADORING THE EUCHARIST.
1841. *Pl. 100*

ISABEY, JEAN-BAPTISTE. 1767—1855

266 PORTRAIT OF PRINCE BORIS GOLITSYN. *Pl. 88*

ISABEY, EUGÈNE LOUIS GABRIEL. 1803—1886

267 MORESQUE GATE. 1835. *Pl. 103*

268 PROMENADE. 1852. *Pl. 105*

269 LEAVING THE CASTLE. *Pl. 104*

270 IN THE CHURCH. 1843
Oil on panel. 24 × 32 cm. Inv. No 938

271 AN OLD STREET. 1855
Oil on canvas. 39 × 31 cm. Inv. No 936

272 IN THE HAVEN. 1862
Oil on panel. 24 × 19 cm. Inv. No 939

273 HAVEN
Oil on canvas. 51 × 84 cm. Inv. No 941

274 SEASCAPE WITH FISHERMEN
Oil on canvas. 40 × 65 cm. Inv. No 3906

275

278

281

276

279

282

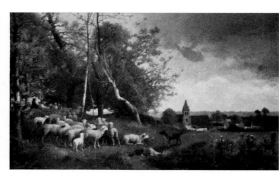

277

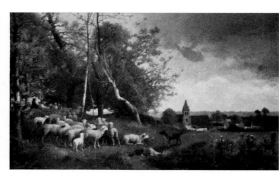

280

283

JACQUES — LEBASQUES

284

285

288

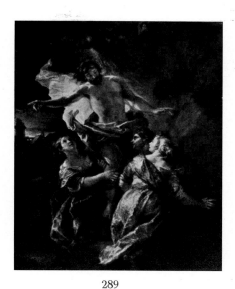

289

290

291

JACQUES, CHARLES ÉMILE. 1813—1894

275 EVENING
 Oil on canvas. 81 × 66 cm. Inv. No 1282

276 GOATS AND CATS
 Oil on canvas. 87.5 × 116.5 cm. Inv. No 2400

277 A FLOCK OF SHEEP AT THE EDGE
 OF A WOOD
 Oil on canvas. 49.5 × 80.5 cm. Inv. No 2848

278 HENS
 Oil on canvas. 33.5 × 43 cm. Inv. No 3030

279 SHEEPFOLD
 Oil on canvas. 43 × 35.5 cm. Inv. No 3256

280 SHEEP AND DOG. 1872
 Oil on canvas. 40 × 76 cm. Inv. No 3792

JEAURAT, ÉTIENNE. 1699—1789

281 VENUS AND ADONIS
 Oil on canvas. 65 × 53 cm. Inv. No 924

JOURDAIN, FRANCIS. 1876—1958

282 SPRING. 1906
 Oil on cardboard. 60 × 100 cm. Inv. No 3382

LABILLE-GUIARD, ADELAÏDE. 1749—1803

283 PORTRAIT OF A LADY
 Oil on canvas. 67 × 54 cm. Inv. No 2921

LACROIX, CHARLES FRANÇOIS. 1700—1782

284 SEASCAPE: MORNING. 1754
 Oil on canvas. 136 × 100 cm. Inv. No 858

285 SEASCAPE: NIGHT. 1753
 Oil on canvas. 136 × 100 cm. Inv. No 859

LAFOSSE, CHARLES DE. 1636—1716

286 ROMULUS AND REMUS. 1715. *Pl. 25*

287 SUSANNAH AND THE ELDERS. *Pl. 26*

288 CHRIST IN THE HOUSE OF MARTHA
 AND MARY
 Oil on canvas. 105 × 147 cm. Inv. No 1136

289 THE HOLY WOMEN
 Oil on canvas. 80 × 65 cm. Inv. No 1137

LAGRENÉE, FRANÇOIS (ANTHELME). 1774—1832

290 PORTRAIT OF PRINCESS V. VIAZEMSKAYA
 Oil on canvas. 66 × 55 cm. Inv. No 978

LA HYRE, LAURENT DE. 1606—1656

291 THE PRESENTATION IN THE TEMPLE. 1636
 Oil on canvas. 291 × 198 cm. Inv. No 976

LA JOUE, JACQUES DE. 1686/7—1761

292 REST AFTER THE HUNT. *Pl. 37*

LANCRET, NICOLAS. 1690—1743

293 A COMPANY AT THE EDGE OF A WOOD. *Pl. 35*

294 PORTRAIT OF A LADY IN THE GARDEN. *Pl. 34*

295 CONCERT IN THE PARK. *Pl. 36*

296 A LESSON IN GALLANTRY GIVEN TO A
 STINGY LADY. Illustration to La Fontaine's *Fables*
 Oil on copper-plate. 28 × 36 cm. Inv. No 982

LARGILLIÈRE, NICOLAS DE. 1656—1746

297 PORTRAIT OF A LADY. *Pl. 23*

LAURENCIN, MARIE. 1885—1956

298 WOMAN'S HEAD. *Pl. 252*

LEBASQUES, HENRI. 1865—1937

299 BEFORE BATHING. Study
 Oil on canvas. 72 × 54 cm. Inv. No 3385

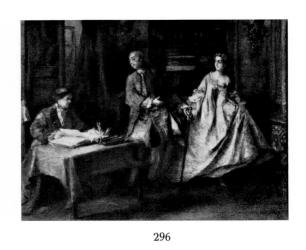

296

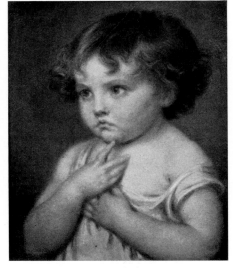

303

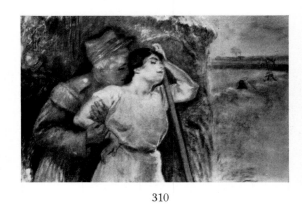

310

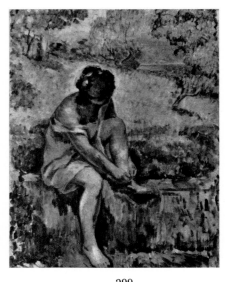

299

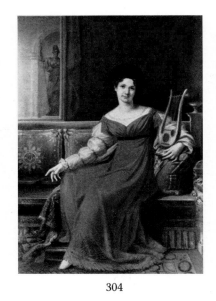

304

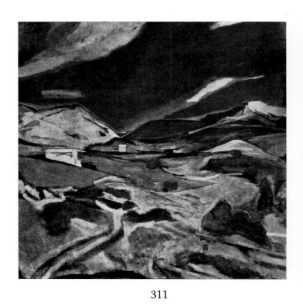

311

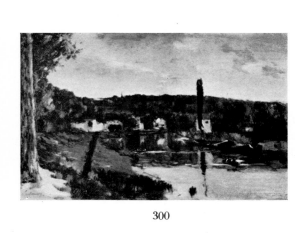

300

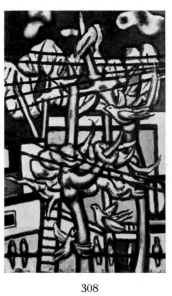

308

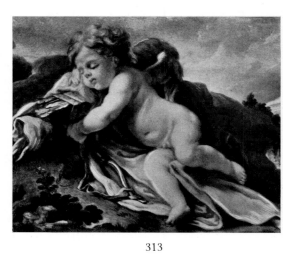

313

LEBOURG — LESUEUR

386

314

318

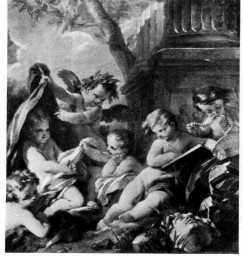

315

319

317

320

LEBOURG, ALBERT MARIE. 1849—1928

300 BY THE RIVER (MAY IN MEUDON)
Oil on canvas. 40 × 65 cm. Inv. No 3386

LE BRUN, CHARLES. 1619—1690

301 THE CRUCIFIXION. 1637. *Pl. 15*

302 PORTRAIT OF MOLIÈRE. *Pl. 16*

LEDOUX, JEANNE PHILIBERTE. 1767—1840

303 A CHILD'S HEAD
Oil on canvas. 40 × 32 cm. Inv. No 991

LEFÈVRE, ROBERT. 1755—1830

304 PORTRAIT OF PRINCESS
EKATERINA DOLGORUKAYA. 1821
Oil on canvas. 193 × 134 cm. Inv. No 1004

LÉGER, FERNAND. 1881—1955

305 COMPOSITION. 1918. *Pl. 277*

306 READING (PORTRAIT OF NADIA LÉGER).
1949. *Pl. 278*

307 BUILDERS (BUILDERS WITH ALOE). 1951.
Pl. 279

308 COMPOSITION WITH BIRDS
Oil on canvas. 55 × 33.2 cm. Inv. No 4137

LEGRAND, LOUIS. 1863—1951

309 THE APACHE'S SUPPER. 1901. *Pl. 191*

310 ON LEAVE
Black chalk and pastel on paper mounted on card-
board. 74 × 109 cm. Inv. No 3387

LEHMANN, LÉON. 1873—1953

311 MOUNTAINS. 1909
Oil on canvas. 81 × 81 cm. Inv. No 3285

LEMOINE, FRANÇOIS. 1688—1737

312 THE RAPE OF EUROPA. 1725. *Pl. 50*

313 SLEEPING CUPID
Oil on canvas. 38 × 46 cm. Inv. No 993

314 THE ALLEGORY OF PAINTING
Oil on canvas. 66 × 79.5 cm (oval). Inv. No 1119

315 THE ALLEGORY OF PAINTING
Oil on canvas. 99 × 85 cm. Inv. No 2920

LENAIN CIRCLE, MASTER OF THE (active in the second
half of the 17th century)

316 PEASANTS BY THE WELL. *Pl. 14*

LÉPICIÉ, NICOLAS BERNARD. 1735—1784

317 PORTRAIT OF THE LEROY FAMILY. 1766
Oil on canvas. 137 × 148 cm. Inv. No 995

318 MAN READING
Oil on panel. 20 × 13 cm. Inv. No 2983

LE PRINCE, JEAN-BAPTISTE. 1733—1781

319 RUSSIAN LANDSCAPE WITH FISHERMEN. 1775
Oil on panel. 46 × 62 cm. Inv. No 996

320 COUNTRY ROAD
Oil on panel. 47 × 62 cm. Inv. No 1241

321 DECORATIVE PANEL. 1768
Oil on canvas. 152 × 169 cm. Inv. No 2924

322 PEASANT WOMAN
Oil on panel. 20 × 12.5 cm. Inv. No 2155

LESUEUR, BLAISE. 1716—1783

323 PORTRAIT OF BARONESS GRAPENDORF
Oil on canvas. 61 × 47 cm. Inv. No 1177

LESUEUR, EUSTACHE. 1617—1655

324 THE NATIVITY OF THE VIRGIN
Oil on panel. 75 × 53 cm. Inv. No 1001

321

324

328

322

325

330

323

327

331

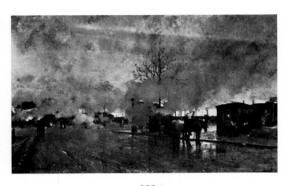

332

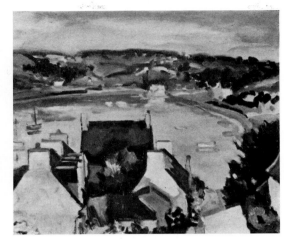

335

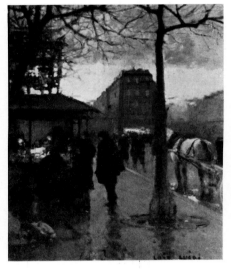

333

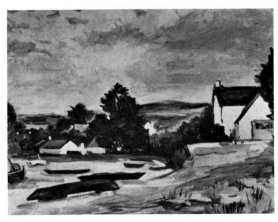

336

334

337

LESUEUR (?)

325 THE CIRCUMCISION OF CHRIST
Oil on canvas. 83 × 58 cm. Inv. No 1002

LHERMITTE, LÉON. 1844—1925

326 REAPERS. *Pl. 141*

327 COURTYARD IN NORMANDY
Pastel on cardboard. 39 × 49 cm. Inv. No 3484

328 A HUT IN NORMANDY
Pastel on cardboard. 31 × 44 cm. Inv. No 3485

LHOTE. ANDRÉ. 1885—1962

329 LANDSCAPE WITH HOUSES. *Pl. 268*

LOBRE, MAURICE. 1862—1951

330 LA GALERIE DE BATAILLES
IN VERSAILLES. 1903
Oil on canvas. 96 × 91 cm. Inv. No 3287

331 INTERIOR OF THE CHÂTEAU
DE VERSAILLES. 1903
Oil on canvas. 93 × 68 cm. Inv. No 3556

LOIR, LUIGI. 1845—1916

332 SMOKE OVER THE CIRCUIT RAILWAY. 1885
Oil on canvas. 296 × 172 cm. Inv. No 1009

333 PARIS AT DAWN
Oil on canvas. 73 × 59 cm. Inv. No 3765

LONGUET, FRÉDÉRIC. Born 1904

334 CENTRAL ELECTRIC POWER STATION
ON THE SEINE. 1946
Oil on cardboard. 50 × 61 cm. Inv. No 3889

335 PRIMEL BAY. FINISTÈRE. 1958
Oil on veneer. 46 × 55 cm. Inv. No 3887

336 SHORE OF THE BAY. FINISTÈRE. 1961
Oil on veneer. 47 × 62 cm. Inv. No 3886

337 PONT ALEXANDRE III IN PARIS
Oil on veneer. 46 × 55 cm. Inv. No 3888

LORRAIN, CLAUDE (CLAUDE GELLÉE). 1600—1682

338 LANDSCAPE WITH APOLLO AND MARSYAS.
Pl. 9

339 THE RAPE OF EUROPA. 1655. *Pl. 7*

340 THE BATTLE ON THE BRIDGE. 1655. *Pl. 8*

LORRAIN, CLAUDE (copy or replica)

341 MORNING (AENEAS ARRIVING IN ITALY)
Oil on canvas. 101 × 136 cm. Inv. No 913

342 EVENING (DECAY OF THE ROMAN EMPIRE)
Oil on canvas. 97 × 129 cm. Inv. No 914

LOUTHERBOURG (or LUTHERBOURG) THE YOUNGER,
PHILIPPE JACOB. 1740—1812

343 FOUR GENRE FIGURES
Oil on canvas. 16.5 × 13 cm. Inv. No 1010

344 LANDSCAPE WITH FIGURES
Oil on canvas. 89 × 168 cm. Inv. No 1011

LURÇAT, JEAN. 1892—1966

345 ORIENTAL LANDSCAPE. 1927. *Pl. 275*

MANET, ÉDOUARD. 1832—1883

346 PORTRAIT OF ANTONIN PROUST. *Pl. 148*

347 THE BAR. *Pl. 147*

MANGUIN, HENRI CHARLES. 1874—1943

348 BATHER
Oil on canvas. 61 × 49 cm. Inv. No 3389

MARILHAT, PROSPER GEORGES ANTOINE.
1811—1847

349 THE EDGE OF A WOOD
Oil on panel. 22 × 17 cm. Inv. No 1013

341

344

355

342

348

356

343

349

357

MARQUET — MEULEN

358

379

377

380

378

381

MARQUET, ALBERT. 1875—1947

350 SUNNY DAY IN PARIS.
THE LOUVRE EMBANKMENT. *Pl. 241*

351 NOTRE-DAME IN WINTER. *Pl. 242*

352 VESUVIUS. *Pl. 243*

353 FLOOD IN PARIS. *Pl. 245*

354 HARBOR AT HONFLEUR. *Pl. 244*

355 PARIS IN WINTER. THE BOURBON EMBANKMENT
Oil on canvas. 65 × 81 cm. Inv. No 3390

356 PARIS IN WINTER WITH PONT SAINT-MICHEL
Oil on canvas. 61 × 81 cm. Inv. No 3293

357 PONT SAINT-MICHEL IN PARIS
Oil on canvas. 65 × 81 cm. Inv. No 3289

MARTIN, JEAN-BAPTISTE. 1659—1735

358 NAMUR BESIEGED
Oil on canvas. 113 × 151 cm. Inv. No 1243

MASTER OF THE PROCESSIONS

359 THE FIGHT. *Pl. 13*

MATISSE, HENRI. 1869—1954

360 THE BOTTLE OF SCHIEDAM. 1896. *Pl. 224*

361 BLUE JUG. *Pl. 225*

362 CORSICAN LANDSCAPE WITH OLIVES.
1898. *Pl. 226*

363 BOIS DE BOULOGNE. 1902. *Pl. 227*

364 STATUETTE AND VASE ON AN ORIENTAL
CARPET. 1908. *Pl. 233*

365 FLOWERS IN A WHITE VASE. *Pl. 232*

366 SPANISH WOMAN WITH A TAMBOURINE.
1909. *Pl. 228*

367 FRUIT AND BRONZES. 1910. *Pl. 238*

368 STILL LIFE WITH GOLDFISH. *Pl. 239*

369 THE LARGE STUDIO. 1911. *Pl. 237*

370 THE STUDIO WITH "LA DANSE". *Pl. 231*

371 CORNER OF THE STUDIO. *Pl. 229*

372 VIEW FROM THE WINDOW. TANGIER. *Pl. 234*

373 ZORAH ON THE TERRACE. *Pl. 235*

374 ENTRANCE TO THE CASBAH. *Pl. 236*

375 IRISES, ARUMS AND MIMOSAS. 1913. *Pl. 230*

376 STILL LIFE WITH A SEASHELL. 1940. *Pl. 240*

377 SEATED NUDE. Study. 1936
Oil on veneer. 18 × 14 cm. Inv. No 4218

MAYER LA MARTINIÈRE.
MARIE-FRANÇOISE CONSTANCE. 1775—1821

378 HEAD OF THE ARCHANGEL GABRIEL
(companion picture to HEAD OF THE VIRGIN
FROM THE ANNUNCIATION by Prud'hon;
see *pl. 84*)
Oil on canvas. 53 × 45 cm. Inv. No 1012

MEISSONNIER, JEAN-LOUIS ERNEST. 1815—1891

379 CAVALIER IN EIGHTEENTH CENTURY
COSTUME. 1855
Oil on panel. 22 × 16 cm. Inv. No 1015

380 ANGRY DUELLIST
Oil on panel. 19 × 15 cm. Inv. No 1016

MENARD, MARIE AUGUSTE ÉMILE RENÉ.
1862—1930

381 LANDSCAPE
Pastel on cardboard. 73 × 87 cm. Inv. No 3305

MEULEN, ADAM FRANS VAN DER. 1632—1690

382 A CAVALRY ENCOUNTER. *Pl. 19*

383 A CAVALRY SKIRMISH
Oil on canvas. 64 × 96 cm. Inv. No 388

383

386

389

384

387

391

385

388

393

MEULEN — MONSIAUX

384 BATTLE SCENE
Oil on panel. 14 × 17.5 cm. Inv. No 474

385 BATTLE BY A HUT
Oil on panel. 14 × 17.5 cm. Inv. No 475

386 BATTLE SCENE
Oil on panel. 14 × 17.5 cm. Inv. No 476

387 ATTACKING A VILLAGE
Oil on canvas. 14 × 17.5 cm. Inv. No 477

MEULEN (atelier)

388 THE ENTRANCE OF LOUIS XIV
INTO VINCENNES
Oil on canvas. 98.5 × 58 cm. Inv. No 3952

MICHELIN, JEAN. *C.* 1623—1696

389 PEASANTS WITH A DONKEY
Oil on panel. 42.5 × 58 cm. Inv. No 2405

394

408

MIGNARD, PIERRE. 1612—1695

390 PORTRAIT OF DUCHESS DE LA VALLIÈRE
AS FLORA. *Pl. 24*

391 PORTRAIT OF A LADY AS FLORA
Oil on canvas. 122.5 × 110 cm (oval). Inv. No 1022

MILLET, JEAN-FRANÇOIS
(called FRANCISQUE). 1642—1679

392 LANDSCAPE WITH A FLOCK OF SHEEP
ON THE ROAD. *Pl. 20*

393 RESTING IN THE WOOD
Oil on canvas. 56 × 47 cm. Inv. No 1018

394 THE EXPULSION OF HAGAR
Oil on canvas. 76 × 105 cm. Inv. No 901

MILLET, JEAN-FRANÇOIS. 1814—1875

395 BRUSHWOOD GLEANERS
(CHARCOAL BURNERS). *Pl. 129*

MILLET (?)

396 HAYSTACKS. 1875. *Pl. 130*

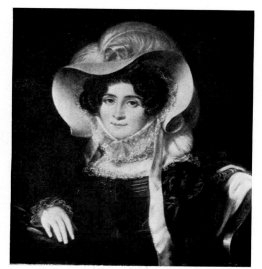

397

414

MITOIRE, BENOIS CHARLES. Active in the first half of the
19th century

397 PORTRAIT OF BARONESS KAMPENHAUSEN
Oil on canvas. 73 × 63 cm. Inv. No 1029

MONET, CLAUDE. 1840—1926

398 LUNCHEON ON THE GRASS. 1866.
Pl. 150

399 BOULEVARD DES CAPUCINES. 1873.
Pl. 149

400 THE ROCKS AT ÉTRETAT. 1886. *Pl. 154*

401 THE ROCKS AT BELLE-ILE. 1886. *Pl. 156*

402 HAYSTACK AT GIVERNY. *Pl. 155*

403 ROUEN CATHEDRAL AT NOON. 1894.
Pl. 151

404 WATER LILIES. 1899. *Pl. 157*

405 VÉTHEUIL. 1901. *Pl. 152*

406 SEA GULLS. THE THAMES IN LONDON.
THE HOUSES OF PARLIAMENT. 1904. *Pl. 153*

407 LILAC IN THE SUN. 1873
Oil on canvas. 50 × 65 cm. Inv. No 3311

408 ROUEN CATHEDRAL IN THE EVENING.
1894
Oil on canvas. 101 × 65 cm. Inv. No 3311

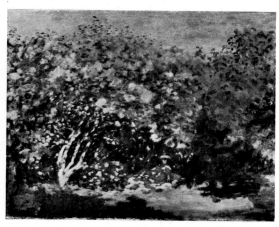

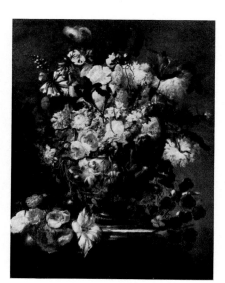

407

409

MONNOYER, JEAN-BAPTISTE. 1636—1699

409 FLOWERS
Oil on canvas. 121 × 95 cm. Inv. No 1027

MONSIAUX, NICOLAS ANDRÉ. 1754—1837

410 SOCRATES AND ASPASIA. 1801. *Pl. 83*

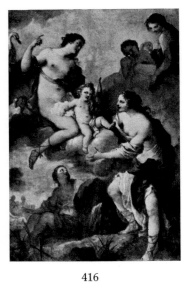

416

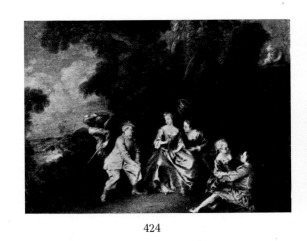

424

440

417

425

441

421

437

446

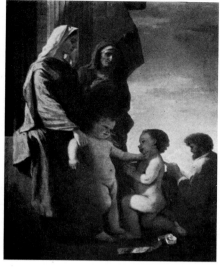

447

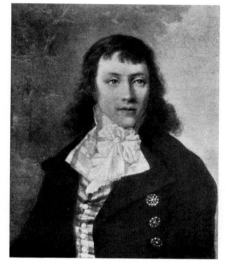

449

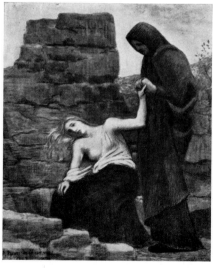

451

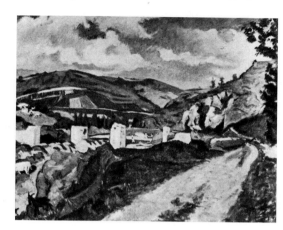

452

453

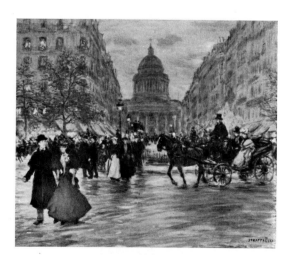

455

456

462

470

460

468

471

461

469

473

479

482

480

483

481

484

POUGNY, JEAN. 1892—1956

441 THE BEACH
Oil on canvas mounted on cardboard. 19.4 × 24 cm.
Inv. No 4090

POUSSIN, NICOLAS. 1594—1665

442 THE VICTORY OF JOSHUA OVER
THE AMORITES. *Pl. 2*

443 RINALDO AND ARMIDA. *Pl. 3*

444 THE MAGNANIMITY OF SCIPIO. *Pl. 4*

445 LANDSCAPE WITH HERCULES AND CACUS.
Pl. 5

446 SATYR AND NYMPH
Oil on canvas. 77 × 62 cm. Inv. No 1049

POUSSIN (?)

447 THE HOLY FAMILY
Oil on canvas. 64 × 49.5 cm. Inv. No 1047

PRUD'HON, PIERRE PAUL. 1758—1823

448 HEAD OF THE VIRGIN FROM
THE ANNUNCIATION. 1811. *Pl. 84*

PRUD'HON (?)

449 PORTRAIT OF A YOUNG MAN
IN A STRIPED WAISTCOAT
Oil on canvas. 65 × 51 cm. Inv. No 3593

PUVIS DE CHAVANNES, PIERRE. 1824—1898

450 A POOR FISHERMAN. Sketch. 1879. *Pl. 212*

451 COMPASSION. 1887
Pastel on canvas. 101 × 81 cm. Inv. No 3325

PUY, JEAN. 1876—1960

452 ROMAN BRIDGE IN SAINT-MAURICE
Oil on canvas. 73 × 92 cm. Inv. No 3326

453 IN THE STUDIO
Oil on canvas. 80 × 98 cm. Inv. No 3404

QUILLARD, ANTOINE. 1704—1733

454 PASTORAL SCENE. *Pl. 32*

RAFFAËLLI, JEAN-FRANÇOIS. 1850—1924

455 BOULEVARD SAINT-MICHEL
Oil on canvas. 64 × 77 cm. Inv. No 3431

456 FLOWER MARKET. 1892
Oil on panel. 26 × 40 cm. Inv. No 3835

RAOUX, JEAN. 1677—1734

457 THE ALLEGORY OF TASTE. *Pl. 38*

458 THE ALLEGORY OF SMELL. *Pl. 39*

REDON, ODILON. 1840—1916

459 NIGHT AND DAY. *Pl. 210*

460 WOMAN'S PROFILE IN THE WINDOW
Pastel on cardboard. 63 × 49 cm. Inv. No 3327

461 SPRING
Oil and tempera on canvas. 178 × 120 cm. Inv. No 3328

REGNAULT, JEAN-BAPTISTE. 1754—1829

462 VENUS AND MARS
Oil on canvas. 208 × 145 cm. Inv. No 1250

RENOIR, PIERRE AUGUSTE. 1841—1919

463 BAIGNADE DANS LA SEINE. *Pl. 164*

464 IN THE GARDEN. *Pl. 165*

465 NUDE. 1876. *Pl. 166*

466 PORTRAIT OF THE ACTRESS
JEANNE SAMARY. Study. 1877. *Pl. 167*

467 GIRLS IN BLACK. *Pl. 168*

485

488

491

486

489

496

487

490

499

500

503

501

506

502

507

RESTOUT, JEAN-PIERRE. 1692—1768

468 JUNO VISITING OCEANUS AND THETIS. 1723
Oil on canvas. 185 × 245 cm. Inv. No 1054

469 THE VIRGIN. 1753
Oil on canvas. 60 × 50 cm. Inv. No 1053

RICHARD, FLEURY FRANÇOIS. 1777—1852

470 MLLE DE LA VALLIÈRE IN THE CONVENT. 1804
Oil on panel. 63 × 47 cm. Inv. No 2407

RIESENER, HENRI FRANÇOIS. 1767—1828

471 PORTRAIT OF A MAN
Oil on canvas. 67 × 55 cm. Inv. No 1057

RIGAUD, HYACINTHE. 1659—1743

472 PORTRAIT OF FONTENELLE (?). *Pl. 30*

RIGAUD (atelier)

473 PORTRAIT OF A LADY
Oil on canvas. 74 × 60 cm. Inv. No 3014

RIVIÈRE, Mlle. Active in the early 19th century

474 PORTRAIT OF A LADY WITH A LYRE.
1806. *Pl. 92*

ROBERT, HUBERT. 1733—1808

475 THERMAE. 1778. *Pl. 74*

476 PYRAMIDS AND TEMPLE. *Pl. 76*

477 THE DESTRUCTION OF A TEMPLE.
Pl. 75

478 FESTIVAL OF SPRING. *Pl. 77*

479 HAYLOFT
Oil on canvas. 37 × 29 cm. Inv. No 1071

480 LANDSCAPE WITH AN OBELISK
Oil on canvas. 239 × 123 cm. Inv. No 1072

481 THE WANDERING MUSICIANS
Oil on canvas. 240 × 113 cm. Inv. No 1073

482 THE STROLLING MUSICIANS
Oil on canvas. 63.5 × 50 cm. Inv. No 1074

483 RUINS
Oil on canvas. 54 × 65 cm. Inv. No 1077

484 SARCOPHAGUS
Oil on canvas. 161 × 104 cm. Inv. No 2799

485 ANTIQUE TEMPLE IN WATER
Oil on canvas. 38 × 55 cm. Inv. No 2890

486 ARCHITECTURAL LANDSCAPE WITH
AN OBELISK IN THE BACKGROUND
Oil on canvas. 160 × 104 cm. Inv. No 2910

487 GALLERY LIGHTED FROM WITHIN
Oil on canvas. 192 × 106 cm. Inv. No 2914

488 THE "MAISON CARRÉE" IN NÎMES
Oil on canvas. 140.5 × 124 cm. Inv. No 3108

ROBERT (?)

489 HORSE RACE
Oil on canvas. 51 × 81 cm. Inv. No 3027

ROBERT, LÉOPOLD LOUIS. 1794—1835

490 THE ARRIVAL OF REAPERS
AT THE PONTIC SWAMPS. 1833
Oil on canvas. 74 × 93 cm. Inv. No 3565

ROBILLARD, HIPPOLYTE. Active between 1830 and 1860

491 STILL LIFE WITH TWO GREY-HENS
Oil on canvas. 89.7 × 68.7 cm. Inv. No 3002

ROUAULT, GEORGES. 1871—1958

492 BATHING IN A LAKE. 1907. *Pl. 251*

ROUSSEAU, HENRI. 1844—1910

493 VIEW OF THE MONTSOURIS PARK. *Pl. 223*

508

515

519

511

516

520

518

521

514

ROUSSEAU — SWEBACH

523

529

525

531

527

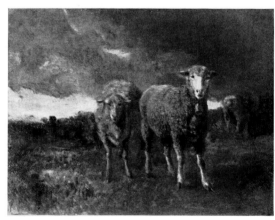

537

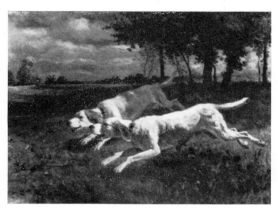

538

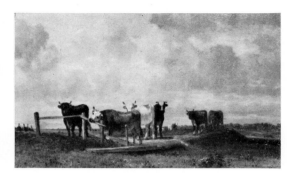

541

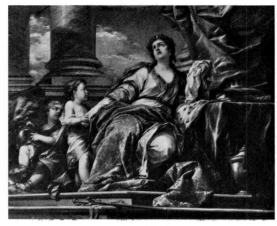

556

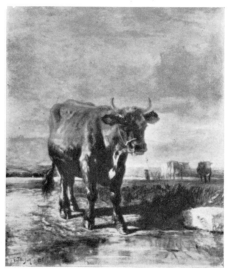

539

543

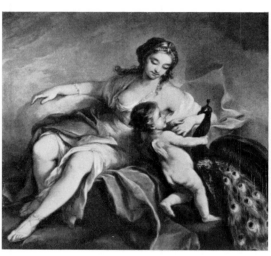

557

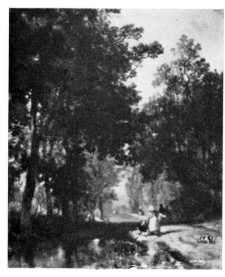

540

547

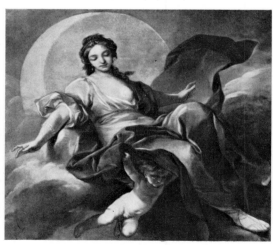

558

SWEBACH — VALTAT

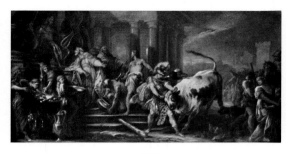

559

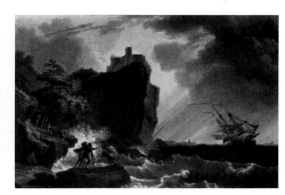

563

560

571

561

572

520 THE DEPARTURE OF CAVALRYMEN
Oil on canvas. 40.5 × 32.5 cm. Inv. No 3026

521 HORSEMAN BY THE BARRIER
Oil on canvas. 45.5 × 37 cm. Inv. No 3031

TARAVAL, HUGUES. 1729—1785
522 THE TOILET OF VENUS. *Pl. 53*

TASLITZKY, BORIS. Born 1911
523 IN THE PARISIAN METRO. 1935
Oil on canvas. 130 × 97 cm. Inv. No 3613

TAUNAY, NICOLAS ANTOINE. 1755—1830
524 VILLAGE WEDDING
(THE BRIDE'S GARTER). *Pl. 87*
525 ARCADIAN SHEPHERDS
Oil on canvas. 128 × 195 cm. Inv. No 2205

TOCQUÉ, LOUIS. 1696—1772
526 PORTRAIT OF NIKITA DEMIDOV. *Pl. 55*
527 PORTRAIT OF THE DAUPHIN
Oil on canvas. 195 × 140 cm. Inv. No 1104

TOULOUSE-LAUTREC, HENRI DE. 1864—1901
528 THE SINGER YVETTE GUILBERT. Sketch.
1894. *Pl. 190*
529 LADY BY THE WINDOW. 1889
Tempera on cardboard. 71 × 47 cm. Inv. No 3288

TOURNIÈRES, ROBERT. 1667—1752
530 CHEVALIER DE MALTE. *Pl. 17*
531 PORTRAIT OF A MAN
Oil on canvas. 75 × 55 cm. Inv. No 1122

TROY, FRANÇOIS DE. 1645—1730
532 PORTRAIT OF ADELAÏDE OF SAVOY.
1697. *Pl. 22*

TROY, JEAN FRANÇOIS DE. 1679—1752
533 SUSANNAH AND THE ELDERS. 1715.
Pl. 21

TROYON, CONSTANT. 1810—1865
534 APPROACHING STORM. *Pl. 124*
535 FISHERMEN. *Pl. 122*
536 DOG AND RABBIT. *Pl. 123*
537 SHEEP
Oil on panel. 30 × 39 cm. Inv. No 1112
538 RUNNING DOGS
Oil on canvas. 75 × 100 cm. Inv. No 1114
539 OX. 1851
Oil on canvas. 89 × 71 cm. Inv. No 1113
540 ROAD IN THE WOOD
Oil on canvas. 27 × 21 cm. Inv. No 116
541 COWS ON THE PASTURE
Oil on canvas. 55 × 88 cm. Inv. No 3548

UTRILLO, MAURICE. 1883—1955
542 LA RUE DU MONT-CENIS. *Pl. 255*
543 A WHITE COTTAGE (THE POOR QUARTER)
Oil on canvas. 65 × 81 cm. Inv. No 4067

VALENTIN DE BOULOGNE. 1594—1632
544 THE DENIAL OF ST PETER. *Pl. 1*

VALTAT, LOUIS. 1869—1952
545 THE SEA AT ANTHÉOR. *Pl. 248*
546 THE FARM (LANDSCAPE). *Pl. 247*
547 A HUT IN THE WOOD
Oil on canvas. 66 × 88 cm. Inv. No 3363

573

576

579

574

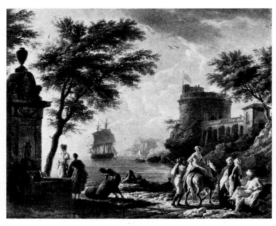

577

580

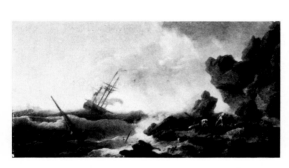

575

578

565

566

567

581

582

584

585

VAN DONGEN, KEES. 1877—1968

548 LADY IN BLACK GLOVES. *Pl. 253*

549 SPANISH WOMAN. *Pl. 254*

VAN GOGH, VINCENT. 1853—1890

550 SEASCAPE AT SAINTES-MARIES.
 Pl. 185

551 THE RED VINEYARD. *Pl. 187*

552 PORTRAIT OF DR REY. 1889. *Pl. 188*

553 THE PRISON-COURTYARD. *Pl. 189*

554 LANDSCAPE WITH CARRIAGE AND TRAIN.
 Pl. 186

VANLOO, CARLE. 1705—1765

555 THE ALLEGORY OF COMEDY. 1753. *Pl. 54*

556 THE ALLEGORY OF TRAGEDY
 Oil on canvas. 121 × 151 cm. Inv. No 741

557 JUNO
 Oil on canvas. 132 × 141 cm. Inv. No 743

558 DIANA
 Oil on canvas. 130 × 148 cm. Inv. No 744

559 THESEUS AND THE BULL OF MARATHON
 Oil on canvas. 78 × 158 cm. Inv. No 746

560 LANDSCAPE WITH A FLOCK
 Oil on canvas. 133 × 245 cm. Inv. No 745

561 THE APOTHEOSIS OF ST GREGORY
 Oil on canvas. 80 × 80 cm (roundel). Inv. No 3044

VANLOO, LOUIS MICHEL. 1707—1771

562 PORTRAIT OF PRINCESS EKATERINA
 (SMARAGDA) GOLITSYNA. 1759. *Pl. 63*

VERNET, ANTOINE FRANÇOIS. 1730—1779

563 SHIPWRECK
 Oil on panel. 42 × 65 cm. Inv. No 2892

VERNET, HORACE. 1789—1863

564 CAVALCADE. *Pl. 106*

565 MAMELUKE
 Oil on canvas. 126 × 94 cm. Inv. No 788

566 ARAB
 Oil on canvas. 86 × 74 cm. Inv. No 2903

567 ARAB HORSE. 1835
 Oil on canvas. 33 × 45 cm. Inv. No 784

VERNET, JOSEPH. 1714—1789

568 ROMANTIC LANDSCAPE (LANDSCAPE
 IN THE STYLE OF SALVATORE ROSA).
 1746. *Pl. 60*

569 SUNRISE. 1746. *Pl. 59*

570 VIEW IN THE PARK OF VILLA PAMPHILI.
 1749. *Pl. 61*

571 SUNSET. 1746
 Oil on canvas. 81 × 97 cm. Inv. No 769

572 MIST
 Oil on canvas. 75 × 108 cm. Inv. No 773

573 HAVEN WITH A CLASSICAL ARCH
 Oil on canvas. 104 × 140 cm. Inv. No 3028

574 SEA BAY WITH A ROTUNDA TEMPLE
 Oil on canvas. 104 × 140 cm. Inv. No 3024

575 STORM ON THE SEA
 Oil on canvas. 58 × 107 cm. Inv. No 774

576 LIGHTHOUSE GLEAMING IN THE STORM
 Oil on canvas. 99 × 136 cm. Inv. No 778

577 SEASIDE HAVEN
 Oil on canvas. 57 × 65 cm. Inv. No 777

578 AFTER THE STORM
 Oil on canvas. 41 × 55 cm. Inv. No 2909

579 CAPRI AT DAYBREAK
 Oil on canvas. 92 × 150 cm. Inv. No 3905

586

589

595

587

592

596

588

594

597

599

600

604

605

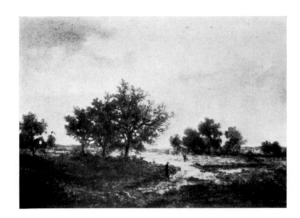

606

609

580 FIRE AT NIGHT
Oil on canvas. 97 × 137.5 cm. Inv. No 3912

VEYRASSAT, JULES JACQUES. 1828—1893

581 ON THE FERRYBOAT
Oil on canvas. 77 × 109 cm. Inv. No 1261

582 SHEPHERD WITH SHEEP
Oil on canvas. 12 × 23.5 cm. Inv. No 767

VIGÉE-LEBRUN, ÉLISABETH LOUISE. 1755—1842

583 PORTRAIT OF PRINCESS ALEXANDRA
GOLITSYNA AND HER SON. 1794. *Pl. 85*

584 PORTRAIT OF PRINCESS EKATERINA
GOLENISHCHEVA-KUTUZOVA
Oil on canvas. 80 × 67 cm. Inv. No 2793

585 PORTRAIT OF SOPHIA STROGANOVA
AND HER SON
Oil on canvas. 35 × 39 cm. Inv. No 2792

586 PORTRAIT OF IVAN SHUVALOV
Oil on canvas. 76 × 63 cm. Inv. No 3193

587 NAIADS
Oil on canvas. 70 × 56 cm. Inv. No 2800

VIGÉE-LEBRUN (copy after)

588 SELF-PORTRAIT IN A STRAW HAT
Oil on canvas mounted on copper-plate. 31 × 26 cm.
Inv. No 2735

VINCENT, FRANÇOIS ANDRÉ. 1746—1816

589 PORTRAIT OF A YOUTH HOLDING
A PORTFOLIO. 1791
Oil on canvas. 73 × 59 cm. Inv. No 3020

VLAMINCK, MAURICE DE. 1876—1958

590 BOATS ON THE SEINE. *Pl. 249*

591 LANDSCAPE IN AUVERS. *Pl. 250*

592 RIVULET
Oil on canvas. 83 × 102 cm. Inv. No 3365

VOILLE, JEAN-LOUIS. 1744 — after 1803

593 PORTRAIT OF EKATERINA NARYSHKINA.
1787. *Pl. 80*

594 PORTRAIT OF ELIZAVETA CHICHERINA
Oil on canvas. 67 × 52 cm. Inv. No 804

595 PORTRAIT OF PRINCESS EVGENIA
DOLGORUKAYA. 1789
Oil on canvas. 64 × 51 cm. Inv. No 2889

596 PORTRAIT OF COUNT FIODOR BUXHOEVDEN.
1789
Oil on canvas. 70 × 53 cm. Inv. No 3752

597 PORTRAIT OF COUNTESS BUXHOEVDEN.
1789
Oil on canvas. 70 × 54 cm. Inv. No 3753

VOLLON, ANTOINE. 1833—1900

598 STILL LIFE. *Pl. 144*

599 STILL LIFE
Oil on panel. 60 × 43 cm. Inv. No 3489

VOUET, SIMON. 1590—1649

600 THE ANNUNCIATION. 1632
Oil on canvas. 230 × 159 cm. Inv. No 806

VOUET (?)

601 THE DEATH OF VIRGINIA. *Pl. 6*

VUILLARD, ÉDOUARD. 1868—1940

602 IN THE GARDEN. *Pl. 213*

603 ON THE SOFA (THE WHITE ROOM).
Pl. 214

604 INTERIOR
Oil on cardboard. 50 × 77 cm. Inv. No 3366

610

613

616

611

614

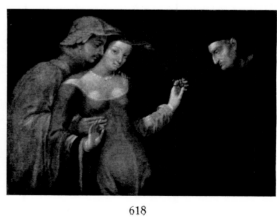

617

612

615

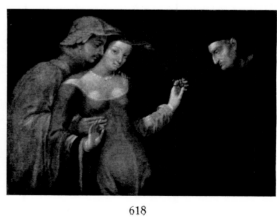

618

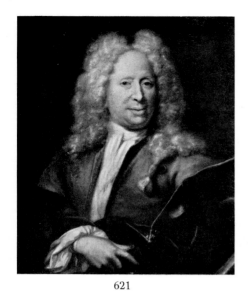

621

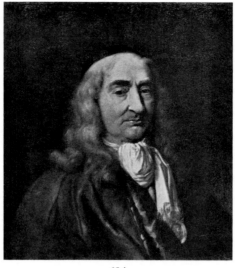

624

622

625

626

623

WATELET, LOUIS ÉTIENNE. 1780—1866

605 A HUT BY A WATERFALL. 1863
 Oil on canvas. 22 × 27 cm. Inv. No 761

WATELIN, LOUIS FRANÇOIS. 1835—1907

606 LANDSCAPE
 Oil on panel. 39 × 55 cm. Inv. No 760

WATTEAU, ANTOINE. 1684—1721

607 SATIRE ON PHYSICIANS. *Pl. 27*

608 THE BIVOUAC. *Pl. 28*

WICAR, JEAN-BAPTISTE. 1762—1834

609 PORTRAIT OF POPE PIUS VII
 Oil on canvas. 198 × 149 cm. Inv. No 797

WILLE, PIERRE ALEXANDRE. 1748—1821

610 THE DEATH OF THE DUKE OF BRAUNSCHWEIG.
 1787
 Oil on canvas. 135 × 113 cm. Inv. No 800

ZAMBAUX, ROBERT. Active in the 1950s

611 SUNDAY (WOMAN PRESSING LINEN)
 Oil on canvas. 131 × 162 cm. Inv. No 3618

ZIEM, FÉLIX PHILIBERT. 1821—1911

612 VENICE
 Oil on canvas. 57 × 72 cm. Inv. No 928

613 THE BOSPORUS STRAIT
 Oil on canvas. 65 × 105 cm. Inv. No 929

614 VENETIAN SCENE
 Oil on panel. 31 × 21 cm. Inv. No 931

615 CARAVAN. 1860
 Oil on canvas. 79 × 145 cm. Inv. No 932

ANONYMOUS MASTERS

16th century

616 PORTRAIT OF AN AGED MAN
 Oil on canvas. 92 × 77 cm. Inv. No 1150

617 LADY AND HER MAID
 Oil on canvas. 102 × 74 cm. Inv. No 1151

618 SCENE FROM BOCCACCIO
 Oil on canvas. 63 × 92 cm. Inv. No 3143

17th century

619 PORTRAIT OF A HORSEMAN IN BLUE.
 Pl. 18

620 PORTRAIT OF A MAN IN A RED GOWN.
 Pl. 31

621 PORTRAIT OF THE PHYSICIAN FAGON (?)
 Oil on canvas. 78 × 63 cm. Inv. No 1171

622 PORTRAIT OF A BOY
 Oil on copper-plate. 22 × 16.5 cm. Inv. No 3218

623 PORTRAIT OF AN AGED LADY
 IN A MOBCAP
 Oil on canvas. 80 × 64 cm. Inv. No 1165

624 PORTRAIT OF A DECORATED ELDER
 Oil on canvas. 68 × 55 cm. Inv. No 1170

625 PORTRAIT OF RIQUET DE CARAMON
 Oil on canvas. 46 × 39 cm. Inv. No 3589

626 ANGEL AND TOBIAH
 Oil on canvas. 120 × 176 cm. Inv. No 2787

627

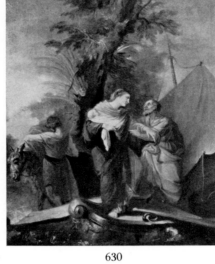

630

628

631

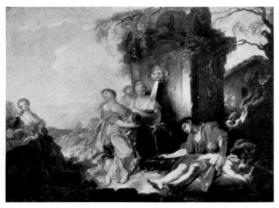

629

ANONYMOUS MASTERS

INDEX OF EXHIBITIONS
ABBREVIATIONS
INDEX OF ARTISTS

1903 Vienna	Impressionist Exhibition of the Vienna Sezession (Die Impressionistenausstellung der Wiener Sezession), Vienna, 1903 *150, 165, 174, 182*
1904 Paris	Claude Monet. Views of the Thames in London (Claude Monet. Vues de la Tamise à Londres). Durand-Ruel Gallery, Paris, 1904 *153*
1905 Amsterdam	Vincent Van Gogh, Amsterdam, 1905 *186*
1905 Paris	Vincent Van Gogh. Retrospective Exhibition, Paris, 1905 *189*
1905 St Petersburg	Exhibition of Russian Portraits in the Taurida Palace in Aid of the Widows and Orphans of Soldiers Killed in Action, St Petersburg, 1905 *55, 58, 63, 64, 69, 80, 85, 88, 108*
1906 Berlin	Exhibition of French Painters (Ausstellung französischer Maler), Berlin, 1906 *149, 193*
1906 Berlin, Stuttgart	Monet — Manet. Faure Collection. Cassirer Gallery, Berlin, Stuttgart, 1906 *149*
1906 Paris	Claude Monet. Faure Collection. Durand-Ruel Gallery, Paris, 1906 *149, 155*
1907 London	French Painting of the 19th Century. Goupil Gallery, London, 1907 *119*
1907 Mannheim	International Art Exhibition (Internationale Kunstausstellung), Mannheim, 1907 *149*
1907 Paris	Henri Edmond Cross. Bernheim Jeune Gallery, Paris, 1907 *207*
1908 Moscow	Exhibition at the Salon of the *Golden Fleece* (*Zolotoye Runo*) Art Review, Moscow, 1908 *208, 251, 253*
1908 St Petersburg	Exhibition of Paintings Organized by the *Old Years* (*Starye Gody*) Magazine, St Petersburg, 1908 *7, 8, 35, 45, 67, 93*
1909 Paris	Vincent Van Gogh. Druet Gallery, Paris, 1909 *186, 188, 189*
1909 Paris (Druet Gallery)	Othon Friesz. Druet Gallery, Paris, 1909 *246*
1909 Paris (Durand-Ruel Gallery)	Claude Monet. Durand-Ruel Gallery, Paris, 1909 *157*
1910 Paris	Henri Matisse. Bernheim Jeune Gallery, Paris, 1910 *238*
1912 St Petersburg	A Century of French Painting. 1812—1912, St Petersburg, 1912 *55, 72, 84, 95, 179*
1913 Berlin	Henri Matisse, Berlin, 1913 *234—236*
1913 Brussels	Interpretation of the South (Inteprétation du Midi), Brussels, 1913 *204*
1913 Paris	Pierre Bonnard. Recent Works (Pierre Bonnard. Œuvres récentes). Bernheim Jeune Gallery, Paris, 1913 *217, 218*
1913 Paris (Bernheim Jeune Gallery)	Henri Matisse. Paintings and Sculptures of the Moroccan Period (Henri Matisse. Tableaux et sculptures marocains). Bernheim Jeune Gallery, Paris, 1913 *230, 234—236*
1914 Petrograd	Art of the United Peoples, Petrograd, 1914 *19, 67, 69, 77, 108*
1915 Moscow	Exhibition of Paintings by Western Old Masters from Private Collections in Moscow, Arranged by the Society of the Rumiantsev Museum Friends in Aid of the Serbs and Montenegrins, Moscow, 1915 *16*
1918 Moscow	First Exhibition of Works from the State Museum Reserve, Moscow, 1918 *42, 63, 64*
1920 Moscow	French Painting. 1820—1870, Moscow, 1920 *99, 113, 115, 116, 120, 121, 132*

1956 Leningrad	French Art from the 12th to the 20th Century, Leningrad, 1956 *1—5, 7, 8, 23, 27, 28, 30, 32, 42, 43, 45—47, 49—51, 58, 61, 65, 66, 69, 70, 72, 81, 82, 84, 88, 94, 95, 98—100, 102—104, 109—130, 132—134, 136, 145, 146, 166, 168, 178—182, 186, 188, 189, 193—197, 201, 202, 212, 224, 225, 227, 228, 230, 232, 233, 238, 239, 241—244, 256—261, 264*
1956 Leningrad (Paul Cézanne)	Paul Cézanne (1839—1906). Half-centennial Exhibition, Leningrad, 1956 *174—184*
1958 Brussels	Fifty Years of Modern Art (Cinquante ans d'art moderne), Brussels, 1958 *189, 197, 200, 231, 237, 239, 261, 266*
1958 Moscow	Albert Marquet. Paintings from the Collection of Marcelle Marquet and from Soviet Museums, Moscow, 1958 *241—245*
1958 Paris	Masterpieces of Henri Matisse (Chefs-d'œuvre de Henri Matisse). Bernheim Jeune Gallery, Paris, 1958 *226*
1959 Leningrad, Kiev	Albert Marquet, Leningrad, Kiev, 1959 *241, 242, 244, 245*
1960 London	Pablo Picasso. Tate Gallery, London, 1960 *256, 259, 261, 266*
1960 Moscow	Exhibition of French Art of the Second Half of the 19th Century from the Stocks of Soviet Museums, Moscow, 1960 *105, 109—130, 132, 133, 135—175, 179, 185—187, 190, 191, 193—195, 197, 200, 203—205, 211, 212*
1960 Paris	Nicolas Poussin. Tercentennial Exhibition, Paris, 1960 *2, 5*
1960 Paris (Musée Jacquemart-André)	Vincent Van Gogh (1853—1890). Musée Jacquemart-André, Paris, 1960 *187—189*
1962 Venice	XXXI Biennale, Venice, 1962 *234*
1962 Paris	Selected Works of 20th Century Art (Œuvres choisies du XXᵉ siècle). Kaganovitch Gallery, Paris, 1962 *280*
1963 Moscow	Fernand Léger, Georges Boquier, Nadia Léger, Moscow, 1963 *278, 279*
1963 Paris	Eugène Delacroix. Centennial Exhibition (Eugène Delacroix. Exposition du Centenaire), Paris, 1963 *99*
1963 Rotterdam	French Landscapes from Cézanne to Our Days (Franse Landschappen van Cézanne tot heden), Rotterdam, 1963 *280*
1963 Versailles	Charles Lebrun (1619—1690), Versailles, 1963 *15*
1964 Leningrad	Western European Paintings from Soviet Museums. Exhibition Marking the Bicentenary of the Hermitage, Leningrad, 1964 *81, 99, 274*
1964 Rotterdam	The Fair of the Naive (De Lusthof der Naïven), Rotterdam, 1964 *221, 222*
1964 Tokyo	Pablo Picasso, Tokyo, 1964 *256, 262, 266*
1965 Berlin	From Delacroix to Picasso (Von Delacroix bis Picasso), Berlin, 1965 *260*
1965 Bordeaux	French Paintings from the Hermitage and from the Moscow Museums (La Peinture française dans les musées de l'Ermitage et de Moscou), Bordeaux, 1965 *1, 28, 43, 46, 61, 63, 66, 67, 82, 132, 146, 148, 165, 181, 183, 188, 199, 215, 227, 231, 244, 264, 266, 269, 277*
1965—66 Paris	Masterpieces of French Painting from the Museums of Leningrad and Moscow (Chefs-d'œuvre de la peinture française dans les musées de Léningrad et de Moscou). The Louvre, Paris, 1965—66 *1, 28, 43, 46, 61, 63, 66, 67, 82, 132, 146, 148, 165, 181, 183, 188, 199, 215, 227, 231, 244, 264, 266, 269, 277*
1966—67 Paris	Homage to Picasso (Hommage à Picasso), Paris, 1966—67 *258, 263, 266*

416

1974 Leningrad

Exhibition of Impressionist Paintings Marking the Centenary of the First Impressionist Exhibition, Leningrad, 1974 *147, 149, 151, 153, 158, 161, 164, 165, 167—171, 179, 182*

1974—75 Moscow

Exhibition of Impressionist Paintings Marking the Centenary of the First Impressionist Exhibition, Moscow, 1974—75 *147—161, 164—174, 178, 179, 182*

1974—75 Paris

From David to Delacroix. French Painting from 1774 to 1830 (De David à Delacroix. La Peinture française de 1774 à 1830), Paris, 1974—75 *79, 97*

1974—75 Paris, New York

Exhibition Marking the Centenary of Impressionism (L'Impressionnisme. Exposition du Centenaire), Paris, New York, 1974—75 *150*

1974—75 Paris (Grand Palais)

The USSR and France. Great Moments of a Great Tradition. Fifty Years of Franco-Soviet Diplomatic Relations (L'URSS et la France. Les grands moments d'une tradition. Cinquantième anniversaire des relations diplomatiques franco-soviétiques). Grand Palais, Paris, 1974—75 *43, 63, 196, 228*

1975 Moscow

Fifty Years of Franco-Soviet Diplomatic Relations, Moscow, 1975 *43, 63, 196, 228*

1975—76 Bordeaux, Paris

Albert Marquet. Galerie des Beaux-Arts, Bordeaux, Orangerie des Tuileries, Paris, 1975—76 *241, 244*

1976 Rome, Dijon

Piranese et les Français, Rome, Dijon, 1976 *76*

1976—77 Paris

Joseph Vernet, Paris, 1976—77 *61*

1978 Düsseldorf

Nicolas Poussin, Düsseldorf, 1978 *2*

1978 Paris

Les frères Le Nain, Paris, 1978 *13, 14*

ABBREVIATIONS

Алпатов 1936	М. Алпатов, *Коро*, Moscow, 1936
Алпатов 1969	М. Алпатов, *Матисс*, Moscow, 1969
Бенуа 1908	А. Бенуа, "Живопись эпохи барокко и рококо", *Старые годы*, 1908, ноябрь — декабрь
Бенуа 1912	А. Бенуа, *История живописи всех времен и народов*, vol. 4, St Petersburg, 1912
Ван Гог 1966	Ван Гог, *Письма*, Leningrad — Moscow, 1966
Вольская 1946	В. Вольская, *Пуссен*, Moscow, 1946
Гоген 1914	П. Гоген, "*Ноа-Ноа*", Moscow, 1914
ГМИИ 1966	*Государственный музей изобразительных искусств имени А. С. Пушкина. Западноевропейская живопись и скульптура*, edited by B. Vipper, Moscow, 1966
Золотов 1968	Ю. Золотов, *Французский портрет XVIII века*, Moscow, 1968
Золотое Руно 1908	"Обзор выставки *Салон Золотого Руна*", *Золотое Руно*, 1908, 7—9
Искусство 1905	*Искусство*, 1905, 2
Кантор-Гуковская 1965	А. С. Кантор-Гуковская, *Поль Гоген. Жизнь и творчество*, Leningrad — Moscow, 1965
Кат. выст. Матисса 1969	*Матисс. Живопись. Скульптура. Графика. Письма*, Leningrad, 1969
Кат. галереи Третьяковых 1911	*Каталог художественных произведений городской галереи Павла и Сергея Третьяковых*, Moscow, 1911
Кат. галереи Третьяковых 1917	*Каталог художественных произведений галереи Павла и Сергея Третьяковых*, Moscow, 1917
Кат. ГМИИ 1948	*Государственный музей изобразительных искусств имени А. С. Пушкина. Каталог картинной галереи*, Moscow, 1948
Кат. ГМИИ 1957	*Государственный музей изобразительных искусств имени А. С. Пушкина. Каталог картинной галереи*, Moscow, 1957
Кат. ГМИИ 1961	*Государственный музей изобразительных искусств имени А. С. Пушкина. Каталог картинной галереи*, Moscow, 1961
Кат. ГМНЗИ 1928	*Государственный музей нового западного искусства. Каталог*, Moscow, 1928
Кат. Румянцевского музея 1912	*Каталог Румянцевского музея*, Moscow, 1912
Кат. Румянцевского музея 1915	*Императорский Московский Публичный и Румянцевский музей. Отделение изящных искусств*, Moscow, 1915
Кат. собр. С. Щукина 1913	*Каталог картин собрания С. И. Щукина*, Moscow, 1913
Кат. Эрмитажа 1916	*Императорский Эрмитаж. Краткий каталог картинной галереи*, Petrograd, 1916
Кат. Юсуповской галереи 1920	*Государственный музейный фонд. Каталог художественных произведений бывшей Юсуповской галереи*, Petrograd, 1920
Кузнецова 1978	И. Кузнецова, *Франсуа Буше* (серия "Образ и цвет"), Moscow, 1978
Леняшина 1975	Н. Леняшина, *Альбер Марке*, Leningrad, 1975
Маковский 1912	С. Маковский, "Французские художники из собрания И. А. Морозова", *Аполлон*, 1912, 3—4
Марке 1969	М. Марке, *Альбер Марке*, Moscow, 1969
Матисс 1958	*Матисс. Сборник статей*, Moscow, 1958
Моне 1969	И. Сапего, А. Барская, Е. Георгиевская, М. Закке, *Клод Моне*, Leningrad, 1969
Моне 1974	Е. Георгиевская, *Клод Моне*, Moscow, 1974

Муратов 1908	П. Муратов, *Щукинская галерея*, Moscow, 1908
Опись галереи Третьяковых 1894	*Опись художественных произведений городской галереи Павла и Сергея Третьяковых*, Moscow, 1894
Перцов 1921	П. Перцов, *Щукинское собрание французской живописи*, Moscow, 1921
А. Прахов 1901	А. Прахов, "Художественное собрание князей Юсуповых", *Художественные сокровища России*, 1901
А. Прахов 1905	А. Прахов, "Художественное собрание Д. И. Щукина", *Художественные сокровища России*, 1905
А. Прахов 1906	А. Прахов, "Художественное собрание князей Юсуповых", *Художественные сокровища России*, 1906
А. Прахов 1907	А. Прахов, "Художественное собрание князей Юсуповых", *Художественные сокровища России*, 1907
Прокофьев 1962	В. Прокофьев, *Французская живопись в музеях СССР*, Moscow, 1962
Разумовская 1938	С. Разумовская, *Коро в музеях СССР*, Moscow, 1938
Ревалд 1959	Дж. Ревалд, *История импрессионизма*, Moscow — Leningrad, 1959
Ренуар 1970	Ж. Ренуар, *Огюст Ренуар*, Moscow, 1970
Ромм 1935	А. Ромм, *Матисс*, Moscow, 1935
Русские портреты 1905—9	*Русские портреты XVIII и XIX столетия*, 5 vols., St Petersburg, 1905—9
Сезанн 1972	*Поль Сезанн. Переписка. Воспоминания современников* (составление, вступительная статья, примечания и хронология жизни и творчества Сезанна Н. В. Яворской), Moscow, 1972
Сезанн 1975	А. Барская, Е. Георгиевская, *Поль Сезанн*, Leningrad, 1975
Сомов 1900	А. Сомов, *Императорский Эрмитаж. Каталог картинной галереи*, part 3: Английская и французская живопись, St Petersburg, 1900
ТГЭ vol. 2	*Труды Государственного Эрмитажа*, Leningrad, 1941, vol. 2: Отдел западноевропейского искусства
Тугендхольд 1914	Я. Тугендхольд, "Французское собрание С. И. Щукина", *Аполлон*, 1914, 1—2
Тугендхольд 1923	Я. Тугендхольд, *Первый музей новой западной живописи*, Moscow — Petrograd, 1923
Эрнст 1924	С. Эрнст, *Юсуповская галерея. Французская школа*, Leningrad, 1924
Яворская 1962	Н. Яворская, *Пейзаж барбизонской школы*, Moscow, 1962
Anciennes écoles de peinture 1910	Les Anciennes écoles de peinture dans les palais et collections privées russes. Exposition organisée à Saint-Pétersbourg en 1909 par la revue d'art ancien *Starye Gody*, Brussels, 1910
Antonova 1977	I. Antonowa, *Die Gemäldegalerie des Puschkin-Museums in Moskau*, Leipzig, 1977
Barr 1951	A. H. Barr, *Matisse. His Art and His Public*, New York, 1951
Blunt 1967	A. Blunt, *Nicolas Poussin*, in: *The A. W. Mellon Lectures in the Fine Arts. 1958*, 2 vols., New York, 1967
Cachin 1968	F. Cachin, *Gauguin*, Paris, 1968
Cahiers d'Art 1950	"Art moderne français dans les collections des musées étrangers. Le Musée d'Art Moderne Occidental à Moscou", *Cahiers d'Art*, 1950
Cat. Crozat 1755	*Catalogue des tableaux du cabinet de M. Crozat, baron de Thiers*, Paris, 1755
Cat. Ermitage 1774	*Catalogue des tableaux qui se trouvent dans les galeries et dans les cabinets du Palais Impérial de Saint-Pétersbourg*, St Petersburg, 1774

Cat. Ermitage 1863	*Ermitage Impérial. Catalogue de la galerie des tableaux*, St Petersburg, 1863
Cat. Impressionnistes 1959	*Catalogue des peintures, pastels, sculptures impressionnistes*, Paris, 1959
Charmet 1970	R. Charmet, *La Peinture française dans les musées russes*, Paris — Geneva — Munich, 1970
Daix et Boudaille 1966	*Picasso. 1900—1906. Catalogue raisonné de l'œuvre peint* (P. Daix: 1900, 1901, 1906; G. Boudaille: 1902 à 1905; catalogue établi avec la collaboration de J. Rosselet), Neuchâtel, 1966
Daulte 1971	F. Daulte, *Auguste Renoir. Catalogue raisonné de l'œuvre peint*, Lausanne, 1971
De La Faille 1928	J.-B. De La Faille, *L'Œuvre de Vincent van Gogh. Catalogue raisonné*, 4 vols., Paris — Brussels, 1928
De La Faille 1970	J.-B. De La Faille, A. M. Hammacher, *The Works of Vincent van Gogh. His Paintings and Drawings*, Amsterdam, 1970
Diehl 1954	G. Diehl, *Henri Matisse*, Paris, 1954
Dimier 1926—27	L. Dimier, *Histoire de la peinture française du retour de Vouet à la mort de Lebrun. 1627—1690*, 2 vols., Paris, 1926—27
Dimier 1928—30	L. Dimier, *Les Peintres français du XVIIIᵉ siècle*, 2 vols., Paris — Brussels, 1928—30
Dorival 1948	B. Dorival, *Cézanne*, Paris, 1948
Dussieux 1856	L. Dussieux, *Les Artistes français à l'étranger*, Paris, 1856
Ernst 1928	S. Ernst, "L'Exposition de la peinture française des XVIIᵉ et XVIIIᵉ siècles au Musée de l'Ermitage à Pétrograd. 1922—1925", *Gazette des Beaux-Arts*, 17, 1928
Ettinger 1926	P. Ettinger, "Die modernen Franzosen in den Kunstsammlungen Moskaus", 2 parts, *Der Cicerone*, 1926
Feist 1961	P. H. Feist, *Auguste Renoir*, Leipzig, 1961
Friedlaender 1914	W. Friedlaender, *Nicolas Poussin*, Munich, 1914
Geffroy 1922	G. Geffroy, *Claude Monet, sa vie, son œuvre*, Paris, 1922
Grautoff 1914	O. Grautoff, *Nicolas Poussin*, 2 vols., Munich, 1914
Grautoff 1919	O. Grautoff, "Die Sammlung Serge Stchoukine in Moskau", *Kunst und Künstler*, 1918—19
Heilbut 1903	E. Heilbut, "Die Wiener Impressionistenausstellung", *Kunst und Künstler*, 1903, 5—6
Ingersoll-Smouse 1926	F. Ingersoll-Smouse, *Joseph Vernet, peintre de marine. 1714—1789*, 2 vols., Paris, 1926
Jourdain 1959	F. Jourdain, *Albert Marquet*, Dresden, 1959
Labensky 1805	C. de Genève, F. Labensky, *Description de la Galerie de l'Ermitage*, 2 vols., St Petersburg, 1805
Lagrange 1864	L. J. Lagrange, *Vernet et la peinture au XVIIIᵉ siècle*, Paris, 1864
Lemoisne 1946—49	P. A. Lemoisne, *Degas et son œuvre*, 4 vols., Paris, 1946—49
Magne 1914	E. Magne, *Nicolas Poussin, Premier peintre du Roi*, Brussels — Paris, 1914
Malingue 1946	M. Malingue, *Lettres de Gauguin à sa femme et à ses amis*, Paris, 1946
Mantz 1880	P. Mantz, *François Boucher, Lemoyne et Natoire*, Paris, 1880
Michel 1886	A. Michel, *François Boucher*, Paris, 1886
Musée de Moscou 1963	*Les Grands maîtres de la peinture au Musée de Moscou*, Paris, 1963

Musée Youssoupoff 1839 *Musée du Prince Youssoupoff*, St Petersburg, 1839

Nolhac 1907 P. de Nolhac, *François Boucher*, Paris, 1907

Notice sur l'Ermitage 1828 *Notice sur les principaux tableaux du Musée Impérial de l'Ermitage à Saint-Pétersbourg*, St Petersburg — Berlin, 1828

Pattison 1884 M. Pattison, *Claude Lorrain*, Paris, 1884

Réau 1924 L. Réau, *Histoire de l'expansion de l'art français. Le Monde slave et l'Orient*, Paris, 1924

Réau 1929 L. Réau, *Catalogue de l'art français dans les museés russes*, Paris, 1929

Reuterswärd 1948 O. Reuterswärd, *Claude Monet*, Stockholm, 1948

Robaut 1905 A. Robaut, *L'Œuvre de Corot. Catalogue raisonné et illustré*, 4 vols., Paris, 1905

Rotonchamp 1906 J. de Rotonchamp, *Paul Gauguin. 1848—1903*, Paris, 1906

Röthlisberger 1961 M. Röthlisberger, *Claude Lorrain*, London, 1961

Smith 1837 T. A. Smith, *Catalogue Raisonné of the Works of the Most Eminent Dutch, Flemish and French Painters*, part 8, London, 1837

Sterling 1957 Ch. Sterling, *Musée de l'Ermitage. La peinture française de Poussin à nos jours*, Paris, 1957 [the paintings from the Pushkin Museum which were included in the 1956 loan exhibition at the Hermitage are here erroneously referred to as belonging to the Hermitage collection]

Stuffmann 1968 M. Stuffmann, "Tableaux de la collection de Pierre Crozat", *Gazette des Beaux-Arts*, 72, 1968

Ternovetz 1925 B. Ternovetz, "Le Musée d'Art Moderne de Moscou", *L'Amour de l'Art*, 1925, 12

Thuillier 1974 J. Thuillier, *Tout l'œuvre peint de Poussin*, Paris, 1974

Van Gogh 1937 *Lettres de Vincent van Gogh à son frère Théo*, Paris, 1937

Venturi 1936 L. Venturi, *Cézanne. Son art, son œuvre*, 2 vols., Paris, 1936

Vollard 1914 A. Vollard, *Paul Cézanne*, Paris, 1914

Waagen 1864 G. F. Waagen, *Die Gemäldesammlung in der Kaiserlichen Eremitage zu St. Petersburg*, Munich, 1864

Wildenstein 1964 G. Wildenstein, *Gauguin*, Paris, 1964

Zervos 1932—59 Ch. Zervos, *Pablo Picasso*, 10 vols., Paris, 1932—59

INDEX OF ARTISTS

Numbers in italics indicate plates

ALLEGRAIN, ÉTIENNE

Born 1644 in Paris, died there 1736. From 1677 member of the Academy. Worked in Paris. Was strongly influenced by F. Millet. Landscape painter.

ARCAMBOT, PIERRE

Born 1914 at Brou. A self-taught artist. Exhibited at the Salon d'Automne, Salon des Indépendants and Salon des Artistes Français. Paints landscapes and scenes in the Primitivist manner.

AUBRY, ÉTIENNE

Born 1745 at Versailles, died there 1781. Pupil of J. Silvestre and J. Vien. From 1775 member of the Academy. Worked in Paris. Painted portraits, historical and genre scenes. *57*

AVED, JACQUES ANDRÉ JOSEPH

Born 1702 at Douai, died 1766 in Paris. Studied in Amsterdam under the engraver B. Picart and in Paris under the portraitist S. Belle. Was influenced by Chardin. Worked in Paris. Portrait painter. *58*

BASTIEN-LEPAGE, JULES

Born 1848 at Damvillers, died 1884 in Paris. Studied under Cabanel at the Ecole des Beaux-Arts in Paris. Worked in Paris. In 1870 took part in the Franco-Prussian war as a franc-tireur. At the end of his life visited Italy and Algeria. Painted almost exclusively rustic genre scenes. *140*

BENOIST, PHILIPPE

Born 1813 in Geneva, date and place of death unknown. Worked in France. Exhibited at the Paris Salons from 1836 to 1879. Painted urban and architectural landscapes. Also known as a lithographer.

BESNARD, ALBERT PAUL

Born 1849 in Paris, died there 1934. Studied under J.-F. Bremond, then at the Ecole des Beaux-Arts under A. Cabanel. Was to a certain extent influenced by Impressionism. Most of his pictures are historical and mythological compositions; he also painted portraits.

BLANCHARD, LAURENT

Born 1762 in Valence, died 1819 in Paris. From 1791 to 1799 lived in Rome, later worked in Paris. Exhibited at the Salon from 1804. Painted pictures on religious and mythological themes, as well as portraits.

BLANCHE, JACQUES ÉMILE

Born 1861 in Paris, died 1942 at Offranville. Trained under H. Gervex, studied extensively the work of Whistler and Manet. Exhibited at the Salon de la Société Nationale des Beaux-Arts. Painted mainly portraits and genre scenes. Created a gallery of portraits of contemporary English and French cultural figures. Painted extensively pastels, made lithographs. Art critic and novelist. *142*

BOILLY, LOUIS LÉOPOLD

Born 1761 at La Bassée, died 1845 in Paris. Painter, miniaturist and lithographer. Pupil of his father, a woodcarver. From 1784 lived in Paris. From 1791 exhibited at the Salon. Painted genre scenes and portraits. *78, 79*

BONHEUR, ROSA

Born 1822 in Bordeaux, died 1899 in By (Seine-et-Marne). Studied under her father, the landscape painter R. Bonheur, then under L. Cogniet. Animal painter.

BONNARD, PIERRE

Born 1867 at Fontenay-aux-Roses (Seine), died 1947 at Le Cannet. A pupil of G. Boulanger and J. Lefèbvre at the Académie Julian. Took part in the "Nabi" movement together with Denis and Vuillard. Did drawings and posters, illustrated books

and designed stage scenery. A painter of mural decorations, portraits, still lifes, landscapes and interiors enlivened with figures. *215—218*

BONNAT, LÉON JOSEPH FLORENTIN

Born 1833 at Bayonne, died 1922 at Mouchy-Saint-Eloi (Oise). Received his first training in Madrid, later studied under L. Cogniet in Paris. From 1859 exhibited at the Salon. Painted historical and religious subjects and portraits. In 1870 made a trip to the Orient. *135*

BOUCHER, FRANÇOIS

Born 1703 in Paris, died there 1770. Painter and engraver. Studied painting under F. Lemoine and engraving under J.-F. Cars. From 1727 to 1731 lived in Italy where he was influenced by Castiglione and Tiepolo. On his return to France worked in Paris. From 1734 member of the Academy, from 1765 its director and the Court Painter. Worked in all genres of painting, made tapestry designs, and illustrated books. *45—49*

BOUDIN, EUGÈNE

Born 1824 at Honfleur, died 1898 at Deauville. Studied at the Ecole des Beaux-Arts in Paris. Was strongly influenced by the painters of the Barbizon School (Troyon and Millet), as well as by Corot and Jongkind. One of the outstanding landscape painters of the nineteenth century, he was a direct precursor of Impressionism. Painted landscapes on the shores of Normandy and Brittany. *145*

BOULLOGNE THE YOUNGER, LOUIS

Born 1654 in Paris, died there 1733. Pupil of his father, Louis Boullogne the Elder, he worked in Paris, at Versailles, Fontainebleau and Chantilly. From 1681 member of the Academy, from 1722 its director, from 1725 *Premier peintre du Roi*. Painted historical, mythological and religious scenes. Also known as the author of large-size decorative paintings. *11*

BOURDON, SÉBASTIEN

Born 1616 at Montpellier, died 1671 in Paris. Was trained in Paris under J. Barthélémy. From 1634 lived in Italy where he was influenced by Poussin and Caravaggio. In 1637 returned to France and worked in Paris, Bordeaux and Montpellier. One of the founder members of the Academy in 1648. Between 1652 and 1654 worked in Stockholm. Painted historical pictures, portraits and genre scenes. *12*

BOZE, JOSEPH

Born 1744 in Martigues (Provence), died 1826 in Paris. Pupil of M. Q. Latour. Worked in Paris. Portrait painter, also known as a pastel painter and miniaturist.

BRAQUE, GEORGES

Born 1882 at Argenteuil, died 1963 in Paris. Trained at the Ecole des Beaux-Arts at Le Havre and in 1902 at the Ecole des Beaux-Arts in Paris, in the class of Bonnat. In 1905—7 was one of the Fauves, in 1908 associated with Picasso and the Cubists. Painted landscapes and still lifes, illustrated books and executed stage designs. *267*

BRASCASSAT, JACQUES RAYMOND

Born 1804 in Bordeaux, died 1867 in Paris. Pupil of T. Richard, his foster father, and L. Hersent. Traveled through Italy from 1827 to 1835, sending his pictures painted there to the Salon. Member of the Academy from 1846. Landscapist and animal painter.

BRETON, JULES

Born 1827 in Courrières (Pas-de-Calais), died 1906 in Paris. Studied first under F. de Vigne, then under Wappers and M. Drölling. Was influenced by G. Courbet. Painted mostly scenes from peasant life.

BRUANDET, LAZARE

Born 1755 in Paris, died there 1804. Pupil of M. Roeser and F. Sarrazin. Worked in Paris and its environs. Landscape painter, also known as an engraver.

CABANEL, ALEXANDRE

Born 1823 at Montpellier, died 1889 in Paris. Pupil of F. Picot. Worked in Paris and in Italy (1845—50). From 1844 exhibited at the Salon. Took part in the decoration of the Panthéon in Paris. Painted historical compositions and portraits. *137*

CAROLUS-DURAN, ÉMILE AUGUSTE

Born 1838 in Lille, died 1917 in Paris. Studied at the Académie Suisse. Visited St Petersburg in 1876. Worked in Paris. Painted mostly portraits, historical and religious compositions.

CARRIÈRE, EUGÈNE

Born 1849 at Gournay, died 1906 in Paris. A pupil of Cabanel, he exhibited at the Salon from 1876. Painted genre pictures and portraits, for the most part of women and children. Was also active as a draughtsman. *211*

CARRIÈRE-BELLEUSE, PIERRE

Born 1851 in Paris, died there 1933. Studied under his father, A. E. Carrière-Belleuse, and A. Cabanel. Worked for the Sèvres porcelain factory. Painted in oils and pastels, mostly landscapes, genre scenes and portraits.

CAZIN, JEAN CHARLES

Born 1841 in Samer (Pas-de-Calais), died 1901 in Lavandou (Var). Studied drawing in Paris under Lecoq de Boisbaudran. Was influenced by J.-F. Millet. Painted genre scenes, landscapes, historical and religious compositions.

CÉZANNE, PAUL

Born 1839 at Aix-en-Provence, died there 1906. Attended the Collège Bourbon with Zola. In 1862 came to Paris and studied at the Académie Suisse. From 1872 to 1874 worked at Auvers and was influenced by the Impressionists, Pissarro in particular. Took part in several Impressionist exhibitions. In 1888—1900 worked at L'Estaque. Painted portraits, landscapes, figure compositions and still lifes. *174—184*

CHAPLIN, CHARLES

Born 1825 in Andelys, died 1891 in Paris. Studied under M. Drölling at the Ecole des Beaux-Arts from 1841. Painted portraits, landscapes, religious compositions and genre scenes. Later worked as a decorative painter. Also known for his drawings and lithographs.

CHARDIN, JEAN-BAPTISTE SIMÉON

Born 1699 in Paris, died there 1779. Pupil of the historical painter P. Cazes and N. Coypel. Worked in Paris. From 1728 member of the Academy. Painted still lifes and genre scenes. In his late years produced portraits in pastel. *51, 52*

CHARLET, NICOLAS TOUSSAINT

Born 1792 in Paris, died there 1845. Pupil of A. Gros. Worked in Paris. Painted battle scenes. Also known as an illustrator and lithographer.

CHARPENTIER, JEAN-BAPTISTE

Born 1728 in Paris, died there 1806. Worked in Paris. Was influenced by J.-B. Greuze. Painted portraits and genre scenes.

CHÉRON, ÉLISABETH SOPHIE

Born 1648 in Paris, died there 1711. Pupil of her father, A. Chéron. Worked in Paris. From 1672 member of the Academy. Painted portraits and pictures on religious subjects. Worked as a miniaturist and engraver. Author of the *Livre de principes à dessiner*, published in Paris in 1706. *29*

CORNEILLE DE LYON

Born between 1500 and 1510 in The Hague, died around 1575 in Lyons. In the early 1530s worked in Lyons. From 1564, *Peintre du Roi*. Painted portraits, was a master of the miniature portrait.

COROT, JEAN-BAPTISTE CAMILLE

Born 1796 in Paris, died there 1875. Painter and draughtsman. Pupil of E. Michallon and V. Bertin, the classicizing landscape painters. Worked in Paris and in Italy (1825—28, 1834 and 1843). Traveled widely in France, visited Switzerland, Holland and London. From 1827 exhibited at the Salon. Painted landscapes, portraits and one-figure compositions. *109—113*

CORTES, ÉDOUARD LÉON

Born at Lagny. Dates of birth and death unknown. Painted scenes of Paris life, landscapes and views of Brittany. Exhibited at different salons, including the Salon des Indépendants.

COTTET, CHARLES

Born 1863 in Le Puy, died 1925 in Paris. Studied under A. F. Roll at the Académie Julian. Worked in Brittany and from 1884 to 1888 in Holland. Visited Algiers in 1892 and Egypt in 1896. Painted mostly landscapes and scenes from the life of Breton fishermen. *143*

COURBET, GUSTAVE

Born 1819 at Ornans (Doubs), died 1877 at La Tour-de-Peilz, Switzerland. In 1840 settled in Paris. Made copies of old Spanish, Dutch and Flemish masters in The Louvre. Worked in Paris, at Ornans, in the south of France and in Normandy. From 1844 exhibited regularly at the Salon. In 1855 had a one-man exhibition and wrote for it a catalogue in which he expressed his views on realism in painting. Worked and exhibited in Germany (1853, 1858, 1869 and 1872) and in Belgium (1861). Active supporter of the Paris Commune. After its defeat went into exile to Switzerland (1873), where he died. Painted scenes from everyday life, portraits, landscapes and still lifes. *131—133*

COURTOIS, JACQUES
(called LE BOURGUIGNON)

Born 1621 in Saint-Hippolyte (Doubs), died 1676 in Rome. Painted battle scenes and religious compositions.

COUTURE, THOMAS

Born 1815 at Senlis (Oise), died 1879 at Villiers-le-Bel (Val-d'Oise). Pupil of Gros, later of Delaroche. From 1840 exhibited at the Salon. Master of historical compositions (*Romans of the Decadence*, 1847, in The Louvre). Painted genre scenes and portraits. Also worked as a mural painter (frescoes in the Saint-Eustache Cathedral in Paris). *139*

COUTURIER, LÉON PHILIBERT

Born 1823 in Chalon-sur-Saône, died 1901 in Saint-Quentin. Studied under C. Couturier and F. E. Picot. Worked in Paris and Saint-Quentin. Painted landscapes, animals and still lifes.

COYPEL, CHARLES ANTOINE

Born 1661 in Paris, died there 1722. Pupil of his father, N. Coypel. From 1680 Court Painter to the Duke of Orléans. Elected to the Academy in 1681; was a professor at the Academy from 1692 and its director from 1714. Painted religious and historical compositions, as well as portraits. Did decorative work and produced cartoons for the Gobelin factory.

COYPEL, NOËL

Born 1628 in Paris, died there 1707. Pupil of N. Quillerier. Worked in Paris. Member of the Academy from 1663. From 1672 director of the Académie de France in Rome, director of the Academy in Paris from 1695 to 1699. Painted pictures on biblical and mythological themes. Carried out several decorative projects in Versailles, the Tuileries, the Palais Royal and others.

CROSS, HENRI EDMOND

Born 1856 at Douai, died 1910 at Saint-Clair (Var). Trained first at the Academy in Lille; later, from 1876, under F. Bonvin in Paris. From 1881 exhibited at the Salon. Worked in Paris, Provence and Italy (1904—8). Was influenced by Seurat, Signac and Denis. Tended towards Neo-Impressionism. Painted almost exclusively landscapes. *207*

DAEL, JEAN FRANÇOIS VAN

Born 1764 in Antwerp, died 1840 in Paris. Studied at the Antwerp Academy. From 1766 worked in Paris. Did decorative work in the castles of Bellevue, Chantilly and Saint-Cloud. Painted flowers and fruits.

DAGNAN-BOUVERET, PASCAL ADOLPHE JEAN

Born 1852 in Paris, died 1929 at Quincey (Haute-Saône). Pupil of Gérôme. Author of genre pictures (mainly from the life of Breton fishermen) and portraits. *136*

DAUBIGNY, CHARLES FRANÇOIS

Born 1817 in Paris, died there 1878. Painter, lithographer, engraver and book illustrator. Pupil of his father, E. F. Daubigny, and of P. Delaroche. Subsequently was influenced by the Barbizon School. Worked mostly near Paris. From 1838 exhibited at the Salon. In 1835 went to Italy; visited England (1866—67), Spain (1868), and Holland (1869). Painted landscapes. *125—128*

DAVID, JACQUES LOUIS

Born 1748 in Paris, died 1825 in Brussels. Studied at the Academy under J. Vien. Worked in Paris, Rome (1775—80 and 1784—85) and Brussels (1816—25). From 1783 member of the Academy. An active participant in the French Revolution. In the years of the Consulate and of the Empire was Court Painter to Napoleon. From 1816, after the Bourbons returned to power, lived in exile in Belgium. Historical painter and portraitist. *81, 82*

DEBUCOURT, PHILIBERT LOUIS

Born 1755 in Paris, died there 1832. Painter, draughtsman and engraver. Pupil of J. Vien. Worked in Paris, exhibited at the Salons of 1783, 1785 and 1814. From 1785 concentrated on drawing with colored aquatint which he brought to perfection. After 1800 gave up engraving original works and turned to etchings of fashion pictures and of caricatures drawn by Carle Vernet. *72*

DECAMPS, ALEXANDRE GABRIEL

Born 1803 in Paris, died 1860 at Fontainebleau. Painter, lithographer and engraver. Worked in Paris. In 1827 began to exhibit at the Salon. In the same year undertook a trip to Asia Minor and Constantinople, which played an important role in his artistic development. Painted historical and genre pictures, pre-eminently on Oriental themes, as well as hunting scenes and landscapes. *101, 102*

DEDREUX, ALFRED

Born 1810 in Paris, died there 1860. Pupil of L. Cogniet. Exhibited at the Salon from 1831 and at the Royal Academy in London in 1850—51. Painted genre scenes and animals.

DE GALLARD, MICHEL

Born 1921 in Villefranche-de-l'Allier. Studied medicine; later turned to art. Paints views of Paris suburbs and the countryside.

DEGAS, EDGAR

Born 1834 in Paris, died there 1917. A pupil of Louis Lamothe. Spent several years in Italy; in 1857 returned to Paris and there began to work as a painter. At the outset of his artistic career painted portraits, but from the 1870s on turned for his subjects to ballet dancers, horse races and café-concerts. After 1890, at the end of his life, worked in pastel and began to sculpt. *169—172*

DELACROIX, EUGÈNE

Born 1798 at Charenton-le-Pont (Saint-Maurice), died 1863 in Paris. Painter and lithographer. Pupil of P. N. Guérin. Worked in Paris. In 1825 visited England, in 1832 North Africa and Spain. From 1822 to 1859 exhibited at the Salon. From 1857 member of the French Institute. Worked in all genres of painting. His principal decorations are murals of the Paris Town Hall, the ceilings of the Salle d'Apollon in The Louvre and in the Luxembourg Palace, as well as works in the Libraries of the Chamber of Deputies and the Senate. *99*

DELAROCHE, PAUL (HIPPOLYTE)

Born 1797 in Paris, died there 1856. Pupil of L. Watelet and A. J. Gros. Worked in Paris and Nice. From 1819 exhibited at the Salon. In 1834—35 and 1843 lived in Italy. From 1832 member of the French Institute. Portraitist and costume-history painter. *107, 108*

DE MACHY, PIERRE ANTOINE

Born 1723 in Paris, died there 1807. Studied under J. Servandoni. Was influenced by H. Robert. Worked in Paris. From 1753 member of the Academy, from 1786 Professor of Perspective. Painted almost exclusively architectural views. *73*

DE MARNE, JEAN-LOUIS

Born 1752 at Brussels, died 1829 in Paris. From 1765 lived in Paris. Studied under G. Briard. Was influenced by Dujardin and Berchem, Dutch animal painters. Painted landscapes, animals and scenes of rural life. *89*

DENIS, MAURICE

Born 1870 at Granville (Manche), died 1943 at Saint-Germain-en-Laye. From 1888 was trained at the Académie Julian under J. Lefèbvre and later at the Ecole des Beaux-Arts in Paris. In 1897—98 worked in Florence; in 1898—1904 in Rome. From 1890 took part in exhibitions. Elaborated "Nabi" theories. Painted pictures on religious and mythological subjects. Produced a large number of mural decorations and lithographs. A prolific writer on art. Experimented with carpet designs, painted cartoons for stained-glass and mosaic panels, and ornamented ceramics. *219, 220*

DERAIN, ANDRÉ

Born 1880 at Chatou, died 1954 at Garches. Studied at the Académie Carrière; in 1901—2 worked with Vlaminck at Chatou (the so-called Chatou School) and in 1905 with Matisse at Collioure. Exhibited at the Salon des Indépendants and at the Salon d'Automne, together with the Fauves whose views he shared at that time (1905—6). From 1907 to 1914 was attracted by Cubism. Was influenced by French Gothic art. Painted landscapes, portraits, still lifes and figure compositions. Designed stage sets, illustrated numerous books, worked as ceramist and sculptor. *269—274*

D'ESPAGNAT, GEORGES

Born 1870 at Melun, died 1950 in Paris. Trained at the Ecole des Arts Décoratifs and the Ecole des Beaux-Arts in Paris. From 1892 took part in exhibitions. Visited Spain, Portugal, Morocco, England, Holland and Germany. Was influenced by the Neo-Impressionists and Bonnard. Painted pictures and murals. *206*

DESPORTES, FRANÇOIS

Born 1661 at Champigneulles, died 1743 in Paris. Studied in Paris under the Flemish animal painter Nicassius. Worked in Paris. Visited Poland (1695—96) and London (1712). Painted hunting scenes, still lifes and portraits. Made cartoons for the Gobelin factory. *40*

DETHOMAS, MAXIME

Born 1869 in Garges-lès-Gonesse, died 1929 in Paris. Studied at the Ecole des Arts Décoratifs in Paris, then under E. Carrière. Painted scenes from everyday life and worked in the fields of monumental and decorative painting. Also known for his drawings. Was influenced by Toulouse-Lautrec.

DIAZ DE LA PEÑA, NARCISSE VIRGILE

Born 1807 at Bordeaux, died 1876 at Menton. Painter and lithographer. Pupil of F. Souchon and X. Sigalon. Was strongly influenced by Correggio, Prud'hon and Delacroix. Worked in Paris and in its suburbs. From 1831 to 1859 exhibited at the Salon. One of the leading figures of the Barbizon School. At the outset of his career painted scenes with mythological or Oriental characters on a landscape background. *118—121*

DRÖLLING, MARTIN

Born 1752 in Oberbergheim near Kolmar, died 1817 in Paris. Worked in Paris from the 1770s. Exhibited at the Salon from 1793. Painted genre scenes and portraits.

DROUAIS THE ELDER, HUBERT

Born 1699 in La Roeque (Normandy), died 1767 in Paris. Moved to Paris around 1717 where he studied under F. de Troy. Worked in Paris. Member of the Academy from 1730. Exhibited at the Salon from 1737. Painted portraits and miniatures.

DROUAIS THE YOUNGER, FRANÇOIS HUBERT

Born 1727 in Paris, died there 1775. Studied under his father Hubert Drouais, attended the studios of Carle Vanloo, Natoire and Boucher. In 1755 first exhibited at the Salon. From 1758 member of the Academy. Portrait painter. *64*

DUFRENOY, GEORGES

Born 1870 at Thiais, died 1944 in Paris. Received his artistic training at the Académie Julian and in the studio of decorative painting of D. Laugée. From 1904 exhibited at the Salon des Indépendants and the Salon d'Automne. Painted views of Paris, Venice and Brussels in an Impressionistic vein. In 1912 executed murals in the chapel of St Pancras and in the Château des Pradines. Illustrated Flaubert. *208*

DUFY, RAOUL

Born 1877 at Le Havre, died 1953 at Forcalquier. From 1892 attended Lhuillier's drawing classes at the Ecole Municipale des Beaux-Arts at Le Havre. In 1900 moved to Paris and there enrolled in Bonnat's class at the Ecole des Beaux-Arts. Visited Spain, Morocco, the USA, England and Germany. Executed landscapes, genre scenes and portraits. Painted interiors and produced stage décors. Illustrated books and created designs for textiles and ceramics. *280*

DUGHET, GASPARD
(called GASPARD POUSSIN)

Born 1615 in Rome, died there 1675. Pupil of Poussin. Worked mostly in Rome, and also at Perugia, Florence and Naples. Landscape painter. *10*

DUMONT, JACQUES
(called DUMONT THE ROMAN)

Born 1701 in Paris, died there 1781. Studied under the landscape painter L. Lebel. Worked in Paris and in Italy. From 1728 member of the Academy, from 1763 its director. Exhibited at the Salon from 1737 to 1761. Painted religious, historical and allegorical pictures and genre scenes. *62*

DUPLESSIS, JOSEPH SIFFRED

Born 1725 at Carpentras, died 1802 at Versailles. From 1745 to 1749 studied under P. Subleyras in Rome. Worked in Paris and at Versailles. Painted portraits. *70*

DUPLESSIS, MICHEL

Born in Versailles. Dates of birth and death unknown. Pupil of a Rouen painter, J.-B. Descamps. Exhibited at the Salon between 1791 and 1799. Painted landscapes.

DUPRÉ, JULES

Born 1811 at Nantes, died 1889 at Isle-Adam (Val-d'Oise). Painter and lithographer. Came to Paris in the late 1820s. Copied landscapes by the Old Masters in The Louvre. In the early 1830s visited England where he was influenced by Con-

stable. In 1831 began to exhibit at the Salon. Worked in various provinces of France. Like Th. Rousseau, was one of the main figures of the Barbizon School. *116, 117*

DUPRESSOIR, FRANÇOIS JOSEPH

Born 1800 in Paris, died there 1859. Did decorative painting on porcelain. In the 1830s turned to watercolor and oil painting. Landscape painter, also known as a lithographer.

FALCONET, PIERRE-ÉTIENNE

Born 1741 in Paris, died there 1791. Son of the sculptor E. M. Falconet. From 1773 lived in England where he studied under J. Reynolds. In 1773—77 was in St Petersburg with his father. Painted mostly portraits.

FANTIN-LATOUR, HENRI

Born 1836 in Grenoble, died 1904 in Buré. Studied under his father, T. Fantin-Latour, then under Lecoq de Boisbaudran and G. Courbet. Worked in Paris, visited England several times. Painted pictures on allegorical and fantastic themes, as well as still lifes and portraits.

FAVANNE, HENRI ANTOINE

Born 1668 in London, died 1752 in Paris. Moved to Paris in 1687. Studied under R. Houasse. From 1693 to 1700 worked in Italy, from 1704 to 1714 in Spain. In 1717 did the decorative painting of St Paul's Cathedral in London. Subsequently worked in Paris and Versailles. From 1748 rector of the Academy. Painted pictures on biblical and mythological subjects.

FORAIN, JEAN-LOUIS

Born 1852 at Rheims, died 1931 in Paris. A pupil of Gérôme at the Ecole des Beaux-Arts in Paris. Was influenced by Manet and Degas. Took part in several Impressionist exhibitions. Painted scenes of contemporary daily life. Worked as a draughtsman and lithographer. *173*

FOUGERON, ANDRÉ

Born 1913 in Paris. A metal-worker by profession, he studied painting on his own. In 1938 executed the fresco *Circus* for the students' sanatorium at Saint-Hilaire-du-Touvet. In 1939 joined the French Communist Party. In 1940, after escaping from the prisoners' camp, took an active part in the French Resistance movement. In 1942 was elected Secretary-General of the National Front of the Arts. In 1944 contributed to the publication an album of lithographs, *To Win*, and was a co-founder of the Salon de la Libération. From 1946 to 1950 was Secretary-General of the Union of Plastic Arts. Traveled widely and had exhibitions in European countries. *281*

FRAGONARD, JEAN HONORÉ

Born 1732 at Grasse, died 1806 in Paris. Pupil of Chardin, Boucher and C. Vanloo. During 1756—61 worked at the French Academy in Rome. In 1765 first exhibited at the Salon. In 1773—74 visited Italy for the second time. From 1793 was Keeper of the Museum of Arts (The Louvre). Painted genre scenes, *fêtes galantes*, pictures on mythological subjects, landscapes and portraits. *65, 66*

FRANQUE, JOSEPH

Born 1774 in Buis-les-Baronnies (Drôme), died 1833 in Paris. Pupil of L. David. Worked in Paris. Painted altarpieces, battle and historical scenes, as well as portraits. Also known as a lithographer.

FRIESZ, ÉMILE OTHON

Born 1879 at Le Havre, died 1949 in Paris. Trained under Ch. Lhuillier at Le Havre, then under L. Bonnat at the Ecole des Beaux-Arts in Paris. In 1904, stimulated by the work of Matisse, joined up with the Fauves. Was influenced by the Impressionists and Cézanne. In 1908 visited Antwerp with Braque; in 1909 Munich with Dufy. Made trips to Italy and Portugal. Exhibited at the Salon des Indépendants (1903) and the Salon d'Automne (from 1904). One of the founders of the Salon des Tuileries. Easel and mural painter, illustrator and ceramist. *246*

FROMENTIN, EUGENE

Born 1820 at La Rochelle, died 1876 at Saint-Maurice. Trained under Rémond and L. Cabat. Worked in Paris and Algeria (which he visited more than once after 1846). From 1847 exhibited at the Salon. A friend of G. Moreau and George Sand. After a trip to Holland and Belgium in 1875 wrote *Les Maîtres d'autrefois*. Painter, art critic and writer. *134*

GAUGUIN, PAUL

Born 1848 in Paris, died 1903 on the island of Dominique in the Marquesas Archipelago. From 1865 to 1871 served in the merchant marine, then was a clerk to a stockbroker. Began to paint and bought pictures by the Impressionists, whom he knew through Pissarro. Exhibited at the Salon in 1876. In January 1883 decided to paint "every day" and abandoned his post and family life. In 1886 was in Brittany, at Pont-Aven, where he formulated his Pont-Aven program. In 1887 spent some time in Martinique; on his return to Paris in 1888 met Van Gogh with whom he worked for a while at Arles. In 1891, charged with a mission, left for Tahiti. Returning to Paris in 1893, exhibited his Tahitian pictures without success and went back to Tahiti, where he produced the major part of his works, then to the island of Dominique (Iva-Hoa). In 1897 illustrated with his woodcuts his diary *Noa Noa*, and later his *Cahier pour Aline* and *Avant et après*. Contributed articles to *Les Guêpes* and *Le Sourire*, and published the latter periodical on the island of Dominique. Painted landscapes, still lifes, portraits and scenes of Tahitian life. Was also active as a sculptor, draughtsman and ceramist. *192—202*

GÉRARD, FRANÇOIS

Born 1770 in Rome, died 1837 in Paris. Painter and draughtsman. Pupil of David. From 1795 exhibited at the Salon. Worked in Paris. Painted pictures on historical subjects and portraits, illustrated books. *93*

GÉRARD, MARGUERITE

Born 1761 at Grasse, died 1837 in Paris. Genre painter, miniaturist and book illustrator. Pupil of Fragonard. Worked in Paris. From 1799 to 1824 exhibited at the Salon. *86*

GÉRICAULT, THÉODORE

Born 1791 at Rouen, died 1824 in Paris. Painter, draughtsman, sculptor and lithographer. Pupil of C. Vernet and P. N. Guérin. Worked in Paris. From 1812 exhibited at the Salon. In 1816—17 visited Italy, in 1820 England. *98*

GÉRÔME, JEAN-LÉON

Born 1824 at Vesoul, died 1904 in Paris. Trained under P. Delaroche and Ch. Gleyre. From 1841 worked in Paris, in 1847 first exhibited at the Salon. In 1855 visited Russia. Traveled in Italy, Turkey and Egypt. Painted pictures on historical subjects, genre scenes and landscapes. During the last years of his life tried his hand at sculpture. *138*

GORP, HENRI NICOLAS VAN

Born 1756 in Paris. Date of death unknown. Pupil of L. Boilly. Worked in Paris. Exhibited at the Salon from 1793 to 1819. Painted portraits and genre scenes.

GRANET, FRANÇOIS MARIUS

Born 1775 at Aix, died there 1849. Studied under J. S. Constantin and David. Worked in Paris and in Italy (from 1802 to 1819 and from 1822 to 1825). From 1799 to 1847 exhibited at the Salon. In 1826 became Keeper of The Louvre, from 1830 to 1848 was Keeper of the picture gallery at Versailles. Painted pictures on historical subjects, landscapes and church interiors. *97*

GREUZE, JEAN-BAPTISTE

Born 1725 at Tournus, died 1805 in Paris. Pupil of the Lyonese painter Ch. Grandon. From 1750 worked in Paris. In 1755—56

visited Francastel in Italy. In 1767 was elected to the Academy. Painted genre scenes and portraits. *67—69*

GRIMOU, ALEXIS

Born 1678 in Argenteuil, died 1733 in Paris. Worked in Paris. Painted portraits and genre scenes.

GROS, ANTOINE JEAN

Born 1771 in Paris, died 1835 at Meudon. Pupil of David. From 1793 to 1801 lived in Italy. Worked in Paris. Painted historical and battle scenes, and portraits. *91*

GUDIN, THÉODORE

Born 1802 in Paris, died 1880 in Boulogne (Hauts-de-Seine), studied under A. L. Girodet-Trioson. Lived in Algeria from 1830 to 1839. Visited London several times. In 1841 worked in Warsaw and St Petersburg. Exhibited at the Salon from 1822, later at the Royal Academy in London. Landscape painter, also known as a lithographer and engraver.

GUÉRIN, CHARLES

Born 1875 at Sens, died 1939 in Paris. A pupil of Moreau at the Ecole des Beaux-Arts in Paris. Was influenced by Monticelli, the Impressionists and Cézanne. Later tended to Fauvism. Was active as a painter, lithographer and stage designer. Painted religious subjects, genre scenes and landscapes. *209*

GUÉRIN, PIERRE NARCISSE

Born 1774 in Paris, died 1833 in Rome. A pupil of N. J. Brenet and J.-B. Regnault. Was strongly influenced by David. In 1800—2 lived in Italy as a holder of the *Prix de Rome*. From 1822 to 1828 director of the French Academy in Rome. Painted pictures on historical and mythological subjects. *95, 96*

GUILLAUMET, GUSTAVE

Born 1840 in Paris, died there 1887. Studied at the Ecole des Beaux-Arts under F. E. Picot. Painted Algerian and Sahara landscapes and genre compositions.

GUILLAUMIN, ARMAND

Born 1841 in Paris, died there 1927. Studied privately under various artists, then in 1864 entered the Académie Suisse, where he met Cézanne and Pissaro. Was influenced by the Impressionists and the Fauvists. His output consists mainly of views of the banks of the Seine, Oise and Creuse as well as marine studies and etchings. *163*

GUILLOT, DONAT

Dates of birth and death unknown. First exhibited at the Salon in 1868. Landscape and animal painter.

HARPIGNIES, HENRI

Born 1819 in Valenciennes, died 1916 in Saint-Privé. Pupil of J. Achard. Was influenced by C. Corot. Worked in France and in various French provinces. Exhibited at the Salon from 1852. Landscape painter, also known as a lithographer.

HELLEU, PAUL

Born 1859 at Vannes, died 1927 in Paris. Trained under Gérôme at the Ecole des Beaux-Arts in Paris. In the early period of his career was influenced by Manet and by the Impressionists. Was a famous portraitist of the *beau monde* in Paris and London. Painted the ceiling of one of the railway stations in New York. Draughtsman and writer. *162*

HENNER, JEAN-JACQUES

Born 1829 in Bernwiller, died 1905 in Paris. From 1844 studied at Ch. Guérin's school of drawing in Strasbourg, then in Paris under M. Drölling and from 1847 at the Ecole des Beaux-Arts under F. E. Picot. Lived in Italy for six years from 1858. Painted mostly female nudes against landscape backgrounds and pictures on religious themes.

HERSENT, LOUIS

Born 1777 in Paris, died there 1860. Pupil of J.-B. Regnault. Worked in Paris. Member of the French Institute from 1822, from 1825 professor at the Ecole des Beaux-Arts. Painted portraits and pictures on historical and literary subjects.

HILAIR, JEAN-BAPTISTE

Born 1751 in Audun-le-Tiche (Moselle), died after 1822. Pupil of J.-B. Le Prince. Worked in Paris. In 1776 made a trip to the Levant, visited the Archipelago and Constantinople. Painted landscapes and genre scenes.

HUET, JEAN-BAPTISTE MARIE

Born 1745 in Paris, died there 1811. Studied under F. Boucher and Ch. Dagomer. Worked in Paris. Animal painter, also known as an engraver.

INGRES, JEAN AUGUSTE DOMINIQUE

Born 1780 at Montauban, died 1867 in Paris. Studied at the Toulouse Academy under G. Roques and J. Briand; from 1797 in Paris under David. Worked in Paris, Rome and Florence. From 1825 member of the French Institute; from 1834 to 1841 director of the French Academy in Rome. Painted portraits and pictures on historical, literary and religious subjects. *100*

ISABEY, JEAN-BAPTISTE

Born 1767 at Nancy, died 1855 in Paris. Pupil of David and the miniaturist painter F. Dumont. Worked in Paris. From 1805 was Court Painter to Empress Josephine. *88*

ISABEY, EUGÈNE LOUIS GABRIEL

Born 1803 in Paris, died 1886 at Lagny (Seine-et-Marne). Painter and lithographer. Was trained by his father, the miniaturist J.-B. Isabey. Worked in Paris. From 1824 to 1878 exhibited at the Salon. In 1830 visited Algeria; made several trips to England. Painted landscapes, seascapes and genre scenes. *103—105*

JACQUES, CHARLES ÉMILE

Born 1813 in Paris, died there 1894. Self-taught artist; began as a lithographer. First exhibited his etchings at the Salon in 1845, his oil paintings in 1848. Joined the artists of the Barbizon School. Worked in Paris and in the environs of Fontainebleau. Landscape and animal painter.

JEAURAT, ÉTIENNE

Born 1699 in Paris, died 1789 in Versailles. Pupil of N. Vleughels. Member of the Academy from 1733. Painted pictures on biblical, mythological and genre themes; was also known as an engraver.

JOURDAIN, FRANCIS

Born 1876 in Paris, died there 1958. Studied at the Ecole des Beaux-Arts; pupil of E. Carrière and A. Besnard. Landscape painter; also known as a decorator and stage designer. Produced color lithographs.

LABILLE-GUIARD, ADELAÏDE

Born 1749 in Paris, died there 1803. Studied under the miniaturist F. Vincent, the pastel painter M. Q. Latour and the painter F. A. Vincent whom she subsequently married. Worked in Paris. Member of the Academy from 1783. From 1785 Court Painter to the daughters of Louis XV. Exhibited at the Salon from 1783 to 1800. Painted portraits.

LACROIX (DELACROIX), called LACROIX DE MARSEILLE, CHARLES FRANÇOIS

Born 1700 in Marseilles, died 1782 in Berlin. Studied under J. Vernet. Worked in Rome. Seascape painter.

LAFOSSE, CHARLES DE

Born 1636 in Paris, died there 1716. Studied under Ch. Le Brun, was strongly influenced by Rubens. Worked in Paris, in Italy (1658—63) and in London (1689—91). From 1673 member of the Academy. Painted pictures on religious and mythological subjects. *25, 26*

LAGRENÉE, FRANÇOIS (ANTHELME)

Born 1774 in Paris, died there 1832. Studied under A. Vincent. Worked in Paris. Visited Russia in the 1820s. Exhibited at the Salon between 1799 and 1831. Painted portraits and miniatures.

LA HYRE, LAURENT DE

Born 1606 in Paris, died there 1656. Studied under his father, E. de La Hyre, and J. Lallemand. Worked in Paris, Saint-Denis and Rouen. Painted pictures on mythological and religious subjects. Executed a series of cartoons for the Gobelin factory. Also known as an engraver.

LA JOUE, JACQUES DE

Born 1686/7 in Paris, died there 1761. Painter, draughtsman and ornamentalist. Worked in Paris. Painted landscapes, hunting scenes, interiors, architectural motifs, etc. *37*

LANCRET, NICOLAS

Born 1690 in Paris, died there 1743. A pupil of P. Dublin and Cl. Gillot, he was strongly influenced by Watteau. Worked in Paris. Member of the Academy from 1719, he painted portraits, pastoral scenes, *fêtes galantes*, and illustrated books by French writers. *34—36*

LARGILLIÈRE, NICOLAS DE

Born 1656 in Paris, died there 1746. Studied under A. Goebouw in Antwerp. During 1674—78 worked in London, later in Paris. From 1686 member of the Academy, from 1728 to 1732 its director. Portrait painter. *23*

LAURENCIN, MARIE

Born 1885 in Paris, died there 1956. Studied drawing at a private academy. At first was influenced by Toulouse-Lautrec and Manet, then joined up with the Fauves and the Cubists. Painted female portraits, flowerpieces and animal scenes. Made stage décors, fabric and dress designs and tapestry cartoons. From 1906 exhibited at the Salon des Indépendants and the Salon d'Automne. *252*

LEBASQUES, HENRI

Born 1865 at Champigné, died 1937. Studied at the Ecole des Beaux-Arts in Angers, from 1886 under L. Bonnat in Paris. Visited England, Spain and Italy. Painted landscapes and compositions in the Impressionist manner.

LEBOURG, ALBERT MARIE

Born 1849 at Monfort-sur-Risle, died 1928 in Rouen. Studied architecture and painting at the Ecole des Beaux-Arts in Rouen. In 1872—75 taught at the Ecole des Beaux-Arts in Algiers. Took part in several exhibitions of the Impressionists. Best known as a landscape painter.

LE BRUN, CHARLES

Born 1619 in Paris, died there 1690. Studied under F. Perrier and S. Vouet. Worked in Italy from 1642 to 1646 and in Paris. In 1648 was one of the founders of the Academy. In 1662 became *Premier peintre du Roi*, in 1668 director of the Gobelin factory. Painted pictures on religious, historical and mythological subjects as well as portraits. Decorated the Galerie des Glaces and other rooms at Versailles. *15, 16*

LEDOUX, JEANNE PHILIBERTE

Born 1767 in Paris, died there 1840. Studied under J.-B. Greuze. Worked in Paris. Exhibited at the Salon from 1793 to 1819.

LEFÈVRE, ROBERT

Born 1755 in Bayeux, died 1830 in Paris. Self-taught artist. From 1784 studied under Regnault in Paris. Worked in Paris. First exhibited at the Salon in 1791, regularly from 1795 to 1827. Painted portraits.

LÉGER, FERNAND

Born 1881 at Argentan, died 1955 at Gif-sur-Yvette. In 1901 entered the Ecole des Beaux-Arts in Paris. Was influenced by Cézanne and Henri Rousseau. From 1910 was attracted by Cubism, later became one of the founders of Futurism in painting. Produced pictures on leisure, labor and sporting themes. Worked extensively as a mural painter, draughtsman, ceramist and applied artist. Designed stage sets and decorations for public holidays. Visited Greece and the USA. *277—279*

LEGRAND, LOUIS

Born 1863 at Dijon, died 1951 near Paris. Studied in Dijon, was influenced by F. Rops. Painted daily life and genre scenes, made lithographs. *191*

LEHMANN, LÉON

Born 1873 at Altkirch, died there 1953. Studied under G. Moreau at the Ecole des Beaux-Arts in Paris. Painted landscapes, still lifes, interior scenes and portraits.

LEMOINE, FRANÇOIS

Born 1688 in Paris, died there 1737. Studied under L. Galloche, was influenced by Correggio and the Venetian masters of the early eighteenth century S. Ricci and A. Pellegrini. Worked in Paris. In 1723—24 visited Italy. From 1718 member of the Academy. Painted almost exclusively mythological, religious and allegorical scenes; did many decorations at Versailles. *50*

LÉPICIÉ, NICOLAS BERNARD

Born 1735 in Paris, died there 1784. Studied under his father, the engraver B. Lépicié, and C. Vanloo. Was influenced by Chardin. Worked in Paris. Member of the Academy from 1761. Painted genre scenes and pictures on religious and mythological subjects.

LE PRINCE, JEAN-BAPTISTE

Born 1733 in Metz, died 1781 in Saint-Denis-du-Port. Pupil of F. Boucher and J. M. Vien. Worked in Paris and from 1757 to 1763 in Russia. Member of the Academy from 1766. Painted genre scenes, landscapes, portraits and decorative panels; also known for his drawings and engravings.

LESUEUR, BLAISE

Born 1716 in Paris, died 1783 in Berlin. Studied under J.-B. Vanloo. Worked in Paris, from 1748 in Berlin.

LESUEUR, EUSTACHE

Born 1617 in Paris, died there 1655. Studied under S. Vouet. Was influenced by N. Poussin. Worked in Paris. Member of the Academy from 1648. Painted pictures on religious and mythological themes.

LHERMITTE, LÉON

Born 1844 at Mont-Saint-Pierre, died there 1925. Trained under Lecoq de Boisbaudran. Worked mainly in Paris. Painted genre scenes of peasant life and landscapes. One of the founders of the Société Nationale des Beaux-Arts. *141*

LHOTE, ANDRÉ

Born 1885 in Bordeaux, died 1962 in Paris. Trained at the Ecole des Beaux-Arts in Bordeaux. First studied sculpture, then painting. From 1908 lived in Paris. Was influenced by Cézanne and associated with the Cubists. Painted for the most part landscapes. Illustrated Claudel and Cocteau. Published a number of books on the theory of art, among them *Traité du paysage*, *Corot* and *Seurat*. Taught at various Paris academies. Visited Holland, Sweden, Belgium, Spain, Hungary and Morocco. *268*

LOBRE, MAURICE

Born 1862 in Bordeaux, died 1951 in Paris. Studied under J.-L. Gérôme and E. A. Carolus-Duran. Painted Versailles palace interiors, portraits and scenes from everyday life.

LOIR, LUIGI

Born 1845 in Goritz (Austria), died 1916 in Paris. Studied at the Parma Academy in 1853. Since 1863 lived in Paris. Landscape painter, stage designer, book illustrator, graphic artist and engraver.

LONGUET, FRÉDÉRIC

Born 1904 in Paris. Was a painter, watercolorist and graphic artist. Was influenced by A. Marquet. Painted views of port cities on the Seine and the Marne.

LORRAIN, CLAUDE (CLAUDE GELLÉE)

Born 1600 at Chamagne (Lorraine), died 1682 in Rome. Painter, draughtsman and engraver. As a young boy went to live in Italy and there was trained under A. Tassi. Was influenced by P. Bril and A. Elsheimer. Worked in Rome. Painted a great number of landscapes. *7—9*

LOUTHERBOURG (or LUTHERBOURG) THE YOUNGER, PHILIPPE JACOB

Born 1740 in Strasbourg, died 1812 in England. Studied under his father, Ph. J. Loutherbourg the Elder, C. Vanloo and Fr. J. Casanova. Worked in France, after 1771 in England. Member of the Paris Academy from 1767, of the Royal Academy in London from 1781. Painted landscapes, seascapes and battle scenes.

LURÇAT, JEAN

Born 1892 at Bruyères (Vosges), died 1966 at Saint-Paul-de-Vence. Studied under V. Prouvet at Nancy. Around 1912 settled in Paris. In 1914 collaborated with J.-R. Bloch, A. Lunacharsky, Ch. Vildrac and E. Faure in *Les Feuilles de Mai*, a review published in Switzerland. During World War I served at the front, was involved in anti-war propaganda activities and was consequently arrested in 1915. Was influenced by Cézanne. A Cubist at the start, he later was classed among the artists more or less related to Surrealism. Worked as a mural painter (frescoes of the Ecole Municipale at Villejuif), book illustrator and draughtsman (series of gouaches *The Peasant War*). From 1915 until the end of his life executed cartoons for gobelins and thus contributed to the revival of this traditional French art (cycle of tapestries *The Song of the Universe*). During World War II took part in the Resistance movement. In 1944 joined the French Communist Party. Was a member of the clandestine society *New Russia*. An exhibition of his works was held in Moscow in 1934. *275*

MANET, ÉDOUARD

Born 1832 in Paris, died there 1883. From 1842 to 1848 studied at the Collège Rollin, in 1849 made a trip to Rio de Janeiro, from 1849 to 1856 attended the Atelier Couture in Paris. In 1856 visited Holland, Austria, Germany and Italy. Played an important part in the organization of the Salon des Refusés in 1863, where he exhibited six works, including *Le Déjeuner sur l'herbe*. Exercised a great influence on the development of French Impressionism. *147, 148*

MANGUIN, HENRI CHARLES

Born 1874 in Paris, died 1943 in Saint-Tropez. Studied at the Ecole des Beaux-Arts from 1894 under G. Moreau. Painted still lifes and landscapes with female figures.

MARILHAT, PROSPER GEORGES ANTOINE

Born 1811 in Vertaizon (Puy-de-Dôme), died 1847. Worked in Paris. Exhibited at the Salon from 1831 to 1844. In 1832—33 traveled in Syria, Palestine and Egypt. Painted landscapes.

MARQUET, ALBERT

Born 1875 at Bordeaux, died 1947 in Paris. In 1890 came to Paris to study at the Ecole des Arts Décoratifs from 1897; was in Moreau's class at the Ecole des Beaux-Arts. Exhibited at the Salon des Indépendants and the Salon d'Automne. For some time associated with the Fauves. Worked and lived in Paris. Visited England, Germany, Spain, Italy, Rumania, Norway, Holland, Egypt, Morocco, Algeria and the Soviet Union (1934). Painted almost exclusively townscapes and views of sea and river ports. Produced drawings, watercolors and book illustrations. Designed ceramics. *241—245*

MARTIN, JEAN-BAPTISTE

Born 1659 in Paris, died there 1735. Pupil of J. Parrocel and Van der Meulen. Worked in Paris. Director of the Gobelin factory from 1690. Painted battle scenes.

MATISSE, HENRI

Born 1869 at Le Cateau (Nord), died 1954 at Nice. Trained under Bouguereau at the Académie Julian (1892), later studied at the Ecole des Arts Décoratifs, then at the Ecole des Beaux-Arts, in the class of Gustave Moreau (until 1898). Also studied at the Académie Carrière. First exhibited at the Salon de la Société Nationale des Beaux-Arts in 1895, at the Salon des Indépendants from 1901, and at the Salon d'Automne from 1903. Headed for some time the Fauve group. Visited London, Corsica, Spain, Morocco and Tahiti. In 1911 visited Russia. Settled at Nice in 1918. Painted still lifes, portraits, landscapes, figure compositions and interior scenes. Was active as a stage designer, draughtsman, book illustrator; made cartoons for tapestries and produced large decorative panels. His last major work was the design and decoration of the Chapel of Dominican nuns (Chapelle du Rosaire) at Vence. Executed decorative compositions out of colored paper cut-outs. *224—240*

MAYER LA MARTINIÈRE, MARIE-FRANÇOISE CONSTANCE

Born 1775 in Paris, died there 1821. Was influenced by J.-B. Greuze. From 1802 pupil and associate of P. P. Prud'hon. Painted pictures on religious, mythological and allegorical themes. Also worked in the pastel and miniature techniques.

MEISSONNIER, JEAN-LOUIS ERNEST

Born 1815 in Lyons, died 1891 in Paris. Studied under L. Cogniet. Worked in Paris. Exhibited at the Salon from 1834. Visited Italy in 1835 and 1859. Member of the French Institute from 1861. Was a draughtsman, lithographer and book illustrator. Painted historical and battle scenes as well as small genre scenes with figures in 17th and 18th century dress.

MENARD, MARIE AUGUSTE ÉMILE RENÉ

Born 1862 in Paris, died there 1930. Studied under A. W. Bouguereau and P. Baudry, as well as at the Académie Julian. Was influenced by J. Bastien-Lepage. Painted mostly landscapes, sometimes with mythological figures.

MEULEN, ADAM FRANS VAN DER

Born 1632 at Brussels, died 1690 in Paris. Studied under P. Snyers in Brussels. Worked in Paris. From 1664 was Court Painter to Louis XIV. Painted almost exclusively battle scenes. *19*

MICHELIN, JEAN

Born c. 1623 in Langres, died 1696 on the island of Jersey. Worked in Paris and provincial towns. Painted street scenes, emulating the Le Nain brothers.

MIGNARD, PIERRE

Born 1612 at Troyes, died 1695 in Paris. From 1628 lived in Paris where he was a pupil of S. Vouet. Worked in Paris and in Rome (1636—57). Director of the Academy of St Luke in Paris. From 1690 director of the Academy and *Premier peintre du Roi*. Designed a number of interiors at Versailles, Saint-Cloud and in Paris. Painted pictures on religious and historical subjects and portraits. *24*

MILLET, JEAN-FRANÇOIS (called FRANCISQUE)

Born 1642 at Antwerp, died 1679 in Paris. Landscape painter and engraver. Studied under L. Francken and A. Guenuls. From 1659 worked in Paris. *20*

MILLET, JEAN-FRANÇOIS

Born 1814 at Gréville (Manche), died 1875 at Barbizon. Painter, draughtsman and engraver. In 1837 settled in Paris, where he studied under P. Delaroche. From 1840 exhibited at the Salon. Worked in Cherbourg, Le Havre and Paris. In 1849 moved to Barbizon and remained there for the rest of his life. Associated with the landscape painters of the Barbizon group. Painted scenes of peasant life, landscapes and portraits. *129, 130*

MITOIRE, BENOIS CHARLES

Dates of birth and death unknown. Worked in Russia in the first half of the 19th century. From 1813 member of the Academy of Arts in St Petersburg. Portrait painter.

MONET, CLAUDE

Born 1840 in Paris, died 1926 at Giverny. Spent his childhood at Le Havre, painted caricature portraits. From 1859 attended the Ecole des Beaux-Arts in Paris, then entered the Atelier Gleyre. From 1865 exhibited at the Salon, headed the Impressionist group in Paris and took part in its exhibitions of 1874, 1876, 1877, 1879 and 1882. Worked at Argenteuil (from 1874), at Giverny (from 1883 and later), in Normandy and Brittany; visited England (1871 and 1901—3) and Norway (1895). In addition to landscapes, painted portraits and still lifes. *149—157*

MONNOYER, JEAN-BAPTISTE

Born 1636 in Lille, died 1699 in London. Studied in Antwerp. Worked in France, from 1685 in England. Member of the Academy in Paris from 1665. Painted still lifes, mostly flower-pieces.

MONSIAUX, NICOLAS ANDRÉ

Born 1754 in Paris, died there 1837. Pupil of J. Peyron. From 1783 member of the Academy. Worked in Paris. Painted historical and mythological scenes. *83*

MONTICELLI, ADOLPHE JOSEPH

Born 1824 at Marseilles, died there 1886. From 1841 to 1844 attended the Marseilles art school, in 1846 moved to Paris, where for some time he took lessons from Delaroche. Eagerly copied old and contemporary masters in the museums of Marseilles and Paris. From 1862 to 1870 worked in Paris and Romainville. Was influenced by Díaz de la Peña and Delacroix. Painted lanscapes, park scenes, still lifes and portraits. *146*

MOREAU THE ELDER, LOUIS GABRIEL

Born 1739 in Paris, died there 1805. Painter, draughtsman and engraver. Studied under P. A. de Machy. From 1764 member of the Academy of St Luke in Paris. Worked in Paris. Painted landscapes. *71*

MOSNIER, JEAN LAURENT

Born 1743 in Paris, died 1808 in St Petersburg. Studied at the Academy of St Luke in Paris. From 1788 member of the Academy. Worked in Paris. From 1791 lived in London and in Hamburg, from 1802 in St Petersburg where he was elected to the Academy of Arts. Portrait painter. *94*

NATOIRE, CHARLES JOSEPH

Born 1700 at Nîmes, died 1777 at Castel-Gandolfo, Italy. Studied under L. Galloche and F. Lemoine. Worked in Rome (1723—29) and in Paris. From 1734 member of the Academy. From 1751 to 1771 director of the French Academy in Rome. Painted pictures on mythological and historical subjects. Produced a number of decorations (Hôtel de Rohan-Soubise, etc.) and several series of tapestry cartoons for the Beauvais and the Gobelin factories. *44*

NATTIER, JEAN-BAPTISTE

Born 1678 in Paris, died there 1726. Elder brother of the portraitist J. M. Nattier. Worked in Paris. Member of the Academy from 1712. Painted pictures on historical and biblical themes.

NATTIER, JEAN MARC

Born 1685 in Paris, died there 1766. Pupil of his father, M. Nattier, and of J. Jouvenet. From 1718 member of the Academy. Portrait painter. *42, 43*

OUDRY, JEAN-BAPTISTE

Born 1686 in Paris, died 1755 at Beauvais. Painter and draughtsman. Pupil of his father, Jacques Oudry, and of Largillière. From 1719 member of Academy, from 1726 worked at the Beauvais tapestry manufactory, and from 1736 was chief inspector of the Gobelin factory. Painted hunting scenes, still lifes and portraits. *41*

OZENFANT, AMÉDÉE

Born 1886 at Saint-Quentin, died 1966 in New York. After graduating from the La Tour art school at Saint-Quentin moved to Paris, where he worked at the Académie de la Palette under Ch. Cottet and J.-E. Blanche. Was influenced by the Cubists. Together with Le Corbusier invented Purism. Contributed to the magazines *L'Elan* (1915—17), *L'Esprit Nouveau* (1921—25), *La Peinture Moderne* (1925) and *L'Art* (1928). Was active as a painter and designed scenery. Worked extensively in the field of mural painting. Founded art academies in Paris, London, and New York. Since World War II lived in New York. Traveled widely, visiting England, Holland and Italy, and spent three years in Russia. *276*

PATER, JEAN-BAPTISTE FRANÇOIS

Born 1695 at Valenciennes, died 1736 in Paris. Studied under Watteau. Worked at Valenciennes and in Paris. From 1728 member of the Academy to which he was admitted as a painter of "modern motifs". Painted genre and battle scenes. *33*

PERIGNON, ALEXIS JOSEPH

Born 1806 in Paris, died there 1882. Studied under his father, A. N. Perignon, and A. Gros. Visited St Petersburg in 1852—53. Founded an art school and museum in Dijon.

PICASSO, PABLO RUIZ

Born 1881 at Málaga, in Spain, died 1973 at Mougins (Alpes Maritimes). First trained by his father, José Ruiz Blasco, a teacher of drawing, later attended the School of Fine Arts in Barcelona and the San Fernando Academy in Madrid. Came to Paris in 1900 and finally settled there in 1904. During the 1900s was influenced by Toulouse-Lautrec, painted café and racing scenes. His work of the Blue period (1901—4) is dominated by tragic themes; his Pink period (from 1905) yielded pictures of wandering actors, mountebanks and harlequins. From 1906 worked in the Cubist manner, becoming for some time the leader of Cubism. Between 1917 and 1921 designed décors for Diaghilev's *Ballets russes*. In the 1920s worked in the Classical and Expressionist manner. In 1937 created his famous monumental composition *Guernica*. In 1946 began to experiment with decorative ceramics at Vallauris. In 1947—50 produced a great number of lithographs and posters. In the 1950s created the series of paintings *Algerian Women* (1954), *The Artist's Studio* (1955—56) and *Menins* (1957). Illustrated Ovid's *Metamorphoses*, Balzac's *Chef-d'œuvre inconnu* and Buffon's *Natural History*. Executed the well-known posters representing the dove of peace, painted murals at Antibes and the large canvases *War* and *Peace* for the Chapel at Vallauris. In 1944 joined the French Communist Party. Was awarded the International Peace Prize. *256—266*

PIERRE, JEAN-BAPTISTE MARIE

Born 1713 in Paris, died there 1789. Studied under J. Natoire and F. de Troy. Was influenced by F. Boucher. Lived in Italy from 1735 to 1740. Worked in Paris. Member of the Academy from 1742, from 1770 its rector and *Premier peintre du Roi*. Painted pictures on biblical and mythological subjects. Also known for his engravings.

PISSARRO, CAMILLE

Born 1830 at St Thomas (Virgin Islands), died 1903 in Paris. From 1842 to 1847 was trained in Paris, then worked with the Danish painter F. Melbye in Venezuela. In 1855 returned to Paris and entered the Académie Suisse. Exhibited at the Salon des Refusés of 1863. Worked at Pontoise, Louveciennes, was influenced by Corot. In 1870 lived in England, where he met Monet. On his return to Paris took part in all Impressionist exhibitions. Painted with Cézanne at Pontoise. From 1884 on worked at Eragny. In 1886—88 was influenced by the Neo-Impressionists. Painted almost exclusively scenes of village life, rural landscapes and, later, views of Paris and Rouen, as well as portraits and still lifes. Produced etchings and lithographs. *160, 161*

POUSSIN, NICOLAS

Born 1594 at Andelys (Normandy), died 1665 in Rome. Studied under Q. Varin and later under N. Jouvenet in Rouen. From 1612 worked in Paris. Among his teachers were G. Lallemand and the Fleming F. Elle. In 1624 settled in Rome. In 1640—42 lived in Paris and was made *Premier peintre du Roi*. In 1642 returned to Rome. Painted pictures on historical, mythological and religious subjects. *2—5*

PRUD'HON, PIERRE PAUL

Born 1758 at Cluny, died 1823 in Paris. Painter and draughtsman. Studied at the Dijon Academy under F. Des Vosges. From 1778 pupil of J.-B. Pierre in Paris. From 1784 until 1789 lived in Italy. His art of the period was influenced by Leonardo and Correggio. From 1789 until 1794 resided in Paris. Between 1794 and 1796 lived in the province of Franche-Comté. In 1796 settled in Paris. Painted portraits as well as pictures on mythological, allegoric and religious subjects. He is also known as a decorative artist and book illustrator. *84*

PUVIS DE CHAVANNES, PIERRE

Born 1824 at Lyons, died 1898 in Paris. First studied painting under Scheffer, spent some time in Italy and then frequented for a short period the studios of Couture and Delacroix. On his return from Italy worked chiefly as a mural painter in the manner of the Italian primitivists. Executed mural decorations for the Panthéon, the Sorbonne and the Hôtel de Ville in Paris, as well as for a number of public buildings at Amiens, Lyons, Marseilles, Poitiers, Rouen and Boston. *212*

PUY, JEAN

Born 1876 at Roanne, died there 1960. Studied in Lyons under L. Toll and later (1898) in Paris under J.-P. Laurens and E. Carrière. Painted landscapes and interior scenes.

QUILLARD, ANTOINE

Born around 1704 in Paris, died 1733 in Lisbon. Painter and engraver. Pupil of the Academy, he was strongly influenced by Watteau. Worked in Paris and in Lisbon. From 1725 was Court Painter to John V of Portugal. Painted religious and mythological scenes, later *fêtes galantes*. *32*

RAFFAËLLI, JEAN-FRANÇOIS

Born 1850 in Paris, died there 1924. Studied under J.-L. Gérôme, was influenced by C. Monet. Painted mostly townscapes.

RAOUX, JEAN

Born 1677 at Montpellier, died 1734 in Paris. Pupil of A. Ranc and Bon Boullogne. Worked in Paris and in Italy (1704—14). From 1717 member of the Academy. In 1720—21 visited London. Painted genre and mythological scenes and portraits. *38, 39*

REDON, ODILON

Born 1840 in Bordeaux, died 1916 in Paris. Studied under Gérôme in Paris; R. Bresdin in Bordeaux introduced him to engraving. Was influenced by Moreau. Fantin-Latour advised him to take up lithography. Visited Belgium, Italy, Holland and Spain. In addition to paintings, produced many pastels, lithographs and a number of cartoons for tapestries. *210*

REGNAULT, JEAN-BAPTISTE

Born 1754 in Paris, died there 1829. Studied under J. Bardin and B. Lépicié. Lived in Italy from 1771 to 1775, a year later was sent there again by the Academy. Worked in Paris. Exhibited at the Salon from 1783 to 1809. Member of the Academy from 1783, of the French Institute from 1795. Painted pictures on biblical and mythological themes. Also known for his engravings.

RENOIR, PIERRE AUGUSTE

Born 1841 at Limoges, died 1919 at Cagnes-sur-Mer. At sixteen painted flowers and embellishments in the Louis XVI style on porcelain; decorated fans and blinds. In 1862 entered the Ecole des Beaux-Arts, where at the Atelier Gleyre he met Sisley, Frédéric Bazille and Monet. From 1864 onwards exhibited at the Salon almost annually. Took part in the first Impressionist exhibition. During the early period of his artistic career came under the influence of Díaz de la Peña, Courbet and Delacroix. From 1872 was influenced by Monet and the Impressionists. In 1881 visited Italy. By 1883 had departed from the principles of pure Impressionism; under the influence of Ingres became attracted to drawing and adopted a more academic manner of painting. In 1890 returned to his previous, freer technique. Afrer visiting Algeria, Spain, Holland, England and Germany, settled at Cagnes in 1906. Painted genre scenes, portraits, nudes and landscapes. Worked as a sculptor and engraver. *164—168*

RESTOUT, JEAN-PIERRE

Born 1692 in Rouen, died 1768 in Paris. Pupil of J. Jouvenet. Worked in Paris. Member of the Academy from 1720, director from 1760. Painted canvases on biblical and mythological themes.

RICHARD, FLEURY FRANÇOIS

Born 1777 in Lyons, died there 1852. Pupil of L. David. Worked in Lyons. Exhibited at the Paris Salon from 1801 to 1839. Painted genre scenes peopled by historic personages.

RIESENER, HENRI FRANÇOIS

Born 1767 in Paris, died there 1828. Pupil of F. A. Vincent and L. David. Worked in Paris. From 1816 to 1823 lived in Warsaw, St Petersburg and Moscow. Portrait painter, also known as a miniaturist.

RIGAUD, HYACINTHE

Born 1659 at Perpignan, died 1743 in Paris. Pupil of the Academy from 1682, its member from 1700, its rector and director from 1733. Worked in Paris. Painted portraits. *30*

RIVIERE, Mlle

Mlle Rivière's first name and dates of her birth and death are unknown. Worked in Paris in the first quarter of the nineteenth century. From 1806 to 1819 exhibited at the Salon. Painted portraits and genre scenes. *92*

ROBERT, HUBERT

Born 1733 in Paris, died there 1808. Painter and draughtsman. Pupil of Ch. Natoire. Worked in Italy (1754—65) and in Paris. From 1767 member of the Academy. Painted decorative landscapes, ruins and views of classical architecture. *74—77*

ROBERT, LÉOPOLD LOUIS

Born 1794 in Chaux-de-Fonds (Neuchâtel), died 1835 in Venice. Lived in Paris from 1810 to 1816, studying there under L. David, A. Gros and Ch. Girardet. From 1818 to 1823 worked in Rome, later in Venice. Painted mostly landscapes and scenes from the life of Italian peasants; also known for his engravings and lithographs.

ROBILLARD, HIPPOLYTE

Active in the mid-19th century. Exhibited at the Salon from 1831 to 1841. From 1842 to 1855 lived in Russia. Painted in oils and pastels.

ROUAULT, GEORGES

Born 1871 in Paris, died there 1958. As a youth, he was apprenticed to a maker of stained glass and attended evening classes at the Ecole des Arts Décoratifs under Delaunay and Moreau (1892—94). Was active as a painter, engraver, book illustrator (Baudelaire, Rabelais), monumental artist (stained-glass windows for the church of Plateau d'Assy) and stage designer (décor and costume designs for Diaghilev's production of *Le Fils prodigue*). Executed tapestry cartoons. Most of his works are scenes from the life of itinerant actors and clowns; he also painted genre and religious pictures. *251*

ROUSSEAU, HENRI

Born 1844 at Laval (Mayenne), died 1910 in Paris. Upon graduating from a lycée at Laval, probably did his military service in a brass band during the Mexican campaign in 1861—67, and was a sergeant in the Franco-Prussian War of 1870—71. Worked in the Paris customs office, hence his nickname *Le Douanier*. At the age of forty left his job and founded an academy (*Association Philotechnique*) where he taught painting and music. From 1885 exhibited at the Salon des Indépendants, from 1905 at the Salon d'Automne. A self-taught artist, he painted genre and fantastic scenes, exotic landscapes, views of Paris suburbs and portraits. *221—223*

ROUSSEAU, THÉODORE

Born 1812 in Paris, died 1867 at Barbizon. Pupil of Ch. Rémond and Guillon-Lethière. Worked in Paris, in its suburbs and in the provinces of France. In 1847 settled at Barbizon, a village near Paris. One of the founders and main figures of the Barbizon School. *114, 115*

ROUSSEL, KER XAVIER

Born 1867 in Lorry-les-Metz, died 1944 in L'Etang-la-Ville. From 1888 to 1890 studied at the Académie Julian and the Ecole des Beaux-Arts. In 1908 taught at the Académie Ranson. Painted landscapes, was also active as a decorator, pastelist, graphic artist and lithographer.

SANTERRE, JEAN-BAPTISTE

Born 1657 in Magny-en-Vexin, died 1717 in Paris. Pupil of F. Lemaire and Bon Boulogne. Worked in Paris. Member of the Academy from 1704. Portrait painter.

SCHEFFER, ARY

Born 1795 in Dordrecht, died 1858 in Argenteuil. Came to Paris in 1812. Studied under P. N. Guérin. Was influenced by E. Delacroix. Exhibited at the Salon from 1812. Painted portraits and canvases on historical and literary subjects.

SIGNAC, PAUL

Born 1863 in Paris, died there 1935. A pupil of Bing, in the beginning of his career he was influenced by the Impressionists. Follower of Seurat. From 1882 the most vocal theorist of Neo-Impressionism; his book *D'Eugène Delacroix au Néo-Impressionnisme* (1899) was the textbook of this movement. Exhibited in 1884 at the first Salon des Artistes Indépendants, then in 1886 at the eighth and last exhibition of Impressionists. Concentrated above all on landscapes. *204, 205*

SIMON, LUCIEN

Born 1861 in Paris, died there 1945. Studied under J. Didier, then at the Académie Julian and under T. Robert-Fleury. Painted portraits and scenes from the life of Breton fishermen.

SISLEY, ALFRED

Born 1839 in Paris, died 1899 at Moret-sur-Loing. Entered the Atelier Gleyre in Paris in 1862 and there met Monet, Renoir and Bazille. In the beginning of his career was influenced by Corot, Courbet and Daubigny. Worked at Marlotte (1866), Honfleur (1867), Bougival and Louveciennes. Between 1870 and 1875 painted at Marly. In 1875—79 lived at Sèvres, in 1882 settled at Moret-sur-Loing. Visited England in 1857, 1874 and 1897. Took part in the Impressionist exhibitions of 1874, 1876, 1877 and 1882. Painted almost exclusively landscapes. *158, 159*

STEINLEN, THÉOPHILE

Born 1859 at Lausanne, died 1923 in Paris. From 1878 on lived in Paris, in 1901 became a French subject. His artistic legacy includes drawings, lithographs, posters, book illustrations and paintings. Contributed to several progressive magazines, newspapers and satirical publications. Derived his subjects from the life of Parisian streets as well as from the life and struggle of the working class. *203*

SUBLEYRAS, PIERRE

Born 1699 at Saint-Gilles-du-Gard (Languedoc), died 1749 in Rome. Studied under his father, M. Subleyras, and later, in Toulouse, under A. Rivalz. From 1726 lived in Paris, from 1728 in Rome. Painted religious scenes and portraits. *56*

SURVAGE (STÜRZWAGE), LÉOPOLD

Born 1879 in Moscow, died 1968 in Paris. Studied at the School of Painting, Sculpture and Architecture in Moscow under L. Pasternak and K. Korovin. In 1908 moved to Paris, where he shared a studio with Matisse. Took part in Cubist exhibitions, also did fresco painting.

SWEBACH, JACQUES-FRANÇOIS-JOSEPH

Born 1769 at Metz, died 1823 in Paris. Painter, engraver, lithographer and porcelain painter. Pupil of M. Duplessis. From 1802 to 1813 worked for the Sèvres porcelain factory; from 1815 to 1820 for the Imperial porcelain factory in St Petersburg. Painted landscapes, genre scenes and pictures on historical subjects. *90*

TARAVAL, HUGUES

Born 1729 in Paris, died there 1785. From 1732 to 1750 lived in Sweden. Pupil of his father, Guillaume Taraval, with whom he painted murals in the royal palace in Stockholm. In 1750 moved to Paris and there studied under J.-B. Pierre. From 1769 member of the Academy in Paris, from 1775 of the Academy in Stockholm. From 1783 inspector of the Gobelin factory. Painted pictures on mythological and allegorical subjects, worked extensively on decorative paintings. *53*

TASLITZKY, BORIS

Born 1911 in Russia, lives and works in Paris. Studied under J. Lipchitz, then in Paris at the Ecole des Beaux-Arts. Studied carpet design under J. Lurçat. Painter and graphic artist.

TAUNAY, NICOLAS ANTOINE

Born 1755 in Paris, died there 1830. Pupil of N. B. Lépicié, F. Casanova and N. Brun. Worked in Paris. From 1784 to 1787 was in Italy. From 1795 member of the French Institute. From 1816 to 1824 lived in Brazil where he established the Academy of Arts in Rio de Janeiro. Painted landscapes, genre, battle and mythological scenes. *87*

TOCQUÉ, LOUIS

Born 1696 in Paris, died there 1772. Studied under J. M. Nattier. Worked in Paris. From 1734 member of the Academy. Between 1756 and 1758 stayed in St Petersburg where he painted a portrait of Empress Elizaveta Petrovna. In 1758—59 worked in Copenhagen. Portrait painter. *55*

TOULOUSE-LAUTREC, HENRI DE

Born 1864 at Albi (Tarn), died 1901 at the Château de Malromé (Gironde). A pupil of René Princeteau and John Lewis Brown. In 1882 entered the studio of Bonnat in Paris, later studied under Cormon. Was influenced by Degas and the Impressionists. Worked as a painter and draughtsman, left a large number of posters, illustrations and lithographs. Found inspiration in the night life of Paris, in dance-halls, cabarets and circuses; painted portraits of artists and writers. *190*

TOURNIÈRES, ROBERT

Born 1667 at Caen, died there 1752. Studied under Bon Boulogne. Worked in Paris. From 1702 member of the Academy. Painted portraits, mythological and genre scenes. *17*

TROY, FRANÇOIS DE

Born 1645 at Toulouse, died 1730 in Paris. In his youth went to live in Paris where his teachers were N. Loir and C. Lefèvre. From 1674 member of the Academy, from 1708 its director. Painter of historical subjects and portraits. *22*

TROY, JEAN FRANÇOIS DE

Born 1679 in Paris, died 1752 in Rome. Studied under his father, François de Troy. Worked in Paris and from 1699 in

Italy. From 1708 member of the Academy, from 1738 director of the French Academy in Rome. Painted mythological, biblical and genre scenes as well as portraits. Worked for the Gobelin factory. *21*

TROYON, CONSTANT

Born 1810 at Sèvres, died 1865 in Paris. Began his career as a porcelain painter at the Sèvres porcelain factory, later studied drawing under A. Poupart. From 1833 exhibited at the Salon. Visited Holland and Belgium in 1847—48, England in 1853. From the 1840s lived at Barbizon where he worked with Dupré, Rousseau and other painters of the Barbizon group. Painted landscapes and animal scenes. *122—124*

UTRILLO, MAURICE

Born 1883 in Paris, died 1955 at Dax (in the Landes). A pupil of his mother, Suzanne Valadon, he received no academic artistic training. Was influenced by Monticelli and the Impressionists. His paintings are almost all views of Paris, sometimes done from picture postcards. Painter, lithographer and etcher. In 1926 produced sets and costume designs for Diaghilev's *Ballets russes*. *255*

VALENTIN DE BOULOGNE

Born 1594 at Coulommiers, died 1632 in Rome. From 1614 lived and worked in Italy and there was strongly influenced by Caravaggio. Painted pictures on religious and genre subjects. *1*

VALTAT, LOUIS

Born 1869 at Dieppe, died 1952 in Paris. From 1888 studied at the Académie Julian, in 1889 was a pupil in the studio of Moreau at the Ecole des Beaux-Arts in Paris. Was influenced by Van Gogh and the Neo-Impressionists. From 1904 exhibited with the future Fauves. Painted landscapes and still lifes, executed stage designs and made ceramics. Traveled widely in France, visited Spain, Italy and Algeria. *247, 248*

VAN DONGEN, KEES

Born 1877 at Delfshaven, near Rotterdam, died 1968 at Monte Carlo. A Dutchman by birth, he lived and worked in Paris from 1897. Was granted French citizenship in 1929. At first contributed drawings to satirical magazines, was influenced by Steinlen, then took to painting. Before 1905 worked in the Impressionist and Neo-Impressionist manner, from 1905 associated with the Fauves. Painted scenes from the life of actresses, dancers, singers and models. Later on produced a number of portraits of statesmen, writers and journalists. Illustrated the works of Margueritte, Kipling, Choderlos de Laclos. Visited Morocco, Egypt and Spain. *253, 254*

VAN GOGH, VINCENT

Born 1853 in Groot-Zundert in the Netherlands, died 1890 at Auvers-sur-Oise. An assistant in a bookshop, then a teacher in London, he became a voluntary evangelist in the coal mines of the Borinage district in Belgium. Began work as a painter after having taken first lessons from Anton Mauve in The Hague. From 1886 attended the Atelier Cormon in Paris. Was influenced by the Impressionists and the Neo-Impressionists. In 1888 worked at Arles, in 1889 at Saint-Rémy-de-Provence, in 1890 at Auvers-sur-Oise. Under the strain of mental disease committed suicide. First worked in the manner of "pure old Dutch painting" and painted peasants, miners and weavers, the interiors of working-class houses, and still lifes. Coming to France, he created portraits, landscapes and still lifes notable for their highly expressive artistic form. *185—189*

VANLOO, CARLE

Born 1705 at Nice, died 1765 in Paris. Pupil of his brother, J.-B. Vanloo, and, later, of the sculptor P. Legros and of B. Louti in Paris. Worked in Rome (1727—34) and in Paris. From 1735 member of the Academy, from 1763 its director. Painted pictures on religious and mythological subjects, portraits and scenes of society life. Author of several monumental murals and of cartoons for the Gobelin factory. *54*

VANLOO, LOUIS MICHEL

Born 1707 in Toulon, died 1771 in Paris. Pupil of his father, J.-B. Vanloo. From 1727 to 1732 lived in Rome; from 1736 to 1753 was Court Painter to Philip V of Spain. *63*

VERNET, ANTOINE FRANÇOIS

Born 1730 in Avignon, died 1779 in Paris. Pupil and emulator of his brother Claude Joseph Vernet. Worked in Paris. Painted landscapes.

VERNET, JOSEPH

Born 1714 at Avignon, died 1789 in Paris. Was trained under his father, Antoine Vernet, and the seascape painters B. Forgioni and A. Manglard. From 1734 to 1753 worked in Italy. Between 1754 and 1762, while working on the *Ports of France* series commissioned by Louis XV, he visited Toulon, Bordeaux, Antibes, La Rochelle and other French towns. From 1762 lived in Paris. Painted seascapes. *59—61*

VERNET, HORACE

Born 1789 in Paris, died there 1863. Painter and lithographer. Pupil of his father C. Vernet and of F. A. Vincent. Worked in Paris and in Rome. From 1829 to 1835 director of the French Academy in Rome. In 1836 and 1842—43 visited St Petersburg. Painted battle and historical scenes and portraits. *105*

VEYRASSAT, JULES JACQUES

Born 1828 in Paris, died there 1893. Studied with Ch. T. Frère, F. Besson and Ch. F. Daubigny. Was influenced by the Barbizon School. Landscape and animal painter.

VIGÉE-LEBRUN, ÉLISABETH LOUISE

Born 1755 in Paris, died there 1842. Pupil of her father, L. Vigée, and of G. Briard and F. Doyen; was influenced by Greuze. From 1783 member of the Academy. Worked in Paris until 1789, when she left France for Italy and Vienna. From 1795 to 1801 lived in St Petersburg (member of the St Petersburg Academy from 1800), subsequently visited England, Holland and Sweden. In 1809 returned to France. Painted portraits. *85*

VINCENT, FRANÇOIS ANDRÉ

Born 1746 in Paris, died there 1816. Pupil of J.-M. Vien. Lived in Rome from 1767 to 1770. Worked in Paris, exhibited at the Salon from 1777 to 1801. Member of the Academy from 1782. Painted portraits and pictures on historical and mythological themes.

VLAMINCK, MAURICE DE

Born 1876 in Paris, died 1958 at Rueil-la-Gadelière. A self-taught artist. Shared a studio with Derain at Chatou (1903—7). From 1904 exhibited at the Salon des Indépendants. One of the first Fauves who exhibited at the Salon d'Automne in 1905. Painted almost exclusively landscapes and portraits, produced drawings, book illustrations, ceramics and stage designs, made cartoons for tapestries. *249, 250*

VOILLE, JEAN-LOUIS

Born 1744 in Paris, died after 1803. Pupil of Drouais the Younger. From 1770 worked in St Petersburg. Painted portraits. *80*

VOLLON, ANTOINE

Born 1833 at Lyons, died 1900 in Paris. From 1851 studied under Vibert at the Ecole des Beaux-Arts in Lyons; from 1858 exhibited at Lyons; from 1864 at the Salon in Paris. Painted mainly genre scenes and still lifes. *144*

VOUET, SIMON

Born 1590 in Paris, died there 1649. Studied under his father, L. Vouet. Worked in London in his early youth, visited Constantinople in 1611—12. From 1614 to 1627 lived in Italy where he fell under the influence of Caravaggio and the Bolognese

school. In 1627 returned to Paris to become Court Painter to Louis XIII. Painted pictures on religious, mythological and allegorical themes, and also large decorative pieces. *6*

VUILLARD, ÉDOUARD

Born 1868 at Cuiseaux (Saône-et-Loire), died 1940 at La Baule (Loiret). Trained in the Atelier Maillart (1887), the Ecole des Beaux-Arts under Gérôme (1888) and later at the Académie Julian. Joined up with Bonnard and Roussel who formed the "Nabi" group. In 1894 painted the series of panels *The Gardens of Paris*. In 1913 produced the decorative panels for the Théâtre de la Comédie des Champs-Elysées (with Bonnard), in 1936 for the building of the League of Nations in Geneva (with Roussel and Denis), and in 1937 for the Palais de Chaillot in Paris (with Roussel and Bonnard). Visited Italy, Switzerland, Holland and Spain. Lived and worked mainly in Paris, spent long periods in Normandy and Brittany. Was active as a painter, lithographer and stage designer. *213, 214*

WATELET, LOUIS ÉTIENNE

Born 1780 in Paris, died there 1866. Worked in Paris. Exhibited at the Salon from 1800 to 1857. Visited Belgium, the Tyrol and Italy. Landscape painter, also known as a lithographer.

WATELIN, LOUIS FRANÇOIS VICTOR

Born 1835 in Paris, died there 1907. Worked in Paris. Exhibited at the Salon from 1870. Member of the Société des Artistes Français. Landscape painter.

WATTEAU, ANTOINE

Born 1684 at Valenciennes, died 1721 in Paris. Painter, engraver and draughtsman. In 1702 went to Paris and studied with C. Gillot and C. Audran. Worked in Paris. During 1709—10 re-visited Valenciennes. From 1717 member of the Academy. In 1720 visited England. Painter of battle and theatrical scenes, *fêtes galantes*, genre pictures and portraits. *27, 28*

WICAR, JEAN-BAPTISTE

Born 1762 in Lille, died 1834 in Rome. Studied at the school of drawing in Lille, from 1776 in Paris under L. David, with whom he went to Italy in 1785, staying there until 1794. In 1796 was sent to Italy to select works of art to be brought to France. Lived in Rome since 1805. Painted pictures on historical themes and portraits.

WILLE, PIERRE ALEXANDRE

Born 1748 in Paris, died there 1821. Studied under his father, G. Wille, and J.-B. Greuze. Worked in Paris. Exhibited at the Salon from 1775 to 1819. Painted pictures of everyday life.

ZAMBAUX, ROBERT

Date of his birth unknown; worked in the 1950s. Painted pictures of everyday life.

ZIEM, FÉLIX PHILIBERT

Born 1821 in Beaune, died 1911 in Paris. Studied at the Architectural School in Dijon. Visited Turkey and Russia in 1841—43. Worked in Paris, Nice and Italy. Landscape painter.